D1307072

American Paintings in the Metropolitan Museum of Art

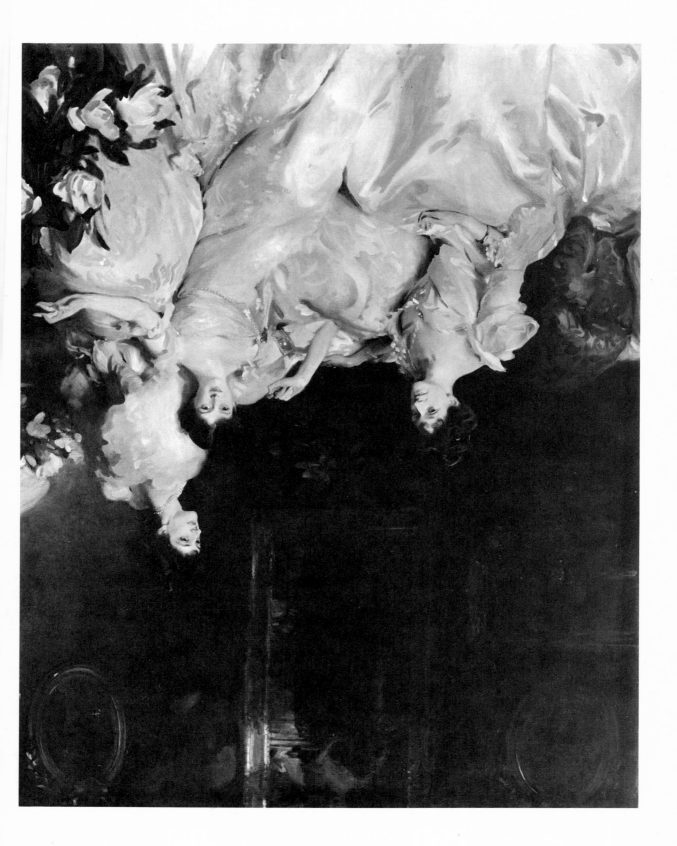

FOREWORD

An essential part of the museum's mission is to provide information on numerous levels and in varying degrees to its widespread and diverse public. One of the most effective means for such communication is through publications, more specifically complete and detailed assessments of the permanent collections. The Department of American Paintings and Sculpture has for some time been involved in such an endeavor. This three-volume catalogue is the realization of such work. Not only will the catalogue be of special use to the general public in its direct and easily comprehensible style and informative text but also it will be an invaluable tool for scholars because of the references and scholarly substance. In turn, the catalogue, the definitive and comprehensive publication of the museum's holdings in American paintings, gives the most current overview of the collection, its strengths and weaknesses.

The publication auspiciously marks the opening of the Metropolitan Museum's new American Wing, which includes the installation of American painting and sculpture galleries, and provides visitors with an indispensable record of its collection of American paintings. Additional information will be conveyed by such other means as audioguides, explanatory labels, gallery lectures, guidebooks, lecture programs, symposia, and similar projects. Such programs will give due recognition and rightly celebrate this long-awaited and immensely important new installation of the museum's finest American paintings and sculptures.

We are deeply indebted to the Ford Foundation for the funding that initiated the project and to the Surdna Foundation for the generous support that has made this publication a reality.

<div align="right">

Philippe de Montebello, *Director*

</div>

PREFACE

THE Metropolitan Museum of Art was established in 1870 following lengthy discussion and dedicated, organized activity by a diverse group of New York's social, religious, mercantile, academic, and artistic leaders. These men arranged the public and political support which allowed formation of the first general museum of art in this country. An early committee report of that year stated that the primary goal of the pioneering institution was to bring together and display "a more or less complete collection of objects illustrative of the history of Art from the earliest beginnings to the present time." Subsumed within this broader aim was the firmly held idea, stated by the leading spokesman for the founders, William Cullen Bryant, that New York City and the nation required "an extensive public gallery to contain the greater works of our painters and sculptors." The idea found ready support in the meetings which led to the museum's foundation, from a numerous group of painters, many of whose names are familiar today and most of whose works are represented in the museum's collection: George A. Baker, Albert Bierstadt, Walter Brown, Frederic E. Church, Vincent Colyer, Christopher Pearse Cranch, R. Swain Gifford, Sanford Gifford, Henry Peters Gray, William Hart, Daniel Huntington, Eastman Johnson, John F. Kensett, John La Farge, Louis Lang, Thomas Le Clear, Jervis McEntee, Aaron Draper Shattuck, Oliver William Stone, Arthur F. Tait, and Worthington Whittredge. Of these Church, Johnson, and Kensett became original trustees of the museum, insuring that the institution would actually collect and display paintings by American artists. The first American painting to enter the collection, Henry Peters Gray's *Wages of War*, was received in 1873. Since then over 1600 American paintings by about 800 artists have entered the collection through purchase, gift, and bequest. Of these, some 950 paintings by approximately 400 artists born before 1876 are the holdings of the Department of American Paintings and Sculpture. The museum's collection of American paintings, given its overall quality and comprehensiveness, is perhaps the finest that exists in public or private hands.

The importance of the collection, and the fact that no scholarly catalogue of it existed, induced the Metropolitan, under the directorship of the late James Rorimer, to prepare one. The Ford Foundation awarded a grant in support of the project in 1963. The late Albert Ten Eyck Gardner, who had previously compiled *A Concise Catalogue of the American Paintings in the Metropolitan Museum of Art* in 1957, and Stuart P. Feld began the project aiming to produce a three-volume publication that would incorporate all American painters represented in the collection who were born before 1876. *American Paintings: A Catalogue of the Collection of the Metropolitan Museum of Art*, Volume I, which included painters born by 1815, prepared by Gardner and Feld, was published in 1965. Subsequently the staff and volunteers in the Department of American Paintings and Sculpture continued to do research and write entries, but with the steady growth of the collection and the rapid acceleration of research, publication, and revision of ideas in the field of American art history, it was determined some years ago to completely revise the existing Volume I and to select a new larger format for the three volumes

projected. The museum received two generous grants from the Surdna Foundation in 1976 and 1978, which made this major undertaking possible. Additional staff was hired to allow the publication of the books in conjunction with the opening of the American Wing.

The three-volume *American Paintings in the Metropolitan Museum of Art* is arranged chronologically by the dates of the artists. Paintings by artists born before 1816 can be found in Volume I. Volume II consists of paintings by artists born from 1816 through 1845. Volume III is a catalogue of paintings by artists born from 1846 through 1864. We hope that a catalogue of the subsequent material, paintings by artists born after 1864, can be prepared at a later time. Meanwhile some information on works in the museum by such painters from that period as Robert Henri, John Sloan, George Luks, William Glackens, and Ernest Lawson can be found in Henry Geldzahler's *American Paintings in the Twentieth Century* (1965). Paintings by American artists born from 1876 on are presently in the care of the Twentieth Century Art Department.

We are extremely grateful for the generosity of the many people who assisted us in the preparation of these volumes. A publication of this size and scope reflects the work of many people in the field and to a great extent the present state of scholarship. We hope that these volumes will add to the knowledge of American art and that where there are gaps, scholars will be inspired to fill them.

John K. Howat
*Curator of American Paintings
and Sculpture*

ACKNOWLEDGEMENTS

We are grateful for the assistance provided over many years by many people and institutions. First of all, we are indebted to our colleagues on the museum staff. Work on this volume was begun under the directorship of Thomas Hoving and continued with the warm support of our current director Philippe de Montebello. James Pilgrim, deputy director of the museum, and Inge Heckel, manager of the Office of Development and Promotion, skillfully guided the initial planning of the project and later anticipated and helped solve many difficulties. Ashton Hawkins, vice president, secretary and counsel, and Penelope K. Bardel, associate secretary and counsel, kindly advised us on a number of legal questions. We are also grateful to Richard Dougherty, vice president for Public Affairs, and Bradford Kelleher, vice president and publisher. The curatorial staff of other departments shared information on their areas of special interest. Marilynn Johnson Bordes and Morrison H. Heckscher of American Decorative Arts and James David Draper, James Parker, and Clare Vincent of European Sculpture and Decorative Arts kindly identified sculpture, furniture, and decorative objects. Laurence Libin of Musical Instruments enthusiastically researched instruments and sheet music for us. Stella Blum, Mavis Dalton, Paul M. Ettesvold, and Helga Kessler of the Costume Institute assisted with the descriptions and dating of costumes. David W. Kiehl of Prints and Photographs shared his extensive knowledge of American prints and drawings. Lowery S. Sims and Ida Balboul of Twentieth Century Art facilitated our research on Louis M. Eilshemius, John Kane, and Anna (Grandma) Moses. We are grateful to John M. Brealey of Paintings Conservation and his staff, Wynne Beebe, Alain Goldrach, and especially Dianne Dwyer who constantly shared with us her knowledge of condition, technique, and aesthetics. Marjorie Shelley of Paper Conservation kindly advised us about works on paperboard. Pieter Meyers of the Research Laboratory, his assistant Maryan W. Ainsworth, and his colleagues at Brookhaven National Laboratory took and interpreted radiographs and autoradiographs of works by Ralph Blakelock, Thomas W. Dewing, and Albert Pinkham Ryder. Their scientific information added greatly to our knowledge of these paintings. Others on the museum staff assisted us by locating and verifying detailed information on the histories of the paintings. Patricia Pellegrini and her staff in Archives, Judith V. Cameron, Gaile Labelle, Frances Oakley, and Jeanie Rengstorff have searched their files for letters and other records pertinent to the museum's acquisition of paintings. Herbert Moskowitz, Laura Rutledge Grimes, and Caryn S. Reid of the Office of the Registrar, and Marica Vilcek and her staff in the Catalogue Department have checked innumerable details about loans and exhibitions. We are also grateful to Mark D. Cooper and Walter J. F. Yee of the Photograph Studio for their constant attention. A research project of this type would have been difficult without the cooperation of Elizabeth R. Usher and her capable staff in the Library of the Metropolitan Museum of Art. We thank David Turpin, Ida Gardner, Ljuba Backovsky, and Céline Palatsky for their efforts on our behalf and Patrick Coman, Melvin Rosen, Philip D'Auria, and Albert Torres for their daily assistance.

Many volunteers and interns in the Department of American Paintings and Sculpture have

contributed to the completion of volume three. We thank John Adler, Gina D'Angelo, Elisabeth Quackenbush, Shelby Roberts, Rebecca Tennen, and Barbara A. L. Woytowicz. Virginia Thors kindly ordered and selected photographs for the book, and Marjorie Reich researched and wrote early drafts on Elliott Daingerfield, Robert Reid, and Edmund C. Tarbell. Marilyn Handler and later Jo-Nelle D. Long assisted in checking many details for this publication and also directed the volunteers and interns.

Many of the artists included in this volume painted well into the twentieth century and, as a result, we were sometimes able to contact their families. Among those who shared papers and personal reminiscences with us were: James Alexander on his brother Henry Alexander, Elizabeth R. Anshutz on her father-in-law Thomas Anshutz, Ernesta Drinker Barlow on her aunt Cecilia Beaux, Frank Benson Lawson on his grandfather Frank W. Benson, William L. Bauhan on his grandfather William L. Lathrop, Nancy D. Bowditch on her father George de Forest Brush, Cora Weir Burlingham on her father J. Alden Weir, H. Russell Butler, Jr., on his father Howard Russell Butler, Margaret Chalfant on her father-in-law Jefferson D. Chalfant, Caroline P. Ely on her grandfather J. Alden Weir, C. Levon Eksergian on his father Carnig Eksergian, Mary A. S. Evans on Caroline A. Cranch, Mrs. Henry Clay Frick on her grandfather George de Forest Brush, Julia K. Gibbons on her grandfather James Jebusa Shannon, Ralph Lawson, Jr., on his grandfather Frank W. Benson, J. Bradford Millet and the late John A. P. Millet on Frank D. Millet, Mrs. Gregory Smith on her grandfather J. Alden Weir, and Hubert D. Vos on his grandfather Hubert Vos. Several descendents of the subjects of our portraits were also helpful. We are grateful for information provided by Thomas Avegno on Madame Pierre Gautreau, Mrs. Douglas Delanoy on Mrs. Henry Galbraith Ward, Mrs. Hadden Fairburn on Charlotte Louise Burckhardt, Susan C. Kennedy on Roland Chase, Kate Lefferts on Alexander Stewart Wetherill, Mrs. Edwin K. Merrill on Edith Minturn Stokes, Mrs. Joseph J. Morsman, Jr., and Mrs. Charles J. Stevens on Hugo Reisinger, William Platt on Eleanor Hardy Bunker, and Alan H. Wright on Alan Harriman.

Scholars who have studied the work of individual artists and patrons responded generously to our requests for information. We thank Lloyd Goodrich, who not only granted us access to his unpublished notes on Albert Pinkham Ryder and Ralph Blakelock but also read and corrected the entries on those artists. The late David McKibbin kindly answered many questions about John Singer Sargent and shared with us material he had gathered over several decades. We are especially grateful to William H. Gerdts, who provided information on several still-life painters; Ronald G. Pisano, who gathered much of the material in our entries on William Merrit Chase and Ruger Donoho; and H. Barbara Weinberg, who shared her information on Frank D. Millet, Robert Reid, and the collector Thomas B. Clarke. The following people also gave us important information: Eleanor S. Apter on Katherine S. Dreier; Leon A. Arkus on John Kane; Elizabeth Bailey on Cecilia Beaux; John I. H. Baur on Theodore Robinson and Stacy Tolman; Madeleine Fidell Beaufort on Samuel P. Avery; Richard Boyle on John H. Twachtman; Thomas Brumbaugh on Abbott H. Thayer; Roy Davis on Maurice Prendergast; Elizabeth de Veer on Willard L. Metcalf; Dorothy Farr on Horatio Walker; Susan Faxon on Frank W. Benson and Edmund C. Tarbell; Stuart P. Feld on Childe Hassam; Edward J. Foote on Frederick MacMonnies; Kathleen A. Foster on Edwin Austin Abbey; Alfred Frankenstein on William Michael Harnett, John F. Peto, and Henry Alexander;

R. H. Ives Gammel on Dennis Miller Bunker; Norman A. Geske on Ralph Blakelock; Mary Anne Goley on John White Alexander; Frank H. Goodyear, Jr., on Cecilia Beaux; Joan H. Gorman on Jefferson D. Chalfant; Denise Browne Hare on Anna Klumpke; Peter Hassrick on Frederic Remington; Sandra D. Heard on Thomas Anshutz; Susan Hobbs on Thomas W. Dewing; Donelson F. Hoopes on Alexander Pope; D. Roger Howlett on Ignaz M. Gaugengigl; the late Otto Kallir on Anna (Grandma) Moses; Cecily Langdale on Maurice Prendergast; Richard Murray on Kenyon Cox; Richard Ormond on John Singer Sargent; Michael Quick on Edwin Austin Abbey and John Singer Sargent; Lilian M. C. Randall on George A. Lucas; Richard S. Reid on Gari Melchers; Gary Reynolds on Walter Gay and Louis Comfort Tiffany; William H. Truettner on William T. Evans; Edwin A. Ulrich on Frederick J. Waugh; Bruce Weber on Robert Blum; Mary Ellen Hayward Yehia on Dwight W. Tryon; and Judith Zilczer on John Quinn.

Several divisions and bureaus of the Smithsonian Institution have facilitated this research. The Archives of American Art, a valuable source of letters, diaries, sketches, exhibition catalogues, and art gallery records, provided much of the manuscript material that was used. We are most grateful to William Wolfenden and Garnett McCoy for making the collection and their staff in the New York and Washington offices available to us. Arthur Breton guided us through the collection, directed us to the descendents of some artists, and often brought pertinent material to our attention. We thank him for his patience and enthusiasm. Nancy Zembala, Judy Throm, Ann Ferrante, Alicia Stamm and others in the Washington office performed innumerable day-to-day services. In the New York office, we thank Butler Coleman, Jemison Hammond, and Paul Cummings. At the Inventory of American Paintings, first Abigail Booth Gerdts and then Martha Shipman Andrews were most helpful in locating paintings related to works in our collection. We owe a special debt to William B. Walker and the ever-helpful staff of the Library of the National Collection of Fine Arts and the National Portrait Gallery. The entire staff of this library has extended itself on our behalf, but we are particularly grateful to Katharine Ratzenberger and Susan Rothwell.

Much of the detailed information included in this volume came from obscure exhibition catalogues, museum publications, books, and articles on little known sitters and artists. These were often provided by the staff of institutions and organizations throughout the country. We are particularly grateful to Galya Gorokhoff, Yale University Art Gallery; Linn Hardenburgh, Art Institute of Chicago; Laura C. Luckey and Barbara Shapiro, Museum of Fine Arts, Boston; and the late Dorothy Phillips, Corcoran Gallery of Art, Washington, D.C., all of whom made innumerable searches through the rich holdings and records of their institutions.

We also thank staff members at: Addison Gallery of American Art, Phillips Academy, Andover, Massachusetts; Albany Institute of History and Art; Albright-Knox Art Gallery, Buffalo; Alderman Library, University of Virginia, Charlottesville; American Academy of Arts and Letters, New York; American Museum–Hayden Planetarium, New York; Arnot Art Museum, Elmira, New York; Art Gallery of Ontario, Toronto; Art Institute of Chicago; Art Museum, Princeton University; Art Students League of New York; Atlanta University Library; Avery Architectural Fine Arts Library, Columbia University, New York; Ball State University Art Gallery, Muncie, Indiana; Baltimore Museum of Art; Bar Harbor Historical Society, Maine; Beinecke Rare Book and Manuscript Library, Yale University, New Haven;

Belmont, the Gari Melchers Memorial Gallery, Fredericksburg, Virginia; Bennington Museum, Vermont; William Benton Museum of Art, University of Connecticut, Storrs; Berkshire Athenaeum Public Library, Pittsfield, Massachusetts; Boston Athenaeum; Boston Public Library; Bowdoin College Museum of Art, Brunswick, Maine; Brandywine River Museum, Chadds Ford, Pennsylvania; British Museum, London; Brooklyn Museum; Brown, Picton and Hornby Libraries, Liverpool, England; Butler Library, Columbia University, New York; California Historical Society, San Francisco; California State Library, Sacramento; Cape Ann Historical Society, Gloucester, Massachusetts; Catalogue of American Portraits, National Portrait Gallery, Washington, D.C.; Century Association, New York; Church of the Ascension, New York; Cincinnati Art Museum; City Museums and Art Gallery, Birmingham, England; Cleveland Museum of Art; Colorado Springs Fine Arts Center; Columbus Gallery of Fine Arts, Ohio; Connecticut Historical Society, Hartford; Cooper-Hewitt Museum of Decorative Arts and Design, Smithsonian Institution, New York; Corcoran Gallery of Art, Washington, D.C.; Cummer Gallery of Art, Jacksonville, Florida; Dallas Museum of Fine Arts; Delaware Art Museum, Wilmington; Detroit Institute of Arts; Everson Museum of Art, Syracuse, New York; Fine Arts Museums of San Francisco; Fitzwilliam Museum, Cambridge; Robert Hull Fleming Museum, Burlington, Vermont; Folger Shakespeare Library, Washington, D.C.; Fogg Art Museum, Harvard University, Cambridge, Massachusetts; French Embassy, New York; Frick Art Reference Library, New York; Isabella Stewart Gardner Museum, Boston; Georgia Museum of Art, University of Georgia, Athens; Hackley Art Gallery, Muskegon, Michigan; Harewood House, Leeds; Harvard Club of New York City; Harvard Theatre Collection, Harvard College Library, Cambridge, Massachusetts; High Museum of Art, Atlanta; Hirshhorn Museum and Sculpture Garden, Washington, D.C.; Honolulu Academy of Arts; Huntington Library, Art Gallery, and Botanical Gardens, San Marino, California; IBM Corporation, New York; Jewett Family of America, Rowley, Massachusetts; John G. Johnson Collection, Philadelphia; Joslyn Art Museum, Omaha; Kresge Art Center Gallery, Michigan State University, East Lansing; Fine Arts Department, Lehigh University, Bethlehem, Pennsylvania; Library Association of Portland, Oregon; Library of Congress, Washington, D.C.; Long Island Historical Society, Brooklyn; Los Angeles County Museum of Art; Massachusetts Historical Society, Boston; Mead Art Building, Amherst College, Massachusetts; Memorial Art Gallery of the University of Rochester; Minneapolis Institute of Arts; Mint Museum of Art, Charlotte, North Carolina; Mississippi Department of Archives and History, Jackson; Missouri Historical Society, St. Louis; Montclair Art Museum, New Jersey; Monterey History and Art Association, California; Morse Gallery of Art, Rollins College, Winter Park, Florida; Musée Jacquemart-André, Paris; Musée National du Louvre, Paris; Musée National d'Art Moderne, Paris; Musée National de la Coopération Franco-Américaine, Blérancourt; Musée National du Chateau de Versailles et de Trianon; Museo de Art de Ponce (Luis A. Ferre Foundation); Museum of Art, Rhode Island School of Design, Providence; Museum of Fine Arts, Boston; Museum of Fine Arts, Springfield, Massachusetts; Museum of Modern Art, New York; National Audubon Society, New York; National Collection of Fine Arts, Washington, D.C.; National Cowboy Hall of Fame and Western Heritage Center, Oklahoma City; National Gallery of Art, Washington, D.C.; National Museum of History and Technology, Washington, D.C.; National Portrait

Gallery, London; National Portrait Gallery, Washington, D.C.; National Society of Colonial Dames in the State of New York; National Trust for Historic Preservation, Washington, D.C.; Newark Museum, New Jersey; New Britain Museum of American Art, Connecticut; New Haven Colony Historical Society; New Haven Free Public Library; Newport Historical Society; New York City Department of Buildings; New York Public Library; New York State Library, Albany; New-York Historical Society; Oakland Museum; Oregon Historical Society, Portland; Parrish Art Museum, Southampton, New York; Peabody Institute of the Johns Hopkins University, Baltimore; Pennsylvania Academy of the Fine Arts, Philadelphia; Philadelphia Museum of Art; Portland Art Museum, Oregon; Portland Museum of Art, Maine; Pratt Institute, Brooklyn; Princeton University Library, New Jersey; Remington Art Museum, Ogdensburg, New York; Rensselaer County Historical Society, Troy, New York; Rhode Island Historical Society, Providence; Nicholas Roerich Museum, New York; Royal Library, Copenhagen; Royal Museum of Fine Arts, Copenhagen; Saint-Gaudens National Historic Site, Cornish, New Hampshire; St. Gregory's Abbey, Shawnee, Oklahoma; St. John's Seminary, Edward Laurence Doheny Memorial Library, Camarillo, California; Salmagundi Club, New York; Santa Barbara Historical Society, California; Seattle Art Museum; Slater Memorial Museum, Norwich, Connecticut; Smith College Museum of Art, Northampton, Massachusetts; J. B. Speed Art Museum, Louisville, Kentucky; Stanford University Libraries, California; Stowe-Day Foundation, Hartford; Tate Gallery, London; Telfair Academy of Arts and Sciences, Savannah; Thorvaldsens Museum, Copenhagen; Toledo Museum of Art; Topeka Public Library; Mark Twain Memorial, Hartford; Union League Club, New York; United States Naval Academy, Annapolis, Maryland; Virginia Museum of Fine Arts, Richmond; Wadsworth Atheneum, Hartford; Walker Art Center, Minneapolis; Walters Art Gallery, Baltimore; Washington County Museum of Fine Arts, Hagerstown, Maryland; Watkinson Library, Trinity College, Hartford; Winsor and Newton, Secaucus, New Jersey; Yale University Art Gallery, New Haven; Yale University Library, New Haven.

The following people were kind enough to provide information and assistance: Nathaly C. Baum, Peter Bermingham, Richard D. Burns, the Marchioness of Cholomondeley, Maurice J. Cotter, Harris Fishbon, Leonora Hornblow, Horst W. Janson, George E. Jordan, Margaret MacDonald, Peter McKinney, Milton Mustin, Carole J. Oja, Dianne H. Pilgrim, Ellen Rodman, Edward V. Sayre, Rolf M. Sinclair, Elizabeth Stowe, John D. Sudjian, Kathleen K. Taylor, Marcia Wallace, Nadia Williams, Oliver Williams, William J. Williams, and Lambertus van Zelst.

Commercial art galleries and auction houses were equally willing to cooperate with our research and have proven most helpful in the documentation of provenance. We are especially grateful to those persons who searched the records of their firms for material on the museum's paintings. The names of people and galleries who supplied information on provenance are given in the reference sections to the individual paintings. Several people were called on consistently, however, for assistance and made many efforts on our behalf; among them were James Graham and Sandra Leff of Graham Galleries; Jane Richards of Hirschl and Adler Galleries; Antoinette Kraushaar of Kraushaar Galleries; Ann Fernandez Wiegert, Richard Finnegan, and Nancy C. Little of the library staff of M. Knoedler and Company; Harold C. Milch of the Milch Gallery; and Robert C. Vose, Jr., of Vose Galleries.

The problem of designing a book with such an unwieldy format was deftly handled by Klaus Gemming. He not only coped with many difficult problems in the layout but also constantly advised on schedules and production. To him we owe an enormous debt. At William Clowes, London, where the typesetting was handled with great care, we would like to thank Geoffrey Armstrong for his supervision of the project. John Peckham, Don Dehoff, and Stephen Stinehour at the Meriden Gravure Company have been more than cooperative.

I am most grateful to my colleagues in the Department of American Paintings and Sculpture, all of whom made contributions to this project. First I would like to thank John K. Howat, who not only offered me the opportunity to work on the catalogue but also allowed me the time to pursue the research and a great deal of freedom in presenting it. No acknowledgement, however long or elaborate, can adequately express my gratitude to Kathleen Luhrs, editor of this publication. She has done far more than improve the prose and tighten the weighty apparatus of references, exhibitions, and provenance; she also contributed sensitive insights and significant art historical information. Natalie Spassky has generously shared her knowledge of the collection and the benefits of her experience as a researcher and writer. Lewis I. Sharp, who never faltered in his warm support, has guided me around several seemingly impassable obstacles. I am also grateful to Linda Bantel, John Caldwell, Dale T. Johnson, Meg Perlman, Oswaldo Rodriguez Roque, and Amy L. Walsh for their encouragement and their willingness to exchange information and discuss ideas. Margaretta Salinger has brought a lifetime of knowledge and professional expertise to bear on a number of the entries. Our departmental assistants, Margaret Lawson and later Marilyn Handler, were a tremendous help in handling the innumerable letters of inquiry necessary for the preparation of the entries. I would also like to thank Emily Umberger, who typed and proofread a major section of the manuscript, Jacolyn Mott, who lent editorial assistance on several occasions, and Darlene DeLillo, who prepared the indexes. Our departmental technicians Roland Brand, George Asimakis, and Vito Luongo patiently located, moved, and unframed each painting for examination.

I am indebted to my adviser William H. Gerdts, professor at the Graduate Center of the City University of New York, not only for sharing his wide knowledge of American art with me, but also for setting a standard of scholarly excellence to which I have aspired. I am grateful to my parents, Mr. and Mrs. Thomas W. Bolger, for their continuing encouragement and support. My husband, Russell Burke, shared his broad knowledge of art history with me, served as a faithful critic, and cheerfully endured several years of inconvenience and neglect.

Doreen Bolger Burke

INTRODUCTION

THE paintings in this volume date from the 1870s to the 1940s. Most of them were painted in styles popular during the last three decades of the nineteenth century, the same period in which the Metropolitan Museum of Art was founded and reached an established position. Then, and during the early years of the twentieth century, the museum's ties with artists were particularly close. Its activities affected the careers of many artists, and in turn they and their associates did much to shape the museum's collection of late nineteenth century American art. Thus, this particular segment of the collection, although enhanced in quality and scope by subsequent gifts and purchases, has a distinct historical significance: it began as a collection of contemporary art and represents both the taste of the time and the accomplishments of at least two generations of American painters.

Artists were involved in the museum from its inception, and they played a wide variety of roles as it developed. The president of the National Academy of Design was an ex officio member of the museum's board of trustees, and prominent artists, including J. Alden Weir and John White Alexander, served in that capacity. They and others, like Edwin H. Blashfield and Augustus Saint-Gaudens, not only recommended and endorsed museum acquisitions but also organized important retrospective and memorial exhibitions of the work of leading painters like Winslow Homer and Albert Pinkham Ryder. Artists such as Frank Millet and Louis Comfort Tiffany served on special committees which advised the museum on collecting plaster casts and similar matters. On several occasions, for example following the deaths of Dennis Miller Bunker and Alfred Q. Collins, artists raised subscriptions to purchase works by their late colleagues for the museum. In 1902 William Merritt Chase's students, who had often visited the museum with him, commissioned his portrait from John Singer Sargent and later presented it to the museum. The admirers of Augustus Saint-Gaudens, in a similar gesture, contributed his portrait by Kenyon Cox when the museum held a memorial exhibition for the sculptor in 1908. These actions were not limited to the artists themselves. Families of such painters as William Picknell, William Dannat, and Colin Campbell Cooper gave or bequeathed examples of the artists' works. Two of the collection's outstanding paintings of western subjects, Charles Schreyvogel's *My Bunkie* and Frederic Remington's *On the Southern Plains*, were bought by the artists' friends and given to the museum. The collection also benefited from the generosity of a number of prominent collectors and patrons of contemporary art. George I. Seney and George A. Hearn, for example, donated many works they had bought directly from the leading artists of the day.

The museum was more than a passive recipient of support from the artistic community. It welcomed artists and art students to copy or study paintings in the collection. Beginning in the 1870s, the Metropolitan Museum mounted loan exhibitions featuring the works of American artists and in 1886 hosted the annual exhibition of the Society of American Artists, one of several special American exhibitions held in the early years. From 1880 to 1894, the museum conducted its own school, which was largely devoted to training in the industrial arts. Lectures

on art by painters like John La Farge, Kenyon Cox, Leon Dabo, and Arthur W. Dow were presented. Then, too, the staff and the administration maintained congenial relationships with artists, so that when paintings entered the collection, artists sometimes made recommendations on framing, glazing, and hanging and volunteered information on themselves or their work. After the turn of the century, Bryson Burroughs, a practicing artist as well as a curator of painting, and Edward Robinson, an administrator sympathetic to artists, encouraged this kind of involvement. Around this time, too, the museum made a concerted effort to collect more American art from all periods. In 1905 the annual report listed artists who were inadequately represented or whose works were not included in the collection. It was noted that "the achievements of American art . . . warrant us in giving it an important place in our American museum."[1] That year, George A. Hearn established a fund for the acquisition of paintings by living American artists. The fund enabled the museum to buy several works each year, including paintings by Ryder, Chase, and Abbott H. Thayer. The Rogers Fund, bequeathed to the museum in 1901, was also used to purchase paintings by Americans; and in the early years works by Childe Hassam and Thomas Dewing were thus acquired. For these artists and others, the Metropolitan Museum's purchase, and implied approval, of their work represented the attainment of a long-awaited goal.

During the decade between the museum's founding in 1870 and its move to Fifth Avenue in 1880, American art changed. There was a noticeable break, stylistically and philosophically, between older artists who had matured before the Civil War and younger artists who were just returning from studies abroad. Trained in Munich and Paris, the young painters eschewed the confident nationalism of the mid-century and instead became self-consciously cosmopolitan. They were as Sadakichi Hartmann wrote, "a throng of vigorous, eager, cosmopolitan young painters, all alike disregardful of older American traditions and filled with new ideas on every subject."[2] Modeling their style on that of their European mentors and contemporaries, they undertook ambitious paintings that were exhibited and judged in an international arena. Their insistence on technical accomplishments—the ability to draw and paint deftly—led to a new interest in the formal qualities of line, color, and design. Always looking to Europe for inspiration, they changed their preference in genres, treated them differently, and explored new subjects. The figure with all its variations and expressive possibilities became their principle concern; the grandiose landscapes of the Hudson River School gave way to a more intimate mode of landscape painting; and, in still-life painting, decorative objects and delicate floral arrangements became the vogue. The 1870s and 1880s were, as Samuel G. W. Benjamin described them, "The age of style . . . a period of imitation, and we may also add of materialism The young art of a new people necessarily borrows its methods, too often also its ideas, as children imitate their elders." In terms of development Benjamin saw this "hesitating and preparatory" period, "giving place to organized effort, definite aims, and concerted action."[3] The new generation of artists soon made the nation's art institutions respond to their needs. There was an unprecedented growth of art schools, organizations, and publications. The

[1] *The Metropolitan Museum of Art: Thirty-Fifth Annual Report of the Trustees* (New York, 1905), p. 8.

[2] Sadakichi Hartmann, *A History of American Art* (2 vols., Boston, 1902), 1, p. 217.

[3] Samuel G. W. Benjamin, "Tendencies of Art in America," in Walter Montgomery, ed., *American Art and American Art Collections* (2 vols., Boston [1889]), 2, pp. 995, 993.

number of exhibitions multiplied; they improved in quality; and artists enjoyed wider patronage. It was this growth that made new sorts of American accomplishments possible by the 1890s.

In the late nineteenth century, Munich and Paris replaced London, Düsseldorf, Rome, and Florence as the European cities where most Americans chose to work and study. Naturally, these two places exerted a strong influence on the development of American art. Munich enjoyed its greatest popularity during the decade that followed Germany's victory in the Franco–Prussian War in 1871 and continued to attract art students during the 1880s. The art training in this city was dominated by one institution, the Royal Academy. There, the program emphasized portraiture and the painting of historical scenes (rather than the nude figure as in Paris). Students were grounded in the study of the old masters, especially Hals, Rembrandt, Velázquez, and Ribera. After learning basic techniques, they entered a master class and worked closely with their instructor. Following the strong current already evident in German art, they acquired a realistic approach.

In 1870 American students in Munich were introduced to a distinct style of realism in the work of Wilhelm Leibl. Soon to become the leader of the city's young realists, he had been strongly influenced by the French artists Edouard Manet and Gustave Courbet. Placing his subjects against simple often dark backgrounds, Leibl concentrated on their essential features in sketch-like paintings that defied the academic canons of finish. This spirit of experimentation was soon evident in the academy, where students of progressive teachers like Wilhelm Diez produced paintings of a similarly unfinished appearance. American students at the academy, Frank Duveneck, William Merritt Chase, and J. Frank Currier followed Leibl in their use of vigorous brushwork, a direct painting technique, and a dark, somber palette. Duveneck's *Lady with Fan* (p. 65), done in 1873, is a typical example of this realist style.

Duveneck left Munich in 1873 and came back to the United States for two years. His paintings were well received when exhibited in 1875 in Boston, where Henry James praised "their extreme naturalness, their unmixed, unredeemed reality."[4] When he returned to Munich that year, American students flocked to him for instruction and advice. His painting classes, held first in the city and then in the country, at Polling, were attended by such Americans as Joseph DeCamp and John White Alexander. When Duveneck and his students went to Italy in 1879, Munich lost some of its best American talent. By then, however, the realistic style that developed there had made its mark on American art. Paintings by Americans in Munich were shown in the 1875 and 1877 annual exhibitions at the National Academy of Design in New York, and German-trained artists like Chase and Duveneck made a strong showing at the first exhibition of the Society of American Artists in 1878.

Like Duveneck, Chase was influential in spreading German realism not only through his portraits and figure paintings but also by teaching. Thus, the influence of the Munich school continued, even though fewer Americans actually went there to study. Some Americans, particularly those of German descent, like Louis Moeller and Charles Ulrich, did study there in the 1880s and were influenced by the academy's emphasis on seventeenth-century Dutch and Flemish genre painting. They painted everyday scenes, often of craftsmen or businessmen at work, that were remarkable for their meticulous details and crowded settings. The same care

[4] Henry James, "On Some Pictures Lately Exhibited," *Galaxy* 20 (July 1875), pp. 94–95.

in rendering the textures and surfaces of objects can be seen in the still lifes of William Michael Harnett and the interior scenes of Henry Alexander, both of whom worked in Munich during the early 1880s.

A significant number of American art students went to Paris in the 1850s and 1860s. By 1880 the French capital had eclipsed all other European cities as the place to study. Besides its many schools, it offered rich art collections, many galleries, and a number of regular exhibitions. The government-sponsored Ecole des Beaux-Arts offered students the most comprehensive training. There they enjoyed a program based on an appreciation of the classical tradition in art and centered on the study of the nude. The school and its instructors, like Jean Léon Gérôme and Alexandre Cabanel, had great influence on the many Americans who studied there, among them, some of this country's most important late nineteenth century painters.

Gérôme, whose American students included Edwin Lord Weeks, George de Forest Brush, and Thomas Eakins, was by far the most popular teacher. His influence can be seen in the style, subject matter, and philosophy of these and his other students. Some, like Weeks, painted the kind of oriental scenes that were Gérôme's specialty and followed his style almost slavishly while others absorbed their teacher's lessons but painted distinctly American subjects. Notable examples of this kind of response to Gérôme's influence can be found in Brush's paintings of American Indians in the 1880s. In these, he used his mentor's precise academic style as well as some of his favorite themes, for example the majestic animal in a scene of potential violence or a standing figure absorbed in prayer. Gérôme had an even more enduring effect on Thomas Eakins. Besides borrowing Gérôme's themes, such as the sculptor in his studio or the enraptured musician, Eakins kept to the careful perspective and pyramidal compositions he had learned from his French teacher.[5]

The Ecole des Beaux-Arts was, however, only one of many alternatives. Independent studios run by successful academic artists were also popular with Americans. Some students attended these ateliers to prepare for, or supplement their studies at, the Ecole, but others received their main training in them. Naturally each studio reflected the personality and methods of the artist who ran it. Most, however, emphasized drawing and painting the nude. Before his death in 1879, Thomas Couture directed one of the most important studios in Paris. Americans had studied with him since the 1840s, and artists like William Morris Hunt and John La Farge became the exemplars of his style in America. What they had learned from Couture, especially his stress on retaining the freshness of the sketch in the finished work, they passed on to their followers. In Léon Bonnat's popular atelier, students like Edwin H. Blashfield, H. Siddons Mowbray, and Walter Gay were trained to follow Bonnat's close observation and realism. The portrait and figure painter Emile Auguste Carolus-Duran taught a large number of Americans, among them John Singer Sargent, J. Carroll Beckwith, and William Dannat. The Académie Julian, an informal atelier founded by an artist's model, was also very popular with Americans, especially during the 1880s. There students benefited at various times from criticisms by Gustave Boulanger, Jules Joseph Lefebvre, and Tony Robert-Fleury. Thomas Dewing, John H. Twachtman, Childe Hassam, Willard Metcalf, Frank W. Benson, and

[5] Gerald M. Ackerman, "Thomas Eakins and His Parisian Masters Gérôme and Bonnat," *Gazette des Beaux-Arts*, series 6, 73 (April 1969), pp. 235–256.

Edmund C. Tarbell were among the innumerable Americans who studied there. A few also attended other informal studios like the Atelier Colarossi and the Grande Chaumière.

Since their training emphasized the nude, it is hardly surprising that many American painters took up figure painting. Their works were often large-scale, impressive compositions. The figures, because of their placement, size, or sheer force of expression, clearly dominated the settings. Although much care was taken with the treatment of details in costume, setting, and accessories, painters focused on eloquent poses, gestures, and facial expressions. Minimizing action and narrative detail, they often chose a single figure or a small group to convey a mood or sentiment. In *The Arab Jeweler* (p. 119), for example, Charles Sprague Pearce depicts a life-size figure of an artisan. The figure is emphasized by its closeness to the picture plane and by strong, almost dramatic lighting. The setting is kept simple, and the tools of the jeweler's trade are cast in shadow and relegated to the perimeters of the composition. Pearce's treatment of the figure is clearly influenced by his instructor Léon Bonnat in the use of strong draftsmanship, firm modeling, and forceful presentation of a humble subject.

Besides the influence of their French teachers, American figure painters were also inspired by the works of other French artists whose paintings they viewed at the Paris Salon or whose works were collected in the United States. One such artist was the plein-air painter Jules Bastien-Lepage, who specialized in detailed, realistic views of peasants whom he enobled and sentimentalized. Pearce, for example, was influenced by Bastien-Lepage as well as Bonnat; for in 1883, within a year of painting *The Arab Jeweler*, he depicted peasant subjects that show the same cool silvery tonalities and highly finished treatment as is evident in the works of Bastien-Lepage. Another such American painter was Alexander Harrison. In *Castles in Spain* (p. 161), which shows a peasant boy daydreaming on a beach, he followed Bastien-Lepage's outdoor painting technique as well as his inclination to elevate a humble subject to universal stature. Although Harrison continued to do plein-air paintings, he soon chose less derivative subjects, painting instead coastal scenes like *The Wave*, 1885 (Pennsylvania Academy of the Fine Arts, Philadelphia). Thus, if some Americans simply followed a succession of French sources, others, like Harrison, attempted to go beyond them and paint more original works.

In addition to their training in Paris art schools, American artists often worked in the French countryside, at Ecouen, Pont-Aven, and Barbizon, where the landscape and peasant life offered them picturesque subjects. They also had the opportunity to join fellow American artists under relaxed, informal conditions and to meet and work with the European artists they admired. Barbizon, thirty-five miles from Paris, was one of the first of these artists' colonies to affect the development of American art.

From the 1850s, when the Boston painter William Morris Hunt studied with Jean François Millet at Barbizon, American artists came under the influence of this school of landscape painting. Informal subjects and a sketchier treatment distinguished the landscapes and figure studies of such Barbizon artists as Millet, Théodore Rousseau, Jean Baptiste Camille Corot, and Charles Daubigny from contemporary academic paintings. Besides Hunt, who taught the principles of the style to his many students in the United States, George Inness, an admirer of Rousseau, was also influenced by it. Inness gradually moved from a detailed, conventional landscape style in the late 1850s to a loose, expressive one in the 1860s. The work of these two American artists and the avid collection of Barbizon paintings in the United States did much

to foster the style, which remained popular throughout the century. Characterized by simple compositions, these landscapes were usually subdued views of a meadow, forest, or body of water, often with farm laborers, grazing animals, or other hints of man's domesticating role in nature. In an effort to capture nature's changing moods, Barbizon artists and their American followers often chose sunrise and twilight scenes or the transitional seasons of autumn and spring. Rather than direct observations of a scene, these paintings were usually developed from memory or based on broad sketches. They suggested a mood or atmosphere, most often one of serenity or solitude. H. Bolton Jones's *Autumn* (p. 173) and J. Francis Murphy's *Landscape* (p. 154) are typical of these small generalized views. Effects of the Barbizon style can even be seen in the works of the imaginative painters Ralph Blakelock and Albert Pinkham Ryder. Although the mottled paint surface of Blakelock's *Landscape* (p. 44) sets it apart, its mood-like quality and unspecified location are typical of Barbizon painting.

As many American artists returned from studies abroad in the late 1870s, more than just the style of American art was affected. The art academies that had once provided standards and support were openly challenged. Although this situation paralleled contemporary events in France and Germany, where independent groups were creating and exhibiting their work outside of the academies, the American movement was less radical. Nevertheless, it deprived the American academies of their monolithic influence on training, exhibitions, and the determination of aesthetic standards.

Opportunities for art training improved noticeably at this time. First of all, the two leading academies resumed the operation of their schools after significant interruptions. The Pennsylvania Academy of the Fine Arts closed in 1871 and did not reopen until the completion of its new building in 1876. Because of financial problems the National Academy of Design suspended its life class in 1875. This prompted students there to begin their own school, the Art Students League of New York, the first independent art school in the country. Many other art schools were founded about this time as well, among them the Massachusetts School of Art, Boston, in 1873; the California School of Fine Art, San Francisco, in 1874; the St. Louis School and Museum of Fine Arts, in 1875; the School of the Museum of Fine Arts, Boston, in 1876; the Rhode Island School of Design, Providence, in 1877; and the School of the Art Institute of Chicago, in 1879.

Perhaps because so many Americans had been exposed to a fuller program of study in Europe, schools at home finally made an effort to provide better grounding. At mid-century most schools offered only classes in drawing, sometimes from life but more often from casts. There was no sustained relationship between student and teacher, and no formal training was offered in essential areas like painting technique and composition. Artists learned to paint by making copies or by studying outside of the academy in the studio of an established painter. Following the example set by European schools, mainly the Ecole des Beaux-Arts, the American academies began to broaden their programs in the late 1870s. One of the most important changes was the hiring of full-time instructors who worked closely with the students. Painting, first introduced in life classes, became the subject of a separate class within a decade. Soon specialized courses in still-life and portrait painting were added. Probably because of the emphasis on figure painting, the study of anatomy received more attention. Instead of just attending lectures, students made anatomical casts and worked from skeletons. Modeling

classes were established to increase the painter's understanding of three-dimensional form. All these developments had a positive effect. By the 1890s American art students generally went abroad to continue, not to begin, their training.

At the same time the younger generation of artists challenged the program in the nation's art schools, they also contested the selection and hanging of exhibitions at the academies. The first signs of conflict appeared at the National Academy of Design. On one side, younger artists were demanding more space for their works; on the other, the academicians were insisting on maintaining control over the hanging of pictures. In 1875, the hanging committee, which had total control over the selection and placement of paintings, rejected a number of works by younger artists, apparently to accommodate paintings by their fellow academicians. Shortly thereafter, a small group of progressive artists, among them Ryder, Hunt, Thayer, and La Farge, exhibited their work at the New York gallery of Cottier and Company, where their show was recognized as a protest against the academy's policies. The young artists fared better at the 1877 annual, when a more sympathetic hanging committee selected paintings by such artists as Duveneck, Chase, Eakins, and Beckwith. This move, however, only caused further polarization; for the academicians soon voted to guarantee a set amount of wall space for themselves. This outrageous rule, directed at excluding rising young artists, was later rescinded, but discussion of it caused the younger people to lose further confidence in the academy. In June 1877 several of them—Augustus Saint-Gaudens, Walter Shirlaw, Wyatt Eaton, and Helena de Kay—founded their own exhibition organization, the American Art Association. The first exhibition of this organization was held in March 1878, by which time it had been renamed the Society of American Artists and its membership had grown to twenty-two artists, most of whom had trained in Paris or Munich.[6]

Even though the society claimed that it was not in open rebellion against the National Academy, its early exhibitions were very different from those at the academy. Pictures by artists working abroad were actively sought, and, as a result, the latest trends in style and subject matter were well represented in its annual shows. "The room they have filled," commented Edward Strahan on the 1881 exhibition, "if it could be transported just as it is to one of the Paris salons, would form one of the most remarkable chambers there." Not all the critics, however, were so enthusiastic. They noted, for example, the society's preference for "the Munich school, characterized by freedom of treatment and generally sombre tone" and criticized the inclusion of some "sketches and pictures . . . only partially completed." Furthermore, novelty wore thin as it became apparent that the society would be no more successful than the academy at determining an original direction for American art. Homer Saint-Gaudens, noting how "studies and sketches were mingled with Salon pictures, open air compositions, works of minute realism, tonal schemes, and impressionism," maintained that the society's "eclectic stand" prevented "any unified aim."[7]

Although the Society of American Artists continued to conduct annual exhibitions until

[6] National Collection of Fine Arts, *Academy* (Washington, D.C., 1975), exhibition catalogue by Lois Marie Fink and Joshua C. Taylor, pp. 72–81.

[7] Edward Strahan, "Exhibition of the Society of American Artists," *Art Amateur* 4 (May 1881), p. 117; "The Society of American Artists," *Art Interchange* 2 (March 1879), p. 42; Homer Saint-Gaudens, ed., *The Reminiscences of Augustus Saint-Gaudens* (2 vols, New York, 1913), 1, p. 275.

1906 (when it officially merged with the National Academy of Design), it had lost much of its fervor by 1884. That year its annual exhibition was actually held at the National Academy, leaving many of its members questioning the organization's credibility as an independent force. Also, selection and hanging of this exhibition caused serious internal dissension. Paintings were rejected to make room for a comparatively large group of entries by Chase and his followers. "The granting to one man and his pupils about one fourth the space in the whole exhibition may be done for the advancement of art," wrote one angry critic, "but to the layman it flavors strongly of favoritism." In January 1885, in flagrant disregard of the criticism leveled at the selection policies, Chase was elected president of the society (a post he held for the next ten years). The members then defeated a resolution that would have assured each of their number the right to show one work in an annual exhibition. The resolution would have prevented established artists from dominating the exhibitions, but instead the way was left open for continued control by a select group, as in the 1884 exhibition. The society was so shaken by these events that there was no exhibition at all in 1885. For the 1886 exhibition, which was held at the Metropolitan Museum of Art, the selection committee was enlarged to twenty-five members. The result was not, however, greater variety as would be expected but a fairly staid group of pictures. As one critic commented, the society was not "afraid to admit works . . . of more conventional pictorial treatment."[8]

As the viewpoints and exhibitions of the Society of American Artists and the National Academy became increasingly alike, some of the society's most prominent members were also elected to the academy. A number of factors attracted them to the organization they had criticized a decade earlier. The academy had permanent exhibition space; the society did not—until the opening of the American Fine Arts Building in 1892. Then, too, the academy sponsored more than one exhibition each year and hosted others for groups like the American Water Color Society. Generally the exhibitions were larger and more pictures were sold. In the early 1880s the academy instituted several awards obviously intended to attract young artists. The Thomas B. Clarke prize for figure painting particularly encouraged artists trained in Europe, who often specialized in this genre. The three Julius Hallgarten prizes were designated for artists under the age of thirty-five. These prizes were first awarded in 1884, and over the next decade such artists as Charles Ulrich, Louis Moeller, and George de Forest Brush were recipients. The academy was gradually slipping from the control of the older, conservative generation. Its policies and taste were becoming more liberal just when those at the Society of American Artists were becoming less so. The academy's 1886 annual was hailed as representing the recent products of the art schools in New York, Paris, and Munich with "the older element . . . conspicuous by its absence."[9] That same year its jury of selection for exhibitions was enlarged. Also in 1886 the academy hosted an extended version of the exhibition of French impressionist paintings that had opened at the American Art Association. This and a follow-up show held at the academy the following year prompted the American interest in impressionism and did much to revive the academy's popularity among progressive artists.

In Philadelphia the Pennsylvania Academy of the Fine Arts embraced the latest art trends

[8] *Art Interchange* 12 (June 19, 1884), p. 145; 14 (Jan. 1, 1885), p. 5; 14 (May 7, 1885), p. 121.

[9] "The Academy Exhibition," *Art Amateur* 14 (May 1886), p. 119.

from Europe more enthusiastically and far more quickly that its New York counterpart. In 1879, for example, it sponsored exhibitions by the Society of American Artists and another group of young painters, the Philadelphia Society of Artists. Two years later the *Special Exhibition of Paintings by American Artists at Home and Abroad*, featuring a large group of paintings by American artists working in Paris, Munich, and London, was shown at the academy. Edward Strahan compared these cosmopolitan efforts to those of the Society of American Artists, the group usually associated with this trend, and noted that the latter "had not the time, facilities, nor the capital" for such ambitious undertakings.[10] Throughout the 1880s the Pennsylvania Academy continued to solicit paintings from American artists working in Europe. As a result, a number of Salon paintings like Alexander Harrison's *Castles in Spain* (p. 161) were sent from Paris for exhibition in Philadelphia. Furthermore, the academy even bought important paintings by such expatriates as William Picknell and Charles Sprague Pearce. This progressive taste can be attributed to the forward-looking attitude of its directors and the strong influence of the young Philadelphia artists led by Thomas Eakins.

Even with these expanded opportunities for exhibition, American artists still found it difficult to sell their work. Most wealthy collectors and the art dealers who served them preferred European art. In an attempt to heighten interest in native art, the American Art Association was established in 1879 as "a permanent picture-centre, or exchange for the sale of American pictures."[11] There artists could leave their work on view as long as they desired, and collectors could display works they deemed important. Regular exhibitions soon became an important part of the operation. Many of these were atypical in content, featuring for example studies and sketches. The association extended its facilities in 1884, and the following year organized the first of several annual exhibitions that were financed by subscriptions from art patrons like William T. Walters, H. O. Havemeyer, and Benjamin Altman. The painters whose works were judged best were awarded cash prizes, and the paintings were then presented to institutions selected by the subscribers. Two works that entered the Metropolitan collection as a result of the Prize Fund are J. Alden Weir's *Idle Hours* and Charles Ulrich's *Glass Blowers of Murano*. By 1885 the American Art Association was conducting auctions of various artists' work and of such private collections as those of George I. Seney, 1885, Mary J. Morgan, 1886, and A. T. Stewart, 1887. In 1892 and 1895, upon the retirement of its most active members, the association sold parts of its collection of American and European painting. Thus its activities gradually became more commercial.

Artists outside of New York and Philadelphia also had more opportunities to exhibit their work in the 1880s. Industrial fairs, held across the country in places like Louisville, Milwaukee, Cincinnati, and Chicago, displayed fine art along with handicrafts and manufactured goods. One of the most important was the Chicago Inter-State Industrial Exposition, begun in 1873 and continued for the next two decades. There were also special shows, like the Loan Exhibition held in Detroit in 1883. Then too by the early 1880s associations for encouraging art through exhibitions and lectures had sprung up in most major American cities. The Washington Art Club was founded in 1876; the Rochester Art Club in 1877; the Columbus Art Association and Lowell Art Association in 1878; the Brooklyn Art Club, Detroit Art Club, and Springfield Art

[10] Edward Strahan, "Works of American Artists Abroad," *Art Amateur* 6 (Dec. 1881), p. 4.
[11] "The American Art Gallery," *Art Interchange* 2 (May 2, 1879), p. 78.

Association in 1879; the Providence Art Club in 1880; the Chicago Art Club in 1881; and the Illinois Art Association in 1882. In 1883 alone, art clubs and associations were established in Portland (Maine), Buffalo, Syracuse, Detroit, Minneapolis, Nashville, Newark, and New Haven. Added to the exhibitions sponsored by these groups were the annual and special exhibitions held by newly founded museums like the Art Institute of Chicago.

Throughout the 1880s, while changes were taking place in the academies and more independent art organizations were being formed, academic painting, particularly of figure subjects, remained popular in the United States. American figure painters made an impressive showing at the Universal Exposition in Paris in 1889. Among the paintings exhibited were such works as William Dannat's *The Quartette* (p. 157) and Alexander Harrison's *Castles in Spain* (p. 161). By this time, however, American art was taking different directions. Many artists, particularly landscapists, were working in an evocative, romantic style, which is often called tonalism. Using a limited range of colors, the tonalists painted decorative works in which soft generalized lighting obscured detail. This style was strongly influenced by the late landscapes of George Inness and the nocturnes of James McNeill Whistler. Also, like Whistler, they were inspired by oriental art, particularly Japanese prints. Among the artists who worked in this style at various times were George H. Bogert, Thomas Dewing, Dwight W. Tryon, and John H. Twachtman. With its simplified composition and quiet mood, Twachtman's *Arques-la-Bataille* (p. 149) is a particularly striking example of tonalist painting. Composed of horizontal bands of sky, land, and water, punctuated by tall graceful reeds, the picture is painted in cool, delicate tones of blue and green. The color is applied uniformly in broad areas, giving the picture a flat appearance reminiscent of Whistler's nocturnes. For Twachtman, like many other American artists, the lighter colors and simplified treatment of tonalism were a prelude to impressionism. Several aspects of tonalism were, however, opposed to the realistic approach of the French impressionists. The practice of working from memory, the decorative compositions, and the idealized subjects were characteristics of tonalism that persisted in the United States even after the introduction of impressionism. Indeed the reluctance to give up these features tempered the character of American impressionism, distinguishing it from the French style that inspired it.

Impressionism began in France twenty years before it was taken up by American artists. There Auguste Renoir, Claude Monet, Edgar Degas, Camille Pissarro, and others who rebelled against established academic practices formed an independent group that held exhibitions from 1874 to 1886. They chose to paint everyday subjects, drawn from contemporary life; each scene (including those that depicted figures in motion) was shown as it appeared at the moment of viewing. To better capture the transitory effects of light and atmosphere, the impressionists painted outdoors. They used pure, brilliant colors that were applied in varied brushstrokes. Painted side by side or overlapping, these touches of color were meant to be blended by the viewer's eye when the painting was seen from a distance. This technique, which created an impression of shimmering light, enabled the artist to show reflected as well as local color. Even shadows reflected the colors around them. Since traditional modeling and perspective were often ignored, impressionist paintings sometimes appeared flat. Rough paint surfaces and the lack of firm outlines were further departures from the conventional standards for a finished painting.

Immediacy was the keynote of the movement. To capture a scene at the moment of viewing, the impressionists rejected the practice of developing compositions in the studio and worked outdoors. Earlier artists had, of course, made sketches and studies outdoors. Some returned to the studio to produce their finished paintings, but by the mid-nineteenth century more artists were painting entire works outdoors. In the 1860s, the artists who later comprised the impressionist group painted outdoors regularly, producing large-scale finished works intended for exhibition. Although some Americans, followers of the Barbizon School and academics like Bastien-Lepage, worked outdoors in the 1860s and 1870s, plein-air painting was not popular in this country until the late 1880s. American painters then became especially enthusiastic about it, and some built floating studios and movable enclosures that permitted them to work outside in comfort. Edwin Martin Taber's *Mount Mansfield in Winter* (p. 445), for example, was painted in a specially constructed, heated, portable hut.

American artists were selective in their use of impressionist practices. They did follow the French method of returning repeatedly to the same scene and showing it at different times of day or under different weather conditions. For example, Theodore Robinson, a close disciple of Monet, painted several pictures of the rustic building seen in *The Old Mill* (p. 129) under slightly varied conditions. During the winter of 1888–1889, Robinson's friend John H. Twachtman followed his example in a series of paintings showing the cascade and pool on his Connecticut farm. Two of these, *Waterfall* (p. 150) and *Horseneck Falls* (p. 151), show Twachtman's interest in capturing the subtle changes in the landscape around his home, a concern that parallels Monet's activities at Giverny. Although Twachtman followed the impressionist practice of painting more than one version of a scene, he, like most American painters, does not seem to have adhered to it as strictly as the French. The immediacy and spontaneity that they achieved by keeping a number of paintings of the same scene in progress simultaneously is missing from most American works of this kind.

Following the lead of the impressionists, American artists represented everyday scenes of contemporary life. Most, however, geared their choice of subject matter to American taste, and Americans preferred their everyday subjects removed from the drudgeries of life. More often than not, impressionists in this country depicted a deceptively elegant, genteel world. Childe Hassam, for example, spoke of the importance of the artist's "painting the life he sees around him" and making "a record of his own epoch." [12] Yet, his city views such as *Spring Morning in the Heart of the City* (p. 355) show fashionable avenues and pleasant parks with well-dressed people and graceful, horse-drawn carriages. In paintings like *Winter in Union Square* (p. 357), he depicts New York during a snowfall, before the city's fresh white surface is marred. This tendency to prettify is even more apparent in American figure paintings, where there is a definite tendency to avoid the harsh, realistic French subjects like rough-looking laundresses and workmen. Instead American painters favored attractive middle-class women and well-behaved children, pleasantly engaged in outdoor settings or tastefully decorated interiors. Typical examples are pictures like Chase's *For the Little One* (p. 92) which shows the artist's wife seated in front of a sunny window sewing, and Frank W. Benson's *Children in the Woods* (p. 442). By and large, the low and humble subjects characteristic of French painting are absent from

[12] "Talks with Artists: Childe Hassam on Painting Street Scenes," *Art Amateur* 27 (Oct. 1892), p. 116.

the American repertoire until the turn of the century, when they appear in the work of Robert Henri and his followers, the so-called Ashcan School. Meanwhile American critics considered many French works "so terrible in their pessimism" that they seemed "to fill the air with cries of uneasy souls."[13] Mary Cassatt, the American painter most closely allied to the French movement, was criticized in her own country for a "deliberate adherence to the ugly."[14] In a typical statement one American critic contrasted the harshness of the French impressionists' figure paintings to the "tenderness and grace" of their landscapes.[15] Americans clearly responded to the latter in a more positive manner, perhaps because impressionist landscapes so often depicted beautiful, pleasant scenes.

To enhance their idealized subjects, Americans used aspects of the style in a manner opposed to the visual objectivity of the French impressionists. Except for Mary Cassatt, who benefited from sustained contact with the impressionists in France, and perhaps Sargent and Robinson, most American artists adopted only the superficial trappings of impressionism without much understanding of the principles or goals. In general, they accepted only certain hallmarks of the style—varied brushstrokes, bright colors, and roughened paint surfaces, to name the most popular—but they did not usually succeed in integrating the main features in their work. As a rule, they were far less adventurous than artists in France in dissolving outlines, and they still remained tied to the academic conventions of drawing, modeling, and perspective.

Some American painters were prepared for the innovations of impressionism by their experiments in pastels. Inspired by James McNeill Whistler, Jean François Millet, and Giuseppe de Nittis, painters like Chase and Twachtman had worked in this delicate medium earlier in the decade. As has been convincingly demonstrated, American artists working in pastels achieved "an increased awareness and lightening of color, and expressed a growing love of spontaneity and intimacy that we generally associate with the influence of Impressionism," and this was "before the Impressionists had made a direct impact on American artists."[16]

Another factor that prepared the way for the acceptance of impressionism in the United States was the popularity of Edouard Manet's painting. At first only his early, strongly realistic paintings were exhibited here, for example, *The Execution of Emperor Maximilian*, 1867 (Kunsthalle, Mannheim), which was shown in New York and Boston in 1879. Manet's simplification, somber palette, and direct treatment appealed to American artists, and by 1881, several influential painters had become advocates of his work. In Paris, Weir, reportedly encouraged by Chase, purchased Manet's *A Boy with a Sword* and *Woman with a Parrot* (both Metropolitan Museum of Art) for the New York collector Erwin Davis. Chase's figure paintings were so noticeably influenced by the French artist that, in a reversal, one writer described Manet as being "like our own Wm. M. Chase."[17] Although Manet's reputation in this country was based on his early paintings, admiration for his work continued and prepared the way for the acceptance of later works by him and other impressionists as well.

[13] "The Impressionists," *Art Age* 3 (April 1886), p. 166.

[14] "De Omnibus Rebus," *Collector* 5 (Dec. 15, 1893), p. 55.

[15] "The Fine Arts: The French Impressionists," *Critic*, n.s. 5 (April 17, 1886), p. 195.

[16] Dianne H. Pilgrim, "The Revival of Pastels in Nineteenth-Century America: The Society of Painters in Pastel," *American Art Journal* 10 (Nov. 1978), p. 43–44.

[17] R[oger] R[iordan], "The Impressionist Exhibition," *Art Amateur* 15 (June 1886), p. 4.

To be influenced by impressionism in the 1880s, American artists did not have to cross the Atlantic. The style was brought to them. As early as 1883 impressionist pictures were exhibited at Boston's Foreign Exhibition and in New York at the exhibition organized to raise money for the pedestal of the Statue of Liberty. "There is little doubt," one critic speculated at this time, "that all the good painting of the men who will come into notice during the next ten years will be tinged with impressionism; not, perhaps, as it has been put into words by the critics, but as it has been put into paint by Manet and a few others." [18]

The turning point came in 1886, when the American Art Association arranged for the loan of a large group of impressionist oils and pastels from the Parisian art dealer Paul Durand-Ruel, who had long promoted the work of the impressionists in France. These were shown in New York first at the association's galleries and then, with additions from local collections, at the National Academy of Design, where their display was tantamount to academic approval. The exhibition included paintings and pastels by Degas, Manet, Monet, Pissarro, Renoir, and even recent works by Seurat who was then working in the neo-impressionist mode. Through this comprehensive exhibition Americans were exposed at one time to more than twenty years of French impressionism. The reaction of the press was enthusiastic, and before long, artists demonstrated their interest as well.

The 1886 exhibition focused the attention of American artists on the work of Monet in particular. "Monet (not Manet) leads the school," asserted one reviewer, and "whatever is exquisite, tender, subtle, in landscape art," is found in his work. It was from Monet that most American artists chose the aspects of impressionism that they would follow, particularly the landscape subjects, lighter colors, and varied brushwork. Given this response, it is not surprising that within a year of the exhibition, Americans were flocking to Monet's home in Giverny, a village about seventy miles from Paris. In 1887 the Boston correspondent for the *Art Amateur* reported "quite an American colony" in Giverny; among the visitors there over the next few years were John Singer Sargent, Theodore Robinson, John Leslie Breck, Willard Metcalf, Theodore Wendel, Philip Leslie Hale, Lillia Cabot Perry, and Theodore Earl Butler. [19] Of these, two of the most influential were Robinson and Sargent who were among the first to bring Monet's ideas to the United States.

Theodore Robinson was a regular visitor to Giverny between 1887 and 1892. In works like *A Bird's-Eye View* (p. 128) Monet's influence on him is evident in the high-keyed pastel colors, uneven brushwork, and elevated vantage point. Robinson exhibited his paintings in New York and shared his ideas on impressionism with other artists there like J. Alden Weir and John H. Twachtman who took up the style in the late 1880s. Twachtman's American subjects like *Icebound*, 1888–1889 (Art Institute of Chicago) show that, although his style was inspired by French precedents, it developed beyond its early derivations. [20] In certain respects, for example, the dense brushwork, coarse paint surface, and strong decorative quality, Twachtman's paintings parallel Monet's achievements. Design became even more important in

[18] "The Pedestal Fund Art Loan Exhibition," *Art Amateur* 10 (Jan. 1884), p. 42.

[19] "The Fine Arts: The French Impressionists," *Critic*, n.s. 5 (April 17, 1886), p. 196; Greta, pseud., "Boston Art and Artists," *Art Amateur* 17 (Oct. 1887), p. 93.

[20] James L. Yarnall, "John H. Twachtman's *Icebound*," *Bulletin of the Art Institute of Chicago* 7 (Jan.–Feb. 1977), pp. 2–5.

Twachtman's work over the next decade. In paintings like *Horseneck Falls* (p. 151) his concern was as much for the decorative effect of line and color as for capturing the transient effects of light and atmosphere. This interest in design was an important element in the work of other American impressionists as well, for example, in *The Red Bridge* (p. 142), where Weir created a decorative surface pattern of solid forms and mirrored images.

Another early visitor to Giverny and an equally ardent follower of Monet was John Singer Sargent. He was probably exposed to impressionism during his early years in Paris; for as Henry James asserted, "from the time of his first successes at the Salon he was hailed . . . as a recruit of high value to the camp of the Impressionists."[21] Sargent's most active experiments in the style, however, took place in the late 1880s, probably as a result of his friendship with Monet. In 1887 he acquired Monet's *Vagues à la Manneporte*, 1885 (private coll.; ill. in Daniel Wildenstein, *Claude Monet* [1979], 2, no. 1036) and began painting scenery on the Thames from a floating studio like Monet's. Sargent's works from this period like *Two Girls with Parasols at Fladbury* (p. 237) are painted in brilliant colors with bold, varied brushstrokes. He borrowed heavily from Monet's plein-air motifs of women in luminous white garments, strolling by the riverside or sitting in boats on the water. There is little doubt that in 1887 when Sargent visited the United States he was familiar with Monet's style and working method. It is also likely that he introduced American painters like Dennis Miller Bunker to these methods. Bunker, who visited Sargent in England in the summer of 1888, was soon painting striking impressionist landscapes and garden views.

During the 1890s, more American artists turned to impressionism, which soon became the dominant style. There were several reasons why it spread so quickly and became so firmly entrenched. First of all, many of the followers of impressionism taught in the leading art schools. As early as the 1880s, Chase, Weir, and Twachtman taught at the Art Students League in New York, and, in Boston, Bunker and Vonnoh were instructors at the Cowles School. By the 1890s, Tarbell and Benson had joined the School of the Museum of Fine Arts, Boston; and the Pennsylvania Academy, long under the influence of realists like Thomas Eakins and Thomas Anshutz, added a succession of impressionists to its faculty—Vonnoh, DeCamp, Chase, and briefly, Robinson. (The National Academy was the only major school staunchly removed from this trend.) Then, too, the outdoor art class did much to further impressionism. These classes, which were usually held at some scenic location during the summer months, came into vogue during the 1890s. The best known was the Shinnecock Summer School of Art, where Chase taught open-air classes from 1891 to 1902. Similar classes were offered by Robinson at Napanoch, New York, Princeton, New Jersey, and Townsend, Vermont; by Twachtman at Cos Cob, Connecticut; and by Robert Henri at Darby, Pennsylvania, and Avalon, New Jersey, to name but a few. Within a few years, two of Chase's students were conducting outdoor classes, Irving Wiles at Peconic, New York, and Charles Hawthorne, at Provincetown, Massachusetts. These schools and classes, the keynote of art training during the 1890s, help account for impressionism's sustained popularity.

Impressionism became an established, if not the established, style in the United States during the 1890s. A number of exhibitions helped to popularize it. Of them, the World's Columbian Exposition, on view in Chicago in 1893, proved the most significant. It featured the most

[21] Henry James, "John S. Sargent," *Harper's New Monthly Magazine* 75 (Oct. 1887), p. 684.

comprehensive display of French impressionist works shown in the United States since the 1886 exhibition in New York. Borrowed from French artists as well as from American collectors like Mrs. Potter Palmer, Martin Ryerson, Isabella Stewart Gardner, and Alexander Cassatt, the French section was shaped by Sara Hallowell, a remarkable woman who had worked as Durand-Ruel's agent in America. The 1893 exposition clearly demonstrated that impressionism had become a wide movement, and critics like Hamlin Garland noted its influence on the younger artists of many countries. Finally, this exhibition was the first international event at which Americans made a strong showing in the new style.

Spurred by their success at this and other exhibitions, some American impressionists decided to start their own exhibition organization. In 1897 a group of painters resigned from the Society of American Artists and founded the Ten American Painters. They thought that their work, and impressionism in general, was not adequately represented in the society's exhibitions. Then too they wanted to select and install exhibitions with a sense of unity, which was not possible at the large and eclectic annuals. The artists participating in the scheme— Frank W. Benson, Joseph DeCamp, Thomas Dewing, Childe Hassam, Willard L. Metcalf, Robert Reid, Edward Simmons, Edmund C. Tarbell, J. Alden Weir, and John H. Twachtman (succeeded by William Merritt Chase in 1902)—were among the most respected and successful artists of their generation. Of the original ten, all but Weir and Twachtman began their careers in the Boston area, most at the School of the Museum of Fine Arts, and all had studied in Paris, most at the Académie Julian. They continued to hold exhibitions until after World War I, by which time two of their most prominent members, Chase and Weir, had died. The success of the Ten helped keep impressionism alive into the twentieth century.

The strong interest in design apparent in the work of American impressionists was also evident in other styles of paintings. Many artists, influenced by the Arts and Crafts movement, began to work in the applied and decorative as well as the fine arts. The best known of such artists is Louis Comfort Tiffany, who designed and produced stained-glass windows, mosaics, and a wide assortment of decorative objects such as jewelry, tableware, and clocks. Arthur Frank Mathews is another painter whose work on furniture and interiors is significant. Particularly during the 1890s, experience in the decorative arts, and commercial work such as magazine and book illustrations familiarized American painters with the art nouveau style then popular in Europe. Elements of this style, such as the use of sinuous lines and the flattening of three-dimensional form can be seen in such paintings as Mathews's *Afternoon among the Cypress* (p. 389) and John White Alexander's *Study in Black and Green* (p. 212).

An interest in mural painting was also part of this trend. Painters collaborated with architects and sculptors on a number of important projects, including the Library of Congress, the Boston Public Library, and the buildings for the World's Columbian Exposition in Chicago. Strongly influenced by the French painters Pierre Puvis de Chavannes and Paul Baudry, Americans like Edwin H. Blashfield, Kenyon Cox, H. Siddons Mowbray, and Robert Reid developed styles and subjects suitable to the monumental scale and public character of mural painting. Some of the essential qualities of mural painting—the broad, almost coarse, paint application, the strong outlines, and the limitation of spatial recession—also appear in easel paintings of the 1890s. In subject and treatment, for example, Robert Reid's *Fleur de Lis* (p. 435) is not unlike his murals in the Library of Congress.

By the turn of the century, the generation of American artists described by Sadakichi Hartmann as "a throng of vigorous, eager, cosmopolitan young painters" were the recognized leaders of American art. These same men and women who had challenged established art and artists in the 1870s were now in control of the important art schools and organizations; they were setting the standards for style and subject matter. Their achievements were manifold. They had prompted the growth of schools and exhibition organizations and secured a wider base of patronage. More important, they had brought a new level of sophistication to painting in the United States. Responding to a wide range of European influences, they explored them and developed their own styles of painting. The position of this generation of artists would soon be challenged, first by Robert Henri and his realist followers, the so-called Ashcan School, and then more strongly, by the revolutionary styles already emerging in Europe. In reaction to these developments, this generation of artists adopted a conservative stance, completing the cycle begun decades earlier. The radicals of the 1870s and 1880s—artists like Kenyon Cox, Will H. Low, and Edwin H. Blashfield—became the oft-quoted spokesmen for tradition, and once again young progessive artists found it difficult to show their work at established exhibitions. In many respects, however, the accomplishments of the older artists had set the stage for the changes that ensued. As founders of new art organizations they had established precedents for activity outside of, and even opposed to, the academy. Furthermore, their paintings provided a firm foundation for many of the artistic innovations of the early twentieth century.

Some of the great teachers of the period—William Merritt Chase, Thomas Eakins, and Thomas Anshutz—served as links between the Ashcan School and a tradition of realism that stretches back through Manet and Courbet to old masters like Hals and Velázquez. Then, too, the emphasis on technique and the interest in the decorative qualities of line, color, and design, both such strong features of American painting during the 1880s and 1890s, found new expression in the works of young modernists like Marsden Hartley and Georgia O'Keeffe. Finally, these late nineteenth century American artists had created a new, more aggressive role for themselves and their successors. As teachers, tastemakers, and advisers to patrons and institutions, American artists were better equipped to shape the world in which they worked.

Doreen Bolger Burke

READER'S GUIDE TO THE CATALOGUE

THE same format, methods, and procedures have been followed in the three American paintings catalogues, and the reader can use the following guideline for all of them. The general intention in the arrangement of the catalogues has been to trace the history of American painting, and thus the basic organizing principle is a chronological one. Rather than place each painting strictly according to date, however, paintings are grouped by artist, and within each artist's work they are arranged in chronological sequence with the earliest painting first. The order of artists is by birth and death dates. Thus when two or more painters have the same year of birth, the one who died first precedes. Works by unidentified artists are placed according to their period, style, and subject matter. There is a brief biography with a selected bibliography on every artist after which the entries on the individual paintings in the collection follow. After each discussion of a painting specific information is arranged in the following order: medium, support, and dimensions; inscription and canvas stamp; related works; references; exhibitions; on deposit; ex collections; credit line; and accession number. All works in the catalogues are illustrated, each one with a caption giving artist and title. Illustrations of related works, details, artist's signatures, canvas stamps, radiographs, autoradiographs, and photographs showing a painting's previous condition are included where appropriate. Every attempt has been made to check the physical condition of each painting during the cataloguing process, but since some were out of the museum on extended loan, such an examination was not always possible. While there is no separate discussion of condition for each work, severe problems and irreversible conditions are noted and discussed in the text of an entry.

Each volume has two indexes: one for artists and titles of paintings and another for provenance. For the convenience of the reader an alphabetical list of all artists represented in the three catalogues appears at the end of each volume, indicating in which volume the main entry on a particular artist is to be found. A cumulative index is being reserved for the time when a catalogue of paintings in the collection by artists born after 1864 has been prepared. No absolute cutoff date has been used regarding new acquisitions, but only a few major works received after January 1979 have been included.

These catalogues were begun following the same style as the department's earlier Volume I (1965) by Gardner and Feld, which was in turn based on the museum's European paintings catalogues. As work progressed, however, some changes and additions seemed desirable. Rather than revise the basic format completely, we decided to continue with the tried system and add some new features. There are four basic additions.

In the early volume the sources for quotations in a painting entry were not always indicated; some were given in the reference section, which basically was (and is) limited to works that discuss the museum's painting. Now the sources for all quotations and specific information on an artist's work in general or on his other works are given in parentheses immediately following such information. Thus, the reader should be aware that there is a dual system at work. Where

the source for a quotation also mentions the painting, it is listed in the references, and the year of the publication or item is indicated in the text. The reader can then find the work readily in the reference section, which is organized chronologically. Otherwise, the full bibliographical information appears in parentheses in the text itself.

Under the old method, a similar shortcoming existed regarding information in the artists' biographies. There was often no indication of where the material had been obtained. For this reason a selected bibliography has been added to the biographies to show where most of the information on an artist was found and where further details are available. Here, too, if a particular quotation comes from a work not listed in the bibliography, its origin is indicated in the text in parentheses.

Another new section is one on related works. Although by no means inclusive, it has been added to aid the scholar in sorting out studies, copies, prints, and other versions of a work. It was thought that compiling this information in one place would be helpful.

Finally, it should be noted that attempts have also been made to give the present location of all works of art mentioned in the catalogues. When the present location of a work is not known or the work is not readily available to the public, we have tried to cite a publication where a reproduction of it can be found. Many American paintings have changed hands rapidly in recent years, and it has not always been easy to keep track of them; sometimes the best we could do was to give the place and year in which a work was offered for sale.

No matter how hard one tries to anticipate every possibility in devising a catalogue format, the cataloguer is bound to discover some unexpected but useful information concerning a painting for which there is no proper niche. In such cases we have preferred to be a little inconsistent rather than exclude an interesting item merely because it did not exactly fit the format. As a whole, we have tried to make the catalogues useful to scholars without excluding readers whose interest in American painting is more general and without sacrificing visual design. The following is an explanation of the various categories and editorial procedures used in the catalogues.

Biography of the Artist

The first facts provided on an artist are birth and death dates; these are based on the most recent respected authorities, or in a few cases the discovery of new evidence. Each essay attempts to give pertinent information regarding background, training, stylistic development, influence, and significance. Sources for quoted matter are given in full in the text unless the material comes from one of the publications in the bibliography, in which case only the author's name or a short title and the page number are given. The basic information is derived from works cited in the bibliography.

Cross References

The following method has been used both in biographies and painting entries to indicate a cross reference. When the name of an American painter who is not the subject of that particular entry but whose biography and paintings can be found in the catalogues is first used, it is given

in full in small capital letters. For an American painter whose work is not represented in the catalogues, birth and death dates follow the first mention of the name. This is true only for American painters, not sculptors or engravers, or European artists. To find the volume in which a painter is discussed the reader can consult the complete alphabetical list of artists at the end of each volume. When paintings that have their own entries in the catalogues are mentioned under other entries they are followed by (q.v.).

Bibliography

The bibliography is selective and limited to five items arranged chronologically (obituaries are grouped as one item). Reference works were chosen on the basis of their usefulness in providing the information given in the biography and their reliability as sources for further information. In some cases, however, they are simply all that is available. There are brief annotations to guide the reader.

Titles of Paintings

When known, the original title the artist gave the picture or the title under which the painting was first exhibited or published has been used. For paintings that are obviously portraits, the subject's proper name is given as the title. In some cases, a painting has become so well known by a certain title that to change it would cause considerable confusion, so the popular one has been retained. When, however, a title has been changed, this is indicated in the text of the entry; varying titles appearing over the years are noted in "references" and "exhibited". Where the original title is in a foreign language, it appears in parentheses following the English translation.

Medium and Support

Works have been classified as paintings on the basis of medium and/or support. All works in oil done on canvas, wood, metal, leather, or paperboard supports are included; so too are works in wax, tempera, or mixed media on canvas or wood. In general, works on paper are not included except for a few oils.

Measurements

The dimensions of the support are given in inches followed by centimeters in parentheses. Height precedes width.

Inscriptions

The artist's signature, inscriptions, and their location on the support are given. Inscriptions not in the artist's hand are recorded and indicated as such. Canvas and manufacturers' stamps are also included. Certain labels or stickers are noted when they provide information (e.g., on ex collections or exhibition history) that is not available elsewhere, but they are usually

mentioned where that information is relevant, for example, in the text, or under "exhibited," or "ex coll."

Related Works

A work is considered "related" to a painting in the collection if it is thought to be a preliminary drawing or study, a replica, a variant by the artist, a copy by another artist, or a high quality print based on the painting. There are many cases where artists have painted the same scene or subject repeatedly; such occurrences are generally stated in the text of an entry, but works that just treat the same theme are not included under related works unless there is good reason to consider the museum's picture to be based on one of them.

We do not suggest that the related works noted in this section provide a complete listing. Represented are examples known to our authors through publications or brought to their attention by scholars or the owners of such works. In many cases, our authors have not had the opportunity to examine the related works and have had to rely on previously published information or on the owners for attributions and physical descriptions. A reference to a published illustration is given wherever possible, and some related works are illustrated in the catalogues.

Information on related works is listed as follows: Artist (if other than the artist of the museum's work), Title or Description, Medium, Size, Date, Collection, and City (except in the case of prints), Accession number (only where needed, for example, in the case of drawings in large collections), Reproduction (cited as "ill." in Author, Title, Date, Page or Plate number).

References

For the most part these are sources that refer directly to the painting under discussion. Sometimes, however, sources for the biography of a subject or information on settings or items shown in the paintings are included, but they are always annotated as such. The references are selective: contemporary sources on the paintings are included, as are newspaper and periodical reviews of their exhibitions; more recent books, articles, manuscripts, and spoken accounts appear when they offer new information, interpretations, or in general add to the knowledge of the works. When a painting is not included in an exhibition but is *discussed* in an exhibition catalogue, the exhibition catalogue appears in the reference section. Otherwise all information from exhibition catalogues is given under "exhibited." Illustrations are noted in the references, and special attempts have been made to mention at least one reproduction in color. At times too, the authors have indicated that an illustration shows the work in a different condition from the present one.

The standard form for a reference is as follows: the writer's first initials and last name, the main title of the book or periodical (subtitles are usually excluded) or a description of the document, the first date of the writing (with the date of later or revised editions following), the volume in arabic numbers, the page number, and possibly a brief annotation. References are separated from one another by the symbol // unless two works by the same writer happen to come one after the other, in which case a semicolon is used. Newspaper and manuscript refer-

ences follow the method prescribed in the twelfth edition of the Chicago *Manual of Style*. A few abbreviations are used and they are listed at the end of these notes.

Material from the Archives of American Art, Smithsonian Institution, has been cited repeatedly, and the reader should know how we distinguish collections owned by the archives from those owned by others but available on microfilm at the archives. When the Archives of American Art has the collection, the item is described, and the date, collection, and archive number is given, followed by "Arch. Am. Art" (e.g. A. H. Thayer to G. de F. Brush, Jan. 6, 1917, Thayer Papers, D200, Arch. Am. Art). When the material is only on microfilm there, the item is described, and the date, the collection, and the place where the collection is to be found are given, followed by the microfilm number used by the Archives of American Art and its name (e.g. J. S. Sargent to I. S. Gardner, August 18, 1894, Isabella Stewart Gardner Museum, Boston, microfilm 403, Arch. Am. Art).

Documents in the museum's possession are also cited frequently, and they are found either in the files of the Department of American Painting and Sculpture (Dept. Archives) or in the Archives office of the museum (MMA Archives).

Exhibited

The listing of exhibitions in which the painting has appeared is selective. Efforts have been made, however, to include all known exhibitions of a painting before its acquisition by the museum. Also one-man shows, memorials, retrospectives, and major group shows are given. In cases where a catalogue for an exhibition provides new information or places the museum's painting in a new interpretive context, this exhibition, too, is included.

In the listings, the institution, gallery, or exhibition hall is given first, followed by the city (when not already indicated in the name of the institution), the year, the title of the exhibition and catalogue. We then list the author of the catalogue or entry, the number assigned to the painting there, and the title under which the painting was exhibited if it is the first known exhibition or the title is different from the present one. A brief annotation summarizing the information supplied (lender, price, or discussion of the work where significant) is placed last. In the case of regular annual exhibitions the title is dropped (e.g. *Fifteenth Annual Exhibition . . .*) and only the institution or its abbreviation is given (e.g. NAD, 1831, no. 181, as Portrait of a Gentleman, lent by M. E. Thompson).

Exhibitions, like references, are separated from one another by the symbol //. When the same institution appears consecutively, a semicolon is used and the name is not repeated. The places to which an exhibition traveled are listed, except in the case of ones that had many stops, then usually the names of the organizing institutions are given, followed by "traveling exhibition" (e.g. MMA and American Federation of the Arts, traveling exhibition, 1975–1977, *The Heritage of American Art*, cat. by M. Davis, no. 77, ill. p. 172; p. 173).

On Deposit

Paintings are considered as on deposit when they have been housed in, or placed on long-term loan to, an institution or agency that does not own them. Depending on the circumstances,

they may or may not have been available to the general public. Deposits made before the Metropolitan Museum's acquisition of works have been included when known and verifiable.

Ex Coll.

The names of previous owners of a painting from the earliest known to the last are given with their city of residence and the years when they are known to have held the painting. (Dates are usually derived from exhibition information, and owners' death dates are sometimes supplied for the terminal date.) The family relationship of one owner to another is given when known. When a work was owned by, or consigned to, a dealer the preposition *with* appears before the name; a person who simply negotiated the sale or gift of a painting is further described "as agent." Auction information is always given in parentheses. A semicolon is used between the listings of various transactions, except where a painting passed directly from its known owner to an auction sale. A semicolon is also used, however, if we do *not* know or cannot verify the owner at the time of the auction. For example in ". . . Bertha Beckwith, New York, 1917–1926 (sale, Silo's, New York, Nov. 19, 1926, no. 389, as Chase's Wife on the Lake in Prospect Park, 13 1–2 × 19 1–2, $250). . . ." we know that the painting was sold by Mrs. Beckwith at Silo's; if we did not know for sure that she was the owner when Silo's sold the painting, a semicolon would appear before the parenthesis and sale.

Great effort has been made to verify the information we have on previous ownership, but this has not always been successful. In some cases, therefore, a listing may be qualified by "probably," "possibly," or with a question mark. Very often information comes to the museum second hand, and sometimes there is only family tradition to rely on. The sources for the information we have received are usually found under "references" or "exhibited"; otherwise a statement on the source follows the name of the former owner, e.g. James Smith (according to a label on the back). The artist's name is sometimes given in this section when the work remained in his possession for a long period after it was known to have been completed and of course if it later reverted to him.

We have given the names of all collections known to us except in the case of anonymous donors to the museum where the person's intent or legal stipulations prevent such disclosure.

Kathleen Luhrs, *Editor*

ABBREVIATIONS AND SHORT TITLES

Am. Acad. of Arts and Letters	American Academy of Arts and Letters, New York
Arch. Am. Art	Archives of American Art, Smithsonian Institution, Washington, D.C.
Arch. Am. Art Jour.	*Archives of American Art Journal*
DAB	*Dictionary of American Biography* (New York, 1926–1936)
FARL	Frick Art Reference Library, New York
Gardner and Feld	Albert Ten Eyck Gardner and Stuart P. Feld, *American Paintings: A Catalogue of the Collection of the Metropolitan Museum of Art. Volume I: Painters Born by 1815* (New York, 1965)
Groce and Wallace	George C. Groce and David H. Wallace, *The New-York Historical Society's Dictionary of Artists in America, 1564–1860* (New Haven, 1957)
MFA, Boston	Museum of Fine Arts, Boston
MMA	Metropolitan Museum of Art, New York
MMA Bull.	*Metropolitan Museum of Art Bulletin*
MMA Jour.	*Metropolitan Museum Journal*
NAD	National Academy of Design, New York
NYHS	New-York Historical Society
NYPL	New York Public Library
PAFA	Pennsylvania Academy of the Fine Arts

THE CATALOGUE

FRANK MILLET

1846–1912

Francis Davis Millet gained an international reputation as an easel painter, muralist, and illustrator, as well as a journalist. An artist with strong ties to Europe, especially England, he played an important role in art organizations and activities of the period. He was born in Mattapoisett and moved to East Bridgewater, Massachusetts, with his family two years later. A local tutor prepared him for college, and in 1869 he graduated from Harvard, having excelled in history and languages. Even at this date, he pursued a varied career, working for several Boston newspapers and studying lithography with Dominique C. Fabronius, a Belgian-born lithographer and publisher. In 1871, Millet went to Antwerp, where he studied at the Royal Academy for two years, following the required academic course that began with the copying of lithographs, drawings, and casts and culminating in painting from life. Joseph Van Lerius, then director of the painting class, is said to have emphasized a Rubensesque impasto technique. Following his studies, Millet spent several months in Vienna as secretary to Charles Francis Adams, Jr., a commissioner to the 1873 exposition in that city. Soon after he traveled to Italy, where he painted *Sailing in the Bay of Naples*, 1875 (Public Library, East Bridgewater, Mass.), a large-scale figure painting which he submitted to the Brussels Salon of 1875, the first instance of his participation in a major exhibition.

When Millet returned to the United States in the summer of 1875, he intended to remain only a few months, but he did not go back to Europe until January of 1877. During this period, he benefited from a number of experiences that proved significant in his later career. Besides painting portraits and exhibiting at the National Academy of Design in 1876, he worked as a newspaper and magazine correspondent, covering the Centennial Exhibition in Philadelphia, where he became more familiar with the organization and operation of such fairs. There he also admired the displays of historic American objects and very soon was exhibiting genre paintings that represented early American subjects. That same year he assisted JOHN LA FARGE in the decoration of Trinity Church in Boston, his first effort at mural painting, later one of his major interests.

In 1877, Millet joined friends in Europe and, after traveling in Belgium, settled in Paris. In the spring he went to the Russo-Turkish front as a war correspondent and special artist. He then served on the awards committee for the Universal Exposition held in Paris in 1878 and joined the circle of American artists gathered around D. Maitland Armstrong (1836–1918), the United States art commissioner for the exposition. Among his close associates at this time were the painter GEORGE W. MAYNARD and the sculptor Augustus Saint-Gaudens, who did a bronze relief portrait of Millet in 1879 (MMA). That year Millet married Elizabeth Greeley Merrill and on a honeymoon trip to London had an opportunity to meet some of the British artists he had long admired. He returned to Boston in 1879 and two years later went to New York to assist LOUIS COMFORT TIFFANY and the Associated American Artists with the decorative work for the Seventh Regiment Armory. He made a tour of northern Germany and Scandinavia with EDWIN AUSTIN ABBEY and R. SWAIN GIFFORD in 1882 and traveled to England the following

year. His first visit to the artists' retreat at Broadway, Worcestershire, took place in 1884. Not long after, he purchased a house and studio in this small village and divided his time between England and the United States. It is not surprising then that Millet's paintings from the 1880s and 1890s show the influence of British academic painting. Undoubtedly influenced by Sir Lawrence Alma-Tadema, he chose classical subjects for his genre paintings, which, like *Reading the Story of Œnone*, 1883 (Detroit Institute of Arts), show carefully researched period costumes and focus on the everyday aspects of ancient life. More characteristic of his work, however, are the historical genre scenes, which at this time shifted from American to English period settings. Inspired by his picturesque surroundings and perhaps influenced by the historical interests of such Broadway friends as Abbey and the author Edmund Gosse, Millet depicted English scenes, using costumes and interiors that span the Elizabethan and Regency periods. Enormously popular, these paintings were exhibited at home and abroad. *At the Inn*, 1884 (Union League Club, New York) won an award at the Second Prize Fund Exhibition held in New York in 1886, and *Between Two Fires*, 1892 (Tate Gallery, London) was purchased by the Chantrey Fund the year it was completed. Millet continued to paint subjects of this type until at least 1902, when he once again became more interested in portraiture.

The artist's important work as a muralist began in 1892 for the World's Columbian Exposition, where he not only directed the planning and execution of the decorations but also did several murals for the fair buildings. In his early murals classical subjects predominated, but after 1897, historical American events served as his inspiration. Among the more ambitious subjects, *The History and Settlement of Ohio* was completed in 1909 for the Cleveland Trust Company, and for the Baltimore Custom House, a nautical theme, representing the history of shipping, was finished in 1908.

Around the turn of the century, Millet continued to pursue many interests: he worked again as a news correspondent, during the Spanish-American War, and helped organize the American section of the exposition held in Paris in 1900. During the final decade of his life, he was extremely active in a great many organizations, joining the Harvard University Committee on Fine Arts and Architecture, the Niagara Falls Commission, the National Council of Fine Arts, and the National Commission of Fine Arts. He was elected to the National Institute of Arts and Letters in 1908 and the American Academy of Arts and Letters two years later. While serving on the United States commission to the Tokyo Exposition, planned for 1912, he traveled to Japan. A charter member of the American Academy in Rome, founded in 1905, he was deeply involved in establishing its facilities in Italy. While returning to New York on academy business in April 1912, he died when the *Titanic* sank. In a tribute to him, his friend WILLIAM COFFIN wrote: "His place cannot really be filled by any one man that we can think of, for he was capable of filling a number of responsible positions at the same time, and filling them all rather better than anybody else could do" (*Nation* 94 [April 25, 1912], p. 410).

BIBLIOGRAPHY: Francis Davis Millet Papers, ca. 1867–1928, 848–849 and 1096–1099, and Francis Millet Rogers Papers, ca. 1897–1957, 1095–1096, Arch. Am. Art, include letters, sketchbooks, photographs, clippings, and unpublished biographical material on the artist ǁ *Francis Davis Millet Memorial Meeting, the American Federation of Arts* (held at the National Museum, Washington, D.C., 1912). A pamphlet, 1052, in Arch. Am. Art, gives addresses presented on May 10, 1912, by Elihu Root, Henry Cabot Lodge, Charles Francis Adams, Charles D. Walcott, includes an introduction by Cass

Gilbert, tributes by various art organizations and individuals, illustrations, and a partial list of Millet's artistic and literary works // *Art and Progress* (Francis Davis Millet memorial number) 3 (July 1912). Includes articles by Sylvester Baxter, William A. Coffin, Edwin Howland Blashfield, J. Carroll Beckwith, and George W. Maynard // Dayton Art Institute, *American Expatriate Painters of the Late Nineteenth Century* (1977), exhib. cat. by Michael Quick, pp. 114–116, gives biography; pp. 153–154, provides an extensive bibliography // H. Barbara Weinberg, "The Career of Francis Davis Millet," *Arch. Am. Art Journal* 17, no. 1 (1977), pp. 2–18. The most comprehensive treatment of the artist's life and work to date, well-illustrated with extensive footnotes.

A Cosey Corner

A Cosey Corner was painted in 1884, a transitional year in Millet's career; for at this point he began to divide his time between the United States and England. Although the scene depicted has never been identified with certainty, the interior architecture and the figure's costume seem to be English in origin. Indeed several of Millet's contemporaries assumed that the subject was English. When the work was exhibited at the National Academy of Design in 1886, art critics compared the figure to Dolly Varden, a character from Charles Dickens's novel *Barnaby Rudge* (1841), which is set in eighteenth-century England. The costume is a romantic re-creation of several different fashions popular in England at various points during the eighteenth century, and the setting may be equally imaginary. Several features, most notably the large fireplace and "the shelf above," correspond to a published description of "a colonial New England kitchen" in Millet's East Bridgewater, Massachusetts, studio (G. Lathrop, *Boston Herald*, [1880], clipping in Millet Scrapbook 2, Am. Acad. of Arts and Letters, New York). The interior shown in the painting, however, does not resemble any room in the studio as it stands today, and, in general, the style of architecture depicted suggests an English source, perhaps a building in Broadway, the picturesque village in the Cotswolds that Millet first visited in 1884, the year the painting was done.

A drawing for the interior of *A Cosey Corner* is included in an undated Millet sketchbook (Arch. Am. Art). Although inscribed with a New York address, the sketchbook contains several drawings that appear to be of European subjects. The drawing shows the basic elements of the setting viewed from the same angle as the painting, with the fireplace, windows, and windowseat enclosed by the wood mantelpiece and its mortar supports. Many details, for example the placement of the stone slabs around the fireplace, have been re-

tained in the final work, but Millet also made some significant changes, adding some space above and to the left of the fireplace, eliminating the chair between the fireplace and the window alcove, and replacing the bellows with a bunch of dried herbs. Other accessory items have been added in the finished painting to enhance its narrative quality. On the mantel are a number of decorative items, and by the fire are a blue and white porcelain cup and saucer with a silver spoon. A sheer curtain is held back by the woman to admit more light, and her foot is neatly poised on a basket footrest. Given the great interest that Millet displays in these objects, it is not surprising that his friend DENNIS MILLER BUNKER described such scenes as "furniture pictures," where "everything was well painted and drawn excepting the things that should have been most so— I mean the figures" (D. Bunker to E. Hardy [1889–1890], 2, pp. 299–300, Bunker Papers, Arch. Am. Art).

Oil on canvas, 36¼ × 24¼ in. (92.1 × 61.6 cm.).
Signed and dated at lower left: F. D. Millet 1884.
RELATED WORK: Study for the interior setting, pencil on paper, 10⅛ × 7⅝ in. (25.7 × 19.4 cm.), sketchbook, [1880s], p. 13, Francis Davis Millet Papers, 1098, Arch. Am. Art.
REFERENCES: M. G. Van Rensselaer, *Book of the American Figure Painters* (1886), unpaged ill. accompanies a poem by Thomas Hood // *Art Age* 16 (April 10, 1886), p. 116, in a review of the exhibition at the NAD, criticizes it for "a certain fatal smoothness like porcelain" // *Critic* 5 (April 10, 1886), p. 183, in a review of the NAD exhibition, compares figure "seated in the window of an old English kitchen" to Dolly Varden and says "the lines of the flagging are unnecessarily accentuated" // *Art Amateur* 14 (May 1886), p. 120, in a review of NAD exhibition, compares the figure "ensconced in an old-fashioned chimney corner, roasting apples," to Dolly Varden // G. I. Seney to S. P. Avery, March 28, 1887, MMA Archives, offers it to MMA // Printed statement, April 7, 1887, MMA Archives, notes that Seney purchased the painting at the NAD spring exhibition // M. G. Van Rensselaer, *Independent* (April 21, 1887), p. 490, calls it "one of the

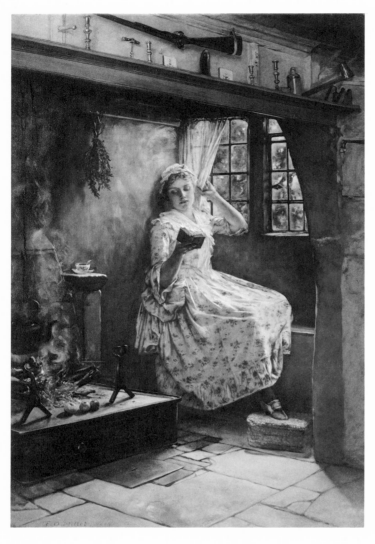

Millet, *A Cosey Corner*.

most charming *genre* paintings recently executed in this country" // G. W. Sheldon, *Recent Ideals of American Art* (1888, rev. ed. 1890), p. 54, notes it as an example of Millet's genre subjects; ill. opp. p. 64; pp. 76–78, says it does not show the influence of Alma-Tadema, notes ease and unconventionality of the composition, and says Millet's reputation has been advancing since its appearance // *American Artists and Their Works* [1889–1891], 2, ill. opp. p. 317 // G. A. Smith, *The Laurelled Chefs-d'œuvre d'art from the Paris Exhibition and Salon* [1890], 2, ill. no. 26 // *Francis Davis Millet Memorial Meeting, the American Federation of Arts* (1912), ill. opp. p. 4; p. 58, includes it under genre in a partial list of the artist's works as no. 27 // W. A. Coffin, *Art and Progress* 3 (July 1912), ill. p. 647 // L. M. Bryant, *American Pictures and Their Painters* (1917), ill. opp. p. 100; p. 102, discusses it as an example of the artist's

genre work // J. Hunt, comp., *A List of Paintings, Drawings, Mural Decorations and Designs, Civil and Military Awards and Literary Works of Francis Davis Millet* (1920), includes it in a list of paintings under genre as no. 27 // L. M. Bryant, *Mentor* 8 (Dec. 1920), ill. p. 17 // F. M. Rogers, "Frank D. Millet, American of Americans," MS [1945], Frank Millet Rogers Papers, 1096, Arch. Am. Art, sec. 8, pp. 10–11, discusses it as an example of a work "done in England during the Broadway period" and includes it as no. 11 in a list of the artist's easel paintings // F. M. Nichols, grandnephew of the artist, letters in Dept. Archives, Oct. 15, 1963, and March 3, 1964, says that his mother, Grace Evelyn Millet, the artist's niece, posed for the picture and that "As far as I know the setting of 'The Cozy Corner' was an old house in East Bridgewater, Massachusetts, one of the early colonial houses of that section" // H. B.

6

Millet, Study for *A Cosey Corner*,
Archives of American Art.

Weinberg, *Arch. Am. Art Journal* 17, no. 1 (1977), p. 8, based on Nichols's letter, gives setting as artist's East Bridgewater studio kitchen and says it is one of his "best known and widely praised American costume works," exemplifying his "long-standing interest in American colonial genre" // R. F. Bartlett, East Bridgewater, Mass., letter in Dept. Archives, March 20, 1978, says that the interior pictured bears no relationship to the Millet studio and residence in that town // L. Dinnerstein, letter in Dept. Archives, May 22, 1978, supplies reference from 1887 *Independent*.

EXHIBITED: NAD, 1886, no. 510, as A Cosey Corner, for sale $1,500 // Lyman Allyn Museum, New London, Conn., 1945, *A Catalogue of Works in Many Media by Men of the Tile Club*, no. 94 // Dayton Art Institute, PAFA, Los Angeles County Museum of Art, 1976–1977, *American Expatriate Painters of the Late Nineteenth Century*, exhib. cat. by M. Quick, no. 30, ill. p. 115; p. 116, discusses Millet's use of eighteenth-century costume.

Ex COLL.: George I. Seney, Brooklyn, 1886–1887.

Gift of George I. Seney, 1887.

87.8.3.

ALBERT PINKHAM RYDER

1847–1917

Albert Pinkham Ryder's imaginative paintings, which belong to the late nineteenth-century visionary tradition, present enormous problems regarding chronology, conservation, and connoisseurship. He never dated and often did not sign his paintings, many of which were reworked over an extended period of time even after they were exhibited or sold. The unsound technical procedures he used have resulted in changes and deterioration in his paintings. Furthermore, although he produced as few as one hundred and sixty pictures, a large number of fakes and forgeries of his work appeared during his lifetime and became even more common after his death, making him the most forged American artist after RALPH BLAKELOCK.

Born in New Bedford, Massachusetts, the artist was the youngest of the four sons of Alexander Gage Ryder and Elizabeth Cobb Ryder, both descended from old-time Cape Cod families. He attended a local grammar school, but impaired eyesight prevented further education. Early accounts state that he followed a "commercial life." He also began to paint, receiving some direction from a local amateur artist.

In 1870, his family moved to New York, where his brother William was a restaurant proprietor. Ryder applied for admission to the school of the National Academy of Design and at

first was refused. He was, however, admitted after some instruction from the portraitist and engraver William E. Marshall (1837–1906). He exhibited for the first time at the National Academy in 1873, and about two years later his work was featured in an important group exhibition at the New York branch of the English firm of interior decorators Cottier and Company. Daniel Cottier and his partner James S. Inglis helped to further the artist's reputation, and, like J. ALDEN WEIR, the sculptor Olin Levi Warner, and the art critic Charles de Kay, they became his close friends. In 1877, Ryder made a trip to London with Cottier and stayed for about a month. That same year he was among the founders of the Society of American Artists, where his work was exhibited regularly over the next decade. During the 1870s, he painted primarily landscapes, usually farm scenes with figures and domestic animals. Small in scale and naturalistic in style, they recall the Barbizon paintings of his contemporaries.

Around 1880, Ryder took a studio in the Benedick Building on Washington Square East, where he lived and worked for the next decade. At this time, his art underwent changes in subject and style. His pictures were based on literary themes drawn from classical mythology, the Bible, poetry, even the opera and were sometimes accompanied by his own poems. His important marine paintings of storm-tossed boats under moonlit skies were also undertaken at this period. Although based on Ryder's observations of nature, these imaginative paintings represent his highly personal vision, with simplified detail, strong overall design, and a concentration on mass and movement. His unusual painting effects, the rich dark colors and enamel-like surfaces, achieved by applying glazes and many layers of pigment, were often the result of unorthodox techniques.

The artistic sources of Ryder's unusual style have not been adequately explored. His exposure to foreign art and its influence was more limited than that of Americans who studied, lived, or worked abroad. He made a second trip to England with Cottier in 1882, and after joining Warner in Paris, they made a hurried tour of Holland, Italy, Spain, and Tangier. His last two trips to Europe, made in 1887 and 1896, seem to have been taken mainly for the sea voyage with only a few weeks spent in London. He had ample opportunity, however, to study European paintings in New York's galleries, museums, and private collections. His paintings show the influence of Jean Baptiste Camille Corot, Adolphe Joseph Thomas Monticelli, and Matthijs Maris, whose works his friends Cottier and Inglis sold. Marshall, his teacher during the early 1870s, and ROBERT LOFTIN NEWMAN, a close friend, were both students of the French painter Thomas Couture, and it seems likely that Ryder was at least aware of this academic's painting technique and artistic philosophy.

During the 1880s, Ryder's work gained wider acceptance, and besides Cottier and Inglis, he was patronized by such important collectors as Thomas B. Clarke. After 1887, his paintings were exhibited at the Society of American Artists only once and, after 1888, not at all at the National Academy, so that during the 1890s his pictures were rarely displayed, except when they were lent by their owners. During the mid-1890s, the artist, who was becoming increasingly eccentric, settled on West Fifteenth Street, where he lived and worked for the next fifteen years. Ryder was, as Lloyd Goodrich has described him, "completely unworldly. He cared nothing for money, social prestige, or even the ordinary comforts of living" (Goodrich, 1959, p. 26). He never married; he dressed, ate, and lived poorly, and depended on his friends to supervise his affairs. He was always shy but grew reclusive in old age and saw only very close friends.

After 1900, Ryder's creative ability diminished, and he began few, if any, new pictures. His work, however, appealed to the rising generation of American modernists—ten of his paintings were included in the Armory Show of 1913. ARTHUR B. DAVIES, Marsden Hartley (1877–1943), Kenneth Hayes Miller (1876–1952), and Rockwell Kent (1882–1971) are among the many younger artists who either sought his advice or were profoundly influenced by his paintings. During the twentieth century, Ryder became one of the most admired artists of his period. His seeming modernity, his choice of romantic themes, and his eccentric behavior are among the many factors that enhanced his appeal to modern artists.

In 1915, Ryder became seriously ill and was hospitalized for several months. Thereafter he lived in Elmhurst, Long Island, with Charles and Louise Fitzpatrick, his former neighbors in Manhattan. He died in Elmhurst on March 28, 1917, shortly after his seventieth birthday, and the following year a memorial exhibition of his work was held at the Metropolitan Museum.

BIBLIOGRAPHY: Lloyd Goodrich, unpublished Ryder material, Lloyd Goodrich Archives, Whitney Museum of American Art, New York, microfilm N/619—N/624, Arch. Am. Art. The richest and most complete body of material on the artist, reflects this scholar's work on Ryder since the 1930s // "Albert Pinkham Ryder—Painter," *Index of Twentieth Century Artists* 1 (Feb. 1934), pp. 65–72, suppl. Reprint ed. with cumulative index. New York: Arno Press, 1970, pp. 94–101; suppl. pp. 110, 112, 114. Contains the most complete bibliography available on the artist; also lists awards and honors, affiliations, and paintings in public collections // Whitney Museum of American Art, New York, *Albert P. Ryder Centenary Exhibition* (Oct. 18—Nov. 30, 1947), cat. by Lloyd Goodrich // Lloyd Goodrich, *Albert P. Ryder* (New York, 1959). The most complete published record of this scholar's work on the artist, it includes a biography and critical analysis, many illustrations, a discussion of forgeries, a chronological note, and bibliography // Lloyd Goodrich, "New Light in the Mystery of Ryder's Background," *Art News* 60 (April 1961), pp. 39–41, 51.

The Smugglers' Cove

This shore scene, painted on gilded leather, may have been done as a decorative commission, presumably early in the artist's career. This possibility is supported by the provenance; for the painting was acquired from the artist by James S. Inglis of Cottier and Company, a firm of interior decorators that also sold paintings. The romantic subject matter and seaside setting are typical of themes painted by Ryder throughout his career, but the extraordinarily thin paint application and decisive execution, with little evident reworking, are unusual in his painting and may be attributed to the commercial nature of the work.

The visual sources for *The Smugglers' Cove* are puzzling. The narrow horizontal format, the treatment of landscape elements, and the warm color harmonies may have been influenced by Piero di Cosimo's *A Hunting Scene*, ca. 1505–1507, a work exhibited at the Metropolitan Museum in 1874 and acquired the following year. Certain aspects of *The Smugglers' Cove* also suggest the influence of Japanese art, which had an impact on American painting by the late 1870s. Beneath the thinly brushed pigment, there is an underlayer of gilt that enhances the texture and gives the painting a warm golden tone. The rocks, cliff, and boat are silhouetted against the flat empty areas of the water and sky. The treatment of such features as the two houses leaning against each other, with their windows and doors reduced to blackened voids, is not duplicated in American art until the advent of modernism in the early years of the twentieth century.

This picture has been mentioned in connection with Ryder's *Pirate's Island* (Georgia Museum of Art, Athens). The two works are similar in size, support, and subject, but the extensive restoration of the Metropolitan picture makes it difficult to evaluate this relationship in terms of style.

Oil on gilded leather, $10\frac{1}{8} \times 27\frac{3}{4}$ in. (25.7 × 70.5 cm.).

REFERENCES: American Art Association, New York, *Illustrated Catalogue of Paintings and Water Colors . . . of the Late James S. Inglis of Cottier and Company New York*, sale cat. (1909), ill. no. 59, describes as painted on canvas and notes that it was purchased from the

artist // B. B[urroughs], *MMA Bull.* 4 (May 1909), pp. 88–89 // *American Art News* 15 (March 31, 1917), p. 4, mentions it in artist's obituary // F. F. Sherman, *Albert Pinkham Ryder* (1920), p. 71, includes it as no. 86 in a catalogue of the artist's work // H. E. Schnakenberg, *Arts* 6 (Oct. 1924), p. 272, says that it must have been done as a panel for a screen // F. N. Price, *International Studio* 81 (July 1925), pp. 287–288 // F. J. Mather, Jr., et al., *The Pageant of America* (1927) 12, ill. p. 61, no. 90 // F. N. Price, *Ryder [1847–1911]* (1932), pp. xx, xxi; no. 166, lists it in a catalogue of the artist's work // *Index of Twentieth Century Artists* 1 (Feb. 1934), p. 71, lists illustrations of it // F. J. Mather, Jr., *Magazine of Art* 39 (Nov. 1946), ill. p. 302, discusses // L. Goodrich, undated notes, unpublished Ryder material, Lloyd Goodrich Archives, Whitney Museum of American Art, New York, microfilm N/620, Arch. Am. Art, compares to Shore Scene; notes, 1947, microfilm N/623, lists references and gives stylistic analysis // W. Sargeant, *Life* 30 (Feb. 25, 1951), color ill. p. 91 // L. Goodrich, *Albert P. Ryder* (1959), ill. pl. 50; *Art News* 60 (April 1961), p. 51, mentions its wide panoramic format and notes possible influence of a Piero di Cosimo painting at MMA // J. Wilmerding, *A History of American Marine Painting* (1968), ill. p. 230; p. 232 // P. Meyers, Research Laboratory, MMA, orally, May 27, 1978, noted that autoradiographs of the picture show the squares of gilt applied to the leather support.

EXHIBITED: Whitney Museum of American Art, New York, 1947, *Albert P. Ryder Centenary Exhibition*, cat. by L. Goodrich, no. 39, gives support as leather with gold leaf.

EX COLL.: with James S. Inglis of Cottier and Company, New York, died 1907; his estate (sale American Art Association, New York, March 12, 1909, no. 59, as The Smugglers' Cove).

Rogers Fund, 1909.

09.58.2.

The Bridge

The painting, done on gilded leather, has the same striking horizontal format and thin paint application as *The Smuggler's Cove* (q.v.), and, like it, may have been done early in the artist's career as part of a decorative project. The stretcher bears the fragmentary stamp of Cottier and Company, a London interior decorating firm with a New York branch that sometimes exhibited and sold paintings. Ryder was on friendly terms with the company's New York proprietors, Daniel Cottier and James S. Inglis, and *The Bridge* remained in Inglis's possession until his death in 1907. It was included in his estate sale two years later.

According to Lloyd Goodrich's unpublished

notes (1947), this panoramic landscape is an imaginative combination of several New York views familiar to the artist: the city skyline is similar to the view from Central Park, and the bridge, arranged parallel to the picture plane, appears to be High Bridge, which spans the Harlem River several miles north of the park. Goodrich concludes, however, that although "Ryder used these familiar elements from New York, . . . the picture is in no way a literal scene of the city."

Oil on gilded leather, 10 × 26¾ in. (25.4 × 67.9 cm.).

Stamped on stretcher: [CO]TTIER & CO / 204 / [NEW] YORK & LOND[ON].

REFERENCES: American Art Association, New York, *Illustrated Catalogue of Paintings and Water Colors . . . of the Late James S. Inglis of Cottier and Company New York*, sale cat. (1909), ill. no. 68, as The Bridge, oil on canvas, purchased from the artist // *George A. Hearn Gift to the Metropolitan Museum of Art . . .* (1913), ill. p. 88 // *American Art News* 15 (March 31, 1917), p. 4, mentions it in obituary of the artist // F. F. Sherman, *Albert Pinkham Ryder* (1920), p. 71, includes it as no. 85 in a catalogue of the artist's work // H. E. Schnakenberg, *Arts* 6 (Oct. 1924), p. 272, says it must have been done as a panel for a screen // F. N. Price, *Ryder [1847–1917]* (1932), no. 13, lists it in a catalogue of the artist's work // *Index of Twentieth Century Artists* 1 (Feb. 1934), p. 69, lists illustrations of it // L. Goodrich, notes [1930s–1940s], unpublished Ryder material, Lloyd Goodrich Archives, Whitney Museum of American Art, microfilm N/622, Arch. Am. Art, lists references and exhibition; gives stylistic analysis; notes, 1947, suggests that although it is an imaginary landscape, it bears resemblance to New York scenes (quoted above) // P. Meyers, Research Laboratory, MMA, orally, May 27, 1978, reported that autoradiographs of the picture clearly show the squares of gilt applied to the leather support.

EX COLL.: James S. Inglis of Cottier and Company, New York, died 1907; his estate (sale, American Art Association, New York, March 12, 1909, no. 68); George A. Hearn, New York, 1909.

Gift of George A. Hearn, 1909.

09.72.8.

Curfew Hour

Completed by 1882, the painting was exhibited soon after at the Metropolitan Museum with the title "The Curfew Tolls the Knell of Parting Day," the opening line of Thomas Gray's "Elegy Written in a Country Churchyard." It seems probable that Ryder either selected or approved

Ryder, *The Smugglers' Cove.*

Ryder, *The Bridge.*

of this title, as the picture was then owned by the mother of his friend Charles de Kay, who undoubtedly was aware of the artist's intentions in regard to the work. Furthermore, Ryder's landscape captures the quietist mood of the opening stanzas of the poem:

> The curfew tolls the knell of parting day,
> The lowing herd winds slowly o'er the lea,
> The plowman homeward plods his weary way,
> And leaves the world to darkness and to me.
> Now fades the glimmering landscape on the sight,
> And all the air a solemn stillness holds.
> Save where the beetle wheels his droning flight,
> And drowsy tinklings lull the distant folds:

> Save that from yonder ivy-mantled tower
> The moping owl does to the moon complain
> Of such as, wandering near her secret bower,
> Molest her ancient solitary reign.

In this poem, Gray reflects on death and affirms the continuity of life, asserting his affinity both with nature and mankind. Ryder's paintings, even at this early date, demand a consideration of just such issues. Here man is in sympathy with his environment, his presence suggested by the domestic landscape with its sturdy stone wall, rutted path, and thatched cottages. There is no sign of movement; the scene is deserted except for two motionless cows that face the farm build-

Ryder, *Curfew Hour*, condition at acquisition, 1909.

ings. The rising moon glowing in the distance further contributes to the sense of stillness.

Writing in 1890, Charles de Kay described *Curfew Hour* as "an ideal twilight warmly brown in tones, showing farm-buildings such as one sees in French Canada, grazing cattle, and a high moon." Indeed, this tranquil rural scene represents a subject and a time of day favored by an entire generation of artists influenced by Barbizon painting, among them Louis Paul Dessar (1867–1952) and the Canadian-born HORATIO WALKER. It is difficult to evaluate the style of the painting today because it has deteriorated beyond recognition, but the broad treatment and extraordinary subtlety evident in early photographs of the work show a similarity to the landscapes of JOHN LA FARGE. The surface is now severely contracted and marred by cracks and discolorations. According to Lloyd Goodrich's unpublished notes, serious cracks had appeared on the surface of the picture by 1935. After examining *Curfew Hour* again in 1938, he observed:

The cracks are very bad, especially in the hill at the upper right and center, where the top layer of paint has contracted into islands, wrinkled in texture, [and is] separated by great wide areas of a transparent glossy substance which looks like varnish. Through this transparent substance can be seen other paint below the surface. The effect is that of a scum of paint floating on a liquid.

The condition has worsened since this date, and although it now seems to have stabilized, as is the case with so many Ryder paintings, there is nothing that can be done to restore the original appearance.

Oil on wood, $7\frac{1}{2} \times 10$ in. (19.1 × 25.4 cm.).

Signed at lower left (no longer visible): APRyder.

REFERENCES: H. Eckford [C. de Kay], *Century*, ns. 18 (June 1890), p. 258, describes it (quoted above) // American Art Association, New York, *Illustrated Catalogue of Paintings and Water Colors . . . of the Late James S. Inglis of Cottier and Company New York*, sale cat. (1909), ill. no. 73, as The Curfew Hour, says purchased from the artist // B. B[urroughs], *MMA Bull.* 4 (May 1909), pp. 88–89, discusses it // *American Art News* 15 (March 31, 1917), p. 4, mentions it in artist's obituary // F. F. Sherman, *Albert Pinkham Ryder* (1920), p. 15, mentions its exhibition at the Society of American Artists; p. 71, lists it as no. 84 in a catalogue of the artist's work; p. 76, includes it in a list of exhibited works; p. 77; "Albert Pinkham Ryder—Supplement," [1920–1940], in unpublished Ryder material, Lloyd Goodrich Archives, Whitney Museum of American Art, New York, microfilm N/621, Arch. Am. Art, under part 3, farm and barnyard pictures, calls Curfew Hour "one of the most elegant works in the series" // F. N. Price, *Ryder [1847–1917]* (1932), p. xxii; pl. 23; no. 23, lists it in a catalogue of the artist's work // T. C. Cole, "Notes on Charles Melville Dewey's Comments on Price's Book," [1932–1937], Thomas Casilear Cole Papers, Arch. Am. Art, says Dewey verified its authenticity // *Index of Twentieth Century Artists* 1 (Feb. 1934), p. 69, lists illustrations // L. Goodrich, undated notes, also May 20, 1938 (quoted above), and Nov. 1947, unpublished Ryder material, Lloyd Goodrich Archives, Whitney Museum of American Art, New York, microfilm N/622, Arch. Am. Art, lists references and exhibitions and gives provenance and stylistic analysis // Whitney Museum of American Art, New York, *Albert P. Ryder Centenary Exhibition* (1947), cat. by L. Goodrich, p. 8 // L. Goodrich, *Albert P. Ryder* (1959), pl. 2; p. 113 // M. J. Cotter, P. Meyers, L. van Zelst, et al., in Accademia Nazionale dei Lincei, Atti de Convegni Lincei, 11, Congresso Internazionale, *Applicazione dei metodi nucleari nel campo delle opere d'arte* [*Applications of Nuclear Methods in the Field of Works of Art*] (1976), published record of a conference held in May 1973, p. 190, indicate presence of antimony and give the relative weight percentages of elements in the pigments; p. 196, discuss its poor condition; ill. p. 198, show present condition and autoradiographs // P. Meyers, Research Laboratory, MMA, orally, May 27, 1978, noted that autoradiographs of the painting indicate that in the process of the deterioration of the paint surface the pigment has separated from the binding medium.

EXHIBITED: Society of American Artists, New York, 1882, no. 90, as Curfew Hour, lent by Mrs. J. H. de Kay // MMA, 1882–1883, *Loan Collection of Paintings and Sculpture*, no. 113, as The Curfew Tolls the Knell of Parting Day, lent by Mrs. J. H. de Kay, New York // MMA, 1918, *Loan Exhibition of the Works of Albert P. Ryder*, cat. by B. Burroughs, ill. no. 12.

EX COLL.: Janet Halleck de Kay (Mrs. George Coleman de Kay), New York, 1882—at least 1883; apparently returned to the artist; James S. Inglis of Cottier and Company, New York, died 1907; his estate (sale, American Art Association, New York, March 12, 1909, no. 73).

Rogers Fund, 1909.

09.58.1.

Ryder, *Curfew Hour*, present condition.

The Toilers of the Sea

This marine painting of a boat crossing a moonlit expanse of water was probably done during the early 1880s. The boat, with its implausible rigging, is thrust forward in a diagonal position and its dark silhouette is surrounded by foam, the only suggestion of movement in an otherwise tranquil setting. The calmness of the sea is emphasized by the flat line of the horizon and the long cloud directly above it. The night is relatively clear, and the full moon, surrounded by an aureole, creates delicate gradations of light. Here Ryder worked with a rich but severely limited palette; the subtle shades vary from luminous gray and nearly black to a golden color, its brilliance tempered by the addition of green.

Although somewhat compromised by its condition, *The Toilers of the Sea* is unusual in its tactile spontaneity, the transparency of its glazes, and the freshness of its brushwork. In some unpublished notes (May 20, 1938), Lloyd Goodrich commented on the artist's application of paint in this picture:

The pigment is quite heavy over the whole surface of the picture, and evidently the result of many layers of paint and glazes. Strangely enough, however, the clouds and the moon seem to have been painted fairly freshly and directly, in opaque pigment. . . . The clear parts of the sky are more transparently painted.

The painting has undergone some deterioration since it was photographed at the Metropolitan Museum in 1915. By 1938, Goodrich had already observed several changes, particularly in the dark areas of the boat and sail which had settled below the level of the surrounding lighter paint areas and had become much glossier in finish. Similar depressions, apparently due to a dark underpaint, were also visible in certain areas of the sky. The artist's signature was already obscured by the disintegration of the paint surface in the lower left.

The Metropolitan acquired the painting at the sale of the collection of Ichabod T. Williams, a wealthy New Yorker, with whom Ryder was well acquainted. Another friend of the artist, the sea captain John Robinson, later discussed the friendship between the two men:

Ryder, *The Toilers of the Sea*.

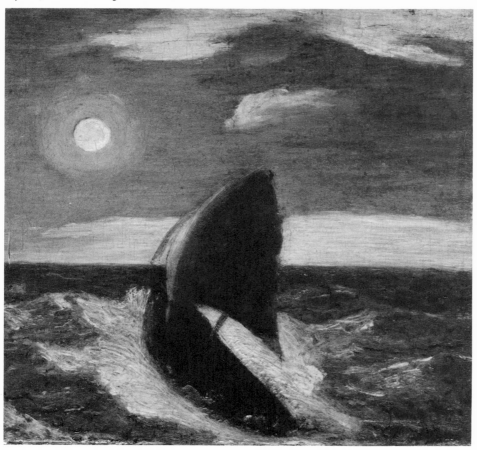

In those days Mr. Ichabod Williams used to like to have Mr. Cottier and some old friends to visit him on Sunday evenings, amongst whom would be Mr. Jas. S. Inglis, Olin Warner, and Albert Ryder; and on a few occasions, I was asked with them. Mr. Williams entertained us in his splendid picture gallery (he had a very fine collection). Ryder, encouraged by our host, would talk more at these gatherings than at any other time (*Art in America* 13 [June 1925], p. 179).

Among the paintings in Williams's collection was a marine by the French artist Jules Dupré done about 1870 (now unlocated). Ryder undoubtedly knew the painting, and it is interesting to note that, although *The Toilers of the Sea* is entirely different in feeling, it does follow the composition of the Dupré, which shows a storm-tossed ship sailing toward a flat horizon (see M. M. Aubrun *Jules Dupré, 1811-1899* [1974], no. 521).

Ryder's painting was titled *The Toilers of the Sea* during his lifetime, although at its earliest documented exhibition in 1884, it was identified only by a poem, presumably written by the artist:

'Neath the shifting skies,
 O'er the billowy foam,
The hardy fisher flies
 To his island home.

Since the painting was owned by one of Ryder's friends, it is likely that the artist either selected or approved the title it now bears. This traditional title, as well as the verse that accompanied the painting, is related to Victor Hugo's novel *Les Travailleurs de la mer* of 1866, which appeared as *The Toilers of the Sea* in its English translation the same year.

The central figure in the novel, Gilliatt, a fisherman on the island of Guernsey, becomes engaged in a desperate struggle with the forces of nature. He falls in love with Déruchette, a beautiful, but clearly unobtainable, young woman. When her uncle's steamboat, which runs between Guernsey and St. Malo, is wrecked through treachery, Déruchette is promised to the man with the courage and skill to salvage the engines. Gilliatt resolves to perform this task and thus win the woman he loves. After an incredible ordeal

Ryder, *The Toilers of the Sea*, condition at acquisition, 1915.

complicated by tides, storms, and a confrontation with a sea monster, he saves the engines and returns to port only to discover that Déruchette is planning to elope with another. After nobly assisting them, Gilliatt sits on a rock by the edge of the sea, waiting for the rising tide and certain death.

Ryder's painting could represent any one of several scenes from Hugo's novel. Early in the narrative, for example, Hugo relates how Gilliatt won his boat in a contest which required the participants to sail single-handedly to a distant place and return to the harbor burdened with a heavy ballast. Even more suggestive are the descriptions of Gilliatt setting out to salvage the engines and his triumphant return, both accomplished at night. Gilliatt's boat is seen departing from Guernsey by a number of observers, among them the keeper of a nearby island:

At the moment when the moon was rising, the tide being high and the sea being quiet, in the little strait of Li-Hou, the solitary keeper of the island of Li-Hou was considerably startled. A long black object slowly passed between the moon and him. This dark form, high and narrow, resembled a winding-sheet spread out and moving. . . . That dark form might undoubtedly be a sail. . . . But the keeper asked himself, what bark would dare, at that hour (Hugo, *The Toilers of the Sea* [New York, 1866], pp. 74–75).

His return is less dramatic, but perhaps more closely related to the picture, given the contents of the brief poem that accompanied it at the time of its first exhibition. Hugo writes:

Gilliatt, in fact, after a passage without accident, but somewhat slow on account of the heavy burden of the sloop, had arrived at St. Sampson after dark, and nearer ten than nine o'clock. He had calculated the time. The half flood had arrived. There was plenty of water, and the moon was shining (p. 138).

Whatever striking similarities exist between Ryder's painting and certain scenes in the novel, the parallels between the artist and Gilliatt are even more telling. Like Ryder, Gilliatt lived alone; a noble but seemingly peculiar man, he had little contact with his neighbors, who eventually concluded that he had mystical powers. He lived in a house believed to be haunted, and the description of its condition is analogous to Ryder's chaotic New York studio. Like the artist, he took pleasure in solitary midnight walks and was drawn "more and more towards the face of nature, and further and further from the need of social converse" (p. 8). Gilliatt's view of nature is compatible with Ryder's; he is a dreamer, immersed in the world of nature. Hugo describes

Gilliatt's imaginative view of the world:

Just as he had often found in the perfectly limpid water of the sea strange creatures of considerable size and various shapes, . . . so he imagined that other transparencies, similar to those almost invisible denizens of the ocean, might probably inhabit the air around us. . . . The discovery of a new world, in the form of an atmosphere filled with transparent creatures, would be the beginning of a knowledge of the vast unknown. But beyond opens out the illimitable domain of the possible, teeming with yet other beings, and characterised by other phenomena. All this would be nothing supernatural, but merely the occult continuation of the infinite variety of creation (pp. 15–16).

Ryder, like Gilliatt, sought to extend "the infinite variety of creation," endowing the simplest physical elements, the clouds, the moon, and the waves, with compelling significance. Each feature of nature in his work is manipulated to express a deeper reality.

Oil on wood, $11\frac{1}{2} \times 12$ in. (29.2 × 30.5 cm.).
Signed (no longer visible): ARyder [?].
RELATED WORKS: *The Toilers of the Sea* has served as the model for many forgeries; among those formerly attributed to Ryder are: *Moonlit Marine*, oil on wood, $11 \times 10\frac{3}{8}$ in. (27.9 × 26.4 cm.), Yale University Art Gallery, 1950.55 // *Outward Bound*, oil on canvas, $12\frac{1}{4} \times 13\frac{1}{2}$ in. (31 × 34.2 cm.), Corcoran Gallery of Art, Washington, D.C.
REFERENCES: *New York Times*, May 25, 1884, p. 9, reviews it in the Society of American Artists, noting "Albert Ryder [has] a marine in a curious scheme of color, the waves full of dash, the ideal bark flying across the water, the clouds original and fantastic after a fashion of which he alone knows the secret" // *New York Daily Graphic*, May 27, 1884, p. 651, notes it in the Society of American Artists exhibition // *New York Sun*, June 1, 1884, p. 7, in a review of the Society of American Artists exhibition, says, "Mr. Albert Ryder has wrapped his mediaeval Italian mantle about him more tightly than ever and sends a wild, ghostly fisherman flying over the billowy to his foaming malachite before a weird gale of insidious brown glazing and thick portentous mastic to his remote island home" // American Art Association, New York, *Notable Collection of Valuable Paintings Formed by the Late Ichabod T. Williams, Esq.* sale cat. (1915), no. 73, as The Toilers of the Sea, describes, quotes poem associated with it, and says it was purchased from Cottier // *American Art Annual* 12 (1915), p. 296, records its sale from Williams collection and its purchase by MMA // *MMA Bull.* 10 (April 1915), p. 81, says medium is wax; ill. p. 85 // F. F. Sherman, *Art in America* 8 (Dec. 1919), p. 31; *Albert Pinkham Ryder* (1920), pp. 30, 53, discusses; p. 71 lists it as no. 83 in a catalogue of the artist's work; pp. 76, 78, notes exhibitions of it; "Albert Pinkham Ryder—A Supplement," MS [1920–1940], in unpublished Ryder material, Lloyd Goodrich Archives,

Whitney Museum of American Art, microfilm N/621, Arch. Am. Art, under part 2, marines, discusses // W. D. Beck, *International Studio* 70 (April 1920), ill. p. xlv // H. E. Schnakenberg, *Arts* 6 (Oct. 1924), p. 274 // F. N. Price, *International Studio* 81 (July 1925), ill. p. 287; *Ryder [1847–1917]* (1932), no. 185, lists it in a catalogue of the artist's work // *Index of Twentieth Century Artists* 1 (Feb. 1934), p. 72, lists illustrations of it // L. Goodrich, notes, May 20, 1938, unpublished Ryder Material, Whitney Museum of American Art, New York, discusses technique and condition (quoted above) // F. J. Mather, Jr., *Magazine of Art* 39 (Nov. 1946), ill. p. 302, discusses it // R. Braddock, "The Poems of Albert Pinkham Ryder Studied in Relation to His Paintings and His Person," M. A. thesis, Columbia University, 1947, copy in Whitney Museum of Art, New York, microfilm N/615, Arch. Am. Art, p. 50, gives Hugo's *The Toilers of the Sea* as literary source; p. 51, lists it under those Ryder themes showing strong men combating the sea // L. Goodrich, notes, Nov. 1947, unpublished Ryder material, Lloyd Goodrich Archives, Whitney Museum of American Art, New York, microfilm N/620, Arch. Am. Art, says painting probably dates from same period as Moonlight Marine (q.v.) // M. Breuning, *Art Digest* 22 (Nov. 1, 1947), p. 35 // L. Goodrich, "Pictures with Early Histories," 1947, Lloyd Goodrich Archives, Whitney Museum of American Art, New York, microfilm N/619, Arch. Am. Art, suggests it was probably shown at the Society of American Artists in 1884; "Notes on Ryders at MMA . . . ," June 1947, microfilm N/620, says that it has served as a prototype for many forgeries; notes, Dec. 1948, says that it was available to forgers; notes, n.d., microfilm N/623, lists exhibitions, references, and provenance and provides extensive stylistic analysis // E. Eastwood, "In His Own Country: The Story of Albert Pinkham Ryder," [1947–1949], Misc. MSS Eastwood, 653, Arch. Am. Art, quotes the poem written to accompany it // R. Braddock, *Gazette des Beaux-Arts*, ser. 6, 33 (Jan. 1948), p. 55, says Hugo's novel is its source // C. E. Fremantle, *Studio* 135 (Feb. 1948), p. 64, mentions painting in a review of the Whitney exhibition; ill. p. 66 // W. Sargeant, *Life* 30 (Feb. 26, 1951), ill. pp. 90–91, shows an X-ray of it // *Munson-Williams-Proctor Institute Bulletin* 4 (April 1952), ill. p. 4, says it is on view there // R. B. Hale, *MMA Bull.* 12 (March 1954), p. 172, calls it one of Ryder's greatest works; ill. p. 186 // L. Goodrich, *Albert P. Ryder* (1959), color pl. 17; pp. 114, 117, discusses it; ill. p. 118, shows radiograph of it // W. I. Homer, *Record of the Art Museum Princeton University* 18, no. 1 (1959), p. 27, discusses the painting // B. Hogarth, *American Artist* 26 (March 1962), ill. p. 57 // H. P. Raleigh, *Art Journal* 21 (Spring 1962), p. 156, discusses it as an example of "imagist" painting; ill. p. 157 // B. Novak, *American Painting of the Nineteenth Century* (1969), ill. p. 218; p. 219, discusses // *Apollo* 91 (April 1970), ill. p. 255 // W. Teller, ed., *Twelve Works of Naïve Genius* (1972), p. 302 // G. Eager, *Art Journal* 35

(Spring 1976), pp. 229–230, discusses image of the boat and notes that in the painting "there is a mingling of man and nature instead of an emphasis on one or the other" // P. Meyers, Research Laboratory, MMA, orally, May 27, 1978, reported that autoradiographs of the painting indicate that the sky was originally striated as in Moonlight Marine (q.v.) and then covered over.

EXHIBITED: Providence Art Club, 1884 (not in cat. but probably exhibited) // Society of American Artists, New York, 1884, between nos. 68 and 69, untitled, lent by T. C. [probably I. T.] Williams, prints poem (quoted above) // MMA, 1918, *Loan Exhibition of the Works of Albert P. Ryder*, cat. by B. Burroughs, ill. no. 35 // Whitney Museum of American Art, New York, 1947, *Albert P. Ryder Centenary Exhibition*, cat. by L. Goodrich, no. 48; ill. p. 11; p. 15, calls it a characteristic marine // Museum of Modern Art, New York, 1976, *The Natural Paradise*, exhib. cat. ed. by K. McShine, essay by R. Rosenblum, p. 26, discusses; ill. p. 27.

EX COLL.: with Daniel Cottier of Cottier and Co., New York; Ichadbod T. Williams, New York, by 1884–1915 (sale, American Art Association, New York, Feb. 4, 1915, no. 73, as The Toilers of the Sea).

George A. Hearn Fund, 1915.

15.32.

Moonlight Marine

The ocean held great significance for Ryder, who spent his childhood in New Bedford, Massachusetts, one of nineteenth-century America's great maritime centers. Later he resided in New York, where one of his closest friends, a sea captain named John Robinson, recalled the artist's visits to his ship when it was in port:

Many evenings he would sit with me alone on board, and on moonlight nights he would go on to the bridge and watch the numerous craft passing up and down the Hudson, getting "moonlight effects." I have known him to walk down to the Battery at midnight, and just sit there studying the effect of clouds passing over the moon, or watching a sailing craft throw the shadow of her sails on the water, or the moonlight ripples where a ferry boat had passed (*Art in America* 13 [June 1925], p. 180).

Probably painted during the 1870s or 1880s, *Moonlight Marine* transcends the literalism of much of the American marine painting that preceded it and looks instead to the earlier romantic tradition exemplified by artists as stylistically diverse as WASHINGTON ALLSTON, MARTIN JOHNSON HEADE, and JAMES HAMILTON. Working on a panel slightly less than a foot square, Ryder developed the composition in broad masses. The dark clouds

form horizontal bands, their undulous contours emphasized by luminous halos. The sails break the continuity of the horizon and are silhouetted against a night sky, which is illuminated by a disc-like moon, fixed central in position. The hull and rigging of the vessel, as well as its passengers and cargo, remain obscure, merging with the clouds and water to create a pattern of highly contrasted areas of rich color. Devoid of narrative incident and literal detail, *Moonlight Marine* lacks conventional spatial relationships, but the carefully selected visual elements express the artist's deep understanding of the forces of nature and man's relationship to them. Here Ryder seems to have followed his own dictum, "The artist should fear to become the slave of detail. He should strive to express his thought and not the surface of it" (*Broadway Magazine* 14 [Sept. 1905], p. 11).

Discussing *Moonlight Marine* in 1908, before its condition had deteriorated to the point at which we see it today, the critic Roger Fry noted that "the quality of the paint has the perfection and elusive hardness of some precious stone." His detailed analysis of its coloristic qualities, now almost totally obscured by deterioration and restoration, suggests just how much the painting's appearance has changed. Fry writes:

The whole effect is that of some uneven enamel, certainly of some thing that has passed through fire to give it so unyielding a consistency. That this extraordinary quality has been reached only with infinite labour is evident from the dangers that this little panel has undergone of cracking up altogether owing to the incessant overloading of one coat of paint on another. Such a technique is for that very reason not in itself desirable; and, could the result here attained have been reached by more controlled, more craftsmanlike methods, one would certainly have preferred it. But we accept it none the less as it is, as something unique in its method, but something in which the peculiar method is felt to be essentially bound up with the imaginative idea and to be justified by the perfection with which it renders that.

I wish I could translate the ominous splendour of the colouring into words. I can only give a faint idea. The sky is of a suffused, intense luminosity, so intense that the straw-coloured moon and yellower edges of the clouds barely tell upon it. The clouds themselves (one may guess from them that Ryder had been a student of Blake), the clouds are of a terrible, forbidding, slatey grey, not opaque, but rather like the grey of polished agate, only darker, and their silhouette on the sky is so fiercely emphasized, that the utter blackness of the sails can barely tell upon them. Almost equal in tone with the clouds is the mass of the sea itself, but in colour it contrasts with them, being of an intense malachite green, dark, inscrutable, and yet full of the hidden life of jewels and transparent things. This note is taken up again, if I remember rightly, in the sky at the top left hand side, but with a tendency to dull peacock. I need say nothing of the composition, of the effect of unending, relentless movement given by the diagonals crossing, at such nicely discovered points and with such just inclinations, the barred horizontals—its rare quality is evident even in our reproduction. Here, then, is a vision recorded for us so absolutely that once seen it can never be forgotten. It has the authoritative, arresting power of genuine inspiration.

The painting has suffered considerably since Fry wrote these appreciative comments in 1908. The boat—now a flat, dark silhouette—once held two figures, and its mainsail was supported by a diagonal spar that is no longer visible. The various stages of the painting's condition are documented in a series of four photographs taken in 1908, 1918, before 1930, and in 1934 and analyzed in Lloyd Goodrich's unpublished notes (1930s–1940s). From the 1908 photograph Goodrich concluded that the sails originally had "more rounded" outlines, "with more effect of their being filled with wind" and that the clouds were "more rounded and graceful" and had "rather more refined outlines . . ., with their light edges . . . more distinct from and lighter than the clear sky." After studying the 1918 photograph of *Moonlight Marine*, he observed several changes that had occurred after only a decade: there was "serious sagging of the paint in the lower cloud, in the lower edge of the sails, and the lower side of the boat's hull." The figures and the spar had disappeared, but the basic outlines of the clouds and sails remained consistent with those recorded in the earlier photograph. The third photograph, taken by 1930, indicated that the painting had been restored after the memorial show of 1918, and Goodrich noted the major changes in the picture's appearance: the triangular mainsail had become quadrilateral; the contours of the clouds were altered, particularly in the upper edge of the lower cloud; the prominent "ridges" in the clouds, the sails, and the hull were "cut down"; the clear part of the sky may have been repainted "with a lighter translucent glaze"; and "a dark glaze" was put over other areas like the sails and clouds, changing their outlines. When the Metropolitan acquired the painting in 1934, it was restored again, and an attempt was made to recapture its earlier appearance. Goodrich observed, however, that in general the contours of the sails and the clouds remained as they had been after the previous restoration. After

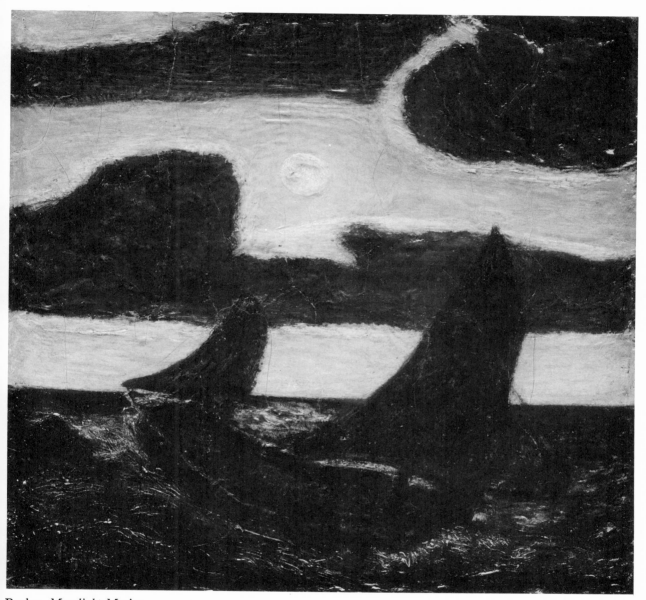

Ryder, *Moonlight Marine*.

examining *Moonlight Marine* and comparing it to the various photographs, he decided that "while many of the brushstrokes in the light-colored solid opaque pigment are still as they were . . ., the dark areas have been largely repainted . . ., and in the process shapes of things have been changed, not always radically, but giving a different total effect." In its original condition, *Moonlight Marine* was "in general somewhat rounder, more graceful, more delicate, and truer naturalistically." In spite of its condition, however, Goodrich concluded his analysis by praising the painting's "extraordinary luminosity," and noting that "the sky seems filled with light, made all the more intense by the dramatic darks of the clouds and the sails and the intense emotion conveyed by the dark boat and sails against the barred sky—[giving] the sense of movement, of darkness, of silence, of mystery and doom."

Moonlight Marine was one of the most often reproduced, discussed, and exhibited of Ryder's paintings and as such played a special role in the history of his popularity. It was owned by the prominent New York art dealer Newman Emerson Montross and was often seen by artists in his gallery. The painting was included in the Armory Show of 1913 and frequently exhibited in New York museums during the 1930s and 1940s. Although it served as the basis for innumerable forgeries, it undoubtedly inspired more positive expressions of admiration in at least three generations of American artists.

Oil and possibly wax on wood, $11\frac{1}{2} \times 12$ in. (29.2 × 30.5 cm.).

Signed at lower left: Ryder.

REFERENCES: R. E. Fry, *Burlington Magazine* 13 (April 1908), ill. p. 59, as in coll. N. E. Montross; p. 64, discusses it, calling it Flying Dutchman (quoted above) // D. Phillips, *American Magazine of Art* 7 (August 1916), ill. p. 387 // *Arts and Decoration* 7 (May 1917), p. 368, mentions it in a review of an exhibition at Montross galleries // H. McBride, *Fine Arts Journal* 35 (May 1917), p. 368, notes it in obituary of the artist // F. F. Sherman, *Art in America* 8 (Dec. 1919), p. 31, mentions its "portentous sky"; *Albert Pinkham Ryder* (1920), p. 53; p. 71, lists it as no. 88 in a catalogue of the artists's work; p. 77 // H. E. Schnakenberg, *Arts* 6 (Oct. 1924), p. 274, calls it a good example of Ryder's marines // S. La Follette, *Art in America* (1929), ill. p. 187 // A. McMahon, *Parnassus* 2 (May 1930), ill. p. 5, in a review of exhibition at Museum of Modern Art // *Art News* 28 (May 17, 1930), ill. p. 5, in a review of exhibition at Museum of Modern Art // F. N. Price, *Ryder [1847–1917]* (1932), p. xxi; no. 106, lists it in a catalogue of the artist's work // J. W. Lane, *Creative Art* 12 (Jan. 1933), ill. p. 53; p. 54, mentions Montross

as owner and says it is on view at MMA // *Index of Twentieth Century Artists* 1 (Feb. 1934), p. 70, lists illustrations of it // H. B. W[ehle], memo in Dept. Archives, April 1934, reports that "several of the high lumpy ridges which are seen in the photogr[aph] taken during Montross's ownership . . . were found to have been cut down by some restorer. These had been repainted" // B. Burroughs, *MMA Bull.* 29 (June 1934), pp. 105–106, discusses it // A. Shilling, orally, June 4, 1934, recorded by H. B. Wehle, said that Ryder painted the work during the late 1880s; it was sold to a Mr. Plumb (?) of Buffalo and returned to Montross around 1890 in an exchange; notes that at one point the wax medium was running, "actually lapping over the frame," and Ryder himself shaved off the excess paint at the bottom and elsewhere // *American Magazine of Art* 28 (Feb. 1935), ill. p. 114 // L. Goodrich, undated notes [1930s], unpublished Ryder material, Lloyd Goodrich Archives, Whitney Museum of American Art, New York, microfilm N/620, Arch. Am. Art, lists references and exhibitions, discusses condition and alteration of the painting over the years (quoted above); notes, Nov. 1947, dates it as probably the same time as The Toilers of the Sea (q.v.) // M. Breuning, *Art Digest* 22 (Nov. 1, 1947), ill. p. 9, notes it in a review of the Whitney exhibition // L. Goodrich, notes, Dec. 1948, unpublished Ryder material, Lloyd Goodrich Archives, Whitney Museum of American Art, New York, microfilm N/620, Arch. Am. Art, says that it was on view at the Montross Gallery from an early date and served as the prototype for many forgeries; orally, recorded in Dept. Archives, April 18, 1950, dated it between 1870 and 1890 // H. McBride, *Art News* 49 (June–Aug. 1950), color ill. p. 37 // D. Brian, *Art Digest* 24 (July 1, 1950), ill. p. 9 // C. Greenberg, *Art Digest* 28 (Jan. 1, 1954), ill. p. 7 // R. B. Hale, *MMA Bull.* 12 (March 1954), p. 172 // M. Breuning, *Art Digest* 29 (April 1, 1955), ill. p. 32 // P. Miller, *Art in America* 47 (Summer 1955), ill. p. 19 // L. Goodrich, *Albert P. Ryder* (1959), color pl. 25; p. 117, says that it has served as the basis for many forgeries // H. Dorra, *Art in America* 48 (Winter 1960), color ill. p. 32; *The American Muse* (1961), color ill. p. 96 // D. L. Smith, *American Artist* 26 (March 1962), ill. p. 32 // A. Frankenstein, *Art in America* 54 (March 1966), p. 77, says it shows a spirit of pessimism and tragedy; color ill. p. 81 // B. Novak, *American Painting of the Nineteenth Century* (1969), ill. p. 219, discusses it // *MMA Bull.* 33 (Winter 1975–1976), ill. p. 60, discusses it // P. Meyers, Research Laboratory, MMA, orally, May 27, 1978, reported that autoradiographs of the picture show tree rings, indicating that the wood support was improperly cut; it also was unprepared so that the pigment has sunk into it, making the surface irregular; there are also indications that the artist painted the sky before he painted the sail; and the lack of crisp edges show that wet paint was applied on top of wet paint.

EXHIBITED: Association of American Painters and Sculptors, New York, 1913, *International Exhibition of*

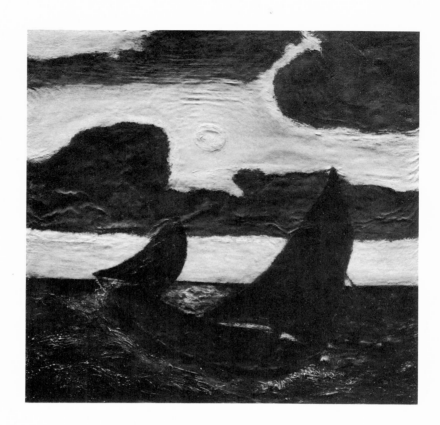

Ryder, *Moonlight Marine*,
condition in 1918.

Audioradiograph of
Ryder, *Moonlight Marine*,
Brookhaven
National Laboratory.

Modern Art, no. 963, as Moonlight Marine, lent by N. E. Montross Esq. // Montross Gallery, New York, 1917, *Exhibition of Pictures by Modern American Masters*, no. 20, as Moonlight—Marine // MMA, 1918, *Loan Exhibition of the Works of Albert P. Ryder*, cat. by B. Burroughs, no. 30, as Moonlight—Marine, lent by N. E. Montross, ill. no. 30 // Museum of Modern Art, New York, 1930, *Sixth Loan Exhibition, Homer, Ryder, Eakins*, cat. by F. J. Mather, Jr., B. Burroughs, and L. Goodrich, no. 73, lent by N. E. Montross; 1932–1933, *American Painting and Sculpture, 1862–1932*, exhib. cat. by H. Cahill, no. 88, lent by N. E. Montross // MMA, 1934, *Landscape Paintings*, no. 79 // Musée du Jeu de Paume, Paris, 1938, *Trois Siècles d'art aux Etats-Unis*, exhib. cat. by A. H. Barr, Jr., et al., no. 145 as Clair de Lune sur la mer // World's Fair, New York, 1940, *Masterpieces of Art*, exhib. cat. by W. Pach et al., ill. p. 213 // Museum of Modern Art, New York, 1943, *Romantic Painting in America*, exhib. cat. by J. T. Soby and D. C. Miller, no. 179, ill. p. 84 // Whitney Museum of American Art, New York, 1947, *Albert P. Ryder Centenary Exhibition*, cat. by L. Goodrich, no. 23 // Brooklyn Museum, 1948–1949, *The Coast and the Sea*, no. 99 // MMA, 1950, *20th Century Painters*, p. 10 // Corcoran Gallery of Art, Washington, C.D., 1959, *The American Muse*, exhib. cat. by H. Dorra, no. 64, ill. p. 3; *Albert Pinkham Ryder*, exhib. cat. by L. Goodrich, no.

25 // Munson-Williams-Proctor Institute, Utica, N.Y., and, Armory of the 69th Regiment, New York, 1963, *1913 Armory Show, 50th Anniversary Exhibition*, no. 963 // MMA, 1965, *Three Centuries of American Painting* (checklist alphabetical) // Marlborough-Gerson Gallery, New York, 1967, *The New York Painter* (benefit exhibition for the New York University Art Collection), p. 96; ill. p. 35 // MMA, 1970, *19th-Century America, Painting and Sculpture*, exhib. cat. by J. K. Howat and N. Spassky, ill. no. 151.

Ex coll.: with Newman Emerson Montross, New York; possibly a Mr. Plumb, Buffalo; with Newman Emerson Montross, New York, by 1908—died 1932; with William Macbeth, New York, 1934.

Samuel D. Lee Fund, 1934.

34.55.

The Forest of Arden

The painting represents a scene from Shakespeare's comedy *As You Like It*. The two figures in the lower left have usually been identified as Rosalind (disguised in male attire) and her cousin Celia who have escaped from the court of Duke Frederick to the Forest of Arden, the refuge of the duke's older and unjustly deposed brother. They could, however, just as easily represent Rosalind being courted by Orlando, the play's hero, or any of the several other pairs of lovers, among them Celia and Orlando's brother Oliver. Perhaps because of its literary source, the painting lacks the mysterious, almost ominous, quality so typical of Ryder's works. Instead there is a pleasant generalized light, and the darkened foreground provides the only hint of foreboding.

As You Like It was very popular in America during the last half of the nineteenth century. The play, however, merely served as a point of departure for Ryder. His approach to the literary subject was quite different from that of his contemporaries, such as EDWIN AUSTIN ABBEY. Uninterested in costumes, props, or period settings, he has painted a landscape in which the performers are relegated to a seemingly unimportant and thoroughly unexpected position in the lower left corner, flush with the edge of the canvas. As Roger Fry suggested in 1908: "One might perhaps wish the lovers away. Mr. Ryder has not quite the power to people his own landscape." The relatively small scale and disquieting placement of the figures are, however, deceptive: in actuality Ryder uses their position as an entrée into the picture space, inviting the viewer into the Forest of Arden with the welcoming gesture of the figure in male attire. The component parts of the landscape, moreover, are selected and

Audioradiograph of Ryder, *The Forest of Arden*, shows earlier composition in which heads are farther apart and the tree trunk more elongated, Brookhaven National Laboratory.

Ryder, *The Forest of Arden.*

arranged to draw attention to the figures. Silhouetted against a dark bush, the two lovers are linked to the forest by the snake-like stream that comes to an abrupt end beside them. The figure in male attire assumes a posture, with head tilted to the side and arm upraised, that is duplicated by the contours of the large tree in the middle ground. As Fry wrote: "What invitation in the winding stream, what unrealized, oft-dreamt possibilities beyond those undulating hills, what seclusion and what delicious terrors in the brooding woods, and what happy augury in the sky!"

The date of the painting has not been determined with certainty. It has been suggested that Ryder began it as early as 1888. He was apparently working on it in the autumn of 1897 when he went to Bronx Park to study the landscape for the setting. On October 12, 1897, he wrote to the widow of the sculptor Olin Levi Warner:

I have every faith that my forest of Arden, will be fully as beautiful as any preceding work of mine; Bronx Park has helped me wonderfully, and I would have gone out today for that breezy agitation of nature that is so beautiful. But the rain has spoiled my plans.

Even earlier, on September 23, he had told J. ALDEN WEIR, " I go out to Bronx Park every day now " (copy, unpublished Ryder material, Lloyd Goodrich Archives, Whitney Museum of American Art, New York, microfilm N/620, Arch. Am. Art). In 1908, the painting, then in the possession of Dr. A. T. Sanden, was recalled by the artist, perhaps for the purpose of doing additional work on it. In a letter to Sanden, dated May 9, 1908, he commented: "I think it well that you have this acknowlegement of the loan of the Forest of Arden and of my responsibility—to return [it] to you after being at my risk for the summer or as you playfully remarked, if it burns up I am to paint you another."

Autoradiographs show that at some point, perhaps in 1908, Ryder made several refinements in the composition. The head of the figure on the left was brought closer to that of the figure on the right; the sky, originally clear, was broken into clouds, and the tree seems to have been made shorter and thicker and some of its foliage and branches painted over.

Oil on canvas, 19 × 15 in. (48.3 × 38.1 cm.).
Signed at lower right: APR(monogram) yder.
REFERENCES: A. P. Ryder to S. M. Warner, Oct. 12, 1897, Sylvia Martinache Warner Papers, in the possession of Mrs. Carlyle Jones, microfilm 270, Arch. Am. Art, discusses progress on the picture (quoted above) // S. Hartmann, *A History of American Art* (1902) 1, pp. 80–81, describes it as one of Ryder's "pure landscapes" and says it was finished in 1897 // R. E. Fry, *Burlington Magazine* 13 (April 1908), ill. p. 62, gives owner as N. E. Montross; p. 64, discusses the painting (quoted above) // A. P. Ryder to A. T. Sanden, May 9, 1908, copy in unpublished Ryder material, Lloyd Goodrich Archives, Whitney Museum of American Art, New York, microfilm N/620, acknowledges the loan of the painting (quoted above), and July 13, 1908, copy, discusses a photograph of it // *Current Literature* 45 (Sept. 1908), ill. p. 292, says owned by Dr. A. T. Sanden and discusses it // D. Phillips, *American Magazine of Art* 7 (Aug. 1916), ill. p. 388 // F. F. Sherman, *Landscape and Figure Painters of America* (1917), ill. opp. p. 34; p. 38, discusses it; *Art in America* 5 (April 1917), p. 162, notes how the tree limbs repeat the gesture of the cavalier // *Literary Digest* 54 (April 21, 1917), p. 1164 // *MMA Bull.* 13 (March 1918), ill. p. 73 // *New York Times Magazine*, March 10, 1918, p. 12, discusses it // *New York Sun*, March 17, 1918, p. 19, mentions it in a review of MMA exhibition // F. F. Sherman, *Albert Pinkham Ryder* (1920), ill. opp. p. 18, as coll. Dr. A. T. Sanden; pp. 57–58, discusses it; p. 72, includes it as no. 102 in a catalogue of the artist's work; p. 77 // W. D. Beck, *International Studio* 70 (April 1920), p. xlii, discusses it; ill. p. xliv // F. F. Sherman, "Albert Pinkham Ryder—Supplement," MS [1920–1940], unpublished Ryder material, Lloyd Goodrich Archives, Whitney Museum of American Art, New York, microfilm N/621, Arch. Am. Art, mentions it under part six, landscapes // R. Rosenfeld, *Dial* 71 (Dec. 1921), p. 652, discusses it // Grand Central Art Galleries, *Retrospective Exhibition of Important Works of John Singer Sargent*, exhib. cat. (1924), p. 70, advertisement says that it is owned by Ferargil, lists names of proprietors as Price and Russell // *Art News* 22 (Feb. 9, 1924), ill. p. 5, says Ferargil purchased the painting, which had been on loan at MMA for many years from A. T. Sanden of New Rochelle // V. Barker, *Arts* 5 (March 1924), p. 164, discusses its acquisition by Ferargil; ill. p. 174 // H. E. Schnakenberg, *Arts* 6 (Oct. 1924), pp. 274–275, discusses the figures in the painting // *Art News* 23 (March 14, 1925), p. 1, says that Ferargil has sold it to a wealthy eastern collector, dates it 1888, says A. T. Sanden purchased it in 1892, but it was not delivered until 1912 // F. N. Price, *Ryder [1847–1917]* (1932), p. xix, says that in it Ryder achieved "an art as distinctive as El Greco, plus romance"; pl. 49; no. 49, lists it in a catalogue of the artist's work as owned by Miss Adah M. Dodsworth, Englewood, N.J. // M. Walker, Ferargil Galleries, New York, letter in Dept. Archives, May 6, 1932, says it was "sold by us several years ago and . . . [is] now here for resale" // T. C. Cole, "Notes on Charles Melville Dewey's Comments on Price's book," [ca. 1932–1937], Thomas Casilear Cole Papers, Arch. Am. Art, verifies its authenticity // L. Goodrich, undated notes [1930s–1940s], unpublished Ryder material, Lloyd Goodrich Archives, Whitney Museum of Ameri-

can Art, New York, microfilm N/620, Arch. Am. Art, gives references, exhibitions, provenance and discusses style; Dec. 13, 1933, notes that he has seen it at Mrs. Kleycamp's, New York, that she represents Miss Mary E. and Miss Alice A. Dodsworth, who inherited the picture when Miss Adah Dodsworth died a year earlier, and in a later note adds that Milch records its purchase from Alice A. Dodsworth and sale to Macbeth Gallery in Nov. 1936 // *Index of Twentieth Century Artists* 1 (Feb. 1934), p. 69, lists illustrations of it // *Bulletin of the Art Institute of Chicago* 28 (April–May 1934), ill. p. 42 // *Art Digest* 8 (June 1, 1934), ill. p. 1 // F. A. Gutheim, *American Magazine of Art* 27 (Aug. 1934), ill. p. 420 // *Art News* 34 (Nov. 16, 1935), ill. p. 10 // J. J. Sweeney, *Cahiers d'art* 13, nos. 1–2 (1938), ill. p. 56, gives Clark as owner // J. W. Lane, *Art News* 38 (Nov. 11, 1939), ill. p. 9 // *Art Digest* 14 (Nov. 15, 1939), p. 28, mentions it in a review of Knoedler exhibition // R. Berenson, *Art News* 42 (Dec. 1, 1943), ill. p. 10, mentions it in a review of Museum of Modern Art exhibition // R. Braddock, "The Poems of Albert Pinkham Ryder Studied in Relation to His Paintings and His Person," M.A. thesis, Columbia University, 1947, copy in Whitney Museum of American Art, New York, microfilm N/615, Arch. Am. Art, p. 45; ill. p. 46; p. 50, gives Shakespearean source for painting; pp. 52, 72; p. 97, calls it the most famous of his idyllic paintings; p. 99, mentions its inclusion in an exhibition at Macbeth's // A. B. L[oucheim], *Art News* 46 (Nov. 1947), color ill. p. 28; ill. p. 31, shows an X-ray of it // M. Breuning, *Art Digest* 22 (Nov. 1, 1947), p. 35 // R. Braddock, *Gazette des Beaux-Arts*, ser. 6, 33 (Jan. 1948), ill. p. 49; p. 56 // J. T. Soby, *Saturday Review of Literature* 31 (Jan. 24, 1948), pp. 36–37 // W. Sargeant, *Life* 30 (Feb. 26, 1951), color ill. p. 90, notes literary source for painting; p. 94, discusses it // L. Goodrich, *Albert P. Ryder* (1959), p. 18, mentions it as an example of a literary theme; pl. 77, shows detail of it; color pl. 78, gives Clark as owner; pp. 116, 121 // T. M. Folds, *Art Journal* 20 (Fall 1960), p. 52 // Corcoran Gallery of Art, Washington, D.C., *Albert Pinkham Ryder* (1961), exhib. cat. by L. Goodrich, pp. 11, 15, discusses it // L. Goodrich, *Art News* 60 (April 1961), p. 51, includes it in a list of Ryder's imaginative works // L. Katz, *Arts Magazine* 35 (Sept. 1961), ill. p. 54; p. 55, discusses it // H. C. Milch, Milch Art Gallery, letter in Dept. Archives, Oct. 6, 1977, provides information on provenance // P. Meyers, Research Laboratory, MMA, orally, May 27, 1978, reported that a study of the autoradiographs show that the artist reworked the head of the figure on the left, the sky, and the tree.

EXHIBITED: MMA, 1918, *Loan Exhibition of the Works of Albert P. Ryder*, cat. by B. Burroughs, ill. no. 38, lent by Dr. A. T. Sanden // Museum of Modern Art, New York, 1930, *Sixth Loan Exhibition, Homer, Ryder, Eakins*, cat. by F. J. Mather, Jr., B. Burroughs, and L. Goodrich, no. 67, lent by Miss A. M. Dodsworth, New York; 1932–1933, *American Painting and Sculpture 1862–1932*, exhib. cat. by H. Cahill, no. 86, lent by Miss A. M. Dodsworth, New York, says completed by 1912 // Art Institute of Chicago, 1934, *Catalogue of a Century of Progress Exhibition of Paintings and Sculpture*, no. 402, lent by the estate of the late Miss Adah M. Dodsworth, Englewood, N.J., says purchased by Dr. Sanden in 1892, four years after Ryder began it and assumes artist kept it in his studio until 1912 // Walker Galleries, New York, 1935, *Opening Exhibition of Paintings by Six Americans*, no. 7, lent by the Misses Dodsworth // Musée du Jeu de Paume, Paris, 1938, *Trois Siècles d'art aux Etats-Unis*, exhib. cat. by A. H. Barr, Jr., et al., no. 142, lent by Stephen C. Clark // M. Knoedler and Co., New York, 1939, *Two American Romantics of the Nineteenth Century*, exhib. cat. by M. Landgren, no. 8, lent by Stephen C. Clark // Museum of Modern Art, New York, 1939, *Art in Our Time* (an exhibition to celebrate the Tenth Anniversary of the Museum of Modern Art), no. 28, lent by Stephen C. Clark // Addison Gallery of American Art, Andover, Mass., 1940, *American Paintings from the Collection of Stephen C. Clark*, ill. p. 8, lists provenance and exhibitions // Carnegie Institute, Pittsburgh, 1940, *Survey of American Art*, no. 204, lent by Stephen C. Clark // Museum of Modern Art, New York, 1943, *Romantic Painting in America*, exhib. cat. by J. T. Soby and D. C. Miller, no. 181, lent by Stephen C. Clark; p. 35, discusses // Macbeth Gallery, New York, 1946, *Albert P. Ryder, 1847–1917*, no. 1, lent by Stephen C. Clark // Century Association, New York, 1946, *Paintings from the Stephen C. Clark Collection* (no cat.) // Whitney Museum of American Art, New York, 1947, *Albert P. Ryder, Centenary Exhibition*, cat. by L. Goodrich, p. 17, says finished in 1897 and describes Rosalind and Celia as "entranced by the unearthly beauty of the landscape"; ill. p. 29 // Museum of Modern Art, New York, 1955, *Paintings from Private Collections*, no. 136, lent by Stephen C. Clark, says it was begun in 1888 and completed in 1897 // MMA, 1958, *Paintings from Private Collections, Summer Loan* (no cat.) // William W. Crapo Gallery, Swain School of Design, New Bedford, Mass., 1960, *A Selection of Paintings by Albert Pinkham Ryder and Albert Bierstadt*, ill. no. 12, lent by Stephen C. Clark // MMA, 1960, *Paintings from Private Collections, Summer Loan* (no cat.); 1961, *Masterpieces of Painting and Drawing from the Bequest of the Late Stephen C. Clark* (no cat.) // Dallas Museum of Fine Arts, 1971, *The Romantic Vision in America*, exhib. cat. by J. Lunsford, no. 55.

EX COLL.: Newman Emerson Montross, New York, 1908; Dr. A. T. Sanden, New Rochelle, N.Y., 1908–1924; with Ferargil, New York, 1924–1925; Miss Adah M. Dodsworth, Englewood, N.J., 1930-1932; estate of Adah M. Dodsworth, Misses Mary E. and Alice A. Dodsworth, until 1935; with Milch Art Gallery, New York, until 1936; with William Macbeth, New York, 1936; Stephen C. Clark, New York, 1936—died 1960.

Bequest of Stephen C. Clark, 1960.

61.101.36.

Landscape

This painting was done, probably in 1897 and 1898, as a commission for Marian Y. Bloodgood, who was a painter herself. She is probably the Miss Bloodgood who exhibited floral still lifes at the National Academy of Design in 1883 and 1884. She knew a number of Ryder's friends, among them Sylvia Warner and Dr. A. T. Sanden, an ardent Ryder collector. Ryder had made her acquaintance by 1897; for on June 2 of that year he wrote graciously to Mrs. Warner: "Yourself and Miss Bloodgood will be welcome whenever it suits you to call" (Sylvia Martinache Warner Papers, in possession of Mrs. Carlyle Jones, microfilm 270, Arch. Am. Art). He was at work on the painting by October 12, when he assured Mrs. Warner: "My work is going tolerably well and your request to see it is not unheeded, nor Miss Bloodgood's commission." A letter from the artist to his client on March 1, 1898, documents his progress on the picture:

I was in Wilmarts [Thomas A. Wilmurt's Sons] yesterday and saw a French frame that he will reproduce for twenty dollars, which I think very reasonable for a frame of that pattern. I would suggest for your consideration that the leaf in the four corners be a little larger or have more spread.

Of course your own choice or selection would be in every way agreeable to me.

I shall of course push the picture to completion as rapidly as possible.

On March 17, he wrote to her again:

I came very near finishing the picture to day; I think I have the little figures capital.

It might be my luck to get the quality I am after to morrow, if so I will bring it up to you tomorrow evening; if not I will take the liberty of calling, to tell you the why and wherefore.

A third letter from the artist to Miss Bloodgood, dated February 11, 1900 (MMA Archives), does not mention the picture, which suggests that it may have been finished and delivered. Presumably this was done in the spring of 1898, although, given Ryder's tendency to work on paintings over an extended period of time, it is difficult to be certain when the picture was actually completed.

Ryder's mention of "little figures" in his letter of March 17, 1898, is somewhat perplexing. Although the single herdsman is the only figure now visible in the landscape, he may have considered the three cows as "figures." The radiograph of the painting shows no additional figures but rather an earlier composition of a cart drawn by horses too large in scale to have been intended for the picture now visible. It is also possible that he was discussing an entirely different picture in these letters and that *Landscape* represents another attempt to fill the commission.

The simple application of the paint and the immediacy of the brushwork in the painting are exceptional for Ryder. The technique shows little indication of his usual practice of gradually building up the paint surface. As Lloyd Goodrich explained in some unpublished notes (1947):

The difference is so marked, and this painting is so direct and elementary in its technique, that one would at first be inclined to doubt its authenticity, except that it has one of the most unquestionable histories in all Ryder's work. Also there is much in it that is characteristic of Ryder; the drawing of the cows and the herdsman; the long rounded lines of the landscape, so similar to "Gay Head" [Phillips Collection, Washington, D.C.]; [and] the remarkable shapes of the clouds.

Goodrich goes on to speculate that the picture's inadequacies may have been caused by the artist's desire to complete his commission quickly. It also seems likely that the harsh design and lack of modeling may be due in part to deterioration. When first painted *Landscape* may have been far more subtle. Even in its current condition however, the painting retains the modern aesthetic quality that inspired the avant-garde painter Marsden Hartley (1877–1943) to describe Ryder as the "master of arabesque, this first and foremost of our designers, this real creator of pattern, this first of all creators of tragic landscape, whose pictures are sacred to those that revere distinction and power in art" (*Seven Arts* 2 [May 1917], p. 95).

Oil on canvas (?), 9½ × 14 in. (24.1 × 35.6 cm.).
Signed at lower left: Ryder.
REFERENCES: A. P. Ryder to S. M. Warner, Oct. 12, 1897, Sylvia Martinache Warner Papers, in the possession of Mrs. Carlyle Jones, microfilm 270, Arch. Am. Art, mentions Miss Bloodgood's commission (quoted above) // Ryder to M. Bloodgood, MMA Archives, March 1, 1898, discusses a frame for the painting (quoted above); March 17, 1898, says it is almost finished (quoted above) // F. F. Sherman, *Albert Pinkham Ryder* (1920), ill. opp. p. 26, as in Bloodgood's collection; p. 58 says Miss Bloodgood selected it from several in his studio, that he kept it a few days "to get just the feeling he wanted it to embody"; p. 70, includes it as no. 51 in a catalogue of the artist's work and dates it 1898 // F. J. Mather, Jr., *Weekly Review* 4 (Jan. 26, 1921), p. 83, says "Nothing could be more [Samuel]

Ryder, *Landscape*.

Palmer-like than Ryder's greatest landscape, that is owned by Miss Bloodgood" // F. N. Price, *Ryder [1847–1917]* (1932), no. 74, lists it in a catalogue of the artist's work as owned by Miss Bloodgood // F. F. Sherman, *Art in America* 25 (Oct. 1937), p. 168, calls it "the finest of all his landscapes" // L. Goodrich, notes on a conversation with Kenneth Hayes Miller, June 22, 1938, recorded on July 21, 1938, in unpublished Ryder material, Lloyd Goodrich Archives, Whitney Museum of American Art, New York, microfilm N/620, notes that Miller "spoke about a landscape belonging to Miss Bloodgood, which he said was very fine"; undated notes, discusses it (quoted above), says that since it was a commissioned work Ryder may have executed it more quickly than some others; for "it lacks the completeness, subtlety, substance and depth of the pictures on which he worked as long as he wanted to," reports that no canvas weave is apparent and it may be done on leather or heavy paper; April 20, 1948, suggests Ryder completed an unfinished picture for Miss Bloodgood rather than undertaking a new work; discusses radiograph, noting that the sky area originally went down to the hill on the right and that there is a cart

drawn by horses beneath the surface // F. Kuhne, letter in MMA Archives, Dec. 12, 1953, says it was originally purchased by his aunt Marian Y. Bloodgood and inherited by him at her death // P. Meyers, Research Laboratory, MMA, orally, May 27, 1978, noted that the radiograph of the picture reveals a cart and horses painted in lead white beneath the surface of the present work; it also indicates that the horizon was raised while the present work was in progress.

EXHIBITED: Whitney Museum of American Art, New York, 1947, *Albert P. Ryder Centenary Exhibition*, cat. by L. Goodrich, as no. 17, Landscape, lent by Mr. Frederick Kuhne, says commissioned by Miss M. Bloodgood in 1898 // Corcoran Gallery of Art, Washington, D.C., 1961, *Albert Pinkham Ryder*, exhib. cat. by L. Goodrich, no. 58, as Landscape, finished in 1898; ill. p. 43.

EX COLL.: Marian Y. Bloodgood, New York, 1898–died after 1932; her nephew, Frederick Kuhne, New York, until 1952.

Gift of Frederick Kuhne, 1952.

52.199.

Albert Pinkham Ryder's work is the most widely faked and forged in American art with the possible exception of works by his contemporary RALPH BLAKELOCK. Even Ryder, an artist noted for his naiveté, noticed and acknowledged this unfortunate situation. "I rarely sign my pictures, having always felt that they spoke for themselves," he wrote in 1915, "but . . . I am sorry to say, a great many spurious Ryders have lately come upon the market" (quoted in *Art in America* 33 [Oct. 1945], pp. 228–229). Lloyd Goodrich, the most recent and exacting connoisseur of Ryder's pictures, sets the artist's œuvre at about one hundred and sixty paintings. There appear to be, however, over five times as many fakes, forgeries, and pastiches. Generally, these appeared after 1912, when the demand for Ryder's work increased and his output greatly decreased, with few new works begun by him after 1900. The forgeries are of two types: deliberate, usually feeble, imitations of Ryder's style, subject matter, and technique; and, genuine works of the period by other artists, with false signatures and fabricated histories. Marine subjects are the most often forged, but the forgeries in the Metropolitan's collection, two landscapes and a literary subject, demonstrate the variety of subjects attempted by Ryder's imitators.

Even during his lifetime, there was little to protect the artist from forgeries. His earliest dealers, Daniel Cottier and James Inglis of Cottier and Company, died before fakes and forgeries of the artist's work became common, and, unfortunately, left no record of his early sales. Strictly speaking, Ryder had no dealer after Cottier, and he often sold paintings directly from his studio to collectors like Charles Erskine Scott Wood, Alexander Morten, and John Gellatly. Although some of these transactions are documented by incontrovertible evidence, others are substantiated only circumstantially, and it is entirely possible that works left the artist's studio with no record.

Ryder was a bachelor, and there were no relatives to preserve his papers or supervise the sale and documentation of his work. Although he maintained a circle of close friends, he was retiring and did not participate actively in the New York art world. Two of his oldest and closest friends were the sculptor Olin Levi Warner, who died in 1896, and the painter J. ALDEN WEIR, who survived Ryder by only two years. Had they lived longer, these two friends might have been able to identify the artist's works accurately. Finally, Ryder was in poor health during the later years of his life, and after 1915, he lived with friends in Elmhurst, Long Island, which separated him even further from developments among New York artists.

Many Ryder fakes and forgeries gained acceptance through the misguided, and in some cases patently dishonest, efforts of his supposed friends, acquaintances, and admirers. CHARLES MELVILLE DEWEY, the artist's executor and "oldest, closest and most intimate friend" was not a good judge of authenticity (T. C. Cole "Notes on Charles Melville Dewey's Comments on F. N. Price's Book," [1932–1937], Thomas Casilear Cole Papers, Arch. Am. Art). Nor was Louise Fitzpatrick, Ryder's student and neighbor, whose work was so strongly influenced by her teacher that it might easily be misattributed to him. Many of those who authenticated Ryders were younger painters, like ALEXANDER SHILLING, ELLIOTT DAINGERFIELD, and Albert L. Groll (1868–1952), all of whom were influenced by Ryder but were not intimately acquainted with him or his work. Others, like Kenneth Hayes Miller (1876–1952), were modernists who became friendly with Ryder during the early years of the twentieth century, when he was generating few new works. None of these artists were connoisseurs of Ryder's work, and at best, their judgments were based on an enthusiastic appreciation of his genius. In the Metropolitan forgery group, one work was authenticated by Dewey and another by Shilling and Daingerfield. The third is reported to have come from Mrs. Fitzpatrick's collection.

Ryder rarely exhibited his work after the late 1880s, so there are relatively few illustrations or descriptions of his paintings in contemporary periodicals. Little was published on the artist or his work during his lifetime, and there was no attempt to systematically record genuine examples of his work until 1920, when forgeries were already common. The first major article on Ryder was written by his friend Charles de Kay under the pseudonym Henry Eckford. Published in *Century Magazine* (June 1890), this appreciative statement illustrates, discusses, and describes a number of Ryder's works, all of which are undoubtedly authentic. So too are those that appear in articles written with the artist's cooperation for *Broadway Magazine* (Sept. 1905). Slightly less reliable are the publications that followed shortly after the artist's death: many were appreciations by younger artists who were enthusiastic about

the modern appearance of Ryder's work; others were anecdotal treatments focusing on Ryder's eccentric personality rather than his artistic accomplishments.

The early monographs on Ryder included catalogues of his work, but, unfortunately, these further complicated the fake and forgery problem. The first book on the artist was written by Frederic Fairchild Sherman, an art collector, book publisher, and the founder of *Art in America*. Published in 1920, *Albert Pinkham Ryder* featured a list of those Ryder paintings considered authentic by the author, who had begun his work before the full extent of the forgery problem had been realized. In 1932, Frederic Newlin Price published another list of the artist's works in *Ryder [1847–1917]: A Study of Appreciation*. Sherman then countered with two supplementary lists of works he felt had been "erroneously attributed" to Ryder. Printed in *Art in America* in October 1936 and April 1937, these compilations list, with some duplication, many works accepted by Price but rejected by Sherman. Charles Melville Dewey also questioned Price's evaluation of Ryder's œuvre. In the document cited above, the painter Thomas Casilear Cole (1888–1976) recorded Dewey's comments on the life and work of Ryder, including a numerical list of those works in Price's book accepted or rejected by Dewey.

When Lloyd Goodrich began his research on Ryder during the 1930s, there was hardly a consensus on what paintings constituted the artist's œuvre. Goodrich established a new standard for Ryder scholarship, combining historical research, stylistic evaluation, and scientific examination to determine which paintings were authentic. As he described the work on his yet unpublished catalogue raisonné:

The first step was to establish which works could be proved genuine by objective evidence, such as unbroken history of ownership going back to the artist, or records of the picture during his lifetime (exhibitions, reproductions, descriptions or other published references). A thorough examination was made of published material since 1865—books, magazines, newspaper reviews, exhibition and auction catalogues. Records of dealers who had handled his work during his lifetime were consulted. . . . This established that over a hundred works were recorded during Ryder's life in such ways as to prove their authenticity.

These works were subjected to thorough study, using X-ray, microscopic examination and examination under ultraviolet light. This study was carried on chiefly in the laboratory of the Brooklyn Museum, with the invaluable help of [the conservator] Sheldon

Keck. . . . It resulted in a more complete knowledge of Ryder's style and technique than had been possible before (L. Goodrich, *Albert P. Ryder* [1959], pp. 117 and 120).

After determining the genuine Ryders and establishing definite scientific characteristics for them based on the radiographs, Goodrich was able to study the remaining undocumented works and separate the authentic from the questionable paintings. By the late 1940s, he had clarified the differences between authentic and forged Ryders, and in effect, had restored the masterful lifework of one of our greatest late nineteenth-century artists.

Acknowledged fakes and forgeries like *Nourmahal*, *Autumn Meadows*, and *Pasture at Evening* are valuable for the study of American art as forgeries of the artist's work continue to be a problem. It is important for the museum to have this group of paintings, which can be scrutinized to provide worthwhile information on the history of Ryder connoisseurship and appreciation.

Autumn Meadows

This landscape, previously attributed to Albert Pinkham Ryder, is now known to be a forgery. Like most deliberately forged Ryders, it probably dates after 1912, when the artist's work became more marketable. It is, however, a relatively early attempt as it was completed by 1917, the year of the artist's death, when it was sold to John F. Braun of Philadelphia. According to Braun's correspondence with the Metropolitan Museum in 1932, he acquired it in 1917 from CHARLES MELVILLE DEWEY, the artist's executor, who reportedly told him that "it was authenticated by Mr. Ryder a short time before his death."

The painter of this forgery has created a pastiche of at least two authentic Ryders: the horse, borrowed from the artist's early pastoral subjects like *Grazing Horse* (Brooklyn Museum), is placed in a landscape based on *The Forest of Arden* (q.v.). The effect is somewhat lifeless, however, and the painting lacks Ryder's powerful sense of design. In the hands of this copier the snake-like contortions of the stream in *The Forest of Arden* become an innocuous curve. The rhythmic swells in the middle ground of the original are flattened here, and the foliage along the horizon is regularized so that the natural forms of the landscape are no longer expressive. The gnarled tree, which in the authentic work looms over the

Formerly attributed to Ryder, *Autumn Meadows*.

figures, is smaller here, more conventional, and less solidly built up. The insipid sky, streaked with shapeless clouds, is perhaps the most telling feature of the picture. The clear areas lack the depth seen in Ryder's authentic works, and the shapes of the clouds are not defined strongly enough to contribute to the overall design of the picture.

The brushwork of *Autumn Meadows* is quite unlike the rich painting effects Ryder achieved with his glazes and constant reworking. Here the paint is applied thinly and fluidly, almost hastily, with impressionistic touches in a wide range of colors. Since this paint application is not characteristic of Ryder, the picture was assumed for a time to be one he had left unfinished, which was then completed by another artist, presumably Dewey—not an uncommon practice at the time. Dewey's comments on paintings left by Ryder are somewhat contradictory. At first he asserted that there were "but few and all of them in bad condition" (letter to W. Evans, July 15 [?], 1917, Ryder File, Library, National Collection of Fine Arts, Washington, D.C.). Later, according to the artist Thomas Casilear Cole (1888–1976), Dewey maintained that "there are no unfinished works left by Ryder in existence." Cole then concluded

that "Ryder did no painting the last two years of his life and had completely finished all that had left his studio. The four or five canvasses left by him after his death—were merely jumbled paint surfaces, quite unfinished, which I saw at the time and which Dewey destroyed" ("Notes on Charles Melville Dewey's Comments on F. N. Price's Book on Ryder, published in 1932," [1932–1937], Thomas Casilear Cole Papers, Arch. Am. Art). But *Autumn Meadows* was never an unfinished Ryder; for the radiograph of the painting shows none of his preliminary working methods, not even "jumbled paint surfaces."

Oil on canvas mounted on panel, 21 × 17¼ in. (53.3 × 43.8 cm.).

REFERENCES: F. F. Sherman, *Albert Pinkham Ryder* (1920), p. 72, lists it as Autumn Afternoon, no. 119, in a catalogue of Ryder's paintings, gives owner as John F. Braun, Philadelphia, and dates it late 1870s // F. N. Price, *Ryder [1847–1917]* (1932), lists it as no. 6, Autumn Afternoon with alternative title of Autumn Meadows // J. F. Braun, letters in Dept. Archives, June 10, 1932, says he purchased it in 1917 from "Charles M. Dewing," who said it was authenticated by the artist shortly before his death (quoted above), and that the artist Horatio Walker saw it and "spoke very highly of it"; June 17, 1932, corrects previous letter by confirming that he purchased the painting from Dewey not Dewing // A. Burroughs, *Limners and Likenesses* (1936), pl. 127, as by Ryder // L. Goodrich, letter in Dept. Archives, Jan. 13, 1970, discusses the provenance and style of the picture, says he first questioned its authenticity in 1947, discusses a radiograph of it, and compares the painting to The Forest of Arden // P. Meyers, Research Laboratory, MMA, orally, May 27, 1978, noted that autoradiographs of the picture show none of the characteristic features of Ryder's style.

EXHIBITED: Philadelphia Museum of Art, 1930, *A Loan Exhibition of American Paintings from the Collection of John F. Braun*, no. 59, as Autumn Meadows by Ryder, dates it 1870–1880 // Grand Central Art Galleries, New York, 1932, *Exhibition of Paintings by American Masters*, no. 50, as Autumn Meadows by Ryder // MMA, 1932, *Landscape Painting*, no. 80 // Musée du Jeu de Paume, Paris, 1938, *Trois Siècles d'art aux Etats-Unis*, cat. by A. H. Barr, Jr., et al., no. 146, as Champs à l'automne by Ryder // Whitney Museum of American Art, New York, 1947, *Albert P. Ryder Centenary Exhibition*, cat. by L. Goodrich, no. 1, as Autumn Meadows by Ryder.

EX COLL.: Charles Melville Dewey, New York, 1917; John F. Braun, Philadelphia, 1917–1932; with Grand Central Art Galleries, New York, as agent, 1932.

Morris K. Jesup Fund, 1932.

32.67.1.

Nourmahal

The painting shows a scene from "The Light of the Harem," the fourth tale in *Lalla Rookh; an Oriental Romance* (1817) by the Irish poet Thomas Moore. The poem relates the story of two Arabian lovers, the powerful Selim and the beautiful Nourmahal. They become estranged, and Nourmahal asks an enchantress to prepare a magical wreath of flowers that will enable her to play her lute and sing so well that she will regain Selim's affection. *Nourmahal* seems to depict the heroine at dawn the morning before a feast at which she plans to perform.

> 'Tis dawn. . . .
> And NOURMAHAL is up, and trying
> The wonders of her lute, whose strings—
> O bliss!—now murmur like the sighing
> From that ambrosial Spirit's wings.
> And then, her voice—'tis more than human—
> Never, till now, had it been given
> To lips of any mortal woman
> To utter notes so fresh from heaven. . . .
> "O! let it last till night," she cries,
> "And he is more than ever mine"
> (*Lalla Rookh* [1860 ed.] pp. 258–259).

That evening the veiled Nourmahal attends the feast, and seeing Selim, she plays her lute and sings. Selim does not recognize her but cries out: "O NOURMAHAL! Hadst thou but sung this witching strain I could . . . forgive thee all!" (p. 269). She reveals her true identity, and they are reconciled.

Although this particular painting is not authentic, Ryder actually did paint a picture titled *Nourmahal*, now unlocated, which was displayed in 1880 at the third annual exhibition of the Society of American Artists. The choice of such a Middle Eastern subject is consistent with other paintings done by the artist at that time, for instance, *By the Tomb of the Prophet* (Delaware Art Museum, Wilmington). It is also not surprising that Ryder selected his theme from the romantic writings of Thomas Moore, whose work was quite popular in America during the late 1870s and 1880s. A sheet of music from Moore's *Irish Melodies*, for example, appears in WILLIAM MICHAEL HARNETT's *Still Life—Violin and Music* (q.v.). Moore's *Lalla Rookh* went through a number of editions at the end of the nineteenth century. One of the most elaborate, published in 1885, was illustrated by such American artists as ROBERT BLUM, KENYON COX, and WILL H. LOW. The book also inspired several musical interpretations: a cantata by Frederic Clay with a libretto by W. G. Wills, first performed at Brighton in 1877, just before Ryder's first trip to England; and at least three operas, among them Félicien César David's *Lalla Rookh*, which premiered in Paris in 1862, and, translated into several different languages, was performed frequently throughout the end of the nineteenth century.

There are no known contemporary illustrations or detailed descriptions of Ryder's authentic *Nourmahal*. One of the few reviews of the painting simply noted: "Like [George] Fuller's work, that of Mr. Ryder makes a sensation, although it is all

Formerly attributed to Ryder, *Nourmahal*.

very small in size. . . . One only has to look at 'Nourmahal' to satisfy one's self that he has the germ of greatness as a colorist," (*New York Times*, March 26, 1880, p. 5). It seems unlikely that the phrase "very small" could be applied to the Metropolitan *Nourmahal*, which is larger than most of the works Ryder produced at this time. The composition, with deep space and a complicated architectural setting, seems too ambitious at this point for Ryder, who, around 1880, was just turning from idyllic landscapes to the literary, biblical, and imaginative scenes which were to occupy his attention during the following decade. Except for the cloud patterns, the painting lacks his powerful sense of design, as one vague form blends into the next. In terms of technique, there is little to suggest the artist's methods. The paint surface is too thin and the cracks superficial; there is no evidence of the layers of paint usually built up by Ryder's many reworkings. Certain details, however, recall motifs from authentic paintings by the artist. The general format, with a gazebo on the left, a fountain on the right, and the figure in the center foreground, is similar to *The Temple of the Mind* (Albright-Knox Art Gallery, Buffalo). The dark clouds, each surrounded by an aureole of light, are similar to those in *Macbeth and the Witches* (Phillips Collection, Washington, D.C.), although their shapes are less expressive. In short, this painting appears to be an intentional forgery, conceived and painted in an attempt to duplicate Ryder's style, albeit unsuccessful.

Oil on wood, $19\frac{1}{2} \times 28\frac{1}{2}$ in. (49.5 × 72.3 cm.).
Falsely inscribed at lower right: AP Ryder.
REFERENCES: K. Wegemann to J. F. Braun, March 24, 1924, Dept. Archives, calls it "Oriental Scene," says it was secured from the artist by a New York antique dealer named Fullerton during the late 1880s and sold to the writer's grandmother, Catherine R. Jussen of Milwaukee, and after her death in 1890, it came into his possession // E. Daingerfield, statement written on a photograph of the painting, [1924–1932], Dept. Archives, testifies to its authenticity and quality // F. F. Sherman, *Art in America* 14 (Dec. 1925), p. 23, mentions exhibition of the original in 1880; p. 25, discusses literary source, assuming that this painting, recently sold to John F. Braun, is the original, and says no descriptions of it appeared in contemporary periodicals at the time of the 1880 exhibition // F. N. Price, *Ryder [1847–1917]* (1932), no. 120, includes this painting in a catalogue of the artist's work // J. F. Braun, letter in Dept. Archives, June 10, 1932, enclosing the Wegemann letter of March 24, 1924, and the photograph inscribed by Daingerfield, says he bought the painting on March 24, 1924, that it remained in his possession until MMA purchased it, and that "it was

examined and highly praised by Elliott Daingerfield, Mr. Groll and others" // A. Shilling, orally, June 4, 1934, recorded by H. B. Wehle in Dept. Archives, said it was painted about 1880 and is a "very early" work // F. F. Sherman, "Albert Pinkham Ryder—Supplement," [1920–1940], unpublished Ryder material, Lloyd Goodrich Archives, Whitney Museum of American Art, New York, microfilm N/621, Arch. Am. Art, discusses it under part 5, subjects from literature and the drama // J. F. Braun to L. Goodrich, May 31, 1947, unpublished Ryder material, Lloyd Goodrich Archives, Whitney Museum of American Art, New York, microfilm N/623, Arch. Am. Art, says he purchased it on May 18, 1924, from Mr. Harbow of Consignment Arts, that it came from Karl Wegemann, who acquired it from his grandmother, Catherine R. Jussen, and that he, Braun, sold it through Grand Central Art Galleries // L. Goodrich, undated notes [Nov.–Dec. 1947], unpublished Ryder material, Lloyd Goodrich Archives, Whitney Museum of American Art, New York, microfilm N/623, Arch. Am. Art, says that John I. H. Baur, Sheldon Keck, and Kenneth Hayes Miller all agree that it is not authentic, gives an extensive stylistic discussion and compares it to Temple of the Mind // R. Braddock, *Gazette des Beaux-Arts*, ser. 6, 33 (Jan. 1948), ill. p. 51; pp. 51–53, includes it in a discussion of Ryder's use of literary sources, noting specific parallels between Moore and Ryder; p. 55, in a list of literary sources used by Ryder, notes "The Light of The Harem" in *Lalla Rookh* as the literary inspiration for this picture // L. Goodrich to J. Lipman, Dec. 6, 1962, unpublished Ryder material, Lloyd Goodrich Archives, Whitney Museum of American Art, New York, microfilm N/620, Arch. Am. Art, explains how he borrowed this and other questionable works not for inclusion but for study purposes during the 1947 Ryder exhibition // L. Goodrich, letters in Dept. Archives, Jan. 13, 1970, says that it is not an authentic Ryder; August 1977, provides a copy of his notes on it from 1940s, with later additions.

EXHIBITED: Philadelphia Museum of Art, 1930, *A Loan Exhibition of American Paintings from the Collection of John F. Braun*, no. 61, as Nourmahal by Ryder, dates it 1880–1890 // Grand Central Art Galleries, New York, 1932, *Exhibition of Paintings by American Masters*, no. 52, as Nourmahal by Ryder.

EX COLL.: Karl Wegemann, New York, by 1924; probably with Consignment Arts, 1924; John F. Braun, Philadelphia, 1924–1932; with Grand Central Art Galleries, New York, as agent, 1932.

Morris K. Jesup Fund, 1932.
32.67.2.

Pasture at Evening

Undoubtedly a fake or a forgery, and probably dating after 1912, *Pasture at Evening* was painted on an old canvas. Beneath the present landscape,

Formerly attributed
to Ryder, *Pasture at Evening*.

Radiograph
of *Pasture at Evening*
shows square-rigged ship
upside down,
Brookhaven National Laboratory.

radiographs of the painting show a marine painting of a square-rigged ship, perhaps an earlier work by the author of *Pasture at Evening*, who reused the canvas as an economy measure. It is also possible, however, that the person who painted this picture reused the canvas intentionally in an attempt to give the work a convincing appearance of age. The pigments have been applied more thinly than was generally Ryder's practice, and the fine web of surface cracks may have been achieved by painting over the old picture, which was already severely cracked.

The Barbizon subject matter of *Pasture at Evening*, with its trees, domestic animals, and distant cottage, is in a sense related to the idyllic landscapes Ryder painted during the late 1870s and early 1880s. There even seems to be a conscious effort to imitate features from specific pictures. The cottage, for instance, is quite similar to the ones in *The Curfew Hour* (q.v.). The painting's rather conventional composition, however, lacks Ryder's sensitivity to design, and the muddied golden tone in no way resembles the rich colors and strongly contrasted areas of value typical of his work.

The painting first appeared on the New York art market in 1932. Its earlier provenance, often given as Louise Fitzpatrick, who died in 1928,

cannot be substantiated. The identity of the artist who painted *Pasture at Evening* remains unknown, as does the degree of that artist's culpability; for it is possible that Ryder's signature was added without the knowledge of the artist who completed the picture.

Oil on canvas, 12 × 16 in. (30.5 × 40.6 cm.).

Falsely inscribed at lower left (no longer visible): A.P. Ryder.

REFERENCES: F. N. Price, *Ryder [1847–1917]* (1932), ill. no. 130, includes it in a list of the artist's works and gives Ferargil Gallery in New York as owner // Ferargil, New York, annual inventories, Dec. 31, 1933—Dec. 31, 1939, Ferargil Gallery Papers, 787, Arch. Am. Art, lists it as no. 5024 // *Index of Twentieth Century Artists* 1 (Feb. 1934), p. 71, lists illustration of it // L. Goodrich, undated notes [1935] headed "#4. Pasture at Evening (Price 130)," in unpublished Ryder material, Lloyd Goodrich Archives, Whitney Museum of American Art, New York, microfilm N/620, Arch. Am. Att. gives size and signature, criticizes drawing and design, and concludes: "In my opinion not characteristic of Ryder" // "Consignment to Kleeman[n] Galleries," Sept. 23, 1935, Ferargil Gallery Papers, 789, Arch. Am. Art, includes it // F. F. S[herman], *Art in America* 24 (Oct. 1936), p. 161, includes it in a list of paintings misattributed to Ryder // "List of Albert P. Ryder's paintings for Mr. Lloyd Goodrich, Whitney Museum," [late 1930s], Ferargil Gallery Papers, 789, Arch. Am. Art, includes it with the notation "Fitzpatrick Collection" // L. Goodrich, notes [1938] headed "Pasture at Evening," in unpublished Ryder material, Lloyd Goodrich Archives, Whitney Museum of American Art, New York, microfilm N/623, Arch. Am. Art, says he examined it at Kleemann Galleries in 1935, gives Miss de Groot as current owner, and reiterates statements made in 1935 notes, says examined it again at the Whitney in May 1938, and discusses X-ray which shows a painting of a square rigged ship beneath it; record of a conversation with Kenneth Hayes Miller, June 27, 1938, written on July 21, 1938, microfilm N/620, says "I showed him Price's *Pasture at Evening* . . . which Price said came from Mrs. Fitzpatrick. He said that . . . [it was] terrible and in his opinion could not be by Ryder"; undated notes, unpublished Ryder material, Lloyd Goodrich Archives, Whitney Museum of American Art, New York, microfilm N/620, Arch. Am. Art, includes it among paintings said to have been owned by Mrs. Fitzpatrick; letter in Dept. Archives, August 1977, provides a copy of his notes from May 1938 with later additions, giving a detailed stylistic and technical discussion of it // P. Meyers, Research Laboratory, MMA, orally, May 27, 1978, noted that autoradiographs of the picture show none of the characteristic features of Ryder's style.

EXHIBITED: Kleemann Galleries, New York, 1935, *Albert Pinkham Ryder Exhibition of Paintings*, no. 4, as Pasture at Evening.

ON DEPOSIT: MMA, 1940–1950, 1952–1967.

EX COLL.: with Ferargil, New York, by 1932–1939; Adelaide Milton de Groot, New York, 1939–1967.

Bequest of Miss Adelaide Milton de Groot (1876–1967), 1967.

67.187.138.

RALPH BLAKELOCK

1847–1919

Early published accounts of the tragic life of Ralph Albert Blakelock are incomplete, inaccurate, and often contradictory. Born in New York, the son of a physician, Blakelock attended public schools and entered the Free Academy of the City of New York (now City College of New York) in 1864. He left in 1866 without completing the five-year course and began to paint. Blakelock was self-trained, but within a year, he was exhibiting at the National Academy of Design, where he displayed his work regularly for the next seven years. Apparently uninterested in foreign study and travel, he made a trip to the West in 1869. He appears to have gone to Kansas, Colorado, Wyoming, Utah, and Nevada and to have lived for a time on the coast of northern California, before returning to New York in 1871. This trip had an enduring effect

on the subject matter of his paintings, in which he often depicted the American wilderness and scenes of Indian life. The artist resided and worked in the New York area but little else is known about his activities during the late 1870s, except that he married in 1877.

Blakelock began to receive some recognition during the 1880s, although he was already plagued with financial problems at this early date. He exhibited at the National Academy regularly between 1879 and 1888 and displayed his work four times at the Society of American Artists during the 1880s. He was occasionally patronized by such prominent collectors as Catholina Lambert and Thomas B. Clarke, but his most enthusiastic supporters, particularly as his work became increasingly unconventional, were his friends Lew Bloom, a vaudeville actor, and HARRY W. WATROUS, a younger and more successful artist. In an attempt to meet the financial demands of his large family, which eventually numbered nine children, one of whom died in infancy, Blakelock sold many of his works through minor auction houses and art dealers. The years from 1889 to 1893 must have been difficult for him, as he exhibited only once at the National Academy and experienced increasing financial problems. In 1891, after a collector refused to pay him the anticipated price for a picture, he had his first mental break-down and was hospitalized briefly. Thereafter his behavior became more eccentric and un-predictable, and he suffered from delusions of grandeur. In 1899 his mental illness, then described as *dementia praecox*, became so severe that he entered Long Island Hospital at Kings Park, and three years later he was transferred to the Middletown State Hospital for the Insane at Middletown, New York, where he spent much of the rest of his life.

Ironically, shortly after Blakelock's confinement, his work achieved critical recognition and commercial success. He received his first and only award at the Universal Exposition in Paris in 1900, and the first full-length article on him appeared two years later. His paintings brought substantial prices beginning in 1904 at the sale of Frederick S. Gibbs's collection. Forgeries of Blakelock's work were noticed as early as 1903, and between 1913 and 1916 they became more common as several important publications and a series of exhibitions increased the value of his paintings. After seventeen years as a mental patient, the artist began to show signs of improvement, although he continued to have delusions of grandeur. In 1916, he was released briefly to attend an exhibition of his work in New York, and thereafter he was in and out of hospitals until his death at Elizabethtown, New York, at the age of seventy-two.

It is difficult, if not impossible, to document individual Blakelock works or establish a detailed chronology of his stylistic and thematic development. Few of his works are dated, few were exhibited or reproduced in his lifetime, and most have no provenance before 1900. His paintings, furthermore, vary considerably in quality. While his best paintings secured his reputation as one of America's leading artists, overall his work is thematically and composi-tionally repetitive and technically erratic. The situation is complicated by the enormous number of forgeries, which today far exceed the number of genuine works.

Blakelock's earliest paintings, done during the 1860s, are somewhat unsophisticated. Clearly influenced by Hudson River School landscapes, they are modest, thinly painted, and pains-takingly drawn, occasionally suggesting a mood of desolation or melancholy. His representa-tions of urban shanties on the outskirts of New York probably date from this, or a slightly later, time. After his return to New York in 1871, he painted many western landscapes in a natural-istic manner. Others, however, are done in a more original style, demonstrating the artist's

growing interest in the painterly problems of color, design, and texture rather than in literal depiction. During the 1880s and 1890s, when Barbizon painting held a dominant influence on his art, he explored romantic subjects, notably nocturnes and scenes of Indian life, using the dark palette and roughened surface textures of the French school. These works, often large in scale and ambitious in conception, either show man in harmony with his natural setting or represent pure landscape, with topographical detail and narrative elements eschewed in favor of strong design, dramatic light effects, and thick paint surfaces. During the 1890s, as his mental state worsened, his brushwork became freer, almost chaotic. He continued to paint after his confinement in 1899, but the scale of his work was reduced and its quality diminished by the makeshift materials he used. As always, landscape was his favorite genre, and he worked spontaneously and directly, creating simple and intense images. Throughout his career, Blakelock's art at its best remained the beautiful and sensitive statement of a highly individual artistic temperament.

BIBLIOGRAPHY: Elliott Daingerfield, "Ralph Albert Blakelock," *Art in America* 2 (Dec. 1913), pp. 55–68, expanded in his *Ralph Albert Blakelock* (New York, 1914), and later printed with deletions and editorial changes in *Art in America* 51 (August 1963), pp. 83–85 // *Index of Twentieth Century Artists* 4 (Dec. 1936), pp. 367–368; (Jan. 1937), pp. 369–373. Reprint ed. with cumulative index. New York: Arno Press, 1970, pp. 663–669. Contains biography, list of public collections that include his work, chronological list of exhibitions, bibliography, and a list of reproductions // Lloyd Goodrich, Blakelock notes, [1946–1947], Whitney Museum of American Art Papers, New York, microfilm N/629–N/632, Arch. Am. Art, and, "Ralph Albert Blakelock 1847–1919," [1946–1947], FARL, are invaluable compilations of biographical information on the artist and observations of individual works // Whitney Museum of American Art, New York, *Ralph Albert Blakelock Exhibition* (1947), cat. by L. Goodrich. A detailed biographical treatment with excellent notes // Sheldon Memorial Art Gallery, University of Nebraska, Lincoln, and New Jersey State Museum, Trenton, *Ralph Albert Blakelock, 1847–1919* (1975), exhib. cat. by Norman A. Geske. Includes an essay on the development of Blakelock's style and subject matter and a detailed catalogue of works exhibited.

The Boulder and the Flume

The Boulder and the Flume depicts one of the natural wonders that made New Hampshire's White Mountains a favorite tourist retreat and artist's haunt during the nineteenth century. Blakelock is said to have visited the site at Franconia Notch on his honeymoon trip, and, although the artist was married in 1877, the painting is traditionally dated the following year.

The picture shows a brook, its waters rushing down the narrow flume, bound on each side by perpendicular walls of rock, with a boulder wedged between them at their narrowest point. Samuel Adams Drake described the scene and its impact just a few years after the painting was executed:

This is a remarkable rock-gallery, driven several hundred feet into the heart of the mountain, through which an ice-cold brook rushes. The miracle of Moses seems repeated here sublimely. Some unknown power smote the rock, and the prisoned stream gushed forth free and lightsome as air. You approach it over broad ledges of flecked granite, polished by the constant flow of a thin, pellucid sheet of water to slippery smoothness. Proceeding a short distance up this natural esplanade, you enter a damp and gloomy fissure between perpendicular walls, rising seventy feet above the stream, and, on lifting your eyes suddenly, espy an enormous bowlder tightly wedged between the cliffs. Now try to imagine a force capable of grasping the solid rock and dividing it in halves as easily as you would an apple with your two hands.

At sight of the suspended bowlder . . . I believe every visitor has his moment of hesitation, which he usually ends by passing underneath, paying as he goes with a tremor of the nerves, more or less, for his temerity (*The Heart of the White Mountains* [1882], p. 226).

Blakelock heightens the psychological effect of the scene with a luminous light above and behind the rock, roots and trees that lean or tumble over

Blakelock,
*The Boulder
and the Flume.*

the edge of the precipice, and a boardwalk, not too solidly constructed, that zigzags into the distance. His rough, scumbled paint application, particularly evident in the rocks, and strong contrasts in value add expression to a composition that seems to permit the spectator only one means of exit—the walk beneath the boulder. Perhaps more than most paintings by the artist, *The Boulder and the Flume* demonstrates the veracity of the analogy one critic drew between Blakelock and his work:

His art, more than that of almost any artist that I know, expressed the social and mental condition of the painter at the time of painting. Generally it has seemed to me that his art was like a dead tree, blasted by the lightning and riven by the storm, and in this respect truly indicative of the exhaustion that followed the terrible struggle that must have been going on while balancing on that narrow shelf that separates insanity from genius (*Art Collector* 9 [Dec. 1, 1899], p. 37).

The picture was at one time owned by Frederick S. Gibbs, a New York businessman and politician, who by 1901 had a collection of fifty-eight works by Blakelock, revealing "him in all his moods and in the full range of his powers" (*Brush and Pencil* 8 [July 1901], p. 220).

Oil on canvas, 54 × 28 in. (137.2 × 71.1 cm.).
Signed at lower left: Blakelock.
REFERENCES: *Paintings by Ralph Albert Blakelock in the Private Collection of Frederick S. Gibbs* (1901), unpaged ill., calls it The Boulder and the Flume in the Franconia Notch, N.H., 1878 // F. W. Morton, *Brush and Pencil* 9 (Feb. 1902), pp. 261, 263, calls it "one of the sanest and most pleasing of Blakelock's canvases," says it was painted on the artist's wedding trip, describes the site, and discusses provenance // American Art Association, New York, *Illustrated Catalogue of Modern Paintings, the Private Collection Formed by the Late Frederick S. Gibbs*, sale cat. (1904), ill. no. 87, discusses (annotated copy, MMA Library, notes price and purchaser) // *American Art Annual* 5 (1905–1906), p. 33, lists it in Gibbs sale, gives price and purchaser // *Index of Twentieth Century Artists* 4 (Jan. 1937), p. 371, lists reproduction of it // L. Goodrich, Blakelock Archives, [1946–1947], Whitney Museum of American Art, New York, microfilm N/632, Arch. Am. Art, lists references, exhibitions, and early provenance; *Gazette des Beaux-Arts*, ser. 6, 31 (Jan.–Feb. 1947), p. 64, seeks current location of the picture // Sheldon Memorial Art Gallery, University of Nebraska, Lincoln, *Ralph Albert Blakelock, 1847–1919* (1974), exhib. cat. by N. A. Geske, p. 26, mentions it as a work "now lost and known only in reproduction," says it was painted during the artist's wedding trip in 1877 and is an "exceptional example" of his interest in "grandiose" subjects // *MMA Bull.* 33 (Winter 1975–1976), ill. p. 241 // H. J. Grant, orally, June 1, 1978, provided information on the provenance.

EXHIBITED: MMA, 1975–1976, *Patterns of Collecting* (no cat.); 1976, *A Bicentennial Treasury*, ill. p. 241.

EX COLL.: Frederick S. Gibbs, New York, by 1901 (sale, American Art Association, New York, Feb. 24, 1904, no. 87, as The Boulder and The Flume, $550); Hugh J. Grant, New York, 1904–1910; his wife, Julie M. Grant, 1910–1944; their children, Julia M., Edna M., and Hugh J. Grant, 1944; Mr. and Mrs. Hugh J. Grant, New York, following the death of his sisters, until 1974.

Gift of Mr. and Mrs. Hugh J. Grant, 1974.
1974.212.

A Waterfall, Moonlight

This painting was completed by 1886, when it was exhibited at the National Academy of Design. Here, as in many of Blakelock's mature works, there is an uneasy balance between the picture plane, where silhouetted forms are arranged decoratively, and the distant space, where a landscape vista is treated somewhat naturalistically. ELLIOTT DAINGERFIELD, who in 1914 described the painting as a "variant" of the better known *Brook by Moonlight*, after 1891 (Toledo Museum of Art), commented that in both works "the composition was quite the same, but in this canvas the labor is felt if not seen; it lacks the suave certainty of the other." The Metropolitan painting, however, is exceptional in the strength and subtlety of its design. The foliage that frames the edge of the canvas complements the irregular contours of the tree. The luminous sky emphasizes the relationship between these two dark areas, which are so closely related in shape that they could almost interlock. Although the composition is tightly orchestrated, the brushwork is varied, with touches of pigment loosely applied to create a richly colored surface, most noticeable in the boundary between the light sky and the dark spiky leaves.

Oil on canvas, 56¼ × 35¾ in. (142.9 × 90.8 cm.).
Signed at lower left in an arrowhead: Ralph Albert Blakelock.
RELATED WORK: S. G. Putnam, *Waterfall by Moonlight*, engraving, 9⅞ × 6 in. (25.1 × 15.2 cm.), in *Engravings on Wood by Members of the Society of American Wood-Engravers* (1887), intro. by W. M. Laffan, sec. 20.
REFERENCES: *Artist* 29 (Jan. 1901), pp. xvii, xix, mentions it in a review of Lotos exhibition as a characteristic example of Blakelock's work // American Art Association, New York, *Catalogue of the Ancient and Modern Paintings and other Objects of Art Collected by the Late William M. Laffan*, sale cat. (1911), no. 14, describes it // E. Daingerfield, *Ralph Albert Blakelock* (1914), p. 36, compares it to a Blakelock painting then in the Lambert collection and says it is more belabored

(quoted above) // F. F. Sherman, *Art in America* 4 (June 1916), p. 241, discusses engraving of it; reprinted in *Landscape and Figure Painters of America* (1917), p. 28 // L. Goodrich, *Gazette des Beaux-Arts*, ser. 6, 31 (Jan.–Feb., 1947), p. 64, inquires about its current location and gives early provenance; "Ralph Albert Blakelock, 1847–1919," [1946–1947], FARL, provides exhibitions, references, and provenance; Feb. 26, 1947, includes 1919 photograph, noting that the condition appears to be the same, and discusses technique and style // R. Irvine, Whitney Museum of American Art, New York, letter in Dept. Archives, Feb. 6, 1952, gives references, exhibitions, and provenance // N. A. Geske, Sheldon Memorial Art Gallery, letter in Dept. Archives, March 20, 1974, designates it NU-353, Category II in Blakelock Inventory.

EXHIBITED: NAD, Autumn 1886, no. 444, as A Waterfall, Moonlight // World's Columbian Exposition, Chicago, 1893, no. 185, as Moonlight, lent by Mr. W. M. Laffan, New York // Art Galleries, University of California, Santa Barbara; California Palace of the Legion of Honor, San Francisco; Phoenix Art Museum; Heckscher Museum, Huntington, N.Y., 1969, *The Enigma of Ralph A. Blakelock*, cat. by D. Gebhard and P. Stuurman, no. 55; p. 17, cite it as an example of a work "dominated by one or more spiky leafed, darkly silhouetted trees"; ill. p. 57.

Ex COLL.: William M. Laffan, New York, by 1893–1911 (sale, American Art Association, New York, Jan. 20, 1911, no. 14, as Moonlight on a Stream, $750); with O. Fukushima, 1911; Eda K. Loeb, New York, by 1919–1951.

Bequest of Eda K. Loeb, 1952.

52.48.2.

Blakelock, *A Waterfall, Moonlight.*

Blakelock, *An Indian Encampment*.

An Indian Encampment

In *An Indian Encampment*, probably painted in the 1880s or 1890s, Blakelock fully integrates the figures in their setting, fusing the Indians, horses, and tepees with the surrounding landscape. Placed in the middle ground, the encampment and the few trees around it provide the focus in an otherwise generalized view. Much of the composition is devoted to richly painted areas like the opalescent sky, which serves as a foil for the spiky foliage silhouetted against it, and the darkened foreground, where Blakelock builds up roughened, irregular textures. The elaborate paint surface with its chalky, variegated colors was reportedly achieved by applying several layers of pigment and then planing them down to different levels with a pumice stone to permit the various colors to show through on the surface.

Gustav Kobbé, in 1913, related an anecdote regarding this painting, the artist, and his fellow painter HARRY W. WATROUS:

One day he [Blakelock] walked into the Watrous studio with a canvas rolled up and looking as long as a roll of oilcloth. He unrolled it on the floor, placed some books along the edges to keep it flat and stood there looking at it. In some places the paint looked as if it were three inches thick and here and there the surface had cracked from the effect of unrolling and rolling up the canvas. "I started it a long time ago," said the artist. "I guess I'll finish it. How do you like it, Watrous?"

"I like both sides, but not the whole thing," said his friend. "There's a separate picture at each end of the canvas, or rather at each side. There's no relationship between the two halves of the canvas."

"Do you want to buy it?"

"No, but if you'll cut it in two, I'll take both halves."

He at once rolled it up again and put it in a closet. About a month later when Mr. Watrous came into his studio Blakelock was there, had the picture spread out on the floor again with a pile of books on each corner and was looking at it.

"Watrous you're dead right about that picture. I painted on it at different times. There really are two

pictures on the canvas." Then he took out his knife and cut it in two. The two parts, now two pictures, were ironed out, lined and stretched, and Blakelock began to work over them, as his friend had agreed to buy them.

An Indian Encampment was one of these paintings. What the other one was is not certain, although it was suggested in 1947 that it was a painting called *Big Tree*, now unlocated.

Oil on canvas, 37⅝ × 40⅝ in. (95.6 × 103.2 cm.).

Signed at lower left, now partially illegible: R. A. Blakelock.

REFERENCES: *Artist* 29 (Jan. 1901), pp. xviii–xix, in a review of the Lotos exhibition, calls it a "characteristic example" of the artist's work // *The George A. Hearn Gift to the Metropolitan Museum of Art . . .* (1906), p. 170; ill. p. 171 // B. D., *MMA Bull.* 4 (March 1909), p. 53 // J. W. Pattison, *Fine Arts Journal* 27 (Oct. 1912), ill. p. 642 // *George A. Hearn Gift to the Metropolitan Museum of Art . . .* (1913), ill. p. 62 // G. Kobbé, *New York Herald*, May 4, 1913, mag. sec., p. 2, relates Watrous's anecdote (quoted above) and mentions Blakelock's use of a pumice stone on this painting // E. Daingerfield, *Ralph Albert Blakelock* (1914), ill. following p. 16; p. 28, discusses its "completeness of vision and fidelity of form," says Rousseaulike; p. 29, compares to The Pipe Dance (q.v.) // R. E. Jackman, *American Arts* (1928), ill. following p. 144 // H. W. Watrous, statement on reverse of photograph, Jan. 24, 1929, in Dept. Archives, says "The painting of which this is a photograph was at one time in my possession. In fact Blakelock finished it in my studio and I always considered [it] one of the finest examples of his work" // *Index of Twentieth Century Artists* 4 (Dec. 1936), p. 368, lists it; (Jan. 1937), p. 372, lists reproductions of it // L. Goodrich, "Ralph Albert Blakelock, 1847–1919," [1946–1947], FARL, lists references, exhibitions, and provenance; Dec. 18, 1946, provides extensive stylistic analysis; May 1947, gives additional stylistic analysis, discusses condition, and reports Mrs. Louis Lemaire as saying her painting "Big Tree" was done on the same canvas as this picture; notes on a conversation with Mrs. J. L. Allen, MMA, June 12, 1947, who reported that in 1906 "two spots from the large tree stuck to the glass" and Bryson Burroughs returned them to the picture // N. A. Geske, Sheldon Memorial Art Gallery, letter in Dept. Archives, March 20, 1974, designates it as NU-348, Category I, Blakelock Inventory.

EXHIBITED: Lotos Club, New York, 1900, *Exhibition of Paintings by Ralph Albert Blakelock . . .*, no. 27, as An Indian Encampment, lent by George A. Hearn // MMA, 1934, *Landscape Paintings*, no. 81 // Carnegie Institute, Pittsburgh, 1940, *Survey of American Painting*, exhib. cat. by H. Saint-Gaudens, no. 175 // Whitney Museum of American Art, New York, 1947, *Ralph Albert Blakelock Centenary Exhibition* (in celebration of the centennial of the City College of New York), cat.

by L. Goodrich, no. 8, ill. p. 2; p. 45, lists references and exhibitions // MMA, 1970, *19th Century America*, exhib. cat. by J. Howat and N. Spassky, ill. no. 150 // National Gallery of Art, Washington, D.C.; City Art Museum, St. Louis; Seattle Art Museum, 1970–1971, *Great American Paintings from the Boston and Metropolitan Museums*, exhib. cat. by T. N. Maytham, no. 65, p. 104, discusses and gives exhibitions and provenance; ill. p. 107.

EX COLL.: Harry W. Watrous, New York; George A. Hearn, New York, 1900–1906.

Gift of George A. Hearn, 1906.

06.1269.

The Pipe Dance

The Pipe Dance, probably done in the 1880s or 1890s, is an example of the enduring effect that Blakelock's western trip had on the subject matter of his art. One of several works representing Indian rituals, it depicts a clearing with a group of dancing Indians, led by a figure who holds what appears to be some kind of musical instrument. This scene is not a factual record of a specific tribe but the product of the artist's fertile imagination. "Never, I think, did he attempt portraiture—Indian portraiture—but the nomadic life, the incidents of daily routine, the building of canoes, or pitching of encampments, the dances—these were his themes, and his love for them never cooled nor grew less," ELLIOTT DAINGERFIELD later noted (*Art in America* 2 [Dec. 1913], pp. 56, 59).

Highlighting Blakelock's interest in music, Gustav Kobbé (1913) described the circumstances under which HARRY W. WATROUS found the artist at work on this picture. One day it seems Watrous

heard sounds of a queer little tune being played on the piano in Blakelock's studio, which was in the Sherwood Building, near the studio Mr. Watrous then and still has. The tune persisted so long that Mr. Watrous went to Blakelock's studio and found him at the piano. On an easel near by stood a canvas with the paint upon it still wet.

"Do they dance? Do they dance?" asked the artist, as he continued playing the queer little tune with its abrupt aboriginal rhythm.

"Does who dance?" asked Mr. Watrous.

"Do those Indians dance?"—pointing to the canvas.

"Why they're jumping out of the picture!" exclaimed Mr. Watrous.

"That's what I want."

Blakelock's sketchily rendered Indians do suggest movement and rhythm. Strong contrasts

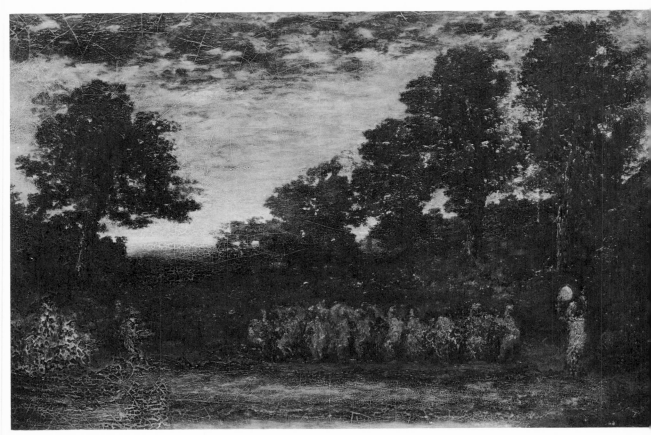

Blakelock, *The Pipe Dance.*

in value, powerfully designed shapes and expressive surface textures heighten the romantic effect of the setting, a dark, primeval forest silhouetted against a golden sky.

Although large in scale and ambitious in conception, *The Pipe Dance* is severely compromised by its poor condition. As early as 1946, Lloyd Goodrich observed the effect of the artist's use of bitumen, which had "melted and slipped down, gathering in wrinkles in various places," giving the dark areas of the picture "an almost completely formless character." Nevertheless, Goodrich concluded that "even in its present condition the picture is quite impressive."

Oil on canvas, 48½ × 72 in. (123.2 × 182.9 cm.).

Signed at lower right, now partially illegible: . . . Bla[kelock].

REFERENCES: *Paintings by Ralph Albert Blakelock in the Private Collection of Frederick S. Gibbs* (1901), unpaged ill. // American Art Association, New York, *Illustrated Catalogue of Modern Paintings, the Private Collection Formed by the Late Frederick S. Gibbs, New York* (1904), no. 253, describes it // *American Art Annual* 5 (1905–1906), p. 50, lists price and purchaser in Gibbs sale // B. D., *MMA Bull.* 4 (March 1909), ill. p. 51; p. 53 // J. W. Pattison, *Fine Arts Journal* 27 (Oct. 1912), ill. p. 643 // Moulton and Ricketts, Chicago, *Catalogue of a Loan Exhibition of Important Works by George Inness, Alexander Wyant, Ralph Blakelock* (1913), unpaged appreciation by H. Monroe, says that it was sold by the artist for a few hundred dollars // *George A. Hearn Gift to the Metropolitan Museum of Art . . .* (1913), ill. p. 63, as Indian Pipe Dance // G. Kobbé, *New York Herald*, May 4, 1913, mag. sec., ill. p. 2, relates Watrous's anecdote (quoted above) // E. Daingerfield, *Ralph Albert Blakelock* (1914), pp. 29–30, calls it one of his "Rousseau-like" pictures and says it is not as complete as Indian Encampment (q.v.); p. 32, discusses it // *New York Times Magazine*, April 2, 1916, p. 8 // *American Art News* 14 (April 8, 1916), p. 2, discusses it // F. F. Sherman, *Art in America* 4 (June 1916), p. 235, mentions it as an example of the artist's work on a large scale; p. 236; reprinted in *Landscape and Figure Painters of America* (1917), pp. 23, 25; *Art in America* 9 (June 1921), pp. 168, 173, discusses it //

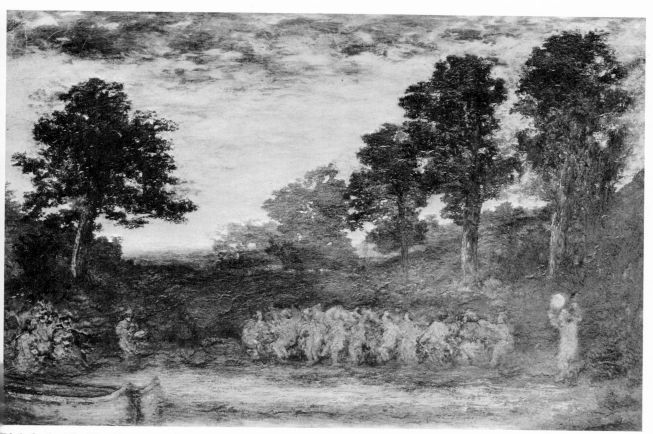

Blakelock, *The Pipe Dance*, condition at acquisition, 1909.

F. J. Mather, Jr., C. R. Morey, and W. J. Henderson, *The American Spirit in Art* (1927), ill. p. 63 // R. E. Jackman, *American Arts* (1928), p. 143, discusses it; ill. following p. 144 // H. W. Watrous, statement on reverse of photograph, Jan. 24, 1929, in Dept. Archives, comments "I known the painting of which this is a photograph. There is no question but what it is by R. A. Blakelock having seen him at work upon it" // *Index of Twentieth Century Artists* 4 (Dec. 1936), p. 368; (Jan. 1937), p. 373, lists reproductions of it // *Life* 5 (Oct. 31, 1938), ill. p. 29 // F. J. Mather, Jr., *Magazine of Art* 39 (Nov. 1946), ill. p. 302; p. 303, discusses it // L. Goodrich, "Ralph Albert Blakelock, 1847–1919," [1946–1947], FARL, lists exhibitions and references, gives provenance and discusses; notes, Dec. 18, 1946, provides a detailed record of the painting's condition, discusses effects of bitumen (quoted above), and records Mrs. J. L. Allen, MMA, stating that it had been a problem for years and that each summer Bryson Burroughs had taken the picture off the wall and stood it upside down "so that the bitumen might run back"; notes, May 1947, discusses its condition and compares to appearance in 1912 reproduction // V. Young, *Arts* 30 (Oct. 1957), p. 26 // Sheldon Memorial Art Gallery, University of Nebraska, Lincoln, *Ralph Albert Blakelock, 1847–1919* (1974), exhib. cat. by N. A. Geske, p. 25, mentions it as an example of the artist's ambitious works; p. 26, notes its imaginative quality; p. 32 // N. A. Geske, Sheldon Memorial Art Gallery, letter in Dept. Archives, March 20, 1974, designates it as NU-349, Category I, in Blakelock Inventory.

EXHIBITED: Lotos Club, New York, 1902, *Exhibition of Paintings by Ralph Albert Blakelock from the Collection of Hon. Frederick S. Gibbs*, no. 22, as The Pipe Dance // Whitney Museum of American Art, New York, 1947, *Ralph Albert Blakelock Centenary Exhibition*, cat. by L. Goodrich, no. 21, lists exhibition, references, and provenance; pp. 20, 32.

EX COLL.: Frederick S. Gibbs, New York, by 1901 (sale, American Art Association, New York, Feb. 26, 1904, no. 253, as The Pipe Dance, $3,100); George A. Hearn, New York, 1904–1909.

Gift of George A. Hearn, 1909.

09.25.1.

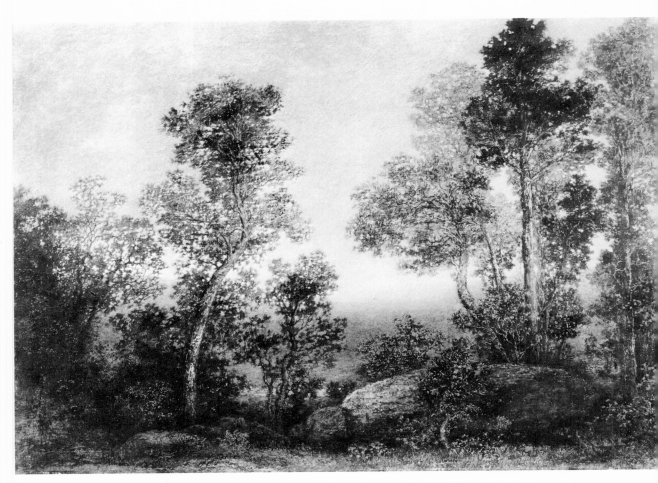

Blakelock, *Landscape*.

Landscape

Landscape, probably painted during the late 1880s or early 1890s, is typical of Blakelock's large-scale woodland scenes in composition. As Frederick W. Morton observed:

Blakelock's compositions for the most part are extremely simple. He beheld a scene and received an impression.... He did not require compositions with minute detail, and hence many of his best works are little more than a mere hint of a landscape—a broad stretch of sky with a few trees sharply outlined against it; a stream or a pool of water, with the reflections of the few near-by shrubs or trees; a hill sharply marked or perhaps a mountain in the distance indistinct in the haze of a summer afternoon. These simple elements sufficed for a framework, and his sense of color and his ability to produce tonal effects supplied the rest (*Brush and Pencil* 9 [Feb. 1902], p. 269).

Here, from the edge of a forest, the viewer looks out on the expansive landscape. The view through the center of the composition is framed by two copses of bushes and trees, their graceful trunks and spiky foliage silhouetted against the luminous sky. The foreground is clearly focused, incisively drawn, and darkly colored, a contrast to the hazy, undefined view beyond. Although ambitious in scale, the painting is not grandiose in effect—the panoramic vista does not show a natural wonder, dramatic weather, or even a recognizable locale. Instead, Blakelock represents a pure landscape at an indefinite time of day and explores the possibilities of color, texture, and pattern. The cool tonal palette, heightened by a chalky white color, seems almost opalescent, and the varied brushstrokes create a rich surface texture, enhancing the decorative effect of the picture. In *Landscape*, as in so many of his successful pictures, Blakelock transcends an observed subject to express his own personal vision.

According to a label on the reverse, the painting was purchased from the artist by HARRY W. WATROUS. This close friend and faithful supporter generously shared his studio with Blakelock and often bought and sold his works, turning over all profits to the artist.

Oil on canvas, 27 × 37⅜ in. (68.6 × 94.9 cm.).
Signed at lower left in arrowhead: R.A. Blakelock. Label on reverse: *This painting before being / relined had the following / inscription printed on back / of canvas. Sold to H.W. Watrous / No. 17 R. A. Blakelock / J. A. Rose.*

REFERENCES: *Index of Twentieth Century Artists* 4 (Dec. 1936), p. 368 // L. Goodrich, "Ralph Albert Blakelock, 1847–1919," [1946–1947], FARL, provides stylistic analysis, compares it to Morning Mists (IBM),

and says he examined it at the time of the Blakelock centenary exhibition // N. A. Geske, Sheldon Memorial Art Gallery, letter in Dept. Archives, March 20, 1974, designates it as NU-351, Category II, in Blakelock Inventory.

EXHIBITED: Art Galleries, University of California, Santa Barbara; California Palace of the Legion of Honor, San Francisco; Phoenix Art Museum; Heckscher Museum, Huntington, N.Y., 1969, *The Enigma of Ralph A. Blakelock 1847–1919*, exhib. cat. by D. Gebhard and P. Stuurman, no. 46, ill. p. 51 // Queens County Art and Cultural Center; MMA; Memorial Art Gallery of the University of Rochester, 1972–1973, *19th Century American Landscape*, exhib. cat. by M. Davis, no. 71.

EX COLL.: Harry W. Watrous, New York; Harmon W. Hendricks, New York, died 1928; his nieces: Eleanor and Emily Tobias; Alice, Fanny H., and Maud Brandon; Edith B. Mayhoff; Ethel and Helen R. Hendricks, New York, and Fanny H. Lazarus, Portland, Oregon, 1928–1929.

Gift of the nieces of Harmon W. Hendricks, 1929. 29.35.

FORMERLY ATTRIBUTED
TO BLAKELOCK

That Blakelock is the most forged American artist can be explained both by economic factors and the tragic circumstances of his life and career. The demand for his work increased dramatically after his confinement to a mental institution in 1899. Isolated from the New York art scene, unable to begin any additional large-scale paintings or comment on the authenticity of works attributed to him, Blakelock was not protected by his family, benevolent collectors, or a sympathetic commercial concern. His most faithful supporter, both during the productive decades of the 1880s and 1890s and during the period of his confinement, was HARRY W. WATROUS, who not only shared his studio with him, but also promoted his paintings among dealers and collectors. Later supporters like ELLIOTT DAINGERFIELD, DE WITT PARSHALL, and Leon Dabo (1868–1960) were not sufficiently familiar with his work to pass judgment on the enormous number of spurious pictures that appeared during the early years of the twentieth century.

Forgeries of Blakelock's work were reported as early as 1903, but the vast majority of them appeared after 1913, when his works began to fetch substantial prices at auction. The activities of forgers escalated in 1916, when Blakelock received a great deal of attention with retrospec-

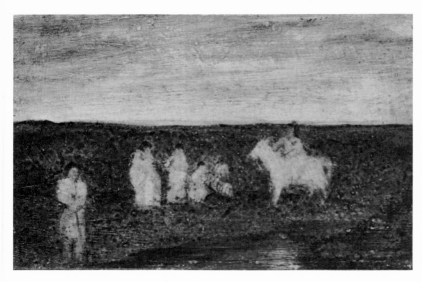

Formerly attributed
to Blakelock,
Landscape and Figures.

tive exhibitions of his work, the establishment of a fund to aid him, and the achievement of a record auction price by a living American artist—$20,000, for *Brook by Moonlight* (Toledo Museum of Art, Ohio). By this time, Blakelock fakes were already so common that Leon Dabo noted that "the market is flooded with pictures that bear the forged name of the artist" (*New York Times*, April 2, 1916, p. 8). According to DeWitt Parshall, supporters of the Blakelock Fund planned to provide "expert appraisement and assistance in selling pictures" (*Fine Arts Journal* 34 [May 1916], p. 261); unfortunately this program does not seem to have been enacted. Two years later, when a New York district attorney's investigation revealed a number of spurious Blakelocks, there were vague references to a "Blakelock Factory" located in Chicago or an unspecified Oklahoma town (*New York Times*, June 4, 1918, p. 2). At this time, the artist was invited to pass judgment on some of the works attributed to him, but this was definitely a case of too little being done too late, and the tide of forgeries, which undoubtedly came from a number of sources, remained unstemmed. In 1947, after a thorough study of Blakelock's work, Lloyd Goodrich concluded: "Today there are unquestionably several times as many false Blakelocks as genuine ones, so that his authentic style is all but lost" (Whitney Museum of American Art, *Ralph Albert Blakelock Centenary Exhibition* [1947], p. 41).

There have been recent attempts to evaluate paintings attributed to Blakelock, notably the experiments with neutron activation autoradiography conducted at Brookhaven National Laboratory between 1969 and 1977 and the ongoing study of Blakelock's work conducted by the Sheldon Memorial Art Gallery of the University of Nebraska, Lincoln, directed by Norman A. Geske. At this point, however, the artist's work remains a difficult, and perhaps insoluble, problem of connoisseurship. The Metropolitan Museum's two questionable works—*Woodland Vista* and *Landscape and Figures*—cannot be rejected with certainty. Undoubtedly inferior in quality, they are retained as a part of the collection in the hope that clearer standards for evaluating Blakelock's style and technique will be developed in the future.

Landscape and Figures

Now regarded as a painting of questionable authenticity, done in what appears to be an imitation of Blakelock's style, *Landscape and Figures* shows the artist's familiar American Indian subject matter. It was first recorded on the New York art market in 1913. Writing three years later, Frederic Fairchild Sherman noncommittally described the work as "interesting." The painting was apparently unknown to Lloyd Goodrich when he did his research on Blakelock during the 1940s. It was bequeathed to the museum in 1952 by Katherine S. Dreier (1877–1952), a painter and well-known patron of modern art. The Nebraska Blakelock Inventory included the painting in group two, paintings "whose technical and stylistic features compare favorably with Group I [documented Blakelock paintings] but which do not have a complete history of ownership" (*Art Journal* 31 [Spring 1972], pp. 305–306). This

46

positive, although in no way unreserved, evaluation was probably prompted by a number of factors that relate this painting to genuine works of mediocre quality. Superficially, it appears to have the same free brushwork and thin paint surface, with lines scratched through to the ground and touches of impasto. On close examination, the surface, however, is more uniform with a thin layer of muddy pigment covering a thick, rough underpaint that has been applied with heavy brushstrokes in a simulation of the artist's richly textured surfaces. The composition also lacks the strong design quality so evident in Blakelock's ambitious works. The figures are grouped in an undefined mass in a setting with a flat horizon and no distinct landscape features.

Oil on canvas, $4\frac{5}{8} \times 7$ in. (11.8 × 17.8 cm.).

Signed at lower left, in an arrowhead: R A Blakelock.

REFERENCES: F. F. Sherman, "Blakelock Paintings," notes, Jan. 28, 1916, in Lloyd Goodrich, Blakelock Archives, Whitney Museum of American Art, New York, microfilm N/631, Arch. Am. Art, records having seen it at Moulton and Ricketts (quoted above) // N. A. Geske, Sheldon Memorial Art Gallery, letter in Dept. Archives, March 20, 1974, designates it as NU-354, Category II, in Blakelock Inventory.

EXHIBITED: Worcester Art Museum, Mass., 1913, *A Exhibition of Thirty Paintings by the Noted Artist Ralph A. Blakelock Loaned by Moulton & Ricketts, New York* (no cat.), possibly this painting.

EX COLL.: with Moulton and Ricketts, New York, by 1913—at least 1916; Katherine S. Dreier, died 1952.

Bequest of Katherine S. Dreier, 1952.

53.45.6.

Woodland Vista

Now considered a work of questionable authenticity, *Woodland Vista* first appeared on the New York art market in 1923 and was attributed to Blakelock until 1947, when Lloyd Goodrich concluded that it was a forgery. After comparing it to documented works in the Blakelock centennial exhibition held at the Whitney Museum of American Art, Goodrich noted that the style of the Metropolitan painting was "quite different in technique and handling" from that of Blakelock's. Explaining some of the factors that had influenced his decision, Goodrich noted that the draftsmanship was too labored with "none of the crispness and the precise, sharp, angular shapes" of the authentic works. Unconvincing too was the thin paint application. John I. H. Baur and Sheldon Keck concurred in Goodrich's judgment, particularly after a scientific examination of *Woodland Vista* indicated that its peculiar appearance was not the result of extensive restoration.

In 1974, however, the painting was evaluated for the Nebraska Blakelock Inventory and assigned a group two rating. This group consists of Blakelock paintings "whose technical and stylistic features compare favorably with Group I [documented Blakelock paintings], but do not have a complete history of ownership" (*Art Journal* 31 [Spring 1972], pp. 305–306). Thus, since scholars are divided on the issue of its authenticity, the attribution of the painting cannot be wholly rejected or accepted until more conclusive criteria

Formerly attributed to Blakelock, *Woodland Vista*.

for judging Blakelock's work are developed. The weight of the evidence, however, is negative.

Oil on canvas, 18 × 24 in. (45.7 × 61 cm.).

REFERENCES: L. Goodrich, notes, [1946–1947], Blakelock Archives, Whitney Museum of American Art, New York, microfilm N/629, Arch. Am. Art, presents a detailed analysis of the painting's style and composition and compares to other works by the artist (quoted above), discusses X-rays taken of it in May 1947, recording the opinions of E. Daingerfield, A. Milch, J. I. H. Baur, and S. Keck, and reports an interview, conducted on Oct. 12, 1948, in which the authenticity of the painting was doubted; notes, May 1947, microfilm N/630, includes it in a list of forgeries mistakenly included in the artist's centenary exhibition // N. A. Geske, Sheldon Memorial Art Gallery, letter in Dept. Archives, March 20, 1974, designates it as NU-352, Category II, in Blakelock Inventory.

EXHIBITED: Whitney Museum of American Art, New York, 1947, *Ralph Albert Blakelock Centenary Exhibition* (in celebration of the centennial of the City College of New York), cat. by L. Goodrich, no. 32, as Woodland Vista, lent by Mr. Francis M. Weld, gives provenance.

EX COLL.: George C. Aronstamm, New York, until 1923; with William Macbeth, New York, 1923; Francis M. Weld, New York, 1923–1949.

Gift of Francis M. Weld, 1949.

49.116.

WILLIAM MICHAEL HARNETT

1848–1892

William Michael Harnett was the leading exponent of the American school of trompe l'œil painting that flourished in the final decades of the nineteenth century. His success in this genre influenced an entire generation of still-life painters, among them JEFFERSON D. CHALFANT, JOHN F. PETO, and JOHN HABERLE. Born in Clonakilty, county Cork, Harnett came to Philadelphia when his family immigrated there, probably around 1849. As a young man, he worked as an engraver and in 1867 and 1868 studied at the Pennsylvania Academy of the Fine Arts. A year later he moved to New York, where he supported himself by working as an engraver for jewelry firms. He attended the school of the National Academy of Design and enrolled in classes at Cooper Union in 1871. Supplementing this training, he took a few lessons with the portraitist Thomas M. Jensen (1831–1916) but found them unsatisfactory. His first oil paintings, often still lifes of fruit and vegetables, date from 1874, and in the following year, he began to exhibit at the National Academy.

Harnett returned to Philadelphia in 1876, resumed his studies at the Pennsylvania Academy, and exhibited there for the first time a year later. He developed a trompe l'œil style characterized by precisely delineated contours, convincingly simulated textures, and highlights built-up with impasto. Painted in dark rich colors, his subjects during the late 1870s were usually tabletops with mugs and pipes or books and writing accoutrements. By 1878, the year of his earliest known mention in the press, Harnett was painting memento mori and bric-a-brac subjects, and the next year, perhaps under the influence of Peto, he did his first rack picture, *The Artist's Letter Rack* (q.v.).

Having saved some money during his residence in Philadelphia, Harnett went to Europe early in 1880 to continue his studies. That spring he painted in London, and then, at the invitation of a man he had met in Philadelphia, he went to Frankfurt to execute some com-

missions. Early in 1881 he arrived in Munich, where he painted for the next three and a half or four years. Although his style was well developed before his departure for Europe, some changes are evident in his European pictures. In general, the still lifes are more crowded, usually with elegant decorative objects. The objects depicted, which previously tended to be life size, are reduced, and at times almost miniaturistic. Settings are more elaborate with backgrounds of drapery or wood paneling, and often objects lie on carved wooden or marble tops or on expensive cloths or oriental rugs. It was probably also at this time that he began painting large-scale game pieces, most notably *After the Hunt*, 1883 (Gallery of Fine Arts, Columbus, Ohio), a still life of game and hunting equipment that he painted in four versions, exhibiting the final one, done in Paris in 1885 (California Palace of the Legion of Honor, San Francisco) at the Salon that year.

Following his return to America in 1886, Harnett settled in New York, which remained the center of his artistic activities for the rest of his career. He was hospitalized in the winter of 1888–1889 and made a trip to Europe for treatments that summer. Although illness reduced his output during the final six years of his life, his works achieved great popularity and commanded substantial prices. Some of the motifs that had appeared in his early work recur in the late still lifes, for example, the mug and pipe, the card rack, and bric-a-brac arrangements. He did turn, however, to some new, more ambitious subjects, often arrangements of a few objects on a vertical support, for example a violin on a door. In these paintings, Harnett displayed a virtuoso command of the trompe l'œil technique, showing convincingly modeled three-dimensional objects.

The artist's career was rather brief, spanning less than two decades. He died in New York in October 1892 and was buried in Philadelphia, where two months later he was honored with a memorial exhibition held at Earle's Galleries. In February of 1893 his collection of paintings, drawings, and models was sold at Thomas Birch's, Philadelphia. Harnett's still-life paintings were "rediscovered" in 1935 when his *The Faithful Colt*, 1890 (Wadsworth Atheneum, Hartford) appeared on the New York art market. Edith Gregor Halpert of the Downtown Gallery promoted his work with a series of exhibitions beginning in 1939. The total development of his style and subject matter was not clear, however, until Alfred Frankenstein isolated the artist's work from a group of forged and misattributed paintings, many of which proved to be original Petos.

BIBLIOGRAPHY: Thomas Birch's Sons, Auctioneers, Philadelphia, *The Wm. Michael Harnett Collection: His Own Reserved Paintings, Models and Studio Furnishings*, sale cat. (Feb. 23–24, 1893), with a biographical statement by E. Taylor Snow. Lists drawings and paintings to be sold, providing descriptive comment; lists and illustrates some objects used by the artist as models // E. Taylor Snow, with an additional statement by the editor, "William Michael Harnett, A Philadelphia Catholic Artist," *American Catholic Historical Researches* 10 (April 1893), pp. 74–76 // Alfred Frankenstein, "Harnett True and False," *Art Bulletin* 31 (March 1949), pp. 38–56. Analyzes the artist's style and that of works by Peto with forged Harnett signatures // Alfred Frankenstein, *After the Hunt: William Harnett and Other Still Life Painters, 1870–1900* (Berkeley and Los Angeles, 1953; rev. ed. 1969). Most complete treatment of the artist and his influence; includes a chronological catalogue of the artist's work and a catalogue of forged works // William H. Gerdts and Russell Burke, *American Still-life Painting* (New York, 1971), pp. 133–143; pp. 248–250, discusses Harnett and his influence, and provides additional bibliography.

William Michael Harnett

The Banker's Table

In a departure from the fruit and vegetable still lifes that Harnett painted at the outset of his career, this tabletop subject of 1877 represents man-made objects. The artist has selected leather-bound volumes with gilt-ornamented spines, a cylindrical ink bottle stained with drippings, and a much-used quill—items showing " the mellowing effect of age " that he once praised in an undated interview (quoted in A. Frankenstein, *After the Hunt* [1953; rev. ed., 1969], p. 55). Arranged against an austere and rather light backdrop, most of these objects are placed close to the picture plane. They are illuminated by a generalized light, their shadows and reflections painted with subtle, translucent glazes, and their highlights indicated by areas of heavy impasto, most evident at the edges of the envelope and the coins. These coins, some enclosed in a torn paper wrapper, offer a contrast to the worn edges of the books and folded currency, giving the artist an opportunity to depict a variety of surfaces and textures.

The inclusion of coins and currency probably determined the painting's title, but there is nothing in the work or its history to indicate that it was commissioned by or for a specific banker. The juxtaposition of groups of objects on opposite sides of the composition, however, suggests a deliberate contrast between money, with its mercantile associations, and the books and writing utensils, representing solitary, intellectual pursuits.

Oil on canvas, 8 × 12 in. (20.3 × 30.5 cm.).

Signed and dated at lower right: wmh (monogram) arnett / 1877.

References: A. Frankenstein, *After the Hunt* (1953; rev. ed. 1969), p. 164, includes it as no. 18, The Banker's Table, in a catalogue of the artist's work, describes it in detail and dates it 1877 // A. T. Gardner, *MMA Bull.* 22 (Jan. 1964), p. 158, discusses it; ill. p. 159.

Exhibited: Marlborough-Gerson Gallery, New York, 1967, *The New York Painter* (a benefit exhibition for the New York University Art Collection), ill. p. 34; p. 87, lists it.

Ex coll.: probably with Downtown Gallery, New York; with Edwin Hewitt Gallery, New York, 1955.

Purchase, Elihu Root, Jr., Gift, 1956.

56.21.

The Artist's Letter Rack

Dated 1879, this is Harnett's earliest known rack picture. It shows a simple grid of pink tape with a colorful selection of envelopes, cards, and other papers. The grid is painted over a background of simulated natural wood, an unusual instance where Harnett's background shows wood graining. Composed of three separate boards, joined in the upper left, this backdrop limits spatial recession and heightens the trompe l'œil effect of the flat objects. Chalk marks and pencil inscriptions, an illegible newspaper clipping, and a worn piece of currency are depicted, as well as a fragmentary label, torn to reveal how the wood has discolored. In the rack, the artist represents a number of envelopes and a postcard, all with the names and addresses partially obscured, as well as several pieces of paper with intriguing inscriptions, for example: "To the lad . . . of the house."

Harnett is believed to have borrowed the card rack subject from john f. peto, whose *Office Board for Smith Bros. Coal Co.*, 1879 (Addison Gallery of American Art, Phillips Academy, Andover, Mass.), dated in June of that year, uses some of the same motifs, for example, the torn label and

Harnett, *The Banker's Table.*

Harnett, *The Artist's Letter Rack.*

looped string. *The Artist's Letter Rack* includes a card postmarked August 26 (no year) and this has been used in an attempt to fix the date of completion a couple of months after Peto's effort in this genre. This cannot be used to fix the precise date of the painting, however, as the postcard was first issued in 1875 and could have been sent in any year between 1875 and 1879. Though it is unclear which artist first used the card rack conception, Peto was certainly influenced by Harnett's treatment of the subject; he owned a photographic negative showing the painting and adopted its simpler grids and more austere arrangement in his later works.

Like his only other known work of this type, *Mr. Hulings' Rack Picture*, 1888 (coll. Mr. and Mrs. Jacob M. Kaplan, New York), the Metropolitan's painting may represent objects that refer to the person who commissioned it. In 1953 Alfred Frankenstein presented an interesting case for its having been commissioned by Israel Reifsnyder, a Philadelphia wooldealer, whose nickname might well have been "Snyde," the inscription that appears to the lower left of the rack. He interpreted "C. C. Peir . . . & Sons" as a reference to Reifsnyder's partner Caleb D. Peirce or his son Clifford C. Peirce. Much of this corroborative evidence, however, was based on the painting's having been formerly owned by Howard Reifsnyder, Israel's son. Although the painting was in Howard Reifsnyder's estate sale in 1929, neither he nor his father appears to have owned this picture in November 1892, when it was included in the memorial exhibition of Harnett's work at Earle's Galleries. The catalogue for this show unfortunately lists lenders separately from the works they contributed. Among the lenders, however, is a name that may be relevant to *The Artist's Letter Rack*—C. W. Pierson, probably Clayton W. Peirson, whose name is often misspelled in Philadelphia city directories as Pierson.

A re-examination of the painting with this in mind, suggests another, and perhaps more logical, explanation of its contents. The blue envelope depicted in the upper right corner of the rack shows the only decipherable surname in the composition, and it is addressed to C. C. Peirson & Sons, a firm that in 1879 was located at 3908 Story Street, Philadelphia, the address clearly visible on the envelope. Here the final three letters of the Peirson name are obscured by the tape, but, on an envelope on the opposite side of the rack, the artist, cleverly, shows only these three letters.

Detail from Harnett, *The Artist's Letter Rack*.

It seems likely that the picture was commissioned by a member of the Peirson family or their firm, which in 1879 listed its specialty as "hides." The business was founded by Christopher C. Peirson, who came to Philadelphia from Baltimore in 1835. Other family members, B. Frank, George F. and William T. Peirson, later joined the business, and by 1893, the year of the elder Peirson's death, the firm was described as "the eldest in the trade of that city" (*Shoe and Leather Reporter* 55 [May 4, 1893], p. 1120). The Peirsons, at least during the 1880s, resided side by side at 3907, 3909, and 3911 Haverford Avenue, where Clayton W. Peirson lived next door to Christopher C. Peirson.

Even if the painting was commissioned by a member of the Peirson family or their firm, many of the inscriptions included remain unexplained. Assuming that the individuals whose names are included were business associates of Peirson's, it is possible to speculate that the painting is a statement about a whole community of Philadelphia businessmen, all active in the production and sale of wool and leather. "Snyde" could indeed refer to Reifsnyder or to a member of the firm Snyder, Land & Company, wool scourers and burr extractors. The latter explanation might also account for the cryptic inscription "Peter Lan[d?] Jr. Esq." In this context, the frayed loop at the top of the picture is most likely a bit of wool yarn, rather than string as it is usually described. Whatever the meaning of the many inscriptions, *The Artist's Letter Rack* remains the most ambitious of Harnett's early trompe l'œil paintings.

Oil on canvas, 30 × 25 in. (76.2 × 63.5 cm.).

Signed and dated at upper left: WMH (monogram) ARNETT / 1879.

REFERENCES: A. V. Frankenstein, "An account of his visit to the residence of Mrs. Laura Harmstad of Philadelphia, daughter of E. Taylor Snow," April 1948, Harnett File, Whitney Museum of American Art, New York, microfilm N/664, mentions a photograph of the then unlocated painting, inscribed on reverse "25 × 30"; *San Francisco Chronicle*, August 29, 1948, pp. 9–11, notes that many of the artist's works are only known through old photographs and says the glass negative of the photograph for this painting, which is illustrated, was found in the residence of Peto's family in Island Heights, New Jersey; *Art News* 47 (Sept. 1948), p. 16, discusses Harnett's use of the card rack; ill. p. 17, shows photograph of painting, notes it is unlocated // California Palace of the Legion of Honor, San Francisco, *Illusionism & Trompe l'œil*, exhib. cat. by A. Frankenstein (1949), pp. 29, 65 // A. Frankenstein, *Art Bulletin* 31 (March 1949), p. 50, mentions Peto negative and Harmstad photograph of the unlocated painting and notes Peto's dependence on it for his use of the rack motif // [E. G. Halpert], notes, [1949], Downtown Gallery Papers, ND/27, Arch. Am. Art, refers to it as The Letter Rack in a private collection, Hollywood, California // L. Goodrich to A. Frankenstein, Oct. 12, 1949, copy and typed statements, Harnett File, Whitney Museum of American Art, New York, microfilm N/664, Arch. Am. Art, provides stylistic analysis of the painting and says radiograph indicates no changes // S. Keck to Frankenstein, Oct. 13, 1949, copy, ibid., reports that on October 5, Edith Halpert, Lloyd Goodrich, John I. H. Baur, and Albert and Elizabeth Gardner met to evaluate the painting // E. Halpert to Frankenstein, Oct. 19, 1949, and Frankenstein to Halpert, Oct. 21, 1949, copies, ibid., discuss the painting and its provenance // Halpert to Goodrich, Nov. 26, 1949, ibid., asks him to authenticate it for the owners // Frankenstein to Goodrich, Dec. 14, 1949, ibid., notes it is in the Hornblow collection and discusses // Goodrich to Halpert, Dec. 15, 1949, copy, ibid., authenticates it // Goodrich to A. Hornblow, Jr., Jan. 16, 1950, copy, ibid., says he has examined the painting at Downtown Gallery and that the early photograph, showing the Harnett signature and date, is "excellent evidence of the authenticity of the painting" // Frankenstein to H. Reifsnyder, Jan. 19, 1950, copy, ibid., provides a detailed discussion of the envelopes and printed items that appear in the painting and speculates that it was painted for Israel Reifsnyder // Frankenstein, *After the Hunt* (1953; rev. ed. 1969), p. 43; pl. 46; pp. 51–53, dates it after August 26, 1879, notes its "exceedingly simple" grid, says it is the only painting in which the artist shows the natural grain of the wood, discusses the words and inscriptions included, noting that the envelope inscribed "C. C. Pier . . . & Sons" is in the artist's hand but that the others are in four different hands, mentions three iconographic elements that appear in other Harnett paintings of the period, comparing them to those used in Peto's work and gives the painting's provenance; pp. 52–53, discusses the relationship between Reifsnyder and other individuals whose names appear in the painting; p. 90, notes that the newspaper clipping is similar to one in The Old Cupboard Door, 1889 (Graves Art Gallery, Sheffield, England); p. 96, says that references in it "remain completely unexplained"; p. 108, notes its possible influence on Peto's use of the simpler grid; p. 169, includes it as no. 45, The Artist's Card Rack, in a catalogue of the artist's works // *Arts* 34 (March 1960), color ill. p. 27 // *Museum News* 43 (March 1965), ill. p. 10, notes it is for sale // R. B. Hale, *MMA Bull.* 25 (Oct. 1966), pp. 65–67, discusses its purchase // A. Frankenstein, *Auction* 2 (Feb. 1969), ill. p. 6; p. 9, compares it to the Hulings' Rack Picture // M. D. Schwartz, *Arts* 44 (April 1970), pp. 32–33; color ill. p. 34 // W. H. Gerdts and R. Burke, *American Still-life Painting* (1971), pp. 135, 142, describe it as "light, brightly colored" and "far more precisionistic" than rack paintings by Peto which influenced Harnett // L. Hornblow, orally, May 1978, provided information on provenance; July 1978, supplied copies of letters discussing authenticity and provenance.

EXHIBITED: Earle's Galleries, Philadelphia, 1892, *Paintings of the Late W. M. Harnett*, intro. by E. T. Snow, no. 25, as The Artist's Letter Rack, cover design indicates composition of the painting // American Federation of Arts, traveling exhibition, 1953, *Harnett and His School*, unnumbered checklist by A. Frankenstein, lists as The Artist's Card Rack, lent by Mrs. Arthur Hornblow, Beverly Hills, and says it is the artist's only known rack picture, which was sold to the wool merchant Israel Reifsnyder // Milwaukee Art Center, 1960, *American Painting, 1760–1960* (Fleischman Collection), p. 55; ill. p. 56 // University of Arizona Art Gallery, Tucson, 1964, *1765–1963, American Painting* (Fleischman Collection), no. 36, color ill. cover and title page // La Jolla Museum of Art and Santa Barbara Museum of Art, 1965, *The Reminiscent Object*, exhib. cat. by A. Frankenstein, no. 10, as Rack Painting (The Artist's Card Rack), lent by Hirschl and Adler Galleries // MMA, 1970, *19th Century America*, exhib. cat. by J. K. Howat and N. Spassky, color ill. no. 170, discusses // National Gallery of Art, Washington, D.C.; City Art Museum, St. Louis; Seattle Art Museum, 1970–1971, *Great American Paintings from the Boston and Metropolitan Museums*, exhib. cat. by T. N. Maytham, no. 62, discusses // Hirschl and Adler Galleries, New York, 1973, *Retrospective of a Gallery* (for the benefit of Youth Consultation Service), ill. no. 48.

EX COLL.: probably Clayton W. Peirson, Philadelphia, by 1892; Howard Reifsnyder, Philadelphia (sale, American Art Association, New York, April 23, 1929, no. 611, as The Letter Rack, $240); Mr. Leon Schinasi, 1929; his daughter, Mrs. Arthur Hornblow (née Leonora Schinasi), Beverly Hills and New York, until 1958; with Robert Carlen, Philadelphia, and Hirschl and Adler Galleries, New York, 1958; Mr. and Mrs. Lawrence A. Fleischman, Detroit, 1958–1965; with Hirschl and Adler Galleries, New York, 1965–1966.

Morris K. Jesup Fund, 1966.
66.13.

Harnett, *Still Life*.

Still Life

Reportedly completed on March 27, 1888, this still life shows a simple tabletop supporting an arrangement of objects less elegant than those featured in Harnett's European still lifes. The austere setting allows him to focus on the textures and surfaces of a well-lit frieze of objects: worn books shown with gilt spines and fanned pages, a candlestick, a piccolo, and some stained, torn sheet music hanging off the table edge. The Dutch jar, one of his most familiar models, which was featured in his 1893 estate sale, is among the more decorative items in the picture. These objets d'art would have enhanced the picture's appeal to Harnett's patrons, who, as William H. Gerdts has pointed out, were avidly collecting such bric-a-brac.

Harnett painted in a highly realistic style understood and appreciated by a wealthy untutored class, but one little-mentioned source of his appeal was that he painted the very objects that such people were busy collecting. Particularly after he went abroad in 1880, bric-a-brac that he himself appears to have collected abounds in his pictures, in place of the beer steins and pipes in his earlier works. Although these . . . may not have commemorated the collecting pursuits of anyone but the artist, they represent the *kinds* of things being collected by others and mark a distinct change in the

character of his paintings. The decorative arts of earlier times, rare old books, sculptured likenesses of writers and philosophers of the past—these ornamented the homes of those to whom Harnett hoped to sell (*Antiques* 100 [Nov. 1971], p. 74).

Harnett often used the same objects in a number of subtlely varied compositions, exploring formal differences in arrangement, setting, and lighting. The selection of things depicted in *Still Life* is quite similar to that in several other of the artist's works of the same year. It is perhaps closest to *My Gems*, 1888 (National Gallery of Art, Washington, D.C.), believed to be the second work done by Harnett in 1888. In both pictures the objects are placed on what appears to be an identical tablecloth in front of a dark background that gives the appearance of depth behind them, but in *Still Life* the artist alters the axis of the composition making the Dutch jar the only strong vertical element in the picture.

Oil on canvas, 14 × 17⅛ in. (35.6 × 43.5 cm.).

Signed and dated at lower left: WMH (monogram) ARNETT. / 1888. Inscribed on reverse: Painted to order / by / Wᵐ M. Harnett, / Studio 28 E 14ᵗʰ St., / New York./ Finished—March 27, 1888.

REFERENCES: A. V. Frankenstein, "Provable Harnetts," April 1948, Harnett File, Whitney Museum of American Art, New York, microfilm N/664, Arch. Am.

Art, lists it under paintings involving models from Harnett's estate sale and gives Clark as owner; *After the Hunt* (1953; rev. ed. 1969), pp. 68–69, discusses Harnett's use of the Dutch jar as a model; p. 84, discusses the painting among other 1888 tabletop still lifes and comments on its relative austerity; p. 179, includes it as no. 110, Still Life, in a catalogue of the artist's works, describes it in detail and relates to My Gems // C. J. Oja, "Musical Subjects in the Paintings of William Michael Harnett," M.A. thesis, University of Iowa, 1976, p. 41, says the rolled music score depicted is for *Rigoletto* and was also used in My Gems; p. 83, says sheet music shown is probably "Hélas quelle douleur"; *Musical Quarterly* 63 (Oct. 1977), p. 510, says the piccolo is the same one depicted in My Gems; p. 516, discusses opera score; p. 523, includes the painting as no. 30 in a list of Harnett's musical subjects // R. J. H. Salfeld, M. Knoedler and Co., letter in Dept. Archives, Jan. 30, 1978, provides provenance.

EXHIBITED: National Gallery of Art, Washington, D.C.; Whitney Museum of American Art, New York; University Art Museum, Berkeley, and California Palace of the Legion of Honor, San Francisco; Detroit Institute of Arts, 1970, *The Reality of Appearance*, exhib. cat. by A. Frankenstein, no. 53, as Still Life; p. 90, discusses models used in it; ill. p. 91 // American Federation of Arts, traveling exhibition, 1975–1976, *The Heritage of American Art*, exhib. cat. by M. Davis, no. 70, p. 158, discusses; ill. p. 159 // William Rockhill Nelson Gallery of Art, Mary Atkins Museum of Fine Arts, Kansas City, Mo., 1977–1978, *Kaleidoscope of American Painting*, no. 84, as Still Life; ill. p. 70, discusses.

EX COLL.: probably with Frost and Reed, London, 1940; with M. Knoedler and Co., 1940–1941; Stephen C. Clark, New York, 1941–1960; his wife, Susan Vanderpoel Clark, New York, 1960–1967.

Bequest of Susan Vanderpoel Clark, 1967.

67.155.1.

New York Daily News

Working on a very small scale, Harnett painted this still life which depicts a gray beer stein, a folded issue of the *New York Daily News* for April 3, 1888, a meerschaum pipe, two small round biscuits, and a variety of crumbs, matches, ashes, and tobacco flakes. The rich colors, often built up with impasto to achieve more convincing trompe l'œil effects, are enhanced by the warm tone of the wood support beneath them. Although dated 1888, the subject recalls the mug and pipe still lifes the artist painted during the late 1870s. An important difference in the composition of this painting, however, is that the major vertical element is located on the left rather than on the right as is almost invariably the case in Harnett's early treatments of the subject.

In an interview published in the *New York Daily News*, he described his early dependence on these objects: "I could not afford to hire models as the other students did, and I was forced to paint my first picture from still life models. These models were a pipe and a German beer mug." (Undated clipping, quoted in A. Frankenstein, *After the Hunt* [1953; rev. ed. 1969], p. 29.) The artist's estate sale, which lists a "Stone Beer Mug, 'Old Friend,'" and an extensive collection of pipes, attests to his continued interest in these typical masculine possessions (Thomas Birch's Sons, Philadelphia, *The Wm. Michael Harnett Collection*, sale cat. [1893], pp. 13, 16–17).

New York Daily News is closely related to two other 1888 mug and pipe paintings now unlocated. All three are shown in a photograph

Harnett, *New York Daily News*.

(formerly coll. Catherine Barry), on the back of which is a note stating that this painting and one of the others was done for "John Hedges/Phila." The museum's painting is inscribed "7/88" on the reverse, a possible indication of when it was done that year, apparently the only period when the artist attempted to record the sequence of his works. *Still Life—Violin and Music* (q.v.), for example, is similarly inscribed, being "10/88."

Oil on wood, 5½ × 7½ in. (14 × 19.1 cm.).

Signed and dated at lower right: WMH (monogram) ARNETT / 1888. Inscribed on reverse: 7/88.

REFERENCES: [E. G. Halpert], notes, [1940s], Downtown Gallery Papers, ND/27, Arch. Am. Art, gives provenance // A. V. Frankenstein, "Provable Harnetts," April 1948, Harnett File, Whitney Museum of American Art, New York, microfilm N/664, says its authenticity is provable "through external evidence," gives McKim as owner, and notes photograph of it in the Blemly Scrapbook; *After the Hunt* (1953; rev. ed. 1969), p. 42; pp. 84–85, notes that this is the only located example of three small mug and pipe paintings done in 1888, which appear together in an undated photograph (formerly coll. Catherine Barry), indicating that it and one of the others were owned by John Hedges of Philadelphia, and notes that, in all three of these pictures, the main vertical element is on the left side, and from 1877 to 1880, it was "almost invariably" on the right; p. 179, includes it as no. 113, New York News, in a catalogue of the artist's work // W. L. McKim, letter in Dept. Archives, Oct. 14, 1973, says it was not lent for exhibition while he owned it, encloses information from his personal catalogue that describes it, says he purchased it from Knoedler on November 13, 1940, and that "Mrs. Edith Halpert owned an old snapshot of Harnett's studio, which showed this painting in it" // R. J. H. Salfeld, M. Knoedler and Co., letter in Dept. Archives, Jan. 30, 1978, provides information on provenance.

EX COLL.: John Hedges, Philadelphia, by 1892; probably with Frost and Reed, London, 1940; with M. Knoedler and Co., New York, 1940; Mr. and Mrs. William L. McKim, New York and Palm Beach, 1940–1973.

Gift of Mr. and Mrs. William L. McKim, 1973.
1973.166.1.

Still Life—Violin and Music

Dated 1888 and probably painted in New York, this still life recalls the selection and arrangement of objects in Harnett's *The Old Violin*, 1886 (coll. William Williams, Cincinnati). As in that acclaimed picture, attention here is focused on a few objects arranged in a vertical format. The painting is distinguished, however, by its light background and sophisticated treatment of the shadows cast by the partially opened door.

Music was a recurring theme in Harnett's work. He is said to have played the flute, and the estate sale of his studio effects included many of the instruments and sheet music that had served as models for his paintings. In this work, one of the best of Harnett's musical subjects, he presents a convincing depiction of a standard nineteenth-century violin. Great care has been taken with such details as the rosin dust beneath the strings, the plain bow with an inlaid frog, and an ivory and granadilla wood piccolo. Both the bow and the piccolo correspond to items included in his estate sale.

Although concerned with the differentiation of textures, Harnett does not demand complete veracity in the depiction of objects. "In painting from still life I do not closely imitate nature. Many points I leave out and many I add. Some models are only suggestions" (quoted in Frankenstein, [1953; rev. ed. 1969], p. 55). Here, for example, he has only approximated the proper notation on the sheet music.

It is not known what title the artist originally gave the painting, but when it appeared on the art market in 1941, it was called simply *Still Life—Violin and Music*. Perhaps to distinguish it from similar paintings of the subject, it was soon dubbed *Music and Good Luck*, a reference to the horseshoe and sheet music. Although a horseshoe, in general, is taken as a sign of good luck, hung upside down as it is here, it can indicate bad luck, with good luck pouring out of its open end. Also the sheet music the artist chose to depict, "'Saint Kevin' or 'By That Lake Whose Gloomy Shore,'" is a melancholy ballad from Thomas Moore's *Irish Melodies* (1807), and one which would hardly be associated with good luck. As in many of his other works, Harnett seems to "endeavour to make the composition tell a story" (quoted in Frankenstein, [1953; rev. ed. 1969], p. 55). If the painting's early history ever comes to light, details such as the DM or MD monogram on the matchbox and the all-seeing eye on the padlock may provide clues to the actual meaning and title of the painting. Meanwhile the museum prefers to use the simpler descriptive title.

The inscription on the reverse of the painting, "10/88," is apparently an indication of when Harnett completed his works in 1888. A similar notation appears on the reverse of *New York Daily News* (q.v.).

Oil on canvas, 40 × 30 in. (101.6 × 76.2 cm.).
Signed on the calling card at lower right: *W. M.*

Harnett, *Still Life — Violin and Music.*

Harnett. Dated at lower right: 1888. Inscribed on the reverse before lining: 10/88.

REFERENCES: [E. G. Halpert], notes, [1940s], Downtown Gallery Papers, ND/27, Arch. Am. Art, gives exhibitions and provenance, listing Jennings as owner // W. Born, *Magazine of Art* 39 (Oct. 1946), p. 253; *Still-Life Painting in America* (1947), p. 33 // A. V. Frankenstein, "Provable Harnetts," April 1948, Harnett File, Whitney Museum of American Art, New York, microfilm N/664, Arch. Am. Art, includes it in a list of paintings that contain examples of Harnett's handwriting; *After the Hunt* (1953; rev. ed. 1969), p. xi, mentions a pastiche that shows the same piece of music; p. xiv, corrects first edition in which hasp was called a shuttle; p. 19, note 13, discusses signature; p. 85, discusses treatment of shadows, says the realistic rendering is "flawless," and that the light color of the door is exceptional in the artist's work; p. 86, discusses painting in reference to the artist's practice of numbering his paintings in 1888; p. 92, pl. 79; p. 179, includes it as no. 115, Music and Good Luck, in a catalogue of the artist's work // R. B. Hale, *MMA Bull.* 22 (Oct. 1963), ill. p. 58, notes museum's acquisition of the painting // *Art Quarterly* 26, no. 4 (1963), ill. p. 492 // A. T. Gardner, *MMA Bull.* 22 (Jan. 1964), color ill. p. 157; pp. 157–165, discusses it; ill. p. 160, shows detail of the hasp, padlock, and signature // S. P. Feld, *Antiques* 87 (April 1965), ill. p. 443, says it dates from the period of the artist's "greatest success" // L. C. Basler, Jr., Samuel T. Freeman and Company, Philadelphia, letter in Dept. Archives, Dec. 7, 1965, says that it was consigned to auction by Mrs. P. N. Mathieu of Philadelphia and purchased by Edith Gregor Halpert of the Downtown Gallery // E. Hewitt, letter in Dept. Archives, Feb. 1, 1966, discusses provenance // W. H. Gerdts and R. Burke, *American Still-life Painting* (1971), ill. p. 141; p. 143, say it is "quite complicated

but still monumental in imagery" // L. Libin and S. Farrell, Musical Instruments, MMA, orally, Oct. 6, 1974, provided information on the instruments and sheet music // E. Selch, orally, Oct. 11, 1974, provided information on the instrument and sheet music // C. J. Oja, "Musical Subjects in the Paintings of William Michael Harnett," M.A. thesis, University of Iowa, 1976, p. 22; p. 28, discusses piccolo depicted in the painting; pp. 43, 84, gives publisher of the sheet music depicted as J. J. Daly; *Musical Quarterly* 63 (Oct. 1977), p. 510, notes the artist's use of a nineteenth-century piccolo with an ivory mouthpiece; p. 518, discusses the sheet music; p. 523, includes the painting as no. 31, Music and Good Luck, in a list of Harnett's musical subjects.

EXHIBITED: Museum of Modern Art, New York, 1943, *American Realists and Magic Realists*, no. 8, lent by Mrs. Edith G. Halpert // Downtown Gallery, New York, 1948, *Harnett Centennial Exhibition*, no. 14, lent by Oliver B. Jennings // MMA, 1965, *Three Centuries of American Painting* (checklist arranged alphabetically) // National Gallery of Art, Washington, D.C.; University Art Museum, Berkeley, and California Palace of the Legion of Honor, San Francisco; Detroit Institute of Arts, 1970, *The Reality of Appearance*, exhib. cat. by A. Frankenstein, no. 52, discusses it in terms of Harnett's treatment of the violin theme. (Included as Music and Good Luck in all of the above).

Ex COLL.: Mrs. P. N. Mathieu (sale, Samuel T. Freeman and Co., Philadelphia, Nov. 19, 1941, no. 21, as Still Life—Violin and Music); with Downtown Gallery, New York, 1941–1943; Oliver B. Jennings, New York, 1943–1963; with James Graham and Sons, New York, 1963.

Catharine Lorillard Wolfe Fund, 1963.
63.85.

CHARLES NOËL FLAGG

1848–1916

A distant descendant of the painter WASHINGTON ALLSTON, Flagg was born in Brooklyn where his father, Jared Bradley Flagg (1820–1899), was a clergyman. The Flaggs were an artistic family. Charles's uncles George Whiting Flagg (1816–1897) and Henry Collins Flagg (1811–1862) were painters, and his father devoted himself to portrait painting after 1863. In that year, the family moved to New Haven, formerly their summer residence. There Charles attended the Hopkins Grammar School, but most of his education took place at home in his father's library and studio, where he began to paint at an early age. In 1868, he established his own

studio in Hartford, and by 1872 he was exhibiting his work at the National Academy of Design in New York.

Flagg worked diligently to raise funds to study in Europe, and in 1872 he accompanied his half-brother Montague Flagg (1842–1915) and the painter Robert B. Brandegee (1849–1922) to Paris. All three studied in the atelier of Jacquesson de la Chevreuse, a pupil of Ingres, who conducted a small class noted for its instructor's constant attention to his pupils. Flagg's fellow American students in Paris at that time included DWIGHT W. TRYON, William Bailey Faxon (1849–1941), and Samuel Isham (1855–1914). After two years Flagg returned home and married Ellen Fannie Earle. He went abroad again in 1877 and stayed for five years. On his return, he settled in Eastchester, New York, and during the winter months commuted to New York, where he shared a studio with Montague and taught drawing.

In the summer and fall of 1885, Flagg painted portraits in Minneapolis and St. Paul, and in October a comprehensive exhibition of his work was held at the Wales Gallery. In 1887, he returned to Hartford, where the following year he offered free instruction to a group of young men. This inaugurated the Flagg School for Men (later the Connecticut League of Art Students), one of the earliest cooperative art schools in America. Classes there were attended not only by art students but by draftsmen anxious to improve their positions and even local businessmen. "The course of instruction was from the beginning directed by a desire to enable each member to earn something through the skill he might be able to acquire in his studies," Flagg noted. "From the first to last correct construction is insisted upon, and is taught by a long and severe course in outline drawing. . . . There is no studio sketch class or any other fanciful adjunct. . . . The motto of the school is 'Le dessin est la probité de l'art'" (*Atlantic Monthly* 86 [Sept. 1900], p. 397). In addition to his role as a teacher, Flagg was also active in Connecticut art societies. He was one of the founders and first secretary of the Society of Hartford Artists, formed in 1892, and he helped organize its first annual exhibition. In 1904, he was chairman of the selection committee for Connecticut artists at the Louisiana Purchase Exposition and was elected president of the newly formed Municipal Art Society of Hartford. He also served on the Connecticut State Capitol Commission on Sculpture and in 1910 became president of the Connecticut Academy of Fine Arts.

Competent but undistinguished, Flagg specialized in academic portraits, often of Connecticut sitters. Elected an associate member of the National Academy of Design in 1908, he gained recognition when his portrait of the sculptor Paul Wayland Bartlett, 1908 (NAD) won the academy's Thomas R. Proctor Prize for portraiture. He continued to paint until 1916, when at the age of sixty-eight he died from heart failure, shortly after the deaths of his friends HENRY WARD RANGER and WILLIAM GEDNEY BUNCE.

BIBLIOGRAPHY: Charles Noël Flagg, "Art Education for Men," *Atlantic Monthly* 86 (Sept. 1900), pp. 393–399, presents the artist's ideas on and methods of teaching art // Helen D. Perkins, "Charles Noel Flagg, A.N.A. 1848–1916," *Connecticut Historical Society Bulletin* 40 (Oct. 1975), pp. 97–153, prepared to accompany an exhibition of the artist's works, includes a biography, bibliography, and annotated catalogue.

Flagg, *Mark Twain.*

Mark Twain

The portrait depicts the popular American novelist and humorist Samuel Langhorne Clemens (1835–1910), better known by his pseudonym Mark Twain. Painted in Hartford, Connecticut, where Clemens had settled in 1871, the portrait was done in the autumn or winter of 1890, when the subject was fifty-five years old. His biographer Albert Bigelow Paine, who helped the museum acquire the portrait, wrote in 1912, describing Clemens's sittings with Flagg, then one of Hartford's leading artists:

Clemens rather enjoyed portrait-sittings. He could talk and smoke, and he could incidentally acquire information. He liked to discuss any man's profession with him, and in his talks with Flagg he made a sincere effort to get that insight which would enable him to appreciate the old masters. Flagg found him a tractable sitter, and a most interesting one. Once he paid him a compliment, then apologized for having said the obvious thing.

"Never mind the apology," said Clemens. "The compliment that helps us on our way is not the one that is shut up in the mind, but the one that is spoken out."

When Flagg's portrait was about completed, Mrs. Clemens . . . came to the studio to look at it. Mrs.

Clemens complained only that the necktie was crooked.

"But it's always crooked," said Flagg, "and I have a great fancy for the line it makes."

She straightened it on Clemens himself, but it immediately became crooked again. Clemens said:

"If you were to make that necktie straight people would say, 'Good portrait, but there is something the matter with it. I don't know where it is.'"

The tie was left unchanged.

The portrait was painted during a difficult period in the subject's life. In October his mother had died and in November Mrs. Clemens's mother also died. His financial affairs were reaching such a point that by June he would be forced to close Nook Farm and take up lecturing abroad to meet his debts. As it turned out, Mrs. Clemens was unable to pay Flagg for the portrait, and it remained in the artist's possession until his death in 1916.

In 1908 Flagg considered giving the portrait to the Metropolitan Museum, and he began to re-work it. On July 8 of that year he wrote to Paine:

"I think that I have made a great improvement in the 'M.T.' portrait. His left hand always bothered me because it looked to be in the air, resting on nothing as in the photograph which I will enclose. I have made the arm of the chair very much lighter so that the hand is no longer 'cue one.' This and lightening other near parts of the chair has helped the composition a lot. When a thing is honestly based on nature it is sometimes possible to improve it if you get to know a little more" (quoted in *Twainian*, 1972).

Oil on canvas, 40¼ × 32⅜ in. (102.2 × 82.2 cm.).

Signed, dated, and inscribed at lower left: Charles Noël Flagg / 1890. / Copyright 1908 / by C. N. Flagg.

REFERENCES: *New York Times*, April 6, 1891, p. 4, mentions it in a review of NAD exhibition // *McClure's Magazine* 8 (March 1897), ill. p. 382, says that it is reproduced for the first time, notes it "hangs in Mr. Clemens's house at Hartford," and was painted for Mrs. Clemens in 1891, when sitter was fifty-five // A. B. Paine, letters in MMA Archives, Dec. 21, 1908, says that it was painted in 1890–1891, calls it "the only good painting ever made of Mr. Clemens during the more active period of his literary life," notes that both artist and subject would like to see it hung in the museum, but he is writing without their knowledge to suggest that the museum make an effort to acquire it, states that it is in Flagg's Hartford studio, and "it is my understanding that the portrait would be presented by Mr. Flagg to the museum; Dec. 22, 1908, says that the artist would be glad to ship it to the museum // C. N. Flagg, letters in MMA Archives, Dec. 23, 1908, says it was painted for Mrs. Clemens, exhibited at the NAD and at the World's Columbian Exposition, and that when the Clemens family went abroad, it was lent to

the Wadsworth Atheneum; Jan. 5, 1909, encloses a photograph of it and says "it was painted entirely from life, when Mr. Clemens was fifty-five years of age" // A. B. Paine, letter in MMA Archives, Jan. 6, 1909, discusses it // C. N. Flagg, letter in MMA Archives, Jan. 8, 1909, says that he gave it a coat of varnish and is waiting for the "touching up" to dry and then will ship it; Jan. 27, 1909, says he made the frame himself "at the time Mr. Clemens lost his fortune" // A. B. Paine, *Mark Twain* (1912), 2, p. 902, discusses sittings for it (quoted above) // E. E. Flagg, the artist's daughter, letters in MMA Archives, April 22, 1917, offers it to the museum, noting that it was painted in 1890, "as an order for Mrs. Clemens," but that before it was completed a financial crisis occurred in the Clemens family, and although the artist offered to give it to Mrs. Clemens, who regarded it highly, she felt that she could not accept it as a gift; Mrs. Clemens died shortly thereafter and "the portrait stayed in father's possession"; April 29, 1917, says that she is shipping it; May 29, 1917, expresses the hope that it will be exhibited regularly // E. H. Long, *Mark Twain Handbook* (1958), p. 217, discusses it // H. D. Perkins, *Connecticut Historical Society Bulletin* 40 (Oct. 1975), p. 113, includes it in an annotated catalogue of the artist's works and discusses it // [C. L. Davis], *Twainian* 31 (March–April 1972), pp. 2–3, quotes C. N. Flagg letters to A. B. Paine, July 8, 1908 (quoted above), also notes he may exhibit it in Boston, but only if it will not interfere with its acquisition by the museum; Dec. 1910, relates conversation with Clemens while it was being painted.

EXHIBITED: NAD, 1891, no. 378, as Portrait of Mark Twain, lent by Samuel L. Clemens, Esq. // World's Columbian Exposition, Chicago, 1893, *Official Catalogue ... Fine Arts*, no. 429, as Mark Twain, lent by Samuel L. Clemens, Hartford // MMA, 1939, *Life in America*, exhib. cat. by H. B. Wehle, no. 259 // National Portrait Gallery, Washington, D.C., 1968, *This New Man*, ed. by J. B. Townsend, essay by O. Handlin, ill. p. 179, discusses sitter // Austin Arts Center, Trinity College, Hartford, Conn., 1974, *Charles Noel Flagg, 1848–1916*, unnumbered cat., dates it 1891 in a chronology on the artist.

EX COLL.: Samuel L. Clemens, Hartford, 1890–at least 1893; returned to the artist, Hartford, by 1904–died 1916; his daughter, Ellen Earle Flagg, Hartford, 1916–1917.

Gift of Miss Ellen Earle Flagg, 1917.

17.96.

FRANK DUVENECK

1848–1919

Duveneck first established his artistic reputation with an accomplished group of portraits and figure studies, and like his friend WILLIAM MERRITT CHASE, he became a leading exponent of the realistic painting style developed in Munich during the 1870s. His late paintings show a decline in originality, but through his activities as a teacher he continued to have an impact on American art.

Born Francis Decker in Covington, Kentucky, not far from Cincinnati, the artist was the son of German immigrants. His father, Bernard Decker, was a shoemaker, and his mother, the former Catherine Siemers, had been a domestic servant in the home of the painter James Beard (1812–1893). After his father's death in 1849, his mother was married to Joseph Duveneck, a successful businessman, and young Francis assumed his stepfather's name. He attended local schools and worked as a sign painter, doing his first easel paintings at the age of twelve or fourteen. He attracted the attention of the German-born church decorator Wilhelm Lamprecht (1838–?) and spent several years as his assistant, learning a variety of crafts—carving, gilding, and painting—and doing decorative work in Pittsburgh and Newark.

When the twenty-one-year-old Duveneck left for Munich in 1870, he intended to continue his study of church decoration. Impressed by the accomplishments of artists specializing in

secular subjects, however, he enrolled in the Royal Academy there. He spent three months in the antique class before entering the composition class under Alexander Straehuber and the life class under Wilhelm von Diez, who recognized his abilities and encouraged his efforts. Like his fellow students Ludwig von Löfftz and Wilhelm Trübner, he was profoundly influenced by Wilhelm Leibl, leader of a circle of young realists, whose unconventional, everday subjects and technical virtuosity were inspired by progressive French painters, notably Gustave Courbet. Duveneck tempered his intense observation of nature with an appreciation of the works of the old masters, particularly the Dutch and Flemish painters Frans Hals, Rembrandt, and Peter Paul Rubens. It was a period of tremendous growth for him; starkly realistic portraits and figure studies such as *Lady with Fan* (q.v.) demonstrate the progress he made in the three years after his arrival in Munich.

Duveneck left Munich in 1873, and, after working on a decorative project in Chicago, he returned to Cincinnati, where he did some portraits and continued to paint church decorations. In 1874 he took a teaching position at the Ohio Mechanics Institute, where his students included ROBERT BLUM and JOHN H. TWACHTMAN. His studio, which he shared for a time with Henry Farny (1847–1916) and the sculptor Frank Dengler, became a gathering place for the city's young artists. Duveneck successfully exhibited a small group of his works in Boston in 1875, first at the Boston Art Club and then at Doll and Richards Gallery.

That same year, accompanied by Twachtman and Farny, he returned to Munich. Painting in a studio at the Royal Academy, he developed an impressive reputation among his American contemporaries. He was in Paris briefly in 1876 and the following year made an extended visit to Venice with Chase and Twachtman. In reaction to the increasing conservativism of the Munich academy, Duveneck started his own painting class, which he conducted first in Munich and then in the Bavarian village of Polling. The American artists Julius Rolshoven (1858–1930), Otto Bacher (1856–1909), Theodore Wendel (1859–1932), Walter McEwen (1860–1943), Theodore Wores (1859–1919), Joseph DeCamp (1858–1923) and JOHN WHITE ALEXANDER were among his many students. Late in 1879 Duveneck and his followers went to Italy and worked together for about two years in Florence and Venice. In 1880, he was elected a member of the Society of American Artists, a new organization especially responsive to young Americans trained abroad. Working with Bacher and JAMES MC NEILL WHISTLER in Venice that same year, Duveneck began to experiment with etching. At that time, his earliest prints, shown at the New Society of Painter-Etchers in London, were thought to have been done by Whistler under an assumed name. After 1880 Duveneck's painting changed significantly; he chose livelier subjects, often attractive Italian peasants, worked in a lighter palette, and gave his works more highly finished surfaces.

In 1886 Duveneck married his pupil Elizabeth Boott (1846–1888), a former Bostonian who had studied under WILLIAM MORRIS HUNT and Thomas Couture. The Duvenecks spent their brief married life in Florence, where their only son was born in 1886, and in Paris, where Elizabeth died unexpectedly in 1888. After her death, Duveneck returned to the Cincinnati area. He sculpted a memorial to his wife, a bronze version of which was placed at her tomb in the Allori Cemetery, Florence, in 1891. There are several replicas of the monument, including a bronze in the Metropolitan's collection. Duveneck continued to teach in Cincinnati and also conducted special classes in New York and Chicago. He often traveled to Europe. In 1894, he

visited Italy, Spain, and France, and the following year, when the memorial to his wife won an honorable mention at the Salon, he went to Paris. He was elected president of the Society of Western Artists at its founding in 1896.

Duveneck's late paintings, executed in a derivative impressionist style, are done with brilliant, sometimes harsh, colors and less assured draftsmanship. An impressive series of nudes, however, dates from this period and includes the pastel *Siesta* (Cincinnati Art Museum). The artist spent the remaining years of his career teaching at the Art Academy of Cincinnati, joining its faculty in 1900. He continued to receive national recognition for his work, and in 1901 was awarded a silver medal at the Pan-American Exposition. Three years later he served on the jury of awards at the Louisiana Purchase Exposition. He was elected an associate member of the National Academy of Design in 1905, and five years later his work was included in an important exhibition of American art held in Berlin and Munich. At the Panama-Pacific Exposition in San Francisco in 1915, an entire room was devoted to Duveneck's paintings and etchings and he was given a special gold medal. Two years later he received an honorary degree from the University of Cincinnati. Duveneck presented an important collection of his art in a variety of media to the Cincinnati Art Museum before his death in 1919.

At the time of his death at the age of seventy-one, his students noted:

> Frank Duveneck, master in sculpture, in etching, and supremely master with the brush, has left in his words a legacy of unlimited value. We . . . who worked under him in the early days in Europe, in Boston, or here in Cincinnati, are possessed of a treasure even richer, the inspiration of his character, of his vigorous and tender personality, of the high ideals of art and of life he implanted. Great teacher, most kindly and just of critics, dear friend, he has been to us like a father to his children (quoted in J. W. Duveneck, p. 163).

BIBLIOGRAPHY: "Frank Duveneck," and George McLaughlin, "Cincinnati Artists of the Munich School," in Walter Montgomery, ed., *American Art and American Art Collections* (Boston, [1889–1890]), 2, pp. 984–988, and 1, pp. 145–160 // Norman Heermann, *Frank Duveneck* (Boston, 1918). An appreciative biography, anecdotal in nature, by a friend and student // Cincinnati Art Museum, *Exhibition of the Work of Frank Duveneck* (May 23–June 21, 1936), cat. by Walter H. Siple. Includes an annotated catalogue of works in the exhibition, a list of works by the artist, a chronology and bibliography // Mahonri Sharp Young, "The Two Worlds of Frank Duveneck," *American Art Journal* 1 (Spring 1969), pp. 92–103 // Josephine W. Duveneck, *Frank Duveneck: Painter—Teacher* (San Francisco, 1970). An appreciative biography, written by the artist's daughter-in-law, includes many quotations from primary material, illustrations, a chronology, bibliography, and index.

Lady with Fan

Duveneck's three-quarter length standing portrait of a woman holding a fan was painted in Munich in 1873. The composition, subject matter, and direct technique show the influence of the young German realists led by Wilhelm Leibl. Simply posed against a dark background, the figure, with her tentative gesture and confronting gaze, recalls Leibl's *Frau Gedon*, 1867–1868 (Neue Pinakothek, Munich), a portrait Gustave Courbet admired in Munich in 1869. The subject of a woman with a fan was treated with equal im-

mediacy in 1873 by Wilhelm Trübner, a member of the Leibl circle and one of Duveneck's fellow students in Wilhelm von Diez's class at the Royal Academy. Like Trübner's *Portrait of a Lady with Japanese Fan*, 1873 (Kunsthalle, Bremen), Duveneck's composition concentrates on essentials. The focus is on the hands, held in a slightly awkward gesture, and on the head, illuminated and shown in a position not quite profile nor yet three-quarter view. As one critic observed when the picture was exhibited in New York in 1879: "the nose [is] seen too much in profile for the rest of the face."

Lady with Fan demonstrates Duveneck's bold, masterful painting technique. In 1875, a critic, probably the Boston painter Frederic Porter Vinton (1846–1911), gave an account of this working technique, "derived from Mr. Duveneck himself":

His pallet is very simply made up: the only thing essentially different from that in use by most portrait painters, being his use of black in the grays instead of blue. Upon a slight drawing, he begins painting in thick square patches of color, laying a broad mass wherever it is possible, and imitating the model as closely as he can. He depends very much upon his background color to assist in modelling the face; as, for instance, on the shadow side, he will paint that color in first, then overlay the flesh tones firmly. . . . He finds it impossible to work on a head until thus laid in, with thick masses of wet color. When it is desirable to finish very smoothly and closely, he allows his first painting to dry thoroughly, and rubs the surface down with *ossa sepia* until he obtains a surface almost as smooth as glass, and by using raw linseed oil upon it, and with his color, keeps it wet as long as possible. In this manner he worked several weeks upon one of his pictures.

The immediacy of this portrait is thus deceptive; it is clearly the result of extended work. As the artist is said to have commented on it years later (1918): "In those days I had eyes like a hawk and yet I painted two days on that one eye in the light."

In 1875, *Lady with Fan* was included in a small but well-received Duveneck exhibition held in Boston, where the painting style promoted by WILLIAM MORRIS HUNT had prepared the public for the dark tones and sketch-like appearance of the work. Henry James was among the critics who commented on the painting:

The third picture is a half-length of a lady in a brown dress and scarf, and a white cambric hat, holding a fan, with the body in profile and the face three-quarters full. This was the first female subject by Mr. Duveneck we had seen, and it is quite the finest of his portraits; this, too, in spite of the fact that only the face is finished. This face strikes us as a very considerable achievement. The consummate expressiveness of the eyes, the magnificent rendering of flush and bloom, warmth and relief, pulpy blood-tinted, carnal substance in the cheeks and brow, are something of which a more famous master than Mr. Duveneck might be proud. The figure is, moreover, full of movement, spirit, and style; its lightest touches tell of a talent which has excellent reason for self-confidence. Mr. Duveneck is essentially a portraitist; it is hard to imagine a more discriminating realism, a more impressive rendering of the special, individual countenance. That analogy with Velasquez, proportions considered, of which we formerly spoke, strikes us

afresh in the works to which we now allude. It is not too much to say that in the portrait of the lady it is, in a very noble sense, deceptive.

Oil on canvas, 42¾ × 32¼ in. (108.6 × 81.9 cm.).
Signed and dated at lower left: *FD* (monogram) *uveneck | Munich 1873.*
REFERENCES: F. P. V[inton?], *Boston Evening Transcript*, August 10, 1875, p. 5, discusses its exhibition at Doll and Richards, says the painting demonstrates Duveneck's "ability to paint a refined and graceful portrait of a lady, as well as the coarser, more powerful types of manhood," notes that parts of the picture remain unfinished, preserving "all the dash and freshness of a sketch, with its infinite suggestions," discusses the artist's technique (quoted above), and notes that all the paintings sent to Doll and Richards have been sold // [H. James], *Nation* 21 (Sept. 9, 1875), pp. 165–166, reviews it in the exhibition at Doll and Richards (quoted above) // *New York Times*, March 8, 1879, p. 5, in a review of the Society of American Artists exhibition says the artist "does not hold his own so well in the present show," but the painting has "vividness and more than its usual neglect of accessories" // S. N. Carter, New York *Art Journal* 5 (May 1879), p. 157, reviews it at the Society of American Artists exhibition (quoted above) // N. Heermann, *Frank Duveneck* (1918), p. vii; p. 9, mistakenly lists it among the five works exhibited at the one-man show in Boston; p. 12, quotes Duveneck's comment about painting the eye (quoted above); ill. opp. p. 12; p. 74, says it sold from the Boston exhibition for three hundred dollars // *American Art News* 17 (Jan. 11, 1919), p. 4, mentions it in the artist's obituary // E. Clark, *John Twachtman* (1924), p. 19, notes it was one of the works that helped to establish Duveneck's reputation // F. E. W. Freund, *International Studio* 85 (Sept. 1926), p. 100, discusses it // F. F. Sherman, *Art in America* 16 (Feb. 1928), p. 92; p. 97, includes it as no. 12, Woman with a Fan, in a list of Duveneck's portraits // E. M. Clark, *Ohio Art and Artists* (1932), p. 87 // M. L. Alexander, *Cincinnati Enquirer*, May 17, 1936, sec. 3, p. 7, discusses it in retrospective and says it was also shown in Cincinnati in 1915, just prior to its being sent to the Panama-Pacific Exposition; May 24, 1936, sec. 4, p. 5, notes that the artist said it was originally sold for three hundred dollars to Miss Curtis of Boston, who left it to Mrs. Quincy who in turn gave it to her daughter, who owned it at the time it was first exhibited in Cincinnati, and says generous offers to purchase it were made to the owners // W. H. Siple, *Art News* 34 (June 13, 1935), ill. p. 15, discusses it // *Cincinnati Enquirer*, Jan. 18, 1937, p. 6, discusses it in exhibition of the Williams collection // M. Alexander, *Cincinnati Enquirer*, Oct. 22, 1939, sec. 4, p. 6, says it was included in an exhibition of the Williams collection at the Cincinnati Art Museum; Nov. 5, 1939, sec. 4, p. 10, discusses its history // F. Watson, *Magazine of Art* 33 (Nov. 1940), ill. p. 617 // R. Neuhaus, *Bildnismalerei des Leibl-Kreises (Verlag des Kunstgeschichtlichen Seminars Marburg)* (1953), p. 47,

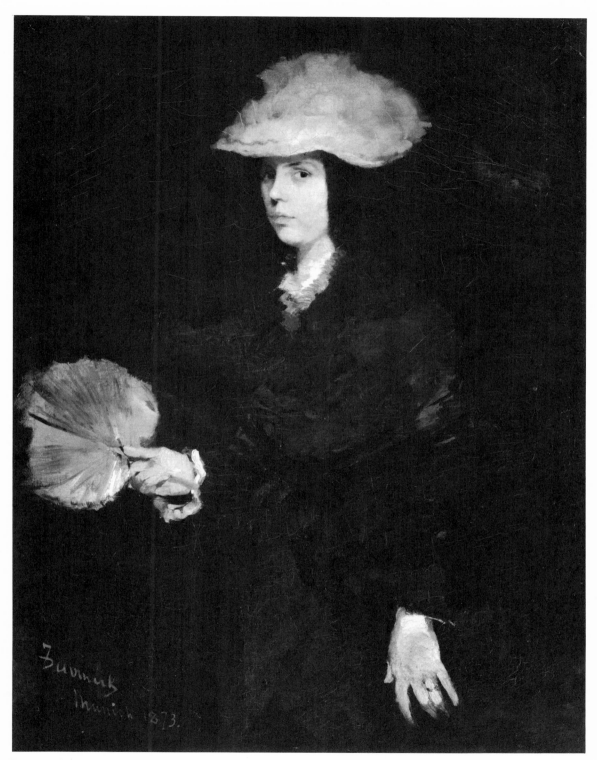

Duveneck, *Lady with Fan.*

discusses it; pl. 16 // J. L. Sweeney, ed., *The Painter's Eye* (1956), pp. 105–106, reprints James's 1875 review of it // H. Howe, *The Gentle Americans, 1864–1960* (1965), p. 360, discusses provenance of the painting, mistakenly says it was sold to the Cincinnati Museum, and says the profits of the sale were divided "among the grandchildren of the 'lady' the portrait was supposed to resemble" // N. Heermann, letters in Dept. Archives, Oct. 26, 1965, gives information on provenance and says Williams family will offer it to the Metropolitan; Nov. 7, 23, 1965, discusses its history // W. J. Williams, letter in Dept. Archives, Nov. 30, 1965, lists its exhibitions // N. Heermann, letters in Dept. Archives, Dec. 5, 8, 21, 1965, and Jan. 4, 1966, discusses details relative to its acquisition by the museum; Jan. 21, 1966, encloses a receipt from himself to M. A. De Wolfe Howe for its sale on May 19, 1934; May 26, 1966, gives provenance and exhibition history; July 18, 1966, says it was exhibited at the Cincinnati Art Museum and quotes Duveneck's comment on it after Heermann noted the similarity of the unfinished hands to those of the artist's Whistling Boy (Cincinnati Art Museum): "I'd get tired of that so-called finish. As long as the gesture is right. Look at Rembrandt" // W. J. Williams, letter in Dept. Archives, Oct. 27, 1966, provides several newspaper clippings that discuss the painting // A. von Saldern, *Antiques* 92 (Nov. 1967), p. 701, discusses it; ill. p. 702 // M. S. Young, *American Art Journal* (Spring 1969), pp. 94–95, says that after Duveneck's exhibition closed in 1875, it was among three additional works placed on view; ill. p. 96 // B. R. Booth, "A Survey of Portraits and Figure Paintings by Frank Duveneck, 1848–1919," Ph.D. diss., University of Georgia, 1970, pp. 46–48, discusses it says influenced by Leibl's portrait of Frau Gedon; p. 61, notes it among works added to Duveneck's exhibition in Boston in 1875; pp. 64, 66, discusses critics comments on it // J. W. Duveneck, *Frank Duveneck* (1970), ill. following p. 48; p. 50, says it shows Spanish influence in subject and treatment; p. 58 // M. S. Young, *Apollo* 92 (Sept. 1970), p. 212, discusses it; ill. p. 213 // Chapellier Gallery, New York, *Frank Duveneck* (1972), exhib. cat. by F. W. Bilodeau, unpaged, says it was painted in Munich where the subject was a favorite one // P. P. Rutledge, Cincinnati Art Museum, letter in Dept. Archives, Jan. 12, 1978, provides information

on exhibitions in Cincinnati // L. Luckey, MFA, Boston, letter in Dept. Archives, Jan. 28, 1978, provides information on Boston exhibitions and provenance.

EXHIBITED: Doll and Richards, Boston, 1875 (no cat. available) // Society of American Artists, New York, 1879, no. 77, as Lady, with a Fan, lent by Miss Curtis, Boston // Cincinnati Art Museum, 1915, *Special Exhibition of the Work of Frank Duveneck . . . to Fill a Special Gallery at the Panama-Pacific Exposition* (no cat.) // Panama-Pacific International Exposition, San Francisco, 1915, *Catalogue Deluxe of the Department of Fine Arts*, ed., by J. E. D. Trask and J. N. Laurvic, 2, no. 3911, as Woman with a Fan, lent by M. A. De Wolfe Howe // Cincinnati Art Museum, 1936, *Exhibition of the Work of Frank Duveneck*, cat. by W. H. Siple, no. 10, as Lady with a Fan, lent by Mr. and Mrs. Charles F. Williams; pp. 9, 26; 1937, *Exhibition of Paintings from the Collection of Mr. and Mrs. Charles Finn Williams*, cat. by W. H. Siple, no. 4, as Lady with a Fan; pp. 5–6 // Whitney Museum of American Art, New York, 1938, *Paintings by Frank Duveneck, 1848–1919*, essay by N. Heermann, no. 5, lent by the family of Charles F. Williams; n.p., says it shows influence of Dutch painting // Cincinnati Art Museum, 1939, *Paintings from the Collection of Mr. and Mrs. Charles F. Williams* (no cat.) // Carnegie Institute, Pittsburgh, 1940, *A Survey of American Painting*, exhib. cat. by H. Saint-Gaudens, no. 128, as Lady with a Fan, lent by Mr. and Mrs. Charles F. Williams family // Brooklyn Museum; Virginia Museum of Fine Arts, Richmond; California Palace of the Legion of Honor, San Francisco, 1967–1968, *Triumph of Realism*, exhib. cat. by A. von Saldern, no. 41, as Lady with Fan; ill. p. 127.

ON DEPOSIT: MFA, Boston, 1887–1891, lent by Mary F. Curtis, but returned to Mrs. J. P. Quincy; 1912 and 1920, lent by Mrs. M. A. De Wolfe Howe.

EX COLL.: Mary Frazier Curtis, Boston, 1875—at least 1887; Mrs. Josiah P. Quincy, Boston, by 1891; her daughter, Fanny Quincy Howe (Mrs. Mark A. De Wolfe Howe), Boston, by 1912—died 1933; with Norbert Heermann, as agent, 1934; Charles F. Williams, Cincinnati, 1934—died 1952; family of Charles F. Williams, Cincinnati, until 1966; with Norbert Heermann, Woodstock, N.Y., as agent, 1966.

Gift of the Charles F. Williams family, 1966.
66.19.

EDWIN H. BLASHFIELD

1848–1936

One of the leading academic painters at the turn of the century, Edwin Howland Blashfield did most of his important easel paintings during the late 1880s and early 1890s. Thereafter he worked primarily as a muralist, convinced that "the decoration of public buildings is the most important question in the consideration of our art of the future" (*Scribner's Magazine* 54 [Sept. 1913], p. 353). He was born in Brooklyn and spent much of his youth there and in New York, although he also attended schools in Hartford and Boston. His mother, Eliza Dodd Blashfield (1831–1910), was an amateur portraitist and encouraged his artistic interests and those of his younger brother, Albert Dodd Blashfield (1860–1920), who later became an illustrator. Edwin studied engineering in Germany in 1863, but, after three months, family circumstances brought him home. He then attended the Boston Institute of Technology, where among other subjects he studied drawing. After a friend showed some of his drawings to Jean Léon Gérôme, who said that they showed promise, Blashfield's father permitted him to pursue a career in art. At the suggestion of WILLIAM MORRIS HUNT, Boston's leading art teacher, Blashfield spent several months in a class conducted by Thomas Johnston (1834–1869) and attended anatomy lectures presented by William Rimmer (1816–1879).

When Blashfield sailed for Europe in May 1867, he intended to enroll in the Ecole des Beaux-Arts, but he was unable to gain admission. Instead he attended classes in Léon Bonnat's private atelier until 1870. He had, however, the benefit of informal criticism from Gérôme, who was at that time an instructor at the Ecole des Beaux-Arts. Among Blashfield's American friends in Paris was the artist Milne Ramsey (1846–1915), and, after 1869, they shared a studio. They also summered together in the French countryside and in 1870 made a tour of the continent, spending eight months in Florence. After three years in New York, 1871–1874, Blashfield returned to Paris and studied under Bonnat for another six years. In 1876, he began to exhibit at the Paris Salon and the Royal Academy in London. His close associates at this time included such Bonnat and Gérôme students as CHARLES SPRAGUE PEARCE and Frederick Arthur Bridgman (1847–1928), and later H. SIDDONS MOWBRAY, but unlike these Americans, he did not paint the Middle Eastern subjects of his teachers but preferred instead historical genre scenes of "early Gothic subjects, pages in costume, knights in armor, etc." (Blashfield, interview, July 1927, De Witt Lockman Papers, NYHS, microfilm 502, Arch. Am. Art). Relatively little is known about his student work, although it was probably rather derivative. His historical genre scene *The Beauty Spot*, 1877 (London art market, 1977), for example, shows the influence of Ernest Meissonier in its high finish and the choice of subject matter.

During the early 1880s, Blashfield settled in New York with his bride, the writer Evangeline Wilbour, and worked in a studio in the Sherwood Building. In 1882, he became an associate of the National Academy of Design and also a member of the Society of American Artists. He traveled a great deal during this period, visiting Italy, Greece, and Egypt. In 1887 he stayed in the English village Broadway, where he associated with FRANK MILLET, JOHN SINGER SARGENT, and EDWIN AUSTIN ABBEY, all of whom influenced his development as a muralist.

His mature painting style retains the strong draftsmanship and figure subjects of his student period. During the late 1880s and early 1890s, he did allegorical and religious paintings, as well as more fanciful works like *Bells*, 1891 (Brooklyn Museum) and *Fuga* (NAD). He also wrote and did illustrations, often in collaboration with his wife. In 1895, working with WILL H. LOW and WALTER SHIRLAW, he helped design a new issue of currency for the United States government.

Blashfield received his first decorative commission in the late 1880s and thereafter devoted much of his career to mural painting, becoming a major exponent of this genre. Two of his early projects were decorations for the World's Columbian Exposition in Chicago and the Library of Congress in Washington. Other large commissions included churches, such as St. Matthew the Apostle, Washington, and the Church of the Saviour, Philadelphia, and courthouses in Newark, Jersey City, Youngstown, Baltimore, and Wilkes-Barre. The homes of Adolph Lewisohn in New York and Everett Morss in Boston are among the many residences he decorated. He did much to promote mural painting: in 1909, an exhibition of studies and photographs of his decorative work toured the country, and, four years later, he published *Mural Painting in America*, a collection of essays based on his lectures on the theory and practice of decorative painting. He was also a longtime member of the Society of Mural Painters, an organization founded in 1895.

Although working in an outdated and academic style, Blashfield remained an influential figure among his contemporaries. Elected a full member of the National Academy of Design in 1888, he served as its president from 1920 to 1926, and, in 1927–1928, the American Academy of Arts and Letters honored him with a major retrospective. Always the reasoned spokesman for the traditional in art, he praised "the new movement" evident in American art following the Armory Show of 1913 for "its concentration upon color and light, its development, through experiment, of effects produced by broken color and the novel manipulation of material," but condemned the new generation of artists for an unwillingness to labor over their work and "a fatuous contempt for the lesson of the past" (*Century Magazine* 87 [April 1914], p. 837). He continued to maintain a studio in New York until 1933, when he retired to Cape Cod. He died there at the age of eighty-five, and his second wife, the former Grace Hall, presented a large group of his works and his collection of fine and decorative art to Williams College.

BIBLIOGRAPHY: Edwin Howland Blashfield Papers, NYHS, 1867–1936. Includes correspondence, diaries in letter form, art notes, writings on art and artists, and miscellaneous papers // Ernest Knaufft, "An American Decorator: Edwin H. Blashfield," *International Studio* 13 (March 1901), pp. 26–36. Discusses many of his mural projects // Edwin Howland Blashfield, *Mural Painting in America* (New York, 1913) // Royal Cortissoz, *The Works of Edwin Howland Blashfield* (New York, 1937). Heavily illustrated // Sterling and Francine Clark Art Institute, Williamstown, Mass., *The Mural Decorations of Edwin Howland Blashfield (1848–1936)* (1978), exhib. cat. by Leonard N. Amico. A thorough discussion of individual mural projects with illustrations, a chronological list of murals, and an extensive bibliography.

Design for the Washington Centennial Celebration Souvenir

This grisaille, painted in January and February of 1889, was used as the frontispiece for a souvenir booklet commemorating the one hundredth anniversary of the inauguration of George Washington. It shows the allegorical figure of Columbia with one hand resting on a pedestal that supports a bust of George Washington. In the lower left, a putto displays a placard inscribed with the years of the inauguration and its centennial. A large American flag, its stars and stripes barely visible, serves as a backdrop. There are laurel wreaths at the base of the Washington bust and what appear to be palm fronds behind the putto and at the feet of Columbia.

The work was commissioned by the Committee on Art and Exhibition, part of the Washington Centennial Celebration Committee. Henry Gordon Marquand, chairman of the art committee, had made an arrangement with Blashfield for the painting by January 23, and the completed work was displayed at a meeting on February 13. The grisaille was illustrated in a souvenir booklet that also included a watercolor design by WILL H. LOW (MMA) and a commemorative medal designed by Augustus Saint-Gaudens and modeled by Philip Martiny (MMA). The typography for the booklet was selected by the architect Stanford White, and its production was supervised by a number of artists, including DANIEL HUNTINGTON, FRANK MILLET, and WILLIAM COFFIN.

At a meeting of the art committee held on February 27, it was announced that Blashfield and Low would be "very glad" to present their designs to Marquand. The following year, Marquand, then president of the Metropolitan Museum of Art, gave these decorative works and two casts of the Saint-Gaudens commemorative medal to the museum.

Blashfield also prepared the cover illustration for the *Harper's Weekly* "Washington Centennial Number," which appeared on May 4, 1889. This illustration, showing allegorical figures gathered around a Washington bust, is similar to the design of the grisaille. The artist later returned to allegorical figures, flags, and other symbols of American patriotism for the paintings and poster designs he did during World War I.

Oil on canvas board, 20 × 16 in. (50.8 × 40.6 cm.).
Signed at lower left: Edwin H Blashfield.

Blashfield, *Design for the Washington Centennial Celebration Souvenir.*

Stamped on reverse: RUSSELL'S / CANVAS BOARD, / PATD. MAR. 18th, 1879.

REFERENCES: R. W. Gilder, Minutes of the Committee on Art and Exhibition, Jan. 23, 1889, Records of the Washington Centennial Celebration Committee, NYHS, records that Marquand reported "an arrangement" with Blashfield and Low for designs; these artists, who have "freely offered their services," are to be given tickets to the banquet and ball // W. A. Coffin, Minutes of the Supervising Committee of the Committee on Art and Exhibition, Feb. 13, 1889, Records of the Washington Centennial Celebration Committee, NYHS, notes that the Blashfield design was exhibited; Feb. 20, 1889, notes that Coffin reported progress from the supervising committee regarding the designs by Blashfield and Low; Feb. 27, 1889, notes that designs were exhibited, reports discussion on appropriate size for reproduction, notes that R. W. Gilder reported to the Committee on Entertainment that the designs were finished, that Huntington suggested they be used for a "souvenir invitation," and that Coffin stated that the artists were amenable to presenting their designs to Marquand // Washington Centennial Celebration Committee, *Centennial Celebration of the Inauguration of George Washington as President of the United States* (1889), frontis. ill., unpaged, discusses it // C. W. Bowen, ed., *The History of the Centennial Celebration of the*

Inauguration of George Washington as First President of the United States (1892), ill. opp. p. 136, discusses it.

EXHIBITED: Metropolitan Opera House, New York, 1889, *Catalogue of the Loan Exhibition of Historical Portraits and Relics* (for the Centennial Celebration of the Inauguration of George Washington as First President of the United States), no. 3, p. 6, under decorative designs, as black and white drawing in oil, lent by the Committee on Art and Exhibition.

EX COLL.: with Committee on Art and Exhibition, Washington Centennial Celebration Committee, 1889; Henry Gurdon Marquand, New York, 1889–1890.

Gift of Henry G. Marquand, 1890.
90.18.3.

H. BOLTON JONES

1848–1927

Hugh Bolton Jones, the son of an affluent businessman, was born in Baltimore. He attended classes at the Maryland Institute, probably studying under the portraitist David Acheson Woodward (1823–1909), then instructor of drawing there, and first exhibited his work at the Maryland Institute Fair. Although Baltimore remained his residence, Jones spent much of his time in New York between 1865 and 1876. He studied under Horace W. Robbins (1842–1904) in the New York studio of the art designer Carey Smith (1837–1911) in 1865 and two years later began to exhibit at the National Academy of Design. In the autumn of 1868 or 1869, he went to West Virginia and in June 1870 made a four-month tour of Europe with his family. On his return to Baltimore, he exhibited his work locally and joined the Allston Association, a social club whose members included collectors as well as artists. He was in New York again in 1875 and spent that summer in the Berkshires. Jones's early landscapes, often of readily recognizable sites, show a meticulous attention to detail that allies them to the Hudson River School tradition.

In July 1876, the artist and his younger brother, FRANCIS COATES JONES, went to Europe, stopping first in London to visit EDWIN AUSTIN ABBEY and another friend before going on to Paris. Family tradition says that he studied at the Académie Julian, but a 1927 interview with his brother suggests that he spent most of his time at Pont-Aven, Brittany, where he painted outdoors, producing landscapes that often included picturesque architecture and French peasants. He may have been attracted to this provincial village by a Baltimore acquaintance, THOMAS HOVENDEN, who was working there at the time. In the spring of 1878, Jones joined his brother in Paris for a trip to Tangier, and later, they toured Italy, Belgium, France, and Switzerland with their family. In June 1880, Jones returned to Baltimore, where he sold a group of his paintings at auction, and then went off on a trip to Spain and North Africa.

When he came back to America in 1881, Jones settled in New York and was elected a member of the Society of American Artists and an associate of the National Academy of Design. He became an academician two years later. Although he participated in the first exhibition of the Society of Painters in Pastel in 1884, his work in this medium has not been studied. In 1888, he and his brother moved their studio from the Sherwood Building to the Clinton Studio Building, where they lived with their widowed sister, Louise Chubb. During

this period, most of Jones's landscapes were titled by season. Mainly interested in depicting subtle plein-air scenes, he chose simple, often repetitious, compositional arrangements. A clear, almost sparkling, light illuminates these landscapes, and details are crisply rendered. Later his palette became cooler and more tonal, and his mature works are more lyrical, the influence perhaps of Barbizon painting.

For Charles Dudley Warner's book on the western United States, *Our Italy* (1891), Jones made a trip west to do the illustrations. His work appeared regularly in annual exhibitions in many major cities after the turn of the century, and in 1902, he received an award for landscape painting from the Society of American Artists. During the final decades of his career, Jones's painting became increasingly outmoded in style and repetitive in subject and composition. He spent most of his summers at his cottage in South Egremont, Massachusetts, painting and sketching in the Berkshires. In New York, he continued to share a studio with his brother, and in 1905 or 1906 they moved to the Atelier Building. Jones was elected a member of the National Institute of Arts and Letters, and after 1914 the Century Association became the center of his social life. In 1926, the artist contracted pernicious anemia and died the following year in New York.

BIBLIOGRAPHY: "American Painters—H. Bolton Jones," *Art Journal* 6 (Feb. 1880), pp. 53–54, revised with additions and reprinted as "H. Bolton Jones: Chapter Eighty-Sixth," in Walter Montgomery, ed., *American Art and American Art Collections* (Boston [1889–1890]), 2, pp. 936–939 // Notes on Francis Coates Jones made during an interview with him and a typescript biography, [1927], De Witt McClellan Lockman Papers, NYHS, microfilm 503, Arch. Am. Art, includes information about the Jones brothers' life together, especially in France // Joan Hanson Zeizel, "Hugh Bolton Jones, American Landscape Painter," M.A. thesis, George Washington University, 1972, a detailed biography and discussion of stylistic development, includes a catalogue of works with exhibitions and references and an extensive bibliography // National Collection of Fine Arts, Washington, D.C., *American Art in the Barbizon Mood* (1975), exhib. cat. by Peter Bermingham, pp. 154, 187, discusses Jones in the context of Barbizon painting.

Spring

Like many of Jones's landscapes, this picture is titled simply by season. It has been suggested that the scene depicted is the Rahway River in New Jersey. *Spring* may also represent the artist's attempt to record the light effects at a particular time of day; for dates and what may be times of day—afternoons in May 1885 and 1886—are inscribed along the tacking edge. Since many of Jones's paintings are unlocated or poorly documented, it is difficult to ascertain whether these detailed notations were typical of his working procedure. The dates and times inscribed on the Metropolitan's painting may simply indicate the time he spent on it either outdoors or in his studio.

The simple composition is typical of the artist's work. In the foreground, the placid, highly reflective water surface is arranged on an unobtrusive diagonal. Most elements, however, are placed in horizontal lines, parallel to the picture plane, and recede toward the horizon, with tree trunks, foliage, and a broken-down rail fence creating a screen across the center. The foreground and middle ground are clearly illuminated, while the distant meadow and forest are dissolved in a luminous light. The careful observation, meticulous detail, and sparkling light effects seen in *Spring* distinguish it from the repetitious landscapes the artist painted later in his career.

Oil on canvas, 24¼ × 40⅛ in. (61.6 × 101.9 cm.).
Signed at lower left: H. BOLTON JONES. Inscribed in pencil along the tacking edge from left to right in seven groups:

May 3	May 18/85	May 15	May 12 1885
1886	1:30—3.20	1.45	[illeg.]
1.15		5.00	
May 1 [?]	May 2nd [?]	May 3rd	
4.45	12—	1:30—	

Jones, *Spring*.

REFERENCES: *New York Times*, April 18, 1887, p. 4, mentions it in a discussion of the exhibition of the Seney collection // G. I. Seney to S. P. Avery, April 18, 1887, receipt in MMA Archives, mentions it // W. L. Fraser, *Century*, n.s. 25 (March 1894), ill. p. 771, shows an engraving after it by I. Lester Cohen; p. 799, discusses the painting // S. Isham, *The History of American Painting* (1905; rev. ed. 1915), ill. p. 443 // *Art Digest* 2 (Oct. 1, 1927), p. 9, mentions it in an obituary of the artist // W. H. Downes, *DAB* (1931; 1961), s.v. "Jones, Hugh Bolton" // E. V. Connet [Counett?], Jr., orally, Oct. 1, 1935, said that he was with the artist when he painted it on the Rahway River in New Jersey // J. H. Zeizel, "Hugh Bolton Jones, American Landscape Painter," M.A. thesis, George Washington University, 1972, pp. 115–116, say it was in Seney's collection in 1887; p. 150; ill. p. 175, pl. xli; pp. 198–199, includes it as no. 133 in a catalogue of the artist's work, lists exhibitions and references, and dates it ca. 1887.

EXHIBITED: Brooklyn Art Association (for the benefit of the Brooklyn Home for Aged Men), 1887, *Catalogue of Mr. George I. Seney's Collection of Paintings*, no. 147 // Inter-State Industrial Exposition, Chicago, 1887, no. 243, as Spring, lent by George I. Seney // MMA, 1897, *The Catharine Lorillard Wolfe Collection and Other Modern Paintings*, no. 215.

Ex COLL.: George I. Seney, Brooklyn, 1887; with Samuel P. Avery, New York, as agent.

Gift of George I. Seney, 1887.
87.8.9.

Autumn

Done on an intimate scale, *Autumn* was painted sometime after 1881, when the artist returned from Europe, and before 1892, when the painting was placed on deposit at the Metropolitan Museum. It most likely dates from the late 1880s or early 1890s, when Jones, working in the Barbizon style, favored landscape scenes representing the mood of a season or time of day rather than the appearance of a specific locale. These paintings were described by one critic as "always refined and delicate, sensitive sometimes to the subtler aspects of things, and happy in the modest exposition of them" (W. Montgomery, ed., *American Art and American Art Collections* [1889–1890], 2, p. 938).

Oil on canvas, 10 × 14 in. (25.4 × 35.6 cm.).
Signed at lower right: H. BOLTON JONES.
REFERENCES: "Pictures Lent by Mr. Tho. P. Salter, 1892," MMA Archives, lists it // T. P. Salter, letters in MMA Archives, Nov. 12, Dec. 31, 1906, offers it to MMA // *Art Digest* 2 (Oct. 1, 1927), p. 9, mentions it in artist's obituary // J. H. Zeizel, "Hugh Bolton Jones, American Landscape Painter," M.A. thesis, George Washington University, 1972, p. 152, says it is painted with "a vague, sketchy, vibrating brushstroke and surface"; p. 165, pl. xxii; p. 208, no. 214, misdates it ca. 1907, in catalogue of the artist's work.

Jones, *Autumn*.

EXHIBITED: MMA, 1897, *Loan Collections and Recent Gifts to the Museum*, no. 133, as Autumn, lent by Mr. Thomas P. Salter; 1897–1898, *Loan Collections and Recent Gifts to the Museum*, no. 133, lent by Mr. Thomas P. Salter // National Collection of Fine Arts, Washington, D.C., 1975, *American Art in the Barbizon Mood*, exhib. cat. by P. Bermingham, no. 60; ill. p. 154.

ON DEPOSIT: MMA, 1892–1907.

EX COLL.: Thomas P. Salter, Portsmouth, N.H., 1892–1907.

Gift of Thomas P. Salter, 1907.

07.119.8.

LOUIS COMFORT TIFFANY

1848–1933

Louis Comfort Tiffany painted in oil and watercolor throughout his career, producing genre scenes, landscapes, and still lifes as well as sketches for his decorative work. He was aware of his limitations as a painter, however, and after 1880, devoted himself primarily to decorative work and the design and production of glass, becoming the leading exponent of art nouveau in America. The son of Charles L. Tiffany, founder of the New York jewelry store that still bears the family name, he was educated in boarding schools. He was not interested in the family business, however, and in 1866 decided to study art rather than attend college. He sketched rural scenes in upper Manhattan and frequented the studio of GEORGE INNESS, who apparently offered the young artist some criticism and instruction.

Louis Comfort Tiffany

Tiffany began to exhibit at the National Academy of Design in 1867, and the following year he left for Europe. In Paris he studied with Léon Belly, who specialized in landscapes and Islamic genre scenes, and in the spring of 1869, he accompanied SAMUEL COLMAN on a trip to North Africa. Under Colman's influence, he made outdoor sketches in watercolors and on his return to New York joined the American Water Color Society. He became a member of the Century Association in 1870 and the following year was elected an associate of the National Academy of Design. Tiffany went back to Europe in 1874 and spent the summer in Brittany. Throughout the 1870s he did paintings which were often based on his travels in Europe and North Africa. These were exhibited at the Centennial Exhibition in 1876 and the Paris Exposition in 1878; two years later he was made an academician at the National Academy.

In 1879, at the age of thirty-one, Tiffany embarked on a new career, that of interior decoration. Encouraged by Edward C. Moore, his father's chief designer, he joined with Colman, Lockwood de Forest (1850–1932), and Candace Wheeler, a textile and needlework designer, to found Louis C. Tiffany and Associated Artists. Strongly influenced by JAMES MC NEILL WHISTLER's interior designs, the firm incorporated exotic decorative motifs in its tiles, embroidered hangings, painted friezes, and colored glass. Their first complete interior was done for the George Kemp residence in New York, and in 1880 they decorated the public rooms of the city's Seventh Regiment Armory. Other prominent clients included Hamilton Fish, Henry de Forest, and John Taylor Johnston. After their final collaborative project, the Church of the Divine Paternity in New York, Candace Wheeler continued her textile work under the name of Associated Artists, and Louis C. Tiffany and Company handled decorative projects on a reduced scale.

Tiffany devoted much of the next two decades to work in glass. His earliest practical experiments with glass had been on a limited scale with the Associated Artists, but now he organized an atelier, surrounded himself with a group of talented young artists, and catered not to individual clients but to architects like Stanford White and Thomas Hastings. In 1895 Samuel Bing, the Parisian promoter of art nouveau, described the purpose of Tiffany's enterprise:

> Tiffany saw only one means of effecting this perfect union between the various branches of industry: the establishment of a large factory, a vast central workshop that would consolidate under one roof an army of craftsmen representing every relevant technique: glassmakers and stone setters, silversmiths, embroiderers and weavers, casemakers and carvers, gilders, jewelers, cabinetmakers—all working to give shape to the carefully planned concepts of a group of directing artists, themselves united by a common current of ideas (S. Bing, *La Culture artistique en Amérique* (1895), tr. B. Eisler, in R. Koch, ed., *Artistic America, Tiffany Glass, and Art Nouveau* [1970], p. 146).

In an attempt to create quality objects for a broad public audience, Tiffany developed a process for producing bowls and vases of Favrile glass, which he patented in 1894. Satiny in texture, Favrile glass is iridescent with variegated colors; its forms suggest organic abstractions. Tiffany further expanded his activities and established a metalwork department, producing lamps, sconces, and chandeliers. He also did work in mosaics and between 1889 and 1893 decorated several churches in New York and New England. He exhibited a chapel, a light room, and a dark room at the World's Columbian Exposition in 1893. Soon after, with Bing's assistance, he displayed a group of ten windows designed by such avant-garde artists as

Pierre Bonnard and Paul Sérusier. Among the many other decorative objects made by Tiffany Studios after 1900 were enameled boxes, jewelry, tableware, and a wide assortment of household items, among them clocks, dishes, and trays. The expansion in the type and number of objects precipitated a change in policy: there were fewer unique objects, and well-designed matched sets, made of the finest materials, were promoted. Furthermore, Tiffany was occupied with managing his business concerns and increasingly depended on others for designs. Among the large-scale commissions his firm undertook after the turn of the century were the curtain for the National Theater in Mexico City, completed by 1911, the windows for the Catholic cathedral in St. Louis, and a glass mosaic mural designed by Maxfield Parrish (1870–1966) for the Curtis Publishing Company building in Philadelphia. Tiffany Studios, an outgrowth of Tiffany Glass and Decorating Company, continued until 1928, but it had significantly curtailed its operation and reduced its production by World War I.

Always conscious of his public image, Tiffany gave several lectures, the first in 1910, and financed several publications, among them his biography, written by Charles de Kay. In 1918, the artist founded the Louis Comfort Tiffany Foundation, a retreat for young artists, designers, and craftsmen, which operated out of Laurelton Hall, his home since 1905. When he died at the age of eighty-four, however, Tiffany's accomplishments as a designer had been over-shadowed by the functional aesthetic of the Bauhaus. Not until the 1950s was there a resurgence of interest in his work, spurred by an important series of exhibitions held in Europe and America. Tiffany's decorative work is represented in the Metropolitan Museum by two collections of glass, one given by Henry Osborne Havemeyer in 1896, and another by an anonymous donor with Tiffany family associations in 1955. Another group of objects, featuring examples of glass and enamel on copper, was given to the museum by the Tiffany Foundation in 1951.

BIBLIOGRAPHY: [Charles de Kay], *The Art Work of Louis C. Tiffany* (Garden City, N.Y., 1914). This appreciative book was based on interviews with the artist and contains chapters on various aspects of his career, including "Tiffany the Painter" // Louis Comfort Tiffany Foundation, *Catalogue of the Tiffany Gallery* [1918], pamphlet listing many of his watercolors and oils // René de Quélin, "A Many-Sided Creator of the Beautiful: The Work of Louis Comfort Tiffany as Viewed by an Associate," *Arts and Decoration* 17 (July 1922), pp. 176–177, gives particular attention to the artist's watercolors // William Macbeth, New York, *Retrospective Exhibition of Paintings by Louis Comfort Tiffany* (Dec. 9–29, 1924), lists oils and watercolors // Robert Koch, *Louis C. Tiffany, Rebel in Glass* (New York, 1964; rev. ed. 1966). Biography and discussion of Tiffany's work as an artist, designer, and decorator; heavily illustrated, with some color, and an extensive bibliography.

Snake Charmer at Tangier, Africa

Tiffany's fascination with exotic art and culture, particularly evident in his paintings of the 1870s and 1880s and in his decorative work, was encouraged by his contact with other artists and craftsmen. Edward C. Moore, the chief designer for his family's firm and a collector of oriental art, directed his attention to Islamic, Chinese, and Japanese art, stimulating his interest in non-European cultures. Later as a student in Paris,

Tiffany worked with Léon Belly, who specialized in Middle Eastern genre subjects, and in 1869, he made a sketching tour of Spain and North Africa with SAMUEL COLMAN, who introduced him to Islamic textiles.

Although the date on the canvas is illegible, *Snake Charmer at Tangier, Africa* was completed by 1872, when it was exhibited at Snedecor's Gallery in New York. Its rich colors and dramatic light effects are similar to those in paintings by Tiffany's American contemporaries, Colman

Tiffany, *Snake Charmer at Tangier, Africa.*

and William Sartain (1843–1924). The painterly application of pigment and choice of an exotic subject also recall the work of French orientalist painters. The composition resembles that of Jean Léon Gérôme's *The Snake Charmer* (Sterling and Francine Clark Art Institute, Williamstown, Mass.), and both works may well have a common source. Like Gérôme, Tiffany shows the snake charmer with his left arm raised and his back to the viewer, facing an audience positioned against a wall that limits spatial recession. Treating the subject less academically, however, Tiffany does not follow Gérôme's method of careful research and meticulous depiction.

Oil on canvas, 27½ × 38½ in. (69.9 × 97.8 cm.).
Signed and dated at lower left: Louis C. Tiffany—[illeg.].
REFERENCES: *New York Times*, Sept. 15, 1872, p. 3, praises it in Snedecor exhibition // R. W. de Forest, memo in MMA Archives, Nov. 16, 1921, offers choice of this or another painting on behalf of the Tiffany

Foundation and says that F. C. Jones and E. H. Blashfield have approved of the selection // R. Koch, *Louis C. Tiffany, Rebel in Glass* (1964; rev. ed. 1966), ill. p. 26, says exhibited at Centennial // G. Reynolds, Grey Art Gallery New York University, letter in Dept. Archives, August 11, 1978, provides information on early exhibition and references, dating it to 1872.
EXHIBITED: Snedecor's Gallery, New York, 1872 (no cat.) // Brooklyn Art Association, 1872, no. 262, as Snake Charmer at Tangier, Africa, for sale // Centennial Exhibition, Philadelphia, 1876, *Official Catalogue, Department of Art*, no. 429a // Louis Comfort Tiffany Foundation, Laurelton Hall, Oyster Bay, New York, 1918, *Catalogue of the Tiffany Gallery*, under oils, no. 3, misdates it 1905 // MMA, 1970, *19th Century America, Paintings and Sculpture*, exhib. cat. by J. Howat and N. Spassky (not in cat.).
EX COLL.: the artist, New York and Oyster Bay, until 1918; Louis Comfort Tiffany Foundation, Laurelton Hall, Oyster Bay, N.Y. 1918–1921; with Robert W. de Forest, New York, as agent, 1921.
Gift of Louis Comfort Tiffany Foundation, 1921.
21.170.

EDWIN LORD WEEKS

1849–1903

A native of Newtonville, near Boston, Massachusetts, the painter, illustrator, and author Edwin Lord Weeks was educated in Boston and Newton. In 1869, he began the first of many travels with a sketching trip to Florida; that same year he visited Surinam and other places in South America. On his return to Boston, he painted history pictures and landscapes, which his friend Samuel G. W. Benjamin (1837–1914) described as "pleasing woodland scenes." Between 1869 or 1870 and 1871, Weeks studied in Paris at the Ecole des Beaux-Arts under Jean Léon Gérôme and also in the atelier of Léon Bonnat. Perhaps inspired by Gérôme's exotic subjects, he traveled in North Africa, the Middle East, and Spain, accompanied for part of the trip by another artist, A. P. Close, who died in Beirut. In 1871, Weeks returned to Newtonville, where he opened a studio and married Frances Rollins Hale of Rollinsford, New Hampshire. The following year the couple joined the Scottish painter Robert Gavin for a trip to the Mediterranean and Morocco. Although little is known about Weeks's activities between 1872 and 1878, it is thought that he spent a good deal of time in Morocco. He also seems to have returned to Boston during this period; for in 1874 he was mentioned as having a studio decorated in the oriental manner there, and in 1876 he exhibited at the Boston Art Club. It was probably at this time that he prepared the illustrations that appear in C. J. Maynard's *The Naturalist's Guide in Collecting and Preserving Objects of Natural History, with a Complete Catalogue of the Birds of Eastern Massachusetts* (1877), which was published in Salem.

Returning to Paris by 1880, Weeks spent the remainder of his career as an expatriate. His travels during the 1880s are not well documented, but it is known that he spent some time in India. He was there for a year from 1882 to 1883 and returned to Jodhpur in 1887. In July 1892, he set out on an extended journey through Turkey, Persia, and India with Theodore Child, a scholar of Russian affairs. Weeks recorded the adventures of this trip and his impressions of the Middle East and Asia in a series of copiously illustrated articles that appeared in *Harper's* between 1893 and 1895 and later in book form as *From the Black Sea through Persia and India* (1896). During the 1890s, Weeks achieved international recognition as a writer and painter. In 1896, he was made a knight of the French Legion of Honor and, two years later, an officer of the Order of St. Michael of Bavaria.

Weeks's artistic development has not yet been thoroughly examined. Most of his works, particularly those dating from the 1890s, are unlocated, and of those that are located, few are dated. His pictures cannot be dated accurately by subject alone; for he seems to have based some of his large works on earlier drawings, sketches, and photographs. Beginning in the 1870s, when he assumed the realistic style and exotic subject matter of his teacher Gérôme, Weeks's development can be seen within the context of French academic painting. *Departure from the Stronghold* (Maryland art market) is perhaps typical of the painterly style that he favored during this decade. Works from the 1880s like *The Gate at the Fortress at Agra* (Union League of Philadelphia) and *The Great Mogul and His Court Returning from the Great Mosque at Delhi, India* (Portland Museum of Art, Maine) display a drier, more detailed

Weeks, *The Rajah Starting on a Hunt*.

realism, which may be the result of his experiments in photography. During the last years of his life, Weeks worked on an important series of paintings, *One Thousand and One Nights*, but these works remain unlocated.

Two years after his untimely death in 1903, his widow sold the contents of his Paris studio and some 277 paintings and sketches at auction in New York.

BIBLIOGRAPHY: Samuel G. W. Benjamin, "Edwin Lord Weeks," in *Our American Artists* (Boston, 1881), pp. 27–31. Discussion of training and early career // George William Sheldon, *Recent Ideals of American Art* (New York, 1888–1890), ill. opp. p. 8; pp. 14–15; ill. opp. p. 34; p. 38; ill. opp. p. 56; ill. p. 57; pp. 135–136; ill. opp. p. 142. Contains illustrations of many of Weeks's paintings // Edwin Lord Weeks, *From the Black Sea through Persia and India* (London, 1896). Combines nine articles that originally appeared in *Harper's New Monthly Magazine* 87–91 (Oct. 1893–Nov. 1895); copiously illustrated by the artist // American Art Association, New York, *Catalogue of Very Important Finished Pictures, Studies, Sketches and Original Drawings by the Late Edwin Lord Weeks*, sale cat. (March 15–17, 1905), with biographical introduction by Frank Millet // University Art Galleries, University of New Hampshire, Durham, *The Art of Edwin Lord Weeks (1849–1903)* (1976), preface by Susan C. Faxon; "Edwin Lord Weeks—His Life" by Kathleen Duff Ganley and Leslie K. Paddock; "Edwin Lord Weeks—His Art" by Kathleen Duff Ganley; chronology; discussion of works included in the exhibition; bibliography, including a list of published material by Edwin Lord Weeks; heavily illustrated.

The Rajah Starting on a Hunt

Weeks is known to have traveled to India in 1882–1883, 1887, and 1892. This unfinished painting, showing preparations for a hunting expedition in the courtyard of the palace of the Seths at Ajmer, appears to date from Weeks's trip of 1892. The architectural background is identical to an illustration from the artist's article "Notes on Indian Art" that appeared in *Harper's New Monthly Magazine* in September 1895. In this account of part of his journey of 1892, Weeks described the setting:

The palace of the Seths, at Ajmeer, is one of the most attractive modern instances of elaborate decoration. The façade of this palace, fronting one of the principal streets, is completely covered by tiers of projecting windows, of varying design, in which white alternates with brown stone, all remarkable for breadth and delicacy of treatment, and the whole pile is wonderfully light and airy in effect, while the principal courtyard within has some admirable oriel-windows, and the intervening wall spaces show much originality in their decoration (p. 585).

The size, complexity, and details of the painting suggest that it was painted during a long stopover on the trip, if not later, after the artist's return to Paris, from photographs, drawings, or oil sketches. Although the subject dates the picture to the 1890s, stylistically it is not unlike works that Weeks completed in the late

1880s. The intricate patterns created by colorful figures, animals, and birds in the foreground stand out in sharp relief against the sun-washed façade. The exotic subject, clear colors, strongly contrasting light effects, and the ambitious arrangement of the figures reflect the influence of Weeks's teacher Gérôme.

Oil on canvas, $39\frac{9}{16} \times 32$ in. (100.5 × 81.3 cm.).
Signed at lower left: E. L. Weeks. The initials E. L. are surrounded by a faintly painted hexagram enclosed in a circle.

RELATED WORK: *In the Court of the Palace of the Seths, Ajmeer*, engraving, depicts the same architectural setting as the painting but does not include figures or animals, and the lower left corner is obliterated by text, ill. in E. L. Weeks, *Harper's New Monthly Magazine* 91 (Sept. 1895), p. 581, and *From the Black Sea through Persia and India* (1896), p. 343.

REFERENCES: B. B[urroughs], *MMA Bull.* 10 (April 1915), p. 67, mentions it as part of the Mrs. Morris K. Jesup bequest // University Art Galleries, University of New Hampshire, Durham, *The Art of Edwin Lord Weeks (1849–1903)*, exhib. cat. by K. D. Ganley and L. K. Paddock (1976), ill. p. 15, places it with works executed during the 1880s, notes its detailed treatment and suggests influence of photography, says that no drawing survives for it.

EX COLL.: Morris K. Jesup, New York, died 1908; his wife, Maria DeWitt Jesup, New York, died 1914.

Bequest of Maria DeWitt Jesup, from the collection of her husband, Morris K. Jesup, 1915.

15.30.68.

WILLIAM MERRITT CHASE

1849–1916

Chase was a virtuoso artist who experimented in various mediums, including oils, tempera, pastels, and prints, producing a wide variety of subjects in an accomplished style. Born in Williamsburg (now Nineveh), Indiana, he received his first art instruction in 1867 in Indianapolis from Barton S. Hays (1826–1914), a portrait painter. Two years later, encouraged by Hays, he went to New York with a letter of introduction to Joseph O. Eaton (1829–1875), at whose suggestion he entered the school of the National Academy of Design, where he studied under Lemuel E. Wilmarth (1835–1918). Chase joined his family in 1871 in St. Louis, where he painted portraits and still lifes for local art patrons, whose financial assistance enabled him to go to Europe. In 1872, he entered the Royal Academy in Munich, which had replaced Düsseldorf as the German art center during the 1870s. There he studied with Karl Theodor von Piloty and Alexander von Wagner and came under the influence of the young realist Wilhelm Leibl. He assimilated the current taste for Spanish and Dutch painting, employing the dark palette favored by the Munich school and the bravura brushwork and broad handling of paint that would remain a characteristic feature of his style for the remainder of his career. In 1877, Chase traveled to Venice accompanied by the American painters FRANK DUVENECK and JOHN H. TWACHTMAN and worked there for nine months before returning to New York in 1878.

On his return, Chase took a studio in the famous Tenth Street Studio Building, which had been built two decades earlier to provide New York artists with studios and exhibition space. There he entertained his friends and fellow artists in a lavish studio filled with his extensive collection of paintings, curios, and objets d'art. Over the next ten years, Chase became very active in New York professional art organizations. In 1878, he participated in the first exhibition of the Society of American Artists, an organization begun by young European-trained artists who considered the National Academy of Design too conservative. He later served as the society's president. Chase was a founding member of the Society of Painters in Pastel and exhibited in their first exhibition in 1884. He was a member of the social Tile Club (1877–1886) and joined in many of its sketching trips. In 1886, he had his first one-man show at the Boston Art Club. Elected an associate member of the National Academy of Design in 1888, Chase became an academician two years later. During the 1880s, he also managed several trips to Europe, visiting Spain, Holland, France, and England.

Chase devoted much of his career to teaching. To quote the American critic Royal Cortissoz, "he is remembered both for what he did and for what he taught others to do" (Am. Acad. of Arts and Letters, *A Catalogue of an Exhibition of the Works of William Merritt Chase* [1928], p. 10). He taught at the Art Students League (1878–1885, 1886–1896, 1907–1912), the Brooklyn Art School, the Chicago Art Institute (1897), the Pennsylvania Academy of the Fine Arts (1897–1909), and the Chase School (later the New York School of Art and then Parsons School), which he founded in 1896. He conducted summer classes at Shinnecock, Long Island, between 1891 and 1902, and in the early 1900s, he took groups of students

to Europe. Chase's students included artists as diverse as IRVING WILES, Rockwell Kent (1882–1971), Arthur B. Carles (1882–1952), and Joseph Stella (1879–1946). Although his own painting style remained tied to representational realism, his emphasis on technique and the aesthetic qualities of art fostered a generation of modernists.

In his later years, Chase won wide recognition for his accomplishments as an artist and a teacher. He exhibited widely and won awards at home and abroad. In 1902, after the death of his friend Twachtman, he joined the Ten American Painters, a distinguished exhibition organization. He was also commissioned to paint a self-portrait for the collection of the Uffizi in Florence, an honor shared by few of his American contemporaries. His admiring students commissioned his friend JOHN SINGER SARGENT to paint his portrait in 1902 and presented it to the Metropolitan (q.v.). After his death in New York, Chase was extolled as a "painter's painter," a teacher, a collector, and a dynamic leader of American art.

BIBLIOGRAPHY: Katharine Metcalf Roof, *The Life and Art of William Merritt Chase* (New York, 1917). Includes an introduction by the artist's wife, Alice Gerson Chase, anecdotal reminiscences by the artist, letters from his friends, illustrations of paintings and sketches, a list of works in public collections, medals, and awards // "William Merritt Chase—Painter," *Index of Twentieth Century Artists* 2 (Nov. 1934), pp. 17–27, suppl., Reprint ed. with cumulative index. New York: Arno Press, 1970, pp. 270–280, suppl., pp. 286, 288. The most complete bibliography available, it lists awards and honors, affiliations, public collections that include his work, exhibitions, and reproductions of major works // John Herron Art Museum, Indianapolis, *Chase Centennial Exhibition, Commemorating the Birth of William Merritt Chase: November 1, 1849,* cat. by Wilbur D. Peat (1949). Includes biography and critical analysis, lists provenance, references, and exhibitions for those paintings included, and gives a checklist of his known works // Heckscher Museum, Huntington, N.Y., and the Parrish Art Museum, Southampton, N.Y., *The Students of William Merritt Chase,* exhib. cat. by Ronald G. Pisano (Sept. 28–Dec. 30, 1973). Includes biographical essays on many of Chase's students // M. Knoedler and Co., New York, *William Merritt Chase (1849–1916)* (a benefit for the Parrish Art Museum), exhib. cat. by Ronald G. Pisano (1976), also printed in *American Art Review* 3 (March–April 1976), pp. 32–48.

James Abbott McNeill Whistler

During the summer of 1885, Chase visited London on his way to Madrid, where he planned to study the work of Velázquez. In London he met JAMES MC NEILL WHISTLER, the American expatriate artist, whose work was familiar to him long before their meeting. This portrait documents the brief but tumultuous friendship of the two artists, who spent a month in London painting each other's portraits and then traveled to Belgium and Holland together at the end of the summer. Although they never saw each other after that time, Whistler's technical and formal innovations appear frequently in Chase's work, particularly in this portrait, where Chase not only depicts the appearance and personality of his subject but also mimics the distinctive style of portraiture that Whistler developed during the 1870s and early 1880s. Here, as in so many of Whistler's portraits, details of costume and setting are subordinated to strengthen the total impression created by the subject, a monumental figure who assumes an elegant pose and is silhouetted against an austere backdrop. The broad, free handling of paint, often applied in thin washes, and the low-key palette also recall Whistler's work during this period and remind us of the admiration for Velázquez shared by both Whistler and Chase.

Chase recorded his reminiscences about this visit to London and the circumstances under which he painted Whistler in an article which appeared in *Century Magazine* in 1910: "I felt Madrid calling me again and determined to be off; but he, noting my preparations, was

Chase, *James Abbott McNeill Whistler*.

instantly the charming, affectionate host. 'Don't go,' he urged, 'Stay, and we'll paint portraits of each other.' As usual, Whistler had his way. He had his way with respect to the portraits, too, I discovered. It was arranged that whichever was specially in the mood was to paint while the other posed. Whistler, I speedily found, was always 'specially in the mood,' and as a consequence I began posing at once, and continued to pose." A letter of August 8, 1885, that Chase sent to his future wife, Alice Gerson, suggests that he had wearied of posing for Whistler: "I really begin to feel that I never will get away from here." But he added: "I am getting on well with my portrait of Whistler which promises to be the best thing I have ever done." Whistler had a different opinion of the portrait, for he wrote to Chase shortly before that artist's departure for America: "neither master is really quite fit for public presentation as he stands on canvas at the present moment. So we must reserve them, screening them from the eye of jealous mortals on both sides of the Atlantic until they burst upon the painters in the swagger of completeness." Chase planned to bring both portraits back with him, but returned with only his portrait of Whistler, which was displayed in Boston and New York in spite of the subject's admonitions. In a letter to a friend published in the *New York Tribune*, Whistler called Chase's portrait a "monstrous lampoon" and asked "How dared he—Chase—to do this wicked thing? and I, who was charming and made him beautiful on canvass, the master of the avenues."

In his article in *Century Magazine*, Chase described his sitter's personality. "There are two distinct sides to Whistler, each one of which he made famous," wrote Chase. "He succeeded as few ever have in creating two distinct and striking personalities, although as unlike as the storied Dr. Jekyll and Mr. Hyde. One was Whistler in public—the fop, the cynic, the brilliant, flippant, vain and careless idler; the other was Whistler of the studio." In this portrait, Chase has portrayed the public Whistler, whom he described as "a dainty, sprightly little man, immaculate in spotless linen and perfect-fitting broadcloth. He wore yellow gloves and carried his wand poised lightly in his hand. He seemed inordinately proud of his small feet and slender waist; his slight imperial and black mustache were carefully waxed; his monocle was indispensable."

The portrait was later attacked by Whistler's

friend and biographer Joseph Pennell and by the modernist Max Weber (1881–1961), who called it "colorless and formless." Chase, however, esteemed the work, which he exhibited often and kept in his personal collection, until he sold it to William Hall Walker, reportedly under the condition that it eventually be given to the Metropolitan. The fate of Whistler's portrait of Chase is not known, but since Whistler was dissatisfied with it and Chase wrote to him on September 3, 1885, urging him "to give it up, and forget that it was ever begun," it seems likely that it was destroyed by the artist. Chase also executed *Whistler with the Wand* (unlocated) and a bust-length portrait that has been identified as Whistler (formerly coll. Dr. Chester J. Robertson, Pelham Manor, N.Y.).

Oil on canvas, 74⅛ × 36¼ in. (188.3 × 92.1 cm.).

Signed, dated, and inscribed at upper left: To my friend Whistler / W^m M. Chase / London 1885.

REFERENCES: W. M. Chase to A. Gerson, August 8, 1885, in William Merritt Chase Papers, Roger Storm Collection, microfilm N/69–137, Arch. Am. Art (quoted above) // J. M. Whistler to W. M. Chase [August or Sept. 1885], and W. M. Chase to J. M. Whistler, Sept. 3, 1885, Birnie Philip Collection. BP 11 C/60, Library, University of Glasgow, discuss the portraits (quoted above) // R. Blum to Virginia [Gerson?], Sept. 22 [1885], Misc. MS Blum, D8, Arch. Am. Art, says "Well I suppose you have seen Mr. Chase by this time that is I suppose he has condescended to show himself. He must be quite unbearable since Whistler painted his portrait" // *New York Tribune*, Oct. 12, 1886, p. 1, publishes Whistler's letter (quoted above) // *Art Review* 1 (Feb. 1887), p. 20, describes it as "a smoky vision which leaves a vivid impression of a long lank form, a Mephistophelean face surmounted by a white plume, and a long wand. As for the deep study of character, it is not asked for" // *Art Amateur* 16 (April 1887), p. 100, notes "Of the many portraits, that of Whistler interested most people. The subject himself protests against it, and it is not surprising. He is hoisted on his own petard. At first sight the picture certainly does look like a caricature of Whistler's person as well as his method, but those who know the eccentric genius will recognise it to be the truth—the harsh truth—neither more or less" // C. Cook, *Art and Artists of Our Time* (1888), 3, ill. p. 257 // *New York Commercial Advertiser*, March 8, 1889, [p. 4], mentions that Chase is exhibiting portraits of Whistler // J. M. Whistler, *The Gentle Art of Making Enemies* (1890; 1892), pp. 184–185, gives extracts from his 1886 letter // E. G. Kennedy to J. M. Whistler, Feb. 1901 (copy), offers explanation for Chase's behavior, and Whistler to Kennedy, April 17, 1901, Whistler Papers, Manuscript Division, NYPL, expresses his anger at Chase's behavior and Kennedy's

inability to control him. (Portraits of Edward G. Kennedy by both Chase and Whistler are in MMA [qq.v.].) // F. U. De Voll, "Reminiscences of a Student," n.d., typescript in Chase Papers, N/69–137, Arch. Am. Art, writes that "soon after Whistler passed on, Mr. Chase gave a most interesting account of their art life together [,] and the portrait of Whistler, full length standing figure, which he, Mr. Chase, painted of his friend was on exhibition at the 'School' at the same time" // J. W. McSpadden, *Famous Painters of America* (1907; 1916), pp. 337–339, discusses // E. R. and J. Pennell, *The Life of James McNeill Whistler* (1908), 2, pp. 29–30, discuss the portraits painted by Chase and Whistler; (6th ed., 1919), pp. 235–236 // *Academy Notes* 4 (Feb. 1909), p. 144, discusses the painting and mentions that Chase was expected to give a lecture on Whistler in Buffalo in Jan. 1909; ill. p. 145; (March 1909), p. 176, discusses Chase's lecture // K. M. Roof, *Craftsman* 18 (April 1910), ill. p. 40 // W. M. Chase, *Century Magazine*, n.s. 58 (June 1910), ill. p. 218; pp. 220, 222 (quoted above), also includes Whistler's 1886 letter // *Outlook* 114 (Nov. 8, 1916), p. 537 // *Literary Digest* 53 (Nov. 11, 1916), p. 1251 // H. Tyrrell, *New York World*, Nov. 12, 1916, magazine section, p. 2, discusses the painting // *Fine Arts Journal* 34 (Nov. 1916), p. 497 // K. M. Roof, *Life and Art of Chase* (1917), pp. 112, 114, quotes Chase's letters to A. Gerson; pp. 115, 121, 124–125, reprints Chase's comments from *Century Magazine*; pp. 139–145, discusses portrait and quotes letter from Whistler in which he suggests they should both refrain from displaying the portraits (quoted above); pp. 288–289, calls it the "most brilliant" of his male portraits, says that "it is even touched with the very art personality of the subject" // *Century Magazine*, n.s. 71 (April 1917), ill. p. 839 // *New York Sun*, Dec. 30, 1917, sec. 5, p. 12, publishes letter from J. Pennell which condemns the portrait and reply by H. McBride; Feb. 17, 1918, sec. 5, p. 24, contains letter from J. Pennell asking McBride and readers their opinion of the portrait; March 10, 1918, sec. 5, p. 18, prints letter from M. Weber which condemns it and reply by McBride // A. E. Gallatin, *Portraits of Whistler* (1918), p. 14, calls it "an excellent piece of work" and quotes Whistler's comment on it; p. 39, ill. no. 56, states that William Hall Walker purchased it from the artist // E. R. and J. Pennell, *Whistler Journal* (1921), p. 8, mention the "weak caricature now at the Metropolitan which could so much more easily have been spared" // *Mentor* 12 (Oct. 1924), ill. p. 32 // R. E. Jackman, *American Arts* (1928), p. 111; pl. XLI // *Connoisseur* 88 (Nov. 1931), ill. p. 319; p. 345, discusses // E. Alexander, *American Magazine of Art* 27 (Sept. 1934), suppl. p. 17 // *Index of Twentieth Century Artists* 2 (Nov. 1934), p. 27, lists exhibitions and references // A. Burroughs, *Limners and Likenesses* (1936), p. 188; pl. 167 // E. Neuhaus, *World of Art* (1936), ill. p. 145 // M. T. Buel, letter in MMA Archives, Oct. 19, 1937, states that the painting was sold to a great admirer of Whistler's who promised

that it would eventually be given to MMA // F. F. Sherman, *Art in America* 28 (July 1940), p. 135 // J. T. Flexner, *Art News* 48 (Dec. 1949), p. 34 // M. S. Young, *Apollo* 76 (May 1962), ill. p. 191; p. 193, discusses // H. S. Francis, *Bulletin of the Cleveland Museum of Art* 52 (Jan. 1965), p. 20 // Wildenstein Galleries, New York, and Philadelphia Museum of Art, *From Realism to Symbolism: Whistler and His World* (exhibition organized by Department of Art History and Archaeology, Columbia University, and the Philadelphia Museum of Art) (1971), entry by L. F[erber], pp. 66–67, discusses portrait and the relationship between the artist and sitter // A. D. Milgrome, "The Art of William Merritt Chase," Ph.D. diss., University of Pittsburgh (1969), 1, p. 197, no. 119, lists it // M. F. MacDonald, University of Glasgow, letter in Dept. Archives, Nov. 27, 1974, gives references.

EXHIBITED: Boston Art Club, 1886, *Exhibition of Pictures, Studies and Sketches by Mr. Wm. M. Chase of New York City*, no. 6 // Moore's Art Galleries, New York, 1887, *Paintings by Mr. William M. Chase*, no. 111, lent by William Merritt Chase // Inter-State Industrial Exposition, Chicago, 1888, *Catalogue of the Paintings Exhibited by the Inter-State Industrial Exposition, Sixteenth Annual Exhibition*, no. 75 // St. Louis Exposition and Music Hall Association, 1892, *Catalogue of the Art Collection*, no. 33 // PAFA, 1896–1897, no. 55 // Cincinnati Art Museum, 1908, *Fifteenth Annual Exhibition of American Paintings*, no. 5 // John Herron Art Museum, Indianapolis; Albright Art Gallery, Buffalo; Cincinnati Art Museum; St. Louis Museum of Fine Arts, 1909, *A Collection of Oil Paintings by William Merritt Chase, N.A.*, no. 24 // National Arts Club, New York, 1910, *William Merritt Chase Retrospective Exhibition*, no. 93, lent by William Merritt Chase // Worcester Art Museum, Mass., 1912, *Fifteenth Annual Exhibition of Oil Paintings*, no. 8 // Panama-Pacific International Exposition, San Francisco, 1915, *Catalogue Deluxe of the Department of Fine Arts . . .*, ed. by J. E. D. Trask and J. N. Laurvik, 1, no. 3759, ill. opp. p. 26; p. 27, discusses // John Herron Art Museum 1949, *Chase Centennial Exhibition*, cat. by W. D. Peat, no. 16, provides references and gives exhibitions // Art Gallery, University of California, Santa Barbara; La Jolla Museum of Art; California Palace of the Legion of Honor, San Francisco; Seattle Art Museum; Gallery of Modern Art, New York, 1964–1965, *The First West Coast Retrospective Exhibition of Paintings by William Merritt Chase (1849–1916)*, no. 10 // Brooklyn Museum; Virginia Museum of Fine Arts, Richmond; California Palace of the Legion of Honor, San Francisco, 1967–1968, *Triumph of Realism*, no. 60 // National Portrait Gallery, Washington, D.C., 1968, *This New Man*, comments by O. Handlin, p. 50, discusses // National Gallery of Art, Washington, D.C.; City Art Museum, St. Louis; Seattle Art Museum, 1970–1971, *Great American Paintings from the Boston and Metropolitan Museums*, exhib. cat. by T. Maytham, no. 72, p. 115, discusses.

Ex COLL.: the artist, New York, 1885—at least 1915; William H. Walker, New York and Great Barrington, Mass., by 1916–1918.

Bequest of William H. Walker, 1918.

18.22.2.

Mrs. Chase in Prospect Park

The painting depicts the artist's wife, Alice Gerson Chase (ca. 1866–1927), in a rowboat on the lake in Prospect Park, Brooklyn. According to the artist's biographer, Katharine Metcalf Roof (*Life and Art of Chase* [1917], pp. 151–152), Chase painted his sketches of Prospect Park between 1886 or 1887, when the newly married couple moved to Brooklyn, and 1891. Later in the 1890s he painted similar scenes in Manhattan's Central Park. In this painting, the artist shows an impressionist's interest in reflected light and flickering shadows. He retains, however, the dark-toned palette and fluid brushwork of his Munich period.

Mrs. Chase in Prospect Park is inscribed to the artist J. CARROLL BECKWITH, who had painted similar park subjects as early as 1880. Chase and Beckwith met in the autumn of 1878, when they were both returning to New York from their studies in Europe. "We had exhaustive consultations regarding our future," Beckwith reminisced about their youthful aspirations. "We felt convinced that at the beginning we would not be able to earn our living by our brush. . . . [but] Chase said with deep determination, '. . . I must continue to paint'" (*American Art News* 15 [Nov. 4, 1916], p. 4). During the 1880s, both artists were able to support themselves with portrait commissions and by working as teachers, primarily at the newly founded Art Students League. Chase and Beckwith were at the center of artistic developments in New York. Among their most important collaborations was the organization of the Bartholdi Pedestal Fund Art Loan Exhibition, held in 1884, which featured works by such impressionists as Manet and Degas. Chase's popularity and artistic achievements soon eclipsed those of Beckwith, but the Metropolitan painting documents a friendship that remained strong until Chase's death in 1916.

Oil on panel, 13¾ × 19⅝ in. (34.9 × 49.9 cm.).

Signed and inscribed at lower right: To my friend J. Carroll Beckwith / Wm M. Chase.

REFERENCES: *American Art Annual* 24 (1927), p. 453, notes sale to Chester Dale and price // John Herron Art Institute, Indianapolis, *Chase Centennial Exhibition*, cat. by W. D. Peat (1949), includes it in a checklist under landscapes as On the Lake In Prospect Park, Mrs. Chase, owned by Chester Dale // M. L. D'Otrange-Mastai, *Connoisseur* 139 (June 1957), ill. p. 269 // A. D. Milgrome, "The Art of William Merritt Chase," Ph.D. diss., University of Pittsburgh, 1969, 1, pp. 51–52, compares it to Monet's and Renoir's work at Argenteuil, noting its greater "precision"; p. 203, includes it as no. 53 under female portraits in a checklist of Chase's work; mistakenly lists it as in the Chester Dale Collection at the National Gallery of Art, Washington, D.C.

EXHIBITIONS: Union League Club, New York,

Chase, *Mrs. Chase in Prospect Park*.

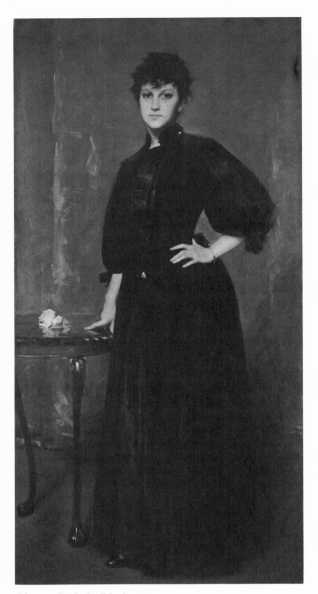

Chase, *Lady in Black.*

1937, *American Paintings from the Chester Dale Collection,* no. 34 // Parrish Art Museum, Southampton, N.Y., 1957, *William Merritt Chase, 1849–1916: A Retrospective Exhibition,* no. 39, as lent by National Gallery of Art, Washington, D.C., Chester Dale Collection // M. Knoedler and Co., New York, 1976, *William Merritt Chase (1849–1916)* (a benefit for the Parrish Art Museum), exhib. cat. by R. G. Pisano, no. 33.

Ex coll.: J. Carroll Beckwith, New York, until 1917; his wife, Bertha M. Beckwith, New York, 1917–1926 (sale, Silo's, New York, November 19, 1926, no. 389, as *Chase's Wife on the Lake in Prospect Park,* 13½ × 19½, $250); Chester Dale, New York, 1926–1962.

Bequest of Chester Dale, 1962, the Chester Dale Collection
63.138.2.

Lady in Black

Mrs. Leslie J. Cotton (1868–1947), born Marietta Benedict, was a student of Chase's and later a successful society portraitist in New York and London. She posed for the artist in 1888 at the age of nineteen, and Chase described the circumstances:

It takes inspiration to produce a masterpiece. One morning a young lady came into my Tenth Street studio, just as I was leaving for an art class in Brooklyn. She came as a pupil but the moment she appeared before me I saw her only as a splendid model. Half way to the elevated station I stopped, hastened back, and overtook her. She consented to sit for me; and I painted that day without interruption, till late in the evening. The result is the "Lady in Black," now hung in the Metropolitan Museum. Such a model is a treasure-find. It is the personality that inspires, and which you depict upon the canvas. That is real art; skill in construction we will take for granted. But to make a vivid personality glow, speak, *live* upon the canvas that is an artist's triumph.

Like so many of Chase's portraits of family, friends, and students, *Lady in Black* transcends individual characterization and functions as an aesthetic statement, an opportunity for the artist to explore the formal problems of color and design. Marietta Benedict Cotton, dressed in a black dinner dress, rests her right hand on a Chippendale revival table, on which a single pink rose adds a color note to an otherwise subtly neutral color scheme. "His aim in portraiture, as in all else, was the triumph of paint . . . he does call forth our enjoyment in the things which he enjoyed—play of light, material surfaces, richness, voluptuous, even barbaric color coupled with exquisite refinement of tone," wrote HOWARD RUSSELL BUTLER (*Scribner's Magazine* 61 [Feb. 1917], p. 257). Mrs. Cotton was the model for another work by Chase, *Portrait of a Lady in Pink,* ca. 1888 (Museum of Art, Rhode Island School of Design), in which she is shown seated and in profile.

Oil on canvas, 74¼ × 36 5/16 in. (188.6 × 92.2 cm.).
Signed at upper right: W^m M. Chase.
RELATED WORK: Henry Wolf, *Portrait of a Lady in Black,* engraving, 7 13/16 × 4 1/16 in. (19.8 × 10.3 cm.), ill. in *Harper's Monthly Magazine* 121 (Sept. 1910), opp. p. 590.

REFERENCES: W. M. Chase, "How I Painted My Greatest Picture," article n.d., clipping file, Corcoran Gallery of Art, Washington, D.C. (quoted above) // *Art Amateur* 20 (Jan. 1889), p. 29, notes in a review of the seventh annual Autumn Exhibition at the NAD, that "Mr. Chase, the President of the Society of American Artists, makes much more of a show; in the South Gallery in his full-length portrait of Mrs. Leslie Cotton, in a black dress narrow in the skirts and very full in the sleeves, with one hand on her hip and the other on the slim-legged table beside her" // *American Art News* 3 (Dec. 31, 1904), [p. 2], says that the sitter was nineteen years old when the portrait was painted // J. W. McSpadden, *Famous Painters of America* (1907; 1916), ill. opp. p. 342; p. 346, discusses // C. H. Fiske, *Chautauquan* 50 (March 1908), ill. 75 // *Palette and Bench* 1 (Oct. 1908), ill. p. 3 // L. Mechlin, *Studio* 48 (Dec. 1909), ill. p. 186 // *International Studio* 39 (Jan. 1910), ill. p. 186 // W. S. Howard, *Harper's Monthly Magazine* 121 (Sept. 1910), p. 590, says of it and other portraits: "with all he may do of set purpose in recording what his eye sees, more is accomplished by the eliminating and harmonizing process of the unconscious mind in its effort to express the hidden import of character"; opp. p. 590, illustrates Wolf's engraving of it // J. Howard, *Arts and Decoration* 1 (June 1911), ill. p. 339 // J. W. Alexander, *Art and Progress* 3 (May 1912), ill. p. 577 // MMA letter to W. M. Chase, Nov. 21, 1913, MMA Archives, requests the artist to examine it since "the surface has disintegrated" // Chase letter in Dept. Archives, Dec. 27, 1913, expresses his pleasure that the picture has been restored to its original condition // *Nation* 103 (Nov. 2, 1916), p. 428 // D. Phillips, *American Magazine of Art* 8 (Dec. 1916), ill. p. 47 // K. M. Roof, *Life and Art of Chase* (1917), p. 158, states that the painting was executed in 1888 and given to MMA in 1891 // *MMA Bull.* 12 (May 1917), p. 118 // MMA, *Loan Exhibition of Paintings by William M. Chase* (1917), p. xxiv // *Literary Digest* 85 (April 4, 1925), p. 35 // F. J. Mather, *The American Spirit in Art* (1927), ill. p. 96 // R. C. Smith, *Life and Works of Henry Wolf* (1927), p. 90, lists engraving of it // *Index of Twentieth Century Artists* 2 (Nov. 1934), p. 25, gives references to it // F. J. Mather, Jr., *Magazine of Art* 39 (Nov. 1946), ill. p. 303 // Grandson of sitter, orally, April 2, 1947, stated that sitter was born in 1868 and was still alive // R. B. Hale, *MMA Bull.* 12 (March 1954), p. 177 // M. S. Young, *Apollo* 76 (May 1962), ill. p. 190 // A. D. Milgrome, "The Art of William Merritt Chase," Ph.D. diss., University of Pittsburgh, 1969, 1, p. 77, compares it to Madame Gautreau by J. S. Sargent (q.v.); p. 208, lists it as no. 46 // M. Bordes, American Wing, MMA, orally, Sept. 24, 1974, identified the table in the picture as "an 1880s or early 1890s interpretation of an eighteenth-century Chippendale table" // M. Dalton and S. Blum, Costume Institute, MMA, orally, Oct. 9, 1974, said the sitter's dinner dress with its standup collar, reduced bustle, and full sleeves was progressive for the period.

EXHIBITED: NAD, Autumn 1888, no. 315, as Portrait of Mrs. C. // American Art Association, New York, 1890, *Catalogue of Paintings Exhibited by the Following American Artists, J. Wells . . . Carleton Wiggins*, no. 207, as Portrait of Mrs. C., or no. 220, as Portrait of a Lady in Black // John Herron Art Museum, Indianapolis, 1949, *Chase Centennial Exhibition*, cat. by W. D. Peat, ill. no. 23, as Lady in Black (Mrs. Leslie Cotton), dates it 1888, lists exhibitions, includes in unnumbered checklist // M. Knoedler and Co., New York, 1976, *William Merritt Chase (1849–1916)* (a benefit for the Parrish Art Museum), exhib. cat. by R. G. Pisano, no. 38; pp. 38, 42, discusses and quotes undated clipping in the Corcoran Gallery of Art; ill. p. 41.

Gift of William M. Chase, 1891.

91.11.

Carmencita

The dancer Carmencita, known as "The Pearl of Seville," was born Carmen Dauset (or Dausset) in 1868 in Almería, Spain, and appeared on stage for the first time at the Cervantes Theater in 1880. She spent the next four years in her native land, where she was famous for dancing the Petenera and the Vito. After a brief appearance in Paris in 1884, she returned to Spain, performing in Madrid and Valladolid. By the end of the decade, she was in Paris again, this time at the Nouveau Cirque. In April 1899, she signed a contract with the manager Bolossy Kiralfy, agreeing to appear in America, where she made her debut at Niblo's Garden in New York in the summer of 1889—unfortunate timing since many of the city's citizens were vacationing out of town. Carmencita then made a tour of the West, appearing in San Francisco and Sacramento, and returned to New York in February 1890. New Yorkers were soon flocking to Koster and Bial's Concert Hall on 23rd Street near Sixth Avenue, where Carmencita performed each night, relieving the otherwise monotonous show. A contemporary critic described her much as she appears in Chase's painting:

Carmencita is dressed in a long dancing costume, freely bespangled with ornaments and glittering coins, with a profusion of white petticoats just short enough to disclose a pair of exquisitely formed ankles and high-heeled boots. She poises on one foot for a moment . . . and . . . flutters across the stage in graceful abandon. Now it is the brilliant quivering of a hummingbird shaking its wings which catches the eye. Then it is the grand flexibility of a perfect physique, the constant changing of attitudes, the kaleidoscopic

scintillations of cultured grace and the bewildering whirls which charm the club man in the main hall, or cause the natural color to come to the cheeks of the fair occupants of the half-draped boxes ("Graceful Carmencita," n.d., Dance Clipping File, Lincoln Center, NYPL).

Enormously popular, Carmencita was besieged with requests for private performances. The painter J. CARROLL BECKWITH was among the first to invite her to dance in his studio. JOHN SINGER SARGENT, who was already at work on a portrait of Carmencita which he finished later that year (Louvre, Paris), wanted her to dance for Isabella Stewart Gardner and some friends. Perhaps he was hoping to sell his portrait to the prominent Boston collector. Realizing that his own studio was too small and dark, however, Sargent wrote to Chase in March 1890: "Would you be willing to lend your studio for the purpose

Chase, *Carmencita*.

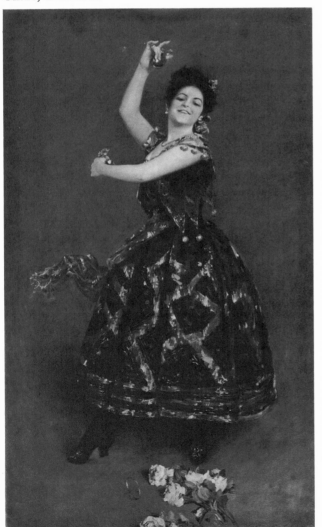

and be our host . . . ? We would each of us invite some friends, and Mrs. Gardner would provide the Carmencita [,] & I the supper and whatever other expenses there might be. I only venture to propose this as I think there is some chance of your enjoying the idea and because your studio would be such a stunning place."

Carmencita gave a memorable performance in Chase's Tenth Street studio on the evening of April 1, 1890. Chase and Sargent prepared a stage for her by placing a square cloth on the floor directly in front of a white canvas backdrop. Her accompanists—four Spanish musicians who played mandolins and guitars—were seated on a sofa at the left of the stage. The evening, however, did not begin well. Carmencita arrived wearing an excessive amount of makeup and with uncombed, frizzed hair. She was in a surly mood and was barely gracious to the guests, although once she began to dance, her attitude improved. Her small audience responded enthusiastically; the ladies even removed their jewels and threw them at her feet.

The most positive result of the evening, and of a second performance that Carmencita gave at Chase's studio, was that Chase began work on a portrait of the dancer, perhaps in an attempt to rival Sargent. In contrast to Sargent's more sedate presentation, Chase depicts Carmencita in motion, her eyes flashing and castanets clicking. He captures the spirit of the occasion by including a gold bracelet and a colorful bouquet of flowers tossed at the dancer's feet. The snapshot quality of the pose has led to speculation that Chase worked from photographs by Sarony, but no known photographs show the pose or costume he selected. Furthermore it is known that the dancer posed for the artist on several occasions.

Carmencita remained in America during the early 1890s and then returned to Spain for some years. The events of the final years of her life remain somewhat obscure. In July 1905, Oscar Hammerstein brought her back to New York for a brief appearance, but she never achieved her former success. She is reported to have died shortly thereafter on a tour in South America.

Oil on canvas, 69⅞ × 40⅞ in. (177.5 × 103.8 cm.). Signed at lower right: Wᵐ M. Chase.

REFERENCES: J. S. Sargent to W. M. Chase [late March 1890], William Merritt Chase Papers, Roger Storm Collection, microfilm N/69–137, Arch. Am. Art, asks for use of Chase's studio (quoted above) // J. Ramirez, *Carmencita, the Pearl of Seville* (1890),

pp. 122–123, discusses occasion for the painting // American Art Galleries, New York, *Illustrated Catalogue of the Private Collection of Modern Paintings ... Collected by the Late Alexander Blumenstiel*, sale cat. (1906), p. 104 // *American Art Annual* 6 (1907–1908), p. 46, lists it in Blumenstiel sale // *Palette and Bench* 1 (Oct. 1908), ill. p. 5 // *Literary Digest* 53 (Nov. 11, 1916), ill. p. 1252 // G. Beal, *Scribner's* 61 (Feb. 1917), p. 258 // Roof, *Life and Art of Chase* (1917), pp. 155–158, discusses the painting and publishes Sargent's letter to Chase // L. M. Bryant, *American Pictures and Their Painters* (1921), pp. 159–160, compares Chase's painting to Sargent's // L. R. McCabe, letter in Dept. Archives, Feb. 12, 1922, recalls seeing the painting in Chase's studio during the early 1890s and says that she has a letter from Sargent in which he said that he did not know that Chase also painted Carmencita; *New York Times*, July 8, 1923, ill. p. 4; p. 23, discusses // W. H. Downes, *John S. Sargent* (1925), pp. 31–32, discusses sitter and occasion of her posing // M. Carter, *Isabella Stewart Gardner and Fenway Court* (1925), pp. 117–118, discusses occasion for the painting // H. Gerwig, *Fifty Famous Painters* (1926), ill. opp. p. 384 // E. Charteris, *John Sargent* (1927), pp. 110–113, discusses sitter and occasion for her posing // *Index of Twentieth Century Artists* 2 (Nov. 1934), p. 24, lists references and exhibitions // C. M. Mount, *John Singer Sargent* (1955; 1969), pp. 164–174, establishes that Sargent's picture was begun before Chase's, notes that Chase decided to paint it when the sitter danced in his studio, says Chase wanted it to compete with Sargent's, and that since the dancer would only pose a couple of times, Chase finished it from photographs by Sarony; pp. 414–415, gives sources for information // M. S. Young, *Apollo* 76 (May 1962), p. 191; ill. p. 193 // L. H. Tharp, *Mrs. Jack* (1965), pp. 143–144, describes occasion for painting // G. McCoy, *Arch. Am. Art Jour.* 6 (Jan. 1966), p. 8, discusses it // M. S. Haverstock, *Art in America* 54 (Sept.–Oct. 1966), p. 55, discusses; ill. p. 56 // A. D. Milgrome, "The Art of William Merritt Chase," Ph.D. diss., University of Pittsburgh, 1969, 1, pp. 200–201, lists it as no. 10 // R. Ormond, *John Singer Sargent* (1970), ill. p. 83; pp. 246–247.

EXHIBITED: St. Louis Exposition and Music Hall, 1891, *Catalogue, Art Department*, no. 240, as Carmencita // John Herron Art Museum, Indianapolis, 1949, *Chase Centennial Exhibition*, cat. by W. D. Peat, no. 27, lists references and exhibitions, includes it in un-numbered checklist // Parrish Art Museum, Southampton, N.Y., 1957, *William Merritt Chase, 1849–1916: Retrospective Exhibition*, no. 66 // National Portrait Gallery, Washington, D.C., 1971, *Portraits of the American Stage, 1771–1971* (An Exhibition in Celebration of the Inaugural Season of the John F. Kennedy Center for the Performing Arts), cat. by M H. Fabian, no. 33, p. 76; ill. p. 77 // M. Knoedler and Co., New York, 1976, *William Merritt Chase (1849–1916)* (a benefit for the Parrish Art Museum), exhib. cat. by R. G. Pisano, no. 49.

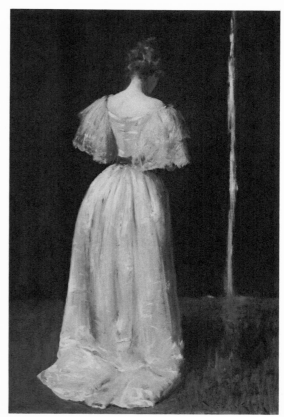

Chase, *Seventeenth Century Lady*.

Ex COLL.: Alexander Blumenstiel, New York, died 1905 (sale, American Art Galleries, New York, Feb. 15, 1906, no. 104, as Carmencita, 70 × 40 in., $220); with L. A. Lanthier, New York, 1906; Sir William Van Horne, 1906.

Gift of Sir William Van Horne, 1906.
06.969.

Seventeenth Century Lady

Although the figure is in contemporary dress, the title of this painting of about 1895 recalls Chase's interest in the old masters, particularly those of the baroque period. "I studied the works of the masters in many cities to which I traveled, and made copies after Hals, Velasquez, Rembrandt, and others," said Chase, in an interview with Walter Pach.

But, in my great desire to build my art on the eternal principles which govern theirs, I fell almost unavoidably into an error. This was brought home to me in striking fashion by Alfred Stevens, who said to me . . .

"Chase it is good work, but don't try to make your pictures look as if they had been done by the old masters." I saw the truth of his remark, modern conditions and trends of thought demand modern art for their expression. I saw a new light in the sublime example of Velasquez [who]—with all his acquirement from the masters who had gone before him—felt the need of choosing new forms and arrangements, new schemes of color and methods of painting, to fit the time and place he was called on to depict (*Outlook* 95 [June 25, 1910], p. 442).

In *Seventeenth Century Lady* Chase uses the fluid bravura brushwork and dramatic light effects that he acquired from studying the old masters. He places the figure with face averted and back turned to the spectator—a pose which suggests a contemplative mood and allies the painting to the work of such quietists as THOMAS DEWING.

A label on the back of the frame reads: "May 9, 1896. / Painting by William M. Chase / entitled Seventeenth Century Lady. / Presented to Arthur H. Hearn / on his birthday / by his father George A. Hearn."

Oil on canvas, 36½ × 23¾ in. (92.7 × 60.3 cm.).
Signed at lower right: Wᵐ M. Chase.
REFERENCES: Photograph, n.d., Misc. MSS., William Merritt Chase Papers, Roger Storm Collection, microfilm N/69–137, Arch. Am. Art, shows the framed picture in the artist's studio // *The George A. Hearn Gift to the Metropolitan Museum of Art* . . . (1906), unnumbered pl. // *George A. Hearn Gift to the Metropolitan Museum of Art* . . . (1913), ill. p. 69 // MMA, *Loan Exhibition of Paintings by William M. Chase* (1917), p. xxxiv, lists it // Newhouse Galleries, St. Louis, *Paintings by William Merritt Chase, N.A., LL.D., Memorial Exhibition* (1927), unpaged // John Herron Art Museum, Indianapolis, *Chase Centennial Exhibition,* cat. by W. D. Peat (1949), includes it in unnumbered checklist // A. D. Milgrome, "The Art of William Merritt Chase," Ph.D. diss., University of Pittsburgh, 1969, I, p. 65, discusses; p. 211, lists it as no. 110 // M. Dalton and S. Blum, Costume Institute, MMA, orally, Oct. 9, 1974, said the costume, from the early 1890s, is made of satin with lace trim.

EXHIBITED: Lotos Club, New York, 1901, *American Paintings from the Collection of George A. Hearn,* no. 12 // American-British Art Center, New York, 1948, *William M. Chase, 1849–1916: A Selected Retrospective Exhibition of Paintings,* no. 1.

EX COLL.: George A. Hearn, New York, before May 9, 1896; his son, Arthur H. Hearn, New York, 1896–1906; George A. Hearn, New York, 1906.

George A. Hearn Fund, 1906.

06.1220.

Edward Guthrie Kennedy

Born in Ireland, Edward Guthrie Kennedy (1849–1932) immigrated to the United States at the age of eighteen. After a decade in the art business in Boston, he joined the New York art gallery Wunderlich and Company, which now bears his name. In 1916, he resigned from the gallery to devote himself to his collections of cloisonné and Japanese robes, which he later presented to the Metropolitan.

Chase's portrait of Kennedy was painted before 1895, when it was exhibited at the National Academy of Design. By this date, Chase and Kennedy were friends as well as professional associates, a relationship illustrated by a note that the artist wrote to Kennedy in London the following year: "I am so disappointed not to find you here . . . I would have liked to have seen the exhibitions with you. . . . I shall have much to tell you when we meet again" (W. M. Chase to E. G. Kennedy, May 22, 1896, Whistler Papers, Manuscript Division, NYPL). In the same letter, Chase asked Kennedy to convey his condolences to their mutual acquaintance JAMES MCNEILL WHISTLER, whose mother had died recently. Until Whistler's death in 1903, Kennedy served as an intermediary

Chase, *Edward Guthrie Kennedy.*

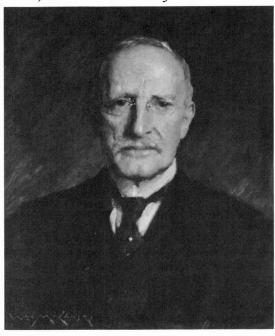

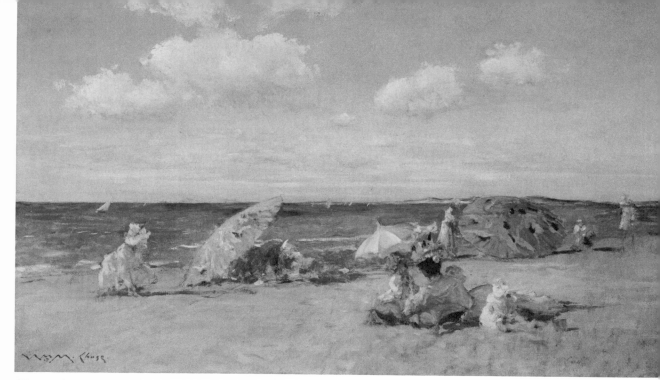

Chase, *At the Seaside*.

between these two artists, who had a falling out in 1885 after painting portraits of each other. The temperamental Whistler considered Chase's portrait of him (q.v.) a "monstrous lampoon" and was horrified every time Chase exhibited it or presented one of his entertaining public lectures about his experiences with Whistler.

The Metropolitan also owns a full-length portrait of Kennedy by Whistler (q.v.) painted in 1895, the same year that Chase first exhibited this bust-length portrait. Given the great professional rivalry between Chase and Whistler, the portraits of Kennedy may well have been another round in their artistic duel.

In this portrait, Chase employs the dark palette and bust-length frontal pose popularized by the German realist Wilhelm Leibl, with whom he associated during his student days in Munich in the 1870s. Like his contemporary JOHN SINGER SARGENT, Chase experimented with a broad range of subject matter and produced a large number of commissioned portraits, the most sensitive of which are those of his friends and family. "It is the personality that inspires and which you depict upon the canvas," William H. Downes quotes the artist as stating. "To make a vivid personality glow, speak, live upon the canvas—that is the artist's triumph" (*International Studio* 39 [Dec. 1909], p. xxx).

Oil on canvas, 22 × 17⅞ in. (55.9 × 45.4 cm.).
Signed at lower left: W^m M. Chase.
REFERENCES: E. H. Bell to E. G. Kennedy, Oct. 16, 1895, Kennedy Papers, Manuscript Division, NYPL, requests its loan for exhibition at NAD // Kennedy Galleries, New York, letters in Dept. Archives, Jan. 11, Nov. 12, 1974, give its provenance.

EXHIBITED: NAD, 1895, *Loan Exhibition of Portraits* (for the Benefit of St. John's Guild and the Orthopaedic Hospital), no. 64, as E. G. Kennedy, lent by E. G. Kennedy.

EX COLL.: the subject, by 1895–1932; his nephew Otto Torrington; his son, E. K. Torrington; with Kennedy Galleries, New York; Mr. and Mrs. Raymond J. Horowitz, New York, until 1973.

Gift of Mr. and Mrs. Raymond J. Horowitz, 1973. 1973.342.

At the Seaside

Beginning in 1891 William Merritt Chase taught at a summer art school in Shinnecock, Long Island. The following year he and his family moved into their new summer home, Shinnecock Hall, which was designed and built by the well-known firm of McKim, Mead and White. Chase taught at this beach resort until 1902, conducting open-air classes for as many as a hundred students each summer. *At the Seaside* depicts women and children, possibly the artist's

family and friends, relaxing beside the water. It is characteristic of Chase's outdoor scenes of the 1890s, which focus on figures engaged in informal activities on Long Island beaches. As his biographer Katharine Metcalf Roof commented: "No one has appreciated as he has the value of the small decisive human note in relation to large spaces of sea and earth and sky, the significant accent of that small spot of red or blue or black. The 'spot' was usually one of his decorative children" (*International Studio* 60 [Feb. 1917], p. cv).

In his representation of the figures in this scene, Chase suggests faces and limbs with single virtuoso strokes. He disregards the conventions of academic perspective and distributes the figures along the water's edge with little concern for their relative scale or spatial position. The stylistic and compositional innovations in *At the Seaside* and Chase's other Shinnecock landscapes can be seen as a response to impressionism, an influence that became widespread in American painting during the 1890s. "The school of the Impressionists has been an enormous influence upon almost every painter of this time," Chase once noted. "The successful men like Monet succeede [*sic*] in rendering a brilliant and almost dazzling impression of light and air" (Lecture Notes and Speeches, n.d., Chase Papers, N/69–137, Arch. Am. Art). In *At the Seaside*, Chase strives for just such an effect, replacing his earlier low-keyed palette with lighter colors— clear bright blues, reds, and whites. He avoids, however, the broken brushstrokes and harsh, pure colors of impressionism, which he described as "more scientific than artistic." This expanded range of color and tone and his greater freedom in the application of paint may also relate to his experiments with pastels in the 1880s.

Oil on canvas, 20 × 34 in. (50.8 × 86.4 cm.).

Signed at lower left: W^m M. Chase. There are traces of a previous signature at lower right: W^m M.

REFERENCES: John Herron Art Museum, Indianapolis, *Chase Centennial Exhibition*, cat. by W. D. Peat (1949), includes it in checklist, owned by Adelaide Milton de Groot // *Life* 59 (July 23, 1965), color ill. p. 77 // A. D. Milgrome, "The Art of William Merritt Chase," Ph.D. diss., University of Pittsburgh, 1969, 1, p. 215, lists it as no. 8 under landscapes, erroneously gives de Groot as owner at this time // R. Finnegan, M. Knoedler and Co., New York, orally, August 1974, gave information on the provenance // P. Bott, Grand Central Art Galleries, New York, orally, August 1974, provided information on the provenance.

EXHIBITED: Gallery of Fine Arts, Columbus, Ohio, 1958, *Masterpieces from the Adelaide Milton de Groot Collection*, no. 3, dates it 1905 // Art Gallery of Toronto; Winnipeg Art Gallery Association; Vancouver Art Gallery; Whitney Museum of American Art, New York, 1961, *American Painting, 1865–1905*, no. 11, lent by Adelaide Milton de Groot // Art Gallery, University of California, Santa Barbara; La Jolla Museum of Art; California Palace of the Legion of Honor, San Francisco; Gallery of Modern Art, New York, 1964–1965, *The First West Coast Retrospective Exhibition of Paintings by William Merritt Chase*, cat. by A. Story, no. 13, dates it about 1892, lent by Adelaide Milton de Groot; unpaged intro. mentions it as an example of Chase's Shinnecock landscapes of the 1890s // MMA, 1965, *Three Centuries of American Painting*, dates it about 1892, lent by Adelaide Milton de Groot // National Gallery, Washington, D.C.; Whitney Museum of American Art, New York; Cincinnati Art Museum; North Carolina Museum of Art, Raleigh, 1973–1974, *American Impressionist Painting*, no. 18, dates it about 1892.

EX COLL.: Laird collection, Philadelphia (sale, Samuel T. Freeman and Co., Philadelphia, April 19, 1943, no. 26, $155); with Mr. Michelotti, New York, 1943; with M. Knoedler and Co., New York, 1943; with Grand Central Art Galleries, New York, 1943; Adelaide Milton de Groot, New York, 1943–1967.

Bequest of Miss Adelaide Milton de Groot (1876–1967), 1967.

67.187.123.

For the Little One

Formerly called *The Hall at Shinnecock*, this painting of about 1895 depicts the artist's wife, Alice Gerson Chase, sewing beside a window in their summer residence on Long Island. The leisure-time activities and quiet domestic pursuits of his family were among Chase's favorite subjects during the 1890s. These paintings create a mood that Duncan Phillips described as "a hint of once familiar moments long forgotten, a sentiment for the quiet dignity of a patrician home" (*American Magazine of Art* 8 [Dec. 1916], pp. 49–50). Like such American impressionists as FRANK W. BENSON and EDMUND C. TARBELL, Chase often posed his models in interior settings filled with antique furniture, framed pictures, and bric-a-brac. His fascination with sunlight is as evident in the interior scenes as in the landscapes. In this painting, light filters through the window, caressing the folds of Mrs. Chase's white skirt and pink blouse and highlighting the polished wood surfaces of the floor and furniture. The picture displays a greater austerity and a more controlled sense of formal

design than the elaborate studio interiors that Chase painted over a decade earlier. The composition is arranged on a disconcerting diagonal, and the figure and furniture are relegated to the middle ground, leaving the foreground bare except for a white scrap. As the American critic Sadakichi Hartmann noted when the picture was exhibited at the Society of American Artists in 1897, *For the Little One* "reveal[s] subtleties that are on a par with Degas."

The painting was acquired from Mrs. Chase in 1917, in exchange for *Annie Traquair Lang*, 1911 (now in Philadelphia Museum of Art), a portrait which the Metropolitan had purchased in 1913.

Oil on canvas, 40 × 35¼ in. (101.6 × 89.5 cm.).
Signed at lower left: Wᵐ· M. Chase.
REFERENCES: S. Hartmann, *Art News* 1 (May 1897), p. 2, in a review of the exhibition of the Society of American Artists, writes that "Chase's technic seems to me steadily progressing . . . 'For the Little One,' although rather shallow in content, reveal[s]

subtleties" (quoted above) // E. Knaufft, *International Studio* 12 (Jan. 1901), ill. p. 150 // *MMA Bull.* 12 (May 1917), ill. p. 118, notes its acquisition from Mrs. Chase and mentions that it was included in the MMA 1917 loan exhibition of paintings by Chase // *Index of Twentieth Century Artists* 2 (Nov. 1934), p. 25, lists reproductions // John Herron Art Museum, Indianapolis, *Chase Centennial Exhibition*, cat. by W. D. Peat (1949), includes it in unnumbered checklist as The Hall at Shinnecock: For the Little Ones // M. L. D'Otrange-Mastai, *Connoisseur* 139 (June 1957), ill. p. 269, as The Hall at Shinnecock: For the Little Ones, compares it to Manet // M. S. Young, *Apollo* 76 (May 1962), ill. p. 195, as Hall at Shinnecock // A. D. Milgrome, "The Art of William Merritt Chase," Ph.D. diss., University of Pittsburgh, 1969, 1, p. 67, discusses; p. 213, lists it as no. 12 under Interiors in checklist // R. J. Boyle, *American Impressionism* (1974), p. 202, compares it to work by Tarbell, says it is "unusually gentle and restrained for Chase"; ill. p. 204.

EXHIBITED: Society of American Artists, New York, 1897, no. 290, as For the Little One // PAFA, 1898, no. 72 // Saint Louis Exposition and Music Hall

Chase, *For the Little One.*

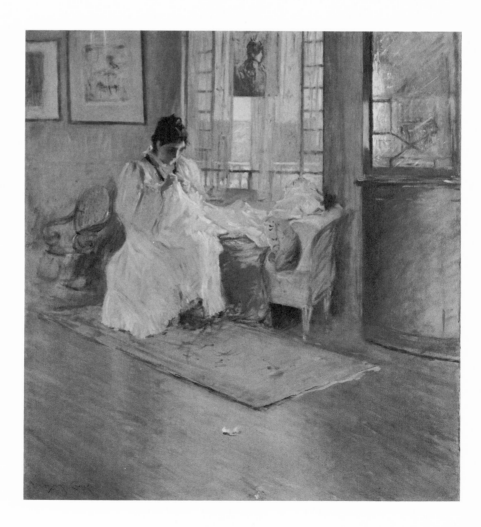

Association, 1898, no. 71 // MMA, 1917, *Loan Exhibition of Paintings by William Merritt Chase* (not in cat.).

Ex COLL.: the artist, New York, from at least 1897–1916; his wife, Alice Gerson Chase, New York, 1916–1917.

Amelia B. Lazarus Fund by Exchange, 1917.
13.90.

Roland

William Merritt Chase and his wife, Alice, had eight surviving children—two sons, Robert Stewart and Roland Dana, and six daughters, Alice Dieudonnée, Koto Robertine, Dorothy Bremond, Hazel Neamaug, Helen Velasquez, and Mary Content—all of whom appeared repeatedly in his portraits and figure studies. "Chase's home life was one of special harmony," his biographer Katharine Metcalf Roof wrote. "Although an extremely nervous man, he never seemed to be disturbed by the presence of his children even in his studio, perhaps because they understood so well how to keep their freedom from becoming an intrusion" (*Life and Art of Chase* [1917], p. 264). This portrait, painted about 1902, is of Roland Dana Chase (1901–), the artist's younger son. The critic for *Harper's Weekly* (1902) called Chase's portraits of children

Chase, *Roland*.

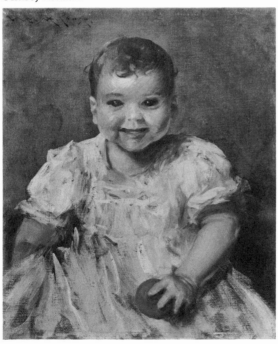

remarkable: "Witness the portrait of 'Roland,' who is depicted with splendid brush-work as a rollicking brown rogue, holding in his admirable baby hand the only note of color—a red ball."

Oil on canvas, 20⅜ × 16¼ in. (51.8 × 41.3 cm.).
Signed at upper left: W^m M. Chase.
REFERENCES: *Harper's Weekly* 46 (Nov. 8, 1902), p. 1627, discusses it as a recent work (quoted above), illustrates detail // *New York Times*, April 10, 1934, p. 25 // *Index of Twentieth Century Artists* 2 (Nov. 1934), p. 24, lists reproductions of it and other portraits of the same sitter // *MMA Bull.* 32 (July 1937), p. 166 // John Herron Art Museum, Indianapolis, *Chase Centennial Exhibition*, cat. by W. D. Peat (1949), includes it in unnumbered checklist as Master Roland Dana Chase, ca. 1902, owner unknown // A. D. Milgrome, "The Art of William Merritt Chase," Ph.D. diss., University of Pittsburgh, 1969, p. 192, includes it in catalogue as no. 16 // R. Pisano, orally, March 1976, identified the sitter.

EXHIBITED: M. Knoedler and Co., New York, 1903, *Catalogue of Portraits by W. M. Chase*, no. 12, lent by Judge Garey [*sic*].

Ex COLL.: Elbert H. Gary, New York, 1902–died 1927; his wife Emma T. Gary, New York, probably 1927–1937.

Bequest of Emma T. Gary, 1937.
37.20.1.

Mrs. Robert W. Vonnoh (Bessie Potter)

The sculptor Bessie Potter (1872–1955) was born in St. Louis and around 1890 went to Chicago, where she studied under Lorado Taft. She assisted him with his sculptural decorations for the World's Columbian Exposition, held in that city in 1893, and in 1895 and 1897 she traveled abroad. She was married to the painter ROBERT VONNOH in 1899 and resided in New York, where she and her husband undoubtedly knew Chase. After Vonnoh's death, she married Edward L. Keyes. Bessie Potter Vonnoh is best remembered for her small-scale statues of unpretentious and intimate subjects. Four of her statues, including her most popular piece, *Young Mother*, 1896, are in the Metropolitan's collection.

"When you meet Mrs. Vonnoh," noted a contemporary art critic, "you are impressed by a quiet absence of eccentricity, and of over-emphasis, whether of dress, of manner, or of opinion" (*International Studio* 54 [Dec. 1914], p. lii). In his portrait of Mrs. Vonnoh, Chase captures her sensitive but reserved personality. He selects a half-length format and a simple, yet elegant, costume and focuses on her expressive

facial features. The face is framed by short curls and a soft turban, Mrs. Vonnoh's favorite head-gear. Her attire and pose recall the well-known self-portrait of the French painter Elisabeth Vigée-Lebrun, 1790 (Uffizi), although the artistic tools of the Vigée-Lebrun *portrait d'apparat* are lacking.

The painting is not dated, but it was probably done between 1899, when the sitter settled in New York, and 1905, when it was first exhibited. The subject's turban resembles the "directoire hat" that became fashionable in the spring of 1902. Mrs. Vonnoh, who was abroad at the time of the portrait's completion, did not purchase it until a decade after Chase's death.

Oil on canvas, 32 × 25⅝ in. (81.3 × 65.1 cm.).
Signed at lower left: W^m M. Chase.

REFERENCES: *American Art News* 3 (March 11, 1905), [p. 3], describes it in Philadelphia exhibition as being posed "a la Mme. La Brun" [*sic*] // *Academy Notes* 2 (July 1906), p. 20, in a review of the Buffalo exhibition notes her resemblance to Vigée-Lebrun and praises the "life-like" face // Mrs. W. M. Chase, notarized statement, Nov. 25, 1925, typed copy in FARL, states that it is "a most interesting canvas of Bessie Potter Vonnoh, painted by my husband" // John Herron Art Museum, Indianapolis, *Chase Centennial Exhibition*, cat. by W. D. Peat (1949), lists it in unnumbered checklist as owned by Mrs. Edward L. Keyes // A. D. Milgrome, "The Art of William Merritt Chase," Ph.D. diss., University of Pittsburgh, 1969, p. 206, lists it as no. 119, mistakenly gives Mrs. Edward L. Keyes as owner at this time // B. Newhouse, Newhouse Galleries, New York, orally, Dec. 27, 1974, and Jan. 2, 1975, gave its provenance.

EXHIBITED: McClees Gallery, Philadelphia, 1905 (no cat. available) // Buffalo Fine Arts Academy, Albright Art Gallery, 1906, no. 24 // Carnegie Institute, Pittsburgh, 1907, no. 88 // Cincinnati Art Museum, 1909, *Special Exhibition of Oil Paintings by William M. Chase, N.A., of New York*, no. 47 // Panama-Pacific International Exposition, San Francisco, 1915, *Catalogue Deluxe of the Department of Fine Arts . . .*, ed. by J. E. D. Trask and J. Nilsen Laurvik, 1, no. 3760 // Am. Acad. of Arts and Letters, 1928, *A Catalogue of an Exhibition of Works of William Merritt Chase . . .*, no. 13, lent by Mrs. Bessie Potter Vonnoh; p. 17, says that the artist began the portrait a number of years before his death, but the sitter was in Europe at the time of its completion and was not able to gain possession of it until about 1927.

EX COLL.: the artist, died 1916; his wife, Alice Gerson Chase, New York, 1916–1926; with Newhouse Galleries, St. Louis, Mo., 1926; Bessie Potter Vonnoh Keyes, New York, 1926–1955.

Bequest of Bessie Vonnoh Keyes, 1955.
55.118.

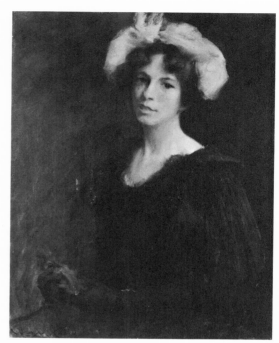

Chase, *Mrs. Robert W. Vonnoh.*

Fish

"It may well be," commented William Merritt Chase, "that I will be remembered as a painter of fish" (W. H. Fox, *Brooklyn Museum Quarterly* 1 [Jan. 1915], p. 198). This painting, which dates before 1910, is one of the many still lifes of fish produced by the artist after the very favorable reception of his *An English Cod*, 1904 (Corcoran Gallery of Art, Washington, D.C.). These works were often painted during summer teaching trips abroad. Executed with the bravura brushwork of his Munich period, this painting shows the influence of Chase's contemporary, the French artist Antoine Vollon. The pictures of both artists recall Spanish still lifes of the seventeenth century, in which fluidly painted objects are presented against a dark background. Chase collected examples of Vollon's work in this genre, such as *Still Life with Cheese* (MMA), and told his students that he valued them highly.

Fish shows a tabletop with a plate containing a striped bass and a salmon; a weakfish lies directly on the table, and a bowl is visible in the background. The painting seems to fulfill Chase's "aim to make an uninteresting subject

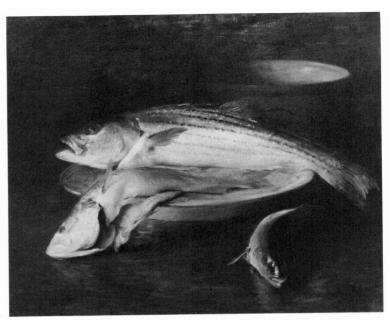

Chase, *Fish.*

so inviting and entertaining by means of fine technique that people will be charmed at the way you've done it" (*American Magazine of Art* 8 [Sept. 1917], p. 433).

The still life was given to the museum in 1925 in memory of the artist by Edward G. Kennedy, the art dealer and collector whose portrait by Chase (q.v.) is also in the collection.

Oil on canvas, 29 × 36 in. (73.7 × 91.4 cm.).
Signed at lower left: Wᵐ M. Chase.
REFERENCES: *Century*, n.s. 59 (Jan. 1911), color ill. p. 413, calls it A Plate of Fish // E. G. Kennedy, letter in MMA Archives, June 8, 1925, describes it as "fine" and offers it to MMA in memory of the artist // R. B. Hale, *MMA Bull.* 12 (March 1954), ill. p. 186 // John Herron Art Museum, Indianapolis, *Chase Centen-nial Exhibition*, cat. by W. D. Peat (1949), includes it in unnumbered checklist as Fish, incorrectly gives E. G. Kennedy as owner at this time // A. D. Milgrome, "The Art of William Merritt Chase," Ph.D. diss., University of Pittsburgh, 1969, 1, p. 225, lists it as no. 28 in checklist as in the collection of E. G. Kennedy, 1917; p. 226, lists it as no. 64 in MMA.

EXHIBITED: PAFA, 1910, no. 457; unnumbered pl., as Fish // MMA, 1917, *Loan Exhibition of Paintings by William Merritt Chase*, no. 35, lent by E. G. Kennedy; p. 19, identifies the fish.

Ex COLL.: Edward G. Kennedy, New York, by 1917–1925.

Gift of Edward G. Kennedy, in Memory of William Merritt Chase, 1925.

25.131.

Still Life: Fish

Completed by 1908, *Still Life: Fish* provided the artist with an opportunity to demonstrate his extraordinary ability to paint different textures and surfaces. "I enjoy painting fishes: in the infinite variety of these creatures, the subtle and exquisitely colored tones of the flesh fresh from the water, the way their surfaces reflect the light, I take the greatest pleasure. In painting a good composition of fish I am painting for myself," Chase told William H. Fox in 1912 (*Brooklyn Museum Quarterly* 1 [Jan. 1915], p. 199).

The American connoisseur Leo Stein com-

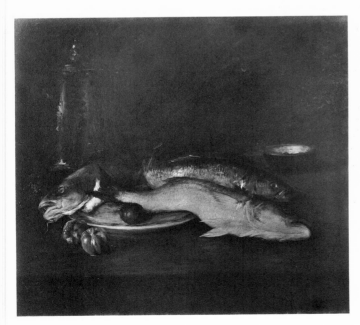

Chase, *Still Life: Fish.*

mented on the formal qualities of Chase's still lifes of fish. "Of all non-sentimental still life . . . they are with their bulging mass and sweeping line the most expressive. Chase seems to take a saturated satisfaction in the swell and swing of the thick soft-bodied fish. They give far more result at a lesser price of organization than groups of smaller or less expressively shaped objects" (*New Republic* 10 [March 3, 1917], p. 134).

Oil on canvas, 40⅛ × 45 1/16 in. (101.9 × 114.5 cm.).
REFERENCES: G. A. Hearn, letter in MMA Archives, April 6, 1908, proposes to purchase the painting which was in the Montross exhibition and writes that Chase "says that it is the best thing that he has every [*sic*] done, and I understand that all the Artists are very enthusiastic" // A. Hoeber, *International Studio* 35 (July 1908), p. xxvi, comments on it in a review of the Ten American Painters: "William M. Chase had several contributions, but they were all eclipsed by his remarkable still life, of some fish, and no one quite reaches Mr. Chase's excellence in the portrayal of such themes" // E. Carlsen, *Palette and Bench* 1 (Oct. 1908), ill. p. 8 // *George A. Hearn Gift to the Metropolitan Museum of Art . . .* (1913), ill. p. 84 // *Literary Digest* 53 (Nov. 11, 1916), ill. p. 1251 // MMA, *Loan Exhibition of Paintings by William Merritt Chase* (1917), p. xxiv, lists it as one of his works in a public collection // K. M. Roof, *Life and Art of Chase* (1917), ill. opp. p. 228 // A. E. Bye, *Pots and Pans* (1921), ill. opp. p. 202; pp. 203–204, describes it as "one of the best examples of Chase's studies of fish" and speculates that the artist may have used a medium of siccatif and varnish // *Index of Twentieth Century Artists* 2 (Nov. 1934), p. 25, and p. 27, lists reproductions of it // J. L. Marcus, letter in MMA Archives, Feb. 25, 1937, compares it to still lifes by the correspondent's brother Antoon Marcus and by Charles Frederic Ulrich and discusses Chase's sojourn in Haarlem in 1903 // John Herron Art Museum, Indianapolis, *Chase Centennial Exhibition*, cat. by W. D. Peat (1949), includes in unnumbered checklist as Still Life with Fish, and dates it ca. 1907 // A. D. Milgrome, "The Art of William Merritt Chase, Ph.D. diss., University of Pittsburgh, 1969, 1, p. 227, lists it as no. 80 in checklist, dates it ca. 1907.
EXHIBITED: PAFA, 1908, no. 607, as Still Life: Fish // Montross Gallery, New York, 1908, *Eleventh Annual Exhibition, Ten American Painters*, no. 6.
EX COLL.: with Montross Gallery, New York, 1908; with George A. Hearn, as agent, New York, 1908.
George A. Hearn Fund, 1908.
08.139.2.

ABBOTT H. THAYER

1849–1921

The landscape and figure painter Abbott Handerson Thayer was born in Boston, but in 1856 his family settled in Keene, New Hampshire, not far from Dublin. In 1864 he returned to Boston and began his artistic training the following year under the amateur animal painter Henry D. Morse (1826–1888). In 1867, his family moved to Brooklyn, New York, and between 1868 and 1874, he studied at the Brooklyn Art School and then at the school of the National Academy of Design, where he had been exhibiting animal paintings since 1868.

Following his marriage to Kate Bloede in 1875, Thayer went to Paris where he continued his studies at the Ecole des Beaux-Arts, first under Henri Lehmann and then under Jean Léon Gérôme. He exhibited at the Paris Salon and continued to submit his work to major exhibitions in New York. In Paris and at French summer resorts, Thayer associated with his fellow students, the Americans GEORGE DE FOREST BRUSH and DWIGHT W. TRYON and the Englishmen Arthur Bell and Everton Sainsbury.

Returning to New York in 1879, he joined the newly founded Society of American Artists. For the next decade, he maintained a studio in the city, although he often lived in country

homes in Cornwall, Peekskill, or Scarborough, New York, and sometimes spent the summers in Dublin and West Keene, New Hampshire. In 1888, his wife was confined to a hospital, and shortly after her death in 1891, he married his former student Emma Beach (1850–1924). After 1892, he worked in his studio at Dublin, New Hampshire. About this time, he began to enjoy the patronage of such wealthy and prestigious collectors as Charles Lang Freer and J. Montgomery Sears.

Thayer made a brief trip to Italy in 1898 and two years later returned with his family for an extended stay. It was at this time that he began to accept studio assistants, such as Barry Faulkner (1881–1966), who was his second cousin, and later Rockwell Kent (1882–1971). In return for painting lessons, his assistants would make copies of his paintings. Helen M. Beatty described Thayer's unusual studio practice (1919):

> Mr. Thayer will begin a picture, and as soon as he feels it has become a valuable thing he will get an assistant to make him a copy of it. On this he goes forward again, lighted by the measureless comfort of the original's safety, while it directs his handling of the replica, which under his hand soon outstrips the first. He will then take up the first picture, or begin a third. The hindermost, so to speak, of the three learns from the superiorities of the others which of these virtues to appropriate, and thereby become[s] the best of all. Thus he works with the assurance that he cannot lose anything already secured. It may be that the second picture will be the one which in the end he will feel is the best, or it may be the third, or the first. (pp. 19–20).

Thayer pursued a dual career as an artist and naturalist. He had always studied animals and birds in their natural settings, and after 1896, when he gave his first public demonstration of his theories of protective coloration, he was generally recognized as an authority in this field. His theories and those of his son Gerald are recorded in their book *Concealing Coloration in the Animal Kingdom* (1909). He continued to paint until his death, but much of the remainder of his career was devoted to the study of camouflage and his unsuccessful efforts to promote its use for military purposes.

BIBLIOGRAPHY: Carnegie Institute, Pittsburgh, *An Exhibition of Paintings by Abbott H. Thayer* (1919). Includes a biographical statement by H[elen] M. Beatty, a record of his paintings and a bibliography of books and articles written by Thayer on protective coloration // Abbott H. Thayer Memorial Number, *The Arts* 1 (June–July 1921). Includes: John Gellatly, "Thayer in the American Renaissance," p. 5; George Grey Barnard, "The Genius of Thayer," p. 6; Royal Cortissoz, "Personal Memories," pp. 8–24; T. W. Dewing, "A Letter to Abbott Thayer," p. 24; Gerald H. Thayer, "The Last Rites," pp. 24–27 // MMA, *Memorial Exhibition of the Work of Abbott Handerson Thayer* (March 20–April 30, 1922). Introduction by Royal Cortissoz and an annotated catalogue with illustrations // Nelson C. White, *Abbott H. Thayer: Painter and Naturalist* (Peterborough, N.H. 1951). Lists memberships, awards, representation in galleries and museums. Contains bibliography and index. Appendices reprint Thayer's written comments on restoration, camouflage, and protective coloration.

Mrs. William F. Milton

The Thayers summered in the Berkshire Mountains of Massachusetts in 1879 and 1880, and it may well be that the artist executed the oil sketch for this painting (coll. Nelson C. White, Waterford, Conn.) in nearby Pittsfield at that time. Completed in 1881, the Metropolitan's portrait is realistically painted in subdued, almost somber browns and grays. Mrs. Milton's face is well modeled, brightly illuminated, and set against a dark neutral background. Her

Thayer, *Mrs. William F. Milton.*

carefully arranged pose and fashionable costume reflect lessons learned by the artist during his four years of academic study under Gérôme in Paris. It also demonstrates Thayer's dependence on old master models, a typical feature of American artistic practice at the time. Here Mrs. Milton's pose and costume recall those of Hélène Fourment in Rubens's *Park of the Château of Steen* (Kunsthistorisches Museum, Vienna).

The subject, née Anna Ridgway Miller, was the daughter of Daniel and Anna (Ridgway) Miller. She was married to William F. Milton in Philadelphia on March 22, 1873, and took a honeymoon trip around the world. Beginning in 1880, the Miltons summered at Unkamet Farm on Milton Avenue in Coltsville, outside of Pittsfield, Massachusetts. Mrs. Milton continued to maintain Unkamet Farm until 1913, when her name disappears from the Pittsfield directory. After her husband's death in 1905, she

Abbott H. Thayer

resided on Fifth Avenue in New York. She was a fellow of the Metropolitan Museum, which received her art collection following her death in February 1924.

Oil on canvas, 32 × 24 in. (81.3 × 61 cm.).

Signed, dated, and inscribed vertically at the right: Abbott H. Thayer 1881. Inscribed on the reverse: *W. F. Milton / Pittsfield / Mass.*

RELATED WORK: *Study for Portrait of Mrs. William F. Milton*, oil on canvas, 10 × 9 in. (25.4 × 22.9 cm.), coll. Nelson C. White, Waterford, Conn.

REFERENCES: Carnegie Institute, Pittsburgh, *Exhibition of Paintings by Abbott H. Thayer*, cat. by H. M. B[eatty] (1919), p. 39, lists it and misdates it 1880 // N. Pousette-Dart, comp., *Abbott H. Thayer* (1923), unnumbered pl., as coll. Mrs. William F. Milton // L. D. Bates, Harvard Club, orally, Nov. 23, 1976, provided biographical information about the sitter.

EXHIBITED: MMA, 1922, *Memorial Exhibition of the Work of Abbott Handerson Thayer*, cat. by R. Cortissoz, no. 19, as Portrait, lent by Mrs. William F. Milton; ill. p. 3, says it was one of his earliest commissions, dates it and gives Pittsfield as the location of its execution // Lyman Allyn Museum, New London, Conn., 1961, *Abbott H. Thayer 1849–1921*, no. 7.

EX COLL.: the subject, Pittsfield, Mass., and New York, 1881–1923.

Gift of Mrs. William F. Milton, 1923.

23.77.3.

Young Woman

Idealized women were popular subjects in late nineteenth-century American art and were especially favored by the Beaux-Arts sculptors Augustus Saint-Gaudens and Daniel Chester French. Dated about 1898, *Young Woman* exemplifies Thayer's treatment of the subject, which occupied his attention between 1890 and 1905. With the figure draped in classical style and set against a generalized foliated background, *Young Woman* is one of the works that the critic Royal Cortissoz described in 1923 as a "celebration" of the theme "womanhood endowed with beauty. . . . There are women on Thayer's canvases who with their maidenly bloom have also the heroic dignity of the Roman matron of legend. Their charm is drawn, as I have indicated, from Olympian sources. Yet it is one of their finest traits that they stand with their feet unmistakably on the solid earth. They are profoundly human presences."

The model for the painting was Bessie Price (1879–1968), a young Irish immigrant who joined her family in Dublin, New Hampshire, in 1896. Bessie worked as a servant in the Thayer household and soon became one of the artist's favorite models. The first time Thayer painted her was probably for the half-length portrait he did in 1897 (coll. Nelson C. White, Waterford, Conn.). She also posed for *Seated Angel*, 1899 (Wadsworth Atheneum, Hartford), and the *"Stevenson Memorial" Angel*, 1903 (National Collection of Fine Arts, Washington, D.C.). Bessie Price was later married to Fred Beaulieu, a French-Canadian who made and carved a number of frames for Thayer's paintings. In 1914, the couple moved to Connecticut where Mr. Beaulieu became a building contractor. Bessie was the mother of seven children.

The painting was sent to the Paris Exposition in 1900, where it received a gold medal. It bears its original frame, inspired by the designs of the architect Stanford White. The frame was constructed at the shop of William Clausen in New York.

Oil on canvas, 39⅝ × 31⅝ in. (100.7 × 80.3 cm.).

Signed at lower right: Abbott H. Thayer.

REFERENCES: A. H. Thayer to his wife, n.d., typescript copy, Abbott Handerson Thayer Papers, 200, Arch. Am. Art, may refer to it when he writes: "You know how we liked the brightening of the lower part of the Bessie figure, well I afterward felt that I had a little *passed the point* and worked it backward (darkward) finishing and smoothing as I went and of a sudden it became what each subsequent look has confirmed *a marvelous hit*. I can tell you how all of a piece and all of one vivid, *best* expression, color, *background* and all it has become! I shall let it dry *one week* and then try a little retouching of the hands when I can wipe off— but it is *done* now and finished" // W. Walton, *Exposition Universelle, 1900: The Chefs-d'œuvre* (1900), ill. p. 3, shows it in original frame // L. Greder, *Loisirs d'art* (1901), p. 119 // *International Studio* 14 (1901), p. xvii // C. H. Caffin, *Harper's Weekly* 45 (July 13, 1901), ill. p. 708, in a review of the Pan-American Exposition // K. Cox, *Cosmopolitan Magazine* 32 (April 1902), ill. p. 595, as Portrait of a Young Maiden; p. 596, discusses // W. S. Howard, *MMA Bull.* 1 (March 1906), p. 55, discusses; ill. p. 57 // *The George A. Hearn Gift to the Metropolitan Museum of Art . . .* (1906), p. 208, discusses; ill. p. 209 // K. Cox, *Nation* 84 (April 18, 1907), p. 369, discusses it at 1907 Carnegie annual, notes its "grand silhouette" and "restrained and beautiful color" // *Smith's Magazine* 6 (March 1908), ill. p. 909 // J. W. Alexander, *Art and Progress* 3 (May 1912), ill. p. 579 // Carnegie Institute, Pittsburgh, *Exhibition of Paintings by Abbott H. Thayer*, cat. by H. M. B[eatty] (1919), p. 37, includes it in list of works // L. M. Bryant, *American Pictures and*

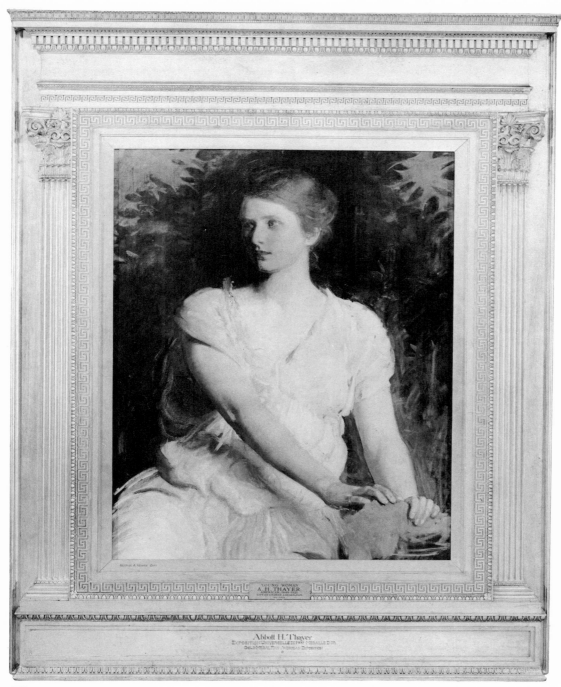

Thayer, *Young Woman.*

Their Painters (1921), ill. opp. p. 103; p. 104 discusses the role of women in Thayer's paintings // *American Art News* 19 (June 4, 1921), p. 4 // G. Teall, *Literary Digest* 69 (June 18, 1921), ill. p. 29 // R. Cortissoz, *Arts* 1 (June–July 1921), pp. 15, 17; ill. p. 23 // C. B. S. Quinton, *Academy Notes* 16 (July–Dec. 1921), p. 81 // H. M. Beatty, *Scribner's Magazine* 70 (Sept. 1921), ill. p. 383 // R. Cortissoz, *American Artists* (1923), p. 32, says it celebrates womanhood (quoted above) // C. B. Ely, *Art in America* 12 (Feb. 1924), pp. 87–88, discusses // *Art News* 25 (March 12, 1927), p. 8 // *Antiquarian* 12 (May 1929), ill. p. 40 // *New York Times*, August 5, 1951, p. 72, supplies biographical information on the sitter // N. C. White, *Abbott H. Thayer* (1951), color ill. frontis.; pp. 76–77, 80, discusses model and her posing for the artist; pp. 210–211, quotes R. Cortissoz on it // H. J. Stoeckel, *Hartford Courant*, Feb. 3, 1963, magazine section, pp. 3, 8, gives biography of the sitter and discusses the painting // T. Brumbaugh, *Bulletin: Wadsworth Atheneum* 7 (Spring and Fall 1971), pp. 52–65, discusses Thayer's idealized female figures, gives biographical information about the sitter; ill. p. 65, includes other paintings of the same sitter // W. H. Truettner, *American Art Journal* 3 (Fall 1971), p. 78, includes it in a checklist of American paintings acquired by William T. Evans, says it was acquired directly from the artist // T. Brumbaugh, letter in Dept. Archives, Sept. 12, 1974, discusses sitter and notes another treatment of the theme (private collection, Santa Rosa Beach, Fla.).

EXHIBITED: Society of American Artists, 1899, no. 329, as *Young Woman* // Paris Exposition, 1900, *Official Illustrated Catalogue*, Fine Arts Exhibit, United States of America, no. 92, lent by George A. Hearn // Pan-American Exposition, Buffalo, N.Y., 1901, *Catalogue of the Exhibition of Fine Arts*, no. 627, lent by George A. Hearn // Lotos Club, New York, 1901, *Exhibition of Paintings Selected from the Pan-American Exposition*, no. 22, lent by George A. Hearn // Lotos Club, New York, 1901, *American Paintings from the Collection of George A. Hearn*, no. 34; 1905, *Exhibition of American Figure Paintings*, no. 37 // Carnegie Institute, Pittsburgh, 1907, no. 449 // Roman Art Exhibition, 1911, *Catalogue of the Collection of Pictures and Sculpture in the Pavilion of the United States of America*, no. 38 // MMA, 1922, *Abbott H. Thayer Memorial Exhibition*, no. 49; p. 9, notes that the model is Bessie Price (Mrs. Fred Beaulieu) and lists other pictures for which she posed // Lyman Allyn Museum, New London, Conn., 1961, *Abbott H. Thayer, 1849–1921*, no. 17, as Young Woman in White.

Ex COLL.: the artist; William T. Evans, New York (sale, American Art Galleries, New York, Jan. 31, 1900, no. 90, $2,050); George A. Hearn, New York, 1900–1906.

Gift of George A. Hearn, 1906.
06.1298.

Winter Sunrise, Monadnock

After Abbott Thayer spent the summer of 1888 in Dublin, New Hampshire, and moved his studio there in 1892, one of his favorite landscape subjects was nearby Mount Monadnock. *Winter Sunrise* is one of several examples of this theme executed between 1917 and the artist's death four years later. "The picture I want to paint with all the advantages," he wrote to his neighbor GEORGE DE FOREST BRUSH in January 1917, "is my old theme, winter dawn over our mountain. I *long* to do at last, a picture of it, that shall *be* and *stay*, as flat and as free of half tints as the scene itself or many a Jap[anese] print." The painting captures an oriental quality in the horizontally banded color areas of the sky and mountains and the delicate, almost calligraphic, touches of the evergreens that fill the middle ground.

A letter written in 1917 by the artist's wife, Emma, dates this particular version of the theme to the third week of October 1917. The existence of two nearly identical compositions—*Winter Dawn on Monadnock*, 1918 (Freer Gallery of Art, Washington, D.C.), and *Sunrise on Mt. Monadnock*, 1919 (Princeton Art Museum)—suggests that all three were the result of Thayer's studio practice of experimenting with the same theme on several canvases. The versions completed later are distinguished by a greater variety of color and brushstrokes and a wealth of detail, whereas in this painting, the artist has reduced the scene to its essential forms and colors.

Thayer sold the painting to the museum through his friend the New York businessman and art collector John Gellatly. "As to the picture itself," wrote Gellatly to the museum in 1917, "[Daniel Chester] French—[Herbert] Adams—[Francis C.] Jones and [Thomas W.] Dewing all seemed very enthusiastic about it, and all expressed their desire that the museum would buy it—You can imagine what this picture means to Thayer, for many years this view greeted him every morning—it is the actual place enveloped in an atmosphere of beauty."

Oil on canvas, 54⅜ × 63⅜ in. (138.1 × 161 cm.).

Signed vertically at lower left and incised in paint surface: Abbott H [illeg.].

RELATED WORKS: *Winter Dawn on Monadnock*, oil on canvas, 44¾ × 65¾ in. (113.7 × 167 cm.), 1918, Freer Gallery of Art, Washington, D.C., 19.1 // *Sunrise on Mt. Monadnock, New Hampshire*, oil on canvas, 52⅜ × 62 3/16 in. (133 × 158 cm.), 1919, Princeton University Art Museum, 53–56.

Thayer, *Winter Sunrise, Monadnock.*

REFERENCES: A. H. Thayer to G. de F. Brush, Jan. 6, 1917, Abbott Handerson Thayer Papers, D200, Arch. Am. Art, discusses his desire to do a picture of Monadnock (quoted above) // E. B. Thayer to J. Gellatly, Nov. 26, 1917, MMA Archives, dates it to the third week of October 1917 and says it is too soon to retouch or varnish it // J. Gellatly, letter in MMA Archives, Dec. 7, 1917, discusses it (quoted above) and emphasizes that other institutions are also interested in purchasing it // *MMA Bull.* 13 (Feb. 1918), p. 53, announces its acquisition // A. H. Thayer to C. L. Freer, Nov. 26, 1918, in Thayer Papers, D200, Arch. Am. Art, compares it to Winter Dawn on Monadnock, 1918 // Carnegie Institute, Pittsburgh, *Exhibition of Paintings by Abbott Handerson Thayer*, cat. by H. M. B[eatty] (1919), p. 37, lists it in record of paintings // W. Benignus, letter in MMA Archives, Feb. 27, 1919, records a poem by Benignus inspired by it // *American Art News* 19 (June 4, 1921), p. 4 // *Arts* 1 (June–July 1921), p. 24, gives a letter from T. W. Dewing to A. H. Thayer, n.d., in which Dewing writes of the painting: "It is the finest landscape ever painted in the world—It is extraordinary" // R. Cortissoz, *Arts* 1 (June–July 1921), ill. p. 12; p. 17, calls it "one of the greatest landscapes ever painted in America or anywhere else" // C. B. S. Quinton, *Academy Notes* 16 (July–Dec. 1921), p. 81, discusses // H. M. Beatty,

Scribner's 70 (Sept. 1921), ill. p. 380, discusses // H. Tyrrell, *New York World*, March 19, 1922, ill. p. M 7 // R. Cortissoz, *New York Tribune*, March 19, 1922, sec. 4, p. 7; *American Artists* (1923), p. 33 [reprint from *Arts* 1 (June–July 1921), p. 12] // N. Pousette-Dart, comp., *Abbott H. Thayer* (1923), with an introduction by R. Cortissoz, unnumbered pl. // C. B. Ely, *Art in America* 12 (Feb. 1924), ill. p. 91, calls it "the symbol of the overwhelming experience beyond which is spiritual revelation"; *Modern Tendency in American Painting* (1925), ill. opp. p. 36; pp. 40–41, discusses // W. H. Downes, *American Magazine of Art* 25 (Oct. 1932), ill. p. 196; p. 200 // N. C. White, *Abbott H. Thayer* (1951), ill. opp. p. 216; pp. 216–217, quotes Mrs. Dewing reminiscing about one of the Monadnock paintings // H. J. Stoeckel, *Hartford Courant Magazine*, Jan. 4, 1953, p. 9, quotes R. Cortissoz and N. C. White // T. Brumbaugh, *Bulletin: Wadsworth Atheneum* 7 (Spring–Fall 1971), pp. 57–58, quotes E. B. Thayer, letter to J. Gellatly, Dec. 20, 1917, "To think of having $12,000 clear when we looked with doubt upon a possible $4,000 for the Monadnock, and that lessened by the cost of its frame!"; p. 59, quotes E. B. Thayer, letter to J. Gellatly, Dec. 30, 1917, says that she hopes to receive the money for it in time to receive interest on it; *Antiques* 103 (June 1973), p. 1139 relates Monadnock paintings to contemporary

landscapes of Edvard Munch; p. 1139, states that the painting was developed out of a series of smaller studies; letter in Dept. Archives, August 10, 1974, clarifies his statement about preparatory studies for the painting, writing that he "think[s] there are only close stylistic and compositional relationships among the pictures. Nothing very close. Thayer seems rarely to have made studies in the ordinary sense."

EXHIBITED: MMA, 1922, *Memorial Exhibition of the Work of Abbott H. Thayer*, cat. by R. Cortissoz, no. 72;

p. 13, says that it was painted at the artist's home in Dublin, New Hampshire, and that he painted several versions of varying sizes; misdates it 1918 // Lyman Allyn Museum, New London, Conn., 1961, *Abbott H. Thayer, 1849–1921*, no. 23, misdates it 1918.

EX COLL.: the artist, 1917; with John Gellatly, New York, as agent, 1917.

George A. Hearn Fund, 1917.

17.180.1.

ALEXANDER POPE

1849–1924

Born in Dorchester, now a part of Boston, Pope sketched and carved animals as a youth. During the 1860s and 1870s, he worked for his family's lumber business, and in 1873, he married Alice d'Wolf Downer. Howard J. Cave reports that Pope studied perspective and drawing with the Boston painter and sculptor William Rimmer (1816–1879), but the artist himself claimed: "I am selftaught, never had any instruction in painting or modelling" (A. Pope to G. W. Stevens, May 12, 1910, Stevens Collection, D34, Arch. Am. Art). Pope's career as an artist began in the late 1870s. He earned the title of "the Landseer of America" with a series of illustrations for two portfolios of lithographs, *Upland Game Birds and Water Fowl of the United States* (1878) and *Celebrated Dogs of America* (1882), and with his animal sculptures, two of which were reportedly sold to the Czar. After 1881, he maintained a residence in Dorchester—taking in boarders to make ends meet—and commuted regularly to the Boston studio he had taken the previous year. When he began painting in oils in 1883, he specialized in sentimental animal portraits, although he occasionally attempted more ambitious themes such as *Calling Out of the Hounds*, 1886 (unlocated), which he painted in collaboration with EMIL CARLSEN. Between 1886 and 1888, city directories list no studio under Pope's name, but in 1888, he is mentioned as the president of Durham House Drainage Company, a business venture which appears to have been unsuccessful.

After 1887, Pope produced about a dozen trompe l'œil still lifes of military objects and trophies of the hunt, the best known of which is *The Trumpeter Swan*, 1900 (M. H. de Young Memorial Museum, San Francisco). "One of Pope's favorite pastimes," wrote Howard J. Cave, "is to paint firearms, birds, rabbits, and the like hanging to a slate-colored door, and cause them to stand out with a semblance to reality that deceives the sense of sight" (p. 112).

In 1903 Pope moved to Hingham, Massachusetts, but he maintained his studio in Boston, devoting the final years of his career to portraiture.

BIBLIOGRAPHY: Frank T. Robinson, "An American Landseer," *New England Magazine*, n.s. 3 (Jan. 1891), pp. 631–641 // Howard J. Cave, "Alexander Pope, Painter of Animals," *Brush and Pencil* 8 (May 1901), pp. 105–112 // Alfred Frankenstein, *After the Hunt: William Harnett and Other*

American Still Life Painters, 1870–1900 (Berkeley and Los Angeles, 1953; rev. ed., 1969), pp. 139–141. Places Pope's work in the context of late nineteenth-century trompe l'œil still-life painting ∥ Donelson F. Hoopes, "Alexander Pope, Painter of 'Characteristic Pieces,'" *Brooklyn Museum Annual* 8 (1966–1967), pp. 129–146. Most complete treatment of the artist's life and work ∥ William H. Gerdts and Russell Burke, *American Still-life Painting* (New York, 1971), pp. 156–157, 250. Places Pope in the context of late nineteenth-century still-life painting.

The Oak Door

Dated 1887, this painting may be the earliest known example of what Pope called his "characteristic pieces." In an article on the artist, Donelson F. Hoopes has explained that Pope did not mean that his still lifes are representative of his total œuvre but that he used the word characteristic "to connote ideas of close observation and faithful rendering of the distinctive qualities of visual phenomena." *The Oak Door* is a still-life trophy of the hunt painted with extraordinary verisimilitude. On a door decorated with an assortment of metalwork—large Renaissance revival hinges, a colonial revival Chippendale escutcheon, and a Federal style lion's head pull—Pope displays a ring-necked pheasant (*Phasianus colchicus*), a Remington Arms shotgun, and a crocheted gamebag. Instead of simulating the wood grain of the door in the usual trompe l'œil manner, he paints on an actual oak panel. The work is closely related to Pope's polychrome carving *A Pheasant Hanging on a Wall with a Game Bag* (New York art market, 1977), which includes similar still-life objects also on an oak panel.

The artist's career had been previously devoted to sculptured and painted animals. He seems to have turned to trompe l'œil themes following the popular reception of WILLIAM MICHAEL HARNETT's *After the Hunt*, 1885 (Cali-

Pope, *The Oak Door*.

fornia Palace of the Legion of Honor, San Francisco). Indeed, Pope has used many of the same elements of that painting in *The Oak Door* but in a far less original way. Although the painting is inscribed 1887 on the reverse, the acceptance of this date has been questioned because the model of shotgun depicted was not manufactured commercially until 1889.

Oil on oak panel, including matching frame 50 × 41 in. (127 × 104.1 cm.).

Signed at lower left: ALEX-POPE. Inscribed on the back: Painted by / ALEX. POPE–1887.

RELATED WORK: *A Pheasant Hanging on a Wall with a Game Bag*, carved and painted wood, 31½ × 23½ in. (80 × 59.7 cm.), New York art market, 1977.

REFERENCES: P. H. Tillou, Tillou Gallery, Litchfield, Conn., letter in Dept. Archives, August 11, 1966,

says it was purchased in Palm Beach // D. F. Hoopes, *Brooklyn Museum Annual* 8 (1966–1967), p. 129, explains "characteristic pieces" (quoted above) and includes the painting in a checklist; ill. p. 134; pp. 138–140, notes that it is an early oil painting related to the artist's polychrome woodcarving // M. Heckscher, American Wing, MMA, orally, August 8, 1974, identified the metalwork // R. L. Plunkett, National Audubon Society, letter in Dept. Archives, August 12, 1974, identifies the bird // R. W. Lowe, National Rifle Association, letter in Dept. Archives, August 12, 1974, identifies shotgun, notes that it was first produced in 1889.

EX COLL.: Eugene Tompkins, Boston; unidentified private collection, Palm Beach, Fla.; with Tillou Gallery, Litchfield, Conn., until Oct. 1964; with Graham Gallery, New York, 1964–1965.

Arthur Hoppock Hearn Fund, 1965.
65.168.

DWIGHT W. TRYON

1849–1925

The landscape painter Dwight William Tryon was born in Hartford, Connecticut, where he worked in a bookstore until his success in business permitted him to open a studio in 1873. After painting and exhibiting in his hometown and in New York, he left in 1876 for three years of study in Paris, working at a drawing school run by Jacquesson de la Chevreuse, once a pupil of Ingres. Perhaps more significant for the development of his landscape style, he met Henri Joseph Harpignies and worked briefly with Charles François Daubigny. As a result of his contact with these Barbizon painters, Tryon turned to poetic rural scenes, which he executed in dark, somewhat muddy, colors. He spent the summer of 1877 in Guernsey with his friend ABBOTT H. THAYER and in other years summered in Normandy, Brittany, Venice, and Dordrecht.

Returning to New York in 1881, he opened a studio in the Rembrandt Building on West 57th Street, where THOMAS DEWING was his neighbor. He took some students, and by 1883 had established a summer studio in South Dartmouth, Massachusetts. Two years later he was made professor of art at Smith College in Northampton, Massachusetts, teaching there until his resignation in 1923. He also advised the college in the expansion of its art collection, urging the selection of works by such contemporary artists as Dewing, Thayer, ALBERT PINKHAM RYDER, GEORGE INNESS, and RALPH BLAKELOCK.

Tryon's most characteristic landscapes are lyric depictions of rural New England, executed with the broad treatment and monochromatic palette of Whistlerian tonalism. During the 1890s, he assumed the subject matter and some of the more decorative stylistic elements of impressionism, lightening his palette and using a broken brushstroke. At this time he became

Tryon, *Moonlight*.

interested in pastels and executed few oil paintings. He achieved great critical success, being described in 1895 by Royal Cortissoz as the most "complete painter's painter in America today." He was elected an academician at the National Academy of Design in 1891, and his work was acquired by such prominent collectors as Charles Lang Freer and Thomas B. Clarke. During the final two decades of his career, the artist produced few paintings, most of them small in scale. By 1924, illness forced him to stop painting completely. The following year Smith College broke ground for the Tryon Gallery, a museum building donated by the artist to house a collection of his work and that of his American contemporaries.

BIBLIOGRAPHY: D[wight] W. Tryon, "Charles-François Daubigny," in John C. Van Dyke, ed., *Modern French Masters: A Series of Biographical and Critical Reviews* (New York, 1896), pp. 155–166. Includes a biographical note on the author by the editor // Charles H. Caffin, *The Art of Dwight W. Tryon: An Appreciation* ([New York], 1909). Essay, illustrations, and a significant list of pictures painted by Tryon before 1909 // Henry C. White, *The Life and Art of Dwight William Tryon* (Boston, 1930). Includes a list of awards, bibliography, and index // Museum of Art, University of Connecticut, Storrs, *Dwight W. Tryon: A Retrospective Exhibition* (April 19–May 30, 1971). Includes a biographical statement by Nelson C. White and a chronology // Mary Ellen Hayward Yehia, "Dwight W. Tryon: An American Landscape Painter," Ph.D. diss., Boston University, 1977. Includes bibliography and illustrations in color.

Moonlight

"In his earliest period . . . [Tryon] loved black nights with troubled skies, [and] a yellow moon casting fitful gleams over the hard and rough old earth," noted Duncan Phillips (*American Magazine of Art* 9 [August 1918], p. 392). The dark tonality and soft chiaroscuro of *Moonlight* are typical of the artist's early Barbizon-influenced landscapes. Unlike the Barbizon painters he admired, however, Tryon painted from memory rather than nature; his goal was not realism but an idealized interpretation of the landscape. He preferred to convey a mood rather than to depict a particular topographical view. When the artist praised the French landscape painter Charles François Daubigny, he cited his "deep sentiment and feeling about nature," and his "breadth of treatment" (J. C. Van Dyke, ed., *Modern French*

Masters [1896], pp. 162–163). Tryon met Daubigny in the winter of 1877, when he went to the artist's Parisian studio on the rue Notre Dame de Lorette with a group of figure studies and pictures he had painted around the city. Until his death the following year, Daubigny served as Tryon's informal instructor.

Throughout his career Tryon continued to paint romantic nocturnal scenes, often depicting the countryside around his summer home in South Dartmouth, Massachusetts.

Oil on wood, 14 × 22 in. (35.6 × 55.9 cm.).
Signed and dated at lower right: D. W. TRYON–87.
REFERENCES: W. S. Howard, *MMA Bull.* 1 (1906), p. 58, says the painting is typical of Tryon's nocturnes // *The George A. Hearn Gift to the Metropolitan Museum of Art...* (1906), p. 220, describes; ill. p. 221 // D. W. Tryon, letter in Dept. Archives [May 1909], answers an inquiry about the title of the painting, which had previously been listed as October Night, approves title Moonlight // C. H. Caffin, *The Art of Dwight W. Tryon* (1909), p. 64, lists it // *Art News* 25 (March 12, 1927), p. 8 // M. E. Yehia, letter in Dept. Archives, July 18, 1975, discusses Tryon's treatment of this subject throughout his career until 1913–1915 and says that the artist often walked in the countryside where he could see cottages such as this illuminated by moonlight; "Dwight W. Tryon," Ph.D. diss., Boston University, 1977, pp. 103–104, says it is one of Tryon's earliest tonalist landscapes and discusses related subjects he painted between 1887 and 1890; color ill. p. 105; pp. 109, 188, 225; p. 227, says it was among four works Hearn purchased between 1887 and 1893.
EXHIBITED: Lotos Club, New York, 1901, *American Paintings from the Collection of George A. Hearn*, no. 38, as Moonlight // Museum of Art, University of Connecticut, Storrs, 1971, *Dwight W. Tryon: A Retrospective Exhibition*, no. 25.
EX COLL.: possibly Rose A. Dorn, New York,

sometime after 1887 and before 1901, as indicated by an exhibition label on reverse; George A. Hearn, New York, by 1901–1906.
Gift of George A. Hearn, 1906.
06.1299.

Moonrise at Sunset

Dated 1890, the painting repeats the subject and composition of Tryon's acclaimed picture *The Rising Moon: Autumn*, 1889 (Freer Gallery of Art, Washington, D.C.), the first of many of his paintings purchased by his patron Charles Lang Freer. Like this earlier work, *Moonrise at Sunset* features a salt haystack. Tryon actually painted very few pictures of haystacks, a typical sight around his summer home in South Dartmouth, Massachusetts. Notable examples include *Moonlight*, 1887 (Freer Gallery of Art) and *Dewy Night—Moonrise*, 1890 (coll. Lee Anderson, New York), both of which retain the somber palette, blurred contours, and dramatic light effects of Tryon's early Barbizon-inspired landscapes. In the Metropolitan's painting, however, the artist has used a delicate pastel palette, which is not only lighter but more tonal, and the composition of the picture is simpler than in the other works.

A close examination of the picture reveals a pentimento, where the artist painted out a second haystack in the left middle distance. In 1912, the haystack began to show through, and when the museum asked the artist to rework this area, he responded that "it will be next to impossible for me to eradicate the showing through of the small stack without danger of completely upsetting the color qualities of the work. . . . As my technique today is entirely unlike what it is in the picture, I might not be able to unite the qualities with the rest of the work." He did, however, assist a conservator and later wrote, "After the surface was prepared I found little difficulty in completing it and I think you will find it as good as when it was purchased."

Oil on wood, 24⅛ × 23⅛ in. (61.3 × 58.7 cm.).
Signed and dated at lower right: D. W. TRYON 1890.
REFERENCES: *Catalogue of the Collection of Foreign and American Paintings Owned by Mr. George A. Hearn* (1908), ill. no. 257, p. 197 gives incorrect title and measurements as Moonrise before Sunset, h. 24 in., w. 29 in. // C. H. Caffin, *The Art of Dwight W. Tryon* (1909), p. 59, lists it in the collection of George A. Hearn, New York // MMA Registrar's Records, vol. I, no. 155, indicate that the painting was returned to the artist

Tryon, *Moonrise at Sunset.*

for retouching between Nov. 19, and Dec. 31, 1912 // D. W. Tryon, letters in MMA Archives, Nov. 20, 1912, says he hesitates to undertake the restoration himself (quoted above); Dec. 2, 1912, says his technique has changed (quoted above) but he has found a man who can repair it; Dec. 28, 1912, says it is restored (quoted above) // *George A. Hearn Gift to the Metropolitan Museum of Art* . . . (1913), ill. p. 93, gives variant title // L. Merrick, *International Studio* 77 (Sept. 1923), p. 501, mentions Tryon paintings in the Hearn collection // S. Sherrill, *Antiques* 99 (April 1971), ill. p. 458 // M. E. Yehia, letter in Dept. Archives, July 18, 1975, identifies other paintings of similar subjects; "Dwight W. Tryon," Ph.D. diss., Boston University, 1977, pp. 227–228, mentions it as owned by Hearn and describes as "an Impressionist-colored view of a Dartmouth field with a haystack."

EXHIBITED: Lotos Club, New York, 1901, *American Paintings from the Collection of George A. Hearn*, no. 35, as Moonrise at Sunset // Union League Club, New York, 1902, *Paintings from the Collection of George A. Hearn, Esq.*, no. 43 // Hathorn Gallery, Skidmore College, Saratoga Springs, N.Y., 1970, *Some Quietist Painters*, p. 19, no. 13; p. 20, fig. 5 // Museum of Art, University of Connecticut, Storrs, 1971, *Dwight W. Tryon: A Retrospective Exhibition*, no. 29, ill. p. 33.

EX COLL.: George A. Hearn, New York, by 1901–1910.

Gift of George A. Hearn, 1910.

10.64.12.

Evening, New Bedford Harbor

Dated 1890, the painting shows the harbor at New Bedford, Massachusetts, an important nineteenth-century maritime center that Tryon had depicted in at least two earlier views, *Daylight—Fairhaven*, 1885 (Rhode Island School of Design, Providence), and *Scene at New Bedford*, 1889 (unlocated), as well as in a group of drawings (Smith College Museum of Art, Northampton, Mass.). A contemporary critic's description of Tryon's treatment of this theme conveys the mood of the Metropolitan's painting but does not correspond with any of the known paintings in detail, suggesting yet another unlocated painting of the harbor. The critic called the work "a beautiful study of lazily moving water with pale green reflections, a lighted city beyond, and a crescent moon in a vague vaporous sky" (*New York Tribune*, March 3, 1890, p. 7).

The horizontally banded composition and cool tonal paint surface, which is enlivened by flickering yellow lights along the shoreline, recall JAMES MC NEILL WHISTLER's nocturnes of the

1870s, works that Tryon would have been familiar with in the 1880s.

Like most of Tryon's paintings done after his return from Europe, the work is executed on wood and backed with a complicated wood cradle to prevent warping. The artist began to use these supports in 1885, when a Brooklyn manufacturer of veneers developed mahogany and whitewood panels composed of five thin layers glued together under heavy pressure.

Oil on wood, $20\frac{1}{4} \times 31\frac{1}{2}$ in. (51.4 × 80 cm.).

Signed and dated at lower right: D. W. TRYON 1890.

RELATED WORK: *Evening, New Bedford Harbor*, pencil and watercolor on paper (11.2 × 16.2 cm.), in a portfolio of drawings, bound in white parchment, Smith College Museum of Art, Northampton, Mass., 30: 3–134.

REFERENCES: *New York Sun*, Feb. 3, 1900, p. 4, reviews it in Montross Gallery show // C. H. Caffin, *The Art of Dwight W. Tryon* (1909), p. 63, lists it in the collection of George L. Jewett, New York // H. C. White, *Life and Art of Tryon* (1930), p. xv, gives incorrect date; ill. after p. 227, shows unlocated view of New Bedford // M. E. Yehia, letters in Dept. Archives, July 18, 1975, dates it, provides information about related works, gives exhibitions and reviews; August 14, 1975, provides photograph of preparatory sketch; May 15, 1976, provides particulars about the preliminary drawing; "Dwight W. Tryon," Ph.D. diss., Boston University, 1977, p. 230, mentions Jewett's ownership.

EXHIBITED: Montross Gallery, New York, 1900, *Loan Exhibition of Paintings by Dwight W. Tryon*, no. 25, as New Bedford Harbor lent by George L. Jewett // Museum of Art, University of Connecticut, Storrs, 1971, *Dwight W. Tryon: A Retrospective Exhibition*, no. 35.

EX COLL.: George Langdon Jewett, New York, by 1900–1917.

Gift of Mrs. George Langdon Jewett, 1917.

17.140.3.

Dawn—Early Spring

Sadakichi Hartmann wrote about Tryon's landscapes that:

His magic brush leads us to silent meadow-lands and straw-coloured fields, where human life seems extinct and only long rows of trees lift their barren branches into dawn. . . . These simple subjects Tryon moulds into simple repetitions of horizontal lines, embroidered with the fretwork of details, into nameless nuances of colours, fragrant in their vitality and yet so fragile that the ordinary eye can hardly distinguish and appreciate them. . . . Tryon's pictures are almost, literally speaking, musical in their effect, not unlike the pizzi-

Tryon, *Evening*, *New Bedford Harbor*.

Tryon, drawing for *Evening*, *New Bedford Harbor*, Smith College.

cato notes on the A string of a violin. . . . He composes his pictures as a composer does his score. His parallelism of horizontal and vertical lines is like melodic phrasing (*A History of American Art* [1902], 1, pp. 129–134).

In *Dawn—Early Spring*, 1894, Tryon achieves this "melodic phrasing" with a high, flat horizon, strengthened by a series of horizontal landscape elements and punctuated by delicate vertical trees that support leafy tracery on slender trunks. This compositional arrangement of horizontal and vertical elements appears repeatedly in Tryon's paintings between 1892 and 1894 and is inspired by the success that he achieved in an important series of murals for a room in the residence of his patron Charles Lang Freer of Detroit. In this mural cycle, painted 1892–1893 (Freer Gallery of Art, Washington, D.C.), Tryon depicted the four seasons. The overmantel *Dawn*, 1893, which completed the room's decoration, seems to be most directly related to the Metropolitan's picture in aesthetic approach and choice of subject, although in the latter painting he confined the trees to a more rigid pattern, unifying their crowns to create a continuous line. As he wrote to his friend, the artist George Alfred Williams (1875–1932): "After spending so much time as I did on this theme (two years), it was natural for me to try to embody the idea in isolated easel pictures, hence came the long 'Dawn' and a number of other similar works. I think they are quite my own and unlike the work of any other man." The picture represents the culmination of principles Tryon had explored in other easel paintings, *Midsummer Moonrise*, 1892 (National Collection of Fine Arts, Washington, D.C.), *Twilight—Early Spring*, 1893 (Freer Gallery of Art), *Evening—June*, 1893–1894 (Brooklyn Museum), and *Twilight—May*, 1894 (Smith College Museum of Art, Northampton, Mass.).

Oil on wood, 20⅜ × 36¼ in. (51.8 × 92.1 cm.).
Signed and dated at lower left: D. W. TRYON. 1894.
REFERENCES: R. Cortissoz, *Harper's Magazine* 91 (July 1895), pp. 170–172, discusses its style and describes it as "quiescent as a mirror"; ill. p. 175 // C. H. Caffin, *Art of Tryon* (1909), p. 63, lists it in the collection of Mr. George L. Jewett, New York // H. C. White, *Life and Art of Tryon* (1930), pp. 152–153, connects it to the Barbizon style and quotes R. Cortissoz's comments in *Harper's Magazine* (1895); pp. 82–83, quotes an unlocated letter to George Alfred Williams, n.d. (quoted above); after p. 227, unnumbered pl. as Early Spring // M. E. Yehia, letter in Dept. Archives, July 18, 1975, discusses its relationship to Freer murals, identifies the 1892–1894 paintings related to it; "Dwight W. Tryon," Ph.D. diss., Boston University, 1977, pp. 154–155, says it began a new trend in Tryon's work, "richer, thicker color," compares to Freer mural; color ill. p. 156; pp. 227, 230, lists it among paintings purchased by Jewett between 1890 and 1895; p. 237, compares it to Sunrise—April, purchased by Freer in 1899.

EXHIBITED: Montross Gallery, New York, 1900, *Loan Exhibition of Paintings by Dwight W. Tryon*, no. 24, as Dawn, lent by George L. Jewett // Museum of Art, University of Connecticut, Storrs, 1971, *Dwight W. Tryon: A Retrospective Exhibition*, no. 31.

EX COLL.: George Langdon Jewett, New York, by 1900–1917.

Gift of Mrs. George Langdon Jewett, 1917.
17.140.4.

Tryon, *Dawn—Early Spring*.

CHARLES MELVILLE DEWEY

1849–1937

Born in Lowville, New York, Dewey worked as a janitor in order to purchase painting supplies after his family refused to pay for his art education. For two seasons, he studied at the National Academy of Design, where he exhibited for the first time in 1876. He then went to Paris, spending two winters in the atelier of Emile Auguste Carolus-Duran and working in the Louvre. For several years after his return to New York, Dewey gave private painting lessons, offering a life class in the winter and a landscape course in the summer. He exhibited at the Society of American Artists and at the Lotos Club, where he was an active member. In 1886, he took a studio in the Chelsea Hotel, where he resided until his death. Elected an associate member of the National Academy of Design in 1903, Dewey became an academician four years later. During the early 1900s, he was a close friend of ALBERT PINKHAM RYDER and served as the executor of this eccentric painter's estate.

Although Dewey sometimes painted during summer trips to England, he established his reputation as a poetic interpreter of the American landscape. In 1907, W. Stanton Howard described these landscapes as "peaceful scenes with quiet pools, whispering trees, and pensive skies bathed in tender light."

BIBLIOGRAPHY: W. Stanton Howard, "A Landscape by C. M. Dewey," *Harper's Monthly* 114 (Feb. 1907), pp. 444–445 // Thieme-Becker (Leipzig, 1913), 9, p. 194 // Obituary. *New York Times*, Jan. 19, 1937, p. 23 // American Art Association, Anderson Galleries, New York, *Nineteenth Century Paintings with a Few of Earlier Period . . . Property of the Estate of the Late Charles Melville Dewey, N.A. Sold by Order of the Attorneys . . .*, sale cat. (April 8, 1937). His collection of works by other artists.

Sun Shower

In its diffused light and delicate color gradations, *Sun Shower*, painted by 1912, is typical of American tonalism, a style that came into vogue about thirty years earlier. The generalized half-light, enhanced by an overall green tone, disintegrates the solid forms of the landscape and obliterates any suggestion of specific detail.

Dewey, *Sun Shower*.

Oil on canvas, 36¾ × 52⅜ in. (93.3 × 133 cm.).
Signed at lower right: Charles Melville Dewey.
REFERENCE: *American Art News* 10 (April 27, 1912),
p. 2, in a review of Dewey's exhibition, says that it
and another landscape "emphasize the rare color
sense and poetic feeling for Nature of the artist."

EXHIBITED: M. Knoedler and Co., New York,
1912, *Landscapes by Dewey* (no. cat.).
Ex COLL.: the artist, until 1920.
Arthur Hoppock Hearn Fund, 1920.
20.26.

GEORGE HITCHCOCK

1850–1913

George Hitchcock was born in Providence, Rhode Island, the son of Charles Hitchcock, who is described as a portrait painter. He graduated from Brown University in 1872, and after receiving a law degree from Harvard in 1874, practiced briefly in Providence and New York before deciding on a career in art. He opened a studio in Chicago but was unsuccessful in his attempts to sell the watercolors he produced. By 1879, he was enrolled in Heatherley's School of Fine Art in London. Dissatisfied with his instruction there, however, the artist moved on to Paris and studied for a year at the Académie Julian under Gustave Boulanger and Jules Lefebvre. He also spent a winter at the Düsseldorf Academy and a couple of summers in The Hague at the atelier of the Dutch marine painter Hendrik Willem Mesdag. He traveled throughout Holland with GARI MELCHERS and eventually settled in Egmond near Amsterdam. Although Hitchcock usually spent his winters in France, he maintained a studio in Holland for the rest of his life. In an article in *Scribner's Magazine* (2 [August 1887], p. 161), he described Holland as "the most harmonious of all countries, either in sun or shadow. It is never crude; it is always a picture, atmospherically, as it stands, without change or thought of change."

Hitchcock exhibited at the New York Water Color Society in 1881 and at the National Academy of Design in 1885, but he established his reputation as a painter of Dutch themes at the 1885 Paris Salon with *La Culture des Tulipes*, which the French painter Jean Léon Gérôme acknowledged as the best American picture of the year. Two years later Hitchcock won an honorable mention at the Salon. His international reputation and critical success continued throughout his career. In 1905 he returned to America to exhibit his paintings in New York, Providence, and Detroit. That same year, after his divorce from the former Henrietta Richardson, he married one of his students, the British artist Cecil Jay.

Hitchcock was an officer of the Franz Joseph Order of Austria and was elected an associate of the National Academy of Design in 1909. His work from the 1880s and 1890s shows a strong dependence on French academic painters, such as Jules Bastien-Lepage, both thematically, in his portrayal of peasants and religious subjects, and stylistically, in his detailed renditions of landscape and costume. He has been called the "painter of sunlight," a description particularly suitable for the decorative impressionist paintings he executed around the turn of the century.

BIBLIOGRAPHY: Lionel G. Robinson, "Mr. George Hitchcock and American Art," *Art Journal* 43 (Oct. 1891), pp. 289–295 // Arthur Fish, "George Hitchcock: Painter," *Magazine of Art* 22 (1898), pp. 577–583 // Christian Brinton, "George Hitchcock—Painter of Sunlight," *International Studio* 26 (July 1905), pp. i–vi // Guy Pène Du Bois, "George Hitchcock: Painter of Holland," *Arts and Decoration* 3 (Oct. 1913), pp. 401–404 // Thieme-Becker (Leipzig, 1915; 1964), 17, pp. 150–151.

Vespers

After settling in Egmond near Amsterdam, Holland, in the early 1880s, Hitchcock specialized in figure paintings and landscapes depicting the picturesque life and scenery of this coastal area. This painting, probably dating from the late 1890s, shows a Dutch woman walking to evening prayers, or vespers. The windmill, the quaint village, and the verdant landscape could easily be found at any point along the coast, from the artist's studio in Egmond in the north to Zeeland in the south. Likewise, the woman's colorful cape and cap fit the artist's description of Dutch costume in general. In an article the artist noted that most Dutch women wore "a short, circular cloak in a variety of colors," but that nearly every Dutch town had its own individual headdress. "In Zeeland," wrote Hitchcock, "the cap is large and exceedingly beautiful, like a bridal veil almost, always worn at work or play; this clean, white, transparent stuff falling

Hitchcock, *Vespers.*

in folds around any face, enhances its beauty, if young, or its effect, if old and wrinkled." (*Scribner's Magazine* 10 [Nov. 1891], pp. 624–625.) This description suggests that the woman depicted in *Vespers* lived in Zeeland.

Hitchcock has placed his model close to the picture plane with her back to the viewer, a departure from his more academic compositions of the previous decade. The figure, placed in shadow, is silhouetted against a brilliantly colored landscape setting, where flowers and foliage, architecture, and dappled areas of sunlight and shadow create a strongly patterned decorative effect. Hitchcock's less conventional composition, his interest in pattern, and his choice of an intense, often harsh, palette are the result of his assimilation of impressionism during the 1890s.

Oil on canvas, 44⅜ × 35¾ in. (112.7 × 90.8 cm.).
Signed at lower left: G HITCHCOCK.
REFERENCES: H. Frantz, *Magazine of Art* 25 (July 1901), p. 420, states that in it Hitchcock "shows himself still as the master painter of the flower garden" // *American Art News* 3 (Feb. 18, 1905), ill. [p. 5], notes that it is on view at Glaenzer Gallery // C. Brinton, *International Studio* 26 (July 1905), ill. p. iv; p. vi, describes the religious quality of the painting // C. Brinton, *L'Art et les artistes* 17 (1913), ill. p. 64 // E. D. Libbey, letter in MMA Archives, Dec. 18, 1917, donates painting, calling it "a fine example of the late Mr. Geo. H. Hitchcock one of the best American artists" // *MMA Bull.* 13 (Jan. 1918), p. 53, announces its acquisition // P. Boswell, *Arts and Decoration* 14 (Feb. 1921), p. 297, mentions the "beautiful 'Hour of Vespers'" // *Art and Archaeology* 11 (March 1921), p. 115.
EXHIBITED: Royal Art Exhibition Hall, Munich, 1900, *Offizieller Katalog der Internationalen Kunst-Ausstellung des Vereins bildender Künstler Münchens "Secession,"* no. 115, as Beim Vesperläuten // Paris Salon, 1901, no. 1026, as L'heure des vêpres // Rhode Island School of Design, Providence, R.I., 1905, *Exhibition of Paintings by George Hitchcock*, no. 17, as Vespers // Glaenzer Gallery, New York, 1905 (no cat. available) // Brooklyn Museum, 1914, *Paintings by George Hitchcock*, no. 39 // Albright Art Gallery, Buffalo Fine Arts Academy, 1914, *Catalogue of an Exhibition of Paintings of Flower Fields in Holland*, no. 41 // Memorial Art Gallery, Rochester, New York,

1915, *Exhibition of Paintings by George Hitchcock*, no. 36 //
Toledo Museum of Art, 1915, *Catalogue of Paintings and
Drawings in the Permanent Collection, Transient Exhibitions*,
no. 230.

Ex COLL.: Edward Drummond Libbey, Toledo,
Ohio, probably 1915–1917.
Gift of Edward Drummond Libbey, 1917.
17.182.

THOMAS ANSHUTZ

1851–1912

One of the most gifted teachers in the history of American art, Thomas Pollock Anshutz
serves as a link between the late nineteenth-century realism of his mentor THOMAS EAKINS and
that of the so-called Ashcan school. For over thirty years he taught at the Pennsylvania
Academy of the Fine Arts, where he trained artists as different in style as Charles Sheeler
(1883–1965), Robert Henri (1865–1929), and John Marin (1870–1953). Although his
Ironworkers—Noontime, 1880–1881 (Fine Arts Museums of San Francisco) is a pioneering
example of urban American painting, the artist never again equaled this achievement—
perhaps, as Francis Zeigler suggested in 1899, because he "[gave] much of his time to teaching,
instead of devoting all his efforts to creative work " (p. 277).

Anshutz was born in Newport, Kentucky, and spent his youth in Moundsville, Ohio, and
Wheeling, West Virginia, before coming to New York in 1872 to study art. While in New
York, he maintained a studio in Brooklyn, where he also contributed to local art exhibitions
and joined the Brooklyn Art Club. According to the records of the National Academy of
Design, he enrolled in that institution's school on October 6, 1873, and by March 1875, had
advanced to the life class, developing a competent but hard, linear style under the tutelage
of Lemuel Wilmarth (1835–1918) and William Rimmer (1816–1879). Dissatisfied with the
instruction at the National Academy, which he described as "a rotten old institution,"
Anshutz left for Philadelphia in 1875. That same year he attended Thomas Eakins's life class
at the Philadelphia Sketch Club. When the Pennsylvania Academy of the Fine Arts opened
its new building in 1876, he entered as a student under Eakins and Christian Schussele
(1824 or 1826–1879). Although his student days continued through 1882, he was made an
assistant demonstrator in the dissecting room in 1880 and the following year was advanced
to chief demonstrator under Dr. W. W. Keen, the anatomy lecturer at the academy. During
the early 1880s, Anshutz and other faculty members experimented with photography and
assisted Eakins and Eadweard Muybridge with their historic photographic motion experiments
at the University of Pennsylvania. At this time, Anshutz painted in the mature style that would
characterize his work until 1892. His portraits and figure paintings display a concern for
modeling, a thorough understanding of anatomy, and an interest in reducing the subject to its
most essential forms.

In September 1892, Anshutz left for a year in Europe with his bride, the former Effie
Shriver Russell. He spent most of his time in Paris, where he studied at the Académie Julian
under Lucien Doucet and William Adolphe Bouguereau. On his return to Philadelphia and

the Pennsylvania Academy in October 1893, the artist took a new interest in pastel and watercolor painting and turned more often to painting light-filled landscapes. This new direction in medium and subject matter may have been inspired by his contact with impressionism. In 1898, he extended his teaching activities through the summer by founding the Darby School of Art in Fort Washington, Pennsylvania, with Hugh Breckenridge (1870–1937). He became head of the faculty at the Pennsylvania Academy of the Fine Arts in 1909, and the following year was elected president of the Philadelphia Sketch Club.

In September 1910, his son Edward accompanied him to Bermuda, and in May 1911, the family went to Bad Nauheim, in Germany, in an attempt to restore Anshutz's failing health. Although he continued to teach at the academy until October 1911, his condition worsened, and, after several months of hospitalization, he died of bronchial illness and heart trouble on June 16, 1912.

BIBLIOGRAPHY: Francis J. Ziegler, "An Unassuming Painter—Thomas P. Anshutz," *Brush and Pencil* 4 (Sept. 1899), pp. 277–284 ∥ Pennsylvania Academy of the Fine Arts, Philadelphia, *Thomas P. Anshutz, 1851–1912* (Jan. 17–Feb. 18, 1973), essay by Sandra Denney Heard. Good critical biography based on the author's M.A. thesis, 1969, University of Delaware ∥ Ruth Bowman, "Nature, the Photograph and Thomas Anshutz," *Art Journal* 33 (Fall 1973), pp. 32–40.

Cabbages

During the 1870s, such American realists as WINSLOW HOMER, THOMAS EAKINS, and his pupil

Thomas Anshutz created figure paintings depicting blacks engaged in their daily activities. These were often sensitive studies that revealed a deep understanding of the emotional and psychological attitudes of black people. Dated 1879, *Cabbages* is an early example of Anshutz's treatment of this subject. Here the artist portrays a woman and her children caring for their vegetable garden. The pleasant rural setting, however, does not obviate the sense of despair and contained anger in the poses and facial expressions of the figures.

Although the composition of the picture is ambitious, the anatomical treatment of the three figures is surprisingly inadequate. Anshutz, who was then studying anatomy at the Pennsylvania Academy of the Fine Arts, elongated the right arm of the woman and ignored details in the hands and feet of the children.

Anshutz continued to explore similar subjects during the 1880s and early 1890s. "Cabbages 17 × 24" appears in a list of paintings owned by the artist in 1893, and although the painting's early history is not well documented, it is likely that it remained in Anshutz's possession until his death.

Oil on canvas, 24 × 17 in. (61 × 43.2 cm.).
Signed and dated at lower right: Thos. Anshutz / 1879.
REFERENCES: T. P. Anshutz, notebook labeled "Thomas Pollock Anshutz, Paris, May 1893,"

Anshutz, *Cabbages*.

Thomas Pollock Anshutz Papers, Arch. Am. Art, includes it in a list of paintings // H. B. Wehle, *MMA Bull.* 35 (May 1940), pp. 117–118, discusses the possible locale for the painting and compares it to works of similar subjects by Homer // *Art Digest* 14 (Sept. 1, 1940), p. 22, announces MMA's acquisition of it // E. R. Anshutz, son of the artist, letter in MMA Archives, May 19, 1943, clarifies the painting's provenance // H. W. Williams, *Mirror to the American Past* (1973), p. 218, discusses it as a sympathetic and realistic depiction of Afro-American life in the nineteenth century; ill. p. 219 // M. Knoedler and Co., New York, letter in Dept. Archives, July 17, 1974, discusses provenance // E. Anshutz, daughter-in-law of the artist, letter in Dept. Archives, Aug. 7, 1976, clarifies its provenance.

EXHIBITIONS: Philadelphia Art Alliance, 1942, *Memorial Exhibition of the Work of Thomas Anshutz*, cat. by H. W. Henderson, unnumbered, as The Cabbage Patch // PAFA, 1955, *The One Hundred and Fiftieth Anniversary Exhibition*, no. 172 // James Graham and Sons, New York, 1963, *Thomas Anshutz, 1851–1912*, no. 2.

EX COLL.: the artist's sister Edith Anshutz, by 1912; Mrs. Wiley, before 1935; with Norman Hirschl Gallery, New York, until 1940; with M. Knoedler and Co., New York, 1940.

Morris K. Jesup Fund, 1940.

40.40.

CHARLES SPRAGUE PEARCE

1851–1914

A grandson of the poet Charles Sprague, Pearce was born and educated in Boston, where he attended the Brimmer and Boston Latin schools. For five years he worked in his father's mercantile office before embarking on a career as a painter in 1872. Although he had originally planned to study in Munich, on the advice of WILLIAM MORRIS HUNT he went instead to Paris and entered the atelier of Léon Bonnat. Poor health, which had delayed his departure for Europe, soon forced him to take the first of many winter trips to a warmer climate. In 1873 and 1874, the artist traveled on the Nile for four months with Frederick A. Bridgman (1847–1928), a fellow art student. On his return to Paris, his weakened physical condition confined him to a private studio, but he was visited often by Bonnat, who criticized his work and aided his progress. In 1876, he began to send his paintings to the Paris Salon, exhibiting primarily portraits, religious subjects, and occasionally oriental genre scenes. By 1885 he had settled twenty miles outside of Paris in Auvers-sur-Oise, where he remained for the next three decades. In a glass-enclosed outdoor studio, in which he was able to paint under all weather conditions, he executed sentimental interpretations of rural life in northern France. These works are allied to the style and subject matter of the French academic peasant painters Jules Bastien-Lepage and Jules Breton. At the turn of the century, Pearce contributed a series of six lunette murals to the decoration of the Library of Congress, climaxing an artistic career in which he had won recognition both at home and abroad.

BIBLIOGRAPHY: "Charles Sprague Pearce," *Art Amateur* 10 (Dec. 1883), pp. 5–6. Discusses his early career // George William Sheldon, *Recent Ideals of American Art* (New York and London, 1888–1890), opp. p. 4, pp. 9–11, 15–16, 20, 23–25, 33, 50, 59–60, 75, opp. p. 112, opp. p. 128, p. 134, opp. p. 160 // Herbert Small, comp., *Handbook of the New Library of Congress in Washington* (Boston, 1897), pp. 28–31. Discusses his murals in the Library of Congress.

The Arab Jeweler

The Arab subject matter of this painting was probably inspired by Pearce's travels, particularly a four-month boat trip that he took along the Nile in 1873 with the painter Frederick A. Bridgman (1847–1928). As reported a decade later, both artists spent the trip "sketching and gathering artistic material" (*Art Amateur* 10 [Dec. 1883], p. 6). Throughout the late 1870s and early 1880s, Middle Eastern subjects continued to be common in Pearce's œuvre. *The Arab Jeweler* was exhibited at the Paris Salon in 1882. In it, Pearce presents a dramatic close-up of a nearly life-size figure, solidly modeled. The sensuously rendered textures and meticulously recorded details resemble the work of his teacher Léon Bonnat. The picture is an exotic version of the craftsman themes popularized in America during the 1880s and 1890s by such artists as EDGAR MELVILLE WARD and JEFFERSON DAVID CHALFANT.

Oil on canvas, 46 × 35⅜ in. (116.8 × 89.9 cm.).
Signed and inscribed: Charles Sprague Pearce/Paris.
REFERENCES: *Art Amateur* 7 (August 1882), p. 46 // S. N. Pearce, father of the artist, to G. Corliss, secretary, PAFA, Dec. 8, 1883, PAFA Archives, microfilm P77, Arch. Am. Art, after negotiating the sale of his son's painting Fantasie to the academy, states that it "is of the same size, and I think a more pleasing subject as the 'Arab Jeweller' which was sold to New York for $1500."
EXHIBITED: Paris Salon, 1882, no. 2067, as Orfèvre arabe // Dayton Art Institute; PAFA; Los Angeles County Museum of Art, 1977, *American Expatriate Painters of the Late Nineteenth Century*, cat. by M. Quick, no. 35, p. 122, discusses its possible exhibition in the Paris Salon of 1882 and says it dates from about 1882; ill. p. 123.
EX COLL.: private coll., New York, by 1883; Edward D. Adams, New York, until 1922.
Gift of Edward D. Adams, 1922.
22.69.

THOMAS DEWING

1851–1938

Thomas Wilmer Dewing was born in Boston, the son of a milliner. His father died while Dewing was still a child, and he was educated at home by one of his sisters. At the age of sixteen or seventeen, having shown a remarkable talent for drawing, he began to study at the School of the Museum of Fine Arts. Dewing first worked for a commercial lithographer, and then for a year or two, he drew portraits in Albany, New York, to finance a trip to Europe. He left for Paris in 1876 and remained there for three years, studying at the Académie Julian with Jules Lefebvre and Gustave Boulanger. On his return in 1879, he took a studio in Boston and two years later moved to New York, where he married the noted flower painter Maria Oakey (1945–1938). That same year, and until 1888, he taught at the Art Students League. Beginning in 1879, he exhibited at the National Academy of Design, where he was elected an academician in 1888. He was elected to the Society of American Artists in 1880 and exhibited there until 1897. In that year he resigned to join the Ten American Painters, a group composed largely of American impressionists, who sought an exhibition organization more responsive to their work.

Dewing was a protégé of the well-known architect Stanford White, who often designed his frames. It was White who brought Dewing's work to the attention of a number of important patrons, among whom were Charles Lang Freer of Detroit and John Gellatly of New York.

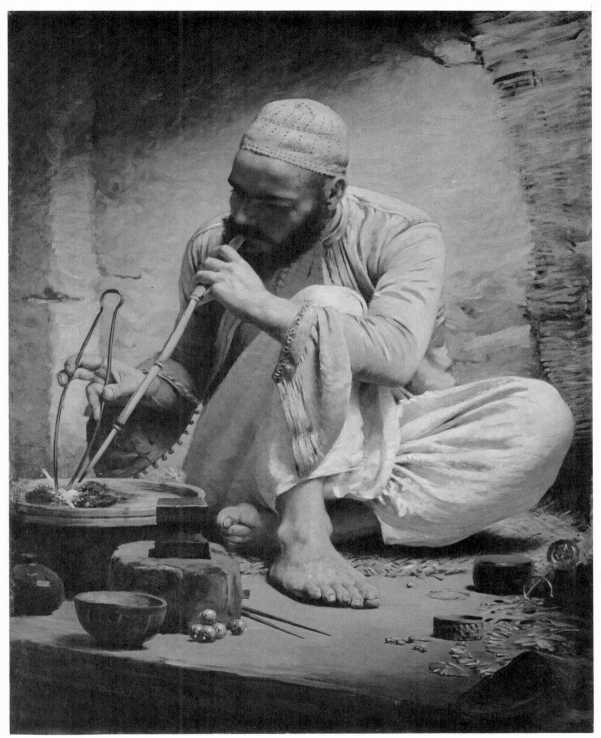

Pearce, *The Arab Jeweler*.

Their collections of Dewing's paintings are now preserved at the Freer Gallery of Art and the National Collection of Fine Arts, respectively.

Like many of his contemporaries, Dewing specialized in the theme of the idealized woman. He originated, moreover, a certain refined feminine type. As the critic Sadakichi Hartmann wrote of him in 1902, his sole aim was "to represent beautiful ladies, mostly mature women of thirty . . . [who] seem to possess large fortunes and no inclination for any professional work. They all seem to live in a Pre-Raphaelite atmosphere, in mysterious gardens, on wide, lonesome lawns, or in spacious empty interiors . . . there they sit and stand, and dream or play the lute or read legends . . . they all have a dream-like tendency, and, though absolutely modern, are something quite different from what we generally understand by modern women" (pp. 301–302). Although often associated with the American impressionists, Dewing is more properly described as a quietist or tonalist.

Dewing's career has not yet been fully studied, and, as a result, it is difficult to discuss the development of his style and subject matter. After his return from Paris, he painted nudes (now unlocated), and, during the next decade, he mainly did realistic portraits and ambitious figure studies like *Tobias and the Angel* (q.v.). His decorative paintings of women set in generalized landscapes, bathed in a diffused half-light, seem to date from the 1890s. After the turn of the century, however, his figures are set in austere Whistlerian interiors. He continued to work until a decade before his death, producing an impressive body of work, not only in oil, but in pastel and silverpoint, two mediums which enjoyed a revival in America during the 1880s and 1890s.

BIBLIOGRAPHY: Sadakichi Hartmann, *A History of American Art* (Boston, 1902), I, pp. 299–308 ∥ Charles H. Caffin, "The Art of Thomas Dewing," *Harper's Magazine* 116 (April 1908), pp. 714–724 ∥ Royal Cortissoz, "An American Artist Canonized in the Freer Gallery—Thomas W. Dewing," *Scribner's Magazine* 74 (Nov. 1923), pp. 539–546. Same as Royal Cortissoz, "Thomas W. Dewing," in *American Artists* (New York, 1923), pp. 45–56 ∥ Nelson C. White, "The Art of Thomas W. Dewing," *Art and Archaeology* 29 (June 1929), pp. 253–261 ∥ M. H. de Young Memorial Museum and the California Palace of the Legion of Honor, San Francisco, *The Color of Mood: American Tonalism, 1880–1910*, exhib. cat. by Wanda M. Corn (Jan. 22–April 2, 1972). Places Dewing in the context of late nineteenth-century quietist painting. Includes biographical sketch and bibliography.

Tobias and the Angel

This painting represents the artist's rather personal interpretation of a biblical scene from the Book of Tobit. The story, from the Apocrypha, concerns the elderly Tobit, who was blinded by sparrow dung. His son Tobias travels to Media accompanied by a dog and the angel Raphael, who is in the guise of a young man, to collect a debt for his father's support. On his trip, Tobias is startled by a fish while bathing in the river Tigris. Raphael instructs him to seize the fish and save the heart, liver, and gall. Later

the heart and liver are used to drive an evil spirit away from Sara, Tobias's future wife. The spirit has already killed seven of her bridegrooms, but Tobias is spared. The gall is then used to restore Tobit's sight.

In his painting, Dewing does not represent a specific incident in the story but instead shows Raphael and Tobias, two of its central figures, in a romantically interpreted scene. In the foreground, he places the angel Raphael, an androgynous figure with feathery wings, described by one critic as "great gull's wings, delightfully painted." Clad in a filmy robe and carrying a

Dewing, *Tobias and the Angel*.

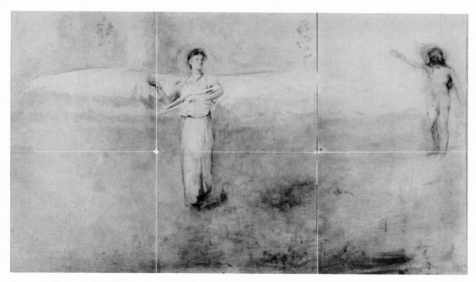

Autoradiograph of Dewing, *Tobias and the Angel*,
Brookhaven National Laboratory.

harp, the angel wanders in a sparse, flower-sprinkled landscape. The picture was originally titled "Tobit and the Angel," but the isolated figure on the right is clearly Tobias. This is obvious from his age, his position following Raphael, and the net and fish he carries. In fact when the painting was first exhibited at the Society of American Artists in 1887, some critics took issue with the title. Charles de Kay wrote:

T. W. Dewing's "Tobit and the Angel" has many admirers among the artists who do not look closely to the connection between title and picture, but enjoy intensely the painting of the drapery of the angel, the harmony of colors, the fine brushwork in the broad wings that jut from the angel's shoulder. . . . Mr. Dewing does not tell anything of the story . . . but rests his case on the artistic points of the work.

In the painting, Dewing sacrifices the narrative clarity of the scene to intensify the psychological impact. Each figure is isolated from the other: Tobias's gaze and gesture are introspective, and Raphael, seemingly unaware of his presence, looks blankly into the distance. Autoradiographs of the painting reveal an earlier composition quite different in intention. Dewing first showed a more effeminate Raphael with his head turned toward Tobias; Tobias's head was lowered and his right arm raised and extended toward Raphael.

The wealthy New York businessman Edward Dean Adams purchased the painting from the artist in 1887. Its frame was probably designed by Stanford White, the well-known architect who had also designed Adams's country home.

Oil on canvas, 24⅛ × 40⅛ in. (61.3 × 101.9 cm.).
Signed and dated at lower left: T. W. Dewing / 1887.
REFERENCES: *New York Times*, April 24, 1887, p. 6, reviews it in the ninth exhibition of the Society of American Artists (quoted above) // C. de Kay, *Art Review* 1 (April 1887), p. 11, reviews it and questions the accuracy of its title (quoted above) // *Art Age* 5 (June 1887), p. 68, reviews it, calling it "an excellent piece of artistic imagining. It is easy enough to quarrel with his rendering of the story"; he would have done better "to have left his picture unnamed" // T. W. Dewing MS 1899, Charles Lang Freer Papers, Freer Gallery of Art, Washington, D.C., microfilm 77, Arch. Am. Art, lists it among pictures painted in New York between 1880 and 1885 as no. 10, Tobit's Walk with the Angel, sold to E. D. Adams // B. Burroughs, memo in MMA Archives, Nov. 7, 1919, gives Stanford White as frame designer // C. B. Ely, *Art in America* 10 (Aug. 1922), p. 229, discusses its "spiritual beauty"; *The Modern Tendency in American Painting*

(1925), p. 47, discusses // E. V. Sayre, *Technology and Conservation* (Winter 1976), cover ill. shows X-ray and autoradiographs of it; pp. 2, 31, discusses original conception of the painting revealed by autoradiographs and notes that figure of Tobias was changed by the artist at least twice // P. Meyers, Research Laboratory, MMA, memo in Dept. Archives, Oct. 28, 1977, provides a detailed explanation of X-ray and autoradiograph series.

EXHIBITED: Society of American Artists, New York, 1887, no. 50, as Tobit and the Angel, lent by E. D. Adams // Art Institute of Chicago, 1888, *Catalogue of the First Annual Exhibition of American Oil Paintings*, no. 124, as Tobit's Walk with the Angel, lent by E. D. Adams // Society of American Artists, 1892, *Retrospective Exhibition of the Society of American Painters*, no. 100 N, as Tobit's Walk with the Angel, lent by E. D. Adams.

EX COLL.: Edward D. Adams, New York, 1887–1919.

Gift of Edward D. Adams, 1919.
19.171.1.

The Letter

"Some hundreds of years hence," speculated KENYON COX in 1907, "the historian of our time may be puzzled by Mr. Dewing's treatment of our life, and wonder if the ladies of the day usually sat in such bare rooms or wore low-cut dresses in the daytime; but what does it matter? It is a fantasy, but what a delicate one!" In *The Letter*, the artist turns to his favorite theme of a pensive woman immersed in contemplation or quiet intellectual pursuits. This austere but expressive work is a fine example of Dewing's academic figure style and his extraordinary sensitivity to the formal qualities of color and composition, described by Catherine Beach Ely as "a combination of New England austerity and Greek classicism set to the glamour of modern atmosphere and light." The artist's aesthetic quietism had many sources: the intimate interiors of Jan Vermeer, the simplified pictorial design and limited palette of JAMES MCNEILL WHISTLER, and the formal arrangements of Japanese prints.

Dewing's *Writing a Letter* (Toledo Museum of Art), which is a more elaborate interior with two figures, shows what appears to be a similarly dressed model seated at the same desk.

Oil on canvas, 20¼ × 16 in. (51.4 × 40.6 cm.).
Signed at lower left: T W Dewing.
REFERENCES: K. Cox, *Nation* 84 (April 18, 1907), p. 369, reviews it in Carnegie exhibition (quoted

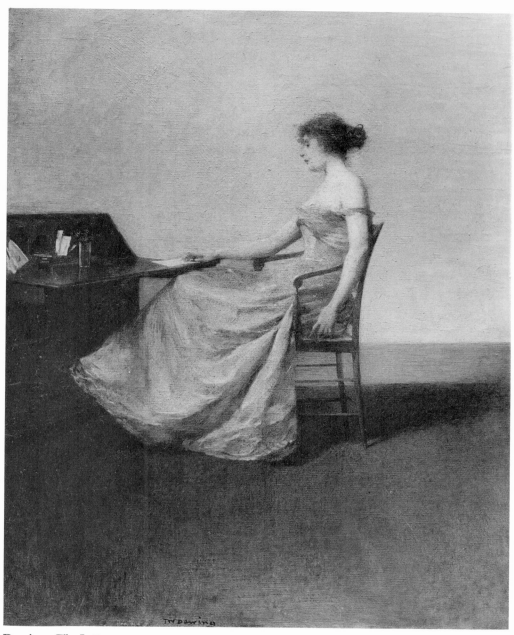

Dewing, *The Letter*.

above) // A. N. Meyer, *Harper's Weekly* 51 (May 4, 1907), p. 655 // T. W. Dewing, letter in MMA Archives, May 7, 1910, gives title as The Letter // K. Cox, *Century Magazine*, n.s. 61 (Dec. 1911), ill. p. 209; pp. 212–213, discusses // C. B. Ely, *Art in America* 10 (August 1922), p. 229, describes it; *The Modern Tendency in American Painting* (1925), p. 48, describes it.

EXHIBITED: Carnegie Institute, Pittsburgh, 1907, no. 132, The Letter // Alaska-Yukon-Pacific Exposition, Seattle, 1909, *Official Catalogue*, no. 365 // Durlacher Bros., New York, 1963, *A Loan Exhibition, Thomas W. Dewing, 1851–1938*, no. 10, dates it 1895–1900.

EX COLL.: the artist, until 1910.
Rogers Fund, 1910.
10.82.

Lilac Dress

"The exquisite figure of the young woman in the 'Lilac Dress' . . . is one of those wonderfully beautiful canvases that has all the charm of a painting in miniature, yet with the breadth of tone, the lighting and coloring of a painting in oil," noted Rena Tucker Magee in 1919. Dewing has applied his paints thinly and fluidly, creating a delicate and refined impression. The figure, seated on a Louis XVI chair and placed at an angle to the viewer, has the remote and intellectual quality that is so distinctive of Dewing's women.

The lilac teagown, with its pouched bodice, loose sleeves, sashed waist, and full skirt, probably does not date before 1904, but since Dewing often kept costumes in his studio and used them over a period of time, the painting cannot be documented until its appearance on the New York art market in 1919.

Oil on canvas, $24\frac{1}{16} \times 20\frac{1}{16}$ in. (61.1 × 51 cm.).
Signed at lower right: T W Dewing.
REFERENCES: [R. T. Magee], *Milch Gallery Art Notes* (Oct. 1919), p. 11, discusses it (quoted above) // R. Cortissoz, *Scribner's Magazine* 85 (Jan. 1929), ill. p. 114, as Lilac Dress.
EXHIBITED: California Palace of the Legion of Honor, San Francisco, 1926–1927, *Catalogue of the First Exhibition of Selected Paintings by American Artists*, no. 53, as Girl in Lilac Dress // Carnegie Institute, Pittsburgh, 1928, no. 20, as Lilac Dress, lent by Milch Galleries // Montclair Art Museum, N.J., 1946, *American Paintings by "The Ten,"* no. 14, as Lady in Lilac, lent by Milch Galleries // Wadsworth Atheneum, Hartford, 1950, *The Adelaide Milton de Groot Loan Exhibition* (no cat.).
EX COLL.: with Milch Gallery, New York, by 1919— probably until 1928; Horatio S. Rubens, New York, until 1948; with Milch Gallery, New York, 1948–1949; Adelaide Milton de Groot, New York, 1949–1967.
Bequest of Miss Adelaide Milton de Groot (1876–1967), 1967.
67.187.124.

Dewing, *Lilac Dress*.

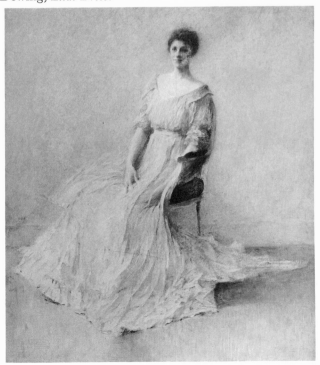

Dewing, *Green and Gold*.

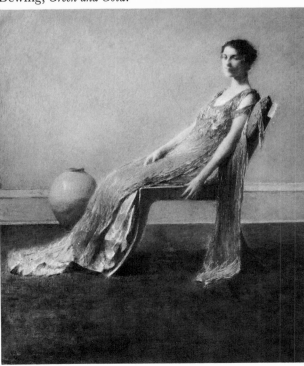

Green and Gold

The quietist painter Thomas Dewing made his reputation with studies of female figures set in Whistlerian interiors such as this, where the sitter's relaxed posture and flowing costume enliven the rigid geometry and plain surfaces of the setting. Writing in 1923 to Mrs. George Ball, then the owner of the painting, the artist described it as "one of the best things I ever did—perhaps the best," and explained that it received its title "from the greenish dress and the gilded chair." He continued: "It is the portrait of an actress who is now in Hollywood and who posed for me some times. The chair was made for the picture from my drawing after the Early Roman design. I hope you will keep it and always like it but if you ever do part with it I sincerely hope it will go to a public museum where it will be safe and permanent."

Oil on canvas, 24⅛ × 22¼ in. (61.3 × 56.5 cm.).
Signed at lower right: T W Dewing.
REFERENCES: Thomas Wilmer Dewing Papers, D22, Arch. Am. Art, includes photograph of the painting inscribed "To E. H. B. from T. W. D. 1917" // Academy Notes 12 (Jan.–Oct. 1917), p. 75, in a review of Albright Art Gallery exhibit says, "The exquisite reserved note, the beautiful conception, color scheme and refinement of this work is attracting much attention"; ill. p. 79 // R. G. McIntyre, William Macbeth Galleries, to Mrs. G. A. Ball, April 28, 1923, copy in Dept. Archives, states that he had asked Dewing to write to her regarding the picture // T. W. Dewing to Mrs. G. A. Ball, April 30, 1923, copy in Dept. Archives, dates the picture 1916 or 1917 and discusses it (quoted above) // E. Ball, letters in Dept. Archives, August 3, 24, 1974, verifies provenance.

EXHIBITED: Albright Art Gallery, Buffalo Fine Arts Academy, 1917, no. 43, as Green and Gold, lent by N. E. Montross, New York // Carnegie Institute, Pittsburgh, 1924, *Exhibition of Paintings by Thomas W. Dewing*, no. 5, lent by Mrs. George Alexander Ball // Macbeth Gallery, New York, 1929, *Thirty Paintings by Thirty Artists*, no. 8.

EX COLL.: Mr. N. E. Montross, by 1913–1919 (sale, American Art Galleries, New York, Feb. 27, 1919, no. 66, $3,900); with Rehn Galleries, New York, 1919; with William Macbeth, New York, by 1923; Mrs. George A. Ball, Muncie, Ind., after 1923; her daughter Elisabeth Ball, Muncie, Ind., until 1953.

Gift of Elisabeth Ball, 1953.
53.69.

THEODORE ROBINSON

1852–1896

Theodore Robinson spent much of his career in France and was influenced by a succession of styles: academic realism, Barbizon painting, and impressionism. A frequent visitor to New York and a resident there in the last years of his life, he introduced many Americans to impressionism.

The artist was born in Irasburg, Vermont, the son of a Methodist minister. In 1855, his family moved to Evansville, Wisconsin, where he attended the Evansville Seminary. He began to draw at an early age, and in 1869 or 1870, he went to Chicago to study art, but poor health, caused by chronic asthma, forced him to spend some time in Denver, Colorado, before returning to Evansville. Settling in New York in 1874, he attended classes at the National Academy of Design and participated in the formation of the Art Students League.

In 1876, Robinson went to Europe and, after traveling through Normandy, took a studio in Paris. At first he studied in Emile Auguste Carolus-Duran's atelier but soon transferred to the Ecole des Beaux-Arts, where he worked under Jean Léon Gérôme. He exhibited at the Paris Salon in 1877 and during that summer painted in the countryside at Grez-sur-Loing

and Veules-les-Roses with WILL H. LOW, Birge Harrison (1854–1929), and others. The following summer or autumn, he went to Venice, where he met JAMES MC NEILL WHISTLER. At the end of his student years, he was painting in a style characterized by literal draftsmanship and bright, often high-key, colors.

Robinson returned to America in 1879 and, after visiting his family in Evansville, settled in New York in 1881. For the next three years, he supported himself by teaching and doing decorative work, first for JOHN LA FARGE in Tarrytown, New York, and then for Prentice Treadwell at the Metropolitan Opera House. After his mother's death in 1881, he visited his family in Wisconsin and Vermont and, the following summer, painted on Nantucket with ABBOTT H. THAYER and Joe Evans (1857–1898). He also visited Boston, presumably to do decorative work, but these decorations have not been identified. The few easel paintings that he did during this period, however, are realistic, broadly painted, and high in key. They show his increasing attention to the effects of light and atmosphere.

In the spring of 1884, Robinson gave up decorative painting and returned to France, where he spent much of the next eight years. Painting in Paris and such rural locales as Barbizon and Giverny, he exhibited at the Salon between 1887 and 1890. At first his work lacked direction: using a dark palette, he painted small simple sketches, often on wood panels, and, at times, he reverted to decorative or sentimental subjects. An admirer of Jean Baptiste Camille Corot and Charles Daubigny, Robinson did somber landscapes and figure paintings of peasants outdoors. Then, in 1888, he met Claude Monet at Giverny. Under the strong influence of this artist, he began to paint in a more impressionistic style. His subjects—landscapes and figures outdoors—remained the same, but his palette became lighter, his paint surfaces less finished, and his compositions less academic. Robinson's forms, however, never dissolved in light; their contours remained decisive. His colors were also more delicate than those favored by the impressionists. More important, he retained a strong sense of design in his compositions, undoubtedly the result of his decorative work during the early 1880s. As a working aid, he often used photographs to record specific effects, particularly for his figurative works. The artist made frequent trips to New York between 1886 and 1890, when he took an extended trip to Italy. Robinson's interaction with his fellow American artists and the exhibition of his paintings in New York and Boston, for instance, his 1891 show with Theodore Wendel (1859–1932), did much to familiarize his contemporaries with impressionism.

When Robinson returned to America permanently in December 1892, it was with the conscious desire to depict American rather than French subjects. During the remaining years of his career, his landscapes became more representational and more topographical. He settled in New York, where his closest friends were J. ALDEN WEIR, JOHN H. TWACHTMAN, and August Jaccaci, then art editor for *Scribner's*. Plagued by ill health and constant poverty, he again supported himself by teaching. He conducted summer classes for the Brooklyn Art School in Napanock, New York, in 1893 and at Evelyn College in Princeton, New Jersey, in 1894; the following year, he took over ROBERT VONNOH's classes at the Pennsylvania Academy of the Fine Arts. In February 1895, the New York art dealer William Macbeth organized Robinson's first one-man show, which later toured the country. He painted landscapes in Greenwich and Cos Cob, Connecticut, and Brielle, New Jersey, but it was not until

1895, while teaching in Brattleboro, Vermont, that he was satisfied with his attempt to depict the American countryside. "All I have done up to this year's work has not been an emotional statement of myself; I have not *felt* my subjects. This year I got back among the hills I knew when a boy . . . and I am just now beginning to paint subjects that touch me," he told Hamlin Garland the last time they met (*Brush and Pencil* 4 [Sept. 1899], p. 285). He died in New York in the spring of 1896, at the age of forty-four, a victim of asthma. His friends held a funeral for him at the Society of American Artists in the Fine Arts Building in New York, and he was buried in Evansville, Wisconsin.

BIBLIOGRAPHY: Theodore Robinson, "Claude Monet," *Century*, n.s. 22 (Sept. 1892), pp. 696–707. Reprinted in John C. Van Dyke, ed., *Modern Masters: A Series of Biographical and Critical Reviews* (London, 1896), pp. 169–174 || Eliot Clark, "Theodore Robinson: A Pioneer American Impressionist," *Scribner's Magazine* 70 (Dec. 1921), pp. 763–768 || Brooklyn Museum, *Theodore Robinson 1852–1896*, exhib. cat. by John I. H. Baur (Nov. 12, 1946–Jan. 5, 1947). The most complete treatment of this artist's life and work; includes a chronology, biography, annotated catalogue, and many quotations from the artist's diaries (March 1892 to March 1896), now in FARL. Reprinted in *Three Nineteenth Century American Painters: John Quidor—Eastman Johnson—Theodore Robinson*, with a new intro. by Donelson F. Hoopes (New York, Arno Press, 1969) || John I. H. Baur, "Photographic Studies by an Impressionist," *Gazette des Beaux-Arts*, ser. 6, 30 (Oct. 1947), pp. 319–330 || Baltimore Museum of Art; Columbus Gallery of Fine Arts, Ohio; Worcester Art Museum, Mass.; Joslyn Art Museum, Omaha; Munson-Williams-Proctor Institute, Utica, N.Y., *Theodore Robinson, 1852–1896*, intro. and commentary by Sona Johnston (May 1, 1973–Feb. 24, 1974). Includes detailed catalogue entries and selected bibliography.

A Bird's-Eye View

In this striking landscape, dated 1889, the artist shows the French village of Giverny from a position high above the rooftops. The vantage point and composition are similar to a number of his works, such as *Giverny*, ca. 1889 (Phillips Collection, Washington, D.C.), and the panoramic *Valley of the Seine from Giverny Heights*, 1892 (Corcoran Gallery of Art, Washington, D.C.). In these paintings, a sparse foreground serves as a visual link to the more distant buildings, fields, and foliage, and a diagonal boundary provides a contrast to the strong horizontal lines of the background.

The artist first visited Giverny in 1887. Returning the following year, he became friendly with Claude Monet, under whose influence he began to develop an impressionist style. Working in refined pastel colors, high in key but not harsh, he showed a new awareness of nature's coloristic variety. In an article on Monet, Robinson praised that artist's use of color and asserted: "That there is more color in nature than the average observer is aware of, I believe any one not color-blind can prove for himself by taking the time and trouble to look for it the modern eye is being educated to distinguish a complexity of shades and varieties of color before unknown" (*Century*, n.s. 22 [Sept. 1892], p. 699). In *A Bird's-Eye View*, Robinson's colors—pinks and lavenders as well as the more readily expected blues, browns, and greens—are rarely applied with the broken brushstrokes of impressionism. In contrast to works by Monet, Robinson's paint surfaces are more varied and, at the same time, more controlled and more carefully confined within outlines.

The composition, with its block-like shapes and elevated vantage point, recalls landscapes by Paul Cézanne. Unlike Cézanne, however, Robinson was more concerned with surface design than with three-dimensional form. Thus in *A Bird's-Eye View* he strengthened the overall pattern created by the component elements in the scene. The rectilinear shapes of the sunlit buildings crowd the middle ground, compressed between foreground and distance, where tree-bound fields recede almost vertically toward the narrow strip of sky at the horizon. "I realize more and more the importance of the 'ensemble,'" he wrote in his diary (FARL) on August 13, 1893, "the whole thing going together, thinking quickly, grasping the whole,

and working from one part to another, sky to reflection of sky, distance, foreground, etc."

Oil on canvas, 25¾ × 32 in. (65.4 × 81.3 cm.).

Signed and dated at lower left: TH. ROBINSON–1889.

REFERENCES: *Nation* 59 (May 8, 1890), p. 382, in a review of the exhibition at the Society of American Artists, calls its color "flat and chalky" and criticizes his use of the impressionist technique // *Critic*, n.s. 13 (May 10, 1890), p. 239, in a review of the Society of American Artists, says it is "French in execution as in subject" // *Catalogue of the Collection of Foreign and American Paintings Owned by Mr. George A. Hearn* (1908), ill. p. 217, as Giverny, France // G. A. Hearn, letter in MMA Archives, April 21, 1910, offers it to the museum // *George A. Hearn Gift to the Metropolitan Museum of Art . . .* (1913), ill. p. 85 // Brooklyn Museum, *Theodore Robinson 1852–1896*, exhib. cat. by J. I. H. Baur (1946), p. 29, discusses technique used in it; p. 58, lists it as no. 17 in a catalogue of Robinson's work, lists exhibitions and references, gives provenance and alternative titles // F. Lewison, *American Artist* 27 (Feb. 1963), ill. p. 45; p. 72, discusses // *Apollo* 78 (Sept. 1963), ill. p. 209 // D. F. Hoopes, *The American Impressionists* (1972), ill. p. 51 // *MMA Bull.* 33 (Winter 1975–1976), no. 72, color ill. and discusses.

EXHIBITED: Society of American Artists, New York, 1890, no. 152, as A Bird's-Eye View // Inter-State Industrial Exposition, Chicago, 1890, no. 249 // PAFA, 1891, no. 250 // Boston Art Club, 1892, no. 134 // Macbeth Gallery, New York, 1895, *Theodore Robinson*, no. 21 // Cotton States and Industrial Exposition, Atlanta, 1895, *Official Catalogue of the Cotton States and International Exposition*, no. 502 // Chicago Society of Artists, 1896, no. 65 // St. Louis Museum of Fine Arts, 1896, *A Collection of Twenty-seven Pictures and Studies by the Late Theodore Robinson . . .*, no. 18 // Cincinnati Museum Association, 1897, *A Collection of Work by the Late Theodore Robinson Embracing Twenty-one Studies and Pictures*, no. 16 // University of Iowa, Gallery of Art, Iowa City, 1964, *Impressionism and Its Roots*, exhib. cat. by F. Seiberling, no. 45; p. 8, mentions; ill. p. 53 // MMA, 1970, *19th-Century America*, exhib. cat. by J. Howat and N. Spassky, ill. no. 186, discusses // Lowe Art Museum, University of Miami, Coral Gables, Fla., 1971, *French Impressionists Influence American Artists*, no. 153 // Baltimore Museum of Art; Columbus Gallery of Fine Arts, Ohio; Worcester Art Museum, Mass.; Joslyn Art Museum, Omaha; Munson-Williams-Proctor Institute, Utica, N.Y., 1973–1974, *Theodore Robinson, 1852–1896*, exhib. cat. by S. Johnston, no. 23; ill. p. 24, discusses, lists exhibitions and references, gives provenance; p. 25, compares it to another view of Giverny in Phillips Collection.

Ex COLL.: Theodore Robinson, 1889–1896; estate of the artist, 1896–1898 (sale, American Art Galleries,

Robinson, *A Bird's-Eye View*.

Robinson, *The Old Mill*.

New York, March 24, 1898, no. 91, as Bird's Eye View—The Valley of the Seine from Giverny, $125); George A. Hearn, by 1908–1910.

Gift of George A. Hearn, 1910.

10.64.9.

The Old Mill (Vieux moulin)

Done at Giverny, probably around 1892, the painting is one of four known depictions of this scene by Robinson. In these paintings, the artist's main concern is with changing appearances under different temporal and climatic conditions. *The Old Mill* shows the scene on a sunless day with no sharp contrasts of light and dark. The rectilinear forms of the buildings are relieved by the curve of the road and the distant hill, its gentle swell rising above the mill's roof-line. The colors are low-key and broadly applied with details like the fence and foliage added only sketchily.

In *Road by the Mill*, 1892 (Cincinnati Art Museum), an almost identical view on a bright day, Robinson altered the composition by adding a peasant girl and a cow and deleting a strip of fencing along the side of the road. Painted with broken brushstrokes that emphasize flickering shadows and highlights, this is probably the painting that was shown to Monet, according to an entry in Robinson's diary on September 15, 1892 (FARL). Another entry, written on November 20, mentions "the 'little mill' sunny effect (cumulus) a thing begun two weeks since,"

suggesting that there is yet another version of this view on a bright day. John I. H. Baur recorded other paintings, *Moonlight, Giverny* (coll. Mrs. George B. Wheeler, New York), and the study for it (Salmagundi Club, New York), both nocturnal versions of the same scene.

Oil on canvas, 18 × 21⅞ in. (45.7 × 55.6 cm.).

Signed at lower left: Th. Robinson.

REFERENCES: R. W. Chambers, letters in MMA Archives, Jan. 8, 1910, says it is a gift of Mrs. Robert W. Chambers; Jan. 31, 1910, says "The title 'Vieux Moulin,' is Robinson's own" // Brooklyn Museum, *Theodore Robinson 1852–1896*, exhib. cat. by J. I. H. Baur (1946), p. 33, mentions its style; p. 71, lists it as no. 165 in a catalogue of the artist's work, lists reference and gives provenance, dates it ca. 1892, lists three works related to it.

EXHIBITED: Akron Art Institute, Ohio, 1946, *America Paints Outdoors*, no. 25 // Mount Holyoke College, Mount Holyoke, Mass., 1956, *French and American Impressionism*, no. 48 // American Federation of Arts, traveling exhibition, 1961–1962, *Monet and the Giverny Group*, no. 6 // Florence Lewison Gallery, New York; Albany Institute of History and Art, 1962–1963, *Theodore Robinson*, no. 6 // Baltimore Museum; Columbus Gallery of Fine Arts, Ohio; Worcester Art Museum, Mass.; Joslyn Art Museum, Omaha; Munson–Williams–Proctor Institute, Utica, N.Y., 1973–1974, *Theodore Robinson, 1852–1896*, exhib. cat. by S. Johnston, no. 46; ill. p. 47, discusses, notes other depictions of the same scene by Robinson, lists exhibitions and references, gives provenance.

EX COLL.: Mr. and Mrs. Robert W. Chambers, New York, by 1909.

Gift of Mrs. Robert W. Chambers, 1910.

10.2.

EDWIN AUSTIN ABBEY

1852–1911

The figure painter Edwin Austin Abbey was born in Philadelphia. There he received his first artistic training in 1866 from the portrait and landscape painter Isaac L. Williams (1817–1895) and attended night classes at the Pennsylvania Academy under Christian Schussele (1824 or 1826–1879). That same year he became an apprentice draftsman in the publishing firm of Van Ingen and Snyder, initiating his career as a popular illustrator. In 1870, *Harper's Weekly* published its first Abbey drawing, and within a year, Abbey was working for Harper and Brothers in New York. He participated in the first exhibition of the American Water Color Society in 1874 and in 1877 was among the half dozen founders of the Tile Club.

Harper and Brothers sent him to England to do research for illustrations of Robert Herrick's poetry in 1878, and the following year, he made the first of a number of annual visits to the Paris Salon. In 1880, he visited Biarritz for his health, spent some time in Paris and London, and then made a "sketching ramble" through Holland with George Henry Boughton (1833–1905). In 1881, he visited Gloucestershire, where he was later to settle, and then traveled to New York, accompanied by his friend Alfred Parsons, the English landscape painter. Abbey returned to England in May 1882, and although he later made occasional trips to New York and Boston in the 1880s and 1890s, he became an expatriate, whose painting style and subject matter reflect the influence of his English contemporaries. In 1885, he spent the first of several summers in the picturesque village Broadway, in Worcestershire, where his friends and associates included the American painters FRANK MILLET and JOHN SINGER SARGENT, the English artists Frederick Barnard and Lawrence Alma-Tadema, and the Anglo-American author Henry James.

First recognized as a pen and ink draftsman, Abbey also produced many watercolors, particularly during the 1870s and 1880s. In 1889, he began to paint seriously in oil and completed a decorative project for the Amsterdam Hotel in New York, the first of a series of mural projects that would occupy his attention for the remainder of his career. Between 1890 and 1901, he worked on the *Quest of the Holy Grail* mural for the Boston Public Library; in 1896, he received a commission to paint a panel for the Royal Exchange, London; and in 1902, he was given a commission for the decoration of the new state capitol at Harrisburg, Pennsylvania, which was completed after his death by Sargent.

In 1894, Abbey began to work in pastel and held successful exhibitions of his work in this medium in London in 1895 and in New York in 1896. In 1890, he sent his first major oil painting *May Day Morning*, 1890–1894 (Yale University Art Gallery), to the Royal Academy in London, which elected him an associate in 1896 and an academician two years later. Abbey was an honorary member of the American Society of Architects, an associate of the Royal Water Colour Society and the Société Nationale des Beaux-Arts, and in 1902, he was elected an academician at the National Academy of Design. Also in 1902, he was commissioned to paint *The Coronation of Edward VII* (Buckingham Palace, London), a work he completed two years later. He suffered a physical breakdown in 1906, but after six months of relaxation

and travel, he was able to resume work. He died in London in 1911 after an illness of several months.

Abbey painted carefully researched period studies, often choosing the literary subjects then popular at the Royal Academy in London. Although his historically correct canvases are realistic, his work is permeated with a lyrical appreciation of the past. "I never know whether I really see what I see or not," he said. "I mean, looking at an old window—suddenly— instantly, if it is suggestive at all, I don't see that window as it is, at all, but as it might have been, with the people whom it was made for and the people who made it looking through it at each other. Everything old I see that way . . . I lose all the pleasure a modern should have in the real aspect of real things" (quoted by Foster, in *Edwin Austin Abbey* [1973], p. 4).

After Abbey's death, his widow, the former Mary Gertrude Mead, bought back a large number of his works, which, together with those included in his estate, she presented to the Yale University Art Gallery in 1937. This concentration of so many of Abbey's works in a single location has created an exceptional study collection, but for a number of years it inhibited the growth of the artist's reputation.

BIBLIOGRAPHY: E[dward] V[errall] Lucas, *Edwin Austin Abbey, Royal Academician: The Record of His Life and Work* (2 vols., London and New York, 1921). The standard biographical source, it includes extensive quotations from letters and manuscripts and is heavily illustrated // Yale University Art Gallery, New Haven; PAFA; and Albany Institute of History and Art, *Edwin Austin Abbey (1852–1911)* (Dec. 6, 1973–Oct. 27, 1974). Includes "The Paintings," by Kathleen A. Foster, "Abbey as Illustrator," by Michael Quick, chronology, extensive catalogue notes, and a bibliography with a list of Abbey's illustrated books. The best coverage of the artist's life and career.

"King Lear," act 1, scene 1

The painting depicts the opening scene of Shakespeare's tragedy *King Lear*. The heroine Cordelia, who stands in the center of this nearly life-sized composition, has just been renounced by her father, King Lear, who is seen exiting on the right, accompanied by his attendants. While the sympathetic king of France bends to kiss her hand, Cordelia confronts her older sisters Regan and Goneril. In her farewell speech, she tells these jealous siblings, who have alienated their father from her:

Ye jewels of our father, with washed eyes
Cordelia leaves you. I know you what you are;
And, like a sister, am most loth to call
Your faults as they are named. Love well our
 father.
To your professed bosoms I commit him.
But yet, alas! stood I within his grace,
I would prefer him to better place.
So farewell to you both.

This speech, which has been associated with the painting from the time of its first exhibition in 1898, also served as the introduction to William Michael Rossetti's poem "Cordelia," published in the Pre-Raphaelite magazine the *Germ* in 1850 (reprinted in 1898). The poem and the illustration that accompanied it—Ford Madox Brown's etching *Cordelia Parting from Her Sisters*—may have been the immediate inspiration for Abbey's painting both in composition and the specific details and attitudes of the characters. In 1898 the art critic A. C. R. Carter noted the relationship between Abbey's painting and Brown's *Cordelia's Portion*, 1867–1875 (Southampton Art Gallery, Southampton, England). This latter work makes a less convincing comparison, however, than the published illustration.

Abbey explored the subject, painting five versions of it between 1897 and 1898. His progress on these pictures is related by his biographer Edward Verrall Lucas (1921). The artist had begun the picture by July 20, 1897, when his wife Gertrude described the composition, "Cordelia is bidding her sisters 'farewell'— the King of France kissing her hand, and the old king and his followers departing from the scene." She also noted that the canvas was to measure four by ten feet, two feet less than the height of the Metropolitan's painting. On November 28, 1897, Abbey was still at work on the pictures.

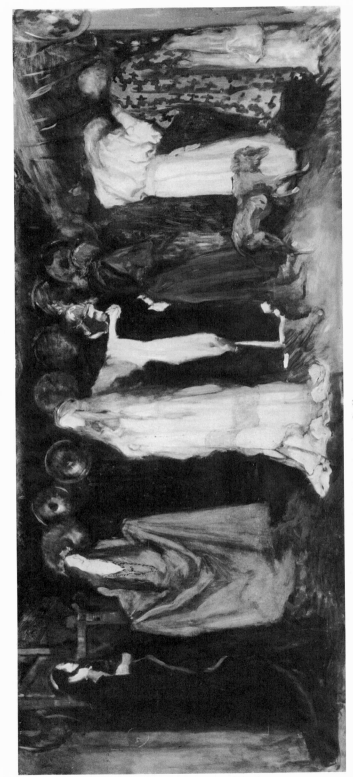

Abbey, preparatory study, *Lear and Cordelia*, Yale University Art Gallery.

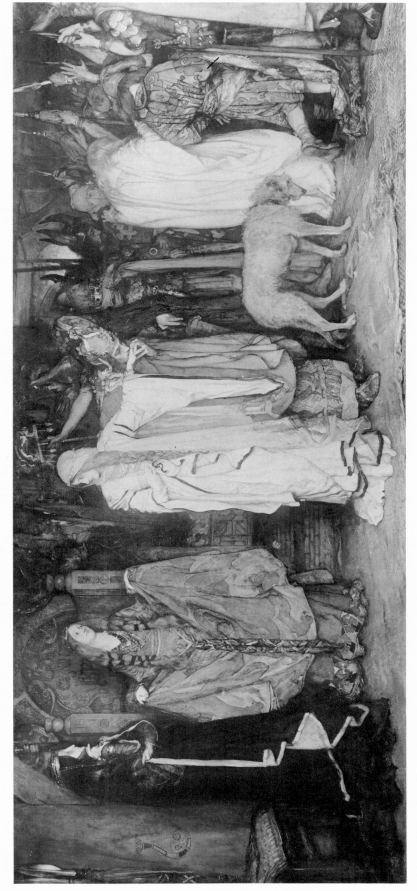

Abbey, "King Lear," act I, scene I.

The artist took painstaking care in selecting and depicting the elaborate costumes for the figures. For example, the costume worn by the fool—the figure who supports the retreating Lear—was made by Abbey's wife from fragments of old textiles, some of them purchased in Venice. In letters to his wife, written during the autumn of 1897, Abbey frequently mentioned the difficulties he was encountering. "I do work pretty hard," he asserted on October 8, 1897, "but I only feel it when I scrub and paint and scrape and cannot get what I see in my mind."

When the painting was exhibited at the Royal Academy in London in 1898, the critic from the *Spectator* praised it for "the balance between colour, form, characterization, and composition" and for achieving "one strong and satisfying harmony." The London *Times*, however, commented: "The difficulty in choosing a Shakespearean subject, especially one as scenic as this, is to avoid suggesting a stage rather than the poet's conception and words we are not quite sure whether he has done so completely in the 'King Lear.'" The painting is indeed theatrical in conception: the large-scale figures are arranged in a frieze parallel to the picture plane and compressed into a shallow stage-like space; the brilliant colors of the costumes are illuminated by harsh, artificial light; and the narrative is suggested by exaggerated poses, gestures, and facial expressions.

Abbey returned to the King Lear theme in 1902, painting *Goneril and Regan* (Yale University Art Gallery), one of four illustrations for an article on the play of that name by Algernon Charles Swinburne in *Harper's Monthly* for December 1902.

Oil on canvas, 54¼ × 127¼ in. (137.8 × 323.2 cm.). Signed and dated at lower left: E. A. Abbey 1898.
RELATED WORKS: *Lear and Cordelia*, 1898, oil on canvas, 54 × 126 in. (137.2 × 320 cm.), unlocated, was exhibited at the Royal Academy, London, winter exhibition, 1912, no. 476, as lent by Mrs. Coutts Michie // *Lear and Cordelia*, preparatory study, oil on canvas, 23½ × 67¾ in. (59.7 × 172.1 cm.), 1937.2212, and additional uncatalogued drawings and oil studies, listed in "Abbey Subject Record," are in the Edwin Austin Abbey Memorial Collection, Yale University Art Gallery.
REFERENCES: *Academy Notes*, no. 24 (1898), p. 8, no. 138, gives speech from *King Lear* (quoted above) // *Times* (London), April 30, 1898, p. 14, reviews it at Royal Academy (quoted above) // *Athenaeum* 111 (April 30, 1898), p. 572, praises it, commenting: "The subject was never more powerfully or more impres-

sively dramatized, even on stage, which is obviously in Mr. Abbey's thoughts" // *Academy* 53 (May 7, 1898), p. 504, lists it as one of "the hundred best [Royal] Academy pictures" // H. S., *Spectator* 80 (May 7, 1898), p. 655; reviews it (quoted above); (May 14, 1898), p. 694 // A. C. R. Carter, *Art Journal* (London) (June, 1898), p. 176, reviews it in exhibition at the Royal Academy, mentions Brown's painting of the same subject, and notes "that his decorative style is capable of giving the fullest expression to dramatic motives" // M. H. Spielmann, *Magazine of Art* 23 (1899), p. 193, discusses // H. Strachey, *Harper's Magazine* 100 (May 1900), pp. 878, 880, discusses // Mrs. A. Bell (N. D'Anvers), *Artist* 29 (Dec. 1900), pp. 174, 177, discusses // J. W. McSpadden, *Famous Painters of America* (1907; 1916), p. 324 // D. C. Thomson, *Art Journal* (London) (Feb. 1908), p. 43, discusses as part of McCulloch collection // *Arts and Decoration* 1 (Sept. 1911), p. 445, illustrates a study for it // L. A. Holman, *Craftsman* 21 (Oct. 1911), p. 15, illustrates a study for it // N. N. [E. Pennell], *Nation* 94 (Jan. 18, 1912), p. 70 // Christie, Manson and Woods, London, *Catalogue of the . . . Collection . . . Formed by the late George McCulloch, Esq.*, sale cat. (1913), p. 39, discusses and gives exhibition record; ill. opp. p. 39 // W. G. Peckham, *International Studio* 56 (July 1915), ill. p. xv // A. T. Van Laer, *Century* 94 (July 1917), color ill. frontis.; p. 155, discusses // L. M. Bryant, *American Pictures and Their Painters* (1921), ill. opp. p. 153; pp. 154–155, discusses // E. V. Lucas, *Edwin Austin Abbey* (1921), 2, p. 297, says McCulloch paid £2,500 for it and that it sold at Christie's for £5,040; pp. 311–312, quotes from Mrs. Abbey's letters in 1897 giving details of the artist's progress on the paintings (July 20, quoted above); pp. 312–316, gives extracts from Abbey's letters to his wife in 1897, in which he discusses his work (Oct. 8, quoted above); pp. 317–318, gives its early history; ill. opp. p. 317; p. 354, notes its exhibition at Guildhall // Am. Acad. of Arts and Letters, New York, *A Catalogue of a Memorial Exhibition of the Work of Edwin Austin Abbey, R.A., N.A.* (1928), p. 24, states that it is the "completed painting," the fifth on King Lear executed by Abbey in 1897–1898; p. 93, includes it in a list of his works // Yale University Art Gallery, *Edwin Austin Abbey*, exhib. cat. (1973), p. 2, includes in chronology; ill. p. 6, and also illustrates visual sources by Brown; pp. 7–8, discusses sources; p. 10 // D. R. Howlett, Childs Gallery, letter in Dept. Archives, Dec. 23, 1974, mentions a copy of it.
EXHIBITED: Royal Academy, London, 1898, no. 138, as "King Lear," act 1, scene 1 // Guildhall, London, 1900, *Catalogue of the Loan Collection of Pictures by Living British Painters*, cat. by A. G. Temple, no. 11, as King Lear, lent by George McCulloch; pp. 16–17, discusses // Royal Academy, London, 1909, *Exhibition of Modern Works in Painting and Sculpture Forming the Collection of the Late George McCulloch, Esq.*, no. 109, as Lear and Cordelia, lent by Mrs. McCulloch; p. 28, describes, gives literary source.

Ex COLL.: George McCulloch, London, 1898–died 1907; estate of George McCulloch, London, 1907–1913 (sale, Christie, Manson and Woods, London, May 29, 1913, no. 108, as "King Lear," Act I, Scene I, £5,040); with M. Knoedler and Co., New York, as agent, 1913; George A. Hearn, New York, 1913.

Gift of George A. Hearn, 1913.
13.140.

J. CARROLL BECKWITH

1852–1917

James Carroll Beckwith was born in Hannibal, Missouri, but his family soon moved to Chicago, where he first studied art with WALTER SHIRLAW in 1868. In 1871, he moved to New York and studied at the National Academy of Design under Lemuel Wilmarth (1835–1918). Then in October 1873, he went to Paris and remained abroad until 1878, studying primarily in the atelier of Emile Auguste Carolus-Duran. In 1877, with his fellow student JOHN SINGER SARGENT, he assisted his teacher with a large ceiling decoration for the Louvre. That same year Beckwith began to exhibit his work at the Paris Salon and the National Academy of Design. He also attended classes at the Ecole des Beaux-Arts and Léon Bonnat's atelier. As part of his training, he frequented museums and galleries, studying the work of Raphael, Tintoretto, Veronese, Tiepolo, and Velázquez. Reminiscing about this period he later said: "The 'wander years' open a new window in the chamber of life through which the world of beauty and of art is seen in wider prospect, and splendid cargoes of impressions are brought home which furnish inspiration for a lifetime" (*International Studio* 66 [Jan. 1919], p. xc).

On his return in 1878, he settled in New York, where he assumed a position of leadership among American artists trained abroad. He contributed to the first exhibition of the Society of American Artists in 1878 and taught an antique class at the Art Students League until 1882, and again between 1886 and 1897. In 1884, he exhibited pastels at the first exhibition of the American Painters in Pastel and helped his friend WILLIAM MERRITT CHASE organize the Bartholdi Pedestal Fund Art Loan Exhibition, which featured works by such painters as Manet and Degas. That same year, he was elected an associate of the National Academy of Design, and in 1894 became a full member.

Beckwith achieved great success as a portraitist with such works as *William Walton*, 1886 (Century Association, New York). But as Charles Larned wrote in 1895: "He has settled into portraiture, not altogether from preference, I think, but because it is almost inevitable under present art conditions in this country. . . . His taste . . . would lead him toward imaginative composition, and a ceiling or wall panel would bring out his best powers" (p. 137). Beckwith painted many imaginative figure studies, usually of women, and executed murals for the World's Columbian Exposition in 1893.

For many years, he worked in the Sherwood Studios in New York and spent his summers upstate. In 1914, after four years in Italy, he opened a New York studio in the Hotel Schuyler,

where he continued to paint until his death. The final two years of his life were marred by illness.

BIBLIOGRAPHY: Charles William Larned, "An Enthusiast in Painting," *Monthly Illustrator* 3 (Feb. 1895), pp. 130–137 // Robert J. Wickenden, "The Portraits of Carroll Beckwith," *Scribner's* 47 (April 1910), pp. 449–460 // American Art Galleries, New York, *Catalogue of Oil Paintings, Studies, Sketches and Studio Effects* . . . (April 14 and 15, 1910) and *Finished Pictures and Studies Left by the Late Carroll Beckwith, N.A.* (March 20 and 21, 1918), sale cats. // "Confessions of Carroll Beckwith," *International Studio* 66 (Jan. 1919), pp. xc–xci. A first-person article resulting from a conversation between the artist and Harriet Washburn Stewart in 1910. Discusses old masters.

Lake of Orta

Lake of Orta is located in the Piedmont area of northern Italy and is separated from the popular nineteenth-century resort Lake Maggiore by Mount Mottarone. Orta, a picturesque resort town, lies at the tip of the peninsula that juts out into the lake from the base of Sacro Monte. Beckwith has selected a view from Orta looking across the lake to San Giulio, a small rocky island distinguished by the basilica and monastery that dominate it.

The painting, done in 1910 or 1911, is one of many plein-air studies of monuments, buildings, and landscapes that the artist executed during his last European trip. Painted on a small wood panel, it displays bright colors and an elevated vantage point derived from impressionist landscapes.

Oil on wood, 13¾ × 10½ in. (34.9 × 26.7 cm.).
Signed at lower right: CARROLL BECKWITH.
EXHIBITED: John Herron Art Museum, Indianapolis, 1911, *Exhibition of Paintings by Carroll Beckwith, N.A.*, no. 22.
EX COLL.: the artist, until 1917 (sale, American Art Galleries, New York, March 20, 1918, no. 54, as Lake of Orta, $60); Mrs. Chelsea, from 1918; Susan Dwight Bliss, New York, until 1966.
Bequest of Susan Dwight Bliss, 1966.
67.55.164.

Beckwith, *Lake of Orta*.

J. ALDEN WEIR

1852–1919

Julian Alden Weir was born at West Point, New York, where his father, ROBERT W. WEIR, was professor of drawing at the United States Military Academy. Like his brother JOHN FERGUSON WEIR, who later became professor of painting and design at Yale, he first received instruction from his father. After studying for three years at the National Academy of Design, he went to Paris, where he enrolled at the Ecole des Beaux-Arts in 1873 and worked under Jean Léon Gérôme. As a student, he traveled to Holland and Spain, where he admired the work of Hals and Velázquez, and to Barbizon and Brittany, where he became a close friend of the French peasant painter Jules Bastien-Lepage. Considering his academic training, it is not surprising that he found the third French impressionist exhibition in 1877 a "Chamber of Horrors." "They do not observe drawing nor form but give you an impression of what they call nature," he complained in a letter of April 15, 1877, to his parents (Young, p. 123).

Returning to New York in the autumn of 1877, Weir became a charter member of the Society of American Artists and participated in its exhibitions over the next twenty years. He also continued to exhibit at the National Academy of Design, where he had first shown his work in 1875. He supported himself with portrait commissions and by teaching at the Cooper Union Women's Art School, the Art Students League, and in private classes.

While in Europe during the summers of 1880 and 1881, he acted as agent for the New York collector Erwin Davis, purchasing Bastien-Lepage's *Joan of Arc* and two paintings by Manet, *Woman with a Parrot* and *Boy with a Sword*. (Davis later presented all three works to the Metropolitan Museum.) By this time it was obvious that Weir had lost his distaste for the new movements in French art. His figure paintings of the 1880s, for example *The Miniature*, 1888 (Heckscher Museum, Huntington, N.Y.), and *Against the Window*, 1884 (private collection), show the influence of Manet in their creamy low-key colors, broadly applied.

In 1883, following his marriage to Anna Baker, he again went to Europe, but by September he was back in New York. Elected an associate of the National Academy of Design in 1885, he became an academician the following year. In 1887, he turned to etching, which held his interest over the next seven years. The subjects of his etchings range from portraits of family members to landscapes with fishermen's cottages on the Isle of Man. In February 1889, Weir and his friend JOHN H. TWACHTMAN exhibited and sold a large number of their works at Ortgies Gallery in New York.

The decade of the 1890s was one of artistic experimentation for the artist. The paintings in his one-man show at the Blakeslee Gallery in 1891 displayed the influence of impressionism. Two years later the American Art Association paired his paintings and Twachtman's in a comparative exhibit with those of Claude Monet and Paul Besnard. In 1893, a year after his wife's death, he married her sister Ella. He spent much of his time at his country home in Branchville, near Ridgefield, Connecticut, where he was frequently visited by such friends and neighbors as Twachtman, EMIL CARLSEN, and ALBERT PINKHAM RYDER. Weir was among the founders of the Ten American Painters in 1897 and participated in its exhibitions.

After the turn of the century his reputation continued to grow. He was awarded medals at home and abroad, and between 1915 and 1917, he was president of the National Academy of Design and ex officio trustee of the Metropolitan Museum. Weir died in 1919 and five years later was honored with a memorial exhibition at the Metropolitan Museum.

There are two portraits of the artist in the Metropolitan's collection: a bronze portrait bust by Olin Levi Warner and a bronze plaquette by John Flanagan.

BIBLIOGRAPHY: *Julian Alden Weir: An Appreciation of His Life and Works* (New York, 1921). First published by the Century Association, includes essays by Duncan Phillips, Emil Carlsen, Royal Cortissoz, Childe Hassam, J. B. Millet, H. de Raasloff, Augustus Vincent Tack, C. E. S. Wood, with a list of paintings compiled by the artist's daughter, Dorothy Weir. Reprinted with eight additional illustrations for the Phillips Memorial Gallery by E. P. Dutton (New York, 1922) // National Collection of Fine Arts, Washington, D.C.; Columbus Museum of Fine Arts; Brigham Young University, Provo, Utah, *J. Alden Weir, An American Printmaker* (May 5–Oct. 1, 1972), exhib. cat. by Janet A. Flint, includes a selected bibliography // Dorothy Weir Young, *The Life and Letters of J. Alden Weir* (New Haven, 1960). The most detailed treatment of the artist's life and art, includes extensive quotations from his letters.

Idle Hours

When Weir returned from Europe in September 1883, he intended to earn his living by painting portraits, but throughout the 1880s, he found commissions difficult to obtain. As a result, most of the portraits from this period are of friends and family, particularly his wife, Anna, and their first child, Caroline Alden Weir, who was born in March 1884. The artist most often worked in a large sunny room just off the dining room and pantry of his home. *Idle Hours*, completed in 1888, was exhibited that year at the Fourth Annual Prize Fund Exhibition where it was awarded the two-thousand dollar prize. A critic for the *Art Amateur* described it in a review of the show:

The subject is a favorite one with the painter. A lady and a little girl, understood to be the wife and child of the artist, both dressed in white, are seated on a long divan strewn with cushions, with their backs to a white curtained window through which the light filters. . . . The group has no particular composition nor unity of effect, the drawing is good without being scientific and the redeeming qualities are Mr. Weir's well-known charm of gray color tones and dignity and refinement of treatment.

In this picture, Weir's restrained palette, realistic figure style, and carefully arranged composition continue the painting style he had developed during the 1880s under the influence of such French artists as Jules Bastien-Lepage and the more progressive Edouard Manet. Its informal, leisure-time subject and emphasis on

Weir, preliminary drawing
for *Idle Hours*,
private collection.

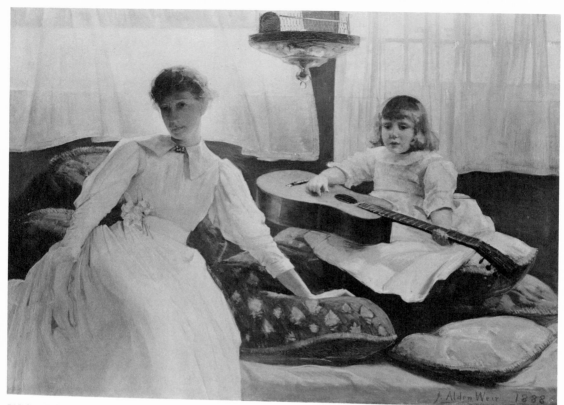

Weir, *Idle Hours.*

light, however, look ahead to Weir's personal impressionist style, which he developed during the 1890s.

Oil on canvas, 51¼ × 71⅛ in. (130.2 × 180.7 cm.). Signed and dated at lower right: J. Alden Weir—1888.

RELATED WORK: Preliminary drawing squared for transfer; pencil, black and white chalk on gray paper; 13⅝ × 18½ in. (34.6 × 47 cm.); private coll.

REFERENCES: *New York Times,* May 4, 1888, p. 4, lists sponsors of the Prize Fund and comments on the painting, "its defects are a lack of unity and a rallying point of interest" // *Art Amateur* 19 (June 1888), p. 6, describes it in Prize Fund exhibition (quoted above) // *Art Age* 8 (July 1888), p. 12, discusses it in a review of the Prize Fund exhibition // American Art Association, letter in MMA Archives, Oct. 15, 1888, offers it to MMA // C. Cook, *Art and Artists of Our Time* (1888), 3, p. 261, calls it Mother and Child // G. W. Sheldon, *Recent Ideals of American Art* (1888–1890), p. 35, mentions it in the Prize Fund exhibition // H. Eckford, *Century,* n.s. 35 (April 1899), p. 957,

describes it as "simple, graceful figures in the light of a window" // H. R. Butler, *Scribner's* 59 (Jan. 1916), p. 4 // E. Clark, *Art in America* 8 (August 1920), pp. 234–235, discusses // *Julian Alden Weir: An Appreciation of His Life and Works* (1921), p. 126, includes it in a list of works compiled by D. Weir // MMA, *Julian Alden Weir: A Memorial Exhibition* (1924), essay by W. A. Coffin, p. xv // *New York Times,* Feb. 3, 1952, section 2, p. 9 // J. T. Flexner, *Nineteenth Century American Painting* (1970), color ill. p. 252.

EXHIBITED: American Art Association, New York, 1888, *Fourth Prize Fund Exhibition,* no. 322, as Idle Hours // Am. Acad. of Arts and Letters, New York, 1952, *J. Alden Weir, 1852–1919: Centennial Exhibition,* no. 17.

EX COLL.: subscribers to the Fourth Prize Fund Exhibition, New York, including George Seney, Joseph J. Little, Benjamin Altman, Andrew Carnegie, Erwin Davis, Cornelius Vanderbilt, Thomas B. Clarke, James F. Sutton, Thomas E. Kirby, and W. T. Walters, 1888.

Gift of Several Gentlemen, 1888.
88.7.

J. Alden Weir

139

Weir, *Connecticut Village*.

The Red Bridge

During the 1890s, Weir adopted a lighter palette and broken brushstrokes, turning to the principles of plein-air impressionism. *The Red Bridge*, painted in 1895, is an excellent example of his work in this idiom. Like his *The Factory Village*, 1897 (coll. Mrs. Charles Burlingham), it shows an interest in industrialization that is unusual in American impressionism. In 1960, the artist's daughter, Dorothy Young, recalled his reaction to the subject, an iron bridge near his family's summer home in Connecticut:

When the family went up to Windham for their annual visit, Julian was dismayed to find that one of the picturesque old covered bridges that spanned the Shetucket River had been taken down and a stark iron bridge erected in its place. He missed the old landmark and regretted the necessary march of progress until one day he suddenly saw in the ugly modern bridge a picture that I am sure no one but he had ever seen. Perhaps he went by just after the fresh coat of paint had been applied, and the vibrant red color caught his eye. The severe iron bridge with its preparatory undercoating of red lead, gay against the green landscape, the river, the sky, and the luxuriant river banks all form a harmonious whole, redolent of summer.

Although he works with complementary colors, mainly red and green, Weir maintains an overall tonal quality in the picture by using colors of an almost equal intensity. He unites the sky, reflecting water surfaces, verdant foliage, and even the red bridge with a cool silvery light reminiscent of Jules Bastien-Lepage's plein-air paintings. The geometric structure of the bridge and its reflection in the river are seen through an intricate grill of branches, creating a decorative surface pattern of solid forms and mirrored images.

The painting remained in Weir's possession until at least 1910, and was widely exhibited. It was not signed until 1914, when it was presented to the Metropolitan by Mrs. John A. Rutherfurd.

Oil on canvas, 24¼ × 33¾ in. (61.6 × 85.7 cm.).
Signed at lower left: J. Alden Weir.
REFERENCES: *New York Times*, March 27, 1896, p. 5, describes it as "glowing with rich soft tones" // H. P., *Scrip* 1 (March 1906), p. 196, says it "just miss[es] being very fine" // *New York Times*, Feb. 16, 1911, p. 20 // Letter to J. Alden Weir in MMA Archives, Dec. 28, 1914, asks the artist to sign the work and inquires about its date // J. A. Weir, letters

Connecticut Village

This rural village scene probably represents Windham, Connecticut. The bold, unfinished quality of the painting makes it difficult to date the work, but it was probably executed after 1891, when Weir first began to develop his personal impressionist style.

Oil on canvas, 24⅛ × 20⅛ in. (61.3 × 51.1 cm.).
Signed at lower left: J. Alden Weir.
REFERENCE: C. Burlingham, daughter of the artist, orally, Oct. 25, 1977, identified the scene as Windham, Connecticut.
EXHIBITED: Wadsworth Atheneum, Hartford, 1950, *The Adelaide Milton de Groot Loan Collection* (no cat.) // Gallery of Fine Arts, Columbus, Ohio, 1958, *Masterpieces from the Adelaide Milton de Groot Collection*, no. 46
EX COLL.: estate of Edward Coykendall, Kingston, N.Y., until April 1949; with Milch Galleries, New York, April–Dec. 1949; Adelaide Milton de Groot, New York, Dec. 1949–1967.
Bequest of Miss Adelaide Milton de Groot (1876–1967), 1967.
67.187.143.

eir, *The Red Bridge*.

in MMA Archives, Dec. 30, 1914, agrees to sign it, erroneously estimates date as 1908; Jan. 13, 1915, does not think it was ever called "Iron Bridge," says it was painted near Windham, Connecticut, where the bridge spans the Shetucket River, does not remember date // *New York Times*, April 29, 1915, p. 7 // D. W. Young, "Records of the Paintings of J. Alden Weir," ca. 1920, in the possession of the artist's descendants, vol. 3, pp. 221–222, gives provenance and exhibition record, dates it 1895 // *Julian Alden Weir: An Appreciation of His Life and Works* (1921), p. 116, C. E. S. Wood relates anecdote about it; p. 133, appears in list of paintings compiled by D. Weir // C. B. Ely, *Art in America* 12 (April 1924), pp. 116–117, discusses it and gives the setting as the artist's farm in Connecticut; *The Modern Tendency in American Painting* (1925), p. 31, discusses // F. J. Mather, Jr., *Magazine of Art* 39 (Nov. 1946), ill. p. 307 // D. W. Young, *The Life and Letters of J. Alden Weir* (1960), p. 187, discusses subject (quoted above).

EXHIBITED: NAD, 1896, no. 159, as Iron Bridge at Windham // Carnegie Institute, Pittsburgh, 1896–1897, no. 299, as Iron Bridge at Windham // Boston Art Club, 1900, no. 123, as The Red Bridge // Rhode Island School of Design, Providence, 1903, *Catalogue of Autumn Exhibition*, no. 40, as The Red Bridge // Cincinnati Art Museum, 1905, no. 18 // Art Institute of Chicago, 1905, no. 354 // Detroit Institute of Arts, 1906, no. 67 // Montross Gallery, New York, 1907, *Exhibition of Pictures by J. Alden Weir*, no. 8 // PAFA, 1908, *Ten American Painters*, no. 85 // Lotos Club, New York, 1910, *Exhibition of Paintings by French and American Luminists*, no. 49, lent by Mrs. John Rutherford [*sic*] // Century Association, New York, 1911, *Thirty-five Pictures by J. Alden Weir* (no cat.) // Carnegie Institute, Pittsburgh, 1911, no. 311 // MMA, 1924, *Julian Alden Weir: A Memorial Exhibition*, no. 33 // Am. Acad. of Arts and Letters, 1952, *J. Alden Weir, 1852–1919: Centennial Exhibition*, no. 10, unpaged appreciation by M. S. Young, mentions // University of Iowa Gallery of Art, Iowa City, 1964, *Impressionism and Its Roots*, exhib. cat. by F. Sieberling, no. 48; p. 9, discusses // American Federation of the Arts, traveling exhibition, 1967–1968, *American Masters: Art Students League*, no. 45, entry by S. P. Feld, p. 114, discusses; ill. p. 115 // MMA, 1970, *19th-Century America*, exhib. cat. by J. K. Howat and N. Spassky, ill. no. 195, discusses // Phillips Collection, Washington, D.C.; Gallery of Fine Arts, Columbus, Ohio; Brigham Young University Art Gallery, Provo, Utah, 1972, *Paintings by Julian Alden Weir*, no. 15; ill. p. 8.

ON DEPOSIT: Rhode Island School of Design, Providence, 1904.

EX COLL.: the artist, until at least 1910; Mrs. John A. Rutherfurd, New York, by 1910–1914.

Gift of Mrs. John A. Rutherfurd, 1914.

14.141.

The Green Bodice

"I always cite Weir's portrait of a young woman standing by a mirror, entitled 'The Green Bodice' (at the Metropolitan Museum) when I am asked . . . who has painted a notable portrait," the artist's friend CHILDE HASSAM commented in his reminiscences of Weir (1921). The asymmetrical placement of the figure, whose mirrored reflection fills the center of the canvas, and the roughened texture of the paint surface show the impressionist influence on Weir's style during the 1890s. His palette, however, is limited to deep blacks and greens, relieved by an occasional touch of red in the woman's bodice. The painting is not dated, but it was certainly painted after 1896, when the full sleeves, Louis XVI collar, diminutive waistline, dark plumed hat, and feather boa were in vogue. The picture was one of the eight paintings exhibited by Weir in the first show of the Ten American Painters, held at the Durand-Ruel Gallery in New York in the spring of 1898. At this time, the critic for the *New York Times* described it as "strongest, well drawn and good in color." The same year Weir also painted *The Grey Bodice* (Art Institute of Chicago), depicting the same model who, it is said, was the sister of the actor Henry Dixey. In the juxtaposition of actual and reflected images the Metropolitan painting is similar to *Interior with a Figure*, 1896 (Museum of Art, Rhode Island School of Design, Providence).

Charles Erskine Scott Wood, a friend and patron of Weir's, admired the painting, and when the artist offered it to him at a nominal price, he refused but found a buyer for it in E. F. Milliken, who voiced an objection to the feather boa that the model wore around her neck, since "feather boas were out of style now nearly three years, and the costume would soon be antiquated" (Young, 1960).

The picture, once overcleaned and then heavily repainted, has lost the delicacy of Weir's original treatment especially in the reflected image.

Oil on canvas, $33\frac{15}{16} \times 24\frac{3}{4}$ in. (86.2 × 62.9 cm.).

REFERENCES: *New York Times*, March 30, 1898, p. 6, reviews it in the first annual exhibition of the Ten (quoted above) // *International Studio* 4 (1898), p. xiv, in a review, calls it "reserved, tender and consistent" // "Triumph of the Seceding Ten" [1898], clipping in J. Alden Weir Papers, 70, Arch. Am. Art, reviews it // H. Eckford [C. de Kay], *Century*, n.s. 35 (April 1899), p. 851, shows engraving after it by Henry Wolf; p. 957, compares it to Velázquez // American Art Galleries, New York, *Catalogue of Mr.*

E. F. Milliken's Private Collection of Valuable Paintings (1902), sale cat., no. 7, describes // New York Times, Nov. 11, 1904, p. 5, mentions it in a review of an exhibition // W. Howard, MMA Bull. 1 (March 1906), p. 55, discusses // The George A. Hearn Gift to the Metropolitan Museum of Art . . . (1906), p. xii; p. 204, discusses; ill. p. 205 // K. Cox, Burlington Magazine 15 (May 1909), ill. p. 130; pp. 131–132, discusses // G. P. Du Bois, Arts and Decoration 2 (Dec. 1911), p. 57, 78, discusses // George A. Hearn Gift to the Metropolitan Museum of Art . . . (1913), ill. p. 67 // New York Times, April 29, 1915, p. 7 // H. R. Butler, Scribner's 59 (Jan. 1916), pp. 130–131 // American Art News 18 (Dec. 13, 1919), p. 4 // Literary Digest 63 (Dec. 27, 1919), ill. p. 32 // Bulletin of the Rhode Island School of Design 8 (Jan. 1920), p. 9, relates it to Interior with Figure, also called Reflections in the Mirror // Julian Alden Weir: An Appreciation of His Life and Works (1921), p. 73, "Reminiscences of Weir" by C. Hassam (quoted above); p. 133, includes it in a list of works compiled by D. Weir // C. B. Ely, Art in America 12 (April 1924), p. 117, discusses it, calls model professional; The Modern Tendency in American Painting (1925), pp. 31–32, discusses the painting // R. C. Smith, Life and Works of Henry Wolf (1927), p. 73, no. 588, lists Wolf's engraving after it // D. W. Young, The Life and Letters of J. Alden Weir (1960), p. 199, discusses model; p. 211, discusses C. E. S. Wood's role in selling picture to E. F. Milliken; p. 212, notes Milliken's objections to it (quoted above) // R. Finnegan, M. Knoedler and Co., letter in Dept. Archives, March 31, 1975, gives provenance.

EXHIBITED: Ten American Painters, New York, 1898, The First Exhibition, no. 39, as The Green Bodice // Union League Club, New York, 1902, Paintings from the Collection of George A. Hearn, Esq., no. 35 // Galleries of the American Fine Arts Society, New York, 1904, Comparative Exhibition of Native and Foreign Art, no. 171, lent by G. A. Hearn // MMA, 1924, Julian Alden Weir: A Memorial Exhibition, no. 34, essay by W. A. Coffin, pp. xvi–xvii // Am. Acad. of Arts and Letters, 1952, J. Alden Weir, 1852–1919:

Weir, The Green Bodice.

Centennial Exhibition, no. 25 // Montclair Art Museum, N.J., 1972, J. Alden Weir, no. 10.

Ex COLL.: with C. E. S. Wood, as agent, New York, 1898; E. F. Milliken, 1898–1902 (sale, American Art Galleries, New York, February 14, 1902, no. 7, as Reflections, $1,125); with M. Knoedler and Co., New York, as agents, 1902; George A. Hearn, New York, 1902–1906.

Gift of George A. Hearn, 1906.
06.1302.

BEN FOSTER

1852–1926

Born in North Anson, Maine, the younger brother of the painter Charles Foster (1850–1931), Ben Foster specialized in poetic interpretations of the New England countryside. A youth marred by financial struggle compelled him to pursue a commercial career until he was nearly thirty. He studied in New York at the Art Students League and with ABBOTT H. THAYER

before going to Paris, where in 1886–1887 he worked under Aimé Morot and Luc Oliver Merson. As Alice S. Randall commented on his career: "his great teacher has been Nature. Of his life abroad he says little except to confess how woefully homesick he was and how he longed to get back to his own; and 'his own,' as any one familiar with his work must know, is the woods and fields and hills of New England" (p. 142).

He began exhibiting his work regularly at the Society of American Artists in 1882 and at the National Academy of Design in 1884. Recognition came in 1893 when he won a medal at the World's Columbian Exposition. By the turn of the century, he had achieved such success that his painting *Lulled by the Murmuring Stream* was purchased by the French government for the Luxembourg. He was elected an associate of the National Academy in 1901, and three years later he became an academician. Besides painting, Foster wrote art criticism for the *New York Evening Post* and the *Nation*. He was a member of the Century, the Lotos, and the Salmagundi clubs. He remained a bachelor and died in New York in 1926.

BIBLIOGRAPHY: Alice Sawtelle Randall, "Connecticut Artists and Their Work: Ben Foster, a Painter of Nature . . .," *Connecticut Magazine* 9, no. 1 (1905), pp. 139–143 // The Editor, "A Collection of Ben Foster's Landscapes," *Fine Arts Journal* 34 (April 1916), pp. 176–180 // Obituary. *Art News* 24 (Feb. 6, 1926), p. 6 // "Ben Foster," *American Art Student* 9 (Spring 1926), p. 20.

In the Connecticut Hills

The area around Foster's country home in Cornwall Hollow, Connecticut, provided the setting for many of his works. He did not, however, paint directly from nature. *In the Connecticut Hills* was probably painted shortly before its exhibition at the National Academy of Design in 1914. It is typical of the artist's autumnal landscapes of this period, of which one critic later wrote: "one cannot forget his quiet skies, rich but low keyed color, and feeling of love for the shadows and the glories of the dying year . . . so many of . . . [his] most brilliant canvases were in the tawny reds, browns, and grays of autumn with touches of darker evergreen among the swift changing trees" (*Fine Arts Journal* 34 [April 1916], p. 178).

The roughened surface textures and the compositions of his landscapes are similar to the work of American artists like J. ALDEN WEIR and EMIL CARLSEN, both of whom adapted impressionist ideas for their plein-air views of the Connecticut landscape. Foster's work is separated from impressionism by his use of a limited palette of brown, gray, and warm fall colors like yellow and rust, his insistence on firm contours, and his predilection for overcast, mood-filled autumnal scenes.

Oil on canvas, 41⅞ × 47⅞ in. (106.4 × 121.6 cm.).
Signed at lower right: Ben Foster.
REFERENCES: *MMA Bull.* 9 (June 1914), p. 150, notes its acquisition; ill. p. 151 // *Art News* 24 (Feb. 6, 1926), p. 6 // *American Art Student* 9 (Spring 1926), ill. p. 20.
EXHIBITED: NAD, 1914, no. 254, as In the Connecticut Hills.
Ex COLL.: the artist, until 1914.
Arthur Hoppock Hearn Fund, 1914.
14.70.

Foster, *In the Connecticut Hills.*

WILLIAM PICKNELL

1853–1897

William Lamb Picknell was born in Hinesburg and lived in North Springfield, Vermont, from 1857 until 1867, when his father, a minister, died. He was then sent to live with guardians in Boston. In the early 1870s, he went to Europe, and for his first two years abroad he studied in Rome with the landscape painter GEORGE INNESS. Later he spent two years in Jean Léon Gérôme's class at the Ecole des Beaux-Arts in Paris. Although his family and friends urged him to return to America after completing his studies, Picknell decided to remain abroad. In 1876, he joined the international art colony that had gathered around the Anglo-American painter Robert Wylie (1839–1877) in Pont-Aven, Brittany, and there his companions included THOMAS HOVENDEN, ALEXANDER HARRISON, and H. BOLTON JONES. Picknell learned Wylie's painting techniques, particularly his use of the palette knife.

In 1880, he became a member of the Society of American Artists and also won an honorable mention for *The Road to Concarneau*, 1880 (Corcoran Gallery of Art, Washington, D.C.) at the Paris Salon, where he had begun to exhibit four years earlier. Not long after, the Parisian dealer Goupil offered to purchase all the paintings Picknell could produce. Indeed, for the artist, the 1880s were marked by both critical success and a growing reputation at home and abroad. He spent two winters in England, where he painted pictures of the frozen countryside, such as *Wintry March*, 1885 (Walker Art Gallery, Liverpool). He also returned to New England and painted at Annisquam and Coffin's Bay. During the winter months, Picknell traveled to temperate areas like California and Florida, where he could work outdoors. He married in 1889, and the following year, he and his wife settled in Moret-sur-Loing near Fontainebleau. In 1891, he was elected an associate of the National Academy of Design, where he had exhibited as early as 1879.

The Picknells spent the winters at Antibes, largely because of the artist's failing health. There in 1897 their only child died and the artist's health worsened. In July, he and his wife sailed to visit relatives in New England, where he died in August at the age of forty-three. "His life should not be measured by years," Edward Waldo Emerson wrote in 1901. "He was complete in that, without great physical strength or unusual opportunities, he had . . . won knowledge and skill, recognition, sustenance, fame, respect, and love" (p. 712).

The artist's brother George W. Picknell (1864–1943) was also a painter.

BIBLIOGRAPHY: Paul Leroi, "Salon de 1894: William L. Picknell," *L'Art* 2 (1894), pp. 170–171 // Obituary. *American Architect and Building News* 57 (Aug. 28, 1897), p. 70 // Edward Waldo Emerson, "An American Landscape-Painter: William L. Picknell," *Century Magazine*, n.s. 40 (Sept. 1901), pp. 710–713 // Sadakichi Hartmann, *A History of American Art* (Boston, 1902), 1, pp. 85–86 // Richard Boyle, *American Impressionism* (Boston, 1974), pp. 117–118.

Banks of the Loing

The painting depicts the Loing, a canalized river that flows through Moret-sur-Loing, the town where Picknell spent the last years of his life. Among the artist's final works, it displays the firm draftsmanship, clear articulation of form, and brilliant color effects that had won

Picknell, *Banks of the Loing*.

him recognition at the Paris Salon. His selection of a deep diagonal perspective for the composition and his effective use of the palette knife to apply impressionistic touches of pigment, especially in the foreground, ally his work to that of his French contemporaries.

The picture was exhibited at the Paris Salon in 1897, the year of the artist's death. "The last pictures," Edward Waldo Emerson wrote of Picknell's work, "showed a great gain in freedom and in charm, so he felt at liberty to be less conscientiously imitative, a discipline that he had at first and wisely imposed upon himself with rigor. But first and last he painted as was said of him in France, 'richly and joyously'" (*Century Magazine*, n.s. 40 [Sept. 1901], p. 712).

When *Banks of the Loing* was exhibited at the National Academy of Design in 1898, one critic said it is "an exceptionally strong thing and will hold its own anywhere." It remained in the possession of the artist's wife until her death in 1905.

Oil on canvas, 58¼ × 83 in. (148 × 210.8 cm.).
Signed at lower right: W. L. Picknell.
REFERENCES: E. R. Pennell, *Nation* 64 (June 10, 1897), p. 432 // O. Lowell, *Brush and Pencil* 2 (May 1898), pp. 83–84, reviews it in NAD exhibit (quoted above) // *International Studio* 4 (1898), p. xiv, calls it a "realistic study" // *MMA Bull.* 1 (Sept. 1906), ill. p. 133; p. 134, calls it Borders of the Loing.
EXHIBITED: Paris Salon, 1897, no. 1337, as Les bords du Loing // Art Institute of Chicago, 1897, no. 291 // NAD, 1898, no. 192, as Banks of the Loing.
Ex COLL.: the artist, 1897; his wife Gertrude (later Mrs. Flagg), Cambridge, Mass., 1897–1905; estate of Gertrude Flagg, 1905–1906.
Bequest of Mrs. Gertrude Flagg, 1906.
06.199.

JOHN H. TWACHTMAN

1853–1902

The landscapist John Henry Twachtman was born to German immigrant parents in Cincinnati, Ohio. He was a part-time student at the Ohio Mechanics Institute from 1868 until 1871, when he enrolled at the McMicken School of Design (now the Art Academy of Cincinnati). The Munich-trained painter FRANK DUVENECK, his instructor and a family friend invited him to paint in the studio he shared with Henry Farny (1847–1916) and the sculptor Frank Dengler. When Duveneck returned to Munich in 1875, Twachtman accompanied him and studied at the academy there under Ludwig von Löfftz, painting during the summer with other Americans in nearby Polling. In 1877, he spent about nine months in Venice with Duveneck and WILLIAM MERRITT CHASE and the following year returned to Cincinnati briefly before going to New York. There he participated in the first annual exhibition of the Society of American Artists, which elected him to membership in 1880, and joined in the more social activities of the Tile Club. In 1879, he returned to Cincinnati to teach a women's art class, and the following year, he taught with Duveneck in Florence. After his marriage to the amateur painter Martha Scudder in 1881, he made a European tour, visiting England, Holland, Belgium, and Germany. In Holland, he went on painting trips with J. ALDEN WEIR and JOHN FERGUSON WEIR and became familiar with the work of the European artists Anton Mauve and Jules Bastien-Lepage. Throughout this period, his paintings show the influence of his Munich training in the forceful, heavy brushwork and limited, low-key palette.

In 1883, he went to Paris for two years to continue his studies. He enrolled at the Académie Julian under Gustave Boulanger and Jules Lefebvre and met the American artists CHILDE HASSAM, WILLARD METCALF, FRANK W. BENSON, EDMUND C. TARBELL, and ROBERT REID, many of whom became his lifelong friends. During the summer, he painted near Honfleur and Dieppe and in Italy, where he visited Duveneck and ROBERT BLUM. His work changed dramatically at this time: his palette, still low-key and almost monochromatic, became lighter and more closely modulated, and his brushwork less evident.

After his return to America, he went to Chicago where he worked on a cyclorama. During the late 1880s, he exhibited at the Society of Painters in Pastel and the American Water Color Society. In 1889, he and J. Alden Weir held a joint exhibition at the Fifth Avenue Art Galleries in New York, and four years later, the American Art Gallery in New York featured their work in a comparative exhibition with that of Claude Monet and Paul Besnard. Twachtman produced illustrations for *Scribner's* from 1888 to 1893, and in 1889, he began to teach at the Art Students League. These activities gave the artist added income, with which to purchase a farm in Cos Cob, near Greenwich, Connecticut, in 1889. His change in residence coincided with a new period in his stylistic development. Lighter in palette and looser and rougher in application, Twachtman's work from this period is often described as impressionistic. His introduction to this style came not only through French painters but also through friends like THEODORE ROBINSON. His carefully structured compositions, however, continued to show the same strong sense of design so evident in his earlier work.

Twachtman was a founding member of the Ten American Painters in 1897 but was never elected a member of the prestigious National Academy of Design. After 1900, he spent his summers at the harbor town of Gloucester, Massachusetts, where he painted *alla prima*, using brighter colors to produce lively, unified paint surfaces. A one-man show of his paintings and pastels was held at Durand-Ruel in 1901. The artist died suddenly in Gloucester the following year, despondent over his lack of critical success. His friend THOMAS DEWING wrote at the time: "By the death of John H. Twachtman, the world has lost an artist of the first rank. . . . He is too modern, probably, to be fully recognized or appreciated at present; but his place will be recognized in the future" (*North American Review* 176 [April 1903], p. 554).

BIBLIOGRAPHY: Eliot Clark, *John Twachtman* (New York, 1924). Includes a limited bibliography // Allen Tucker, *John H. Twachtman* (New York, 1931). A volume in the Whitney Museum's American artist series, it is a discussion of the artist by one of his former students; includes bibliography // "John Henry Twachtman—Painter," *Index of Twentieth Century Artists* 2 (March, 1935), pp. 87–91, suppl. Reprint ed. with cumulative index. New York: Arno Press, 1970, pp. 353–357; suppl., pp. 365, 366. Lists his affiliations, awards, honors, works in public collections, exhibitions, and bibliography. Includes a biography and a list of reproductions of his major works // John Douglass Hale, "The Life and Creative Development of John H. Twachtman," Ph.D. diss., Ohio State University, 2 vols., 1957. Discusses his creative development; includes biography, chronology, and catalogue of his oils, watercolors, and pastels // Cincinnati Art Museum, *A Retrospective Exhibition: John Henry Twachtman* (Oct. 7–Nov. 20, 1966). Includes an introduction with an annotated catalogue by Richard J. Boyle, a discussion of Twachtman's prints by Mary Welsh Baskett, and a chronology.

Arques-la-Bataille

Between 1883 and 1885, Twachtman lived in Paris, where he studied at the Académie Julian. During these student years, he completed several works ambitious in size and composition, including *Springtime*, ca. 1883–1885 (Cincinnati Art Museum) and *Windmills*, ca. 1885 (New York art market, 1977), which marked a departure from the dark palette and thick paint surfaces of his Munich years. *Arques-la-Bataille*, painted in 1885, is perhaps the most successful example of this new tonal style. Completed from a preliminary oil study (unlocated), the painting depicts a river scene at Arques-la-Bataille, a town four miles southeast of Dieppe, where the Béthune and two other streams join to form the Arques River. The painting's strength lies in its composition, in which broad horizontal masses are relieved by elegant calligraphic reeds. Twachtman ignores conventional perspective in his focus on the reeds, which are greatly enlarged and placed disconcertingly close to the picture plane. He treats the surrounding landscape, the river, its embankment, and the sky as flat areas of color. CHILDE HASSAM, a close friend of the artist's, later noted: "the great beauty of design which is conspicuous in Twachtman's paintings is what impressed me always; it is apparent to all who see and feel, that his works were sensitive and harmonious, strong and at the same time delicate even to evasiveness, and always alluring in their evanescence" (*North American Review* 176 [April 1903], p. 555). This interest in design and in the contemplative interpretation of nature allies *Arques-la-Bataille* with the aesthetic of the oriental print, then an important influence on French painting. It seems likely that Twachtman was also aware of the nocturnes painted by JAMES MC NEILL WHISTLER during the previous decade. Like Whistler, he strives for mood rather than representational detail and uses a cool palette of delicate grays, greens, and blues, thinly applied to obliterate the brushwork.

Twachtman retained the limited palette and powerful design elements seen in *Arques-la-Bataille* for the duration of his career, but he later adopted the roughened surface textures of impressionism. He never again reached, however, the intensity achieved in this monumental painting.

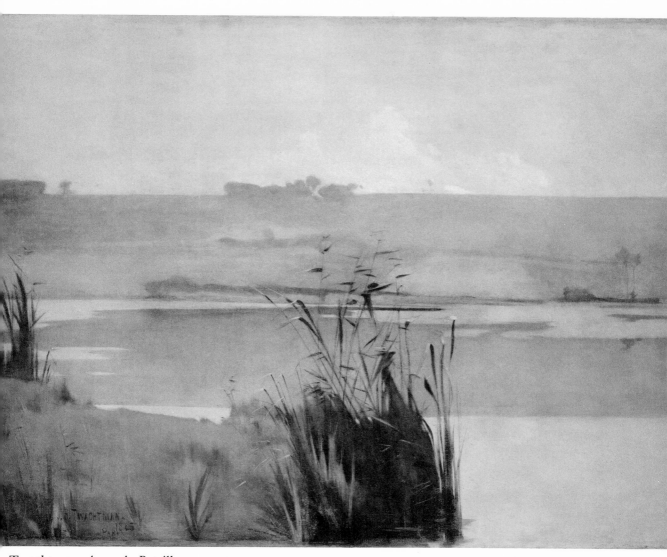

Twachtman, *Arques-la-Bataille*.

Oil on canvas, 60 × 78⅞ in. (152.4 × 200.3 cm.).

Signed, dated, and inscribed at lower left: J. H. Twachtman / 1885 / Paris.

RELATED WORKS: *Arques-la-Bataille*, 1883–1885, oil on canvas, 18 × 26 in. (45.7 × 66 cm.), unlocated, formerly coll. Albert R. Jones, Kansas City, Mo., ill. in Hale (1957), 1, p. 202, fig. 25 // *Arques-la-Bataille*, 1885, preliminary study for MMA painting, oil on canvas, 18 × 26 in. (45.7 × 66 cm.), unlocated, ill. in Clark (1924), opp. p. 20.

REFERENCES: E. Clark, *John Twachtman* (1924), ill. opp. p. 20, shows study for it; pp. 38–39, discusses it, misdates it 1855 // *Index of Twentieth Century Artists* 2 (March 1935), p. 90, lists oil study and reference // J. D. Hale, "The Life and Creative Development of John H. Twachtman," Ph.D. diss., Ohio State University, 1957, 1, pp. 200–205, discusses and illustrates related studies for it; 2, p. 427, lists several unlocated landscapes painted at Arques-la-Bataille, 1883–1885; p. 539, lists it as no. 9, gives owner as J. Alden Twachtman, dates it 1883, Paris, provides provenance and exhibition record, gives incorrect measurements; p. 598 // *Art News* 67 (March 1968), p. 10 // *MMA Bull.* 27 (Oct. 1968), pp. 70–71; ill. p. 72 // M. D. Schwartz, *Connoisseur* 174 (August 1970), color ill. p. 293.

EXHIBITED: Brooklyn Museum, 1932, *Exhibition of Paintings by American Impressionists and Other Artists of the Period 1880–1900*, no. 111, lent by Mrs. John H. Twachtman // Cincinnati Art Museum, 1966, *A Retrospective Exhibition: John Henry Twachtman*, no. 29, lent by Dr. Eric Twachtman, Essex, Conn.; intro. by R. J. Boyle, p. 8, mentions it as a representative work

of his Paris period; p. 13, lists provenance, exhibitions, and references // Ira Spanierman, New York, 1968, *John Henry Twachtman, 1853–1902*, no. 10; ill. on cover; unpaged essay by R. J. Boyle, discusses // MMA, 1970, *19th Century America, Paintings and Sculpture*, exhib. cat. by J. K. Howat and N. Spassky, no. 182, color ill. and discussion // National Gallery, Washington, D.C.; City Art Museum of St. Louis; Seattle Art Museum, 1970–1971, *Great American Paintings from the Boston and Metropolitan Museums*, exhib. cat. by T. N. Maytham, no. 76, discusses.

EX COLL.: Martha Twachtman, wife of the artist, Greenwich, Conn.; her son, J. Alden Twachtman, 1935; his son, Dr. Eric Twachtman, Essex, Conn., 1935–at least 1966; with Ira Spanierman, New York, 1968.

Morris K. Jesup Fund, 1968.

68.52.

Waterfall

In the autumn of 1889, after Twachtman's financial security was assured by a teaching appointment at the Art Students League, he decided to buy property within commuting distance of New York. On the advice of a friend, he went to look at a seventeen-acre farm in Cos Cob, Connecticut. Horseneck Brook with its picturesque cascade, just above the Hemlock Pool on Blue Brook, made this piece of land quite attractive to the artist. On first encountering the falls, he reportedly threw up his arms and exclaimed, "This is it!" Once he had purchased the property, Twachtman planned the alterations of the rundown farmhouse and did much of the carpentry and masonry work himself. In succeeding years, this secluded home was often visited by Twachtman's friends J. ALDEN WEIR, CHILDE HASSAM, THEODORE ROBINSON, and other artists who rented or purchased homes nearby.

Twachtman's impressionist period began during the late 1880s. Several other American artists like Weir, Hassam, and Robinson were also working in this idiom. Twachtman's style at this time is distinguished by rough textures and light, bright pigments applied on dark grounds, characteristics that relate to his work in pastel as well as oil painting. Like Monet, he returned to the same subjects, depicting them under varying climatic and temporal conditions. Instead of recording the realities of the scene before him, however, Twachtman became increasingly concerned with pictorial design and the expression of his emotional response to the landscape.

Twachtman, *Waterfall*.

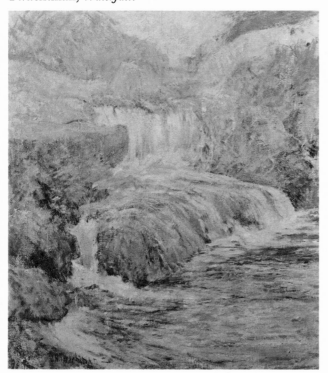

In this picture the waterfall is shown from an oblique angle. The artist portrayed the brook from the same vantage point in several other paintings, *The Waterfall* (Worcester Art Museum, Mass.), *The Waterfall, Blue Brook* (Cincinnati Art Museum), and *The Cascade* (IBM Corporation, New York). Since the pictures are not dated, it is difficult to establish the relationship between them. In these and other views of Horseneck Falls, Twachtman arranged and manipulated the curving lines of massive rocks and flowing water to create decorative patterns. As Childe Hassam wrote: "You felt the virile line. It was in his clouds and tree forms, in his stone walls and waterfalls. . . . His use of line was rhythmic, and the movements were always graceful" (*North American Review* 176 [April 1903], p. 555).

During the early 1890s, Twachtman was commissioned to paint Niagara Falls and Yosemite Falls, where he confronted the same problems but on a monumental scale. In his treatment of these spectacular themes, however, he subordinated his concern for decorative pattern to a representational style more appropriate for such commissions.

Oil on canvas, 30⅛ × 25⅟₁₆ in. (76.5 × 63.7 cm.).
Signed at lower left: J. H. Twachtman.
REFERENCES: A. H. Goodwin, *Country Life* 8 (Oct. 1905), ill. p. 625, shows photographs of setting // *MMA Bull.* 4 (March 1909), ill. p. 53 // *George A. Hearn Gift to the Metropolitan Museum of Art* . . . (1913), ill. p. 90 // E. Clark, *Art in America* 7 (April 1919), ill. p. 135 // L. M. Bryant, *American Pictures and Their Painters* (1921), p. 182, discusses; ill. opp. p. 183 // *Index of Twentieth Century Artists* 2 (March 1935), p. 91, lists exhibitions and references // F. J. Mather, Jr., *Magazine of Art* 39 (Nov. 1946), ill. p. 306, and discusses // J. D. Hale, "The Life and Creative Development of John H. Twachtman," Ph.D. diss., Ohio State University, 1957, 2, p. 575, no. 671 in catalogue, lists exhibitions, references, and provenance; p. 603.
EXHIBITED: Lotos Club, New York, 1907, *Exhibition of Paintings by the Late John H. Twachtman*, no. 2, as The Waterfall, lent by Mr. George A. Hearn // Queens County Art and Cultural Center, MMA, Memorial Art Gallery of the University of Rochester, 1972–1973, *19th Century American Landscape*, exhib. cat. by M. Davis and J. K. Howat, no. 25, discusses.
EX COLL.: George A. Hearn, New York, by 1907–1909.
Gift of George A. Hearn, 1909.
09.25.2.

John H. Twachtman

Horseneck Falls

Like *Waterfall* (see above), the painting depicts the falls of Horseneck Brook on the artist's property in Cos Cob, Connecticut. Of the many views that Twachtman painted of this scene between 1890 and 1900, it most resembles *The Waterfall* (Corcoran Gallery of Art, Washington, D.C.), which shows only the cascade and not the large rocks that are such a prominent feature in the foreground of *Horseneck Falls*.

Oil on canvas, 30 × 25 in. (76.2 × 63.5 cm.).
Signed at lower left: J H Twachtman.
REFERENCES: A. H. Goodwin, *Country Life* 8 (Oct. 1905), ill. p. 625, shows photograph of the site // *Academy Notes* 8 (April 1913), p. 66; ill. p. 67; ill. p. 70, shows painting in exhibition at the Buffalo Fine Arts Academy // *Art Notes* [Macbeth Gallery], no. 67 (Jan. 1919), ill. p. 1111; p. 1117, states that it is from the Twachtman estate // D. Phillips, *International Studio* 66 (Feb. 1919), ill. p. cvii // *Art Notes* [Macbeth Gallery], no. 69 (Jan. 1920), p. 1159, says that the gallery has bought it back from the unspecified individual who purchased it in 1919 exhibition; ill. p. 1161 // *Index of Twentieth Century Artists* 2 (March 1935), p. 90, lists references for it // J. K. Reed, *Art Digest* 24 (Nov. 15, 1948), ill. p. 17 // J. D. Hale, "The Life and Creative Development of John H. Twachtman," Ph.D. diss., Ohio State University, 1957, 1, p. 316, fig. 79; 2, p. 459; pp. 547–548, no. 159 in catalogue, dates it 1890s, lists references, exhibitions,

Twachtman, *Horseneck Falls*.

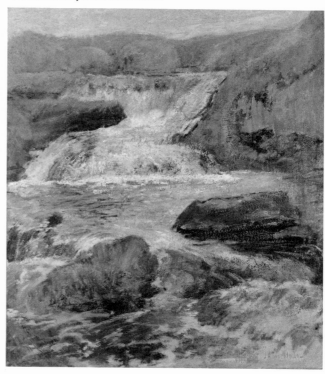

and provenance // H. C. Milch, Milch Art Galleries, letter in Dept. Archives, Jan. 1975, documents provenance.

EXHIBITED: New York School of Applied Design for Women, New York, 1913, *Exhibition of Fifty Paintings by the Late John H. Twachtman*, no. 3 // Buffalo Fine Arts Gallery and Albright Art Gallery, 1913, *Catalogue of an Exhibition of Paintings and Pastels by the Late John H. Twachtman*, no. 2, lent by the estate of J. H. Twachtman // Macbeth Gallery, New York, 1919, *Exhibition of Paintings by John H. Twachtman*, no. 9, as Horseneck Falls, ill. p. 10; p. 11, discusses // Wadsworth Atheneum, Hartford, 1950, *The Adelaide Milton de Groot Loan Collection* (no cat.) // Gallery of Fine Arts, Columbus, Ohio, 1958, *Masterpieces from the Adelaide Milton de Groot Collection*, no. 42.

EX COLL.: the artist, Greenwich, Conn., until 1902; estate of the artist, 1902–at least 1911; with G. D. McDonough; with Macbeth Gallery, New York, by 1919, repurchased, 1920; Harris Whittemore, Conn., 1920–1948 (sale, Parke-Bernet Galleries, New York, May 20, 1948, no. 183, Horseneck Falls, $775); with Milch Art Gallery, New York, 1948–1949; Adelaide Milton de Groot, New York, 1949–1967.

Bequest of Miss Adelaide Milton de Groot (1876–1967), 1967.

67.187.142.

J. FRANCIS MURPHY

1853–1921

The landscapist John Francis Murphy, born in Oswego, New York, was almost entirely self-taught. Around 1870, he was employed by a Chicago concern as a sign painter, but he was soon dismissed for laziness. The Chicago fire of 1871 made that city an inauspicious place to begin an art career, and in 1875 Murphy moved to New York, renting a studio on Ninth Street near Grace Church. He made sketching trips around Orange, New Jersey, where he taught a group of young ladies during the summer. Among them was the landscapist Adah Clifford (1859–1949), who later became his wife. In 1876 he began to exhibit at the National Academy of Design, and two years later he joined the Salmagundi Club.

For Murphy, the 1880s were marked by artistic success. By 1881, he was a member of the American Water Color Society and, in 1883, the Society of American Artists. Two years later he won the second Hallgarten Prize, awarded each year by the National Academy of Design to an artist under thirty-five, and was elected an associate of that institution. In 1887, he became an academician, and soon after, his work became popular with collectors and museums. He built a summer studio at Arkville, New York, in the Catskills, where he found inspiration for his landscapes in the surrounding countryside. ALEXANDER H. WYANT became his neighbor in 1889. Although he spent as much as six months a year at Arkville, he also maintained a studio in the city at the Chelsea Hotel.

Until 1885, Murphy's work was based on the direct observation of nature, recorded with realistic detail in preliminary pencil studies. His later, more poetic landscapes, which are largely influenced by the Barbizon style of Wyant and GEORGE INNESS, are highly formularized and seem to be executed from memory rather than observation. "Murphy has been charged with monotony, with diffidence," Charles L. Buchanan wrote in 1914:

To those people . . . who think of him as a mere formulist gifted with a certain pretty but rather uninspired facility for painting, I advance the significance of his recent record. . . . True, he is

concerned mostly with nature's brooding periods, her aloofness from change and stress. . . . To charge Murphy with monotony is about as adequate a form of criticism as it would be to . . . censure Winslow Homer for not painting interiors. He has been content to work the genuine vein of his talent; the question is not what he attempts, but, conclusively enough, what he succeeds so satisfyingly in accomplishing (pp. viii and x).

Between 1900 and 1916, Murphy produced some of his finest works in oil. These paintings combined a quietist interest in the expressive possibilities of the landscape, the limited palette typical of tonalism, and the roughened surface textures of impressionism, a synthesis of several styles, all of which were by then passé.

Murphy's health began to fail about two years before his death. In 1921, after spending the winter in Florida, he was stricken with pneumonia and died in New York.

BIBLIOGRAPHY: Harold T. Lawrence, "J. Francis Murphy, American Landscape Painter," *Brush and Pencil* 10 (July 1902), pp. 205–218 // Charles L. Buchanan, "J. Francis Murphy, a Master of American Landscape," *International Studio* 53 (July 1914), pp. iii–x // Eliot Clark, *J. Francis Murphy* (New York, 1926). Includes a bibliography, and list of his medals, honors, and exhibitions // M. H. de Young Memorial Museum and the California Palace of the Legion of Honor, San Francisco, *The Color of Mood: American Tonalism, 1880–1910* (Jan. 22–April 2, 1972), exhib. cat. by Wanda M. Corn. Places Murphy in the context of quietist painting during the late nineteenth century. Includes a biography and bibliography.

Landscape

Throughout his career, Murphy produced intimate canvases, often on the scale of this six by eight inch landscape. During the 1880s and 1890s, these small views constituted a significant portion of his œuvre. Enclosed by heavy, expensive frames, they were particularly suitable for hanging in a private home. "Murphy's technical manner and his pictorial conception never fitted him for filling large surfaces or executing monumental paintings," wrote Eliot Clark. "Content with a most simple life and environment Murphy never sacrificed his artistic integrity, but it was happy indeed that he could make his living by producing these little pictures of his fancy" (*J. Francis Murphy* [1926], pp. 31–32).

Not as topographical as the artist's earliest work, this picture displays Murphy's interest in

Murphy, *Landscape.*

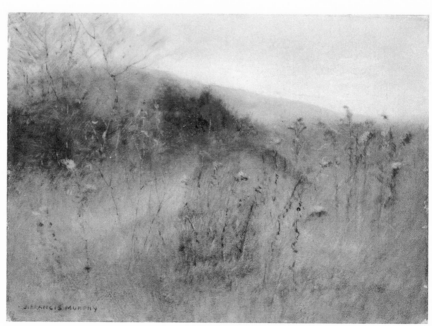

the effects of light and the changing moods of nature. The generalized appearance of the landscape is largely the result of Murphy's painstaking technical procedure, which required an extended period of time for completion. He often began his paintings without any definite composition in mind and applied one overall tone to the canvas, which he permitted to dry for as long as a year. Then, working from memory in his studio, he added paint in thin layers, using transparent glazes or scumbling to achieve the delicate, translucent effects which are notable in this painting.

Oil on canvas, 6 × 8 in. (15.2 × 20.3 cm.).
Signed at lower left: J. FRANCIS MURPHY.
Ex COLL.: Susan Dwight Bliss, New York, until 1966.
Bequest of Susan Dwight Bliss, 1966.
67.55.165.

The Old Barn

In 1906, Murphy returned from a trip abroad and spent the winter at his country home in Arkville, New York. "I am very comfortable here and hard at work," he wrote to his New York dealer William Macbeth on November 27, 1906. "The country is fine and the weather unusually good. A lot of buckwheat [,] potatoes [,] and coal on hand [,] also a large stock of materials—all these are temptations too strong to resist—so I remain" (William Macbeth Papers, NMc 9, Arch. Am. Art). *The Old Barn* was probably a product of this stay in the country.

Sometime after the first of the year, Murphy returned to the city. On April 17, he saw the collector George A. Hearn, who had sent *The Old Barn* to the Metropolitan Museum for consideration a week earlier. The two must have discussed the painting and its prospects for acquisition. A week later when Murphy left for Arkville, the situation was still not resolved, and the artist interpreted this delay negatively, assuming that the museum was unwilling to accept his picture. On June 6, he wrote to Macbeth, who had tried to assuage his fears: "You speak of the buying committee at the Museum [.] What have they to do with it [?] I thought that Hearn purchased the picture from you and was to present it to the Museum and I naturally supposed that they had refused to accept it—Please tell me the facts in this case."

The Metropolitan soon purchased the picture with the funds Hearn had given to acquire "newly selected" paintings, and a contrite Murphy answered Macbeth's explanation on June 8: "I must say I am delighted [.] I understand the whole thing now. I had entirely forgotten about the Hearn Fund for purchasing works for the Museum. I am glad that that particular picture has found a home there for I like the picture very much. I congratulate you

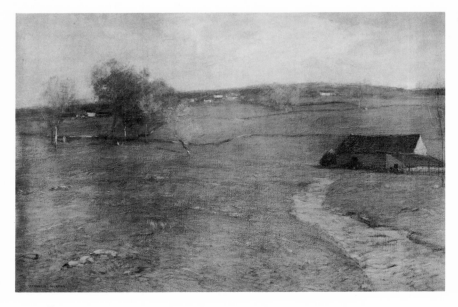

Murphy,
The Old Barn.

and also thank you for your share in the affair. Kindly thank Mr. Hearn for me when you again see him."

The painting represents the mature style evident in Murphy's poetic landscapes after the turn of the century. "He reflects little of his actual environment except the light, the tone, and the effect of atmosphere, and uses his simple store of the objective world to reflect his subjective nature," wrote Eliot Clark (*J. Francis Murphy* [1926], p. 37).

Oil on canvas, 24¼ × 36¼ in. (61.6 × 91.8 cm.).

Signed and dated at lower left: J. FRANCIS MURPHY 1906.

REFERENCES: W. Macbeth, letters in MMA Archives, April 6, 1907, says that he is willing to accept Hearn's proposal for the sale of the painting; April 17, 1907, calls it a fine example of Murphy's work, states that "in case he should produce a picture within the next few years which the Museum might prefer, it shall be exchanged for the one now offered. We wish the Museum to have the very best Murphy attainable" // G. A. Hearn, letters in MMA Archives, April 10, 1907, states that he is having the picture sent to the museum for inspection; April 17, 1907, states that he met Macbeth with whom he discussed it and urges its acceptance // J. F. Murphy to W. Macbeth, April 17, 1907, William Macbeth Papers, NMc 9, Arch. Am. Art, mentions conversations with Dielman and Hearn; June 6, 1907 (quoted above); June 8, 1907 (quoted above) // F. Dielman, letter in MMA Archives, ca. April 19, 1907, relates conversation with the artist; "He says that he thinks it one of his best and is entirely satisfied to be represented by it" // A. C. Murphy to W. Macbeth, July 8, 1907, in Macbeth Papers, NMc 9, Arch. Am. Art, writes "That was a good piece of news your placing one of J. F.'s pictures in the Museum and a good representation too—and Mr. Murphy's friends are all glad he is represented by a good one. It made a little stir—all such affairs help the cause along" // *George A. Hearn Gift to the Metropolitan Museum of Art . . .* (1913), ill. p. 92 // D. Bolger, *Arch. Am. Art Jour.* 15, no. 2 (1975), p. 10; ill. p. 11; p. 12, discusses and quotes letters regarding its acquisition.

EX COLL.: with Macbeth Gallery, New York, probably 1906–1907; with George A. Hearn, New York, as agent, 1907.

George A. Hearn Fund, 1907.

07.139.

WILLIAM DANNAT

1853–1929

William Turner Dannat was born in New York, the son of wealthy parents who fostered his artistic talents. He first went abroad at the age of twelve and later studied architecture in Hannover and Stuttgart, until his interest turned to painting. After studying at art academies in Munich and Florence, he returned in the winter of 1877–1878 to New York, where he showed his work in the first exhibition of the Society of American Artists. In 1879, he went to Paris and studied under Emile Auguste Carolus-Duran and the Hungarian artist Mihály Munkácsy. During the early 1880s, he had an elegant studio on the avenue de Villiers. He made sketching tours of Spain, gathering ideas for pictures like *The Quartette* (q.v.), which established his reputation at the Paris Salon in 1884. He was elected to the Society of American Artists in 1881 but never became a member of the National Academy of Design, where he exhibited his work in annual exhibitions only in 1888 and 1904.

During the late 1880s and 1890s, Dannat was successful as an academic figure and portrait painter, and his work showed the impact of progressive ideas. Financially secure, he devoted much of his leisure time to fencing, boxing, and later, automobile racing. Beginning in 1896, he immersed himself for eight years in a study of artistic technique. Working in his studio he

made a close examination of paintings in his own collection, which included works attributed to such artists as Piero della Francesca and Jean Antoine Watteau. Late in his career, he painted imaginary landscapes that recall rococo *fêtes galantes*. Dannat was one of the most active and influential members of the American art colony in Paris, serving as president of the Paris Society of American Painters and as a member of the Artists' Committee of One Hundred, organized in 1919 to aid the families of artists who had served in the French army. He died in Monte Carlo in 1929.

BIBLIOGRAPHY: Julia F. Opp, "William T. Dannat," *Munsey's Magazine* 13 (August 1895), pp. 513–517 // Armand Dayot, "William T. Dannat," *Art et décoration* 15 (March 1904), pp. 69–77; translated by Irene Sargent in *Craftsman* 6 (May 1904), pp. 154–161 // Thieme-Becker (Leipzig, 1913; 1964), 8, pp. 366–367.

The Quartette (Un quatuor)

During the 1880s, a number of American artists became interested in Spanish art and culture. This was especially the case with the students of Emile Auguste Carolus-Duran and Léon Bonnat. This genre scene was painted by Dannat in 1884 after he had made several sketching trips to Spain. Choosing a nearly square canvas for his four life-size figures, the young artist demonstrated his skill in depicting varying ages, facial expressions, gestures, and poses. He later admitted that he had some difficulty in executing the background: "by scraping to remove some undesirable 'loading' in the raw background," he "got down to the grain of the canvas," causing some disturbing spots to appear in the painting a decade later. Although he undoubtedly made a number of studies for this major work, only one small oil version is known. The painting was exhibited at the 1884 Paris Salon, where the critic William C. Brownell called it "an extremely successful *tour de force*" and noted the artist's exacting concern for literal detail. Dannat's realism and dark, warm Rembrandtian palette recall his admiration for the interior scenes of one of his teachers, the successful Salon painter Mihály Munkácsy.

In another review of the 1884 Salon, a critic for the *Art Amateur* hailed *The Quartette* as "one of the striking pictures of the Salon, painted with 'virtuosité' and a vigor of the rarest kind, and composed with great originality." It is reported that the picture was so successful that the French government offered to buy it, but the artist declined, preferring to sell it to the New York art dealer William Schaus. The following year Schaus lent it to the Chicago Inter-State Indus-

trial Exposition, reputedly for a fee of one thousand dollars, forcing the exposition's organizers to display it in a side show for a ten-cent admission. The artist's mother purchased the painting in 1886 and arranged to keep it in Dannat's native city by lending it to the Metropolitan. Schaus then displayed it in his window with a notice that it had been "purchased for the Metropolitan Museum of Art," an erroneous assertion that may have influenced Mrs. Dannat to make her loan to the museum a gift. The painting was also shown at the Universal Exposition in Paris in 1889, where it was very popular. Many observers felt that it would have won an award had Dannat not been on the International Jury of Recompense, which disqualified him from competition.

Oil on canvas, 94⅜ × 91¾ in. (239.7 × 233 cm.).

Signed and dated at lower left: W–T–DANNAT–/84.

RELATED WORK: An oil study attributed to William Dannat, but not seen by the author, was recently on the New York art market.

REFERENCES: T. Child, *Art Amateur* 10 (March 1884), p. 86, describes it and says that it will be sent to the Salon under the title L'Aragonese // Fourcard, *Gazette des Beaux-Arts* 29 (1884), p. 477, reviews it at the 1884 Salon, "M. Dannat, que son grand *Quatuor* d'Espagnols noirs et blancs, chantant et s'accompagnant de la guitare et des castagnettes, a tiré de la foule; et quantité d'autres encore" // W. Sharp, *Art Journal* [London] 36 (July 1884), p. 222, in a review of the Paris Salon, calls it "one of the most striking canvases in [Salle 5]," compares it to similar subjects by Madrazo, notes Dannat's "mastery over chiaroscuric effects" // E. V., *Art Amateur* 11 (July 1884), p. 35, discusses it in review of Paris Salon (quoted above) // W. Brownell, *Magazine of Art* 7 (Sept. 1884), ill. p. 493, in a review of Paris Salon; p. 495, compares it to a painting by Alexander Harrison, mentions that the French government has

Dannat, *The Quartette*.

Dannat, *Margarette A. Jones.*

offered to buy it, notes its critical success; p. 498, discusses subject matter and composition (quoted above) // Montezuma [pseud.], *Art Amateur* 12 (Jan. 1885), p. 29, compares it to J. S. Sargent's El Jaleo // *Studio*, no. 6 (Oct. 25, 1885), pp. 62–63, says "For, striking and interesting it is, in spite of all its positive faults and shortcomings," notes Schaus's ownership, calls it a "tableaux vivant" // Montezuma [pseud.], *Art Amateur* 13 (Nov. 1885), p. 110, discusses its inclusion in the Chicago Inter-State Industrial Exposition, lent by Mr. Schaus for $1,000 // W. H. Dannat, father of the artist, letter in MMA Archives, May 13, 1886, says Schaus has been ordered to deliver it to the museum for loan in October, encloses order to Schaus // S. P. Avery, letters in MMA Archives, May 21, 1886, explains that the artist's family owns the painting and merely planned to lend it to the museum, discusses Schaus's display of it; Oct. 11, 1886, expresses his desire for the museum to acquire it // A. Trumble, *Representative Works of Contemporary Artists* (1887), sec. 6, unpaged, ill. as The Quartette, notes its acquisition by MMA, says it is life size // Mrs. W. H. Dannat, letter in MMA Archives, Oct. 31, 1887, confirms her offer of gift made informally in May 1886 // G. W. Sheldon, *Recent Ideals of American Art* (1888–1890), ill. opp. p. 24; pp. 133–134, discusses its exhibition at Universal Exposition of 1889, says now on exhibition at MMA // C. Cook, *Art and Artists of Our Time* (1888), 3, pp. 274–276, erroneously says Schaus gave it to MMA; ill. p. 275 // T. Child, *Harper's Monthly* 79 (Sept. 1889), p. 502, says it "is

not Mr. Dannat's finest work" // Thiebault-Sisson, *L'Exposition de Paris de 1889*, no. 56 (Nov. 27, 1889), ill. p. 121, shows engraving after it by A. Leveille; pp. 126–127, discusses // G. A. Smith, *The Laurelled Chefs d'œuvre d'art from the Paris Exhibition and Salon* [1890], 1, ill. no. 19, discusses // *Magazine of Art* 14 (1891), p. 210 // T. Child, *Art and Criticism* (1892), p. 97, pp. 101–102, discusses // J. F. Opp, *Munsey's Magazine* 13 (August 1895), pp. 513–514, discusses it as "his first picture to attract attention"; ill. p. 515 // C. H. Caffin, *International Studio* 14 (Oct. 1901), p. xxxi, mentions it in a review of the Pan-American Exposition // A. Dayot, *Art et décoration* 15 (Feb. 1904), ill. p. 71; p. 72; trans. by I. Sargent, *Craftsman* 6 (May 1904), ill. p. 155; p. 157 // *Public Opinion* 36 (April 28, 1904), p. 531 // *American Art News* 3 (Dec. 24, 1904), [p. 2] // S. Isham, *The History of American Painting* (1905), ill. p. 402; p. 407, notes Albert Wolff's praise of it in the 1884 Salon // W. T. Dannat, letter in MMA Archives, Jan. 25, 1907, requests to have it sent to Paris, where he would like to retouch the background // G. B. Zug, *Chautauquan* 50 (April 1907), ill. p. 208; p. 227 // C. L. B., *New York Tribune*, May 4, 1913, part 6, p. 6 // W. T. Dannat, letter in MMA Archives, March 5, 1914, says he noticed the problem of "spots in the background" in 1894 and that they resulted from trouble he had in the original execution of it (quoted above), offers to restore it; letter to J. Seligmann, in MMA Archives, Dec. 13, 1919, gives its provenance and complains it is not hung in a suitable location // B. Burroughs to J. Seligmann, copy in MMA Archives, Jan. 27, 1920, assures him that it is well hung // S. P. Avery, letter in MMA Archives, June 28 [?], says Dannat will work on it the following Sunday // *Art Digest* 3 (April 1, 1929), p. 13 // *Art News* 27 (April 13, 1929), p. 14 // E. Neuhaus, *The History and Ideals of American Art* (1931), ill. p. 166; p. 173 // J. S. Kysela, *Art Quarterly* 27, no. 2 (1964), p. 155, discusses it in the Inter-State Industrial Exposition in 1885 // A. T. Gardner, *MMA Bull.*, 23 (April 1965), ill. p. 268; p. 272, discusses // W. D. Garrett, *MMA Journal* 3 (1970), p. 332, discusses; ill. p. 333.

EXHIBITED: Paris Salon, 1884, no. 651, as Un quatuor // Inter-State Industrial Exposition of Chicago, 1885, p. 5, as A quartette, says shown in art annex, unnumbered // William Schaus Art Gallery, New York, 1886 (no cat.) // Exposition Universelle, Paris, 1889, *Catalogue Illustré des Beaux-Arts, Etats-Unis*, no. 73.

Ex COLL.: with William Schaus, New York, 1884–1886; Mr. and Mrs. William H. Dannat, parents of the artist, New York, 1886.

Gift of Mrs. William H. Dannat, 1886.
87.26.

Margarette A. Jones

The portrait depicts the artist's aunt Margarette A. Jones, the daughter of Daniel and Margaret Jones. A resident of New York, she died on July 11, 1905, bequeathing this portrait, substantial funds, and a collection of porcelains to the Metropolitan Museum. Dated 1894, the picture was probably painted during the artist's visit to New York in that year. It shows Dannat's response to some of the influences that were shaping French modernism during the early 1890s, among them oriental art. The subject's face, shown in profile and silhouetted against a rich crimson background, is masklike, and its three-dimensional forms are reduced to flat unmodeled paint surfaces. The pigments are very thinly applied.

Dannat may have had some doubts about the aesthetic success of this picture; for he wrote to the museum from Paris on January 18, 1909: "I hope you have not hung it—not that I am absolutely sure that it is not a good thing—but because—not having seen it for fourteen years I *am in doubt* about it—and if it were to be hung—I should have been glad to see it over here first and put in proper order to be exhibited."

Oil on canvas, 24 × 20 in. (61 × 50.8 cm.).

Signed and dated at upper right: W–T–DANNAT—/1894.

REFERENCE: W. T. Dannat, letter in MMA Archives, Jan. 18, 1909, discusses it (quoted above).

Ex COLL.: the subject, New York, 1894–1905; her estate, 1905–1906.

Bequest of Margarette Jones, 1906.

07.233.40.

ALEXANDER HARRISON

1853–1930

Thomas Alexander Harrison was born in Philadelphia and studied for a short time at the Pennsylvania Academy of the Fine Arts. At the age of nineteen he joined the United States Coast and Geodetic Survey and spent nearly six years charting the coasts of Maine, Rhode Island, and Connecticut. He also worked four winters in the Florida swamps and later, on the West Coast, surveyed Puget Sound. This youthful experience probably stimulated the artist's interest in the ocean, which is so evident in such marines as *The Wave* (PAFA). "I have always loved big nature and the sky and the feeling of *space*," he once commented in a letter to George W. Stevens (June 1, ?, Stevens Collection, D34, Arch. Am. Art). In 1877, he left Seattle intending to go directly to Paris to resume his art studies, but instead he spent eighteen months at the Art School of San Francisco and participated in the activities of the Bohemian Club.

In the spring of 1879 Harrison arrived in Paris, where he maintained a residence for the rest of his career. He studied with Jean Léon Gérôme at the Ecole des Beaux-Arts for about a year and a half and thereafter spent much of his time painting outdoors in Brittany with the group of artists who had gathered around the painter Robert Wylie (1839–1877). Among Harrison's associates during the 1880s were the French peasant painter Jules Bastien-Lepage and the writer Robert Louis Stevenson.

In 1881, Harrison exhibited at the Paris Salon. He achieved critical acclaim throughout the 1880s and 1890s, and his work was widely sought by collectors. By the mid-1880s he had established himself as a painter of nudes in outdoor scenes, idyllic women bathing or relaxing

in forest settings, and also children frolicking on beaches. In 1890, when Meissonier led the revolt against the old Paris Salon and founded the new Salon, Harrison was a charter member, served on its first jury, and exhibited there annually. He also exhibited in New York at the Society of American Artists and the National Academy of Design, becoming an academician in 1901. His work appeared in annual exhibitions at the Carnegie Institute and the Pennsylvania Academy of the Fine Arts as well. In 1898 he made an extended trip to America to visit his family.

His brothers Butler and [Lowell] Birge Harrison (1854–1929) were also painters. In 1913 and 1914, he and Birge were honored by a special exhibition of their work, which traveled to several major American cities. In Paris, Harrison was a familiar figure in Montparnasse, where he had his studio. At the time of his death, the *New York Times* called him the "dean of American painters" in the French capital.

BIBLIOGRAPHY: Charles Francis Browne, "Alexander Harrison—Painter," *Brush and Pencil* 4 (June 1899), pp. 132–144 // Charles Louis Borgmeyer, "Alexander Harrison," *Fine Arts Journal* 29 (Sept. 1913), pp. 514–544 // "A Twin Exhibition— Alexander and Birge Harrison at the Albright Art Gallery," *Academy Notes* 8 (Oct. 1913), pp. 152–173 // Obituary. *Art Digest* 5 (Oct. 15, 1930), p. 22.

Castles in Spain
(Chateaux en Espagne)

Harrison painted *Castles in Spain* in Pont-Aven, an artists' colony in Brittany. After making preliminary studies on the beach six kilometers away, he dumped two cartloads of sand in the courtyard of his studio in the village and completed the painting outdoors. Writing about the picture in 1913, Charles Borgmeyer noted: "From the first, his real inspiration, when dealing with figure studies, was to have youth, or childhood in the open air in sentimental and sympathetic accord with nature in her quiet moods. During his entire career, he has never painted a serious indoor canvas."

The painting was exhibited at the Paris Salon of 1882, where it was the artist's first success. A critic for the London *Art Journal* noted that the painting had "a higher charm, owing to its idyllic character" and described its subject matter: "A boy, having exhausted all the resources at hand, in building a turreted castle out of stones, shells, grasses, and sea-birds' feathers, has stretched himself on his back on the sand hills, and gazing upwards, indulges in 'Dreams that wave before the half-shut eye: / And castles in the clouds that pass / For ever flushing round a summer sky.'" The painter Jules Bastien-Lepage admired its plein-air realism, and, as a result, sought Harrison's friendship. This favorable reception came to the

ambitious artist in his twenty-ninth year and represented the goal to which he had aspired since his student days at the Ecole des Beaux-Arts. Harrison considered the painting auto-biographical: "It was rather symbolic of my own state of mind at that time" (Dewhurst, 1904).

The artist may also have been inspired by Henry Wadsworth Longfellow's poem of 1877 "Castles in Spain," which describes the optimistic daydreams of youth. Longfellow died in 1882, the year Harrison completed the painting. Between 1882 and 1884, contemporary exhibition records mention a number of treatments of this theme, among them JOHN G. BROWN's *Castles in Spain*, 1882 (private coll., Maryland).

Oil on canvas, 37⅜ × 73¾ in. (94.9 × 187.3 cm.). Signed at lower right: Alex Harrison.

RELATED WORK: William B. Closson, *Castles in Spain*, wood engraving, 4⅜ × 8⅝ in. (11.1 × 21.9 cm.), ill. in S. R. Koehler, *American Art* (1886), opp. p. 54.

REFERENCES: *Livret illustré du salon* (1882), ill. p. 88 // *Le Solon illustré par les principaux artistes, peintres et sculpteurs* (1882), ill. p. 21 // M. du Seigneur, *L'Artiste* 1 (March 1882), p. 648 // *Art Journal* [London] 34 (July 1882), p. 218, discusses (quoted above) // Montezuma [pseud.], *Art Amateur* 7 (Oct. 1882), p. 90 // Sigma [pseud.], *Art Amateur* 8 (Dec. 1882), p. 10, calls it "most beautiful" and says, "It is an admirable performance in every respect, and is, all things being considered, fairly entitled to be regarded as the most successful picture of the exhibition, as its qualities are such to challenge the admiration of both

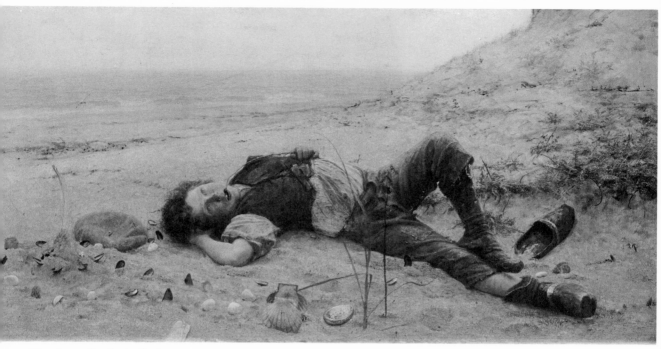

Harrison, *Castles in Spain.*

the learned and the unlearned" // *Magazine of Art* 6 (1883), p. 7 // F. S. D., *Studio* 1 (April 14, 1883), p. 134 // A. Harrison to Mr. Corliss, secretary, PAFA, July 1 [1883], PAFA, microfilm P74, Arch. Am. Art, discusses its sale to J. G. Johnson, says he wishes the PAFA had purchased it, and calls the boy's eyes its "master stroke" // S. R. Koehler, comp., *The United States Art Directory and Year-Book* (1884), p. 2, notes its exhibition at PAFA // S. R. Koehler, *American Art* (1886), pp. 51–52, discusses its exhibition record and provenance (quoted above); opp. p. 54, illustrates wood engraving of it by Closson // T. Child, *Harper's Monthly* 79 (Sept. 1889), p. 497, illustrates engraving of it by Charles Baude; p. 506, notes influence of Bastien-Lepage and Manet; reprinted in *Art and Criticism* (1892), ill. pp. 107, 109 // G. A. Smith, *The Laurelled Chefs-d'œuvre d'art from the Paris Exhibition and Salon* [1890], 1, ill. no. 18 // W. A. Coffin, *Harper's Weekly* 35 (Jan. 10, 1891), p. 21, calls it artist's first success; *Century*, n.s. 20 (August 1891), p. 637 // *Catalogue of a Collection of Paintings Belonging to John G. Johnson* (1892), p. 38, no. 112, lists, describes, and gives exhibitions and references for it // C. G. Browne, *Brush and Pencil* 4 (June 1899), p. 134, says it has been "realistically treated" // S. Hartmann, *A History of American Art* (1902), 2, pp. 178–179 // W. Dewhurst, *Impressionist Painting* (1904), p. 93, quotes Harrison, who calls it symbolic (quoted above) // J. W. Pattison, *Painters since Leonardo* (1904), p. 248, lists it among the artist's major works // C. L. Borgmeyer, *Fine Arts Journal* 29 (Sept. 1913), pp. 529–530, discusses it, gives setting; p. 530, says it is an example of his plein-air style (quoted above); pp. 531, 538 // *New York Times*, Oct. 14, 1930, p. 25, discusses // I. Konefal, John G. Johnson Collection, Philadelphia Museum of Art, letter in Dept. Archives, March 17, 1975, gives references and information about its early history.

EXHIBITED: Paris Salon, 1882, no. 1306, as Chateaux en Espagne // PAFA, 1882, no. 150, lent by W. S. Stuyvesant, St. Louis // American Art Galleries, New York, 1884, *Catalogue of Paintings, Works of Alexander Harrison and Birge Harrison*, no. 12, lent by J. G. Johnson, discusses its exhibition at the Salon of 1882, says photographed by Goupil and engraved for illustration in journals; no. 70, lists possible study for it // Exposition Universelle, Paris, 1889, *Catalogue Illustré des Beaux-Arts*, Etats-Unis, no. 139 // American Art Galleries, New York, 1894, *Catalogue of Paintings and Studies by Alexander Harrison*, no. 3, lent by J. G. Johnson.

EX COLL.: W. S. Stuyvesant, St. Louis, 1882; John G. Johnson, Philadelphia, by 1883–1912.

Anonymous Gift, 1912.

12.226.

CAROLINE CRANCH

1853–1931

Caroline Amelia Cranch was born at Fishkill Landing, New York, the daughter of the poet, painter, and Unitarian minister Christopher Pearse Cranch (1813–1892). She spent her early years, 1853–1863, in Paris and, after her family's return to New York, lived on Staten Island. Most of her life, however, was spent in Cambridge, Massachusetts. Throughout her career she had the benefit of her father's friends and acquaintances, who included the painter Edward May (1824–1887), the sculptors Richard Greenough and William Wetmore Story, and the philosopher William James.

Miss Cranch's art education was varied and sporadic. In 1870–1871 she attended drawing classes at Cooper Union in New York. By 1876, she was painting in her father's studio, and the following year she began to exhibit portraits at the Boston Art Club. In October of that year, she and her father traveled to Philadelphia to see the Centennial Exhibition. Clement and Hutton, describing her as "a young artist of much promise," reported that she also studied with WILLIAM MORRIS HUNT. In 1879, the Cranch family spent two months in New York, where Caroline studied at the Art Students League with WILLIAM MERRITT CHASE and exhibited for the first time at the National Academy of Design. In 1880, they went abroad, and according to the artist's father, this was "chiefly on Carrie's account. It is a fine opportunity for her, and will, we hope, do a great deal towards her completion in her art education" (Scott, p. 306). She visited the galleries and museums of London, Paris, Venice, and Rome, studying and copying the work of past and contemporary masters. The winter of 1880–1881 was spent in Paris, where Caroline studied briefly with the portraitist Emile Auguste Carolus-Duran and with Jean Jacques Henner. On December 30, 1880, her father wrote:

> Carrie has been going every day to Carolus-Duran's class of young ladies, and she works there from eight to one, after which she sometimes goes to the Louvre to copy . . . M. Duran comes twice a week, and M. Henner twice. Their criticism has been useful, Carrie thinks, but she will not continue another month. Carrie thinks the advantages for art in New York are better than here. But then there is no Louvre in New York (Scott, p. 319).

After returning to Cambridge in July 1882, father and daughter had an exhibition at J. Eastman Chase's gallery in Boston, where Caroline displayed several original paintings and some copies made in Paris and Venice. In later years, poor health made it difficult for her to paint, and little is known about her career after the turn of the century.

BIBLIOGRAPHY: Clara Erskine Clement and Laurence Hutton, *Artists of the Nineteenth Century* (Boston, 1880), I, p. 169 ‖ Leonora Cranch Scott, *The Life and Letters of Christopher Pearse Cranch* (Boston, 1917; reprinted 1969), pp. 175, 293, 295, 300–301, 303, 306, 308, 310, 315–316, 319–321, 325, 327, 330, 336, 348. Information on the artist is included in this biography of her better known father, compiled by her sister.

William Henry Huntington

Born in Norwich, Connecticut, William Henry Huntington (1820–1885) went to Europe in 1853 and remained there. He resided in Paris, where he was a correspondent for the *New York Tribune* for nearly twenty years and also for the *Cincinnati Commercial* from 1870 to 1871. His extraordinary capacity for friendship made him the center of a group of American artists, writers, and students. Huntington had a great interest in all phases of American history, and, as a collector, he concentrated on prints, medals, busts, paintings, and books related to Benjamin Franklin, George Washington, and the Marquis de Lafayette. In 1883, he presented his collection of two thousand American portraits to the Metropolitan.

Huntington's association with the Cranch family began when he was their fellow passenger on the *Germania*, which sailed from New York to Europe in October of 1853, the year of the artist's birth. Caroline's father, Christopher Pearce Cranch, noted that during the decade they spent abroad, Huntington "became intimately acquainted with us, and during our long residence in Paris we were often together. He was a true friend, a man of sterling character, of a most lovable nature, and great mental originality" (Scott, *Life and Letters of Cranch* [1917], p. 200). It appears that the Cranchs renewed their friendship with Huntington when they were again in Paris in the early 1880s, since he is mentioned in Mr. Cranch's journal for that period. Caroline Cranch probably did the portrait in Paris, for Huntington rarely left the French capital, and the canvas itself bears the stamp of a Parisian artist's supply shop. The portrait is a student work, showing the influence, but not the facility, of Miss Cranch's teacher Carolus-Duran. The sitter is stiffly posed and

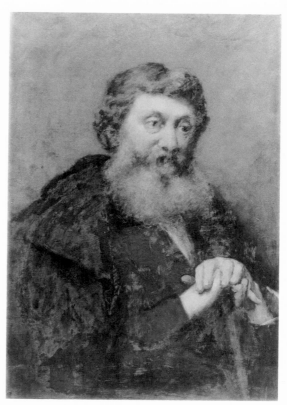

Cranch, *William Henry Huntington.*

wears a simple costume; his hands rest awkwardly on a cane, and his facial features are rendered in a belabored manner.

Oil on canvas, 30¼ × 19⅞ in. (76.5 × 50.5 cm.).
Canvas stamp: A LA PALETTE BEBIAS[?] / No [illeg.] St. MARTIN [illeg.] / TOILES COULEURS / TABLEAUX / Rue de Seine No 4.
Ex coll.: James W. Pinchot, New York, to 1889.
Gift of James W. Pinchot, 1889.
90.29.

EMIL CARLSEN

1853–1932

Emil Carlsen was born and trained in Copenhagen, Denmark. Before coming to the United States in 1872, he studied painting with a talented cousin, but his most extensive education was in architecture at the Royal Academy in Copenhagen. Settling at first in Chicago, he

served as a studio assistant to Lauritz Bernhard Holst (1848–1934), a Danish marine painter. He also worked as an architect's assistant and conducted a school for mechanical drawing. His first teaching position was at the Chicago Academy of Design (now the Art Institute of Chicago), but Carlsen's biographers disagree whether this was before or after a trip to Denmark and France in 1875. During this European sojourn, made at the suggestion of the portraitist Lawrence Carmichael Earle (1845–1921), Carlsen studied the still lifes of the French eighteenth-century artist Jean Siméon Chardin, whose work had an important influence on the development of his style. On his return he worked for a short time in New York, where J. FRANCIS MURPHY, an acquaintance from Chicago, was his neighbor. He went to Boston in 1876, maintaining a studio there for almost three years until financial difficulties forced him to give it up, auction his paintings, and take up work as a designer and engraver.

By 1883 or 1884, Carlsen was able to return to Paris, financed by the New York art dealer T. J. Blakeslee, for whom he painted a still life a month. He stayed two years, and though he associated primarily with French artists, his acquaintances included the Americans WILLARD METCALF, H. SIDDONS MOWBRAY, and Samuel Isham (1855–1914). In 1885, he exhibited at the Paris Salon and the National Academy of Design. By 1886, he was back in New York, in a studio on 55th Street.

In 1887 Carlsen accepted the directorship of the San Francisco Art School and held the post for two years. He continued to paint and teach in San Francisco until 1891. After returning to New York, he began to exhibit his work more widely. He became a member of the Society of American Artists in 1902, an associate of the National Academy of Design in 1904, and an academician two years later. He was elected to the National Institute of Arts and Letters in 1906. Between 1906 and 1909, Carlsen taught at the National Academy and from 1912 to 1918, at the Pennsylvania Academy of the Fine Arts.

Carlsen distinguished himself as a still-life painter, portraitist, figure painter, and landscapist. His impressionist landscapes show the influence of J. ALDEN WEIR and JOHN H. TWACHTMAN in the soft, generalized light and cool tonal palette. His style is distinctly individual, however, with granular paint surfaces and carefully designed decorative shapes.

The artist's son Dines (1901–1966) was also a successful still-life painter.

BIBLIOGRAPHY: F. Newlin Price, "Emil Carlsen—Painter, Teacher," *International Studio* 75 (July 1902), pp. 300–308 // Duncan Phillips, "Emil Carlsen," *International Studio* 61 (June 1917), pp. cv–cx // John Steele, "The Lyricism of Emil Carlsen," *International Studio* 88 (Oct. 1927), pp. 53–60 // William H. Gerdts and Russell Burke, *American Still-life Painting* (New York, 1971), p. 204. Discusses his still-life paintings // Wortsman Rowe Galleries, San Francisco, *The Art of Emil Carlsen, 1853–1932* (Jan. 10–Dec. 1975). Catalogue for a traveling exhibition, with remarks by Erwin S. Barrie. Includes biographical statement, discussion of Carlsen as a teacher, his memberships and awards, and five early essays on him by A. E. Bye (1921), F. N. Price (1902), J. Steele (1927), D. Phillips (1917), E. Clark (1919). Gives permanent collections where he is represented, chronology, and bibliography.

Blackfish and Clams

Like his contemporaries Henry Golden Dearth (1864–1918) and Joseph Decker (1853–1924), Emil Carlsen was impressed by the still lifes of Jean Siméon Chardin, the eighteenth-century French painter whose work had a revival at the end of the nineteenth century. Carlsen studied these paintings in Paris during the early 1880s, and in an article in 1908, he called Chardin "the

Carlsen, *Blackfish and Clams*.

very greatest still life painter." *Blackfish and Clams* displays Chardin's influence in its humble subject matter, its carefully designed, austere composition, its soft, impressionistic contours, and its low-key color harmonies. For Carlsen, "the study of values was the most important problem that faced the still-life painter," and in his article, he urged the selection of objects "for their beauty of line and color; and . . . the choice of white, grey and black as much as possible . . . fine blacks, fine whites and greys."

Painted in somber tones, the picture shows a simple basket and a napkin surrounded by fish and clams—the rounded contours of their bodies and shells resting on an unadorned support. In spite of the large size of this still life, it conveys an impression of intimacy that is reinforced by its unpretentious subject.

Oil on canvas, $34\frac{1}{4} \times 38\frac{3}{16}$ in. (87 × 97 cm.).
Signed at lower right: Emil Carlsen.

REFERENCES: *Illustrations of Selected Works in . . . the Department of Art . . . Universal Exposition, St. Louis, 1904* (1904), p. xxxvii, lists it as receiving a gold medal; ill. p. 235; pp. 235–236, discusses it // *MMA Bull.* 1 (Nov. 1905), p. 24, discusses it // E. Carlsen, *Palette and Bench* 1 (Oct. 1908), p. 6, discusses it and influence of Chardin (quoted above); ill. p. 7 // A. E. Bye, *Pots and Pans* (1921), ill. opp. p. 214; pp. 216–218, discusses it // W. Born, *Gazette des Beaux-Arts* 29 (May 1946), p. 317; *Still-life Painting in America* (1947), p. 42; pl. 114.

EXHIBITED: NAD, 1903, no. 324, as Blackfish and Clams // Universal Exposition, St. Louis, 1904, *Official Catalogue of Exhibitors* (rev. ed.), p. 25, no. 113a, as Still Life.

EX COLL.: William A. Read, New York, until 1905.
Gift of William A. Read, 1905.
05.36.

Carlsen, *The Open Sea.*

The Open Sea

Dated 1909, the picture is one of many marine and coastal scenes painted by Carlsen. In it he focuses on the changing conditions of sky and sea, reducing his composition to very simple elements: a low horizon, barely broken by ridges of water; a cloud-filled sky, which occupies the upper two-thirds of the canvas; and a few rolling waves breaking into sea foam. At the turn of the century, the empty ocean was a favorite motif of such American marine painters as FREDERICK J. WAUGH, Frank K. M. Rehn (1848–1914), and Charles H. Woodbury (1865–1940), most of whom preferred to show the sea at more turbulent, dramatic moments. *The Open Sea* recalls the deserted seascapes Gustave Courbet painted in the mid-1850s, but it lacks the psychological impact of this French realist's work.

Duncan Phillips wrote of Carlsen's marine scenes,

In his dream-world there is no conception of passion, no revolt, no vain questioning. With calm acquiescence in nature monotony is cherished. For us of the Western world such moods are not altogether foreign. We all know those blue mornings at sea when, gazing across opaque shimmering waters, lazily dormant, like our dreams, under a spread of sun, the monotony seems somehow a solace. We watch with deep content the curve and crest of the waves as they fall (*International Studio* 61 (June 1917), p. cvi).

The Open Sea was most likely painted at the artist's favorite sketching place, the northernmost coast of Denmark that juts out into the Kattegat strait.

Oil on canvas, 48 × 58 in. (121.9 × 147.3 cm.).

Signed and dated at lower left: Emil Carlsen–1909–

REFERENCES: *Academy Notes* 5 (April 1910), p. 21, speculates that it was painted on the Danish coast between the Kattegat and the Skagerrak, describes it as "a study of the open sea from the coast line" // A. Hoeber, *Mentor* 1 (July 7, 1913), p. 10; unnumbered pl. // *George A. Hearn Gift to the Metropolitan Museum of Art* . . . (1913), ill. p. 98.

EXHIBITED: Albright Art Gallery, Buffalo Fine Arts Academy, 1910, *Catalogue of a Collection of Paintings and Sketches by Emil Carlsen: Lent by Folsom Gallery, New York,* no. 2, as Open Sea // Carnegie Institute, Pittsburgh, 1910, no. 39 // Union League Club, New York, 1911, *Paintings by American Artists,* no. 6.

EX COLL.: with Folsom Gallery, New York, by 1910; George A. Hearn, New York, 1910.

Gift of George A. Hearn, 1910.

10.64.1.

WILL H. LOW

1853–1932

Born in Albany, New York, Low received his first exposure to art in the studio of the sculptor Erastus Dow Palmer. At the age of seventeen, he came to New York, where he earned his living as an illustrator. He exhibited at the National Academy of Design for the first time in 1872. The following year, he went to Paris, where he spent the next five years. He studied briefly with Jean Léon Gérôme at the Ecoles des Beaux-Arts and then with Emile Auguste Carolus-Duran. In 1873, he spent the first of several summers in Barbizon, where he met the French peasant painter Jean François Millet, as well as the Americans Henry Bacon (1839–1912), Wyatt Eaton (1849–1896), and Daniel Ridgway Knight (1840–1924). The following year, he exhibited at the Paris Salon and spent the summer near Grez-sur-Loing with his French bride.

Low returned to America at the end of 1877. In New York in the 1880s he was friends with such artists as Wyatt Eaton and Augustus Saint-Gaudens. He taught at the Women's Art School at Cooper Union, produced commercial illustrations, and did decorative work for JOHN LA FARGE, endeavors which left him little time for his painting. In 1886, the financial and critical success of his illustrations for Keat's *Lamia*, published the previous year, permitted him to return to Paris after an eight-year absence. He spent the summer in the French capital and then traveled in Italy and England, returning to New York in 1887.

Low was one of America's foremost muralists in the 1890s. He did the ceiling decorations for the Waldorf Astoria, which were commissioned in 1892, and is most noted for an ambitious series of murals in the New York State Education Building in Albany. He was also an active art critic, contributing articles to *McClure's*, *Scribner's*, and the *Century*. He settled permanently in Bronxville, New York, in 1896, and in 1909, nearly twenty years after the death of his first wife, married the painter Mary Fairchild (1858–1946), former wife of FREDERICK MAC MONNIES.

Low had been an innovative illustrator and decorative painter during the 1880s and 1890s, but after 1900, his work, eclipsed by new developments, fell out of favor. His awareness of this is apparent in a letter he wrote to his friend EDWIN H. BLASHFIELD on September 18, 1923: "all that I am trying to do is to make things of beauty and there comes the thought that this effort, this desire, is so out of key with the present time! If so I am as extinct as the dodo" (Edwin H. Blashfield Collection, NYHS).

BIBLIOGRAPHY: Will H. Low and Kenyon Cox, "The Nude in Art," *Scribner's Magazine* 12 (Dec. 1892), pp. 741–749 ∥ Will H. Low, *A Chronicle of Friendships: 1873–1900* (New York, 1908); *A Painter's Progress* (New York, 1910). Originally the Scammon Lectures, delivered at the Art Institute of Chicago, April 1910 ∥ Obituaries. *New York Times*, Nov. 28, 1932, p. 15; *Art Digest* 7 (Dec. 1, 1932), p. 32; *Art News* 31 (Dec. 3, 1932), p. 8.

Aurora

The painting depicts the goddess of the dawn, Aurora, in her traditional saffron-colored robe with rays of sunshine around her head. She stands beside a fountain, its water pouring into the pool at her feet. Like his illustrations from the 1880s, *Aurora* shows Low's admiration for the

expressive figure style of the Pre-Raphaelite painters.

During the 1880s and 1890s, Low worked as a stained-glass designer and mural painter and participated in the American Arts and Crafts movement, which was inspired by British artists and artisans. Thus, it is not surprising that this picture served as a model for the stained-glass window *Young Woman at a Fountain* (Morse Gallery of Art, Winter Park, Fla.), produced by LOUIS COMFORT TIFFANY's firm.

The painting met with a mixed reaction when it was exhibited at the Society of American Artists in 1894 and at the Pennsylvania Academy of the Fine Arts a year later. The critic for the *Outlook* called it "a strange production . . . [and] much too large." Even Low later admitted that it "was not . . . representative of my more mature work" (1919).

Oil on canvas, 52¾ × 33¼ in. (134 × 84.5 cm.).

Signed and dated at lower left: 1894 WILL H. LOW.

RELATED WORK: Tiffany Studios, *Young Woman at a Fountain*, stained-glass window, about 58 × 37 in. (147.3 × 94 cm.), Morse Gallery of Art, Winter Park, Fla., 66-4.

REFERENCES: *Art Interchange* 22 (May 11, 1889), pp. 152–153, illustrates a drawing of a "classical figure" which may be a source for the pose // *Outlook* 49 (March 31, 1894), p. 601, reviews its exhibition at the Society of American Artists (quoted above) // W. T. Evans, letter in MMA Archives, before April 13, 1895, states that it is on view at the Lotos Club // G. B. Zug, *Chautauquan* 50 (April 1907), ill. p. 216 // W. S. Howard, *Harper's Monthly* 116 (March 1908), ill. p. 615, shows Henry Wolf's engraving of it; p. 616, discusses the painting, stating that "it shows a fusion of the historical sense with a sense of beauty and truth" // W. H. Low, letter in MMA Archives, Feb. 15, 1919, discusses (quoted above) // R. C. Smith, *Life and Works of Henry Wolf* (1927), p. 88, no. 701, lists Wolf's engraving of it // *New York Herald Tribune*, Nov. 28, 1932, p. 17, mentions the painting in artist's obituary // *Art Digest* 7 (Dec. 1, 1932), p. 32 // W. H. Truettner, *American Art Journal* 3 (Fall 1971), p. 76, in a list of Evans's collection, says it was acquired by 1895 // R. B. Tonkin, Morse Gallery of Art, letter in Dept. Archives, May 24, 1976, provides information about the stained-glass window.

EXHIBITED: Society of American Artists, New York, 1894, no. 222, as Aurora // PAFA, 1894–1895, no. 214 // Lotos Club, New York, 1895 (no cat. available) // MMA, 1897, *Loan Collections and Recent Gifts to the Museum*, no. 176.

Ex COLL.: William T. Evans, New York, by 1895.

Gift of William T. Evans, 1895.

95.3.

Low, *Aurora*.

Tiffany Studios, *Young Woman at a Fountain*, Morse Gallery of Art.

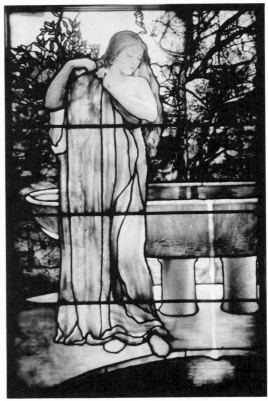

JOHN F. PETO

1854–1907

John Frederick Peto's career can be conveniently divided into two periods: his Philadelphia years, from 1875 to 1889, and his Island Heights, New Jersey, period, from 1889 until his death. Born in Philadelphia, this still-life painter is described by his contemporaries as self-taught, although he was a student at the Pennsylvania Academy of the Fine Arts in 1878 and exhibited there between 1879 and 1887. His trompe l'œil still lifes were inspired by WILLIAM MICHAEL HARNETT, whom he apparently knew quite well before that painter's departure for Europe in 1880. Although the similarities between the two artists later resulted in problems of attribution, Peto is the least imitative of Harnett's many followers. His drawing, use of color, application of paint, and often his choice of subject are very different. Unlike Harnett he does not strive for naturalistic effects of form and texture; his contours are less decisive, his subjects more ordinary and dilapidated. Concerned with light and decorative values, he painted with muted colors and achieved a soft, powdery Vermeer-like texture.

Peto's years in Philadelphia were marked by financial difficulties. He produced rack pictures like *Office Board* (q.v.) for local business and professional men, and is reported to have done both photographic and painted portraits to support himself. In June 1887, he married Christine Pearl Smith of Lerado, Ohio. About this time, he began to play the cornet at religious camp meetings at Island Heights, New Jersey, where he built a house in 1889. Peto appears to have stayed in Island Heights for the rest of his career, except for an extended visit to Lerado with his wife and daughter in 1894. The trip was probably made to execute a picture (now unlocated) for the proprietors of the Stag Saloon in nearby Cincinnati. Peto continued to paint a wide variety of still-life subjects: racks holding printed matter; tabletops with mugs and pipes, writing materials, or decorative objects; shelves of books; and doors with hanging musical instruments.

Working in relative isolation, Peto never attained the renown that Harnett enjoyed during his final years. By the time Edith Gregor Halpert revived interest in trompe l'œil painting with an exhibition at the Downtown Gallery in 1939, many of Peto's pictures had acquired the false signature of Harnett, whose works were more marketable. Clearly Peto himself was not responsible for the forgeries; his works show no attempts at imitating Harnett's style, specific models, or handwriting. It was not until 1949 that Alfred Frankenstein isolated about twenty of Peto's still lifes, previously ascribed to Harnett's "soft" style, and established Peto's particular contribution to late nineteenth-century American painting.

BIBLIOGRAPHY: Alfred Frankenstein, "Harnett, True and False," *Art Bulletin* 31 (March 1949), pp. 38–56 ‖ Lloyd Goodrich, "Harnett and Peto: A Note on Style," *Art Bulletin* 31 (March 1949), pp. 57–59 ‖ Brooklyn Museum, *John F. Peto* (March 1–July 9, 1950). Catalogue of a traveling exhibition with a critical biography by Alfred Frankenstein ‖ Alfred Frankenstein, *After the Hunt: William Harnett and Other American Still Life Painters, 1870–1900* (Berkeley and Los Angeles, 1953; rev. ed., 1969), pp. 99–111 ‖ William H. Gerdts and Russell Burke, *American Still-life Painting* (New York, 1971), pp. 143–144; 248–249, gives bibliography.

Peto, *Old Souvenirs*.

Old Souvenirs

Arrangements of objects in a rack have long been popular still-life subjects. Peto's taped grids with printed matter follow in the trompe l'œil tradition first explored in America by RAPHAELLE PEALE. In the late nineteenth century, however, Peto was the undisputed master of this genre, producing a number of these pictures between 1879 and 1885 and returning to the subject again in 1894. In a reversal of the usual artistic relationship between Peto and WILLIAM MICHAEL HARNETT, Peto's success with this genre may have inspired Harnett's two known rack paintings, *The Artist's Letter Rack*, 1879 (q.v.), and *Mr. Hulings' Rack Picture*, 1888 (coll. Mr. and Mrs. Jacob M. Kaplan, New York). These pictures in turn influenced Peto's later rack paintings, in which he adopted Harnett's simplified grid.

Old Souvenirs is an intricate composition. The grid, actually four racks in one, is typical of Peto's early paintings and contains several items that appear in other pictures of this period: a green pamphlet bearing the title "Report," a small envelope inscribed with the words "Important Information Inside," and a greeting card decorated with a lily. Judging by the evidence of other items represented, the painting was worked on over a period of almost twenty years, from 1881 to 1900. A folded copy of the *Philadelphia Evening Bulletin* for October 10, 1881, suggests that the painting was begun in that year. An upside-down postcard, addressed to Peto at 1027 Chestnut Street, must be dated 1887, the only year that his studio was located at this address. A picture of his daughter Helen (born 1893) is painted over an earlier portrait (visible in the X-ray) and was probably added around 1900, since she appears to be about seven years old. The same depiction of her appears in *Still*

X-ray of Peto, *Old Souvenirs*.

Life with Portrait of the Artist's Daughter, 1901 (coll. Howard Keyser, Island Heights, N.J.). The presence of the earlier portrait indicates that the painting may have been intended originally as an office board. The only clues to the identity of the original client may be the card postmarked New York, October 1, addressed to an individual named Mr. John (surname obscured), and, below it, a letter postmarked Philadelphia, November 10, addressed to an individual named Harper on Pine Street.

Old Souvenirs is one of many works by Peto that were once considered to be by Harnett because of the addition of a spurious signature.

Oil on canvas, 26¾ × 22 in. (67.9 × 55.9 cm.).
Falsely inscribed and dated at lower left: WMH (monogram) ARNETT / 1881.
REFERENCES: Undated photograph, Downtown Gallery Papers, ND27, Arch. Am. Art, lists it as by Harnett and gives early references and exhibitions //

E. Roditi, *View*, ser. 5, no. 4 (Nov. 1945), ill. p. 9, as by Harnett; p. 19, calls photograph of girl "presumably forgotten or dead woman" // W. Born, *Magazine of Art* 39 (Oct. 1946), ill. p. 248, discusses it as a Harnett; p. 252, calls it a free version of Vaillant's Letter Rack; *Still-Life Painting in America* (1947), pp. 32–33, discusses it; pl. 85, as by Harnett // A. Frankenstein, *Art Bulletin* 31 (March 1949), pp. 44–48, presents his case for its reattribution to Peto, including laboratory examination by Sheldon Keck, and discusses objects included in it; p. 50, notes the influence of Harnett on Peto's rack paintings; *After the Hunt* (1953; rev. ed. 1969), pp. 5, 8, 17–19; ill. opp. p. 19, as pl. 19; pp. 20–22, presents case for attribution to Peto; p. 51, corrects his original assumption that Harnett's rack pictures influenced Peto, notes that "Peto was the forerunner and Harnett the follower," compares it to other Peto rack pictures; p. 95, discusses Born's interpretation of it; p. 108; p. 184, includes it as no. 16 in a list of forgeries of and misattributions to Harnett; *Art News* 67 (March 1970), ill. p. 52 // S. B. Sherrill, *Antiques* 97 (May 1970), ill. p. 646 // W. D., *Arts* 44 (Summer 1970), ill. p. 58 // J. T. Butler, *Connoisseur* 174 (August 1970), ill. p. 314.
EXHIBITED: Downtown Gallery, New York, 1939, "*Nature-Vivre*" *by William M. Harnett*, no. 8, as Old Souvenirs by Harnett, lent by the Downtown Gallery // Detroit Society of Arts and Crafts, 1939, [Exhibition of Works by William M. Harnett] (no cat. available) // Arts Club of Chicago, 1940, *Paintings by William M. Harnett*, no. 13, as by Harnett, lent by Downtown Gallery // La Jolla Museum of Art, and Santa Barbara Museum of Art, 1965, *The Reminiscent Object*, exhib. cat by A. Frankenstein, ill. no. 25, as by John F. Peto, lent by Oliver B. Jennings, dates it 1881 // National Gallery, Washington, D.C., Whitney Museum of American Art, New York; University Art Museum, Berkeley; California Palace of the Legion of Honor, San Francisco; and Detroit Institute of Arts, 1970, *The Reality of Appearance*, exhib. cat. by A. Frankenstein, no. 56, p. 96, calls it a palimpsest, dates it 1881 with the painted photograph of the artist's daughter added about 1900; ill. p. 97 // Civic Museum of Turin, 1973, *Combattimento per un'Immagine Fotografi e Pittori*, exhib. cat. by D. Palazzoli and L. Carluccio, unnumbered ill., as Vecchi ricordi, discusses it.
EX COLL.: with Downtown Gallery, New York, until 1940; Oliver B. Jennings, New York, by 1945–1968.

Bequest of Oliver Burr Jennings, 1968.
68.205.3.

Office Board

Dated 1885, *Office Board* is one of the many rack pictures Peto painted during his residence in Philadelphia. Like most of these trompe l'œil pictures done between 1879 and 1885, it is composed of tapes strung in a complicated pattern of rectangles and triangles, and holds a variety of printed and written matter that sometimes offers clues to the identity of the painting's original owner. Here the only readily identifiable objects are a postcard and a letter addressed to Dr. Bernard Goldberg at his Chestnut Street office. It seems likely that Goldberg, who was a chiropodist and the artist's neighbor during the 1880s, commissioned the work. He is probably also the subject of the simulated photograph, perhaps copied from one by Peto, since the artist did take photographic portraits at this time.

Many of the objects rendered in *Office Board* are unreadable or illegible, perhaps intentionally so. The folded magazine tucked in the rack above the photograph is totally anonymous and the one beneath it is folded in half so that only the least informative part of its title,

". . . ulletin:/. . . urnal," is visible. The publication hanging from the lower half of the rack is open to a picture of a waterfall with two columns of unreadable text below. Barely visible behind this is a pamphlet, its cover and title completely obscured except for the letters *ker*. The tattered labels, tickets, and clippings are equally unintelligible. These visual clues are meant to engage the viewer's attention and arouse his curiosity; presumably they are also related to Dr. Goldberg's life, career, or interests.

Oil on canvas, 24⅜ × 19⅞ in. (61.9 × 50.5 cm.).

Signed, dated, and inscribed at lower right: John F. Peto / 4.85. / Phila. Signed, dated, and inscribed on the back: OFFICE BOARD / JOHN F. PETO / ARTIST / 4.85. Canvas stamp: JANENTZKY & WEBER / ARTISTS MATERIALS / No. 1125 Chestnut Street / PHILADELPHIA.

REFERENCES: M. Roche, *House Beautiful* 92 (May 1950), color ill. p. 131 // A. Frankenstein, *After the Hunt* (1953; 1969), p. 103, states that it was painted for Goldberg; misdates it 1880; letter in Dept. Archives, May 3, 1963 discusses Goldberg and the relationship of objects in the picture to him // P. Magriel, letter in Dept. Archives, after May 7, 1963, gives information about its provenance // T. H.

Peto, *Office Board*.

Peto, *The Old Cremona*.

Robsjohn-Gibbings, letters in Dept. Archives, June 26, July 9, 1963, gives information about its provenance and history // A. T. Gardner, *MMA Bull.* 22 (Jan. 1964), ill. p. 165, calls it The Letter Rack and compares it to works by Harnett.

EXHIBITED: MMA and American Federation of Arts, traveling exhibition, 1975–1977, *The Heritage of American Art*, exhib. cat. by M. Davis, no. 77, ill. p. 172; p. 173, discusses it.

EX COLL.: with Downtown Gallery, New York, by 1949; T. H. Robsjohn-Gibbings, New York, 1949–1953; George P. Guerry, New York, 1953; with Paul Magriel, New York, 1953–1955.

George A. Hearn Fund, 1955.

55.176.

The Old Cremona

The Old Cremona was attributed to WILLIAM MICHAEL HARNETT because of the false signature it bears as well as the composition, which resembles Harnett's renowned treatment of the subject in *The Old Violin*, 1886 (coll. William J. Williams, Cincinnati). Harnett's painting was popularized by Frank Tuchfarber's 1887 chromolithograph of it, with which Peto was undoubtedly familiar. He may even have seen the painting in Cincinnati, where, according to his daughter, he visited in 1887. *The Old Cremona* is not dated but was probably painted after 1887, when the chromolithograph appeared, and before 1890, since it does not have the kind of commercial stretcher Peto used almost exclusively after that year.

It is possible that this is the same painting that was sold at auction in Philadelphia in 1893 as *Hang Up the Fiddle and the Bow*, a work forged as a Harnett. A newspaper article preserved in the scrapbook of Harnett's friend William Blemly recounts that: "The picture was never painted by Harnett but owes its origin to a young artist named Peto." The article goes on to say that a well-known Philadelphia newspaper publisher was a still earlier owner of the work.

The painting is typical of Peto's trompe l'œil style. Unlike Harnett, whose paintings are more three-dimensional in treatment, Peto flattens forms, emphasizing their shapes and colors to achieve a decorative effect that is striking in its modernity. He minimizes textural differences, and most surfaces, whether the wood of the violin, the metal of the hinge, or the paper of the music pamphlet, have a somewhat velvety appearance. Peto's areas of light and shade are highly contrasted, with distinctly outlined shadows and little modeling.

Oil on canvas, 16 × 12 in. (40.6 × 30.5 cm.).
Falsely inscribed at lower right: WMH (monogram) ARNETT.
RELATED WORK: *Old Violin on Wall with Music*, oil on canvas, 16¼ × 12¼ in. (41.3 × 31.1 cm.), private coll., Chicago.
REFERENCES: "Harnett's Name Forged," clipping, [May 1893], in copy of Blemly Scrapbook, Alfred Frankenstein Papers, microfilm 1374, Arch. Am. Art, discusses forged Harnett sold at Freeman and Co., Philadelphia, May 16, 1893, in William Culp's estate sale, possibly this painting (quoted above) // Undated photograph, Downtown Gallery Papers, ND27, Arch. Am. Art, gives as by Harnett and includes information on provenance // E. G. Halpert, Downtown Gallery, letter in Dept. Archives, Feb. 1, 1940, discusses its provenance // H. W. Williams, Jr., *MMA Bull.* 35 (June 1940), pp. 134–135, mentions it as by Harnett // *Antiques* 43 (June 1943), ill. p. 260, as a Harnett // A. Frankenstein, *Art Bulletin* 31 (March 1949), p. 46, includes it as no. 2 in a list of Peto works previously ascribed to Harnett; pp. 46–47, discusses false signature and speculates that painting may be Hang Up the Fiddle and the Bow; p. 50 discusses influence of Harnett's The Old Violin; *After the Hunt* (1953; rev. ed. 1969), pp. 17, 20–21, 77, 184 // A. T. Gardner, *MMA Bull.* 22 (Jan. 1964), p. 164; ill. p. 165.
EX COLL.: William Hughes, Washington, D.C., until 1939; with Downtown Gallery, New York, 1939.
Harris Brisbane Dick Fund, 1939.
39.172.1.

WALTER LAUNT PALMER

1854–1932

The landscapist Walter Launt Palmer was born in Albany, New York, the son of the sculptor Erastus Dow Palmer and was named in part for his father's student Launt Thompson. He spent his childhood surrounded by such Albany artists as JAMES HART, WILLIAM HART, HOMER DODGE MARTIN, EDWARD GAY, and George H. Boughton (1833–1905), who frequented the Palmer residence. The successful portraitist CHARLES LORING ELLIOTT gave young Palmer his first painting lessons, and during the early 1870s, he studied with the Hudson River School landscapist FREDERIC E. CHURCH, a family friend. In 1872, Palmer began to exhibit at the National Academy of Design. The following year, he made a tour of Europe with his family and spent the winter in Paris studying with Emile Auguste Carolus-Duran. After a brief visit home, he returned to Paris and continued his studies there until 1876. He then settled in New York, taking a studio on West Tenth Street. He traveled to Venice in 1881, and there he gathered material for the Venetian scenes, such as *On the Lagoon, Venice* (Topeka Public Library), that dominated his work during the early 1880s. Palmer was among the earliest American artists to make a sketching tour of China and Japan.

Palmer returned to Albany by 1882, thereafter making his residence in that city and contributing his work to important exhibitions in New York. In 1887, after one of his snowscapes received the Hallgarten Prize at the National Academy, he was elected an associate member of that institution, and in 1897 he became an academician. A successful water-

colorist, Palmer exhibited at the American Water Color Society, winning its Evans Prize in 1895. He continued to paint well into the twentieth century and specialized in snowscapes, done in a decorative impressionist style, popular but rather outdated. He died in Albany, and was eulogized as "one of the last members of that group of nineteenth century artists whose work is in no small measure responsible for the evolution of the American landscape school of painting" (*Bulletin of the Minneapolis Institute of Arts* 24 [March 23, 1935], p. 58).

BIBLIOGRAPHY: Walter Launt Palmer, "On the Painting of Snow," *Palette and Bench* 2 (Feb. 1910), pp. 90–91 ‖ Obituaries. *Art News* 30 (April 23, 1932), p. 12; *Art Digest* 6 (May 1, 1932), p. 4.

Silent Dawn

The style of Palmer's lyric winter landscapes resulted from a wide range of influences: the subtle tonal control of his teacher Carolus-Duran, the oriental and impressionist interest in the changing conditions of weather and atmosphere, and the delicate nuances of color and surface texture in the snowscapes of his contemporary JOHN H. TWACHTMAN. Pale blue and lavender colors appear in the deeper shadows of this painting, but spatial depth is suggested more by subtle changes in the tone and texture of the white pigment. The austere palette is surprising, since Palmer himself commented on the coloristic possibilities of snow: "Snow, being colorless, lends itself to every effect of complement and reflection. Each variation is emphasized as the human eye takes up and exaggerates the suggestion, and perhaps one of the most valuable functions of the artist is . . . to record with more evident vividness, the delicate beauties that only his trained eye perceives" (*Palette and Bench* 2 [Feb. 1910], p. 91).

Palmer preferred to paint his luminous snow scenes in his studio, working from memory. He thought that the snowscapist encountered too many obstacles outdoors: "The cold is only one of these," he pointed out. "The light is dazzling and bewildering and the effects are very transient" (p. 90). His technique called for many preliminary pencil sketches, written notes, and photographs, all of which were put aside when he actually began to paint. He cautioned against too strong a dependence on photographs, pointing out that they "are valuable for some details, but are very misleading for general effects and relations" (p. 90).

Silent Dawn was one of Palmer's more successful paintings. Exhibited at the Chicago Art Institute in 1919, it won the Edward B. Butler Popular Prize. When the artist offered it to the Metropolitan in 1920, he noted that "It is the sort of thing that no-one else tackles—the snow-laden trees."

Oil on canvas, 30 × 40 in. (76.2 × 101.6 cm.).
Signed at lower left: W. L. PALMER.
REFERENCES: *Bulletin of the Art Institute of Chicago* 14 (Jan. 1920), p. 12, states that it won the Edward B. Butler Popular Prize of one hundred dollars based on

Palmer, *Silent Dawn*.

votes of visitors to the institute // W. L. Palmer, letters in MMA Archives, Jan. 10, 1920, discusses it (quoted above) and mentions Union League exhibition; April 18, 1920, says "I do not think it likely that I will do anything better than the 'Silent Dawn'" // *American Magazine of Art* 12 (June 1921), ill. p. 190 // *Art Digest* 6 (May 1, 1932), p. 4.

EXHIBITED: Art Institute of Chicago, 1919, no. 163, as Silent Dawn // Union League Club, New York, 1900, *Paintings by Well-known American Artists*, probably no. 9, called Winter's Calm.

Ex COLL.: the artist, Albany, N.Y., until 1921.

George A. Hearn Fund, 1921.

21.38.

ALFRED Q. COLLINS

1855–1903

The life and work of Alfred Q. Collins has not been adequately documented. His place and date of birth have been variously reported, but it seems most likely that he was born in Portland, Maine, in 1855. He studied in Paris, first at the Académie Julian and then in the atelier of Léon Bonnat, where he developed his realistic portrait style. In 1880, he exhibited *Un Courtisan* (unlocated) at the Paris Salon. After his return to America, he is reported to have worked primarily in San Francisco, Buffalo, and Boston, but by the late 1880s, he appears to have been working in New York. In 1889, he became a member of the Society of American Artists, serving on their committee of selection during the next decade, and, in 1890 and 1891, he exhibited at the National Academy of Design. His career, however, was marked by private accomplishment rather than public recognition.

Collins was an exacting craftsman. He studied geometric forms in his studio and considered a knowledge of European painting essential to his creativity. He was a frequent visitor to the Metropolitan Museum, where he studied the paintings closely. EDWIN H. BLASHFIELD reported that,

> On one occasion, and having very little time to spare from his work, yet wishing for that freshening of impression and immediate stimulus which should come from . . . an abrupt confrontation of the art of the past with his own seeking and results in the present. . . . he took the double voyage to and from Europe, made a flying trip through a number of the great continental galleries, travelling by night, gathering and noting his impressions by day . . . and returning to his New York studio almost before his portrait in hand had dried upon the canvas (p. 125).

In 1903, before making another trip to Europe, he went through the contents of his studio, destroying practically all of his paintings. He died just a few weeks later, leaving only a small but accomplished group of portraits to maintain his reputation.

BIBLIOGRAPHY: Obituaries. *Boston Evening Transcript*, July 22, 1903, [p. 151]. *New York Times*, July 23, 1903, p. 7, and K. Dunham, "Tribute to Artist Collins," letter to editor, July 29, 1903, p. 6 // Edwin Howland Blashfield, Frank Fowler, Kenneth Frazier, Will H. Low, and Robert Reid, "Alfred Quinton Collins: Memories of His Life and Work," *Scribner's Magazine* 35 (Jan. 1904), pp. 125–128 // Kenneth Frazier, "Alfred Quentin Collins," *Arts* 7 (April 1925), pp. 219–225.

Alexander Stewart Wetherill

Probably painted in New York in the 1890s, this portrait represents Alexander Stewart Wetherill (1885–1914), the young son of Kate Annette (Smith) and Joseph Bloomfield Wetherill, rector of St. Ambrose Chapel and assistant at Trinity Church, New York. Mrs. Wetherill's sister was the wife of the architect Stanford White. At the request of the subject's mother, White commissioned the portrait of his nephew and designed its gilt frame, which is decorated with Corinthian columns, egg and dart motifs, and leaf patterns.

Collins has concentrated on the boy's face and hands, simplified the costume details, and given the background a broad application of a neutral grayish-brown color. The subject died in an accident at the young age of twenty-eight.

Oil on canvas, $59\frac{3}{4} \times 37\frac{3}{4}$ in. (151.8 × 95.9 cm.).

REFERENCES: K. Frazier, *Arts* 7 (April 1925), ill. p. 221, as owned by Barent Lefferts, Esq. // *Brooklyn Museum Quarterly* 12 (April 1925), ill. p. 98 // K. Lefferts, letter in MMA Archives, April 10, 1967, gives provenance and the subject's biography.

EXHIBITED: PAFA, 1904, no. 243, as Lex, lent by Mrs. J. Bloomfield Wetherill, Philadelphia // Universal Exposition, St. Louis, 1904, *Official Catalogue of Exhibitors* (rev. ed.), no. 147, as Portrait, lent by Mrs. Bloomfield Wetherill // Brooklyn Museum, 1925, *A Collection of Paintings by the late Alfred Quinton Collins, A.N.A.*, no. 4, as Portrait of Alexander Wetherill, lent by Mrs. Barent Lefferts.

EX COLL.: Mr. and Mrs. Joseph Bloomfield Wetherill, New York and Philadelphia, parents of the subject, by 1904; their daughter, Mrs. Barent Lefferts, New York and St. James, N.Y., by 1925–1964; her daughters, Kate Lefferts, Mrs. Oliver Edwards, Mrs. Phillip Bartlett, New York, 1964–1965.

Gift of Miss Kate Lefferts, Mrs. Oliver Edwards, Mrs. Phillip Bartlett, 1965.

65.19.

Collins,
Alexander Stewart Wetherill.

Collins, *Mrs. Alfred Q. Collins*.

Mrs. Alfred Q. Collins

In 1928 CHILDE HASSAM described this picture as "a masterpiece of painting and of portraiture." It is typical of the intensely realistic bust-length portraits that constitute the major part of Collins's work. The solid modeling and firm draftsmanship of the work reflect his strong and progressive attitude toward abstract form. As Kenneth Frazier noted in 1925: "In almost the words of Cézanne, Cézanne whose very name was unknown at that time in America, Collins declared that everything in nature was a spheroid in space and should be represented with that theme as its basic quality." The artist kept a large egg-shaped object, slightly larger than a human head, suspended on a cord in his studio, studying the effects of light on its surface. This awareness of three-dimensional form is evident in his portraits, each of which was preceded by a series of studies.

In 1904, the year after the artist's death, this unfinished portrait was displayed at the Pennsylvania Academy of the Fine Arts and at the Universal Exposition. It was presented to the Metropolitan the following year by a group of the artist's friends. Among them was J. ALDEN WEIR, who had written to Childe Hassam shortly after Collins's death:

I shall miss him greatly[.] I went on to his funeral at Cambridge[.] it was sad indeed for his poor little wife bears up bravely[.] life will indeed be sad and dreary for her[.] I went to New York & called on her yesterday[.] she has taken his studio for another year and hopes to try & do something by selling some of the paintings[.] I fear his affairs were not in a very flourishing condition . . . I think we might get some of his things for the Museum" (August 2, 1903, Childe Hassam Papers, Am. Acad. of Arts and Letters, microfilm NAA-2, Arch. Am. Art).

Unfortunately little is known about Mrs. Collins.

Oil on canvas, 27 × 22 in. (68.6 × 55.9 cm.).
REFERENCES: J. A. Weir and C. A. Platt, letter in MMA Archives, May 15, 1905, offer it to the museum, say it has been acquired by subscription // *MMA Bull.* 1 (Nov. 1905), ill. p. 10, and discusses // C. H. Fiske, *Chautauquan* 50 (March 1908), ill. p. 69 // K. Frazier, *Arts* 7 (April 1925), ill. p. 220 (quoted above) // *Brooklyn Museum Quarterly* 12 (April 1925), ill. p. 98 // C. Hassam, *Art News* 26 (April 14, 1928), p. 22 (quoted above) // *Coronet* 1 (April 1937), color ill. on cover // P. M. Pennell, "Portland Painter's Life a Mystery," *Portland* [*Me.*] *Coligram*, August 10, 1941, clipping in vertical file, MMA Library, ill. and discusses.
EXHIBITED: PAFA, 1904, no. 229, as Portrait of Mrs. A. Q. Collins, lent by Mrs. A. Q. Collins // Universal Exposition, St. Louis, 1904, *Official Catalogue of Exhibitors* (rev. ed.), p. 26, no. 148, lent by Mrs. Alfred Q. Collins, New York // Brooklyn Museum, 1925, *A Collection of Paintings by the Late Alfred Quinton Collins*, *A.N.A.*, no. 9, as Portrait of the Artist's Wife, ill. on cover.
EX COLL.: the artist, New York, until 1903; the artist's wife, New York, 1903–1904; with J. Alden Weir and Charles A. Platt, New York, 1904–1905, as agents.
Gift of the Artist's Friends, 1905.
05.34.

WILLIAM COFFIN

1855–1925

The landscape painter and art critic William Anderson Coffin was born in Allegheny City, Pennsylvania. He graduated from Yale in 1874, where his instructor in art was most likely JOHN FERGUSON WEIR. The *Art Amateur* noted his early interest in art: "In a desultory way he drew from the casts in the art school connected with the college, and was there led to take up drawing seriously." In 1877, he left for Paris and continued to draw from the antique, but in the spring of 1878 he entered the atelier of Léon Bonnat and remained for about three years. As a student, he exhibited at the Paris Salon, his first contribution, in 1879, being a view of Bonnat's life class.

Although he continued to maintain a country home, Pine Spring Farm, at Jennerstown, Pennsylvania, Coffin settled in New York by 1883. He exhibited regularly at the American Water Color Society and became a member of the Society of American Artists in 1886. He also exhibited at the National Academy of Design and won its second Hallgarten Prize in 1886, but he was not elected an associate until 1898 or an academician until 1912.

Much of Coffin's career, however, was devoted to criticism and the support of art organizations. He was a member of the Architectural League, the Union League Club, and the Lotos Club. He wrote for the *New York Evening Post*, 1886–1891, and was art editor of the *New York Sun*, 1896–1901. During the 1890s, he frequently contributed to such periodicals as the *Nation*, *Harper's Weekly*, *Century*, and *Scribner's*, writing articles on American and French painting, sculpture, and illustration. In 1901, he became director of fine arts for the Pan-American Exposition at Buffalo and, in 1915, also helped organize the Panama-Pacific Exposition. He remained a bachelor and died in New York at the age of seventy.

BIBLIOGRAPHY: "Talks with Artists: IV. Recollections of Mr. W. A. Coffin of Bonnat's Life School" and "William Anderson Coffin," *Art Amateur* 17 (Sept. 1887), p. 75 // William A. Coffin, "Theodore Rousseau," and "Pascal Dagnan-Bouveret," in John C. Van Dyke, ed., *Modern French Masters: A Series of Biographical and Critical Reviews* . . . (New York, 1896), pp. 119–128 (includes a biographical note on Coffin by the editor); and pp. 239–248. Critical pieces by the artist present his views on French painting // Obituary. *Art News* 24 (Oct. 31, 1925), p. 4.

The Rain

In this view of hills and overcast sky, Coffin depicts a subject and mood made popular by the painters of the Barbizon School. His thin paint surface and simplified composition, however, are more closely related to the works of tonalists like JOHN H. TWACHTMAN. Dated 1889, *The Rain* was exhibited at the National Academy of Design that year but received scant notice. Two years later, at the Society of American Artists, it was awarded the Webb Prize for the best landscape by a painter under forty years of age. In a review of the exhibition, a writer for the *New York Times* questioned the practice of awarding this prize to members only, and in this case, particularly to Coffin, who was secretary of the organization: "Doubtless this honor has been awarded him in recognition of his services, which are and have been great. It could hardly have been meant as the society's stamp of approval on No. 46, 'The Rain,' To believe that would be to credit the jury with a preference for landscapes which may be fairly ranked below those of half a dozen exhibitors who meet the demands of the competition."

Coffin, *The Rain*.

Oil on canvas, 30 × 40 in. (76.2 × 101.6 cm.).

Signed and dated at lower right: Wᵐ· A. Coffin / 1889 (date obscured by overpainting).

REFERENCES: C. M. Kurtz, ed., *National Academy Notes* (1889), p. 95, mentions it as "representing a rain"; p. 113, lists price as $400 // *Critic*, n.s. 15 (May 2, 1891), p. 243, in a review, says it is "an excellent study of atmospheric effect," but criticizes composition // *New York Times*, May 24, 1891, p. 5, discusses it in exhibition (quoted above) // S. P. Avery, letters in MMA Archives, April 22, 1892, and Jan. 14 [?], gives provenance // *Art Amateur* 40 (May 1899), p. 115 // *New York Herald Tribune*, Oct. 27,

1925, p. 19 // *Art News* 24 (Oct. 31, 1925), p. 4.

EXHIBITED: NAD, 1889, no. 34, as The Rain, $400 // Society of American Artists, New York, 1891, no. 16.

Ex COLL.: the artist, New York, 1889—probably 1892; H. G. Marquand, B. Altman, W. H. Fuller, M. Knoedler, T. B. Clarke, S. White, C. T. Barney, H. S. Webb, C. J. Lawrence, and A. Saint-Gaudens, New York, by subscription, 1892; with S. P. Avery, New York, as agent, 1892.

Gift of Several Gentlemen, 1892.

92.16.

FRANK BOGGS

1855–1926

The impressionist Frank Myers Boggs spent his formative and mature years abroad and in 1923 became a naturalized French citizen. He was born in Springfield, Ohio, but moved as a young boy to New York, where his father was a newspaper executive. The artist began his career at the age of seventeen as a wood engraver for Harper's, preparing illustrations for *Harper's Weekly* and for an American edition of the works of Charles Dickens. It has also been stated that he studied with the portraitist John Bernard Whittaker (1836–1926). After working at Niblo's Garden in New York with a scene painter named Vauglin, Boggs went to Paris to study scene painting. On his arrival there in 1876, he was unable to find anyone to

instruct him in this field and instead entered the Ecole des Beaux-Arts. Realizing that Boggs was not well suited to painting figurative subjects, his teacher Jean Léon Gérôme advised him to try some outdoor landscapes. Between 1877 and 1881, he concentrated on marine pictures and harbor scenes in Dieppe, Honfleur, and Grandcamp. Views of architecture and street scenes also fascinated him, and he painted them throughout his career. In 1878 or 1879, Boggs returned to New York. He did much of his painting on Shelter Island and exhibited at the National Academy of Design. His progressive French style, however, was not well received and he soon left again for Paris. In 1880 he began to exhibit at the Salon, and within the next few years, his work was attracting attention both in Paris and London. In 1884, Theodore Child described Boggs as "one of the most successful and one of the most promising of the young American painters in Paris" and lamented that he was not better appreciated in his native land. That same year, the artist spent March and April in New York before leaving for Holland and England, where he continued to work on marine and harbor views.

By the late 1880s, Boggs was acquainted with the impressionists Claude Monet, Alfred Sisley, Pierre Auguste Renoir, and Eugène Boudin, but his affinity for marine subjects, his use of a somber tonal palette, and restrained impressionist technique better reflect his admiration for the Dutch marine painter Johann Barthold Jongkind, whom he met in Paris at this time. In 1888, on the death of his parents, he returned to New York. He exhibited the following year at the Universal Exposition in Paris and then in 1890 made a trip to Algiers, which precipitated a number of sketches and paintings of Arab themes. Throughout the next decade Boggs traveled extensively in Europe and frequently visited his family in America. He exhibited at the Salon, at most of the international expositions, and in major cities at home and abroad. By 1903 he settled more into Parisian life and two years later moved into an elegant house on the rue de Biraque. He worked extensively in watercolors, many of which depicted architectural subjects, and in 1921 had his first exhibition of etchings. His health having failed by 1923, he died peacefully three years later in Meudon. Boggs was awarded the French Legion of Honor posthumously.

BIBLIOGRAPHY: Theodore Child, "Frank Myers Boggs," *Art Amateur* 11 (August 1884), pp. 53–54. An important early article on the artist // Emile Sedeyn, "Frank Boggs," *L'Art et les artistes* 13 (Nov. 1913), pp. 70–77 // Arsène Alexandre, *Frank Boggs* (Paris, 1929). Extensive biography, heavily illustrated.

On the Thames

Boggs painted this 1883 river scene in London, where a successful exhibition of his work was held that year. He opened a studio in that city the next year and, according to Theodore Child, planned to "devote himself to painting local scenes, the shipping on the Thames, with its many picturesque opportunities, affording him, he finds, ample scope for the display of his special abilities" (*Art Amateur* 11 [August 1884], p. 54).

The Thames had inspired JAMES MC NEILL WHISTLER's nocturnes of the 1870s, and these in turn may have had an impact on Boggs's tonal palette and compositional arrangement, in which simplified silhouetted forms are concentrated in a narrow horizontal band across the center of the canvas. Also aware of the Thames scenes painted by Monet in 1870 and 1871, he shows a similar interest in the reflective possibilities of water and the moist atmosphere of London but does not adopt Monet's bright impressionist palette, preferring the tonal colors of the Dutch

Boggs, *On the Thames*.

artist Jongkind. "Mr. Boggs's painting is that of an impressionist who is peculiarly sensible to the delicacies and subtleties of the grays and blues and greens of the sea-coast and of the sea that is rather sulky and menacing. . . . he avoids highly luminous effects, and dwells with pleasure on soft gray tones that round off the angles and caress the eye" (T. Child, *Art Amateur* 11 [August 1884], p. 54).

Oil on canvas, 38¾ × 51½ in. (98.4 × 130.8 cm.).

Signed, inscribed, and dated at lower left: BOGGS / LONDON 83. Canvas stamp: 56 [illeg.] / Cherche [illeg.] / PARIS / HARDY ALAN CARPENTIER / [illeg.] / [il-leg.] / [illeg.].

REFERENCES: Penguin [pseud.], *American Architect and Building News* 15 (June 21, 1884), p. 296, says that "Mr. Boggs is better in his Dutch scene than on the Thames, but he is always good" // W. C. Brownell, *Magazine of Art* 7 (1884), p. 498, notes that "his

Thames view was decidedly wan: similar subjects, but painted in colour by Lépine, a Frenchman just pushing his way to the front are worth Mr. Boggs's attention" // E. V., *Art Amateur* 11 (July 1884), p. 35, calls it "a fine piece of Thames shipping scenery" // A. Dayot, *Le Salon de 1884* (1884), ill. opp. p. 52 // C. Cook, *Art and Artists of Our Time* (1888), 3, pp. 297–298, calls it "one of his best pictures" // B. D., *MMA Bull.* 4 (March 1909), p. 53; ill. p. 54 // *George A. Hearn Gift to the Metropolitan Museum of Art . . .* (1913), ill. p. 94, as The Thames // A. Alexandre, *Frank Boggs* (1929), p. 38 // A. Goldin, *Arts* 40 (Dec. 1965), p. 59.

EXHIBITED: Paris Salon, 1884, no. 270, as Sur la Tamise, près Londres // Bernard Black Gallery, New York, 1965, *Frank Boggs*, no. 1 // Dayton Art Institute, Ohio; PAFA; Los Angeles County Museum of Art, 1977, *American Expatriate Painters of the Late Nineteenth Century*, cat. by M. Quick, no. 4, ill. p. 85.

EX COLL.: George A. Hearn, New York, by 1909.

George A. Hearn Fund, 1909.

09.26.2.

Paris Street Scene

Like French impressionists Camille Pissarro and Claude Monet and the American impressionist CHILDE HASSAM, Boggs delighted in the street life of the city—in its crowds and the bustling activity of its daily life. This painting, dated 1893, represents the busy corner where the boulevard de la Madeleine, the rue Sèze, and the boulevard des Capucines meet. The artist began to paint subjects of this type during the early 1880s, and in this picture he still retains the tonal palette that Theodore Child once described as having "soft gray and blue harmonies" (*Art Amateur* 11 [August 1884], p. 53). The leaden sky, bare trees, and stone architecture produce an overall gray effect that is heightened by the artist's subtle treatment of the scene's more ephemeral features: clouds of chimney smoke, glistening pavement, spinning carriage wheels, and debris being swept from the street. The buildings lining the boulevard de la Madeleine fill the center of the picture and define its composition. Here Boggs creates an elegant, detailed view of his favorite subject, Paris and its inhabitants.

Oil on canvas, $46\frac{1}{2} \times 57\frac{3}{4}$ in. (118.1 × 146.7 cm.).

Signed and dated at lower left: BOGGS / 1893. Canvas stamp: TASSET & LHOTE / ENCADREMENTS / 51 rue Fontaine 51 / PARIS / TOILES COULEURS FINES.

REFERENCES: *Gazette des Beaux-Arts* ser. 6, 81 (Feb. 1973), suppl., ill. p. 146 // J. P. Guérin, French Embassy, letter in Dept. Archives, March 12, 1976, identifies scene // A. G. Altschul, letter in Dept. Archives, June 10, 1976, provides information about its provenance and exhibition record.

EXHIBITED: Yale University Art Gallery, 1968, *American Art from Alumni Collections*, no. 128, as Paris Street Scene, lent by Mr. and Mrs. Arthur Altschul // MMA, 1968, *New York Collects*, no. 7, lent by Mr. and Mrs. Arthur Altschul // Century Association, New York, 1969, *American Paintings from the Collection of Arthur Altschul*, no. 15.

EX COLL.: Leon Gerard, Paris; Michael Paul, New York; with Castellane Gallery, New York.

Gift of Mr. and Mrs. Arthur G. Altschul, 1971. 1971.246.1.

Boggs, *Paris Street Scene.*

LOUIS MOELLER

1855–1930

Born in New York, the figure painter Louis Charles Moeller may have received his first artistic training from his father, Charles, who was a decorative painter. After studying drawing at the National Academy of Design, the young artist went to Munich, where in October 1873, he enrolled at the Royal Academy and studied under Wilhelm von Diez. He remained in Munich for six years, and like most American art students there, he sought advice and criticism from FRANK DUVENECK. His early work, executed on a large scale, was characterized by careful draftsmanship and accurate rendering of color, texture, and form. On his return to America, he began to produce cabinet-size pictures such as *Puzzled* (unlocated), which won the National Academy of Design's Hallgarten Prize in 1884. He was elected an associate of the academy the same year and exhibited there regularly during the 1880s and 1890s, becoming an academician in 1894.

Moeller was popular with critics and collectors in the late nineteenth century, particularly Thomas B. Clarke, who owned at least a dozen of his works. In 1894, the sculptor F. Wellington Ruckstuhl praised the quality of Moeller's brushwork, adding that, "If he can retain this with his superb drawing and fine composition and marvellous power of expression, stick to the *dramatic*, and acquire more *richness* of color, he may soon earn the title of the Meissonier of America" (pp. 351–352). The artist lived in Mount Vernon and Wakefield, New York, and later in Weehawken, New Jersey, but maintained a studio in New York City. He died in Weehawken, illness and old age having prevented him from painting in his later years.

BIBLIOGRAPHY: F. Wellington Ruckstuhl, "A Sculptor's Opinion of a Painter," *Quarterly Illustrator* 2 (Oct., Nov., and Dec. 1894), pp. 345–352 // American Art Galleries, New York, *Catalogue of the Private Art Collection of Thomas B. Clarke, New York*, sale cat. (Feb. 14–18, 1899), pp. 85–86. Includes biographical statement // Obituaries. *Art Digest* 5 (Nov. 15, 1930), p. 5; and *Art News* 29 (Nov. 22, 1930), p. 14 // William H. Gerdts, "The Empty Room," *Allen Memorial Art Museum Bulletin* 33 (1975–1976), pp. 72–88.

Sculptor's Studio

Moeller's figure paintings display his interest in gestures, poses, and facial expressions, but none of these are as strong or as poignant as this unoccupied studio interior. Possibly the sculpture studio of a friend or acquaintance—such as F. Wellington Ruckstuhl who published an article on the artist in 1894—the room reveals the taste and activities of its absent inhabitant, whose tools, equipment, and wooden horses are piled against the walls. The keys to the identity of the sculptor are the maquettes and the standing figure supported by the wooden workstand. Unfortunately, none have yet been identified.

Some of the objects that decorate the studio are, however, recognizable. Among the papers tacked on the wall above the table are two prints showing sculptures: on the left an illustration of an equestrian piece, which is probably a modern interpretation of the Roman statue of Marcus Aurelius or the Renaissance *Colleoni*, and, below it to the right, a group of three figures, undoubtedly *Les Premières funérailles* by Louis Ernest Barrias. The small circular casts that hang behind the stovepipe are possibly copied after Chinese mirror backs of the Chou or Han periods. There are also two casts after well-known antique reliefs: on the back wall is the wounded lioness from the Assyrian relief of Ashurbanipal's lion hunt, and above the door,

beller, *Sculptor's Studio*.

hangs a section from the north frieze of the Parthenon representing the procession of the Athenian cavalry. The small rectangular relief between them resembles Bertel Thorvaldsen's *Cupid Stung by a Bee Complains to Venus*, although it may well be a derivative work by a little-known sculptor.

Sculptor's Studio probably dates from the 1880s, when Moeller's work was characterized by firm draftsmanship, neutral or pale colors, smooth paint surfaces, and an effective use of spatial voids that draws the viewer's attention to a few carefully selected and arranged objects. The picture was certainly painted after 1878, when the plaster of Barrias's *Les Premières funérailles* was exhibited for the first time, and probably after 1883, when the marble was completed and shown at the Paris Salon. The print was very likely clipped from *Salon de 1883*, published in that year by Goupil.

Oil on canvas, 23 × 30 in. (58.4 × 76.2 cm.).
Signed at lower right: Louis Moeller.

REFERENCES: *Antiques* 91 (April 1967), ill. p. 438 // V. D. Spark, letter in Dept. Archives, Feb. 22, 1975, discusses provenance // H. W. Janson, letter in Dept. Archives, April 14, 1975, identifies the Barrias print, says the equestrian statue appears to be a modern reinterpretation of the Colleoni, calls the standing figure a pilgrim, and speculates ca. 1884–1885 as date of painting // A. David, of David David, Philadelphia, letter in Dept. Archives, May 5, 1975, gives provenance // H. B. Weinberg, orally, May 1975, gave information about another Moeller studio interior (unlocated), discussed in *Studio* (April 21, 1883) // W. H. Gerdts, orally, Oct. 29, 1975, speculated that it is a memorial to a deceased sculptor // C. Vincent and J. Draper, Western European Arts, MMA, orally Nov. 20, 1975, questioned the attribution of the small rectangular relief to Thorvaldsen, suggesting Dannecker, and said that the rondels were possibly after Chinese mirror backs of the Chou or Han periods // R. Kashey, Shepherd Gallery, New York, orally, Nov. 21, 1975, discussed sculptures included in it // D. Helsted, Thorvaldsens Museum, letter in Dept. Archives, Feb. 3, 1976, says that the small rectangular relief resembles Thorvaldsen's Cupid Stung by a Bee Complains to Venus, but that it might also depict

Detail of Moeller, *Sculptor's Studio.*

Moeller, *Appraisement*.

Caproni casts of sculptures by Pietro Galli and Antonio Marsure, speculates that the work in progress is William Bradford by Cyrus Dallin // W. Craven, letter in Dept. Archives, May 14, 1976, says that it probably does not represent Dallin's studio // W. H. Gerdts, *Allen Memorial Art Museum Bulletin* 33 (1975–1976), p. 86, calls it Moeller's best-known work; ill. p. 87; pp. 87–88, discusses.

EXHIBITED: Dallas Museum for Contemporary Arts, 1961, *The Art that Broke the Looking Glass*, no. 66, as Artist's Studio, lent by Victor D. Spark, New York // American Federation of Arts, traveling exhibition, 1974–1975, *Revealed Masters*, no. 30, essay by W. H. Gerdts, p. 34, discusses; ill. p. 102.

EX COLL.: Springfield, Mass., art market, early 1950s; with Victor D. Spark, New York, early 1950s–1967; with David David, Philadelphia, 1967; with Kennedy Galleries, New York, 1967.

The Bertram F. and Susie Brummer Foundation, Inc. Gift, 1967.

67.70.

Appraisement

Moeller's first pictures were executed on a large scale, but after his return to New York he concentrated on cabinet-size paintings like *Appraisement*, which were often done on wood panels. "To these small works he brings the correctness and strength of drawing and handling he showed in his larger productions," noted one writer. "His complete knowledge of the human figure, and the precision of his technique, when condensed into work of this minute character, give it that amazing brilliancy and quality which have been recognized in Meissonier, as the result of a similar foundation of knowledge" (American Art Association, *Catalogue of the Private Art Collection of Thomas B. Clarke*, sale cat. [1899], p. 86).

Appraisement was exhibited at the National Academy of Design in 1888 but excited little comment from the critics. *National Academy Notes* describes the picture as "Custom House inspectors examining a pile of silks spread on the table before them. The importer is expostulating with them. Gray walls, dull red carpet. Silks of pale yellow, blue, and gray-green." Although the occupations of the gentlemen portrayed may only have been inferred by the writer, the stark, functional decor of the room, the door labeled

Moeller, *A Discussion*.

"OF[FICE]" and the professional demeanor of the figures suggest some similar business activity.

The painting displays the artist's interest in formal design, a characteristic of his compositions during the 1880s. The figures occupy a spacious interior, which is austerely but judiciously decorated with simple furniture, framed pictures and prints. The arrangement of these accessory elements and the flat, blank areas of wall, floor, and ceiling direct the viewer's attention to the dramatic facial expressions and gestures of the figures. Moeller's delicate neutral colors are applied with dry precision to give minimal visual evidence of brushwork.

Oil on wood, 14⅝ × 18 in. (37.2 × 45.7 cm.).
Signed at lower right: Louis Moeller.
REFERENCES: C. M. Kurtz, ed., *National Academy Notes and Complete Catalogue* (1888), ill. p. 37, describes it (quoted above) // W. L. and C. McKim, letters in MMA Archives, Sept. 2, 1973, and Oct. 14, 1974, supply entry from the donors' handwritten catalogue //

R. Finnegan, M. Knoedler and Co., New York, letter in Dept. Archives, March 31, 1975, gives information on provenance.

EXHIBITION: NAD, 1888, no. 583, as Appraisement, lent by Thomas McKie.

EX COLL.: Thomas McKie, New York, by 1888; with the Old Print Shop, New York, by 1941; with M. Knoedler and Co., New York, 1941; Mr. and Mrs. William L. McKim, New York and Palm Beach, 1941–1973.

Gift of Mr. and Mrs. William L. McKim, 1973. 1973.166.2.

A Discussion

"If Moeller is not a poet, he is a remarkable dramatist," commented the sculptor F. Wellington Ruckstuhl.

The chief element of high dramatic art is the telling of a story in the fewest words, in the least time, in a limited space, in such a manner that when the auditor

looks upon the stage he feels he is regarding an actual scene in real life. The more intense this expression of life, the more all the actors on the stage contribute to produce a *oneness* of effect, the more dramatic a picture do we behold. From this point of view Moeller is one of the most dramatic painters of the day (*Quarterly Illustrator* 2 [Oct.–Dec. 1894], p. 349).

Moeller's interest in drama—in the different facial expressions and gestures of his figures and the use of a stage-like interior setting—allies his subjects to the type of genre painting popular in the mid-nineteenth century.

A *Discussion* is undated, but the signature on it lacks the N.A. that Moeller often added to his name after his election to the National Academy of Design in 1894. Stylistic considerations also suggest that it dates from the early 1890s, when Moeller's interiors were more crowded and the figures placed closer to the picture plane. Instead of the pale colors of the earlier interiors, like *Appraisement* (q.v.), he uses dark rich colors, juicily applied. Moeller sometimes painted interiors showing a specific person surrounded by his possessions or engaged in a characteristic activity, for instance *Dr. Abraham Coles in His Study* (Newark Museum). A *Discussion* may be a portrait of this type.

Oil on canvas, 18 × 24$\frac{3}{16}$ in. (45.7 × 61.4 cm.).
Signed at lower right: Louis Moeller.
REFERENCE: B. Hellinger, letter in MMA Archives, Nov. 2, 1971, discusses provenance.
EX COLL.: New York art market, early 1920s; Samuel and Bertha Hellinger, New York, early 1920s–1971.
Gift of Mrs. Samuel Hellinger, 1971.
1971.247.

IGNAZ MARCEL GAUGENGIGL

1855–1932

Ignaz Marcel Gaugengigl has been called the American Meissonier, a designation he earned for the precisely rendered historical genre scenes that dominated his work until 1900. After this date, however, he turned to painting society portraits in the style of JOHN SINGER SARGENT. He was born in Passau, Bavaria, the son of a professor of oriental languages, who was recognized for his special services to the king. Gaugengigl entered the Royal Academy in Munich in 1874 and studied under Wilhelm von Diez. After four years, he left the academy, having established a local reputation with the sale of a painting to Ludwig II. He traveled to Italy and Paris before coming to America in 1880 to visit his married sister. At first the artist planned to stay for only three months, but he soon decided to make Boston his home. It was not long before his works became popular with prominent collectors. Among Gaugengigl's close acquaintances was the poet Celia Thaxter, whose home he often visited along with his student CHILDE HASSAM and the landscape painter J. Appleton Brown (1844–1902). Over the years he was active in a number of art organizations in Boston and New York. He was a member of the Guild of Boston Artists, the Copley Society, the St. Botolph Club, and the council of the School of the Museum of Fine Arts. He was elected to the Society of American Artists in 1895, and became an associate of the National Academy of Design in 1906. Gaugengigl was honored with one-man shows in Boston in 1919 and 1929. He died in his home in Back Bay Boston after several years of poor health.

BIBLIOGRAPHY: "Ignaz Marcel Gaugengigl," *The Studio; A Journal Devoted to the Fine Arts* 2 (Dec. 8, 1883), pp. 257–258. Reviews exhibition held at Moore and Clark, New York // Frank T.

Robinson, "Ignaz Marcel Gaugengigl," *Living New England Artists* (Boston, 1888), pp. 75–82 ‖ Greta [pseud.], "A Successful Bavarian Artist," *Art Amateur* 19 (July 1888), p. 28 ‖ Kuno Francke, "Ignaz Marcel Gaugengigl, ein Münchener Maler in Neu-England," *Festschrift zum Sechzigsten Geburtstag von Paul Clemen, 31 Oktober 1926* (Bonn, 1926), pp. 503–507.

A Difficult Question
(Une question difficile)

During the 1880s and 1890s, Gaugengigl specialized in historical genre scenes, romanticized depictions of daily life in Europe during the late seventeenth and eighteenth centuries. In *A Difficult Question* the artist shows two connoisseurs examining a statuette, while a second objet d'art awaits their inspection on a chair piled high with books. Gaugengigl's choice of subject and his concern for the detailed treatment of setting, costumes, and accessories would have appealed to his American patrons, who were enthusiastically collecting and displaying antique decorative objects and bric-a-brac. The painting displays a romantic eclecticism, in which the fashions and decorative objects from several periods are brought together. The satin frock coats, frilled cuffs, snug breeches, and silk stockings worn by the connoisseurs were particularly fashionable during the 1730s, but their loose, unpowdered hairstyle could be associated with an earlier date. One connoisseur is seated on a Windsor chair, probably American, the other on a medieval style chair, and the books rest on a late seventeenth or early eighteenth century style European chair. The tapestry and paneled wall, not atypical of contemporary Victorian interiors, appear again in *Un Patriote Elégant* (unlocated).

A critic praised Gaugengigl for painting "not merely the clothes of his subjects, not only the satin breeches and silk stockings, the laces and perukes of his fine gentlemen and their valets of an age gone by, but their very characters, their

Gaugengigl, *A Difficult Question*.

UNE QUESTION DIFFICILE. I M GAUGENGIGL

distinction, their leisurely, well-bred airs and graces, showing their habits of mind and morals, and way of taking life as well." He added: "The true spirit of aristocratic society in former days can only be carried in the mind of the artist, and a keen and capable mind it must be for that. This is Gaugengigl's highest quality, the thing that distinguishes him from the common run of painters of those pinchbeck cavaliers, pages, and ladies that are plainly mere masquerading models" (*Art Amateur* 19 [July 1888], p. 28).

Oil on panel, 11⅝ × 16 in. (29.5 × 40.6 cm.).

Signed, dated, and inscribed at lower right: UNE QUESTION DIFFICILE. I. M. GAUGENGIGL. 1883. Label: PREPARED PANEL / WINSOR & NEWTON / ARTIST COLOUR-MEN / To Her Majesty / AND TO / T. R. H. THE PRINCE AND PRINCESS OF WALES, / 38, RATHBONE PLACE, W. / NORTH LONDON COLOUR WORKS, KENTISH TOWN, N. W.

RELATED WORK: *A Difficult Question*, etching, 6⅛ × 9 in. (15.6 × 22.9 cm.) (image), is in S. R. Koehler, *American Art* (1886), pl. 14, opp. p. 32.

REFERENCES: *Studio* 2 (Dec. 8, 1883), p. 258 // S. R. Koehler, *American Art* (1886), p. 49, discusses it // F. T. Robinson, *Living New England Artists* (1888), p. 75, illustrates an engraving of a detail of it; p. 81, discusses its style // K. Francke, *Festschrift zum Sechzigsten Geburtstag von Paul Clemen* (1926), p. 507, lists it // D. R. Howlett, letter in Dept. Archives, Dec. 23, 1974, gives references, exhibitions and information about the etching.

EXHIBITED: Brooklyn Art Association, 1884, *Oil Paintings Loaned for Exhibition in Aid of the Bartholdi Statue Pedestal Fund*, no. E173, as A Difficult Question, lent by George I. Seney // Union League Club, New York, 1886, *Exhibition of Paintings*, no. 72, lent by J. M. Fiske // St. Botolph Club, Boston, 1919, *Exhibition of Paintings by Ignaz Marcell Gaugengigl at the St. Botolph Club*, no. 17; 1929, *Exhibition of the Paintings of I. M. Gaugengigl*, no. 17.

EX. COLL.: George I. Seney, Brooklyn by 1884–1885 (sale, American Art Galleries, New York, April 2, 1885, no. 203, A Difficult Question, 12 × 16, dated 1883, $1,600); with M. Knoedler and Co., New York, as agent; Josiah M. Fiske, New York, by 1886–died 1892; Martha T. Fiske Collord, New York and Newport, by 1892–1908.

Bequest of Mrs. Martha T. Fiske Collord, in Memory of Josiah M. Fiske, 1908.

08.136.10.

HUBERT VOS

1855–1935

The Dutch artist Hubert Vos first came to America at the request of his countryman Hendrik Willem Mesdag, who asked him to serve as Holland's acting royal commissioner of fine arts for the World's Columbian Exposition, held in Chicago in 1893. Born in Maastricht, Vos worked as a printer and bookseller before beginning his artistic career. He enrolled in the Royal Academy of Brussels, where Jean Portaels was his instructor for two years, and then worked in Paris with Portaels's former student, Fernand Cormon. A grant from the Dutch government permitted him to work for two years in Rome. On his return to Brussels, he painted under Ernest Blanc-Garin, yet another Portaels student, and studied anatomy at the university and sculpture at the academy. The almshouses, hospitals, and peasant dwellings of Brussels intrigued him, and his first success at the Paris Salon, in 1886, was *A Room in a Brussels Almshouse* (unlocated). The following year, Vos opened a studio in London, where he offered instruction to some students. He worked primarily as a portraitist and between 1888 and 1891 exhibited at the Royal Academy. A member of the Royal Society of British Portrait Painters, the Royal Society of British Artists, and the Society of Pastellists, he also won medals at major exhibitions in Munich, Dresden, Amsterdam, Brussels, and Madrid. He visited Ireland and often spent his summers on sketching tours in Holland.

The exotic displays at the World's Columbian Exposition inspired a change in Vos's subject matter. He became interested in ethnography, and beginning with studies of the American Indian, he made idealized portraits of racial types in Hawaii, Java, China, and Korea. Although he was fascinated by the exotic, he told a representative for the Dutch magazine *Op de Hoogte*: "You may call me a realist with sentiment. I hate everything theatrical and never go in for comedy" (Holland House, Rockefeller Center, *Rulers of the Far East*, exhib. cat. [1944], unpaged). In 1905, he went back to China to paint the dowager Empress Tz'u-Hsi (Fogg Art Museum, Cambridge, Mass.).

After the turn of the century, Vos had studios in Newport, Rhode Island, and Bar Harbor, Maine, and made his residence in New York. The artist was well known for his portraits of successful businessmen, which were often described as "psychological studies." Like HARRY W. WATROUS, he painted still lifes of oriental decorative objects during the final years of his career. Vos died of pneumonia at the age of seventy-nine. In 1940, Kende Galleries of New York auctioned his collection of furniture and decorative objects.

BIBLIOGRAPHY: G. A. T. Middleton, "On the Shores of the Zuyder Zee," *Magazine of Art* 16 (1893), pp. 64–69. Includes a note by Vos and illustrations of his paintings ∥ Charles de Kay, "Painting Racial Types," *Century Magazine*, n.s. 39 (June 1900), pp. 163–169. Discusses Vos's ethnological portraits ∥ "Vos's Portrait Painting," *International Studio* 13 (April 1901), pp. 150–151 ∥ Hubert Vos to Dr. ten Kate, Oct. 9, 1911, copy in Dept. Archives, gives autobiographical information ∥ Obituaries. *New York Times*, Jan. 9, 1935, p. 19; *Art Digest* 9 (Jan. 15, 1935), p. 15; *Art News* 33 (Jan. 19, 1935), p. 8.

Elbert Henry Gary

The lawyer and financier Elbert Henry Gary (1846–1927) was chairman of the board of directors of the United States Steel Corporation when Hubert Vos painted his portrait in 1924. One of the outstanding leaders of American business at the turn of the century, Gary was born near Wheaton, Illinois, and educated at the Illinois Institute, a Methodist college. After serving briefly in the army and teaching school for a year, he began to read law. In 1866, he entered the Union College of Law in Chicago, graduating two years later. As a lawyer he often represented important railroad and industrial corporations. He also served as a judge in Du Page County, Illinois, from 1882 until 1890, and was president of the Chicago Bar Association in 1893–1894.

Closely associated with iron and steel interests in Illinois, Gary moved to New York in 1898 and helped form the Federal Steel Company, later one of the constituent companies of the United States Steel Corporation. The major organizer of this corporation, he advocated company control of all phases of production, from the acquisition of raw materials to the delivery of the finished products. In 1906, the site in Indiana

Vos, *Elbert Henry Gary*.

chosen by United States Steel for a new industrial city was named after Gary.

The meticulous realism evident in this portrait reveals the artist's Dutch background. "He is not of this day. With the Moderns he has no truck," wrote one critic in reference to Vos's portraits. "But I doubt whether in the Academy he would be more at ease. His portraits are too honest, too solidly academic" (*Art News* 24 [Nov. 14, 1925], p. 2).

The portrait was bequeathed to the Metropolitan by Emma Townsend Gary, the sitter's second wife, whom he married in 1905. His first wife, the former Julia Graves, died in 1902.

Oil on canvas, 46 × 36 in. (116.8 × 91.4 cm.).
Signed and dated at lower left: Hubert / vos / 1924.

REFERENCES: *New York Times*, April 10, 1923, p. 25; Jan. 9, 1935, p. 19 // *MMA Bull.* 32 (July 1937), p. 166 // Holland House, Rockefeller Center, New York, *Rulers of the Far East: An Exhibition of the Works of Hubert Vos* (1944), unpaged, mentions.

EXHIBITED: Fearon Galleries, New York, 1925, *Portraits and Pictures by Hubert Vos*, no. 1; no. 13, lists a sketch of the same sitter.

EX COLL.: Elbert H. Gary, New York, 1924–died 1927; his wife, Emma T. Gary, New York, 1927–died 1934; estate of Emma T. Gary, 1934–1937.

Bequest of Emma T. Gary, 1937.
37.20.4.

GEORGE DE FOREST BRUSH

1855–1941

Brush was born in Shelbyville, Tennessee, but his family soon moved to Danbury, Connecticut, where he spent his youth. As a child he was delicate in health and could not attend school regularly, but his mother, an amateur artist, encouraged his interests in photography, music, and art. In 1871, he enrolled in classes at the National Academy of Design under Lemuel E. Wilmarth (1835–1918). In 1874, financial assistance from an anonymous benefactor permitted him to study abroad. He spent nearly six years in Paris, where he worked under Jean Léon Gérôme at the Ecole des Beaux-Arts and met DOUGLAS VOLK and ABBOTT H. THAYER, both of whom remained lifelong friends. In 1875, he began to exhibit at the National Academy of Design.

Brush returned to New York in 1880 and was elected a member of the Society of American Artists. The next year, he and his brother Alfred traveled to Rawlins, Wyoming, and spent the summer in the foothills of the Rockies. There the artist gathered material for paintings like *The Moose Chase*, 1888 (National Collection of Fine Arts, Washington, D.C.), which is typical of the Indian subjects he painted during the next decade. On his return to New York, he did illustrations for *Century* and *Harper's* magazines and, in 1885, he began to teach at the Art Students League. The following year, Brush married one of his students, Mary Taylor Whepley (1866–1949), a sculptor. For two years, the couple lived in a remote area of Quebec and then returned to New York. In 1888, Brush won the Hallgarten Prize at the National Academy and became an associate member there, but it was another twenty years before he was elected an academician.

In the fall of 1889, the artist traveled to Europe and North Africa, spending some time in Paris. It was during this period that he began to paint the family groups that would occupy his attention for the remainder of his career. Returning home in 1892, he taught at the Art

Students League for the next four years. He went abroad again in 1898, first spending some time in the English countryside and then at Marlotte near Fontainebleau. His wife's poor health soon sent them to Florence, where they resided for part of almost every year before World War I. Brush's study of Italian Renaissance art greatly influenced his style and subject matter. His otherwise realistic family groups held the poses and wore the costumes of Renaissance Madonnas and children. He also adopted some aspects of traditional studio practice, training such students as Robert Pearmain (ca. 1888–1912) and Barry Faulkner (1881–1966) as his assistants.

In 1901, Brush purchased a farm in Dublin, New Hampshire, not far from the studio of his friend Thayer. Although he traveled to Europe during the 1920s and also maintained a studio in New York, he worked mainly in New Hampshire until 1937, when a fire destroyed his studio there and a number of his paintings and drawings. A successful and popular artist, he died at the age of eighty-five in Hanover, New Hampshire.

BIBLIOGRAPHY: George de Forest Brush, "An Artist Among the Indians," *Century Magazine* 30 (May 1885), pp. 54–57 // Charles H. Caffin, "George de Forest Brush," in *American Masters of Painting* (New York, 1902), pp. 127–140 // Minna C. Smith, "George de Forest Brush," *International Studio* 34 (April 1908), pp. xlvii–lvi // Royal Cortissoz, "George de Forest Brush," in *American Artists* (New York, 1923), pp. 67–74 // Nancy Douglas Bowditch, *George de Forest Brush: Recollections of a Joyous Painter* (Peterborough, N.H., 1970). Written by the artist's daughter, contains bibliography and index.

Henry George

A native of Philadelphia, Henry George (1839–1897) went to sea when he was about sixteen and later settled in California, where he worked as a typesetter and journalist. Increasingly concerned about the causes of poverty, George developed his doctrine of the "single tax," advocating wider distribution of land and the taxation of land only. After the publication of his *Progress and Poverty* (1879), he became prominent as an economist and reformer. He moved to New York in 1880 and in 1881 lectured on land reform in Ireland, and in 1883 and 1884, in England. Backed by liberals, he was an unsuccessful candidate for mayor of New York in 1886. He then lectured in Australia and Great Britain. Despite a stroke in 1890, he was able to begin work the following year on *The Science of Political Economy* (1897). George ran again for mayor of New York in 1897 as an independent Democrat, but died before the election.

George de Forest Brush was sympathetic to Henry George's philosophical ideals and often held discussions on social reform in his studio on Sunday mornings. "Brush's views on economics and education were as radical as his feelings toward the machine," commented the painter Barry Faulkner. "He believed the capitalistic system to be brutally evil, and was a disciple of Henry George, and an apostle of the Single Tax. He bought no stocks or bonds and the only investment his theories allowed him was the farm in Dublin" (Bowditch, *George de Forest Brush* [1970], p. 230).

George seems to have posed for Brush on two different occasions: around 1888, for a small oil sketch (National Portrait Gallery, Washington, D.C.), and, in 1893, for a full-length portrait commissioned by August Lewis, a political supporter. The 1893 painting developed some disturbing defects as a result of the artist's using faulty pigments, and, at Lewis's request, Brush seems to have painted another, the Metropolitan's painting. It is inscribed "Geo de Forest Brush / 1893 and / Repainted 1903," but its overall good condition and the lack of apparent reworking suggests that it is a replica rather than a revision of the 1893 painting. The artist appears to have had some doubts about the aesthetic quality of the painting, for he deleted it from a list of his best works, commenting that it was "a good portrait but not quite my usual style."

Oil on canvas, 64¼ × 46¼ in. (163.8 × 118.1 cm.).

Signed, dated, and inscribed at lower right: Geo de Forest Brush /1893 and /Repainted 1903.

RELATED WORKS: Four preliminary drawings, probably for the original portrait, ca. 1893: subject seated at a desk, three-quarter length study of the subject seated, a study of his legs and feet, a three-quarter length study of the subject with a book in his lap, coll. Nancy D. Bowditch, Peterborough, N.H.

REFERENCES: G. de F. Brush, list of best works, n.d., Am. Acad. Arts and Letters, microfilm NAA-1, Arch. Am. Art, deletes it (quoted above) // H. George, Jr., *The Life of Henry George* (1900), p. 548, says Lewis commissioned the original painting and describes sittings // *MMA Bull.* 9 (March 1914), ill. p. 75, discusses // E. M. Lewis, letter in MMA Archives, Feb. 27, 1915, confirms that Lewis commissioned it // *Art World* 2 (April 1917), p. 8 // *New York Times*, March 9, 1937, p. 2 // J. L. Allen, *Eminent Americans* (1939), unpaged, mentions; fig. 20 // A. G. de Mille, *Henry George, Citizen of the World* (1950), frontis. ill.; p. 221, discusses original painting // N. D. Bowditch, letter in MMA Archives, Oct. 18, 1963, discusses // N. D. Bowditch to W. Adelson, Adelson Galleries, copy in Dept. Archives, Sept. 14, 1966, notes 1888 oil sketch // N. D. Bowditch, letters in Dept. Archives, April 10, 1967, discusses George sitting for portrait; June 10, 1967, discusses drawings that are preparatory for it // *Antiques* 90 (Oct. 1966), ill. p. 426, discusses 1888 oil sketch of sitter // N. D. Bowditch, *George de Forest Brush* (1970), fig. 21; pp. 42–44, discusses commission of 1893 portrait and discusses other portraits; p. 356 // D. Dwyer, Paintings Conservation, MMA, orally July 15, 1977, said that it did not show evidence of extensive repainting.

EX COLL.: August Lewis, New York, 1903–died 1913; estate of August Lewis, New York, 1913–1914.

Bequest of August Lewis, 1914.

14.16.

Mother and Child

Around 1892, the artist began the series of mother and child themes that would occupy his attention for the next two decades. "George de Forest Brush has earned his success as a man who does one thing well, for though more than a single prop supports his reputation, in the main he owes his position to a series of about eleven 'Mother and Child' canvases, executed during the past thirteen years," wrote the critic Homer Saint-Gaudens. "His results are not 'Madonnas,' as often they have been named in attempts to couple the Modern with the Renaissance. Their mortal beauty accords more literally with their title 'Mother and Child,' although they express the charm of nature with such candor that the

Brush, *Henry George.*

mother requires the halo of her devotion alone to make her holy" (*Critic* 47 [August 1905], p. 135).

Dated 1894, this painting depicts the artist's wife, the former Mary Taylor Whepley, holding daughter Nancy (1890–) while son Gerome (1888–1954) looks on. Both children subsequently pursued artistic careers: Gerome became a sculptor and Nancy, later Mrs. Harold Bowditch, a painter. There are nearly a dozen mother and child pictures, but the size and number of figures, the complexity of their poses, and the breadth of the landscape setting ally this one to *Mother and Child*, 1892 (Addison Gallery of American Art, Andover, Mass.), originally in the collection of Mrs. J. Montgomery Sears of Boston, who also once owned the Metropolitan painting. *In the Garden* (q.v.) also depicts the artist's wife but includes another two of the seven Brush children.

In 1914, in Courmayeur, Italy, working from the drawings he had made two decades earlier, Brush completed a sculpture based on *Mother and Child*. His only major endeavor in three-dimensional form, it was later cast in bronze (coll. Mrs. W. Shelby Coates, Bayville, N.Y.)

Brush, *Mother and Child.*

and carved in marble (coll. Mrs. Henry Clay Frick, Oyster Bay, N.Y.).

In 1896 an engraving after the picture by Timothy Cole was illustrated in *Century*, accompanied by a laudatory remark from the critic John C. Van Dyke: "The characterization parallels but does not imitate that of the Italians. The picture suggests no Italian school or painter, yet reminds us of the Italian conception."

Oil on canvas, $47\frac{1}{2} \times 29\frac{1}{2}$ in. (120.7 × 74.9 cm.).

Signed and dated at lower right: Geo. De F. Brush / 1894.

RELATED WORKS: *Mother and Child* (model completed ca. 1914), marble, coll. Mrs. Henry Clay Frick, Oyster Bay, N.Y.; bronze, coll. Mrs. W. S. Coates, Bayville, N.Y., ill. in Bowditch, *George de Forest Brush* (1970), fig. 49.

REFERENCES: J. Van Dyke, *Century*, n.s. 29 (April 1896), p. 802, illustrates Cole's 1895 engraving after it; pp. 954–955, discusses (quoted above) // P. King,

House Beautiful 2 (Christmas 1901), ill. p. 2; pp. 8, 10, describes // W. Macbeth to J. W. Beatty, March 3, 1911, Carnegie Institute Archives, Pittsburgh, gives provenance // A. Hoeber, *International Studio* 43 (June 1911), p. lxxx, calls it "one of the best of that series he has repeated so many times since" // Print Club of Philadelphia, *Timothy Cole Memorial Exhibition* (1931), p. 26, no. 199, lists engraving of it; p. 28, gives excerpts from the engraver's diary while he was working on it, p. 29, illustrates engraving // T. N. Maytham to J. W. Middendorf II, Dept. Archives, March 9, 1967, discusses loan of the painting to MFA, Boston // N. D. Bowditch to J. W. Middendorf II, Dept. Archives, April 3, 1967, identifies models, discusses provenance and related sculptures; *George de Forest Brush* (1970), fig. 18; p. 142, discusses it; p. 149, gives letter of Nov. 29, 1916, from artist to his daughter, relating how he saw it on exhibition at the Carnegie Institute while lecturing there; p. 238, mistakenly says it was in 1940 Carnegie exhibition; p. 257.

EXHIBITED: Carnegie Institute, Pittsburgh, 1911,

no. 28, Mother and Child // Baltimore Museum of Art and MMA, 1967, *American Paintings & Historical Prints from the Middendorf Collection*, no. 46, entry by S. P. Feld, p. 68, lists references, exhibitions, provenance, discusses related paintings and sculpture; ill. p. 69 // Bristol Art Museum, R.I., 1968, *Paintings by George De Forest Brush*, no. 28, lent by Mr. and Mrs. J. William Middendorf II, unnumbered ill.

ON DEPOSIT: MFA, Boston, 1905–1907, lent by Mrs. J. M. Sears.

EX COLL.: Mrs. J. Montgomery Sears, Boston, by 1905–1911; with Macbeth Gallery, New York, as agent, 1911; Carnegie Institute, Pittsburgh, 1911–1966; Mr. and Mrs. J. William Middendorf II, New York, 1966–1968.

Gift of Mr. J. William Middendorf II, 1968.
68.222.2.

Alan Harriman

Throughout his career, Brush painted many figure and portrait studies of children, a subject that he shared with his friend and neighbor ABBOTT H. THAYER. In 1905 he executed this sensitive portrait of young Alan Harriman (1898 or 1899–1928) in a riding habit. The work was commissioned by the subject's father, Joseph W. Harriman, the founder and onetime president of the Harriman National Bank and Trust Company. Alan's mother was the former Augusta Barney. The family lived in Brookville, New York, and Bernardsville, New Jersey. Alan Harriman later served with the Red Cross in France in 1917 and the American Naval Aviation Service in 1918. He and his wife, Marie Brooke, whom he married on April 21, 1924, lived in Great Neck, New York, and had two children, David and Marie. Harriman owned and ran an automobile agency in Babylon, New York. On January 6, 1928, he was involved in an automobile accident, sustaining injuries that resulted in his death two days later.

In an undated letter to the artist's daughter, Barry Faulkner, a student of Brush's, recalled him painting the portrait:

One day in those [student] years your father searched me out and asked me to come and help him in the studio he had just taken. It was in the Life Building somewhere in the thirties, and he had undertaken to paint . . . Harriman's little boy. . . . I arranged the studio for him, entertained the little Harriman between poses and ran errands. I had that inestimable privilege of watching a great painter at work, of trying to absorb his standard of excellence, and of hearing his stray words and opinions on art dropped casually in the intimacy of studio work.

George de Forest Brush

The portrait remained in the possession of the Harriman family until it was presented to the Metropolitan in 1953.

Oil on canvas, $56\frac{3}{4} \times 37\frac{5}{16}$ in. (144.1 × 94.8 cm.).
Signed and dated at lower right: George De Forest Brush / 1905.

REFERENCES: B. C. Wright, letter in Dept. Archives, Nov. 5, 1953, dates it 1905 and gives provenance // N. D. Bowditch, letters in Dept. Archives, Oct. 18, 1963, April 25 and June 10, 1967, discusses it; *George de Forest Brush* (1970), fig. 39; pp. 194–195, includes letter from Faulkner which describes sitting but incorrectly identifies the sitter's father (quoted above) // A. H. Wright orally, Oct. 16, 1975, gave information on the sitter and donor.

EXHIBITED: Bristol Art Museum, R.I., 1968, *Paintings by George De Forest Brush*, no. 27.

EX COLL: Joseph W. Harriman, 1905 (sale, Plaza Art Galleries, New York, Nov. 15–17, 1934, no. 352); the brother-in-law and sister of the subject, Gen. and Mrs. Boykin C. Wright, Syosset, N.Y., 1934–1953.

Gift of General Boykin C. Wright, 1953.
53.177.

Brush, *Alan Harriman*.

In the Garden

In the fall of 1905 the artist and his family returned to Florence from Dublin, New Hampshire, and took up residence in Villa il Gioiello, which had been their home in Italy since 1903. They were joined by the young Americans Robert Pearmain and Barry Faulkner, who came to study with Brush. The artist rented two studios to accommodate his students and older children, who were also drawing and painting. The happy atmosphere of the household was enhanced by visits from friends and frequent trips to the Florentine galleries and museums.

In the spring of 1906, the artist finished this full-length figure study, for which his wife Mary posed holding their daughter Thea, now Mrs. T. Handasyd Cabot, Jr. (1903–), and accompanied by their daughter Mary, now Mrs. Grenville Clark (1898–). *In the Garden* is not unlike a sculpted relief: the figures are placed close to the picture plane and enclosed in a shallow space. Mrs. Brush and her daughters, garbed in flowing robes, are solidly modeled. Like his friend the sculptor Augustus Saint-Gaudens, Brush used an academic figure style to suggest a more universal theme, in this case, motherhood.

The artist repeated elements of the composition in later works like *At the Fountain* (unlocated) and *A Memory*, 1923 (Newark Museum), although the latter depicts different models. In these later works Brush may have referred to preliminary drawings made for *In the Garden*, such as one for the standing child (coll. Nancy D. Bowditch, Peterborough, N.H.).

During this period of his career, Brush was fascinated with the enduring freshness of the old masters and began an exhaustive study of technique that resulted in his experimentation with grounds and underpainting, and in this instance, the unusual use of a zinc panel as a support.

Oil on zinc, 37¼ × 16⅞ in. (94.6 × 42.9 cm.).

Signed and dated at lower left: George De Forest Brush / 1906.

RELATED WORKS: Drawing for the standing child (Mary Brush), coll. Nancy D. Bowditch, Peterborough, N.H. // Head of Mrs. Brush, a copy after the Metropolitan painting, unidentified medium and support, coll. Nancy D. Bowditch, Peterborough, N.H.

REFERENCES: G. de F. Brush, his list of best works, n.d., Am. Acad. of Arts and Letters Papers, microfilm NAA-1, Arch. Am. Art, includes it // G. A. Hearn, letter in MMA Archives, Oct. 15, 1906, gives provenance and notes that "Those who have seen it agree in saying, that it is one of the best figure pictures, yet painted in the United States" // *The George A. Hearn Gift to the Metropolitan Museum of Art . . .* (1906), suppl., ill. // *MMA Bull.* 2 (Feb. 1907), p. 24, notes it as a gift from G. A. Hearn; ill. p. 25 // G. B. Zug, *Chautauquan* 50 (April 1907), ill. p. 212 // M. C. Smith, *International Studio* 34 (April 1908), p. 1, discusses; ill. p. li // L. Mechlin, *Studio* 48 (Dec. 1909), p. 188 // Letter to G. de F. Brush in MMA Archives, April 25, 1910, answers request for him to "brighten up" the painting // J. W. Alexander, *Art and Progress* 3 (May 1912), ill. p. 574 // *George A. Hearn Gift to the Metropolitan Museum of Art . . .* (1913), ill. p. 64 // *MMA Bull.* 9 (March 1914), p. 75, erroneously gives date of gift as 1907 // R. LeGallienne, *Delineator* 88 (Jan. 1916), color ill. p. 16, includes a poem inspired by it // E. I. S., *Bulletin of the Worcester Museum* 9 (April 1918), p. 6, calls it more Florentine than Worcester Museum's *Mother and Child* // C. B. Ely, *Art in America* 11 (June 1923), p. 206, calls it "rhythmic in treatment"; *The Modern Tendency in Painting* (1925), p. 23 // E. V. Lucas, *Ladies Home Journal* 43 (Oct. 1926), color ill. p. 24, and discusses // *New York Times*, March 9, 1937, p. 2; April 25, 1941, p. 19 // N. D. Bowditch (daughter of the artist), letters in MMA Archives, Oct. 18, 1963, and April 25, 1967, notes that she assisted her father by making sketches for the foliage and identifies models; *George de Forest Brush* (1970), pp. 92–93, says it was painted in 1906 at the Villa il Gioiello in Florence; fig. 38 // Mrs. H. C. Frick, orally, Aug. 16, 1972, identified models // R. Finnegan, M. Knoedler and Co., New York, letter in Dept. Archives, March 31, 1975, gives provenance.

EXHIBITED: PAFA, 1905, no. 405, as In the Garden // Esposizione Internazionale, Rome, 1911, *Catalogue of the Collection of Pictures and Sculpture in the Pavilion of the United States of America . . .*, no. 23 // American Fine Arts Society, New York, 1943, *Fifty Years on Fifty-seventh Street* (for the benefit of the American Red Cross), no. 40.

EX COLL.: with M. Knoedler and Co., New York, 1906, as agent; George A. Hearn, New York, 1906.

Gift of George A. Hearn, 1906.

06.1218.

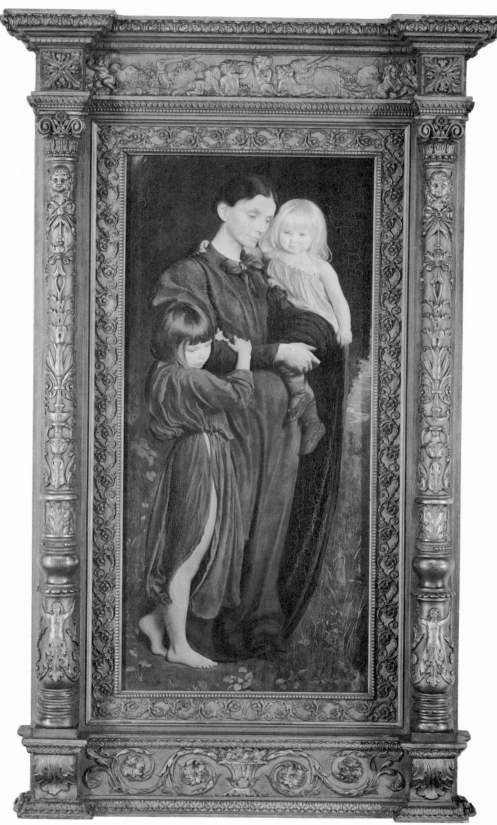

Brush, *In the Garden*.

CECILIA BEAUX

1855–1942

The second daughter of a Frenchman and his American wife, who died twelve days after her daughter's birth in Philadelphia, Cecilia Beaux was raised by her maternal grandmother and aunts. She was educated at home, where her aunt Eliza Leavitt gave her drawing lessons. At the age of fourteen she attended a girls' school run by the Misses Charlotte and Catharine Lyman, and two years later, she studied drawing under Catharine Drinker (later Mrs. Thomas Janvier), a historical and religious painter whose brother eventually married Cecilia's sister Aimée Ernesta.

In 1872 or 1873, Beaux attended a class conducted by Adolf Van der Whelen, a Dutch artist then working in Philadelphia. Under his direction she copied lithographs and made drawings from antique casts. During the late 1870s, she taught drawing at a local girls' school, prepared lithographs for scientific illustrations, and did paintings on porcelain. She also seems to have studied at the Pennsylvania Academy of the Fine Arts. Although she later denied this, her name appears on the student register in 1877 and 1878–1879. The instruction available there under THOMAS EAKINS would account for the remarkable advancement in her painting style over the next decade. Between 1881 and 1883, Beaux attended a class that met in a friend's studio, where William Sartain (1843–1924) offered criticism to the students twice a month.

The artist first exhibited at the Pennsylvania Academy in 1879, and received recognition there some six years later when *Les Derniers Jours d'Enfance*, 1883–1885 (coll. Mrs. Henry Saltonstall, Stratham, N.H.) won the Mary Smith Prize for the best picture by a Philadelphia woman artist, a prize she won again in 1887, 1891, and 1892. In 1887, *Les Derniers Jours d'Enfance* was shown at the Paris Salon, and a year later, Beaux went to study in Paris. She attended classes at the Académie Julian, then taught by William Adolphe Bouguereau and Tony Robert-Fleury, and spent the summer in Brittany at Concarneau, painting with ALEXANDER HARRISON, Arthur Hoeber (1854–1915), and Charles A. C. Lasar (1856–1936). Under their influence, she worked outdoors on landscapes and peasant subjects. After traveling to Switzerland and Italy, she returned to Paris and resumed her studies, this time at the Atelier Colarossi under Pascal Adolphe Jean Dagnan-Bouveret and Gustave Courtois. She also took private instruction from Jean Joseph Benjamin-Constant. In the spring of 1889 Beaux visited her friend Maud DuPuy Darwin near Oxford and in August returned home.

In Philadelphia, Beaux took a studio and worked on portraits in oil and pastel. After her grandmother's death in 1892, she spent more time in New York, where Richard Watson Gilder and his wife the painter Helena de Kay (ca. 1846–1916) introduced her to their circle of friends and acquaintances, including the critics Mariana Van Rensselaer and Leila Mechlin, and the artists JOHN LA FARGE and Augustus Saint-Gaudens. She was elected to the Society of American Artists in 1893 and, the following year, became an associate member of the National Academy of Design, where she had first exhibited in 1892. Beginning in 1895,

Beaux taught drawing and portraiture at the Pennsylvania Academy for the next twenty years. Her mature painting style, developed during the 1890s, is characterized by original compositions and richly colored pigments, fluidly applied. In 1896, on a second trip to Europe, she visited France and spent some time in England, where she admired paintings by JOHN SINGER SARGENT, whose international portrait style strongly influenced her. The first major exhibition of her work was held in 1897 at the St. Botolph Club in Boston, and, in 1902, she was elected an academician at the National Academy. As early as 1899, WILLIAM MERRITT CHASE described her as "not only the greatest living woman painter, but the best that has ever lived" (*Philadelphia Public Ledger*, Nov. 3, 1899, p. 5). Like MARY CASSATT, Beaux achieved critical recognition equaled by only a few of her women contemporaries.

Around 1900, she made New York her residence, and after 1905, her summers were spent at her home Green Alley in Gloucester, Massachusetts. Although she returned to Europe several times, her most memorable visits were in 1919 and 1920, when she executed commissions for the United States War Portraits Commission. Her paintings of Désiré Joseph Cardinal Mercier, 1919, Admiral Sir David Beatty, 1919, and Georges Clemenceau, 1920 (all National Collection of Fine Arts, Washington, D.C.), constitute a more official, and perhaps less original, aspect of her œuvre. On a transatlantic crossing in 1924, Beaux broke her hip, an injury which thereafter limited her activities as a painter. She devoted much of her time to her autobiography *Background with Figures*, published in 1930. In 1934–1935, the American Academy of Arts and Letters in New York organized the largest exhibition of her work held during her lifetime. The artist died in Gloucester at the age of eighty-seven.

BIBLIOGRAPHY: Cecilia Beaux, *Background with Figures: Autobiography of Cecilia Beaux* (New York and Boston, 1930), indexed // Henry S. Drinker, *The Paintings and Drawings of Cecilia Beaux* (Philadelphia, 1955). A complete catalogue of works published by the Pennsylvania Academy of the Fine Arts, includes a transcript of a lecture on portraiture delivered by the artist in 1907 // Frederick D. Hill, "Cecilia Beaux, the *Grande Dame* of American Portraiture," *Antiques* 105 (Jan. 1974), pp. 160–168 // Museum of the Philadelphia Civic Center and the Indianapolis Museum of Art, *Cecilia Beaux: Portrait of an Artist* (an exhibition organized by the Pennsylvania Academy of the Fine Arts, Sept. 6–Oct. 20, 1974; Jan. 21–March 2, 1975), introductory essay by Frank H. Goodyear, Jr., catalogue entries by Frank H. Goodyear, Jr., and Elizabeth Bailey include exhibitions, references, and provenance. Contains a chronology and bibliography.

Ernesta (Child with Nurse)

Ernesta Drinker (1892–), shown here with her nurse Mattie, was Cecilia Beaux's niece and favorite model (see *Ernesta* below). Dated 1894, the painting represents the popular turn of the century subject of a child's first steps. The theme, which was treated sentimentally by most artists, is transformed here into a strong psychological statement. By focusing on the clasped hands of Ernesta and her nurse, Beaux captures the dependent relationship between helpless child and supportive adult. Ernesta, placed in the center of the canvas, is viewed from the eye level of another child, who sees only as high as the skirt and arm of the nurse. From this vantage point the viewer is clearly aware of the world of the child rather than that of the adult.

In this painting, Beaux offers us both "Imaginative *Insight* and *Design*," the two elements that she deemed most important in any work of art (Drinker, 1955, p. 110). Although highly original in conception, it recalls the work of Edgar Degas in the disconcerting cropping of the nurse's figure. This cropping and the uneven distribution of masses, with empty spaces behind and below the central figure, suggest that motion, even movement outside the picture space, is imminent. Careful study went into the arrangement of the composition to create this impression

Beaux, study, *Ernesta with Nurse*,
Pennsylvania Academy of the Fine Arts.

of spontaneity. Beaux habitually made preparatory studies in oil and once explained in reference to another work that she "did the composition small, but containing all the important masses, lines, and color" (Beaux, *Background with Figures* [1930], p. 91). In the oil study for Ernesta, Beaux began with a composition slightly different from the one seen in the finished work. The child was surrounded by more space, and more of the nurse's torso was visible. By painting a series of increasingly constrictive frames around the two figures she arrived at the innovative arrangement seen in the finished version.

The painting was widely exhibited during the artist's lifetime and was most often discussed in terms of its unconventional composition. In 1899, the sculptor Lorado Taft, for example, commented on the child "taking a walk with a fragmentary nurse. The nurse had . . . lost her head, as young and pretty nurses often do. . . . It was a bold thing to compose a picture in that way, and not altogether a happy inspiration perhaps, but the painting was something wonderful."

Oil on canvas, 50½ × 38⅛ in. (128.3 × 96.8 cm.).
Signed and dated at lower left: Cecilia Beaux / 94.
RELATED WORK: Sketch for *Ernesta with Nurse*, ca. 1894, oil on cardboard, 8¾ × 6⅜ in. (22.2 × 16.2 cm.), PAFA, 1950.17.55, ill. in Museum of the Philadelphia Civic Center and Indianapolis Museum of Art, *Cecilia Beaux: Portrait of an Artist*, exhib. cat. (1974), p. 79.
REFERENCES: Typewritten list of paintings executed in "3rd Studio 1710 Chestnut Street," Cecilia Beaux Papers, 428, Arch. Am. Art, includes "Ernesta (with nurse) Haverford" // Century Magazine to C. Beaux, April 6, 1894, Cecilia Beaux Papers, 428, Arch. Am. Art, asks permission to prepare an engraving after it // C. Beaux to R. W. Gilder [ca. April 1894], Century Magazine Papers, NYPL, microfilm N6, Arch. Am. Art, discusses another engraving and queries "But how about 'Ernesta'? You don't want both pictures do you?" // H., *Century Magazine*, n.s. 26 (Sept. 1894), p. 798, says it is "very much admired" // *New York Daily Tribune*, June 16, 1895, ill. p. 25, and, comparing it to a portrait by Sargent, says "the technique is remarkable, but the spirit of the thing is enchantment itself" // H. McCarter to C. Beaux, April 20, 1896, Cecilia Beaux Papers, 426, Arch. Am. Art, discusses and provides a diagram of its installation in a group of Beaux portraits at the Champs de Mars exhibition in Paris // A. Saint-Gaudens to C. Beaux, Dec. 6, 1896, Cecilia Beaux Papers, 426, Arch. Am. Art, sends a letter, dated July 17, 1896, to him from the French sculptor Paul Bion, who praises the Champs de Mars exhibition and writes: "Ce ne sont que des portraits on ne voit pas le haut de la bonne qui mène promener cet enfant—ce n'en a que plus d'attrait pour nous" // C. Beaux, "list of pictures at the Champs de Mars" [1896?], Cecilia Beaux Papers, 428, Arch. Am. Art, includes it // *New York Times*, Dec. 22, 1897, p. 6, calls it one of the best children's portraits in the show at the American Art Galleries // W. Walton, *Scribner's* 22 (Oct. 1897), ill. p. 481; pp. 484–485, mentions its exhibition in Paris and Pittsburgh in 1896 // *International Studio* 6 (Jan. 1899), ill. p. 208, notes its exhibition in London in 1898 // Mrs. A. Bell (N. D'Anvers), *International Studio* 8 (Oct. 1899), p. 219 // L. Taft, "Work of Cecilia Beaux," *Chicago Record*, Dec. 21, 1899, clipping in Cecilia Beaux Papers, 429, Arch. Am. Art (quoted above) // *New York Commercial Advertiser*, March 4, 1903, p. 9, compares it to a portrait by Sargent // C. E. Clement, *Women in the Fine Arts* (1904), p. 36 // A. Hoeber, *International Studio* 31 (June 1907), p. cvi // *International Studio* 41 (July 1910), p. iv // *Art News* 12 (Jan. 17, 1914), p. 9 // *New York Times*, Jan. 18, 1914, sec. 5, p. 15 // L. M. Bryant, *American Pictures and Their Painters* (1921), p. 204 // C. Burrows, *International Studio* 85 (Oct. 1926), p. 77 // C. Beaux, *Background with Figures* (1930), ill. opp. p. 56; p. 348, prints Bion's letter // R. Cortissoz, *New York Herald Tribune* (Dec. 1, 1935), sec. 5, ill. p. 10 // *Art Digest* 15 (Dec. 15, 1940), ill. p. 14, says it was voted the most popular painting in the Carnegie exhibition // *Art Digest* 17

(Oct. 1, 1942), p. 20 // *Syracuse Museum of Fine Arts Quarterly Bulletin* 15 (Oct.–Dec. 1953), ill. on cover; unpaged, says it has been awarded the popular vote in a local exhibition // H. S. Drinker, *The Paintings and Drawings of Cecilia Beaux* (1955), ill. p. 54; p. 55, gives provenance and history, dates it 1894, Haverford, and says it is "probably her best known picture" // J. T. Fraser, *Goya*, no. 6 (May–June 1955), ill. p. 381 // E. Barlow (the subject), letter in MMA Archives, April 19, [1965], verifies that she was model // P. Beam, *Winslow Homer at Prout's Neck* (1966), p. 151, mentions that it won a prize at the Carnegie Institute in 1896 // C. D. Bowen, *Family Portrait* (1970), ill. p. 10, says that Ernesta was two when it was painted and identifies the nurse as Mattie // F. D. Hill, *Antiques* 105 (Jan. 1974), ill. p. 164, discusses // D. Evans, *American Art Review* 2 (Jan.–Feb. 1975), pp. 92–93; color ill. p. 96 // E. Barlow, letter in MMA Archives, April 10, 1975.

EXHIBITED: Society of American Artists, New York, 1894, no. 106, as Ernesta, lent by Mrs. Henry Drinker // PAFA, 1894–1895, no. 6 // Société Nationale des Beaux-Arts, Paris, 1896, *Exposition de 1896 Catalogue Illustré*, no. 78 // Carnegie Institute, Pitts-burgh, 1896–1897, no. 13 // St. Botolph Club, Boston, 1897, *An Exhibition of Paintings by Miss Cecilia Beaux*, no. 12 // American Art Galleries, New York, 1897, *An Exhibition of Paintings by Miss Cecilia Beaux*, no. 12 // International Society of Sculptors, Painters, and Gravers, London, 1898, *Illustrated Souvenir Catalogue of the Exhibition of International Art*, no. 28 // Durand-Ruel Galleries, New York, 1903, *Exhibition of Paintings by Cecilia Beaux*, no. 8 // Carnegie Institute, Pittsburgh, 1907, no. 26 // Woman's Cosmopolitan Club, New York, 1914 (no cat. available) // Panama-Pacific Exposition, San Francisco, 1915, no. 3134 // Am. Acad. of Arts and Letters, New York, 1935–1936, *A Catalogue of an Exhibition of Paintings by Cecilia Beaux*, no. 39, as Child with Nurse, lent by Mrs. Henry S. Drinker, Sr. // Carnegie Institute, Pittsburgh, 1940, *Survey of American Painting*, no. 251, as Child with Nurse—Ernesta, lent by Mrs. Ernesta Drinker Barlow through the courtesy of Mr. and Mrs. Henry S. Drinker // Syracuse Museum of Fine Arts, 1953, *125 Years of American Art* (sponsored by the Syracuse Post-Standard), no. 36, as Ernesta with Nurse, lent by Mrs. S. L. M. Barlow, New York // Toledo Museum of Art; Seattle Museum of Art; Dallas Museum of

Beaux, *Ernesta (Child with Nurse)*.

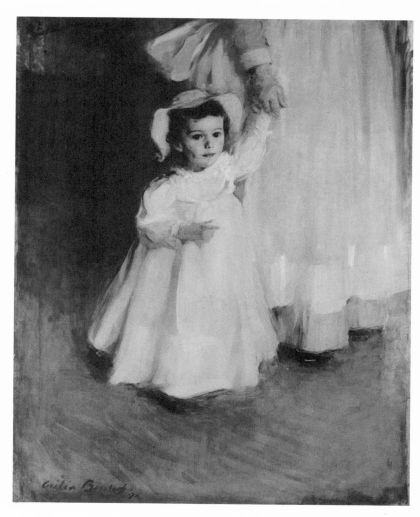

Fine Arts; Santa Barbara Museum of Art; M. H. de Young Memorial Museum, San Francisco, 1954, *Impressionism and Its Influence in American Art*, no. 3, as Ernesta with Nurse, lent by Mrs. S. L. M. Barlow // PAFA, 1955, *The 150th Anniversary Exhibition*, no. 127, as Ernesta and Nurse, lent by Mrs. Samuel L. M. Barlow, New York // Museum of the Philadelphia Civic Center, Indianapolis Museum of Art, 1974–1975, *Cecilia Beaux, Portrait of an Artist* (organized by PAFA), no. 44, as Ernesta with Nurse, color ill. p. 28; p. 29, F. H. Goodyear, Jr., discusses it as an example of her highly original compositions, and p. 78, lists exhibitions, references, provenance, discusses oil study for it; ill. p. 79.

Ex coll.: Mr. and Mrs. Henry S. Drinker, Merion, Pa.; their daughter, the subject, Mrs. Samuel L. M. Barlow, New York, by 1940–1965.

Maria DeWitt Jesup Fund, 1965.

65.49.

Beaux, *Mr. and Mrs. Anson Phelps Stokes.*

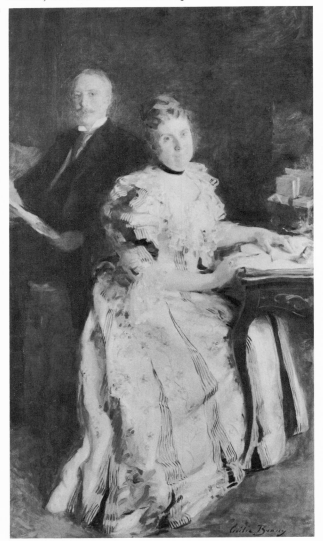

Mr. and Mrs. Anson Phelps Stokes

The subjects of this double portrait are Anson Phelps Stokes (1838–1913) and Helen Louisa (Phelps) Stokes (1846–1930) who were married in 1865. As a young man, Mr. Stokes joined his grandfather's mining and metal manufacturing firm, Phelps, Dodge and Company, becoming a partner in 1861. In 1879, with his father and father-in-law he formed the banking firm of Phelps, Stokes and Company. Later he also organized a number of realty companies in New York. A strong advocate of civil service reform, free trade, and bimetalism, Stokes was active in many political and social reform organizations. In 1899, after a riding accident at his estate in Lenox, Massachusetts, his leg was amputated, and thereafter he devoted much of his time to the study of history and genealogy. He amassed a fine library of Americana and wrote a three-volume history of his family, *Stokes Records* (1910–1915).

The portrait depicting Mr. and Mrs. Stokes in their New York residence on Madison Avenue was most likely painted in 1898, and marks a new direction in Cecilia Beaux's work. Instead of her usual perceptive characterization, she shows a rather superficial concern for depicting opulent fabrics and imposing accessory elements that is typical of society portraiture in the international style. She has also become more interested in technical virtuosity, in creating an impression of artistic ease with broad, facile brushwork. Viewed from an oblique and somewhat disconcerting vantage point, the figure of Mrs. Stokes dominates the painting, while her husband, whose figure is cast in shadow, is relegated to the background. This unconventional composition, with the woman emphasized by placement, lighting, and treatment of detail, is undoubtedly derived from JOHN SINGER SARGENT's portrait of the sitters' son and daughter-in-law, *Mr. and Mrs. I. N. Phelps Stokes* (q.v.), painted in London the previous year. Although Sargent's picture was conceived as a portrait of Edith Minturn Stokes, with her husband added later, the composition is successful in that the figure of I. N. Phelps Stokes is an integral part of it. Beaux, however, borrows this brilliant solution to the double portrait without the spontaneity and psychological power so evident in the Sargent work. She fails to establish the necessary tension between the sitters, and as a result Mrs. Stokes overwhelms rather than

complements her husband. Even I. N. Phelps Stokes, writing a rather complimentary letter to Beaux about the picture, called it "my mother's portrait," noting "how wonderfully you have painted her heart and soul"—his father is not mentioned. In both portraits, the sitters, each self-contained, gaze out at the spectator, rather than at each other. Where this heightens the confrontative power of Sargent's portrait, it renders Beaux's composition discursive.

Although the Sargent portrait may not have been on public exhibition until after Beaux's portrait was painted, it seems likely that she was familiar with it, both because of her sitters' relationship to the younger couple and her own great admiration for Sargent's work. In 1896, while in London, she had studied examples of his work, and later, after meeting him, she noted: "I had seen a good many of Sargent's paintings and had keenly felt his power" (C. Beaux, *Background with Figures* [1930], p. 224).

Both portraits were included in the annual exhibition of the Pennsylvania Academy of the Fine Arts in 1899, and the similarity between them did not escape the notice of contemporaries. Charles H. Caffin compared them in a review of the show and said that Beaux's portrait was "very clever, far too obviously so, and grows tiresome with renewed acquaintance. . . . It is a very unfortunate experiment, not justified by the excellence of portions of the painting." Beaux, nevertheless, must have been pleased with it, for she exhibited it again that year at the National Academy of Design, where a critic for the *New York Times* praised it for its "naturalness and simplicity."

Oil on canvas, $72\frac{1}{16} \times 39\frac{7}{8}$ in. (183 × 101.3 cm.). Signed at lower right: Cecilia Beaux.

REFERENCES: I. N. P. Stokes to C. Beaux [1898–1900], in Cecilia Beaux Papers, 427, Arch. Am. Art, praises it (quoted above) // C. H. Caffin, *Artist* 24 (Feb. 1899), p. xxix, reviews it at PAFA (quoted above); (May–June 1899), p. iv, reviews it at the NAD // *New York Times*, April 1, 1899, p. 224, in a review of the exhibition at the NAD, notes, "The chief portrait of the gallery . . . is Cecilia Beaux's double portrait of Mr. and Mrs. Anson Phelps Stokes, which holds the deserved place of honor. . . . Miss Beaux has given in this canvas one of the most direct, simple and yet forceful translations of personality and character that she has yet painted. . . . The strength of the picture lies in its naturalness and simplicity" (quoted above) // C. Beaux to Rev. A. P. Stokes, June 18, 1935, in Beaux Papers, 427, Arch. Am. Art, requests its loan for exhibition at the Am. Acad. of Arts and

Letters: "I am choosing only those which for different reasons I consider the most interesting—the double portrait of Mr. and Mrs. Phelps Stokes which I saw last in your house in New Haven I remember as being one of these" // A. P. Stokes to Mrs. W. Vanamee, Am. Acad. of Arts and Letters, June 20, 1935, Beaux Papers, 427, Arch. Am. Art, identifies sitters as his parents, giving death dates // H. S. Drinker, *The Paintings and Drawings of Cecilia Beaux* (1955), pp. 99–100, says it was painted in 1898 at their Madison Avenue home // J. D. Hatch, letters in Dept. Archives, June 26, July 5, 1962, Jan. 8, 20, 1965, June 6, 1966, discusses it and offers it to MMA.

EXHIBITED: PAFA, 1899, no. 28 or no. 229, as Portrait // NAD, 1899, no. 123, as Portrait, lent by Anson Phelps Stokes // Boston Art Club, 1907, *Exhibition of Paintings by Cecilia Beaux*, no. 22 (?) // Am. Acad. of Arts and Letters, 1935–1936, *A Catalogue of Paintings by Cecilia Beaux*, no. 42, as Mr. and Mrs. Anson Phelps Stokes, lent by the Rev. Anson Phelps Stokes // Philadelphia Civic Center and Indianapolis Museum of Art, 1974–1975, *Cecilia Beaux, Portrait of an Artist* (organized by PAFA), no. 53, intro. by F. H. Goodyear, Jr., p. 30, discusses it; catalogue entry by E. Bailey, p. 90, lists references and exhibitions; ill. p. 91.

EX COLL.: Mr. and Mrs. Anson Phelps Stokes, New York, and Lenox, Mass., after 1898; their son and daughter-in-law, Rev. and Mrs. Anson Phelps Stokes, New Haven, Conn., and Washington, D.C., until 1962; their family, Rt. Rev. and Mrs. Anson Phelps Stokes, Brookline, Mass., I. N. P. Stokes, Riverdale, N.Y., and Mr. and Mrs. John Davis Hatch, Jr., Lenox, Mass., 1962–1965.

Gift of the Family of the Rev. and Mrs. Anson Phelps Stokes, 1965.

65.252.

Ernesta

The portrait of the artist's niece Ernesta Drinker, now Mrs. Samuel L. M. Barlow, was painted in 1914 at Beaux's summer home in Gloucester, Massachusetts. The artist carefully selected the accessories and Ernesta's costume, choosing mostly polished surfaces and white fabrics to reflect the cool green colors of the background. The seeming elegance of this portrait is somewhat deceptive, however, for, as the subject later wrote (1975):

I had on a white satin petticoat, my satin slippers were on a loose piece of black velvet. I wore a white cashmere sweater and my head went through two yards of white chiffon. The bench was . . . covered in white oil cloth. The studio was very bare—not prettied up at all—the big easel, the platform for some sitters and some wickedly uncomfortable wooden chairs.

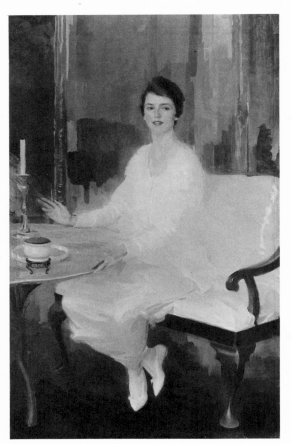

Beaux, *Ernesta*.

The portrait is not as freshly observed or as vigorously painted as the 1894 *Ernesta* (see above). Beaux's fluid brushwork and superficial treatment of character recall portraits done by Sargent a decade earlier. But Beaux lacks Sargent's talent for summary depiction so that portions of the canvas are confusingly abstract. The artist, however, preferred this portrait of Ernesta to others: "My niece Ernesta Drinker, was my choice, and chief reliance, as a model," she reminisced in 1930:

Three times on three different years she gave me long periods of opportunity; but in these I was feeling my way, and never satisfied (if ever I was). . . . The late summer and autumn of 1914, strangely enough, was the period when the best that was to come of our combined effort took place. . . . after the idea of the composition was born, and this was before her arrival, the sight of Ernesta, even among the queer surroundings from which I got the needful accessories, was enough to obliterate every other possible scene.

Painted just prior to the outbreak of World War I and a year after the landmark Armory show, the portrait marks an end, in a way, to both the genteel life-style it depicts and to the innovative phase of Cecilia Beaux's international portrait style.

Oil on canvas, 71¾ × 43⅜ in. (182.2 × 110.2 cm.). Signed at lower left: Cecilia Beaux.

REFERENCES: C. Beaux, letters in MMA Archives, Feb. 22, 28, March 4 [1915], says that her family has "acquiesced" to the sale of the portrait and discusses its inclusion in an upcoming exhibition at Knoedler's // B. Burroughs to C. Beaux, May 5, 1915, Cecilia Beaux Papers, 427, Arch. Am. Art, says that MMA has decided to purchase it // C. Beaux, letter in MMA Archives, May 7 [1915], says that "I am very proud to have a work of mine upon the walls of the Museum" // B. [Burroughs], *MMA Bull.* 10 (July 1915), p. 151, discusses the portrait; ill. p. 152 // *New York Times*, July 12, 1915, p. 7 // *New York Sun*, July 12, 1915, p. 6, announces its acquisition and says "Miss Beaux has called the picture 'Ernesta'" // *New York Times*, August 1, 1915, p. 22 // *Art and Progress* 7 (Nov. 1915), p. 1, discusses; ill. p. 2 // L. R. McCabe, *Art World* 3 (March 1918), p. 490, discusses // C. Beaux, letters in MMA Archives, Feb. 18 and 24 [1919], requests that it be lent to an important exhibition being held at the Luxembourg Museum // L. M. Bryant, *American Pictures and Their Painters* (1921), frontis. ill.; p. 204, discusses // *Arts and Decoration* 18 (Jan. 1923), color ill. on cover; p. 48, discusses // M. Adams, *Woman Citizen* 9 (Feb. 7, 1925), ill. p. 13, says it is "the embodiment of gracious and hospitable youth"; p. 28 // C. Burrows, *International Studio* 85 (Oct. 1926), p. 74; p. 77, discusses its "flashing brilliance" // C. Beaux, letter in MMA Archives, August 20 [1930], requests permission to illustrate it in her autobiography; *Background with Figures* (1930), ill. p. 72, pp. 342–343, discusses Ernesta sitting for it in 1914 (quoted above) // *Literary Digest* 155 (May 6, 1933), p. 13, mentions in a quote from Bryant (1921); ill. p. 14 // C. Beaux to S. C. Woodward [1930s?], in Sidney C. Woodward Collection, D194, Arch. Am. Art, describes, says painted in Gloucester, and identifies sitter // H. S. Drinker, *The Paintings and Drawings of Cecilia Beaux* (1955), ill. p. 52; p. 53, discusses its provenance and history // F. D. Hill, *Antiques* 105 (Jan. 1974), pp. 165–166, discusses; ill. p. 166 // C. D. Bowen, *Family Portrait* (1970), ill. p. 129 // E. Barlow, the subject, letter in Dept. Archives, April 10, 1975, discusses (quoted above).

EXHIBITED: M. Knoedler and Co., New York, 1915, *Catalogue of Portraits by Cecilia Beaux*, no. 7, as Ernesta // Am. Acad. of Arts and Letters, 1935–1936, *A Catalogue of Paintings by Cecilia Beaux*, no. 27 // Art Students League and American Fine Arts Society, New York, 1943, *Fifty Years on 57th St.* (for the benefit of the American Red Cross), no. 12, as Girl in White: Ernesta.

EX COLL.: the artist, 1914–1915.
Arthur Hoppock Hearn Fund, 1915.
15.82.

JOHN WHITE ALEXANDER

1856–1915

John White Alexander was one of the leading American artists at the turn of the century. Trained as a realist, he developed an individual style of figure painting that was strongly influenced by French and English art.

Born in Allegheny City, Pennsylvania, Alexander was orphaned at an early age. He was raised by his grandparents and later adopted by Edward Jay Allen, president of the Atlantic and Pacific Telegraph Company, where young Alexander worked from the age of twelve. In 1875, he went to New York and worked as a cartoonist for *Harper's Weekly*. In the summer of 1877 he sailed for Europe, where he enrolled in the Royal Academy in Munich and studied under Julius Benczur. From 1878 until his return in 1881, Alexander worked with FRANK DUVENECK and a group of American students, first in the Bavarian village of Polling and later in Florence and Venice. The landscapes and unpretentious portraits of local people that he painted in Polling owe a great deal to the impasto techniques that Duveneck developed under the influence of the German realist Wilhelm Leibl. In Venice, however, Alexander met JAMES MC NEILL WHISTLER, whose delicate brushwork and thin paint surfaces he adopted. Over the next two decades the artists became close friends.

On his return to New York, Alexander again did illustrations for *Harper's* and painted a number of portraits. He went West in 1883 to sketch and paint watercolors. The next year, after a sketching tour of North Africa, he visited Spain to study the paintings of Velázquez in Madrid. In London in 1886 he did a series of portraits of famous Americans living abroad, among which is a charcoal drawing of Whistler (MMA). Returning home the following year he married Elizabeth Alexander, a writer whose short stories he later illustrated. In 1891 they settled in Paris, and for the next decade, Alexander was a prominent member of the international community there. His circle of friends included Octave Mirabeau, Oscar Wilde, Henry James, Auguste Rodin, and Whistler, all of whom made this a period of great stimulation for him.

Throughout the 1890s, Alexander's paintings show Whistler's influence in the manipulation of line and color to enhance expressive qualities. He exhibited a group of his interpretive figure studies at the Société Nationale des Beaux-Arts in 1893 and thereafter contributed his work to many exhibitions, not only in Paris, but with secession groups in Munich and Vienna. Perhaps the most fully developed example of his Parisian style is *Isabella and the Pot of Basil*, 1897 (MFA, Boston), in which he combines sensuous flowing lines and harsh theatrical lighting to create an image not unlike those of the symbolists.

In Paris, Alexander maintained contact with developments in America, serving as head of the jury to select works for the 1897 Carnegie Internation exhibition. On his return to New York in 1901, he was elected to the National Academy of Design, where he became an academician the following year. He was commissioned in 1905 to execute an ambitious mural depicting "The Apotheosis of Pittsburgh" for the staircase hall of the Carnegie Institute in Pittsburgh, but the project remained unfinished at his death. Throughout this period,

Alexander's portraits and figure studies continue to show the influence of his Parisian experiments. They become increasingly sentimental, however, with flashier brushwork, harsher colors, and less cohesive compositions. Between 1909 and his death in 1915, Alexander was president of the National Academy and an ex-officio trustee of the Metropolitan Museum.

BIBLIOGRAPHY: "John White Alexander, N.A.: The Man and His Work," *Scribner's Magazine* 58 (Sept. 1915), pp. 385–388. Includes tributes by Edward Robinson, Edwin Howland Blashfield, Kenyon Cox, Howard Russell Butler and Harry W. Watrous, as well as a list of the artist's best known works // Carnegie Institute, Pittsburgh, *Catalogue of Paintings, John White Alexander Memorial Exhibition* (March 1916). Includes introduction by J[ohn] W. B[eatty], biographical statement, "Record of Paintings by John White Alexander: Incomplete List," and a bibliography // *American Magazine of Art* (John White Alexander memorial number) 7 (July 1916). Includes articles by Edwin Howland Blashfield, Howard Russell Butler, Charles Dana Gibson, H. M. B., John W. Beatty, and Homer Saint-Gaudens // Joseph Walker McSpadden, "John White Alexander: The Painter of the Flowing Line," in *Famous Painters of America* (New York, 1916), pp. 355–376 // National Collection of Fine Arts, Washington, D.C., *John White Alexander (1856–1915)* (Dec. 22, 1976–July 4, 1977), exhib. cat. by Mary Anne Goley.

Walt Whitman

In 1886, John White Alexander began a series of portraits of distinguished authors for *Century Magazine*, which eventually included such writers as Thomas Hardy, George Bancroft, and Robert Louis Stevenson. On February 22, 23, and 24, 1886, the artist visited the famous American poet Walt Whitman (1819–1892) at his home in Camden, New Jersey, to begin work on a portrait. In September 1887, it was reported in *Art Age* that Alexander had completed a large study of Whitman in crayon. The oil painting, however, was not finished until 1889, three years after Whitman first posed for the artist. Showing Whitman in a dignified formal pose—an elegant presentation that belies the poet's exuberant ruggedness—Alexander focuses on the face, which is framed by an aureole of white hair and beard. The treatment of Whitman's hands, the only other illuminated features of the portrait, enhances the design of the picture. The right hand does not disturb the line of the body against the neutral background, and the left hand echoes the curves of the arm and legs of the chair. Alexander's sophisticated sense of design, as well as his thin paint application and soft contours, suggest the influence of his friend JAMES MC NEILL WHISTLER.

Although Whitman called Alexander "a first rate young fellow," he was not enthusiastic about the portrait, which may explain why it was excluded from the *Century* series. In 1906, Whitman's friend Horace Traubel recorded the poet's comments on the many portraits made of him:

Of all portraits of me made by artists I like Eakins' best [painted in 1887, now in PAFA]: it is not perfect but it comes nearest being me. I find I often like the photographs better than the oils—they are perhaps mechanical, but they are honest. The artists add and deduct: the artists fool with nature—reform it, revise it, to make it fit their preconceived notion of what it should be. We need a Millet in portraiture—a man who sees the spirit but does not make too much of it— one who sees the flesh but does not make a man all flesh—all of him body. Eakins almost achieves this balance—almost—not quite: Eakins errs just a little— a little—in the direction of the flesh. I am always subjected to the painters: they come here and paint, paint, paint, everlastingly paint. I give them all the aid and comfort I can—I put myself out to make it possible for them to have their fling: hoping all the time that now the right man has come, now the thing will be done completely once and for all and hereafter I can hood my face.

I give the painters all the rope they want: I humor them every way I know. Alexander came, saw—but did he conquer? I hardly think so. He was here several times, struggled with me—but since he left Camden I have heard neither of him nor of his picture. The Century [propose] using the Alexander picture, which, indeed, I never liked. I am not sorry the picture was painted, but I would be sorry to have it accepted as final or even as fairly representing my showdown.

Ironically, the portrait was selected as a frontispiece by *Century*'s competitor *Harper's Monthly* for their April 1892 issue, which commemorated Whitman's death with the publication of his poem "Death's Valley."

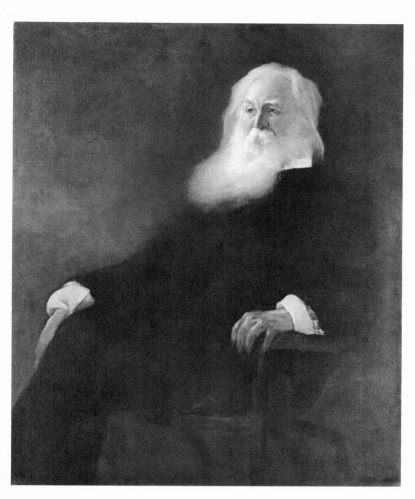

Alexander, *Walt Whitman.*

Oil on canvas, 50 × 40 in. (127 × 101.6 cm.).

Signed and dated at lower right: J W ALEXANDER '89.

RELATED WORK: *Walt Whitman*, chalk drawing, 8¼ × 6½ in. (21 × 16.5 cm.), Am. Acad. of Arts and Letters, 198.

REFERENCES: W. Whitman to J. W. Alexander, Feb. 20, 1886, Alexander Family of Princeton, N. J., Autographs of American and Italian Interest, Firestone Library, Princeton University, acknowledges receipt of his letter of Feb. 19, 1886, states "Yes, Monday will suit me—will be ready for you by 10½ am" // Whitman, "The Commonplace Book," Feb. 22, 23, and 24, 1886, MS in Charles E. Feinberg Collection, Library of Congress, notes "J W Alexander here, painting the portrait—(three sunny days)—" // Whitman to S. Stafford, Feb. 24, 1886, Charles E. Feinberg Collection, Library of Congress, says, "An artist from New York, from the *Century* Magazine, has been here the last three forenoons, painting a big portrait of me—he has finished all he wants here, and has just boxed it up & taken it off to NY by express—he is a first rate young fellow, a good talker, and has

already travelled a good deal over the world—and he made it all very interesting telling me this, that & the other" // *Art Age* 6 (Sept. 1887), p. 37, says that the artist "has completed a full-sized study in crayon" // *Studio*, n.s. 5 (Feb. 15, 1890), p. 105, discusses it as being "not free from the eccentricities that we associate with this artist's work" // Alexander, letters in MMA Archives, April 16, 17, 1891, says he is sending "portrait of Walt Whitman—painted by me in 89 in Camden, N.J. in Mr. Whitman's home" // Whitman to R. M. Bucke, April 18, 1891, Charles E. Feinberg Collection, Library of Congress, notes that he has received a letter from the artist who informed him of the museum's acquisition of his portrait // *Harper's Magazine* 84 (April 1892), p. 652, illustrates an engraving after it; p. 707, illustrates sketch of the sitter by the artist // A. Hoeber, *Harper's Weekly* 39 (Nov. 9, 1895), p. 1061, mentions it in connection with a series of literary portraits by the artist // W. L. Fraser, *Century*, n.s. 32 (May 1897), p. 155 // *Critic* 35 (July 1899), p. 614 // A. Dayot, *Harper's Magazine* 99 (Oct. 1899), pp. 696, 703 // G. Mourey, *International Studio* 11 (August 1900), p. 77 // J. W. Pattison, *Painters*

since *Leonardo* (1904), p. 254, lists it among the artist's major works // C. H. Caffin, *World's Work* 9 (Jan. 1905), ill. p. 5683; p. 5695, notes the emphasis on "expression of character" in male portraits by the artist // H. Traubel, *With Walt Whitman in Camden* (1906), 1, pp. 131–132, compares it to Eakins's portrait (quoted above); p. 284, discusses its use by *Century* // *Current Literature* 42 (June 1907), p. 642 // J. W. McSpadden, *Famous Painters of America* (1907; 1916), p. 371 // H. Traubel, *With Walt Whitman in Camden* (1908), 2, p. 549, quotes J. Burroughs to Whitman, April 13, 1886, indicating that Alexander was at work on it // C. H. Fiske, *Chautauquan* 50 (March 1908), ill. p. 71; p. 86, discusses // A. Hoeber, *International Studio* 34 (May 1908), ill. p. xcvii; p. lxxxix // C. Brinton, *Munsey's Magazine* 39 (Sept. 1908), ill. p. 749; p. 753, mentions as "one of the most important of his commissions," says rejected by the Society of American Artists and then purchased for MMA // A. N. Meyer, *Putnam's Monthly* 4 (Sept. 1908), pp. 707–710, compares it to the Eakins portrait; ill. p. 709 // J. N. Laurvik, *Metropolitan Magazine* 31 (Dec. 1909), pp. 369, 376 // L. Mechlin, *Studio* 48 (Dec. 1909), ill. p. 188 // Alexander, *Art and Progress* 3 (May 1912), p. 571 // J. Burroughs, *Craftsman* 22 (July 1912), ill. p. 356 // F. Weitenkampf, *Bulletin of the New York Public Library* 19 (July 1915), p. 540; ill. opp. p. 540 // *Scribner's* 58 (Sept. 1915), p. 388 // *American Magazine of Art* 7 (July 1916), ill. p. 349 // J. L. Allen, *Eminent Americans* (1919), unpaged, mentions; fig. 19 // J. C. Van Dyke, *American Painting and Its Tradition* (1919), p. 227, associates its style with Alexander's Munich training; ill. opp. p. 236 // S. Hartmann, *A Note on the Portraits of Walt Whitman* (1921), unpaged, calls it and the Eakins painting only portraits of the sitter by "real painters," feels that it makes sitter look "rather genteel and debonair" // H. S. Saunders, comp., "Whitman Portraits," typed MS, 1922–1946, no. 105, Duke University Library, dates it 1889, lists illustrations and references // O. Kaltenborn, *Brooklyn Daily Eagle*, Sunday magazine, Oct. 23, 1927, ill. p. 11, relates an imaginary discussion between the sitter and the author, during which he comments on current affairs // E. V. Lucas, *Ladies Home Journal* 43 (July 1926), ill. p. 16 // H. Van Dyke, *The Man Behind the Book* (1929), ill. opp. p. 80 // E. H. Miller, ed., *Walt Whitman, the Correspondence* (1969), 3, p. 391; 4, p. 20; 5, p. 193, quotes letters relevant to its execution // J. C. Broderick, Manuscript Department, Library of Congress, letters in Dept. Archives, May 13, July 11, 1975, gives published and unpublished manuscript references to it // M. A. Goley, letter in Dept. Archives, June 14, 1976, says Alexander seldom, if ever, made oil versions or smaller studies prior to executing the final piece but notes his drawing for Whitman at Am. Acad. of Arts and Letters // M. M. Mills, Am. Acad. of Arts and Letters, letter in Dept. Archives, July 19, 1976, provides information about the drawing // National Collection of Fine Arts, Washington, D.C., *John White Alexander (1856–1915)* (1976), exhib.

cat. by M. A. Goley, unpaged, cites it as one of the portraits the artist painted during his residence in New York, says these show such Munich characteristics as "generally muted tones with brilliant highlights."

EXHIBITED: PAFA, 1890, no. 1, as *Portrait of Walt Whitman*, $1,500 // MMA, 1897, *The Catharine Lorrillard Wolfe Collection and Other Modern Paintings*, no. 222 // Carnegie Institute, Pittsburgh, 1916, *John White Alexander Memorial Exhibition*, no. 1.

ON DEPOSIT: National Portrait Gallery, Washington, D.C., 1974–1977.

EX COLL.: the artist; Mrs. Jeremiah Milbank, New York, by 1891.

Gift of Mrs. Jeremiah Milbank, 1891.
91.18.

Geraldine Russell

The artist was captivated by the charm of the awkward and wistful child Geraldine Russell (1896–1933). One of the three children of Jane and Charles Howland Russell, Geraldine is said to have been in delicate health for much of her life, a fragility hinted at by the feather she holds. Alexander enhances his depiction of her quiet, pensive personality by placing her in an isolated setting with an overcast sky. The background is merely suggested with broad brushwork on a loosely woven canvas. Alexander concentrates instead on the silhouette of the child's lithe body and the soft lines of her dress.

Probably painted at Onteora, in Tannersville, New York, in 1902 or 1903, the portrait was presented to the subject's family by the artist. About a year later, he painted a portrait (now unlocated) of the subject's father, who was a prominent New York lawyer.

Oil on canvas, 60¼ × 35⅞ in. (153 × 91.1 cm.).
Signed at lower left: John W. Alexander.
REFERENCES: C. H. Caffin, *World's Work* 9 (Jan. 1905), ill. p. 5696 // E. F. Baldwin, *Outlook* 95 (May 28, 1910), ill. p. 176 // *Outlook* 110 (June 9, 1915), p. 298 // C. H. Russell, letter in MMA Archives, June 22, 1964, gives date and setting of the picture and biography of the sitter.

EXHIBITED: National Arts Club, New York, 1909, *John W. Alexander Retrospective Exhibition*, no. 11, as *Portrait of Miss Geraldine Russell* // Carnegie Institute, Pittsburgh, 1916, *John White Alexander Memorial Exhibition*, cat. by J. W. B[eatty], no. 81, as *Geraldine*, lent by Mrs. Charles Howland Russell; p. 47, dates it between Oct. 1902 and Oct. 1903 and includes it in a list of paintings by Alexander.

EX COLL.: Mr. and Mrs. Charles H. Russell, New York; their daughter, Geraldine Russell (the subject),

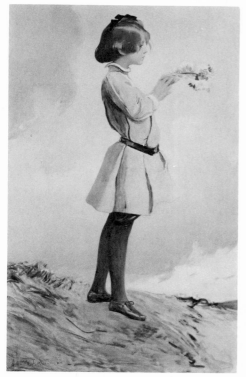

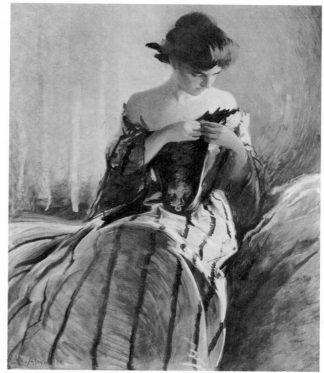

Alexander, *Geraldine Russell*. Alexander, *Study in Black and Green*.

died 1933; her brother, Charles H. Russell, New York, 1933–1964.

Gift of Charles H. Russell, 1964.
64.117.

Study in Black and Green

The idealized woman was a favorite turn of the century theme and one particularly suited to Alexander's temperament. Here a young woman is absorbed in pinning something on the neckline of her elegant evening gown. Completed by 1906, when it was exhibited in Buffalo, the painting is similar in subject to *A Flower*, 1899 (unlocated), in which a standing woman is depicted pinning a flower to her bodice. In *Study in Black and Green*, the figure fills the canvas, and the vibrant green of her costume sets the lively color tone of the picture. The flowing striped pattern of the skirt, the rounded curves at the knees and shoulders, and the lines of the upswept hair justify the description of Alexander as "the painter of the flowing line." His dazzling brushwork, especially notable in the rendering of the

rich fabrics and the otherwise plain background, marks a departure from the thin even paint surfaces of his Parisian paintings.

Oil on canvas, 50 × 40⅛ in. (127 × 101.9 cm.).
Signed at lower left: J. W. Alexander.
REFERENCES: *Academy Notes* 2 (June 1906), ill. p. 2, discusses // A. Hoeber, *International Studio* 34 (May 1908), p. cviii, reviews it at NAD exhibition: "Once more we have a charming disposition of light and shade, always out of the commonplace, yet not strained or *bizarre*, and there is an abiding sense of the decorative here as there is to all his canvases" // P. C. Clarke, *Everybody's Magazine* 21 (Sept. 1909), color ill. on cover; pp. 424–425, discusses // N. Laurvik, *Metropolitan Magazine* 31 (Dec. 1909), ill. p. 371 // C. H. Caffin, *Arts and Decoration* 1 (Feb. 1911), ill. p. 146 // J. W. Alexander, *Art and Progress* 3 (May 1912), p. 571; p. 572, discusses // B. B[urroughs], *MMA Bull.* 7 (July 1912), p. 135 // *George A. Hearn Gift to the Metropolitan Museum of Art . . .* (1913), ill. p. 71 // *Scribner's* 58 (Sept. 1915), p. 388 // Carnegie Institute, Pittsburgh, *Alexander Memorial Exhibition*, cat. by J. W. B[eatty] (1916), p. 60, misdates it 1908, gives title as Study in Green and Black in a list of paintings by Alexander // E. V. Lucas, *Ladies' Home Journal* 43 (July 1926), color ill. p. 17.

Alexander, *The Ring*.

tinued to specialize in this subject, a sentimentalized example of which is *The Ring*, painted almost two decades later. A woman is seated by a window; sunlight streaming through the filmy curtains illuminates her chin, neck, shoulders, and hand. The ring which she holds is clearly the most suggestive detail in the picture, and the spectator's attention is drawn to it by the woman's downcast gaze, the brilliant highlight on her forearm and hand, and the window jamb and curtain, which are directly above her head. The model's deflated posture implies some kind of personal disappointment or uneasiness connected with the ring. Although sentimental, the painting displays Alexander's careful sense of design. The critic John C. Van Dyke noted in 1919 that "the round hat somehow suggests a repetition of the round head, and the dress lines repeat its curves. Great care is taken with the linear arrangements. . . . The composition is carefully thought out, wrought out, brought out."

The pigments are thinly applied so that the canvas support contributes subtle variations to the surface texture.

Oil on canvas, 48¾ × 36⅜ in. (123.8 × 92.4 cm.).

Signed and dated at lower left: John W. Alexander / 1911.

REFERENCES: M. H. Greims to G. H. Hearn, letter in MMA Archives, May 6, 1912, offers to give it to MMA in memory of Arthur H. Hearn // B. B[urroughs], *MMA Bull.* 7 (July 1912), ill. p. 125; p. 135, discusses // F. Weitenkampf, *Bulletin of the New York Public Library* 19 (July 1915), p. 539; ill. opp. p. 540 // *Scribner's* 58 (Sept. 1915), p. 388 // *American Magazine of Art* 7 (July 1916), ill. p. 362 // J. C. Van Dyke, *American Painting and Its Tradition* (1919), p. 229; pp. 230–231, discusses its design (quoted above); ill. opp. p. 230.

EXHIBITED: NAD, Winter, 1911, no. 331, as The Ring // PAFA, 1912, no. 439.

EX COLL.: Mary Hearn Greims, Ridgefield, Conn., by 1912; with her father George A. Hearn, New York, as agent, 1912.

Gift of Mary Hearn Greims, in memory of Arthur Hoppock Hearn, 1912.

12.90.

EXHIBITED: Albright Art Gallery, Buffalo Fine Arts Academy, 1906, no. 4, as Study in Black and Green; ill. p. 9 // PAFA, 1907, no. 168 // Carnegie Institute, Pittsburgh, 1907, no. 10 // NAD, 1908, no. 268.

Ex COLL.: with George A. Hearn, New York, as agent, 1908.

George A. Hearn Fund, 1908.

08.139.1.

The Ring

Alexander achieved his first international success as an artist in Paris during the early 1890s with a series of elegant figure paintings of idealized women in interior settings. He con-

KENYON COX

1856–1919

Best known as a muralist, Kenyon Cox was also a painter of landscapes, portraits, and figure studies, as well as an art critic and teacher. He was born in Warren, Ohio, the son of Major Jacob D. Cox, later governor of that state. Having suffered a serious childhood illness, he remained in somewhat delicate health for much of his life. During the early 1870s, he studied at the McMicken School of Design (now the Art Academy of Cincinnati) and also drew and read independently. Cox went to Philadelphia in 1876 and enrolled in the Pennsylvania Academy of the Fine Arts, where THOMAS EAKINS and Christian Schussele (1824 or 1826–1879) were teaching. The following year he began his studies in Paris under Emile Auguste Carolus-Duran. Soon after, however, he attended the Ecole des Beaux-Arts, first in Alexandre Cabanel's class and then Jean Léon Gérôme's. He supplemented this training with work at the Académie Julian. His works were exhibited at the Paris Salon between 1879 and 1882 and in New York at the Society of American Artists beginning in 1882, when he was elected a member.

Cox returned to America in 1882 and, following a brief visit to Ohio, he settled in New York. Two years later he began to exhibit at the National Academy of Design and joined the faculty of the Art Students League where he was an instructor until 1909. During the 1880s, he painted mostly landscapes and nudes in landscapes. He also illustrated Dante Gabriel Rossetti's " The Blessed Damozel " in 1886, and thereafter did illustrations for such magazines as *Harper's Weekly* and *Scribner's Magazine*. In 1892, he married his talented pupil Louise Howland King (1865–1945), a figure painter who specialized in children's portraits. Cox purchased a summer home in 1897 in Windsor, Vermont, not far from the artists' colony at Cornish, New Hampshire, frequented by his friends THOMAS DEWING and the sculptor Augustus Saint-Gaudens. In 1900, he was elected an associate of the National Academy and three years later became an academician.

Cox produced a number of important murals during the 1890s. He was among the many artists who decorated the Manufactures and Liberal Arts Building for the World's Columbian Exposition. He painted a lunette beneath the dome of the Sculpture Hall of the Walker Art Building at Bowdoin College in Maine and completed two others for the Library of Congress and a frieze of symbolic figures for the Appellate Court Building in New York. After 1900, he developed a confident, urbane mural style, examples of which include his work at the Essex County Courthouse in Newark, New Jersey, the Luzerne County Courthouse in Wilkes-Barre, Pennsylvania, and the Public Library in Winona, Minnesota. He also designed a decorative sculpture, *Greek Science*, 1907–1909, for the Brooklyn Institute of Arts and Sciences. His easel paintings from this period, such as *Tradition*, 1916 (Cleveland Museum of Art), show the influence of his decorative work in the choice of allegorical and classical themes, the idealization of the human figure, and the concern for accurate draftsmanship and well-structured compositions.

Cox began writing art criticism during his student years in Paris. He contributed articles to newspapers and periodicals during the 1880s and 1890s and later became an articulate

spokesman for the traditional in art. "In these days all of us, even Academicians, are to some extent believers in progress. Our golden age is no longer in the past, but in the future," he noted in a lecture given in New York on December 13, 1912. "Having come so far, we are sometimes inclined to forget that not every step has been an advance. . . . The race grows madder and madder. It is hardly two years since we first heard of 'Cubism' and already the 'Futurists' are calling the 'Cubists' reactionary. . . . But while we talk so loudly of progress in the arts we have an uneasy feeling that we are not really progressing" (*Century*, n.s. 64 [May 1913], p. 39). Cox wrote critical reviews of exhibitions and articles on contemporary artists like WINSLOW HOMER, WILLIAM MERRITT CHASE, Saint-Gaudens, and Paul Manship. He also wrote on Raphael, Michelangelo, Veronese, and Holbein and delved into such issues as the relationship between the artist and the public and classic versus modern trends in art. His books include *Old Masters and New* (1905), *Painters and Sculptors* (1907), *The Classic Point of View* (1911), *Artist and Public and Other Essays on Art Subjects* (1914), and *Concerning Painting: Considerations Theoretical and Historical* (1917).

BIBLIOGRAPHY: Kenyon Cox Papers, Avery Library, Columbia University, New York, an extensive collection of the artist's letters and notes // William A. Coffin, "Kenyon Cox," *Century* 41 (Jan. 1891), pp. 333–337 // Kenyon Cox, "Puvis de Chavannes," and "Paul Baudry," in John C. Van Dyke, ed. *Modern French Masters: A Series of Biographical and Critical Reviews* (New York, 1896), pp. 15–28 (includes a biographical note on Cox by the editor); pp. 59–70. Articles on French artists written by Cox // Minna C. Smith, "The Work of Kenyon Cox," *International Studio* 32 (July 1907), pp. i–xiii // Edwin H. Blashfield, *Commemorative Tribute to Kenyon Cox, Read in the 1919 Lecture Series of the American Academy of Arts and Letters* (New York, 1922).

Landscape

By the mid-1880s, Cox was convinced that his future reputation depended on figure paintings rather than landscapes. "As to landscape," he wrote to his father Jacob Dolson Cox from New York, "you know that I have no ability whatever to paint it except directly from nature—. . . . I find that no one here takes my landscape seriously—. . . . my figure pictures, if they are not liked, at least command attention, while my landscapes are scarcely looked at" (June 3, 1884, Kenyon Cox Papers, Avery Library, Columbia University).

Dated 1883, this landscape was probably painted in the summer, possibly in Ohio, when Cox visited his family there, or in Pennsylvania, where he vacationed at the farm of a friend. Like *Flying Shadows*, also 1883 (Corcoran Gallery of Art, Washington, D.C.), it is painted from an elevated vantage point, and Cox has concentrated on the mass and form of the landscape rather than on picturesque details. "In his pictures," wrote WILLIAM COFFIN, "are broad stretches of meadow, round, well-foliaged trees, and simple skies with cloud masses well-drawn and in harmony of line with the land" (*Century* 41 [Jan. 1891], p. 337).

Until its presentation to the Metropolitan, the painting remained in the possession of the family of General Emerson Opdycke and his wife Lucy Stevens Opdycke, whose only child, Leonard, was a close friend of the artist. Cox also painted a number of portraits of the Opdycke family.

At some point, the canvas was reduced at the bottom by two inches (now folded behind the stretcher) and signed a second time.

Oil on canvas, 16 × 30 in. (40.6 × 76.2 cm.).
Signed and dated at lower left: KENYON COX—1883.
REFERENCES: L. E. Opdycke to A. F. Jaccaci, May 15, 1914, August Jaccaci Papers, D 119, Arch. Am. Art, invites him to see the artist's "best landscape" at his mother's home // K. Cox to L. Opdycke, May 18, 1914, Kenyon Cox Papers, Avery Library, Columbia University, includes it in a list of his "best things" for a potential retrospective exhibition // M. E. Peltz, letters in MMA Archives, July 24, 1925, gives prove-

Cox, *Landscape*.

nance and identifies scene as Ohio; July 1975, discusses the Opdyckes's relationship with the artist; August 1, 1975, says that the size of the painting was probably reduced to match another picture hanging in the owner's home; August 15, 1975, added information about provenance.

Ex coll.: Mrs. Emerson Opdycke, New York, by 1914–1922; her grandchildren, Mrs. John DeWitt Peltz, New York, and Leonard Opdycke, Boston, 1922–1964.

Gift of Leonard Opdycke, 1964.

64.221.

Augustus Saint-Gaudens

Kenyon Cox and the sculptor Augustus Saint-Gaudens (1848–1907) first met in Paris in the 1870s and later became close friends. Following Saint-Gaudens's death in 1907, Cox, who had portrayed him a number of times, wrote of his magnetic appearance:

No one who ever came in contact with him, no one who ever saw his portrait, can have missed one of his dominating characteristics, a fiery and compelling energy. That extraordinary head, with its heavy brow beetling above the small but piercing eyes, its crisp and wiry hair, its projecting jaw and great, strongly modelled nose, was alive with power (*Architectural Record* 22 [Oct. 1907], p. 249).

Dated 1908, this portrait is a replica of Cox's 1887 painting, which was destroyed by a fire in Saint-Gaudens's studio in 1904. The replica is larger than the original and lacks its prominent

inscription: "AVGVSTVS SAINT GAVDENS SCVLPTOR· / IN HIS FORTIETH YEAR· / PAINTED BY KENYON COX·1887·" It shows Saint-Gaudens in his 36th Street studio modeling a relief portrait of WILLIAM MERRITT CHASE, 1888 (Am. Acad. of Arts and Letters). Behind the easel rests the scaffolding for Saint-Gaudens's *Shaw Memorial*. To the sculptor's left hangs a solar print of one of his caryatids for the Vanderbilt mantelpiece, 1887 (MMA), and on the back wall are two of his portrait reliefs, a bronze *Homer Saint-Gaudens*, 1882 (marble copy in MMA), and a plaster *Sarah Redwood Lee*, 1882 (Mount Saint Mary's College, Emmitsburg, Md.). On a pedestal behind the sculptor's extended arm stands a plaster cast of the Renaissance *Femme Inconnue* (Louvre), a reminder of both artists' interest in Renaissance art. Cox actually compared the Vanderbilt caryatids to this particular statue in an article. "They are not goddesses, but *women*, alike yet different, each, one feels, with her own character, her own virtues, and perhaps, her own faults." "Here, then," he wrote, "is the note of the Renaissance, the love of individuality, and its complement in the manner of the execution is equally present" (*Century*, n.s. 13 [Nov. 1887], p. 34).

It was common practice in the late nineteenth century for artists to exchange portraits of each other, a well-known example being Chase's portrait of JAMES MC NEILL WHISTLER (q.v.). Most likely the original Cox portrait of Saint-Gaudens was part of such an exchange; two years after it

was painted, the sculptor reciprocated with a bas-relief of Cox (coll. Mr. Allyn Cox, Essex, Mass.). Cox portrays Saint-Gaudens in the sculptor's own style. Imitating his subject's distinctive mode of relief portraiture, Cox shows him in profile with his features strongly defined against a flat background. The scumbled paint surfaces of the background, which capture light and atmospheric effects, are not unlike the mottled grounds of Saint-Gaudens's reliefs. The neutral palette—warm golden beiges, creamy whites, and delicate pinks—recall the materials of Saint-Gaudens's art, plaster, bronze, and marble. In addition, the inscription that Cox put on the original painting copies the mannered inscriptions on the sculptor's portraits. Like Saint-Gaudens, Cox integrated the inscription into the composition, using it to fill an otherwise empty space and to establish a visual relationship with the subject who stands directly beneath it. Finally, Cox carries the idea of artists portraying artists further by depicting Saint-Gaudens modeling a portrait of the painter William Merritt Chase. Cox cleverly places Saint-Gaudens in the same pose that the sculptor chose for Chase. Thus Cox depicts Saint-Gaudens portraying Chase, who reaches out into space to work on an unseen painting.

Cox undertook the replica of the lost portrait with the understanding that it would be presented to the Metropolitan on the occasion of the Saint-Gaudens memorial exhibition in 1908. As early as November 23, 1907, the sculptor Daniel Chester French, chairman of the committee organizing the memorial exhibition, wrote to the committee's treasurer, Frederick S. Wait, suggesting that a patron be found to finance the portrait. French had already discussed the matter with Cox, who responded that "he could paint another nearly as successful from the material that he has and from memory." Then on February 15, 1908, August F. Jaccaci, who had apparently organized a subscription to pay for the work, wrote to the Metropolitan, offering it for the permanent collection on behalf of "a group of friends and admirers of the sculptor."

Cox was at work on the portrait by January 10, 1908. "I am hoping to begin painting on the St. Gaudens portrait tomorrow . . . it is all drawn in and rubbed in with transparent color and looks like an Orchardson!" he wrote to Jaccaci, comparing his limited palette to that of the popular British academician. "I really believe I can make a finer thing of it than the original—however, it lacks the documentary character of a thing from life. I know infinitely more about painting than I did twenty years ago," he concluded.

The Metropolitan's collection also includes a half-length portrait of Saint-Gaudens by Ellen Emmet Rand (1876–1941), dated 1908, and a sculpted head by John Flanagan, begun in 1905.

Oil on canvas, 33½ × 47⅛ in. (85.1 × 119.7 cm.).
Signed and dated at lower right: KENYON COX–1908. Signed, inscribed, and dated on the back: Portrait of Augustus Saint-Gaudens, by Kenyon Cox– / Original Painted, 1887– / Burned 1904– / This Replica Painted, 1908.
RELATED WORK: *Augustus Saint-Gaudens*, oil on canvas, 1887, destroyed 1904, ill. in H. Saint-Gaudens, *The Reminiscences of Augustus Saint-Gaudens* (1913), 2, frontis.

Engraving of destroyed 1887 portrait, from *The Reminiscences of Augustus Saint-Gaudens* (1913).

x, *Augustus Saint-Gaudens.*

REFERENCES: D. C. French to F. S. Wait, Nov. 23, 1907, MMA Archives, proposes portrait for the Saint-Gaudens memorial exhibition (quoted above) // K. Cox to A. F. Jaccaci, Jan. 10, 1908, August F. Jaccaci Papers, D119, Arch. Am. Art, states that he has drawn it in (quoted above) and plans on painting it for the next three days; discusses frame and its plaque // Jaccaci, letter in MMA Archives, Feb. 15, 1908, offers it to MMA (quoted above) // Cox to Jaccaci, April 12, 1908, August F. Jaccaci Papers, D119, Arch. Am. Art, writes "I am glad you liked the portrait which I think, myself, a work that I may be content to rest my reputation on as far as that side of my art is concerned. Of course, I should be very glad to have something of a more decorative and classical type in the Museum— let us hope that may come" // Cox, letter in MMA Archives, April 26, 1908, notes that it is loose in frame and proposes varnishing it; receipt, June 3, 1908, records a ten dollar payment toward its subscription // Cox to L. Mechlin, May 24, 1909, Philadelphia Museum of Art, discusses // Cox to L. Opdycke, May 18, 1914, Kenyon Cox Papers, Avery Library, Colum-bia University, includes it in a list of his "best things" for a potential retrospective exhibition // Art Digest 15 (Nov. 1, 1940), ill. p. 7 // L. H. Tharp, Saint-Gaudens and the Gilded Era (1969), ill. p. 336 // J. H. Dryfhout, Saint-Gaudens National Historical Site, letters in Dept. Archives, July 1, August 12, 1975, verifies identification of objects included in it, gives information about the relationship between Cox and Saint-Gaudens, provides a list of other portraits of the sitter.

EXHIBITED: MMA, 1908, Catalogue of a Memorial Exhibition of the Works of Augustus Saint-Gaudens, no. 128, includes a statement signed by Cox that identifies the objects in the portrait and discusses the original // Corcoran Gallery of Art, Washington, D.C., 1908–1909, no. 188 // Art Institute of Chicago, 1909, no. 63 // John Herron Art Museum, Indianapolis, 1909–1910, Catalogue of Sculptured Works of Augustus Saint-Gaudens, no. 127 // College Art Association, traveling exhibition, 1934, Memorial Exhibition, American Painters since 1900, no. 32 // Union League Club, New York, 1935, An Exhibition of Paintings by American Artists, no. 9 // MMA, 1939, Life in America, no. 253 // Carnegie Institute, Pittsburgh, 1940, Survey of American Painting, no. 165 // MMA, 1950, 20th Century Painters, p. 4 // Brooklyn Museum, 1957–1958, Face of America, no. 77 // National Portrait Gallery, Washington, D.C., 1968, This New Man, ill. p. 55 and discusses // MMA, 1973, Augustus Saint-Gaudens (no cat.).

ON DEPOSIT: Federal Reserve Bank, New York, 1973–1974.

Gift of Friends of the Sculptor (through August F. Jaccaci), 1908.

08.130.

Cox, *The Harp Player*.

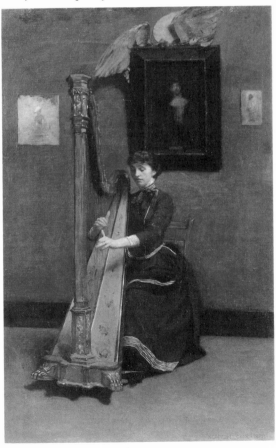

The Harp Player (A solo)

Dated 1888, the picture shows a young woman playing an Erard double-action harp. She assumes the proper hand position for her instrument and plays without a score, which suggests that she may be a professional musician rather than simply an artist's model. The setting has not been identified, but the presence of some paintings and artistic props suggests that this might be an artist's studio. During the 1880s, Cox, a great enthusiast of opera and classical music, often attended concerts in the studio of his friend Augustus Saint-Gaudens. It seems likely that these popular gatherings inspired the artist to undertake this subject, a clear departure from his more typical allegorical themes. The contemplative woman playing a musical instrument is a subject more often associated with Cox's friends THOMAS DEWING, J. ALDEN WEIR, and Saint-Gaudens.

The painting was once in the collection of WILLIAM MERRITT CHASE.

Oil on canvas, 30 × 17⅞ in. (76.2 × 45.4 cm.).

Signed and dated at lower right: KENYON COX–1888–. Signed, dated, and inscribed on reverse: THE HARP-PLAYER / A SOLO [crossed out] / by KENYON COX / 145 W–55th St. / NEW YORK– / 1888–.

REFERENCES: *Art Age* 8 (Dec. 1889), p. 92, says that the figure is "uninteresting in countenance," but that the action of the hands is "well suggested" and her surroundings are "all in good harmony" // M. C. Smith, *International Studio* 32 (July 1907), p. xi, states that it came into Chase's possession within the past year or two, was exhibited at the National Academy, and that "painters contemporary with Mr. Cox have been accustomed to consider [it] his best painting" // American Art Association, New York, *Illustrated Catalogue of the Valuable Paintings and Water Colors Forming the Private Collection of William Merritt Chase* (1912), sale cat., no. 150, discusses it // K. Cox, letter in MMA Archives, March 27, 1912, mentions it // B[urroughs], *MMA Bull.* 6 (May 1912), ill. p. 102, discusses // K. Cox to L. Opdycke, May 18, 1914, Kenyon Cox Papers, Avery Library, Columbia University, includes it in a list of his "best things" for a potential retrospective exhibition // L. Libin, Musical Instruments, MMA, memo in Dept. Archives, July 8, 1975, identifies the harp.

EXHIBITIONS: NAD, Autumn, 1888, no. 133, as A Solo // PAFA, 1891, no. 48 // Pan-American Exposition, Buffalo, N.Y., 1901, no. 635 // Art Institute of Chicago, 1911, *Exhibition of Paintings, Decorations and Drawings by Kenyon Cox*, no. 10, as The Harp-player, lent by Mr. Wm. M. Chase, New York.

EX COLL.: William Merritt Chase, New York, by 1907 (sale, American Art Association, New York, March 8, 1912, no. 150, as The Harp Player, $575).

Rogers Fund, 1912.

12.40.

JOHN SINGER SARGENT

1856–1925

Born in Florence of American parents, Sargent received his first formal art instruction in Rome in 1868 and attended the Accademia delle Belle Arti in Florence. In 1874 he entered the Paris atelier of the portraitist Emile Auguste Carolus-Duran. Following Carolus-Duran's instructions to paint directly from observation, retaining only the salient features and expressing the maximum by means of the minimum, Sargent developed the direct, economical approach, based on observation, and the brilliant handling of paint that characterized his style. His study of the paintings of Velázquez and Hals on visits to Spain and Holland in 1879 and 1880 also influenced his development. At the age of twenty-one, Sargent first exhibited at the Paris Salon. In the late 1870s his genre scenes and portraits of Parisian society brought him success, but the controversy following the exhibition of *Madame X* (q.v.) at the Paris Salon of 1884 marked the end of his Parisian career, and in 1886 he moved to London. Soon recognized internationally as one of the foremost portraitists of the time, he continued to satisfy growing demands for portraits from the great and fashionable.

Throughout his career he made many trips to America, the first in 1876. By 1890, he had begun work on mural decorations for the Boston Public Library. He devoted much of the next twenty-five years to this project, choosing as his subject the development of Western religion. Additional commissions for murals followed: the Rotunda of the Museum of Fine Arts, Boston (1916); the staircase leading to the Rotunda of the Museum of Fine Arts (1921); and two panels for Widener Memorial Library, Harvard University (1922).

In 1897 Sargent was elected an academician at the National Academy of Design in New York and the Royal Academy in London and was made an officer of the Legion of Honor in France. By 1909, when he had painted almost five hundred portraits, Sargent's growing dissatisfaction with the restrictions and demands of portraiture led him to virtually abandon portrait painting. Watercolor became his favorite medium, and his brilliant works demonstrate a complete command of this medium. The Metropolitan Museum owns an important collection of over four hundred of his drawings and watercolors, ranging in subject and date from minor sketches done during his childhood to watercolors executed on the battlefields during World War I. Sargent died in London in 1925, the most acclaimed American artist of his generation.

BIBLIOGRAPHY: William Howe Downes, *John S. Sargent: His Life and Work* (Boston, 1925). Includes a list of honors, medals, and awards, an annotated list of works, and a bibliography // Evan Charteris, *John Sargent* (New York, 1927). Reprint. Detroit: Tower Books, 1971. Includes many quotations from Sargent and his contemporaries, publishes Vernon Lee's "J. S. S.: In Memoriam," provides a list of Sargent's oils, noting exhibitions and owners, and is indexed // "John Singer Sargent," *Index of Twentieth Century Artists* 2 (Feb. 1935), pp. 65–80; (March 1935), pp. 81–86; suppl. nos. 5–6. Reprint ed. with cumulative index. New York: Arno Press, 1970, pp. 331–352, 362–364. Gives biography, awards, honors, affiliations, collections where represented, exhibitions, and lists reproductions of major works. Provides most complete bibliography on the artist // Charles Merrill Mount, *John Singer Sargent: A Biography* (New York, 1955). Reprint ed. with revised catalogue. New York: Kraus Reprint Co., 1969. Biography with a catalogue of Sargent's oil paintings, indexed // MFA, Boston, *Sargent's Boston*, exhib. cat. by David McKibbin (Boston, 1956). Includes an essay, biographical summary, and an invaluable checklist of Sargent's portraits.

Sargent, *A Male Model Standing before a Stove.*

A Male Model, Standing before a Stove

The human figure and the study of its anatomy and expressive possibilities formed the core of French academic art education during the final quarter of the nineteenth century. Sargent's oil sketch of a male nude was probably executed during the late 1870s, his student years in Paris. After his arrival in the French capital in May 1874, he spent two years in the private atelier of Carolus-Duran, a popular teacher whose American students then included J. CARROLL BECKWITH, WILL H. LOW, and Frank Fowler (1852–1910). This study fulfills the criteria propounded by his French teacher: a realistic portrait and a total compositional impression created by the use of contrasting tones broadly applied with little concern for linear detail. Like other Parisian students of the period, Sargent would have begun painting the figure after mastering the academic drawing style and copying the works of the old masters. Academic practice usually required the student to begin with an oil sketch of a head worked in a limited range of pigments, usually earth colors. *A Male Model*, hesitantly executed

in just such a palette, would have represented the next step in the artist's academic progress, the full figure.

Sargent supplemented his studies with Carolus-Duran by enrolling in the Ecole des Beaux-Arts and painting independently both in his studio and outdoors in the French countryside. The studio depicted in this picture, which shows a model posed in front of a stove and some other sketchily rendered studio contents, has not been identified, although its scale and character suggest a private atelier rather than a formal academic setting.

Oil on canvas, 28 × 22 in. (71.1 × 55.9 cm.).
REFERENCES: Christie, Manson & Woods, London, *Catalogue of Pictures and Water Colour Drawings by J. S. Sargent and Works by Other Artists* . . ., sale cat., July 24 and 27, 1925, annotated copy in MMA Library, p. 28, no. 199, lists price and purchaser // *Art News* 23 (August 15, 1925), p. 4, lists price and purchaser // E. Charteris, *John Sargent* (1927; 1971), p. 295, includes it in a list of Sargent's undated oils and says it was no. 199 in the Sargent sale // Dallas Museum of Fine Arts, *Four Centuries of European Painting . . . on Loan to the Museum from the Collections of the Marquess and Marchioness of Amodio* . . . (1951), unpaged, includes it in a list of works on loan to the museum from the Amodio collection but not in the exhibition // C. M. Mount, *John Singer Sargent* (1955; 1969), p. 479, lists it as Male Model: 5 (Standing before a stove), undated, in catalogue of Sargent oils (no. XK6 in early editions), gives information about the Sargent sale (1925) and says that the painting is untraced // Marquis de Amodio, letters in Dept. Archives, n.d., Dec. 15, 1971, Feb. 26 and March 15, 1976, gives information about its provenance // D. McKibbin, letter in Dept. Archives, Feb. 25, 1976, dates it from the late 1870s, "when Sargent was still working in the Paris ateliers," says that the model is not identifiable // J. Lunsford, Dallas Museum of Fine Arts, letter in Dept. Archives, April 6, 1976, gives information about its loan to the Dallas Museum.
ON DEPOSIT: Dallas Museum of Fine Arts, 1949–1972, lent by the Marquis de Amodio.
EX COLL.: the artist, until 1925 (sale, Christie, Manson & Woods, London, July 27, 1925, no. 199, as A Male Model, standing before a stove, 27½ by 22 in.); with Smith, London; Marquis de Amodio, London, 1925–1934; his son, Marquis de Amodio, Geneva, 1934–1972.
Gift of the Marquis de Amodio, O.B.E., 1972.
1972.32.

Gitana

In October 1876, Sargent and his family arrived in Paris after his first trip to America.

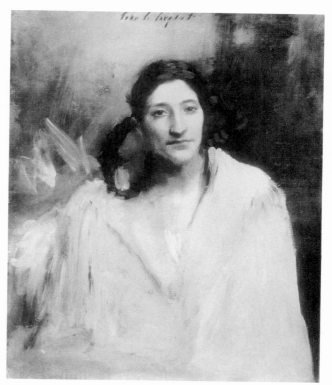

Sargent, *Gitana*.

On his return, he painted *Gitana*, a portrait study in which he has sensitively rendered the facial features of his model. Dramatically illuminated and surrounded by the bright, summarily suggested elements of her costume, she is placed in a somber, richly colored setting. Although the subject has variously been called an American Indian and a gypsy, the latter identification seems more likely.

During the mid-1890s, the painting appeared in a photograph showing the Parisian studio of the figure painter Alfred Philippe Roll, and it seems that this French artist owned the painting at the time the photograph was taken.

Oil on canvas, 29 × 23⅝ in. (73.7 × 60 cm.).
Signed at upper center: John S. Sargent.
REFERENCES: G. Mourey, *Studio*, special winter no. (1896–1897), ill. p. 28, shows it in the studio of A. P. Roll // *George A. Hearn Gift to the Metropolitan Museum of Art* . . . (1913), ill. p. 70 // W. H. Downes, *John S. Sargent* (1925), p. 120, includes it in catalogue of Sargent oils, lists exhibitions, describes the sitter as a gypsy, dates it 1876 // *Index of Twentieth Century Artists* 2 (Feb. 1935), p. 77, lists reproductions // E. Charteris, *John Sargent* (1927; 1971), p. 43, says it was painted in Paris in the autumn of 1876; p. 280, includes it in a list of Sargent oils, gives exhibitions // D. McKibbin, letter in Dept. Archives, March 25,

Sargent, *Studies of a Dead Bird.*

1949, says that it appeared in an illustration of Roll's studio in *Studio* (1896–1897) // C. M. Mount, *John Singer Sargent* (1955; 1969), p. 458, includes it as An American Indian (called "Gitana") in catalogue of Sargent oils (no. 761 in early editions), dates it 1876 among other works painted at sea and in America // E. Clare, M. Knoedler and Co., New York, letter in Dept. Archives, Jan. 5, 1967, provides information about its provenance.

Ex COLL.: probably Alfred Philippe Roll, Paris, by 1896; with J. Chaine and Simonson, Paris, 1909; with M. Knoedler and Co., New York, 1909; George A. Hearn, New York, 1909–1910.

Gift of George A. Hearn, 1910.
10.64.10.

Studies of a Dead Bird

Throughout his career, Sargent observed, drew, and painted birds and such animals as goats and cattle. Traditionally dated 1878, this unfinished sketch is a study of a specimen arranged in two positions: in the upper left, the bird is in flight, its body raised and its wings held in an extended position by two props—devices used by naturalist-artists in an attempt to dupli- cate the natural position of flight—and in the

lower right, the bird is resting on the ground without the benefit of these supports.

The summary character of this sketch makes it difficult to identify the bird with assurance. Its shape and proportions suggest that it is a species of European sparrow, but its face pattern is similar to that of the titmouse, or chickadee as it is called in the United States.

Oil on canvas, 20 × 15 in. (50.8 × 38.1 cm.).
REFERENCES: C. M. Mount, *John Singer Sargent* (1955; 1969), p. 459, includes it as Two Studies of a Bluebird in catalogue of Sargent oils (no. K7810 in early editions), dates it 1878, at sea and in America // R. L. Plunkett, National Audubon Society, letter in Dept. Archives, June 10, 1976, discusses the possible species of the bird.
Ex COLL.: the artist's sister Violet (Mrs. Francis Ormond), London, until 1950.
Gift of Mrs. Francis Ormond, 1950.
50.130.23.

A Group of Sketches from the Trip to Spain and Morocco, 1879–1880

During the winter of 1879–1880, Sargent visited Spain, a trip that was to have a great impact on his style and subject matter during the early 1880s. As his teacher Carolus-Duran was a great enthusiast of Velázquez, it is not surprising that Sargent made at least a dozen oil copies after this artist's work in the Prado. He also produced more informal works, such as the three tonal sketches in this group: *Spanish Land-scape*, *The Balcony, Spain,* and *A Spanish Madonna.* After no more than a month in Madrid, he left for Gibraltar with two French artists and then went on to Tangier in January. "We have rented a little Moorish house (which we don't yet know from any other house in the town, the little white tortuous streets are so exactly alike) and we expect to enjoy a month or two in it very much," Sargent wrote to his friend Ben del Castillo on January 4, 1880.

The patio open to the sky affords a studio light, and has the horseshoe arches, arabesques, tiles and other traditional Moorish ornaments. The roof is a white terrace, one of the thousand that forms this odd town, sloping down to the sea. All that has been written and painted about these African towns does not exaggerate the interest of at any rate, a first visit (quoted in E. Charteris, *John Sargent* [1927; 1971], p. 50).

Here the artist produced a number of architec- tural vignettes that focus on the austere, geo- metric character of the local architecture and

222

Sargent, *Open Doorway, Morocco*.

thinly brushed areas with the wood surface often in evidence. The sketches, which remained in the artist's possession until his death, were among the works presented to the Metropolitan in 1950 by his sister Mrs. Francis Ormond.

White Walls in Sunlight, Morocco

Oil on wood, 10¼ × 13¾ in. (26 × 34.9 cm.).
Inscribed on reverse: *by J. S. Sargent*.
REFERENCE: C. M. Mount, *John Singer Sargent* (1955; 1969), p. 461, lists it as Courtyard with Moorish Door in catalogue of Sargent oils (no. K8028 in early editions), dates it 1880, North Africa.
50.130.4.

Open Doorway, Morocco

Oil on wood, 13⅞ × 10¼ in. (35.2 × 26 cm.).
Inscribed on reverse: *by J. S. Sargent*.
REFERENCE: C. M. Mount, *John Singer Sargent* (1955; 1969), p. 461, includes it as Open Doorway in catalogue of Sargent oils (no. K8027 in early editions), dates it 1880, North Africa.
50.130.5.

Courtyard, Tetuan, Morocco

Oil on wood, 10¼ × 13¾ in. (26 × 34.9 cm.).
Inscribed on reverse: *by J. S. Sargent*.
REFERENCE: C. M. Mount, *John Singer Sargent* (1955; 1969), ill. following p. 144; p. 461, includes it as Courtyard, Tetuan in catalogue of Sargent oils (no. K8026 in early editions), dates it 1880, North Africa.
50.130.6.

capture the brilliant North African light that had fascinated such artists as Eugene Delacroix and Gabriel Alexandre Decamps earlier in the century.

These studies are painted on thin wood panels, small in size and easily transportable. Paint application varies from broad, fluid impasto to

Sargent, *White Walls in Sunlight, Morocco*.

Sargent, *Courtyard, Tetuan, Morocco*.

Moorish Buildings on a Cloudy Day

Oil on wood, 10¼ × 13¾ in. (26 × 34.9 cm.).
Inscribed on reverse: *J. S. Sargent.*
REFERENCE: C. M. Mount, *John Singer Sargent* (1955; 1969), p. 461, includes it as Moorish House on Cloudy Day in catalogue of Sargent oils (no. K8029 in early editions), dates it 1880, North Africa.
50.130.7.

Spanish Landscape

Oil on wood, 10¼ × 13⅝ in. (26 × 34.6 cm.).
Inscribed on reverse: *by J. S. Sargent.*
REFERENCE: C. M. Mount, *John Singer Sargent* (1955; 1969), p. 461, lists it as Landscape with Hills in catalogue of Sargent oils (no. K8030 in early editions), dates it 1880, North Africa.
50.130.8.

Moorish Buildings in Sunlight

Oil on wood, 10¼ × 13⅞ in. (26 × 35.2 cm.).
Inscribed on reverse: *by. J. S. Sargent.*
REFERENCE: C. M. Mount, *John Singer Sargent* (1955; 1969), p. 461, lists it as Moorish Building in Sunshine in catalogue of Sargent oils (no. K8031 in early editions), dates it 1880, North Africa.
50.130.9.

The Balcony, Spain and Two Nude Bathers Standing on a Wharf

Oil on wood, 13¾ × 10¼ in. (34.9 × 26.7 cm.).
REFERENCE: C. M. Mount, *John Singer Sargent* (1955; 1969), p. 461, lists it as Balcony (on reverse) Two Nude Bathers Near Wharf in catalogue of Sargent oils (no. K8032 in early editions), dates it 1880, North Africa.
50.130.10.

A Spanish Madonna

There is an oil sketch in the Isabella Stewart Gardner Museum, Boston, showing the same or a similar statue and niche from a closer vantage point and without the crucifix.

Oil on wood, 13¾ × 10¼ in. (34.9 × 26 cm.).
RELATED WORK: *A Spanish Madonna,* oil on wood, 34 × 15 cm., Isabella Stewart Gardner Museum, Boston, ill. in P. Hendy, *European and American Paintings in the Isabella Stewart Gardner Museum* (1974), p. 227.
REFERENCE: C. M. Mount, *John Singer Sargent* (1955; 1969), p. 461, lists it as Madonna in a Festive Robe in a catalogue of Sargent oils (no. K8033 in

Sargent, *Moorish Buildings on a Cloudy Day.*

Sargent, *Spanish Landscape.*

Sargent, *Moorish Buildings in Sunlight.*

Sargent, *The Balcony, Spain.*

Sargent, *Two Nude Bathers Standing on a Wharf.*

Sargent, *A Spanish Madonna* (version in the Isabella Stewart Gardner Museum is on the right).

early editions), dates it 1880, and erroneously gives its location as North Africa.

50.130.11.

Ex COLL. (50.130.4–50.130.11): the artist's sister Violet (Mrs. Francis Ormond), London, 1925–1950.

Gift of Mrs. Francis Ormond, 1950.

Lady with the Rose (Charlotte Louise Burckhardt)

During the late 1870s and early 1880s, Sargent established his reputation as a portraitist in Paris and exhibited at the Salon, where he first displayed his work in 1877. Many of his portraits depicted fellow artists, family members, friends, and acquaintances. At this time, the artist was acquainted with Valerie Burckhardt and her younger sister, Charlotte Louise (1862–1892), daughters of the Swiss merchant Edward Burckhardt and his American wife, the former Mary Elizabeth Tomes. Between 1878 and 1885, he painted several portraits of the Burckhardt family, including a major double portrait of Charlotte Louise and her mother, 1885 (coll. Mr. and Mrs. Prescott N. Dunbar, New Orleans) and more informal portraits of Edward Burckhardt, 1880 (coll. Mrs. Francis B. Riggs, Cambridge, Mass.) and Valerie Burckhardt, 1878 (coll. Mrs. Hadden Fairburn, Essex, Conn.). By 1882, he had completed the full-length portrait of Charlotte Louise, which he dedicated to her mother and submitted to the Paris Salon as *Portrait de Mlle* ***.

In its realism and attention to detail, this portrait shows the influence of the French academic tradition and especially of Sargent's teacher Carolus-Duran. The sitter's features are well-drawn and sensitively handled, creating a direct, realistic impression. The artist has devoted equal attention to the tactile qualities of his subject's elegant black dress with its soft velvet, shimmering satin, and filmy net.

Probably at Carolus-Duran's suggestion, Sargent traveled to Madrid in the autumn of 1879 and made about a dozen copies of paintings by Velázquez. *Lady with the Rose* shows the impact that the seventeenth-century artist had on the development of Sargent's style. Using a similar palette, predominantly gray and black, but enlivened with occasional color accents, Sargent makes his subject life size, places her against an austere backdrop, and creates convincing light and atmospheric effects around her. The pose recalls a specific Velázquez composition, *Cala-*

bazas, ca. 1628–1629 (Cleveland Museum of Art), which would have been available for the artist's scrutiny in Paris during the 1870s and 1880s. Writing in *Harper's New Monthly Magazine* (Oct. 1887), the author Henry James, a friend of the artist, noted the similarities between Sargent and Velázquez and described the appeal that *Lady with the Rose* held for him:

The young lady, dressed in black satin, stands upright, with her right hand bent back, resting on her waist, while the other, with the arm somewhat extended, offers to view a single white flower. The dress, stretched at the hips over a sort of hoop, and ornamented in front, where it opens on a velvet petticoat, with large satin bows, has an old-fashioned air, as if it had been worn by some demure princess who might have sat for Velasquez. The hair, of which the arrangement is odd and charming, is disposed in two or three large curls fastened at one side over the temple with a comb. Behind the figure is the vague faded sheen, exquisite in tone, of a silk curtain, light, undefined, and losing itself at the bottom. The face is young, candid, peculiar, and delightful. Out of these few elements the artist has constructed a picture which it is impossible to forget, of which the most striking characteristic is its simplicity, and yet which overflows with perfection. Painted with extraordinary breadth and freedom, so that surface and texture are interpreted by the lightest hand, it glows with life, character, and distinction, and strikes us as the most complete—with one exception perhaps—of the author's productions. I know not why this representation of a young girl in black, engaged in the casual gesture of holding up a flower, should make so ineffaceable an impression, and tempt one to become almost lyrical in its praise; but I well remember that, encountering the picture unexpectedly in New York a year or two after it had been exhibited in Paris, it seemed to me to have acquired an extraordinary general value, to stand for more artistic truth than it would be easy to declare, to be a masterpiece of color as well as of composition, to possess much in common with a Velasquez of the first order, and to have translated the appearance of things into the language of painting with equal facility and brilliancy. The language of painting—that is the tongue in which, exclusively, Mr. Sargent expresses himself, and into which a considerable part of the public, for the simple and excellent reason that they don't understand it, will doubtless always be reluctant and unable to follow him. The notation of painting, as one may call it—the signs by which objects are represented—is a very special affair, and of the special the public at large has always a perceptible mistrust. Fortunately the spirit, the feeling, of this magnificent art is not special, but as general and comprehensive as life itself.

Charlotte Louise Burckhardt was married to an Englishman, Alfred Roger Ackerley, on September 24, 1889, in the Church of the Holy Trin-

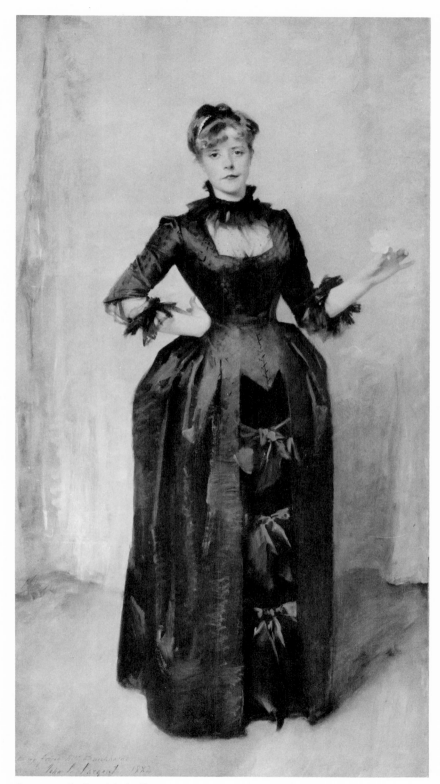

Sargent, *Lady with the Rose*.

ity, avenue de l'Alma in Paris. The newlyweds made a honeymoon trip through Europe, stopping in Basel, Lucerne, Flüelen, Lugano, Milan, and Venice, returning to Paris by way of Turin and Lyons. They spent the following winter at Wiesbaden in Germany. Unfortunately, Charlotte Louise became ill, perhaps with tuberculosis, and died about eighteen months later.

The portrait remained in the possession of the sitter's family until it was bequeathed to the museum in 1932 by her sister Valerie, Mrs. Harold F. Hadden.

Oil on canvas, 84 × 44¾ in. (213.4 × 113.7 cm.).
Signed, dated, and inscribed at lower left: To my friend Mrs. Burckhardt / John S. Sargent 1882.

REFERENCES: O. Merson, *Le Monde Illustré* 26 (May 27, 1882), p. 330, reviews it in the Paris Salon, describing its subject and commenting positively: "Eh bien, cette effigie est à souhait pour plaire. A la fois, elle a l'imprévu et la simplicité de l'attitude, le chois exquis de la coloration, la correcte souplesse du dessin et du modélé, le charme de la physiognomie, qui est jolie et douce, et, voilà le miracle, enveloppant le toute, mariant ensemble et le detail, l'unité de la facture dont les libres et franches ailures ne cachent aucun subterfuge, ne masquent aucune trahison envers la vérité" // *Courrier de l'art* 2 (June 22, 1882), pp. 292–293, mentions it as Portrait de Mlle *** in the Paris Salon // V. Champier, *Art Journal* [London] (July 1882), p. 218, discusses it on exhibition at Paris Salon // *New York Times*, March 25, 1883, p. 14, reviews it in the annual exhibition of the Society of American Artists, praising its "great animation" but criticizing it for "novelty in attitude" // C. Cook, *Art Amateur* 3 (May 1883), p. 124, discusses it in the annual exhibition of the Society of American Artists; ill. p. 125 // H. James, *Harper's New Monthly Magazine* 75 (Oct. 1887), p. 686, describes and comments on it (quoted above); p. 687 illustrates an engraving of it by F. French; p. 689 // *New York Tribune*, March 31, 1888, p. 4, incorrectly recalls it as being exhibited twelve years earlier // H. James, *Picture and Text* (1893), pp. 100–101, 104–105, 109, discusses it in a condensed version of his article in *Harper's*, incorrectly stating that it was exhibited at the Paris Salon in 1881 // *International Studio* 6 (Jan. 1899), p. x, mentions it in connection with Portrait of Mrs. Burckhardt and Her Daughter // M. H. Dixon, *Magazine of Art* 23 (Jan. 1899), p. 115, notes its "indebtedness to Velasquez," incorrectly notes its exhibition as 1881 // S. Isham, *History of American Painting* (1905; 1927), pp. 430–431 // J. W. McSpadden, *Famous Painters of America* (1907; 1916), pp. 285–286, discusses awkwardness of the pose // K. Cox, *Nation* 86 (Jan. 23, 1908), p. 88, says that the artist "has done more vigorous and more brilliant things since 1882, but never anything lovelier" // P. B[oswell], *American Art News* 22 (Feb. 23, 1924), p. 2 // L. Mechlin, *American Magazine of*

Art 15 (April 1924), ill. p. 168; p. 170, misidentifies the sitter as the artist's sister // *Current Opinion* 76 (April 1924), pp. 433–435, discusses it in Grand Central exhibition and quotes review by E. L. Cary in the *New York Times* // R. V. S. Berry, *Art and Archaeology* 18 (Sept. 1924), p. 87, incorrectly asserts exhibited twice in Paris, twice in London, and twice in United States; ill. p. 88 // W. Starkweather, *Mentor* 12 (Oct. 1924), p. 4, cites it as a notable example of Velázquez's influence; ill. p. 9 // MFA, Boston, *Memorial Exhibition Catalogue*, cat. by J. T. Coolidge (1925), p. viii, praises it // W. H. Downes, *John S. Sargent* (1925), p. 9, mentions it in connection with portraits of other members of this family; p. 12; p. 25, discusses James's admiration for it; p. 120, mentions it in connection with a portrait of Mrs. H. F. Hadden; pp. 127–128, includes it in catalogue of Sargent works as Miss Burckhardt ("Lady with a Rose"), gives collection as Mrs. Harold F. Hadden, lists exhibitions including an incorrect listing of the Paris Salon as 1881 and the Royal Academy, London, 1882 // J. Laver, *Portraits in Oil and Vinegar* (1925), p. 4; *Bookman's Journal* 12 (May 1925), p. 49 // J. B. Manson, *Studio* 90 (August 1925), ill. p. 80 // MMA, *Memorial Exhibition of the Work of John Singer Sargent*, cat. by M. G. Van Rensselaer (1926), p. xv // E. Charteris, *John Sargent* (1927; 1971), pp. 54–55, says incorrectly that it was exhibited as Mlle. L.P.; p. 258, includes it in list of Sargent oils as Lady with the Rose, misdates it 1881, incorrectly lists Paris, 1881, and London, 1882, exhibitions // F. J. Mather, Jr., *Estimates in Art*, 2nd ser. (1931), p. 240; p. 247, compares it to Madame X // H. B. Wehle, *MMA Bull.* 28 (Feb. 1933), p. 26, discusses it; ill. p. 29 // *Art Digest* 7 (March 1, 1933), ill. p. 8, misdates it 1881 // *Index of Twentieth Century Artists* 2 (Feb. 1935), p. 79, lists reproductions // C. M. Mount, *John Singer Sargent* (1955; 1969), p. 63, discusses the artist's relationship to the sitter; p. 433, includes it in a catalogue of Sargent's oils as Burckhardt, Louise (no. 823 in early editions), dates it 1882, Paris // MFA, Boston, *Sargent's Boston*, exhib. cat. by D. McKibbin (1956), p. 39, notes James's admiration for it; p. 87, includes it as Louise Burckhardt (Mrs. Roger Ackerley) in checklist of Sargent portraits, dates it 1882, gives provenance, incorrectly lists it in Royal Academy exhibition in 1882 // J. R. Ackerley, *My Father & Myself* (1968), p. 17, mentions it and gives biographical information on the sitter // R. Ormond, *John Singer Sargent* (1970), p. 27, compares it to Velázquez's Calabazas; ill. p. 36, shows both portraits, figs. 10, 11 // Mrs. H. Fairburn, letter in Dept. Archives, Dec. 6, 1975, says she possesses an undated letter from the artist regarding its possible exhibition and owns his portrait of Valerie Burckhardt // D. McKibbin, letter in Dept. Archives, March 31, 1976, gives biographical information on the sitter, mentions Hadden family scrapbook of clippings and letters about it.

EXHIBITED: Paris Salon, 1882, no. 2398, as Portrait de Mlle *** // Society of American Artists, New

York, 1883, no. 103, as Portrait of a Lady // PAFA, 1908, no. 108, as Lady with a Rose, lent by Mrs. Harold Farquhar Hadden // Grand Central Art Galleries, New York, 1924, *Retrospective Exhibition of Important Works of John Singer Sargent*, no. 2, as The Lady with the Rose—My Sister, lent by Mrs. Hadden // MFA, Boston, 1925, *A Catalogue of the Memorial Exhibition of the Works of the Late John Singer Sargent*, no. 18, as Lady with the Rose, lent by Mrs. Harold Farquhar Hadden.

EX COLL.: Mary Elizabeth Burkhardt, Paris, 1882–died 1899; her daughter Valerie (Mrs. Harold Hadden), New York, by 1908–until 1932.

Bequest of Mrs. Valerie B. Hadden, 1932.

32.154.

Madame X (Madame Pierre Gautreau)

Virginie Avegno (1859–1915) was born in Louisiana, the daughter of Major Anatole Avegno of New Orleans, a gentleman whose family had emigrated from Camugli, Italy, and Marie Virginie de Ternant of Parlange Plantation, Louisiana. After Major Avegno died from wounds received at the battle of Shiloh, Mrs. Avegno took her two daughters to Paris. There Virginie became a celebrated beauty and the wife of the Parisian banker Pierre Gautreau. Sargent probably met her in 1881, perhaps through his friend Ben del Castillo, a Cuban-American who was her cousin. In 1882 the artist wrote: "I have a great desire to paint her portrait and have reason to think she would allow it and is waiting for someone to propose this homage to her beauty." Sargent worked on the portrait at the Gautreaus' country home, Les Chênes Paramé, in Brittany, in the summer of 1883. In a letter to his friend Vernon Lee, he reported that he was "struggling with the unpaintable beauty and hopeless laziness of Mᵉ G" (Charteris, 1927). He had difficulties both in selecting the pose and in executing the painting. There are pencil studies showing Madame Gautreau seated on a sofa (MMA) or kneeling on it (private coll., Paris), a watercolor of Madame Gautreau seated with some papers in her lap (Fogg Art Museum, Cambridge, Mass.), and an oil sketch of Madame Gautreau drinking a toast (Isabella Stewart Gardner Museum, Boston), which suggest some of the compositional possibilities the artist explored before he decided on the full-length standing pose. Most of these preliminary sketches, including a bust-length view in the Metropolitan's collection, focus on the sitter's most salient feature, a striking profile,

which Sargent captured particularly well in a number of drawings of her head.

In the standing pose of the final painting, Madame Gautreau appears in profile with a crescent-moon headdress, attribute of Diana, goddess of the hunt. The exhibition of this portrait as *Portrait de Mme* *** at the Paris Salon of 1884 and its reception by the public and press—who were scandalized by the notoriety of the subject, her revealing décolletage, and the lavender coloring of her skin—marked the culmination of the artist's Parisian career. Sargent refused to comply with the demands of Madame Gautreau's mother to withdraw the painting from exhibition. He lost commissions following the uproar over the portrait and later moved to London.

Partly because of its many reworkings, the portrait lacks the brilliant brushwork characteristic of Sargent's paintings, but the eloquent pose and contours of the figure, which recall Sargent's debt to Velázquez, make it one of his most striking canvases. In 1887, Henry James, describing "the remarkable canvas which, on the occasion of the Salon of 1884, brought the critics about our artist's ears," noted: "It is full of audacity of experiment and science of execution; it has singular beauty of line, and certainly in the body and arms we feel the pulse of life as strongly as the brush can give it." When he sold it to the Metropolitan Museum in 1916, Sargent wrote: "I suppose it is the best thing I have done." An unfinished, presumably a second version, of the painting is in the Tate Gallery, London.

Oil on canvas, 82⅛ × 43¼ in. (208.6 × 109.9 cm.).

Signed and dated at lower right: John S. Sargent 1884.

RELATED WORKS: *Study for Madame X*, pencil, 12⅝ × 8¼ in. (32.1 × 21 cm.), head, profile to right, MMA, 31.43.3 // *Madame X*, pencil, 12¾ × 9⅜ in. (32.4 × 23.8 cm.) (sight), head, profile to left, coll. Mr. and Mrs. Stuart P. Feld, New York, ill. in Corcoran Gallery of Art, Washington, D.C., *The Private World of John Singer Sargent* (1964), no. 141 // *Study for Madame X*, pencil, 13³⁄₁₆ × 9¾ in. (33.5 × 24.8 cm.), bust-length, profile to left, MMA, 31.43.2 // *Two Studies of Madame Gautreau* (*Madame X*), pencil, 40 × 24.7 cm., bust-length, head turned three-quarters, profile to right, British Museum, London, 1936–11–16–3, ill. in C. M. Mount, *John Singer Sargent* (1955; 1969), following p. 144 // *Study for Madame X*, pencil, 9¾ × 13³⁄₁₆ in. (24.8 × 33.5 cm.), full-length, seated on sofa, MMA, 1970.47, ill. in C. M. Mount, *John Singer Sargent* (1955; 1969), following p. 144 // Preliminary drawings in sketchbook, 1880s, 9⅝ × 13½ in. (24.5 × 34.3 cm.), pp. 1 (black chalk), 3v (pencil), woman seated on sofa (probably the sitter), p. 4

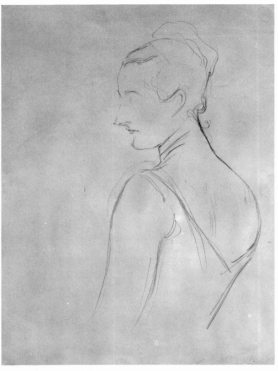

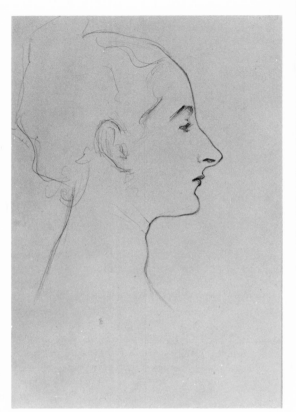

This page: Three Sargent pencil studies in the Metropolitan for *Madame X*. Left: Profile facing right (31.43.3). Top: Bust-length with profile to left (31.43.2). Bottom: Seated on a sofa (1970.47). Facing page: Sargent, *Madame X*.

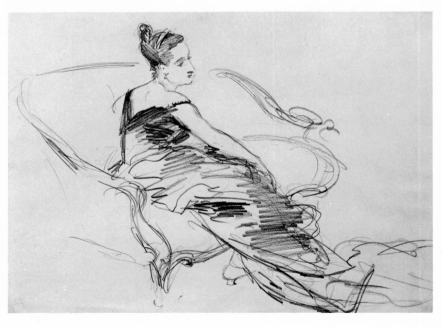

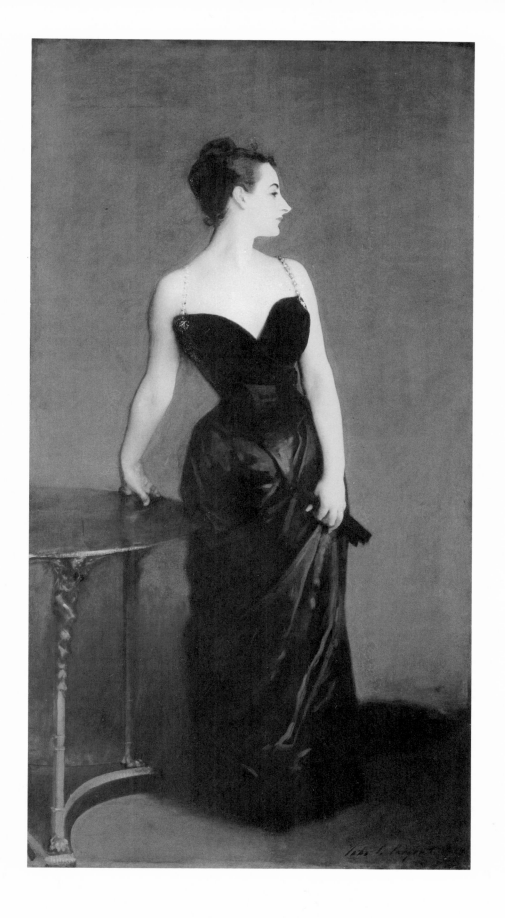

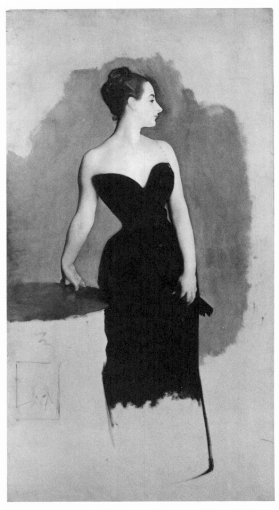

Sargent, *Study of Madame Gautreau*, Tate Gallery.

(pencil), head profile to left (scratched out), p. 4v (pencil), head, frontal, Fogg Art Museum, Cambridge, Mass., 1937.7.21 // *Mme. Gautreau*, pencil, 9⅝ × 10¾ in. (24.5 × 26.4 cm.), full-length, seated on sofa, Fogg Art Museum, Cambridge, Mass., 1943.319 // *Study of Mme. Gautreau (Mme. X)*, pencil, 11½ × 8¼ in. (29.2 × 21 cm.), seen from the back, standing with knee on sofa, private coll., Paris, ill. in *Art Quarterly* 33, no. 1 (1970), inside front cover // *Portrait of Mme. X; Mme. Gautreau*, watercolor, 13¾ × 9⅝ in. (34.9 × 24.5 cm.), three-quarter length on a sofa, profile to right, Fogg Art Museum, Cambridge, Mass., 1943.316, ill. in *Monthly Bulletin of the Columbus Gallery of Fine Arts* 4 (Oct. 1933), cover // *Study of Mme. Gautreau*, oil on canvas, 81¼ × 42½ in. (206.4 × 108 cm.), ca. 1884, unfinished, Tate Gallery, London, 4102, ill. in *Connoisseur* 163 (Dec. 1966), p. 246.

REFERENCES: J. S. Sargent to Mrs. H. White, March 15 [1883], in collection of Joyce W. Treeman, Pacific Palisades, Calif., microfilm 647, in Arch. Am. Art, says that he is still working on the correspondent's portrait and on the portrait of Madame X // J. Péladan, *L'Artiste*, ser. 9, 54 (1884), p. 441, notes "De toutes femmes déshabillées, la seule intéressante est de M. Sargent. Intéressante par sa laideur au fin profil qui rappelle un peu Della Francesca, intéressante par son décolletage encore à chaînettes d'argent, qui est indécent et donne l'impression d'une robe qui va tomber; intéressante enfin par le blanc de perle qui bleuit sur l'épiderme, cadavérique et clownesque à la fois. Et la faute de dessin que toute le monde a vue dans les bras n'y est pas: c'est le bleuissement du blanc de perle qui fausse le raccourci à l'œil" // W. Sharp, *Art Journal* [London] (1884), pp. 179–180, reviews it in the Paris Salon, says it "is produced with something more than artificial cleverness, but there is an almost wilful perversion of the artist's knowledge of flesh-painting" // O. Merson, *Le Monde Illustré* 28 (May 3, 1884), p. 286, includes it in a list of works exhibited at the Salon, no. 1417; (May 24, 1884), p. 327, notes: "Négligeons le *Portrait de Mme Gautereau* [*sic*]. La poitrine, que la robe ouverte en cœur laisse voir jusqu'aux limites permises, et même peut-être au delà, les épaules, les bras, sont néanmoins d'un bon peintre. Reste le visage, de profil. Voilà le malheur, ce profil. Il n'est point commode d'accorder la réputation de beauté du modèle, avec ce ridicule as [*sic*] de carreau tout enfariné. Mais patience, M. Sargent ne se trompera pas toujours; il est homme à prendre avant peu une revanche éclatante" // J. Comte, *L'Illustration* 83 (May 3, 1884), p. 290, reviews it in the Paris Salon, describes sitter and her costume, compares her tiara to that of Diana, notes "quel teint, et quelle couleur," speculates on possible influences on the artist's work // Fourcaud, *Gazette des Beaux-Arts* 29 (1884), pp. 482–484, reviews it in the Paris Salon as "Mme G . . .;" notes the negative comments made by spectators about the portrait, and comments "il a éminemment exprimé l'idole, et c'est là ce qu'il faut voir. La pureté des lignes de son modèle a dû le frapper d'abord, et son parti a été pris aussitôt de faire de ce portrait quelque chose comme un grand dessin en camaieu" // Penguin [pseud.], *American Architect and Building News* 15 (June 21, 1884), p. 296, in review of Salon, comments that "Of Sargent's portrait of Mme . . ., one can say nothing but praise; it is even superior to the one at the Royal Academy, London; vigorous, well-drawn, and full of life. Mr. Sargent is in a fair way to eclipse his master, M. Carolus-Duran, if the world does not spoil him and make him careless" // H. James, *Harper's New Monthly Magazine* 75 (Oct. 1887), pp. 690–691, discusses it and comments on its reception (quoted above); "It is an experiment of a highly original kind. . . . A beauty of beauties. . . . stands upright beside a table . . . the line of her harmonious profile has a sharpness which Mr. Sargent does not always seek, and the crescent of Diana, an

ornament in diamonds, rests on her exquisite head"; revised in *Picture and Text* (1893), pp. 110–112, concludes that "This superb picture, noble in conception and masterly in line, gives to the figure represented something of the high relief of the profiled images on great friezes. . . . The author has never gone further in being boldly and consistently himself" // Montezuma [pseud.], *Art Amateur* 21 (August 1889), p. 46 // T. Child, *Harper's New Monthly Magazine* 79 (Sept. 1889), p. 504, mentions it as "Madame Gauthereau"; describes "the wild and coarse criticism" to which it was subjected at the time of its exhibition in 1884, which "proves only how dangerous it is for an artist to dare to produce something uncommon"; *Art and Criticism* (1892), p. 105, mentions its exhibition at the Paris Salon in 1884; pp. 106–107, says that "the hero of his [Sargent's] thoughts was Piero della Francesca, the impeccable purity and mysterious flatness of whose profiles he ventured to take as his model" // F. Fowler, *Review of Reviews* 9 (June 1894), p. 687, mentions it as "Madame Ganthercan" // W. A. Coffin, *Century Magazine* 52 (June 1896), p. 175, calls it "Madame Gauthereau," says that it was painted in 1883 at the sitter's home in Houlgate and caused a "storm of disapproval," notes that "Painters who have seen the picture speak of its marvelous technical qualities, and of the sensitive drawing of the head. Some of Sargent's friends speak of it as his masterpiece, and others declare that he himself so considers it" // M. H. Dixon, *Magazine of Art* 23 (Jan. 1899), p. 112, mentions it as "Madame Gauthereau"; p. 118, compares it to work by Botticelli, notes the scandal connected with the picture // *Pearson's Magazine* 11 (April 1901), p. 574 // S. Hartmann, *A History of American Art* (1902), 2, p. 216, calls it "Madame Gauthereau," notes the criticism it excited // R. Cortissoz, *Scribner's Magazine* 34 (Nov. 1903), ill. p. 514; pp. 524–525, compares it to a portrait of Madame Gautreau by Gustave Courtois // *Saturday Review* 97 (March 19, 1904), p. 365, says it is "fluent but not very sensitive" // *American Art News* 3 (April 15, 1905), [p. 1], notes the inclusion of "Mme. Gautrian" in an exhibition at the Carfax Gallery, London // Mrs. A. Meynell, *The Work of John S. Sargent R.A.* (1907), unpaged intro., discusses; unnumbered pl. // C. Mauclair, *L'Art et les artistes* 4 (Jan. 1907), p. 377, discusses it as "Madame Gauthereau" // A. Layard, *Die Kunst für Alle* 23 (Oct. 15, 1907), p. 26, discusses it; ill. p. 34 // C. Brinton, *Modern Artists* (1908), ill. opp. p. 158, says it is in the artist's possession; p. 161 // C. Brinton, *Impressions of the Art at the Panama-Pacific Exposition* (1916), ill. p. 89 // J. S. Sargent to E. Robinson, Jan. 8, 1916, MMA Library (quoted above), wishes to offer it to the museum for one thousand pounds after the close of the Panama-Pacific Exposition // J. A. Weir to E. Robinson, Jan. 25, 1916, MMA Library, calls it "truly one of Sargent's fine portraits" and recommends its purchase // D. C. French to Robinson, Jan. 26, 1916, MMA Library, says that its purchase is "a great opportunity" // B. B[urroughs],

MMA Bull. 11 (May 1916), p. 113, announces its acquisition; ill. p. 115 // *Arts and Decoration* 6 (July 1916), ill. p. 396, discusses its acquisition by MMA, calling it Sargent "at his finest" // C. Aitken, *Burlington Magazine* 29 (August 1916), p. 219 // *Art and Archaeology* 4 (Sept. 1916), p. 187 // J. C. Van Dyke, *American Painting and Its Tradition* (1919), pp. 252–253, notes the sharp drawing of the head, calls it "fine portraiture" // R. Cortissoz, *Art and Common Sense* (1923), pp. 229–231, notes its design qualities, compares it to sitter's portrait by Courtois // J. Laver, *Portraits in Oil and Vinegar* (1924), p. 4 // L. Mechlin, *American Magazine of Art* 15 (April 1924), p. 173, praises it // W. H. Downes, *John S. Sargent* (1925), pp. 12–13, mentions the severe criticism it received at the Salon; p. 67, notes its inclusion in the Panama-Pacific International Exposition; ill. opp. p. 72; pp. 133–134, includes it in list of Sargent's works, lists exhibitions, describes, quotes earlier comments on it and says it was painted at Pierre Gautreau's country house, Les Chênes, Paramé // L. Benedite, *Les Chefs d'œuvre du Musée du Luxembourg* [1925], unnumbered pl.; [p. 44], discusses // C. Bell, *New Republic* 42 (May 20, 1925), p. 340 // A. Barnes, *Discovery* 6 (June 1925), p. 209 // E. H. Blashfield, *North American Review* 221 (June 1925), p. 642, discusses it as "Madame Gautraut" // *Literary Digest* 86 (August 22, 1925), p. 24, mentions a study for it in the Sargent sale in London // G. P. Jacomb-Hood, *Cornhill Magazine* 59 (Sept. 1925), p. 288, notes portrait and the attention it received // M. Feuillet, *Le Figaro Artistique* 3 (Oct. 15, 1925), p. 12, discusses // H. B. Wehle, *MMA Bull.* 21 (Jan. 1926), p. 3 // F. H. Hubbard, *American Art Student* 9 (Jan. 31, 1926), p. 51, quotes E. Robinson (1926) // A. D. Patterson, *Canadian Magazine* 65 (March 1926), p. 30, reports a conversation with the artist sometime after 1897, in which Sargent said the sitter's arm had to be repainted // J. E. Blanche, *Revue de Paris* 2 (March–April 1926), pp. 575–576, discusses it // J. W. De Gruyter, *Elseviers Geillustreerd Maandscrift* 71 (June 1926), p. 382; p. 388 // E. Charteris, *John Sargent* (1927; 1971), p. 59, notes that the artist met the sitter in 1881; quotes Sargent to B. del Castillo, n.d. (quoted above); quotes Sargent to V. Lee, Feb. 10, 1883, saying that Madame Gautreau's flesh is "a uniform blotting-paper colour all over," that "she has the most beautiful lines," and quotes Sargent to V. Lee, n.d. (quoted above); p. 60, quotes Sargent to B. del Castillo, n.d., saying that the portrait is completed, that he is pleased with the improvements made on it, and that at the recommendation of Carolus-Duran, who has seen it, he will submit it to the Salon, in spite of his own reservations; pp. 60–63, describes negative reaction to its exhibition in the Salon, quoting a letter written by R. Curtis, n.d., and reviews by the critics H. Houssaye, J. Comte, and Fourcaud which appeared in various French periodicals in 1884; p. 64, compares it to the portrait of Madame Gautreau by Courtois; pp. 64–65, quotes J. S. Sargent to Major Roller, Oct. 3, 1906, relating

that the sitter wrote to him the previous year and asked him to lend it to an exhibition in Berlin; pp. 66–67, compares it to the artist's portrait of Mrs. Henry White, 1883 (Corcoran Gallery of Art, Washington, D.C.); p. 98; p. 165; pp. 250, 252, includes V. Lee, "J. S. S.: In Memoriam" from 1925, which mentions it; p. 258, includes it as Madame X (Portrait of Mme. Gautreau) in list of Sargent oils, dates it 1884 // E. H. Blashfield, *Commemorative Tributes . . . Prepared for the American Academy of Arts and Letters 1926* (1927; Academy Publication no. 57), p. 14, discusses // J. B. Manson and Mrs. A. Meynell, *The Work of John S. Sargent, R.A.* (1927), I, unpaged intro.; unnumbered pl. // Grand Central Art Galleries, New York, *Exhibition of Drawings by John Singer Sargent* (1928), unpaged, mentions several pencil drawings for it // T. Bodkin, *Studies: An Irish Quarterly Review* 17 (June 1928), pp. 259–260, discusses it, noting Sargent's comment of 1916: "I suppose it is the best thing I have ever done" // S. La Follette, *Art in America* (1929), p. 217 // G. Irwin, *Trail-Blazers of American Art* (1930), pp. 184–185, discusses it // M. Hardie, "J. S. Sargent, R.A., R.W.S.," no. 7, in *Famous Water-Colour Painters* (1930), p. 1 // F. J. Mather, Jr., *Estimates in Art*, 2nd ser. (1931), p. 247, discusses it and compares it to Lady with the Rose // *Index of Twentieth Century Artists* 2 (Feb. 1935), p. 77, lists reproductions of it // H. Saint-Gaudens, *Carnegie Magazine* 14 (Oct. 1940), ill. p. 136 // H. deB. Seebold, *Old Louisiana Plantation Homes and Family Trees* (1941), I, pp. 44–45, discusses it // F. J. Mather, Jr., *Magazine of Art* 39 (Nov. 1946), ill. p. 303, discusses // G. L. Pringué, *30 Ans de diner en ville* (1948), pp. 211–215, gives biographical information about the sitter // J. P. Leeper, *Magazine of Art* 44 (Jan. 1951), p. 15 // C. M. Mount, *John Singer Sargent* (1955; 1969), p. 73, says it is not known when the artist first met the sitter, but it was probably by 1880 when he was working on a portrait of Dr. Pozzi, her reputed lover, also Sargent's friend; B. del Castillo knew her socially; pp. 74–76, gives details about her biography and reputation and discusses Sargent's motivation for painting her; pp. 77–78, says that work on the portrait was resumed in Brittany during the summer of 1883 and discusses the preliminary sketches and compositions considered by Sargent before he settled on the final pose; pp. 79–81, discusses the difficulties Sargent had in painting the sitter; pp. 81–83, discusses changes made during the winter of 1883–1884, says Carolus-Duran praised it, that Sargent began a second version, which was not ready when the Salon opened; pp. 83–89, discusses the critical reaction to the portrait at the Salon; pp. 89–90, says Sargent went to London for the summer but fully intended to return in spite of the portrait's failure at the Salon; pp. 100, 109, mentions the scandal attached to it; pp. 114–115, says that H. James took I. S. Gardner to see it; p. 129; p. 131; ill. following p. 144, and includes three sketches for it; p. 197, says that J. Carroll Beckwith saw it in England in 1893; pp. 283–284, discusses Sargent's difficulty in painting

the sitter's right arm; pp. 328–329, quotes Sargent to E. Robinson, Jan. 8, and 31, 1916, in which he says, "By the way, I should prefer, on account of the row I had with the lady years ago, that the picture should not be called by her name, at any rate for the present, and that her name should not be communicated to the newspapers"; pp. 408–410, gives sources for information; p. 439, lists it as Mme. Pierre Gautreau in catalogue of Sargent oils (no. 848 in early editions), dates it 1884, Paramé and Paris, notes related versions // J. G. Smith, *American Artist* 19 (March 1955), p. 29 // C. M. Mount, *Art Quarterly* 18 (Summer 1955), pp. 136–143, discusses Sargent's work on it in relation to his work on a series of portraits of Judith Gautier; p. 136, quotes Sargent's father, letter dated Nov. 1883, saying "John is just now in, or near, Florence whither he betook himself a month ago (his native city, you know!) after having passed most of the summer in Brittany at the chateau of a Frenchman whose wife's portrait he was painting"; p. 137, notes the difficulties Sargent had in obtaining sittings with Madame Gautreau; p. 138, says that Sargent spent "a good deal of the summer [1883] at St. Enogat," the home of Judith Gautier, while working on the painting; p. 141, notes that when the summer ended, he returned to Paris with it incomplete; p. 143, says that when it was exhibited in 1884, the critics in Gautier's circle attacked it violently, perhaps because the artist and Gautier had a falling out // H. Cahill, *Saturday Review* 38 (Nov. 26, 1955), p. 16, discusses the portrait and illustrates a photograph of the artist in his studio with it // MFA, Boston, *Sargent's Boston* (1956), exhib. cat. by D. McKibbin, p. 22, illustrates a photograph of the artist in his studio with the portrait; ill. p. 24; p. 25, discusses its execution and the biography of the sitter; p. 36, mentions that Isabella Stewart Gardner saw it in his studio in 1886; p. 78; p. 97, includes it in a checklist of Sargent's portraits, dates it 1884, Paramé, lists related works // *American Artist* 20 (March 1956), p. 10, discusses // A. T. Gardner, *MMA Bull.* 16 (Summer 1957), p. 1; ill. p. 10 // H. Shepp, *Apollo* 66 (Oct. 1957), p. 102 // B. Hogarth, *American Artist* 26 (April 1962), ill. p. 66 // D. Sutton, *Apollo* 79 (May 1964), p. 399 // R. Ormond, *Apollo* 80 (Oct. 1964), p. 328 // N. Lansdale, *American Artist* 28 (Nov. 1964), pp. 58–59 // D. Hinton, *Connoisseur* 157 (Dec. 1964), p. 249 // A. von Saldern, *Antiques* 92 (Nov. 1967), pp. 702–703, discusses; ill. p. 705 // R. Ormond, *John Singer Sargent* (1970), p. 22, mentions its "sharp profile pose"; pp. 28–29, notes that the artist hoped that it would establish his reputation as a portraitist; p. 31, says that he began it while working on his portrait of Mrs. Henry White; quotes Sargent to V. Lee, Feb. 10, 1883, in which he discusses the sitter's flesh color; says that he did not finish it in time for the Paris Salon in 1883; that he met Madame Gautreau during the winter of 1882–1883, probably through Dr. Pozzi; quotes Sargent to V. Lee [July or August 1883], commenting on the sitter (quoted above); quotes Sargent to B. del Castillo

AMERICAN PAINTINGS · III

[early 1884], saying that he "dashed a tone of light rose over the former gloomy background" and that he was less dissatisfied with it; discusses the artist's original conception of the portrait, i.e. seated on a sofa; says Titian's *Francis I* (Louvre) is a possible source for the final composition; pp. 31–32, discusses its design qualities and describes the critical reaction to it at the Salon and how the sitter and her mother berated the artist; p. 33, discusses the possible impact of the scandal; p. 41, says that Isabella Stewart Gardner demanded "a sensational and unconventional portrait," and compares Sargent's portrait of her to it; p. 45, says that Madame Gautreau portrait was intended to cause a sensation; p. 46, notes its "subtle modeling and sharp profile pose"; [p. 82], fig. 44, shows Courtois's portrait of sitter; [p. 138], pl. 39; p. 241, discusses it and other portraits of the same sitter by Sargent and gives biographical information // P. Hendy, *European and American Paintings in the Isabella Stewart Gardner Museum* (1974), pp. 221–222, discusses Madame Gautreau Drinking a Toast and relates it to MMA painting // G. Jordan, *New Orleans Times-Picayune*, June 22, 1975, sec. 2, ill. p. 2, and also a portrait of the same sitter by Antonio de la Gandara, discusses the circumstances under which Sargent's painting was executed; June 29, 1975, sec. 2, p. 8, gives biographical information on the sitter and her family; letter, Dec. 6, 1975, in Dept. Archives, gives additional biographical material and information about the sitter's descendants.

EXHIBITED: Paris Salon, 1884, no. 2150, as Portrait de Mme *** // Carfax Gallery, London, 1909 (no cat. available) // Panama-Pacific International Exposition, San Francisco, 1915, no. 3630, as "Madam Gautrin" // MMA, 1926, *Memorial Exhibition of the Work of John Singer Sargent*, no. 10, note by M. G. Van Rensselaer, p. xvi, says that it put him in the front rank of the younger painters; ill. following p. 14 // Art Institute of Chicago and MMA, 1954, *Sargent, Whistler and Mary Cassatt*, exhib. cat. by F.

Sweet, no. 49; ill. on cover; p. 40; p. 52, discusses it and gives biographical information on the sitter // Brooklyn Museum; Virginia Museum of Fine Arts, Richmond; and California Palace of the Legion of Honor, San Francisco, 1967–1968, *Triumph of Realism*, exhib. cat. by A. von Saldern, no. 90; ill. on cover; pp. 50–51, 82, discusses; ill. p. 171 // MMA, 1970, *19th Century America, Paintings and Sculpture*, exhib. cat. by J. K. Howat and N. Spassky, ill. no. 178, discusses // MFA, Boston, 1970, *Masterpieces of Paintings in the Metropolitan Museum*, exhib. cat. by C. Virch, E. A. Standen, and T. M. Folds, color ill. p. 109, discusses // National Gallery of Art, Washington, D.C.; City Art Museum of St. Louis; Seattle Art Museum, 1970–1971, *Great American Paintings from the Boston and Metropolitan Museums*, exhib. cat. by T. N. Maytham, no. 69, p. 111, discusses, lists provenance, exhibitions, and bibliography; color ill. p. 112.

Ex COLL.: the artist, 1884–1916.
Arthur Hoppock Hearn Fund, 1916.
16.53.

Two Girls on a Lawn

In this unfinished sketch, Sargent has chosen an informal leisure-time subject. His cropped composition centers on the heads of two women, whose bodies and costumes are hastily rendered against an unspecified background. Probably painted about 1889, the sketch is inscribed "V & Katie Vickers" on the tacking edge of the canvas and may represent the artist's sister Violet and a member of the Vickers family that had patronized Sargent as early as 1882. The subject matter and style of the work are similar to the many oil sketches the artist painted outdoors, influenced by impressionism.

Sargent, *Two Girls on a Lawn.*

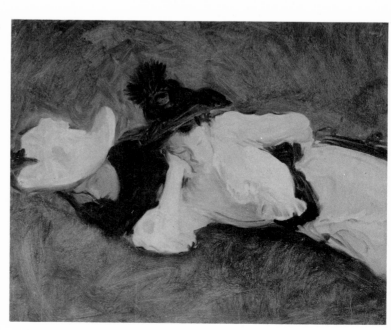

Oil on canvas, 21⅛ × 25¼ in. (53.7 × 64.1 cm.).

Inscribed on the tacking edge: *V & Katie Vickers*.

REFERENCE: C. M. Mount, *John Singer Sargent* (1955; 1969), p. 466, includes it as Sketch of Two Girls on a Lawn in catalogue of Sargent oils (no. K896 in early editions), dates it 1889, England.

EX COLL.: the artist's sister Violet (Mrs. Francis Ormond), London, until 1950.

Gift of Mrs. Francis Ormond, 1950.

50.130.40.

Reapers Resting in a Wheatfield

Sargent spent the summer and autumn of 1885 in England, primarily in Broadway, a remote village in the Cotswolds that had become a retreat for English and American artists and writers. He was introduced to this community by EDWIN AUSTIN ABBEY, who brought him there to recuperate from a head injury received during a boating excursion. Among Sargent's companions were the painters FRANK MILLET, Alfred Parsons, and Frederick Barnard as well as the writers Henry James and Edmund Gosse, some of whom would remain his lifelong friends. Artistically, he was preoccupied with work on *Carnation, Lily, Lily, Rose*, 1885–1886 (Tate Gallery, London), a figure painting that shows Barnard's daughters hanging Chinese lanterns among rose trees and lilies. Sargent also produced a number of plein-air landscapes, which offered him a welcome relief from the formal strictures of figure painting and portraiture.

Reapers Resting in a Wheatfield represents a scene that would have been typical in this rural area. The animated brushwork, summary representation, seemingly unpremeditated selection of subject, and intense palette capture the physical appearance and picturesque atmosphere of a

Sargent, *Reapers Resting in a Wheatfield*.

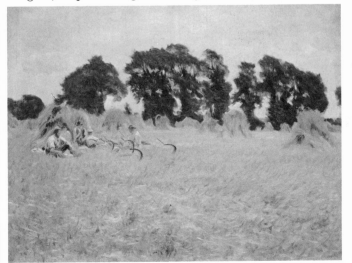

setting that Henry James described as "the perfection of the old English rural tradition." "The place has so much character," James continued:

There is portraiture in the air and composition in the very accidents. Everything is a subject or an effect, a "bit" or a good thing. . . . The garden walls, the mossy roofs, the open doorways and brown interiors, the old-fashioned flowers, the bushes in figures, the geese on the green, the patches, the jumbles, the glimpses, the color, the surface, the general complexion of things, have all a value, a reference and an application (*Picture and Text* [1893], p. 6).

Oil on canvas, 28 × 36 in. (71.1 × 91.4 cm.).

REFERENCES: C. M. Mount, *John Singer Sargent* (1955; 1969), p. 465, includes it as The Threshers in a catalogue of Sargent oils (no. K8512 in early editions), dates it 1885, England.

EX COLL.: the artist's sister Violet (Mrs. Francis Ormond), London, until 1950.

Gift of Mrs. Francis Ormond, 1950.

50.130.14.

Two Girls with Parasols at Fladbury

Painted during Sargent's sojourn in the English countryside at Fladbury in 1889, the style and subject matter of this painting reveal the influence of Claude Monet, with whom Sargent maintained a fairly close association during the late 1880s and early 1890s. In 1887, Sargent frequently visited Monet at the French village of Giverny, which was a favorite country retreat during the late 1880s for such American artists as THEODORE ROBINSON, THEODORE EARL BUTLER, John Leslie Breck (1860–1899), and Lilla Cabot Perry (1848–1933). Sargent's friendship with Monet is documented by such works as *Claude Monet Painting at the Edge of a Wood*, 1887–1889 (Tate Gallery, London), and a profile portrait of the French artist (NAD). Richard Ormond has pointed to Monet's influence on Sargent during the late 1880s, noting the impact on his general stylistic development as well as his choice of themes. Prominent among the shared subjects are boating scenes and plein-air figure studies, such as this painting and *A Morning Walk*, ca. 1888 (coll. Ormond Family, London), both of which depict women clad in luminescent white garments, their faces framed by parasols. The figures are shown promenading beside a vibrant blue river, along a riverbank rendered in high-key colors with strong contrasting areas of sunlight and shadow. Released from the representational demands of formal portraiture,

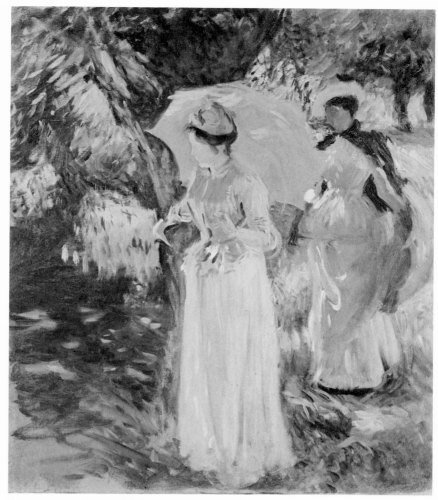

Sargent, *Two Girls with Parasols at Fladbury*.

Sargent reduces the figures' hands to a few suggestive brushstrokes and the faces to flat, undifferentiated areas of color. In a letter to his friend Frederick Jameson, dated March 20, 1911, or 1912, Sargent explained his conception of impressionism:

If you want to know what an impressionist tries for . . . go out of doors and look at a landscape with the sun in your eyes and alter the angle of your hat brim and notice the difference of colour in dark objects according to the amount of light you let into your eyes—you can vary it from the local colour of the object (if there is less light) to something entirely different which is an appearance on your own retina when there is too much light. It takes years to be able to note this accurately enough for painting purposes and it would only seem worth while to people who would wear the same glasses as the painter and then it has the effect of for the first time coming across a picture that looks like nature and gives the sense of living—for these reasons Monet bowled me over—and he counts as having added a new perception to Artists as the man did who invented perspective (quoted in E. Charteris, *John Sargent* [1927; 1971], p. 124).

Oil on canvas, 29½ × 25 in. (74.9 × 63.5 cm.).

REFERENCES: C. M. Mount, *John Singer Sargent* (1955; 1969), p. 466, includes it as Two girls with Parasols at Fladbury in a catalogue of Sargent oils (no. K897 in early editions), dates it 1889, England // R. Ormond, *John Singer Sargent* (1970), p. 245, includes it in a list of paintings executed during the summer of 1888 at Calcot and the summer of 1889 at Fladbury, with Violet Sargent as the model.

EX COLL.: the artist's sister Violet (Mrs. Francis Ormond), London, until 1950.

Gift of Mrs. Francis Ormond, 1950.

50.130.13.

Mannikin in the Snow

The subject of this painting has traditionally been identified as Pistol, the braggart who appears in Shakespeare's *The Merry Wives of Windsor*, *Henry IV*, and *Henry V*. In actuality, its subject is more mundane. Sargent often stayed at the country home of EDWIN AUSTIN ABBEY, and during one such visit in 1889, the two artists were confined by a snowstorm. Undaunted, they arranged a costumed mannikin on a clothes horse outside in the snow. They both proceeded to paint, working in comfort while they observed their model through a window. "The result was two characteristic pictures," reminisced Royal Cortissoz in an essay on Abbey (1939). "Sargent's was an unmistakable 'actuality,' the picture of a mannikin provided with studio properties. Abbey's was the portrait of a living troubadour, wearing his cloak and feathered hat with an air and strumming his lute while he lustily sang. Sargent had made a record of exactly what he saw. Abbey had given free play to his imagination and endowed a senseless thing with life."

Oil on canvas, 25 × 30 in. (63.5 × 76.2 cm.).

Canvas stamp: NEWMAN / SOHO SQUARE / LONDON.

REFERENCES: Yale University Art Gallery, New Haven, *Paintings, Drawings and Pastels by Edwin Austin Abbey* (1939), exhib. cat. with foreword by R. Cortissoz, p. 3, discusses the conditions under which it was painted (quoted above) // C. M. Mount, *John Singer Sargent* (1955; 1969), p. 467, includes it as Pistol in the Snow (Illustration from Shakespeare's Henry V) in catalogue of Sargent oils (no. K895 in early editions), dates it 1889, England // M. Quick, Dayton Art Institute, orally, March 11, 1976, identified the subject of the painting, and in a letter in Dept. Archives, May 11, 1976, provides reference to Abbey catalogue // K. A. Foster, letter in Dept. Archives, June 18, 1976, suggests several paintings by Abbey in the Yale University Art Gallery that may also have been painted on this occasion.

Ex COLL.: the artist's sister Violet (Mrs. Francis Ormond), London, until 1950.

Gift of Mrs. Francis Ormond, 1950.

50.130.12.

Sargent, *Mannikin in the Snow*.

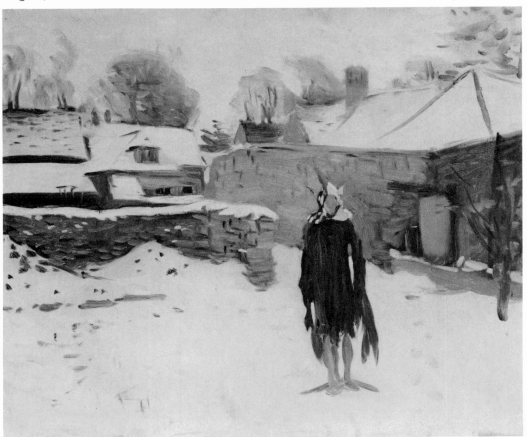

Mrs. Henry Galbraith Ward

Mabel Marquand (1860–1896), one of three daughters of the businessman and art patron Henry Gurdon Marquand, lived in New York and summered at her family's Newport estate, Linden Gate. On August 13, 1891, she was married to the New York lawyer Henry Galbraith Ward and later bore two sons, Galbraith and Marquand, who were killed during World War I.

The portrait is not dated, but it appears to be inscribed with the sitter's married name, which would suggest that it was painted between August 1891, the date of her marriage, and November 1894, when it was exhibited at the National Academy of Design. Family tradition, however, asserts that it was completed before 1890, probably in 1887, when Sargent came to America to paint a portrait of the sitter's mother, Elizabeth Allen Marquand (coll. Mrs. Douglas Delanoy, Princeton, N.J.). A decade later, Sargent painted Henry Marquand's portrait (q.v.), and since the artist was well acquainted with the family, it is possible that he painted the daughter before 1890 and then added the inscription at a later date.

Sargent's portrait was not very well received by the sitter's family. Her sister-in-law Mrs. Allan Marquand later wrote to David McKibbin: "no one . . . liked it as it was not at all characteristic of her." Sargent's contemporaries, however, responded positively to the picture. The distinguished art critic Mariana Van Rensselaer commented in the *New York World* on November 4, 1894, about this and other portraits by Sargent on exhibit at the National Academy: "In each case we feel that . . . no other hand could have done this special piece of portraiture quite so well; in each case we think of the portrait more as a rendering of human individuality than even as a magnificent example of craftsmanship, and in each the refinement of the interpretation delights us quite as much as its exceptional force."

Oil on canvas, 27 × 22 in. (68.6 × 55.9 cm.).

Signed at upper left: John S. Sargent. Inscribed at upper right: Mrs. Ward [?].

REFERENCES: *Critic* 25 (Nov. 10, 1894), p. 317, says that it "place[s] him among the great painters of the century" // C. H. Caffin, *Harper's Weekly* 62 (Nov. 12, 1898), p. 1102, comments upon a "new one of Mrs. Galbraith Ward, which shows the painter in one of his moods of almost brutal frankness" // W. H. Downes, *John S. Sargent* (1925), p. 264, mistakenly lists it as H. Galbraith Ward in a catalogue of Sargent's works // D. McKibbin, letter in MMA Ar-

Sargent, *Mrs. Henry Galbraith Ward.*

chives, July 9, 1947, quotes a letter from Mrs. Allan Marquand that dates it about 1887 and says the family did not care for it (quoted above) // C. M. Mount, *John Singer Sargent* (1955; 1969), p. 455, includes it as Mrs. H. Galbraith Ward in a catalogue of Sargent's oils (no. 879 in early editions), dates it 1887, Newport // MFA, Boston, *Sargent's Boston*, exhib. cat. by D. McKibbin (1956), p. 108, includes it as Mabel Marquand (Mrs. Henry Galbraith Ward) in a checklist of Sargent portraits, dates it 1890, Newport // D. McKibbin, letter in MMA Archives, Oct. 10, 1966, raises the issue of the discrepancy between the date usually given the portrait (1887) and the date based on the inscription (1891) // Mrs. D. Delanoy, letter in MMA Archives, Jan. 8, 1975, gives biographical information on the sitter // D. McKibbin, letter in MMA Archives, Feb. 9, 1976, says that the date of the portrait is still unresolved, speculates that it might have been done after the sitter's marriage and exhibited at the PAFA as a recent work, says he does not know of Sargent portraits of the sitter's husband or of her sister Linda Terry.

EXHIBITED: NAD, 1894, *Portraits of Women, Loan Exhibition* (for the benefit of St. John's Guild and the Orthopaedic Hospital), no. 262, as Mrs. H. Galbraith Ward, lent by H. Galbraith Ward // PAFA, 1894–1895, no. 271, lent by H. G. Ward // Carnegie Institute, Pittsburgh, 1898–1899, no. 142.

EX COLL.: Mr. Henry Galbraith Ward, New York, by 1894–1930.

Gift of Hon. Henry Galbraith Ward, 1930.
30.26.

Sargent, *Egyptian Woman*.

Sargent, *Egyptian Woman with Earrings*.

Egyptian Woman

This unfinished sketch was probably executed during Sargent's trip to Egypt in 1890–1891.

Oil on canvas, 25½ × 21 in. (64.8 × 53.3 cm.).
RELATED WORK: *Head of a Woman*, pencil, 9½ × 7 in. (24.1 × 17.8 cm.), Yale University Art Gallery, 31.21.
REFERENCE: C. M. Mount, *John Singer Sargent* (1955; 1969), p. 467, includes it under Egyptian Women (heads), no. 2, in catalogue of Sargent oils (no. 916 in early editions), dates it 1891, Egypt.
EX COLL.: the artist's sister Violet (Mrs. Francis Ormond), London, until 1950.
Gift of Mrs. Francis Ormond, 1950.
50.130.21.

Egyptian Woman with Earrings

See preceding entry.

Oil on canvas, 28 × 24½ in. (71.1 × 62.2 cm.).
REFERENCE: C. M. Mount, *John Singer Sargent* (1955; 1969), p. 467, includes it under Egyptian Women (heads), no. 3, in catalogue of Sargent's oils (no. 915 in early editions), dates it, 1891, Egypt.
EX COLL.: the artist's sister Violet (Mrs. Francis Ormond), London, until 1950.

Gift of Mrs. Francis Ormond, 1950.
50.130.22.

Egyptians Raising Water from the Nile

This oil sketch, which dates from Sargent's trip to Egypt in 1890–1891, depicts a group of Egyptians using a *shaduf* to raise water from the Nile to fill irrigation ditches, a scene that the artist would have encountered frequently on his trip through the Middle East.

Oil on canvas, 25 × 21 in. (63.5 × 53.3 cm.).
REFERENCES: C. M. Mount, *John Singer Sargent* (1955; 1969), p. 467, calls it Egyptian Indigo Dyers in catalogue of Sargent oils (no. K915 in early editions), actually a change from 1955 and 1957 editions p. 446, p. 356, where it is given as no. K913, Egyptian Pool, dated 1891, Egypt // D. McKibbin, letter in Dept. Archives, March 2, 1976, says it is not Egyptian Indigo Dyers, 1890–1891, which is a different painting now in the Rijksmuseum Hendrik Willem Mesdag, The Hague.
EX COLL.: the artist's sister Violet (Mrs. Francis Ormond), London, until 1950.
Gift of Mrs. Francis Ormond, 1950.
50.130.16.

Sketch of Santa Sofia

Probably painted in 1891 when Sargent was studying Byzantine mosaics in preparation for his murals in the Boston Public Library, this is one of two located oil studies of the interior of Hagia (Santa) Sophia in Constantinople (now Istanbul). The church, a monument of Byzantine art, was built between 532 and 537, during the reign of Emperor Justinian I, and fell into Turkish hands in 1453, subsequently becoming a mosque.

Evan Charteris comments on the execution of another version that is now in the collection of the J. B. Speed Art Museum, Louisville, Kentucky:

by bribing an official, he obtained leave to do a sketch of the interior of Santa Sophia. . . . The study of Santa Sophia was made in the early morning, and is one of the most purely atmospheric canvases which he painted. The picture has charm and mystery, and probably few better examples exist of his power for rendering the structure and spacing of a building with the minimum of definition (*John Sargent* [1925], p. 115).

The Metropolitan's more detailed sketch is ani-

mated by the addition of a crowd of summarily rendered figures and shows the interior from a higher vantage point.

Oil on canvas, $31\frac{1}{2} \times 24\frac{1}{4}$ in. (80 × 61.6 cm.).

RELATED WORK: *Interior of Santa Sofia*, oil on canvas, $30\frac{3}{4} \times 24$ in. (78.1 × 61 cm.), J. B. Speed Art Museum, Louisville, Ky., 60.5, ill. on cover of *J. B. Speed Art Museum Bulletin* 22 (Jan. 1961).

REFERENCES: W. H. Downes, *John S. Sargent* (1925), p. 167, lists Sketch of Santa Sofia, possibly this picture, notes exhibition // C. M. Mount, *John Singer Sargent* (1955; 1969), p. 468, includes it as Interior of Sancta Sophia in a catalogue of Sargent oils (no. K914 in early editions), dates it 1891, Constantinople // M. E. Carver, J. B. Speed Art Museum, letters in Dept. Archives, Nov. 28 and Dec. 3, 1975, provides photograph of the Speed version, as well as information about its provenance, exhibition record, and bibliography.

EXHIBITED: Copley Hall, Boston, 1899, *Catalogue of Paintings and Sketches by John Singer Sargent*, no. 84, as Sketch of Santa Sophia (possibly this painting).

EX COLL.: the artist's sister Violet (Mrs. Francis Ormond), London, until 1950.

Gift of Mrs. Francis Ormond, 1950.
50.130.18.

Sargent, *Egyptians Raising Water from the Nile.*

Sargent, *Sketch of Santa Sofia.*

Sargent, *Cliffs at Deir el Bahri, Egypt.*

Cliffs at Deir el Bahri, Egypt

This unfinished landscape is believed to represent the cliffs at Deir el Bahri, near Thebes, Egypt. Its identification is based on the individuality of the rock formations and crown of the cliffs. The work most likely dates from Sargent's trip to Egypt in 1890–1891.

Oil on canvas, 13¾ × 24¾ in. (34.9 × 62.9 cm.).
REFERENCE: C. M. Mount, *John Singer Sargent* (1955; 1969), p. 471, includes it as Holy Land Mountains in catalogue of Sargent oils (no. K058 in early editions), dates it 1905, the Holy Land.
Ex COLL.: the artist's sister Violet (Mrs. Francis Ormond), London, until 1950.
Gift of Mrs. Francis Ormond, 1950.
50.130.24.

Astarte

This sketch is one of several preparatory oil studies for the figure of the goddess Astarte in Sargent's mural *The Pagan Gods*, which occupies a vault in the third-floor hall of the Boston Public Library. *The Pagan Gods* is part of an ambitious program tracing the development of Western religion from paganism to Judaism and Christianity, which Sargent worked on from 1890 until 1919. The sketches for Astarte are usually dated between 1890, when the artist received verbal confirmation of his commission, and 1895, when *The Pagan Gods* was installed. There is good evidence, however, for placing them between 1892 and 1894. A dated drawing by Sargent (Boston Public Library) of the north end of the library hall reveals that on January 5, 1892, he was working on a composition for the vault that was entirely different from the final version. In addition, the mural was actually finished in 1894 and exhibited at the Royal Academy in London before its installation in Boston.

The Pagan Gods treats the ancient myth of the cycle of the seasons, representing the conflict between winter's barren cold and summer's fertile warmth. The mural is dominated by the monumental head of the Egyptian goddess Neith, which fills the center of the vault. A golden zodiac with a starry firmament at its center covers her chest, and an enormous serpent, symbolizing the forces of winter, curls under her chin and surrounds two small figures of Thammuz, the vegetation god. Thammuz appears first as an archer, victorious over the serpent, and then defeated, a captive in its coils. On the sides of the vault, flanking this central scene, are the figures of two deities, Astarte (Ishtar) and Moloch. Moloch, the bullheaded god with four arms, is seated on the left side of the ceiling arch, with three gods, Osiris, Isis, and Horus, standing below him. A solar disk above Moloch's head and five golden lions that accompany him are reminders of the sun and Moloch's passionate character. Astarte, on the opposite side of the vault, stands on a crescent moon, one of the attributes most often associated with her. Standing in an architectural niche and accompanied by priestesses, the goddess is enclosed in a dia-

phanous veil and surrounded by oval shapes, supposedly the terminations of the tree of life. The opposition of Astarte and Moloch in Sargent's mural thus establishes a contrast between male and female, sun and moon, warmth and cold, summer and winter.

The studies for the mural are done on a flat canvas rather than on a curve as in the final installation. The figures of Astarte, Neith, and Moloch are thus shown in succession, one above the other. The Metropolitan's study represents about two-thirds of the finished mural and focuses on Astarte. Neith's inverted head is directly above her; and Moloch's head, also inverted, is at the top of the canvas.

The various oil studies for *The Pagan Gods* are not dated, and the sequence of their execution is not documented, but some tentative conclusions can be drawn by comparing them to each other and to the mural. *The Pagan Deities* (MFA, Boston) appears to be the earliest extant study; for it varies most from the finished mural and does not include Neith. *Pagan Heads for a Vault* (Yale University Art Gallery) introduces Neith, but Astarte is only slightly altered. The Boston Public Library oil study admits two important additions, Neith's zodiac and the serpent at Astarte's feet. Astarte's costume, however, still lacks certain essential features, for example, the diaphanous veil, elaborate jewelry, and gold girdle. In *Design for an Archway* (Yale University Art Gallery) Sargent shows the goddess in her diaphanous veil and presents the priestesses who surround her. The Metropolitan study, like these others, is broadly painted but shows the final placement of Astarte in relation to other elements in the mural. The study in the Isabella Stewart Gardner Museum, usually described as the original study for *The Pagan Gods*, instead appears to be the final and most developed. Executed in a scale approximately half that of the finished mural, it shows Astarte in relation to her architectural setting and to the nearby mural *The Children of Israel*. The oil studies then, taken as a group, reveal the careful planning that went into each part of the scheme, as well as the gradual evolution of Sargent's ideas.

Sargent's Astarte combines elements from a wide variety of literary, visual, and even musical sources. Astarte is mentioned briefly in the Old Testament and in John Milton's *Paradise Lost*

Sargent, *Astarte*.

(1667), where her chaste lunar character and her juxtaposition to Moloch are developed. Literary interest in this theme was revived during the late nineteenth century, and the goddess was featured in poems by Edgar Allan Poe, Owen Meredith, and Henry Kendall, as well as a novel by Joséphin Péladan. Gustave Flaubert's historical novel *Salammbô* (1863), cited by Evan Charteris as a possible literary source for Sargent's mural, emphasizes Milton's juxtaposition of Moloch and Astarte (Tanit in the novel). The novel, which was revived during the early 1890s in an opera with music by Ernest Reyer and a libretto by Camille du Locle, may have also suggested details of the goddess's costume, particularly the diaphanous veil, which is central to the resolution of the plot. Obvious visual sources for Astarte's general appearance are archaic Greek *kore* figures. There are two pencil studies by Sargent of such figures in the Metropolitan's collection (50.130.143aa and 50.130.143bb), but they cannot be considered studies for Astarte specifically. In addition, Sargent looked to more recent art for inspiration. Astarte's pose recalls Dante Gabriel Rossetti's *Astarte Syriaca*, 1877 (City Art Galleries, Manchester), which also shows the goddess with a nimbus above her head and attendants on either side. An admirer of the Pre-Raphaelites, Sargent was probably aware of the painting as well as Rossetti's poem of the same title.

The historical eclecticism adopted by Sargent for the Boston murals was an approach popular with British academicians like Sir Lawrence Alma-Tadema. Sargent was probably influenced in this respect by EDWIN AUSTIN ABBEY, who was also painting a mural for the Boston Public Library. Indeed, the two artists worked on their murals together in Abbey's studio, and two oil studies remained in Abbey's collection (now at Yale). Sargent's Boston murals, however, although not entirely successful aesthetically, demonstrate an intellectual sophistication that is in marked contrast to the less complex themes chosen by other American muralists around the turn of the century.

Oil on canvas, $38\frac{5}{8} \times 12$ in. (98.1 × 30.5 cm.).
RELATED WORKS: *Frieze of Prophets*, pencil on paper, $17\frac{1}{2} \times 23\frac{7}{8}$ in. (44.5 × 60.6 cm.), Jan. 5, 1892, Boston Public Library. Shows entire north end of the third-floor hall // Study for the Hebraic end of the mural decorations, oil on canvas, 44 × 39 in. (111.8 × 99.1 cm.), ca. 1892, formerly coll. Miss Sargent, ill. in R. Ormond, *John Singer Sargent* (1970), p. 79 // *Astarte*, oil, 64 × 22 in. (162.6 × 55.9 cm.), coll. Emily

Sargent, 1935, currently untraced but listed in C. M. Mount, *John Singer Sargent* (1955; 1969), p. 469 // *Pagan Deities*, oil on canvas, 52 × 12½ in. (132.1 × 31.8 cm.), MFA, Boston // *Pagan Heads for a Vault*, oil on canvas, 67 × 18 in. (170.2 × 45.7 cm.), Yale University Art Gallery. Shows composition for the entire mural // *Astarte*, oil on canvas, $76\frac{3}{8} \times 36\frac{1}{2}$ in. (194 × 92.7 cm.), Boston Public Library // *Design for an Archway*, oil on canvas, $87\frac{1}{4} \times 51\frac{1}{4}$ in. (221.6 × 130.2 cm.), Yale University Art Gallery // *Astarte*, oil on canvas, 91 × 60 cm., Isabella Stewart Gardner Museum, Boston, ill. in P. Hendy, *European and American Paintings in the Isabella Stewart Gardner Museum* (1974), p. 225 // *The Pagan Gods*, oil and mixed media on canvas, $35\frac{1}{2}$ in. (90.2 cm.) wide, completed mural installed in 1895, Boston Public Library, ill. in *Winterthur Portfolio* 11 (1976), p. 159, fig. 8.

REFERENCES: W. H. Downes, *John S. Sargent* (1925), p. 35, discusses the subject matter of the Hebraic section of the murals, says that he derived his ideas regarding Astarte from Flaubert's *Salammbô*, that an archaic Greek statue in Athens served for her appearance, and that the original version of Astarte in the Gardner Museum was painted in a single day; pp. 166–167, discusses Gardner Museum version, gives Milton's *Paradise Lost* as another literary source // E. Charteris, *John Sargent* (1927; 1971), pp. 103–121, discusses the mural commission; pp. 142–144, discusses 1894 exhibition at the Royal Academy of the first installment for the murals; p. 285, includes it in a checklist, incorrectly dates it 1900, lists exhibition, gives provenance // C. M. Mount, *John Singer Sargent* (1955; 1969), pp. 188–198, 209–212, discusses the Boston Public Library commission; p. 469, includes it as Astarte (no. 2), in a catalogue of Sargent oils (no. K933 in early editions), dates it 1893, London // MFA, Boston, *Sargent's Boston* (1956), exhib. cat. by D. McKibbin, pp. 42–43, discusses the commission // R. Ormond, *John Singer Sargent* (1970), pp. 89–93, 98, appendix, discusses the commission // W. M. Whitehill, *American Art Journal* 2 (Fall 1970), pp. 13–35, discusses the history of the building and the decorations // M. Kingsbury, *Winterthur Portfolio* 11 (1976), p. 155, discusses the commission; p. 156, says the Pagan Gods is "a composite of religious figures and legendary relations drawn from Egyptian, Assyrian, and Greek sources"; pp. 156–157, calls the "lascivious" Astarte a travesty of Murillo's cloud-borne Virgins; p. 157, includes the mural among the first set installed in 1895, quotes contemporary critics, and notes influence of Flaubert; pp. 165–166, discusses symbolist influence for Astarte; p. 172, quotes E. Fenollosa's comments (1896) on the Pagan Gods mural // D. B. Burke, *Fenway Court, Isabella Stewart Gardner Museum* (1976), pp. 8–19, discusses the Astarte figure and its sources and shows related works.

EXHIBITED: Royal Academy, London, 1926, *Exhibition of Works by the Late John S. Sargent, R.A.*, no. 126, as Design for the "Astarte": Boston Public Library, lent by Mrs. Ormond // National Gallery, Millbank,

List of Loans at the Opening Exhibition of the Sargent Gallery, p. 7, lent by Mrs. Ormond.

Ex coll.: the artist's sister Violet (Mrs. Francis Ormond), London, by 1926–1950.

Gift of Mrs. Francis Ormond, 1950.

50.130.3.

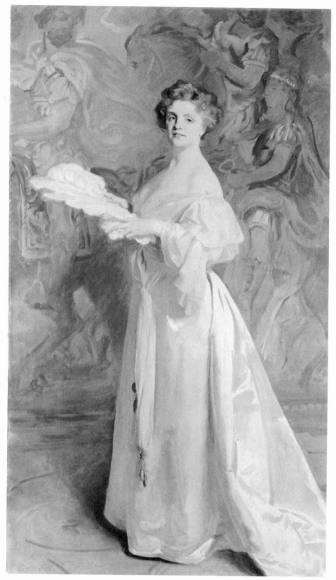

Sargent, *Ada Rehan.*

Ada Rehan

The Shakespearean actress Ada Rehan (1860–1916) was born Delia Crehan in Limerick, Ireland. Following the career chosen by her two older sisters, she made her debut at the age of sixteen with Mrs. John Drew's stock company in Philadelphia, receiving her stage name when a printer billed her as Ada C. Rehan. In 1879, she began a long association with Augustin Daly's theater company, appearing with the group when it made its first trip abroad in 1884. Miss Rehan was performing in London with Daly's company between June 27, 1893, and May 7, 1894, and met Sargent at a dinner party sometime during the winter. The portrait was commissioned by an admirer of Miss Rehan's, Catharine L. Whitin of Whitinsville, Massachusetts, probably in January 1894; for Sargent wrote to Mrs. Whitin on January 27:

Before receiving your letter I had a note from Miss Rehan who informed me that you had cabled to her and invited me to call which, as I was in London, I did at once. I am glad that you incline to a portrait *not* in character, as both she and I feel the same way. This is all that we could decide at the time, but when I go up to town again she is coming to my studio with several dresses to choose from, and there in the proper light, I will be able to come to conclusion about the treatment of the picture. I think it ought to be full length in spite of the fact that it will have to stand on the ground or very nearly. The price that I asked you for painting Miss Rehan ($2,500) is below my usual price and you would do me a favor by not mentioning it, as I have several orders to fulfill in America at a higher figure. I think the whole impression, and the upper part of Miss Rehan's face is very fine, and I hope I shall satisfy your ambition for the portrait. We expect to accomplish it in the months of March and April.

Since Miss Rehan was busy with final rehearsals for Shakespeare's *Twelfth Night* and he was preparing the decorations for the Boston Public Library and paintings to be submitted to exhibitions that year, Sargent did not begin work on the portrait until sometime in April. On April 7, he wrote to Miss Rehan to arrange a sitting: "Today my pictures have left here for the Academy and I am at liberty to resume portrait work—I have not been to town since I called on you and have been so pressed . . . that I have not had a minute for our proposed dress rehearsal." Perhaps it was at this time that the actress expressed her hesitation to pose for the picture. Sargent tried to overcome her reluctance and cajole her into posing. In an undated letter he wrote:

I am very sorry to hear you have been ill and feel unequal to the task of sitting which is a great disappointment. In case there was a chance of making

you change your mind I should argue . . . that a great many people find it rather a rest than otherwise and also that some of my best results have happened to be obtained with few sittings . . . but I always admit beforehand that it may take me much longer—Will you give me a chance? or at any rate will you come to my studio with a dress or two, and let me see if really you look worse for your long season of work. The public does not seem to think so! and I don't believe I shall.

Miss Rehan was troubled by illness and by the relentless demands of her theatrical career, but she eventually consented to pose for Sargent, who must have worked on the portrait during April and early May 1894.

Sargent was still working on the background during the summer; for on August 18, he wrote to the Boston art collector Isabella Stewart Gardner about a carpet he had borrowed to use as a background in the portrait: "It did not answer in Miss Rehan's picture—she became a mere understudy and the carpet played the principal part, so it had to be taken out." Apparently, both the sitter and Mrs. Whitin had objected to the brilliance of the original background. Also during August, the artist received a letter from Mrs. Whitin, who inquired about photographing and exhibiting the portrait. On August 22, he responded, explaining that it was "not yet even finished." It was not until just before March 22, 1895, that Sargent considered the work completed. On that day he wrote to Mrs. Whitin, who had evidently seen the picture and wanted to reduce its size:

Miss Rehan's portrait has only lately been finished, as all winter long I have been unable to work at anything but my Boston decoration for which I have been much pressed by the trustees of the library. Hence the reason of my not having been able to send the portrait to New York. The picture has now a background of tapestry which improves it very much. I have found a charming old frame for it which I hope you will approve of. I think the picture would look much better in an exhibition if it retained the original size of the canvas as you saw it. It will be an easy matter, when you want it in your home to cut a few inches off the top and have the frame reduced to fit the height of your room.

Mrs. Whitin must have requested some additional changes; for on August 22, 1895, he wrote to his client: "I have just returned to London and put Miss Rehan's portrait in my studio and looking very well, I think. As I wrote to you on leaving New York I have in mind your suggestions, and will do some slight work to the background." After making these changes Sargent exhibited the portrait of Ada Rehan at the New Gallery in London and then at the National Academy of Design in New York, where it was included in a special portrait exhibition.

This imposing full-length portrait demonstrates a change in the artist's technique and presentation. He abandons the intensity and austerity of his earlier portraits and paints with a decorative richness, rendering textures in a lush manner. This work establishes a pattern followed in other female portraits painted during the late 1890s, in which the opulent costumes, accessories, and settings receive as much attention as the sitters.

Oil on canvas, 93 × 50⅛ in. (236.2 × 127.3 cm.).
Signed at lower left: John S. Sargent.
RELATED WORKS: Two full-length drawings of Ada Rehan, ca. 1893–1895, in Sketchbook, ca. 1890s, pencil on paper, 5 15/16 × 9¾ in. (15.1 × 23.8 cm.), pp. 19 and 19v, Fogg Art Museum, Cambridge, Mass., 1937.7.11.
REFERENCES: J. S. Sargent to A. Rehan [1893–1895], Folger Shakespeare Library, Washington, D.C., in three letters, discusses sittings for it (quoted above) // J. S. Sargent to Mrs. G. M. Whitin, Jan. 27, 1894, formerly in the possession of her daughter Mrs. E. K. Swift, typed copy in Dept. Archives, discusses plans and fee for it (quoted above) // J. S. Sargent to I. S. Gardner, August 18, 27 [1894], Isabella Stewart Gardner Museum, Boston, microfilm 408, Arch. Am. Art, discusses carpet originally planned for background (quoted above) // J. S. Sargent to Mrs. G. M. Whitin, August 22, 1894, March 22, and August 22, 1895, typed copy in Dept. Archives, discusses exhibition, completion, size, and added work on the background of the painting, (quoted above) // Art Amateur 34 (Dec. 1895), p. 3, mentions it at NAD // Mrs. G. M. Whitin to Mr. Dorney, Feb. 8, 1896, Folger Shakespeare Library, gives permission to reproduce it in a review of the PAFA exhibition in 1896 in Harper's Weekly // Collector 8 (Dec. 1, 1896), p. 35, discusses it on view at Daly's Theatre // E. A. D[ithmar], Memories of Daly's Theatres (1897), ill. frontis. // W. Winter, Ada Rehan (1898), ill. p. 23, detail of head, dates it 1895 // G. P. Lathrop, Century Magazine, n.s. 34 (June 1898), ill. p. 269 // Artist 24 (March 1899), p. xiv, mentions it in a review of the Copley Hall exhibition in 1899 // J. C. Van Dyke, Outlook 74 (May 2, 1903), ill. p. 34 // C. H. Caffin, World's Work 7 (Nov. 1903), ill. p. 4113 // Museum of Fine Arts Bulletin, suppl. to 13 (Feb. 1915), mentions it in opening exhibition of Robert Dawson Evans Memorial Galleries // N. Pousette-Dart, comp., John Singer Sargent (1924), unnumbered pl. // P. B[oswell], American Art News 22 (Feb. 23, 1924), ill. p. 2, in a review of the Grand Central Exhibition // American Art Student and Commercial Artist 7 (March 1924), p. 17 // R. V. S. Berry,

Art and Archaeology 18 (Sept. 1924), ill. p. 89, discusses || W. Starkweather, *Mentor* 12 (Oct. 1924), p. 8; ill. p. 27 || W. H. Downes, *John S. Sargent* (1925), p. 39, mentions that it was exhibited for the first time in 1895; pp. 172–173, includes it in a list of Sargent's works, lists exhibitions, describes || E. Charteris, *John Sargent* (1927; 1971), p. 154, mentions its being exhibited at New Gallery; p. 265, includes it in a list of Sargent's oils, dates it 1894, lists exhibitions || M. S. Shannon, *American Magazine of Art* 18 (April 1927), p. 181, discusses the carpet originally intended for the background || W. G. Robertson, *Life Was Worth Living* [1931], pp. 234–235, discusses sitting || *Index of Twentieth Century Artists* 2 (March 1935), p. 82, lists it || C. Cunningham, MFA, Boston, letters in Dept. Archives, Dec. 19, 1940, July 14, 1941, discusses its exhibition there || Mrs. E. K. Swift, letter in Dept. Archives, Jan. 7, 1941, encloses copies of additional letters from Sargent to Mrs. G. M. Whitin and says that in December 1893, the artist and the sitter met at a dinner party and discussed the portrait, which Mrs. Whitin commissioned in January 1894; notes that Mrs. Whitin saw the portrait in London on her return from Egypt in the spring of 1895; says she does not know why the portrait was not finished in April 1894, but the artist apparently repainted the head; says Mrs. Whitin went to several of the sittings, probably in May or June 1894 and that the original background was "a more brilliant one," which did not satisfy the artist, the sitter, or Mrs. Whitin || H. W. W[illiams], Jr., *MMA Bull.* 36 (Jan. 1941), ill. p. 19, gives biography of the sitter and circumstances under which it was painted || *Theatre Arts* 25 (March 1941), ill. p. 251 || *Art Digest* 15 (March 1, 1941), ill. p. 22, discusses the sitting || H. W. Williams, *Art in America* 29 (July 1941), pp. 173–174, gives text of letters to Mrs. G. M. Whitin, 1894–1895 || C. M. Mount, *John Singer Sargent* (1955; 1969), pp. 199–201, says that it was commissioned by Mrs. Whitin early in 1894, quotes letter from Sargent to Mrs. Whitin, says W. G. Robertson was sitting for him at the same time, describes sitting; pp. 203–204, quotes letters from Sargent to I. S. Gardner; pp. 210, 212–213, quotes letters from Sargent to Mrs. Whitin; p. 449, includes it in catalogue of Sargent's oils (no. 951 in early editions), dates it 1895, London || MFA, Boston, *Sargent's Boston*, exhib. cat. by D. McKibbin (1956), p. 118, includes it in a checklist of Sargent portraits, dates it 1894–1895, London || R. Ormond, *John Singer Sargent* (1970), p. 51, quotes Sargent to A. Rehan, n.d., calls it the first of a series of important full-length standing compositions; p. 63, mentions artist's practice of having female sitters bring a choice of costumes for pose || Folger Shakespeare Library, Washington, D.C., letter in Dept. Archives, Dec. 23, 1975, provides information about correspondence between Sargent and Mrs. Whitin.

EXHIBITED: New Gallery, London, 1895, *Summer Exhibition*, no. 199 || NAD, 1895, *Loan Exhibition of Portraits*, no. 271, lent by Mrs. G. M. Whitin || PAFA, 1895–1896, no. 298, lent by Mrs. G. M. Whitin || Copley Hall, Boston, 1896, *Loan Exhibition of Portraits*, no. 206 || Daly's Theatre, New York, 1896 || Boston Art Students Association, Copley Hall, Boston, 1899, *Catalogue of Paintings and Sketches by John S. Sargent*, no. 18, lent by Mrs. George Marston Whitin; p. 51, lists exhibitions || Worcester Art Museum, Mass., 1914, *Exhibition of Contemporary American Paintings Owned in Worcester County*, no. 36, lent by Mrs. G. M. Whitin || Corcoran Gallery of Art, Washington, D.C., 1914–1915, no. 108, lent by Mrs. G. M. Whitin || MFA, Boston, 1915 || Grand Central Art Galleries, New York, 1924, *Retrospective Exhibition of Important Works by John Singer Sargent*, no. 30, lent by Mrs. G. M. Whitin || MFA, Boston, 1925, *A Catalogue of the Memorial Exhibition of the Works of the Late John Singer Sargent*, no. 58, lent by Mrs. G. M. Whitin.

EX COLL.: Mrs. George M. Whitin, Whitinsville, Mass., 1895–1940.

Bequest of Catharine Lasell Whitin, 1940, in Memory of Ada Rehan.

40.146.

Mr. and Mrs. I. N. Phelps Stokes

Sargent painted this double portrait in 1897. Isaac Newton Phelps Stokes (1867–1944), the son of Mr. and Mrs. Anson Phelps Stokes, was then an architecture student at the atelier de Monclos-Chiflot in Paris. He later distinguished himself as an architect, specializing in office buildings, apartment houses, and model tenements, and as the author of the six-volume *Iconography of Manhattan Island* (1915–1928), a definitive work that presents factual and visual information on the history of Manhattan. His wife, Edith Minturn Stokes (1867–1937), was born in West Brighton, Staten Island, the daughter of the heir to a New York shipping fortune, Robert Browne Minturn, Jr., and his wife the former Susannah Shaw. Her principle interest was in education and the training of small children. She was active in church work for St. George's Parish on Staten Island, and from 1912 to 1933, she was president of the New York Kindergarten Association. The Stokeses were married on August 25, 1895, and the portrait by Sargent was a wedding gift from James A. Scrimser.

The painting was originally intended as a single portrait of Edith, and Sargent planned to paint it during the summer of 1897 in Venice. He was detained, however, in London, where the Stokeses met him in June, and Edith began to pose. Sargent followed his usual procedure, observing her in a variety of dresses, so that he

might choose an appropriate costume for the portrait. After a while he selected a blue satin evening gown and placed her seated beside a small round French table, which she was supposedly tapping with a fan. After four or five sessions, Sargent decided that this pose was inappropriate and told Edith that he wished to try another. In his reminiscences (1932), I. N. Phelps Stokes describes the circumstances which resulted in the pose and costume that were finally selected:

On our next visit to the studio, a very warm morning, we had walked from our apartment. Edith had on a starched white piqué skirt, and a light shirt-waist under her blue serge, tailor-made, jacket. As she came into the studio, full of energy, and her cheeks aglow from the brisk walk, Sargent exclaimed at once: "I want to paint you just as you are." We thought it wise to submit to his whim, although we had, even then, some apprehensions lest our friends at home, and especially Mr. Scrimser, might not altogether approve. However, within a few moments, the first portrait had been scraped off the canvas—the fate which later

Sargent, drawing of Mrs. Stokes, Fogg Art Museum.

befell eight of the nine heads of the second portrait. A new pose was finally decided upon, in which Edith was to stand with one hand resting on the head of a tiger-striped Great Dane, which was to be selected from the kennels belonging to one of Sargent's friends.

A pencil sketch at the Fogg Art Museum summarily captures Edith's pose for the portrait and defines the strong contrast between her bright skirt and dark jacket.

While working on the portrait, Sargent entertained the Stokeses with anecdotes about his sitters and his work. Mr. Stokes recalls:

We were much amused in the studio by his eccentricities; for instance, his habit of standing before the canvas, with brush balanced like a poised dart—in perfect silence until the stroke had been successfully delivered—always accompanied by the exclamation: "pish-tash; pish-tash!" He studied each stroke thoughtfully, and was not satisfied unless it was clearly defined, and of just the right form and consistency. He was particularly well satisfied with the "spiral" stroke with which he produced the diamond in Edith's engagement-ring, and cautioned me, if the picture were ever varnished, to be sure that the protruding whisp of paint was not injured. Alas! it has been.

Meanwhile, Mr. Stokes's mother offered to have his portrait painted as an extra wedding gift for Edith. Sargent was too busy to accept the commission and suggested that they ask Whistler to do it. Unfortunately, the price that Whistler asked was too high, and Mr. Stokes abandoned the idea. But when Sargent had finished painting Edith, he was disappointed to learn that the dog he wanted to pose beside her was no longer available. I. N. Phelps Stokes had "a sudden inspiration, and offered to assume the role of the Great Dane in the picture." Sargent added him to the portrait in three sittings, so that, in a sense, their second desire—a portrait of Mr. Stokes by Sargent—was fulfilled.

The picture was widely exhibited in America and often criticized for the elongated appearance of the figures and for the concentration on costume rather than characterization. Nevertheless, it is an outstanding example of Sargent's portrait style during the 1890s. The composition presents an interesting solution to the problem of the double portrait, maintaining a focus on Edith yet including an expressive likeness of her husband, who is relegated to an accessory position and depicted in shadow. With its fluid brushwork and original composition, and in its grandeur, the portrait is typical of Sargent's figurative work at this time.

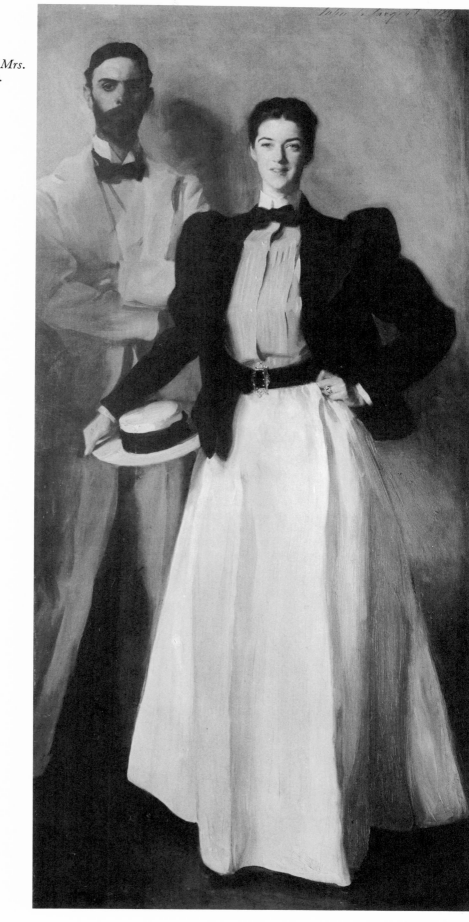

Sargent, *Mr. and Mrs.*
I. N. Phelps Stokes.

Oil on canvas, $84\frac{1}{4} \times 39\frac{3}{4}$ in. (214 × 101 cm.).

Signed and dated at upper right: John S. Sargent 1897.

RELATED WORK: Pencil drawing of Mrs. Stokes, standing full-length, Sketchbook, ca. late 1890s, $5\frac{15}{16} \times 9\frac{3}{8}$ in. (15.1 × 23.8 cm.), p. 24, Fogg Art Museum, Cambridge, Mass., 1937.7.11.

REFERENCES: *New York Times*, March 19, 1898, Saturday Review of Books and Art, p. 141, says it is "the most important" work by Sargent in the annual exhibition of the Society of American Artists; March 26, 1898, Saturday Review of Books and Art, p. 197, calls it one of the "stars" of the exhibition // *Critic* 29 (March 26, 1898), p. 220, praises its realism and says that the treatment of the costumes "might stand alone as a sample of the painter's brush-work" // C. H. Caffin, *Harper's Weekly* 62 (Nov. 12, 1898), p. 1102, mentions it in the annual exhibition at the Carnegie Institute // *International Studio* 4 (1898), p. x, discusses it in the exhibition of the Society of American Artists, says it "lacks quality but for a perspicuous bit of character-rendering it is most eloquent" // C. H. Caffin, ed., *Artist* 24 (Feb. 1899), p. xxix, in a review of the PAFA exhibition, mentions it in connection with Cecilia Beaux's portrait of Mr. and Mrs. Anson Phelps Stokes (q.v.) // F. J. Ziegler, *Brush and Pencil* 3 (Feb. 1899), pp. 292–293, describes it in PAFA exhibition // G. Kobbé, *Century* 59 (Dec. 1899), ill. p. 321, shows a caricature of it by a member of the Society of Fakirs, depicting the Stokeses as clothes horses with a sign above them reading "These stylish suits $49.98" // C. H. Caffin, *International Studio* 14 (1901), p. xxi, reviews it in Pan-American Exposition, noting that "so much cleverness should [not] have been expended to such trivial purpose" // J. W. Pattison, *Painters since Leonardo* (1904), pp. 252–254, mentions it in Pan-American Exposition, 1901, notes its "swift strokes," calls it "Sargent's most important picture" // F. Watson, *Arts* 5 (March 1924), ill. p. 144 // H. McBride, *Dial* 76 (April 1924), pp. 386–387, comments on the excessive height of the figures, notes that during the 1890s, Sargent's audience was not aware of El Greco's influence on Sargent // L. Mechlin, *Magazine of Art* 15 (April 1924), ill. p. 186 // W. H. Downes, *John S. Sargent* (1925), p. 41; pp. 180–181, includes it in a list of Sargent's works, lists exhibitions, describes, quotes M. Bruening in the *New York Evening Post* // H. B. Wehle, *MMA Bull.* 21 (Jan. 1926), p. 4 // *New York Tribune*, Jan. 5, 1926, p. 72 // E. Charteris, *John Sargent* (1927; 1971), p. 266, includes it in a list of Sargent's oils, dates it 1897, lists exhibitions // I. N. P. Stokes, *Random Recollections of a Happy Life* (1932; 1941), ill. opp. p. 115; pp. 115–118, gives detailed account of the sittings (quoted above) // *Index of Twentieth Century Artists* 2 (March 1935), p. 84, lists reproductions // I. N. P. Stokes, orally, June 15, 1938, recorded in memo, MMA Archives, June 16, 1938, described the sittings for it; letter in MMA Archives, August 19, 1938, returns corrected version

of a note on the portrait by J. L. Allen; letter in MMA Archives, August 22, 1938, gives biographical information on Mrs. Stokes // J. L. A[llen], *MMA Bull.* 33 (Sept. 1938), ill. p. 210, discusses sittings for it // E. A. Jewell, *New York Times*, Sept. 18, 1938, sec. 10, ill. p. 7 // *Art Digest* 13 (Oct. 1, 1938), ill. p. 17, discusses sittings for it; (Oct. 15, 1938), p. 18, criticizes the great height of the figures // J. Mellquist, *American Collector* 15 (June 1946), ill. p. 8, says it was given to the Stokeses as a wedding present and describes sittings // A. Bell, *Canadian Art* 7 (Christmas 1949), ill. p. 70; p. 71, mentions its inclusion in the Canadian National Exhibition at the Art Gallery of Toronto // C. M. Mount, *John Singer Sargent* (1955; 1969), p. 448, includes it in a catalogue of Sargent oils (no. 972 in early editions), dates it 1897, London // MFA, Boston, *Sargent's Boston*, exhib. cat. by D. McKibbin (1956), p. 124, includes it in a checklist of Sargent's portraits, dates it 1897, gives biographical information on sitters, and lists drawing in Fogg // J. L. Greaves, "Portrait of Mr. and Mrs. Isaac Newton Phelps Stokes by John Singer Sargent (1856–1925)," unpublished paper, copy in Dept. Archives, gives biographical information on sitters, references, exhibitions, and provenance // A. T. Gardner, *Antiques* 87 (April 1965), ill. p. 438 // W. F. Bell, *Eagle's Berkshire Week* [Summer 1967], copy in Dept. Archives, ill. in a discussion of the Minturn family // R. Ormond, *John Singer Sargent* (1970), p. 52; [p. 169], pl. 71; p. 248, discusses sittings, mentions drawing in Fogg.

EXHIBITED: Society of American Artists, New York, 1898, no. 284, as Portraits of Mr. and Mrs. I. N. Phelps Stokes, lent by I. N. Phelps Stokes, Esq. // Carnegie Institute, Pittsburgh, 1898–1899, no. 52 // PAFA, 1899, no. 9, lent by Isaac N. Phelps Stokes, Esq. // Boston Art Students' Association, Copley Hall, Boston, 1899, *Catalogue of Paintings and Sketches by John S. Sargent*, no. 34, lent by I. N. Phelps Stokes, Esq., New York; p. 9, dates it July 1897, lists exhibitions // Pan-American Exposition, Buffalo, New York, 1901, *Catalogue of the Exhibition of Fine Arts*, no. 28, lent by I. N. Phelps Stokes, Esq. // Grand Central Art Galleries, New York, 1924, *Retrospective Exhibition of Important Works by John Singer Sargent*, no. 58, lent by Mr. Phelps Stokes // MMA, 1926, *Memorial Exhibition of the Work of John Singer Sargent*, no. 30, lent by I. N. Phelps Stokes; 1939, *Life in America*, no. 262; p. 198, says that Mrs. Stokes posed twenty-eight times and that the head was finished on the ninth attempt; ill. p. 199 // MMA and Art Institute of Chicago, 1954, *Sargent, Whistler and Mary Cassatt*, exhib. cat. by F. A. Sweet, no. 60; ill. p. 61, relates the circumstances under which it was painted // Indianapolis Museum of Art, 1970–1971, *Treasures from the Metropolitan*, no. 1, lists exhibitions and references.

ON DEPOSIT: Brooklyn Museum, 1927–1938, lent by I. N. Phelps Stokes, New York.

EX COLL.: Mr. and Mrs. I. N. Phelps Stokes, New York, 1897–1938.

Bequest of Edith Minturn Phelps Stokes (Mrs. I. N.), 1938.
38.104.

Henry G. Marquand

The philanthropist and art patron Henry Gurdon Marquand (1819–1902) was a successful businessman who began his career in real estate and banking. In 1868, he became involved with the Iron Mountain Railroad and served as its vice-president until its merger with the Missouri Pacific Railroad, of which he was also a director. After 1880, he devoted himself primarily to his art collections and to efforts on behalf of the Metropolitan Museum. In 1889 and 1890, he presented his principal gift to the museum—a notable collection of paintings by Rembrandt, Vermeer, Van Dyck, Hals, and other Dutch, Flemish, and British masters—which helped to raise the museum from a provincial position to one of international status. Between February 1889 and his death in February 1902, he served as the museum's second president. In recognition of his contributions, the trustees resolved unanimously on February 17, 1896, to commission a portrait of Marquand "as a permanent memorial of their regard for him, and of their grateful sense of his earnest devotion and munificent liberality."

By February 27, 1896, a committee of three trustees, Cornelius Vanderbilt, William R. Ware, and Charles Stewart Smith, had been appointed to make the arrangements for the portrait. It is not known who made the final selection of the artist, but Marquand himself was certainly consulted. John Singer Sargent would have been a logical choice for him. Sargent had not only established an international reputation as a portraitist, but he was also well acquainted with the Marquand family. In 1887, he had come to America to paint a portrait of the sitter's wife, Elizabeth Allen Marquand, 1887 (coll. Mrs. Douglas Delanoy, Princeton, N.J.) and had executed a portrait of their daughter Mabel, *Mrs. Henry Galbraith Ward* (q.v.). Sargent wrote appreciatively to Marquand in a letter dated simply March 18: "My debt of gratitude to you is one of very long standing, you have not only been a very constant friend to me personally, but a bringer of good luck—My going to America to paint Mrs. Marquand's portrait was a turning point in my portents [?] for which I have most heartily to thank you" (Allan Marquand Papers,

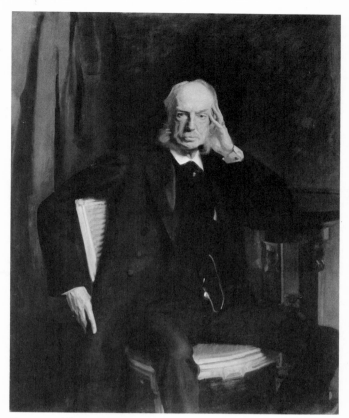

Sargent, *Henry G. Marquand.*

Firestone Library, Princeton University).

It appears that Marquand or his family corresponded with Sargent about the portrait before the committee made the final selection. In an undated letter written to the sitter's son Allan, who taught art history at Princeton and was an acquaintance, Sargent explained that he could not travel to America to paint the portrait, as he was occupied in completing another installment of murals for the Boston Public Library. Instead he suggested:

If your father is coming abroad I should make it convenient to paint him . . . even in July or August. Up to the end of June I am likely to be doing portraits for which I am already booked and it was my intention to go abroad in the middle of the summer. If however your father thought of coming over I should arrange my plans accordingly. There is no immediate hurry on my part to know what you decide but when you have commissioned it I should like to hear whether I have a chance.

The decision to have Sargent paint the portrait must have been made by May 11, 1896, when Vanderbilt wrote to the sitter inquiring: "May I telegram Sargent in regard to your portrait?" Within four days, Vanderbilt had cabled Sargent

and received an affirmative reply. The sittings were scheduled for July 1896.

Marquand himself apparently wrote to the artist and expressed concern about the number and length of the sittings required to complete the work, for he was in poor health. On May 24, Sargent responded from Paris:

I am very glad to have your portrait to do for the Museum, and hope you will be well and strong by that time. It is very difficult to say how many sittings it depends very much on how long you will be able to sit each time, especially as yours will not be the only portrait I will be doing and I doubt if I can see [?] you every day. However, I think I can reply by then the time limit of 3 weeks that you give me ought to be sufficient. Two or three days can't make any difference about your arrival. Please let me know beforehand so that I can arrange my time.

Ill health, however, prevented Marquand from going to London at all that summer. Unfortunately, it appears that he neglected to inform the busy artist about his change in plans. On July 25, the indignant Sargent wrote him from London:

I have of this morning received your letter of July 16th saying that you are ill which I much regret. I did not believe the secretary [?] of the Hotel yesterday when I went there after having expected you and thought that as I had not got a cable long ago you had simply determined to change your hotel. . . . So many plans have hinged upon our engagement from the 24th that you cannot believe how opportune a cablegram received two weeks ago would have been.

Sargent concluded the letter with the hope that Marquand would recover quickly.

Marquand recovered sufficiently from his illness to go to London to pose during the summer of 1897. "I have been sitting almost every day and resting when not sitting for the portrait," Marquand wrote on August 1 to Luigi P. di Cesnola, the museum's director. His last sitting was on July 31, and he sailed for New York four days later. The portrait remained in London until October. The artist suggested that the frame be designed and constructed in New York by "someone Stanford White knows."

The painting, executed at the height of Sargent's artistic powers, was the first of his works to enter the museum's collection. Both Marquand and the trustees appear to have been pleased with it. In 1941, however, the art dealer Martin Birnbaum retold an amusing anecdote about the artist's attitude toward the picture:

Wells Bosworth is authority for . . . [an] example of . . .

[Sargent's] flippancy, which was really evidence of Sargent's humility and extraordinary simplicity, the outstanding keynotes of his character. They were standing, with Miss Emily Sargent, in the Metropolitan Museum, before the famous portrait of Henry G. Marquand which hung near the fine paintings of Franz Hals, and the architect turned to her and said, "If your brother had never painted any other picture than this, he would go down to posterity as the greatest portrait painter of his time." Overhearing this, Sargent pointed to the pink skin drawn over the skull of the aged financier and mumbled disdainfully, "Chicken,—chicken! I can never think of anything else, when I look at this portrait, but plucked fowl in the markets!"

Oil on canvas, 52 × 41¾ in. (132.1 × 106 cm.).
Signed: John S. Sargent.
REFERENCES: Minutes of the board of trustees, MMA, MMA Archives, Feb. 17, 1896, III, pp. 206–207, reports that a committee was appointed to procure a portrait of Marquand (quoted above) // C. Vanderbilt to L. P. di Cesnola, Feb. 27, 1896, MMA Archives, requests the names of men on committee // Cesnola to Vanderbilt, Feb. 27, 1896, MMA Archives, lists C. Vanderbilt, W. R. Ware, and C. S. Smith as committee members // Vanderbilt to H. Marquand, May 11, 1896, MMA Archives, asks if he can telegram Sargent in regard to the portrait and requests the address (quoted above) // Vanderbilt to Cesnola, May 15, 1896, MMA Archives, says he has cabled Sargent and he will do the portrait in the summer, that it should be same size as museum's Léon Bonnat of John Taylor Johnston, 1880, and Daniel Huntington's William C. Prime, 1892 // Minutes of the board of trustees, MMA, MMA Archives, May 18, 1896, III, p. 214, reports on correspondence between the artist and the committee, which hoped that Marquand's health would permit him to sit for the portrait in July 1896 // J. S. Sargent to [A.] Marquand, n.d., Misc. MSS Sargent, Arch. Am. Art, says he would be delighted to paint father's portrait (quoted above); to H. Marquand, May 24 [1896], says he is "very glad" to paint portrait, discusses schedule and sittings (quoted above), and July 25 [1896], says that he has received his letter of July 16 and regrets he did not know change of plans sooner (quoted above) // H. Marquand to Cesnola, August 1, 1897, MMA Archives, says he has been sitting nearly every day and had last sitting on July 31 (quoted above), he is leaving for New York on August 4 and those who have seen the portrait are pleased with it, and on August 18, 1897, notes that Sargent advises the frame be made in New York and has written Vanderbilt about the price of the painting, and that it would not be wise to ship portrait before Oct. 1, since "it dries slowly in London" // Sargent to Cesnola, Oct. 12, 1897, MMA Archives, says he has shipped it and requests it be included in NAD exhibition // Vanderbilt to Cesnola, cable, Oct. 13, 1897, MMA Archives, says it has been

AMERICAN PAINTINGS · III

shipped via the *Majestic* // H. Marquand to Mr. Story, Oct. 13, 1897, MMA Archives, says Sargent made portrait narrower than Bonnat's portrait of Johnston, "I hope that you will have no bother" // Cesnola to H. Marquand, Oct. 26, 1897, in MMA Archives, encloses letter from museum to Sargent for approval // T. W. Wood to Cesnola, Nov. 9, 1897, MMA Archives, says portrait cannot be exhibited at NAD once it is exhibited elsewhere in New York // *Critic*, no. 821 (Nov. 13, 1897), ill. p. 286, notes its presentation to MMA and calls it "a pleasing picture, one which grows upon the spectator with time, and looks better at a second view than at the first" // Minutes of the board of trustees, MMA, MMA Archives, Nov. 15, 1897, III, p. 241, votes to accept it as a gift from the trustees // C. S. Smith to Vanderbilt, Dec. 11, 1897, asks him if he made any agreement with the artist as to price; annotation by Vanderbilt: "Mr. Sargent remarked casually to Mr. Marquand that he had forgotten the price he had named to you for the portrait" // *Art Interchange* 39 (Dec. 1897), ill. p. 121 // Cesnola to W. Ware, Jan. 2, 1898, MMA Archives, encloses a letter prepared by C. S. Smith which is to be sent to the trustees regarding their contribution to cover the cost of the portrait // *International Studio* 3 (Jan. 1898), pp. x–xi, discusses its acquisition, noting that "Mr. Sargent has rarely been more successful in the figures of his sitters than in this canvas" // *Artist* 24 (March 1899), p. xliii, reviews it in the Copley Hall exhibition, calling it one of his "very great works"; p. xiv // A. Hoeber, *The Treasures of the Metropolitan Museum of Art of New York* (1900), pp. 118, 120, discusses it // C. H. Caffin, *American Masters of Painting* (1902), p. 62, compares it to old master paintings by such artists as Hals and Velázquez; ill. opp. p. 62; p. 64, says he has achieved a "deeper level of intimacy"; reprinted in *Current Literature* 34 (April 1903), pp. 445–446 // J. Van Dyke, *Outlook* 74 (May 2, 1903), p. 36, praises it; ill. p. 37; p. 38 // C. H. Caffin, *World's Work* 7 (Nov. 1903), ill. p. 4105; p. 4115, calls it "a memorable piece of psychological portraiture" // S. Isham, *History of American Painting* (1905; 1927), ill. p. 435 // *MMA Bull.* 1 (Nov. 1905), p. 10, says that up to the present time it is the only Sargent on permanent view in New York // C. Brinton, *Munsey's Magazine* 36 (Dec. 1906), ill. p. 274 // C. H. Caffin, *The Story of American Painting* (1907; 1937), ill. p. 248, calls it "one of Sargent's greatest successes in dignity and depth of characterization" // Mrs. A. Meynell, intro., *The Work of John S. Sargent, R.A.* (1907), unnumbered pl. // W. A. Coffin, *Palette and Bench* 3 (Oct. 1910), ill. p. 9, and discusses // *MMA Bull.* 6 (Jan. 1911), ill. p. 4; p. 6 // J. Howard, *Arts and Decoration* 1 (June 1911), ill. p. 340 // *Arts and Decoration* 6 (July 1916), p. 396, compares it to Madame X // *Literary Digest* 56 (Feb. 9, 1918), p. 28 // J. C. Van Dyke, *American Painting and Its Tradition* (1919), p. 257, compares its "bodily presence" to Frans Hals's work // L. Mechlin, *Magazine of Art* 15 (April 1924), p. 188 // W. Starkweather, *Mentor* 12

(Oct. 1924), ill. p. 23 // W. H. Downes, *John S. Sargent* (1925), pp. 41–42; p. 181 includes it in list of works and quotes critics' opinions // E. H. Blashfield, *North American Review* 221 (June 1925), p. 649 // H. B. Wehle, *MMA Bull.* 21 (Jan. 1926), ill. p. 4 // *New York Tribune*, Jan. 5, 1926, p. 22 // *Christian Science Monitor*, Jan. 6, 1926, p. 10 // A. D. Patterson, *Canadian Magazine* 65 (March 1926), p. 31, relates Sargent's reaction after learning that it had been hung between two portraits by Hals: he "threw up his hands with a gesture of despair and said, 'My God!'" // E. Charteris, *John Sargent* (1927; 1971), p. 266, includes it in catalogue of oils, dates it 1897, lists exhibitions // F. J. Mather, Jr., *Saturday Review of Literature* 3 (Feb. 26, 1927), p. 606 // J. B. Manson and Mrs. A. Meynell, intro., *The Work of John S. Sargent, R.A.* (1927), 2, unnumbered pl. // F. J. Mather, Jr., *Estimates in Art* (1931), 2nd ser., p. 240 // *Index of Twentieth Century Artists* 2 (Feb. 1935), p. 80, lists reproductions // M. Birnbaum, *John Singer Sargent* (1941), pp. 41–42, relates an anecdote told by W. Bosworth (quoted above) // F. J. Mather, Jr., *Magazine of Art* 39 (Nov. 1946), ill. p. 304, discusses // J. P. Leeper, *Magazine of Art* 44 (Jan. 1951), ill. p. 13; p. 15, discusses // R. B. Hale, *MMA Bull.* 12 (March 1954), p. 176; ill. p. 183 // C. M. Mount, *John Singer Sargent* (1955; 1969), p. 367; p. 445, includes it in catalogue of Sargent's oils (no. 971 in early editions) // MFA, Boston, *Sargent's Boston*, exhib. cat. by D. McKibbin (1956), p. 108, includes it in a checklist of Sargent's portraits, dates it 1897 // A. T. Gardner, *MMA Bull.* 23 (April 1965), ill. p. 272; p. 273 // R. Ormond, *John Singer Sargent* (1970), p. 52, discusses it as an example of his simpler and more direct characterizations; [p. 182], pl. 84; p. 250, discusses // W. D. Garrett, *MMA Jour.* 3 (1970), ill. p. 311, discusses // Mrs. G. E. Bolhouse, Newport Historical Society, letter in Dept. Archives, Dec. 11, 1975, gives biographical information on the sitter.

EXHIBITED: MFA, Boston, 1925, *A Catalogue of the Memorial Exhibition of the Works of the Late John Singer Sargent*, no. 63 // MMA, 1926, *Memorial Exhibition of the Work of John Singer Sargent*, no. 31.

Gift of the Trustees, 1897.

97.43.

The Wyndham Sisters: Lady Elcho, Mrs. Adeane, and Mrs. Tennant

Early in his career, Sargent had explored the compositional possibilities of the large-scale group portrait in works like *The Daughters of Edward Darley Boit*, 1882 (MFA, Boston). In such austere, intensely realistic paintings the artist employed a cool tonal palette, dramatic spatial recession, and an atmospheric background that depended on traditional conventions like those of Velázquez. During the late 1890s and the

Sargent, drawings for *The Wyndham Sisters*, sketchbook,
ca. late 1890s, p. 10v, Fogg Art Museum.

early years of the twentieth century, however, he produced a series of group portraits that are characterized by a greater opulence in costume and setting, and stylistically, by a greater materiality of pigment and the choice of more daring compositions. This new direction can be explained not only by Sargent's increased self-confidence but by the effect his mural work for the Boston Public Library had on his development as a portraitist. One contemporary critic, writing in the *Saturday Review* in 1900, compared *The Wyndham Sisters* to the artist's decorative work, noting that his "recent work on large schemes of formal design has strengthened his building power and grasp of a large harmony." This group portrait reflects the impact of Sargent's mural work in its large scale, broad treatment of forms, bold contrasts of light and dark, which are best read at a distance, and in the frieze-like arrangement of figures, placed parallel and quite close to the picture plane. Furthermore, Sargent displays the muralist's concern for clearly articulated contours. His three subjects, posed in white gowns on a similarly colored sofa, are set against a dark, almost overpowering, Victorian interior, a contrast which produces a dramatic silhouette. This silhouette was perhaps Sargent's primary formal consideration in *The Wyndham Sisters*. In a series of three drawings for the painting (Fogg Art Museum, Cambridge, Mass.), Sargent drew just the outline that marks

the separation between the light and dark areas of the painting, between the subjects and the setting.

Represented are the three beautiful and talented daughters of the Hon. Percy Wyndham, a wealthy Londoner. Madeline (1869–1941), the wife of Charles R. W. Adeane, lord lieutenant of Cambridgeshire, is seated at the left. Beside her on the sofa is Pamela (1871–1928), then the wife of Edward Tennant, who in 1911 became Lord Glenconner. In 1920 Lord Glenconner died, and Lady Glenconner was married in 1922 to Viscount Grey of Fallodon. Behind Pamela, seated on the back of the sofa is Mary Constance (1862–1937), Lady Elcho, the wife of Hugo Richard Wemyss Charteris Douglas, eleventh earl of Wemyss, also Lord Elcho, earl of March, Viscount Peebles, and Baron of Neidpath. Sargent has included an image of the sitters' mother, Mrs. Percy Scawen Wyndham (née Madeline Caroline Frances Eden Campbell), who is shown above them in a full-length portrait by George F. Watts (formerly coll. the Hon. Percy Wyndham).

Unlike most of Sargent's society portraits, this painting was executed in the Wyndham residence at 44 Belgrave Square, London, rather than in an impersonal studio setting. Wilfrid Scawen Blunt, an English writer, diplomat, and a visitor at the Wyndham home, commented on Sargent's plans for the portrait in his diaries.

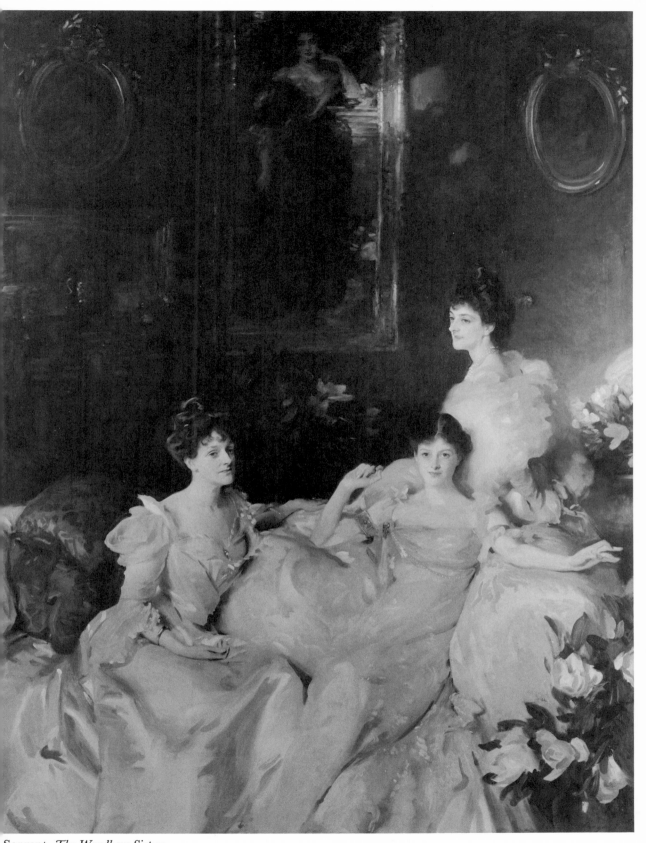

Sargent, *The Wyndham Sisters*.

On February 16, 1899, he noted that "Mary, Pamela and Madeline are sitting for their portraits in a group to Sargent. It is being painted in the drawing room. In the background there will be their mother's portrait by Watts." On March 9, 1899, Blunt reviewed the artist's progress and commented on "the first sketching in of Pamela's head which Sargent had just done in a couple of hour's work. It is wonderful as a likeness and as a bit of rapid execution. . . . Mary, too, has been sketched in not unsuccessfully, and Madeline less well. It should be a remarkable picture, probably Sargent's best. He is to be allowed no license with the magentas and mauves he loves."

In 1900, the painting was exhibited at the Royal Academy's annual exhibition, where it was hailed by the critic for the London *Times* as "the greatest picture which has appeared for many years on the walls of the Royal Academy" and dubbed "The Three Graces" by the Prince of Wales. It remained in the possession of the family until its purchase by the Metropolitan in 1927.

Oil on canvas, 115 × 84⅛ in. (292.1 × 213.7 cm.). Signed at lower right: John S. Sargent.

RELATED WORK: Preliminary drawings in Sketchbook, ca. late 1890s, pencil, 9 × 11⅝ in. (22.9 × 29.5 cm.), pp. 10v, 11, indicate general composition, Fogg Art Museum, Cambridge, Mass., 1937.7.20.

REFERENCES: W. Walton, *Exposition Universelle, 1900: The Chefs d'Oeuvre* (1900), p. 21, says "its elegance and vivacity have no taint of theatrical artifice" // *Magazine of Art* 24 (1900), p. 385, reviews it at the Royal Academy saying it "has established itself as the chief sensation of the season" // D. S. M., *Saturday Review* 89 (May 1900), pp. 583–584, reviews it at the Royal Academy: "Mr. Sargent's portrait of three ladies is one of those . . . where beauty has unquestionably slipped in. I do not mean that the ladies are beautiful, but that the picture is" (quoted above) // *Times* (London), May 5, 1900, p. 14, reviews it at the Royal Academy, saying "in spite of certain obvious faults, this is the greatest picture which has appeared for many years on the walls of the Royal Academy the composition is at once perfectly natural and perfectly artistic"; May 15, 1900, p. 3, alludes to the artist's achievements in this picture // N. N. [E. Pennell], *Nation* 70 (May 31, 1900), p. 413, reviews it at the Royal Academy // *Pearson's Magazine* 11 (April 1901), ill. p. 570 // C. H. Caffin, *American Masters of Painting* (1902), p. 59, calls it "grandiose" // *Living Age* 233 (April 12, 1902), pp. 83–84 // *Saturday Review* 97 (March 19, 1904), p. 365 // K. Cox, *Old Masters and New* (1905), pp. 257–258, says that it is not as satisfying as his single portraits // C. Brinton, *Munsey's Magazine* 36 (Dec. 1906), ill. p. 280; p. 281 // Mrs. A.

Meynell, intro., *The Work of John S. Sargent, R.A.* (1907), unnumbered pl. // C. Mauclair, *L'Art et les artistes* 4 (Jan. 1907), p. 375, calls it "surprenant poème de blancheurs, sont des merveilles de goût d'ingéniosité, decharme vivant qui ravalent à l'élégance des couturiers, des parfumeurs, et des coiffeurs toutes les tentatives de nos faiseurs à la mode"; p. 378 // C. Brinton, *Modern Artists* (1908), p. 162 // Burlington Fine Arts Club, London, *Illustrated Memoir of Charles Wellington Furse, A.R.A.*, exhib. cat. (1908), pp. 28–29, quotes C. W. Furse to K. Symonds, June 6, 1900, commenting on the picture's exhibition at the Royal Academy, noting that it is "a wonderful thing. The three ladies in cool white satin against the sombre green background of the room, whose furniture and pictures are admirably used in rich and well-ordered design. An element of graceful unexpectedness lends piquancy to the composing of the three women filling the lower part of the canvas with a big mass of cool greenish white, while the room rises high and recedes far behind them. The painting is astonishingly full, and fat and simple, as only a consummate painter can make it" // M. H. Spielmann, *Figaro Illustré* (English edition), no. 221 (August 1908), unpaged, reviews it in 1908 exhibition, calling it "the most original and forceful of his compositions" // R. Cortissoz, *Art and Common Sense* (1913), p. 234, discusses the sensation caused by its exhibition at the Royal Academy in 1900 // W. S. Blunt, *My Diaries* (1919), I, pp. 386, 387–388, entries for Feb. 16, and March 9, 1899 (quoted above) // R. Cortissoz, *Scribner's* 75 (March 1924), p. 350, mentions its reception at the Royal Academy in 1900 // W. Starkweather, *Mentor* 12 (Oct. 1924), p. 9 // W. H. Downes, *John S. Sargent* (1925), pp. 54–55, notes comments by contemporary critics; pp. 188–189, includes it in a list of the artist's works, lists exhibitions, quotes reviews from 1900 // M. Feuillet, *Le Figaro Artistique* 3 (Oct. 15, 1925), p. 11 // *Illustrations of the Sargent Exhibition, Royal Academy, 1926* [1926], ill. p. 2 // R. Mortimer, *New Statesman* 26 (Jan. 23, 1926), p. 447, says that "You are dazzled by the way he plays with whites in Lady Elcho, Mrs. Tennant, and Mrs. Adeane, as well as by Mrs. Tennant's wonderful beauty, but nothing is there to hold the picture together" // H. S., *Connoisseur* 74 (March 1926), pp. 185–186, cites it as "beautiful in subject and beautiful in craftsmanship" // *Art News* 25 (Oct. 9, 1926), p. 3, announces its possible sale through Knoedler's // L. G. S., *Art News* 25 (Oct. 16, 1926), ill. p. 2, and says that it is at Knoedler's, London, by arrangement with Capt. Guy Wyndham // *Apollo* 4 (Dec. 1926), color ill. opp. p. 262 // *New York American*, Dec. 8, 1926, ill. p. 5, says that it is on the way to New York from London to be sold // E. Charteris, *John Sargent* (1927; 1971), pp. 68–69, discusses it in the context of Sargent's other group portraits; pp. 174–175, calls it "one of his most purely and unmistakably English pictures, a *tour de force* in characterization, drawing, and the handling of white"; p. 268, includes it in a list of Sargent's oils,

dates it 1900, lists exhibitions // J. B. Manson and Mrs. A. Meynell, intro., *The Work of John S. Sargent, R.A.* (1927), 2, unnumbered pl. // *New York Times*, March 6, 1927, magazine section, ill. p. 9, notes that it has been sold to an American // *Art News* 25 (March 12, 1927), p. 8, discusses its acquisition by MMA // *New York Times*, March 12, 1927, p. 14, discusses *Art News* article and MMA's acquisition of the portrait; (March 13, 1927), p. 19, discusses acquisition // *New York Herald Tribune*, March 13, 1927, clipping in MMA Archives, announces acquisition, says it is "one of Sargent's finest achievements" // F. Watson, "Art Notes," *New York World*, March 14, 1927, clipping in MMA Archives, criticizes its acquisition // *Art Digest* 1 (March 15, 1927), p. 2, notes its acquisition // C. D. Lay to the editor, in *New York Herald Tribune*, March 16, 1927, clipping in MMA Archives, discusses its acquisition // *MMA Bull.* 22 (April 1927), pp. 106–108, discusses acquisition and quotes R. Cortissoz's comments on it from *New York Herald Tribune*, Oct. 17, 1926; ill. p. 107 // *American Magazine of Art* 18 (May 1927), ill. p. 227 // *Town and Country* 82 (May 1, 1927), color ill. p. 42 // F. F. Sherman, *Art in America* 21 (June 1933), p. 95, calls it "artificial" // *Index of Twentieth Century Artists* 2 (March 1935), p. 86, and suppl., lists reproductions // *Times* (London), May 1, 1937, p. 18, mentions it in obituary of Lady Elcho // *New York Herald Tribune*, May 1, 1937, ill. p. 12, and discusses, gives biographical information on Lady Elcho // E. A. Jewell, *New York Times*, Sept. 18, 1938, section 10, ill. p. 7, and discusses // *Art Digest* 13 (Oct. 1, 1938), p. 17 // *Times* (London), August 2, 1941, p. 6, mentions it in obituary of Mrs. Adeane; August 4, 1941, p. 6 // C. M. Mount, *John Singer Sargent* (1955; 1969), pp. 228–229, says that Sargent began the painting in February 1899; pp. 284–285, notes it as an example of the artist's willingness to experiment compositionally, discusses the problems of its execution; p. 457, includes it in a catalogue of Sargent oils (no. 997 in early editions), dates it 1899, London // MFA, Boston, *Sargent's Boston*, exhib. cat. by D. McKibbin (1956), p. 132, includes it in a checklist of Sargent's portraits, dates it 1899, identifies sitters // O. Wyndham, letter in MMA Archives, Feb. 13, 1961, identifies the sitters // G. Monteiro, *Henry James and John Hay* (1965), p. 124, quotes James, who calls it "vast & dazzling" // R. Ormond, *John Singer Sargent* (1970), p. 54, says that the contrast between the creamy, unbroken masses of the sitters' costumes and the dark void behind them produces "romantic grandeur," compares it to C. Furse's Mrs. Oliver and Her Children, 1903, quotes C. Furse, letter, June 6, 1900, praising it; p. 63, says that it was not painted in impersonal surroundings; pl. xiii, shows a detail in color; p. 97, note 131, cites references; pl. 92; p. 252, notes preliminary drawing for it in Fogg, says that W. S. Blunt (1919), discussed the sittings // A. R. Tintner, *Apollo* 102 (August 1975), p. 129, says that Henry James had seen it just before beginning a series of stories about portrait painters,

quotes James to Hay, April 3, 1900; ill. p. 130; p. 131, says that the pearls are too short to be the inspiration for Milly's pearls in the James's *The Wings of the Dove*.

EXHIBITED: Royal Academy, London, 1900, no. 213, as Lady Elcho, Mrs. Adeane, and Mrs. Tennant // Franco-British Exhibition, London, 1908, *Fine Arts Catalogue*, Part I, British section, no. 168, lent by the Hon. Percy Wyndham // Royal Scottish Academy, Edinburgh, 1911, no. 67, as Portrait Group of Lady Elcho and her Sisters, lent by Right Hon. George Wyndham, Rector, Edinburgh University // Royal Academy, London, 1926, *Exhibition of Works by the Late John S. Sargent, R.A.*, no. 292, lent by Capt. G. R. C. Wyndham.

EX COLL.: Hon. Percy Wyndham, London, 1899–died 1911; his son and brother of the sitters, Rt. Hon. George Wyndham, London, by 1911–died 1913; nephew of the sitters, Capt. Guy Richard Charles Wyndham, until 1927; with M. Knoedler and Co., London, 1926–1927.

Wolfe Fund, Catharine Lorillard Wolfe Collection, 1927.

27.67.

William M. Chase, N.A.

This portrait was commissioned by the students of the painter WILLIAM MERRITT CHASE (1849–1916), who was perhaps the most admired art teacher in America at the turn of the century. Chase taught in New York and Philadelphia, in Chicago and on the West Coast. In 1896, he founded the New York School of Art, often called the Chase School. Six years later the students of this school, led by Susan F. Bissell, arranged for John Singer Sargent to paint this portrait.

In July 1902, Chase traveled to Europe with two friends, Harrison S. Morris, director of the Pennsylvania Academy of the Fine Arts, and William Thorne (1864–1956), a portrait painter. In his reminiscences, published in 1930, Morris describes the circumstances under which the portrait was executed:

We arrived in London on the midnight of Derby Day, We were weary from travel and slept late, but when I went downstairs I found Chase, who must have risen very early to undo his trunks which were on the ground floor, draped in all his glorious apparel, including the white carnation in the buttonhole of his frock coat, the eyeglasses on the broad silken leash, the spats, the tuft of the silk necktie clasped with the matchless emerald which flashes in Sargent's portrait, the crowning high hat, and the air of the perfect model of fashion. . . .

"Well, well," I said, "but Sargent won't paint you

Sargent, *William M. Chase, N.A*

Painted on a canvas that had been used previously, the painting was completed in six sittings. In a letter to his sister-in-law Minnie, published in 1917, Chase wrote: "My friends here say it is perfect. The painting is certainly beautiful. . . . I shall be glad to get away now that the picture is done as every American I meet (and there are many of them) wants to go to Sargent's to see me on canvas. I am afraid it will prove a nuisance." In this same letter he mentioned that he and Sargent planned to paint each other's portraits the next time the expatriate was in New York, a possibility which was mentioned in the *New York Times*, October 19, 1902, where Chase is quoted as saying: "I told Sargent the only thing that my wife would regret about this portrait was that it is to be given to the Metropolitan Museum of Art, when it would be such a pride and delight to have it in the family. 'Oh, well,' said Sargent, 'I can do another of you for yourself, and you can do me for myself.'" However, there is no evidence that these portraits were ever painted.

In November 1902, Sargent's *portrait d'apparat* was displayed at M. Knoedler and Company in New York to help raise funds to pay for it. It was subsequently exhibited in New York, Philadelphia, and Chicago, cities where Chase had worked as a teacher, and it was hailed by the critic for the *New York Times* as "one of the most brilliant pictures of the year." After the portrait had been shown at the Universal Exposition in St. Louis in 1904, Susan F. Bissell formally offered it to the Metropolitan. Her letter of February 20, 1905, suggests that it was intended for the museum from the time it was commissioned, a particularly appropriate gesture, since Chase always encouraged his students to study the paintings in the museum's collection and often accompanied them on their visits, during which he lectured flamboyantly.

Oil on canvas, 62½ × 41⅜ in. (158.8 × 105.1 cm.).

Inscribed and dated at upper right (probably by Chase): Copyright by John S. Sargent 1902.

REFERENCES: W. M. Chase to Mr. Johnson, Oct. 5, 1902, the *Century* Collection, Manuscript Division, NYPL, writes that he should contact Susan F. Bissell regarding any matters concerning the portrait // *New York Times*, Oct. 19, 1902, p. 25, says that his female students at the Architectural League in New York have commissioned it and that it is finished and in New York, but Chase will not permit critics to see it, quotes Chase: "It was clear that he [Sargent] took great interest in the work," reports that it was completed in six sittings and that a New York man who is

that way. It ought to be a little pietà, with a student in adoration at each side."

Said he, "I think you could be just as funny some other way"; as much on edge as ever I knew him in our long intercourse to be. . . .

The others came down to breakfast, and saw Chase off to be painted, arranging to meet him at the Royal Academy after his pose.

When we had finished breakfast I plodded up the long stairway to our room, and was busy there about our things, when I heard suspicious movements in Chase's chamber. I went over and looked through the door, and there he was.

"Why, I thought Sargent was painting you," I said.

"Well, you see," he replied, a little sheepishly, and with no reference to my earlier conjecture, "Sargent didn't want to do me in that costume, so I came back for my old blue studio coat." He had found it below in his trunk, and was putting it on.

I could not rub it in. He was too ingenuous. Perhaps I smiled just a little, and went back to our room.

And in that old blue sack coat Chase was painted, as all may see in Sargent's portrait to the very life, in the Metropolitan Museum.

an admirer of Sargent's witnessed its execution, that Chase regrets not being able to keep the portrait in the family, and that Sargent suggested that they do portraits of each other (quoted above); Nov. 2, 1902, p. 12, reviews its exhibition at M. Knoedler and Co., New York (quoted above) // Chase to H. Morris, Jan. 3, 1903, PAFA Archives, says he should contact Curtis and Cameron about the copyright // A. Z. Bateman, *Brush and Pencil* 11 (Feb. 1903), pp. 385–386, reviews it in PAFA exhibition, calling it "a most admirable piece of work—many would not hesitate to call it a monument in American art" // C. H. Caffin, *International Studio* 19 (March 1903), p. cxv, discusses its inclusion in PAFA exhibition, praising it as "eminently the superb expression of a rapidly seized conclusion" // *Century Magazine*, n.s. 43 (March 1903), ill. p. 646, shows a halftone plate engraved after it by H. Davidson; p. 801, discusses Susan F. Bissell's efforts to organize students to commission it and says it will be presented to MMA // *New York Times*, March 28, 1903, p. 5, reviews it in the exhibition of the Society of American Artists, commenting that "Mr. Sargent's life-size portrait of the painter William Merritt Chase is one of the most brilliant pictures of the year, and competes in its delineation of character with that of President Roosevelt [1903; White House, Washington, D.C.] by the same artist" // C. H. Caffin, *International Studio* 19 (May 1903), p. cxxv, mentions its inclusion in the exhibition of the Society of American Artists // J. C. Van Dyke, *Outlook* 74 (May 2, 1903), ill. p. 33 // C. H. Caffin, *World's Work* 7 (Nov. 1903), ill. p. 4110; p. 4115, discusses it as "an impression vivid, composite and concise" // M. G. O., *International Studio* 21 (Nov. 1903), p. 80, reviews it in exhibition of PAFA // C. M. Kurtz, *Official Illustrations of Selected Works in the Various National Sections of the Department of Art . . . Universal Exposition, St. Louis* (1904), p. 247, discusses; p. 248 // S. F. Bissell, letters in MMA Archives, Feb. 3, 1905, says that the New York School of Art did not copyright it; Feb. 20, 1905, says it was commissioned two years earlier by Chase's students and "is considered by critics a Sargent masterpiece, has won prizes and medals at many exhibitions"; Feb. 21, 1905, asks that it be presented to the proper committee for acquisition; Feb. 28, 1905, inquires about procedure for presentation // *American Art News* 3 (March 11, 1905), [p. 4], quotes R. W. de Forest to S. F. Bissell, March 2, 1905, accepting it as a gift from Chase's students // J. S. Sargent, letter in MMA Archives, n.d. but after March 1905, says that he did not copyright it // W. M. Chase, letter in MMA Archives, April 3, 1905, says he plans on coming to MMA with a group of his Philadelphia students and writes that "It would please me immensely if you could have my portrait hung before Friday. Will you not do me this favor" // *MMA Bull.* 1 (Nov. 1905), ill. p. 9; pp. 9–10, discusses // J. W. McSpadden, *Famous Painters of America* (1907; 1916), p. 290; ill. opp. p. 330; p. 345, // *Putnam's Monthly* 5 (Dec. 1908), p. 372 // Chase, letter in MMA Ar-

chives, Jan. 19, 1909, says that he wrote the inscription regarding the copyright on the canvas intending to copyright it but that he never did // *New York Herald Tribune*, April 4, 1909, p. 7, details the circumstances under which it was commissioned and painted // Chase, interviewed by W. Pach, *Outlook* 95 (June 25, 1910), ill. p. 443 // W. A. Coffin, *Palette and Bench* 3 (Oct. 1910), p. 9 // unsigned memo in MMA Archives, Dec. 1, 1913, states that "Wm. M. Chase speaking of his portrait by Sargent said the picture was painted on an old canvas with a portrait of Wertheimer upside down" // J. Cournos, *Forum* 54 (August 1915), p. 234, calls it one of Sargent's "two most theatrical portraits" // *Arts and Decoration* 6 (July 1916), p. 396 // *Outlook* 114 (Nov. 8, 1916), p. 536 // H. Tyrrell, *World Magazine* (Nov. 12, 19[16]), Chase clipping MMA Library, discusses details of the sitting // *MMA Bull.* 11 (Dec. 1916), ill. p. 249 // K. M. Roof, *Life and Art of Chase* (1917), pp. 172–173, quotes letter from Chase to his sister-in-law (quoted above) // H. R. Butler and G. Beal, *Scribner's Magazine* 61 (Feb. 1917), ill. p. 250 // J. C. Van Dyke, *American Painting and Its Tradition* (1919), p. 262; unpaged pl. // W. Starkweather, *Mentor* 12 (Oct. 1924), p. 16; ill. p. 30 // W. H. Downes, *John S. Sargent* (1925), p. 58, notes exhibition at PAFA; p. 113, notes that D. Croal Thomson, who was in Sargent's studio on the day it was painted, says it was completed in less than one hour; pp. 203–204, includes it in a catalogue of the artist's work, lists exhibitions // *New York Tribune*, Jan. 5, 1926, p. 27 // R. Flint, *Christian Science Monitor*, Jan. 6, 1926, p. 10 // F. H. Hubbard, *American Art Student and Commercial Artist* 9 (Jan. 31, 1926), p. 51 // *Good Furniture* 26 (March 1926), p. 117, says that its paint surface is disintegrating // E. Charteris, *John Sargent* (1927; 1971), p. 270, includes it in a list of Sargent's oils, dates it 1902 // S. La Follette, *Art in America* (1929), p. 220 // H. S. Morris, *Confessions in Art* (1930), pp. 73–75, gives detailed account of Chase's sitting for it (quoted above), incorrectly dates it London, 1898 // *Index of Twentieth Century Artists* 2 (Feb. 1935), p. 75, lists reproductions // E. B. Johnston, *Parnassus* 8 (March 1936), p. 15, recalls meeting Chase in 1906 and his comments on it // C. M. Mount, *John Singer Sargent* (1955; 1969), p. 233, dates it to the summer of 1901, says it was exhibited at Knoedler's to raise the funds to pay for it; pp. 233–234, quotes Chase to his sister-in-law Minnie; p. 434, includes it in a catalogue of Sargent's oils (no. 0215 in early editions), dates it 1902, London // MFA, Boston, *Sargent's Boston*, exhib. cat. by D. McKibbin (1956), p. 89, includes it in a checklist of Sargent's portraits, dates it 1902, London // M. S. Young, *Apollo* 76 (May 1962), ill. p. 194 // H. S. Francis, *Bulletin of the Cleveland Museum of Art* 52 (Jan. 1965), ill. p. 20 // D. Dwyer, Paintings Conservation, MMA, orally, Jan. 3, 1977, stated that a radiograph of the portrait verifies that there is another portrait underneath.

EXHIBITED: M. Knoedler and Co., New York, 1902

Sargent, *Edward Robinson.*

(no cat. available) // Copley Society, Boston, 1902, *Second Annual Exhibition of Contemporary Art*, as lent by pupils of Mr. Chase // Society of American Artists, New York, 1903, no. 335, as portrait to be presented to the Metropolitan Museum of Art by his pupils // Cincinnati Art Museum, 1903, no. 1, as portrait painted for presentation to the Metropolitan Museum, New York, by former pupils of Mr. Chase // Art Institute of Chicago, 1903, no. 336, as portrait painted for presentation to the Metropolitan Museum, New York, by former pupils of Mr. Chase // Universal Exposition, St. Louis, 1904, *Official Catalogue of Exhibitors* (rev. ed.), p. 36, no. 671 // MMA, 1926, *Memorial Exhibition of the Work of John Singer Sargent*, no. 39.

Ex coll.: pupils of William Merritt Chase, New York, 1902–1905.

Gift of Pupils of Mr. Chase, 1905.

05.33.

Edward Robinson

Edward Robinson (1858–1931) was a distinguished classical scholar and archaeologist who served the Metropolitan Museum for a quarter of a century, first as assistant director (1905–1910) and then as director (1910–1931). Robinson was born in Boston and graduated from Harvard in 1879. After spending five years in Europe studying classical archaeology, he began his museum career as curator of classical antiquities at the Museum of Fine Arts, Boston, a position which he held between 1885 and 1902, when he was made director of that institution. He developed the classical collection at the Museum of Fine Arts, made significant contributions to archaeological literature, and lectured at Harvard University in 1893–1894 and from 1898 to 1902.

During his tenure as director of the Metropolitan Museum, he helped the museum achieve tremendous growth: its building doubled in size, the Cloisters opened, the collection was enlarged tremendously both by gift and purchase, and several new curatorial departments were created. "As the chief administrative officer of the Museum for over twenty years, Dr. Robinson carried with eminent success a burden of responsibility unprecedented in the history of museums," eulogized the museum's acting director, Joseph Breck, in 1931. "He would have been the first to say, however, that he had not carried this burden alone, since he had the loyal coöperation of the trustees and of the staff. But such coöperation is not given to every man. It is inspired by ability, courtesy, understanding, courage, fairness—qualities that won for Dr. Robinson the unfailing devotion of his associates" (*MMA Bull.* 26 [May 1931], p. 112).

Robinson's acquaintance with Sargent probably dates from the early 1890s when the artist was at work on the murals for the Boston Public Library. After Sargent's decorations for the north end of the hall were unveiled in 1895, it was Robinson who raised a subscription of fifteen thousand dollars to permit him to continue his work. He was also among the Bostonians on the committee that organized the Sargent exhibition held at Copley Hall in 1899. While he was director of the Metropolitan, the museum acquired an important collection of Sargent's works in oil and watercolor. These were often purchased directly from the artist, partly as a consequence of Robinson's amicable relationship with Sargent, whom he described as "a steadfast friend of our Museum, greatly interested in its growth and a firm believer in its future" (MMA, *Memorial Exhibition of the Work of John Singer Sargent* [1926], p. xi).

The portrait of Robinson was painted in 1903,

when he was director of the Museum of Fine Arts. Much of the setting and the costume have been immersed in darkness with only the distinctive facial features and hands illuminated. He is shown in a library interior, appropriate to his scholarly character, a point further emphasized by the inclusion of an object from his personal collection. This piece, later presented to the Metropolitan, is an Etruscan repoussé relief dating from the fourth century B.C. (29.141c). It depicts a drunken Dionysos, supported by Eros and escorted by a woman playing a kithara, and is attached to a plain bronze mirror and cover (29.141 a–b).

Mrs. Edward Robinson presented the portrait to the museum in 1931, noting in a letter written shortly after her husband's death: "I am truly glad to have my husband's portrait go at once to the Museum which he loved and for which he worked so long."

EDMUND C. TARBELL's 1906 portrait of Robinson (MFA, Boston), commissioned by the trustees of the Museum of Fine Arts, may owe a debt to Sargent in the artist's selection of a three-quarter facial view and in the contrast between the sitter's dramatically lit face and hands and the darkened setting, although Tarbell chose a more conventional seated pose.

Oil on canvas, 56½ × 36¼ in. (143.5 × 92.1 cm.).
Signed and dated at upper left: John S. Sargent 1903.

REFERENCES: *Academy Notes* 1 (August 1905), p. 43; ill. p. 45, gives as the property of Helen M. Robinson, Boston // C. H. Fiske, *Chautauquan* 50 (March 1908), ill. p. 64 // *American Art News* 22 (Feb. 2, 1924), p. 2, says that it will be in the Sargent exhibition at Grand Central Art Galleries // *American Art Student and Commercial Artist* 7 (March 1924), p. 17 // L. Mechlin, *American Magazine of Art* 15 (April 1924), p. 170, praises it; ill. p. 179 // R. V. S. Berry, *Art and Archaeology* 18 (Sept. 1924), ill. p. 101; p. 110, says "There is so very little in the portrait which is personal, *only a face and a hand*; all the rest is of the indefinite enveloping, darkened area" // W. H. Downes, *John S. Sargent* (1925), p. 206, includes it in catalogue, lists exhibitions, gives biography of the sitter // *New York Tribune*, Jan. 5, 1926, p. 22 // F. H. Hubbard, *American Art Student and Commercial Artist* 9 (Jan. 31, 1926), p. 51 // E. Charteris, *John Sargent* (1927; 1971), p. 271, includes it in a list of Sargent's oils, dates it 1903, lists exhibitions // J. B. Manson and Mrs. A. Meynell, intro., *The Work of John S. Sargent, R.A.* (1927), say it is an example of the artist's tendency to reveal something real about the sitter; unnumbered pl. // *New York Times*, May 6, 1931, p. 27, announces that it is to be given to MMA upon the death of his widow,

Elizabeth Gould Robinson; July 12, 1931, sec. 2, p. 2, says that Mrs. Robinson has presented it to MMA // Mrs. E. Robinson, letters in MMA Archives, before May 14 and May 14, 1931, offers it to MMA (quoted above) // *Index of Twentieth Century Artists* 2 (March 1935), p. 83, lists reproductions of it // C. M. Mount, *John Singer Sargent* (1955; 1969), p. 450, includes it in a catalogue of Sargent's oils (no. 0314 in early editions); dates it 1903, New York // A. Oliver, Jr., Greek and Roman Art, MMA, memo in Dept. Archives, ca. 1962–1967, identifies the object on the table.

EXHIBITED: Rhode Island School of Design, Providence, 1903, no. 32 // Buffalo Fine Arts Academy, Albright Art Gallery, 1905, *Catalogue of the Inaugural Loan Collection of Paintings*, no. 16, lent by Mr. Edward Robinson // Royal Academy of Art, Berlin, and Royal Art Society, Munich, 1910, *Ausstellung Amerikanischer Kunst*, no. 54, lent by Edward Robinson // Grand Central Art Galleries, 1924, *Retrospective Exhibition of Important Works by John Singer Sargent*, lent by Mr. Robinson // MFA, Boston, 1925, *A Catalogue of the Memorial Exhibition of the Works of the Late John Singer Sargent*, no. 78, lent by Edward Robinson, Esq. // MMA, 1926, *Memorial Exhibition of the Work of John Singer Sargent*, no. 41, lent by Edward Robinson // MFA, Boston, 1956, *Sargent's Boston*, exhib. cat. by D. McKibbin, no. 36; p. 119, dates it 1903.

EX COLL.: Edward Robinson, Boston and New York, 1903–1931; Mrs. Edward Robinson, New York, 1931.

Gift of Mrs. Edward Robinson, 1931.
31.60.

Padre Sebastiano

This young priest was painted by Sargent between 1904 and 1906 in a village on the Italian side of the Alps near the Matterhorn, probably in Giomein. The picture's date and setting have been variously and erroneously reported as Palestine in 1905–1906 and Val d'Aosta in 1908. In a letter to David McKibbin in 1951, the artist's sister Violet Ormond recalled a summer vacation that the artist, their sister Emily, and Vernon Lee spent in the Alps: "it was there my brother met the 'botanizing priest.' I think he had more or less been banished to this obscure little parish, his theological ideas not being strict enough. Soon after, he broke with the R[oman] C[atholic] Church, & went to America. [I] know my brother was very kind & helpful. I don't know what became of him."

Sargent's characterization of Padre Sebastiano is enhanced by his rendition of the sitter's environment, a cluttered bedroom where he sits making notations about the flowers that cover

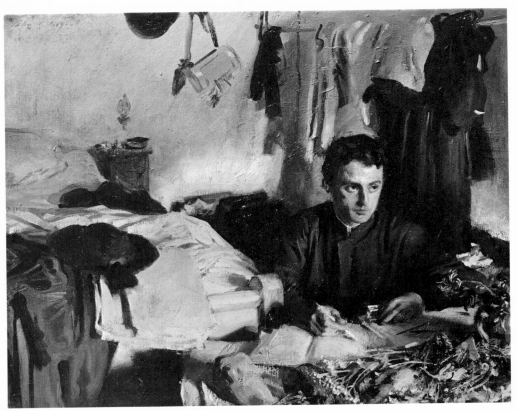

Sargent, *Padre Sebastiano*.

the table in front of him. "The priest, a gracious, thoughtful figure in his black cassock is interpretatively circumstanced. He is at the heart of the picture, and in his heart dwells wonder," wrote Frank Rinder in 1906. "No other living painter could compass just that eloquent disorder, disciplined . . . to fine unity."

Oil on canvas, 22¼ × 28 in. (56.5 × 71.1 cm.).

Signed at upper left: John S. Sargent.

REFERENCES: F. Rinder, *Art Journal* [London] (1906), ill. p. 181, mistakenly calls it Padre Albera, describes it in a review of the exhibition at the New Gallery (quoted above) // *International Studio* 29 (July 1906), p. 14, calls it "a rarely discreet exercise in relations of tone" // C. Brinton, *Modern Artists* (1908), p. 166, notes its "implied spirituality" // J. S. Sargent to E. Robinson, Jan. 6, 1911, in MMA Archives, says that it has been varnished and will soon be packed and forwarded to the museum // B. B[urroughs], *MMA Bull.* 6 (April 1911), p. 100, states that it was painted at Val d'Aosta in 1908 // W. H. Downes, *John S. Sargent* (1925), p. 60, says that it was painted in Palestine in 1905; pp. 218–219, includes it as Padre Sebastiano in list of Sargent's works, gives exhibition // J. B. Manson and Mrs. A. Meynell, intro., *The Work of John S. Sargent, R.A.* (1927), 1, unpaged, call it "romantic portraiture"; 2, unnumbered pl. // E.

Charteris, *John Sargent* (1927; 1971), p. 272, includes it in a list of Sargent's oils, dates it 1905, lists exhibitions // M. N. P. Hale, *World Today* 50 (Nov. 1927), ill. following p. 564 // F. J. Mather, Jr., *Estimates in Art*, 2nd ser. (1931), ill. opp. p. 235 // *Index of Twentieth Century Artists* 2 (March 1935), p. 83; suppl., p. i, lists reproductions // V. Ormond, sister of the artist, to D. McKibbin, March 22, 1951, copy in Dept. Archives, says that John and Emily Sargent spent some time one summer in "Gommein," discusses sitter (quoted above) // C. M. Mount, *John Singer Sargent* (1955; 1969), p. 470, lists it in a catalogue of Sargent's oils (no. K089 in early editions), dates it 1903, Switzerland // MFA, Boston, *Sargent's Boston*, exhib. cat. by D. McKibbin (1956), p. 123, includes it in a checklist of portraits, dates it 1905, says that it was exhibited at the New English Art Club in 1906 as Padre Albera, calls him a "botanizing priest in a disorderly bedroom, at the foot of the Matterhorn" // R. Ormond, *John Singer Sargent* (1970), ill. [p. 201], fig. 103, dates it 1905–1906; p. 255, says Mrs. Ormond has identified the setting of the picture and provided information about the sitter // D. McKibbin, letter in Dept. Archives, Feb. 17, 1976, encloses a copy of letter to him from Mrs. Ormond, March 22, 1951, says Vernon Lee explained that Mrs. Ormond was referring to Giomein, dates it 1904, lists 1906 exhibition and a possible 1909 Berlin exhibition, gives references, and

explains the history of the painting.

EXHIBITED: New Gallery, London, 1906, *Nineteenth Summer Exhibition*, no. 98, mistakenly as Padre Albera // MMA, 1926, *Memorial Exhibition of the Work of John Singer Sargent*, no. 48 // M. H. de Young Memorial Museum and the California Palace of the Legion of Honor, San Francisco, 1935, *Exhibition of American Painting*, no. 197, lists references and exhibitions // M. Knoedler and Co., New York, 1941, *Loan Exhibition in Honour of Royal Cortissoz and His 50 Years of Criticism in the New York Herald Tribune*, no. 34, lists references, reproductions, exhibitions // Art Institute of Chicago and MMA, 1954, *Sargent, Whistler and Mary Cassatt*, exhib. cat. by F. A. Sweet, no. 63, ill. p. 64.

Ex COLL.: the artist, 1906–1911.

Rogers Fund, 1910.

11.30.

Landscape with Goatherd

This oil sketch was probably painted during Sargent's trip to the Middle East in 1905, just when he was beginning to paint extensively in watercolors. Like his watercolors, it is a rapidly executed record of the scene, with thin, fluid pigments broadly brushed over the canvas. As is typical of his summary sketches, the picture depends on color to define the composition. Here dark trees, animals, and cast shadows are silhou-etted against an acid green ground. As Archibald Barnes, a student of Sargent's, observed:

In his smaller work, the landscapes, interiors, architectural studies, the technique varies with almost every picture. Sometimes they are floated on to the canvas with a full liquid brush; at others the paint sparkles with the thick impasto—no ennui here! . . . The handling of these small pictures is astounding, even to those whose knowledge of the technical side of painting renders them almost proof against surprise. An intricate swirl of paint, rose, sienna, and blue, seen at a proper distance becomes a pale, dainty hand. Dabs of blue, brown and gold, apparently shapeless, are transformed into a herd of goats. It is a miracle of vision and execution (*Discovery* 6 [June 1925], p. 210).

The choice of subject matter is not unusual for Sargent. His sketchbooks (Fogg Art Museum, Cambridge, Mass.) are filled with pencil studies of goats. More fully realized studies of these domestic animals in forest settings are *Landscape with Goats*, 1909 (Freer Gallery of Art, Washington, D.C.), and *Olives in Corfu*, 1909 (Fitzwilliam Museum, Cambridge).

Oil on canvas, $24\frac{1}{4} \times 31\frac{7}{8}$ in. (61.6 × 81 cm.).

REFERENCE: C. M. Mount, *John Singer Sargent* (1955; 1969), p. 472, includes it as Woman Goatherd (unfinished) in a catalogue of Sargent's oils (no. K059 in early editions) and dates it 1905, The Holy Land.

Sargent, *Landscape with Goatherd*.

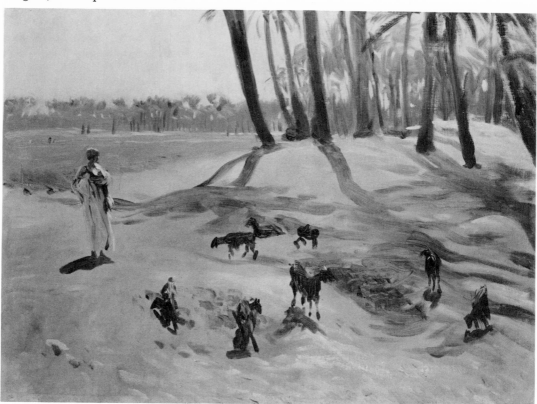

Ex COLL.: the artist's sister Violet (Mrs. Francis Ormond), London, until 1950.

Gift of Mrs. Francis Ormond, 1950.

50.130.17.

Two Arab Women

Although it is possible that this sketch was executed during Sargent's trip to Spain and North Africa during the winter of 1879–1880, his fluid brushwork and summary figure treatment would suggest a later date, perhaps the autumn of 1905, when he traveled to Palestine to gather material for his murals in the Boston Public Library.

Oil on canvas, 21 × 25¼ in. (53.3 × 64.1 cm.).

Ex COLL.: the artist's sister Violet (Mrs. Francis Ormond), London, until 1950.

Gift of Mrs. Francis Ormond, 1950.

50.130.19.

The Hermit (Il solitario)

After his mother's death in 1905, the artist and his sister Emily—often in the company of their sister Violet and other artists and friends—spent their summers in such scenic places as Corfu, Majorca, or in the Val d'Aosta, a valley in northwestern Italy that provided the setting for this picture, done in 1908. Like most of the work Sargent completed on his summer holidays between 1900 and 1914, *The Hermit* shares the unconventional presentation and unrestrained execution of his watercolors. In this picture, he placed a new emphasis on formal rather than representational considerations: he selected a square canvas and applied a varied paint surface of fresh, rich colors, treating light and shadow

Sargent, *Two Arab Women*.

independent of form. In 1911, the painter and art critic KENYON COX called it "the most successful piece of pure impressionism I have ever seen. . . . It is amazingly like nature, and the hermit is as inconspicuous a part of nature as if the picture were intended for an illustration of protective coloring! . . . Sargent . . . convinced me . . . that I did not want to paint nature as it really looks."

The American modernist Manierre Dawson (1887–1969), who observed Sargent at work in Italy just two years after he painted *The Hermit*, commented on the deceivingly facile appearance of his work:

Above all Sargent's painting looks masterfully easy. But I notice one thing. At the start of a painting he is very careful and then as it develops he lays on the paint with more freedom. When about done he looks at it with piercing eyes and making a stroke here and another there, gives the whole a look of spontaneous dash. Although nine-tenths of the work is very careful indeed, there is a look of bold virtuosity when the thing is done (Manierre Dawson Journal, Sept. 26, 1910, 64, Arch. Am. Art).

Depicted is a clearing in a rock-filled forest, in which two alert deer and a seated male figure are shown close-up on a limited spatial stage. The figure's ageless appearance, contemplative demeanor, and harmonious relationship with the natural surroundings ally him with traditional philosophical and religious figures. Kenyon Cox writing in 1912 compared the subject and approach to that of Titian's *St. Jerome in Penitence*, ca. 1555 (Brera Gallery, Milan). Sargent underscored his personal interpretation of this painting, however, in a letter to Edward Robinson on March 16, 1911. Approving of *The Hermit*, as the translated title for the picture, he wrote: "I wish there were another simple word that did not bring with it any Christian association, and that rather suggested quietness or pantheism."

The Hermit seems to convey a more universal message than most of Sargent's plein-air landscapes, which usually depict specific places and identifiable friends and acquaintances. A change in his artistic orientation may help explain his exceptional choice of subject in this case. The painting was completed at a time when Sargent had decided to abandon his lucrative career as a portraitist in order to devote himself to experiments in the watercolor medium and to less marketable landscapes and figure paintings in oil. Like the figure portrayed in the painting, he had immersed himself in the natural landscape—

Sargent, *The Hermit*.

his source of artistic inspiration and, perhaps, personal solace.

Oil on canvas, 37¾ × 38 in. (95.9 × 96.5 cm.).
Signed at lower left: John S. Sargent.

REFERENCES: T. M. W., *International Studio* 38 (Sept. 1909), p. 185, reviews it in New English Art Club exhibition, calling it an "achievement . . . of a miraculous order" // J. S. Sargent to E. Robinson, March 16, 1911, copy in MMA Archives, discusses title (quoted above) // B. B[urroughs], *MMA Bull.* 6 (April 1911), p. 100, says that it was painted in 1908 in the Val d'Aosta and that it was included in the International Exhibition in Venice in 1910 // K. Cox to E. Blashfield, June 16, 1911, Edwin Blashfield Collection, NYHS, discusses it (quoted above) // K. Cox, *Scribner's* 52 (Oct. 1912), ill. p. 509; pp. 509–512, discusses // *MMA Bull.* 7 (Nov. 1912), pp. 205–207; ill. p. 207 // R. Cortissoz, *Art and Common Sense* (1913), p. 237 // K. Cox, *Art World* 1 (Feb. 1917), p. 319, calls it an "extreme example of naturalism" // *Bulletin of the Worcester Art Museum* 8 (Jan. 1918), p. 75 // Petronius Arbiter [pseud.], *Arts and Decoration* 9 (July 1918), ill. p. 150; pp. 149–151, calls it "a trivial work of art" // G. B. Rose, *Sewanee Review* 27 (July 1919), p. 369 // W. H. Downes, *John S. Sargent* (1925), pp. 227–228, includes it as The Solitary or The Hermit in a catalogue of Sargent's works, dates it 1908, Val d'Aosta, lists exhibitions // A. Barnes, *Discovery* 6 (June 1925), p. 210, praises the artist's sense of color // E. H. Blashfield, *North American Review* 221 (June 1925), p. 648, compares the technique to "military and naval camouflage" // R. Flint, *Christian Science Monitor*, Jan. 6, 1926, p. 10 // A. D. Patterson, *Canadian Magazine* 65 (March 1926), p. 31, mentions it in an anecdote // E. H. Blashfield, *Commemorative Tributes . . . Prepared for the American Academy of Arts and Letters, 1926* (1927), p. 12, notes its "amazing rendering of protective coloration" // E. Charteris, *John Sargent* (1927; 1971), p. 170, mentions its being painted during the summer at Val d'Aosta; p. 289, includes it in a list of Sargent's oils, dates it 1908, lists exhibition // F. J. Mather, Jr., *Estimates in Art*, 2nd ser. (1931), pp. 263–264, calls it an "extraordinary study in sheer illusionism" // *Index of Twentieth Century Artists* 2 (Feb. 1935), p. 78, lists reproductions // C. M. Mount, *John Singer Sargent* (1955; 1969), p. 473, includes it in a catalogue of Sargent's oils (no. K087 in early editions), dates it 1908, Switzerland.

EXHIBITED: New English Art Club, London, 1909, no. 54, as The Solitary // Esposizione Internazionale d'Arte, Venice, 1910, *Catalogo*, no. 19, as Il solitario //

Sargent, *Alpine Pool*.

MFA, Boston, 1925, *A Catalogue of the Memorial Exhibition of the Works of the Late John Singer Sargent*, no. 100.

EX COLL.: the artist, 1908–1911.

Rogers Fund, 1911.

11.31.

Alpine Pool

In *Alpine Pool*, which dates from about 1909, the artist presents the viewer with a close-up view of the outdoor world he enjoyed during his summer sketching tours in the Alps. Although his continued interest in light and color, and particularly in reflective water surfaces, recalls his impressionist period during the late 1880s, this painting is more representative of the individual plein-air style that he developed during the early years of the twentieth century. At this time, Sargent painted in rich, often deep, colors and achieved great variety in his surfaces with brushstrokes that ranged from the broad and fluid to the delicate and dry. His freshness of approach is not unlike that of his contemporary work in the watercolor medium, for like his watercolors, *Alpine Pool* captures the colors and surfaces of the scene rather than any three-dimensional structure and the ephemeral qualities of light and air rather than a specific topography.

Lady Seated beside an Alpine Pool, ca. 1911 (coll. Mr. and Mrs. Raymond J. Horowitz, New York) and *Val d'Aosta, a Man Fishing*, 1910 (Addison Gallery of American Art, Andover, Mass.), figure studies in landscape settings that are similar to the one in this painting, are more fully realized examples of Sargent's treatment of outdoor scenes at this time.

Oil on canvas, 27½ × 38 in. (69.9 × 96.5 cm.).

REFERENCES: C. M. Mount, *John Singer Sargent* (1955; 1969), p. 473, includes it as Shaded Alpine Pool in a catalogue of Sargent's oils (no. K1017 in early editions) and dates it 1909, Switzerland.

EX COLL.: the artist's sister Violet (Mrs. Francis Ormond), London, until 1950.

Gift of Mrs. Francis Ormond, 1950.

50.130.15.

Bringing down Marble from the Quarries to Carrara

Sargent visited the marble quarries at Carrara, Italy, in the autumn of 1911. The resultant series of pencil drawings, watercolors, and oils depict not only the laborers who break and haul the stones but also the massive geometric blocks of marble that fill the quarry. Sargent's Carrara sketchbooks (Fogg Art Museum, Cambridge, Mass.) are filled with sketches of individual marble workers, some of whom appear in this painting. The diagonal axis of the composition, created by thick taut ropes, and the general disposition of marble workers and stone blocks are suggested by one of these pencil drawings (Sketchbook, 1911, p. 6), although the finished painting is more considered in design. A number of watercolors in the Museum of Fine Arts, Boston, also capture Sargent's on-the-spot impressions of Carrara and the brilliant colors of the setting but do not directly relate to this painting in vantage point or individual motifs. Sargent completed a second oil painting of the subject, *Marble Quarries at Carrara*, dated 1913 (coll. Lord Harewood, Leeds, Yorkshire). Arranged on a vertical format, this picture shows two workers climbing the steep wall of the quarry, a different setting from the Metropolitan's painting. In both works, however, the surfaces of the marble blocks, which vary in size, shape, and color, produce a strong visual pattern of light and shade.

Shortly after the artist's death, a friend described the qualities of Sargent's personality that enabled him to endure the difficult conditions under which he painted in Carrara:

His enjoyment of life required so few of the ordinary creature-comforts. . . . The simplicity of his habits and of his tastes remained singularly free from any inclination toward luxury or magnificence. . . . During one holiday before the war, while painting at the Carrara marble quarries, he slept for weeks in a hut so completely devoid of all ordinary comforts that his companions, far younger men, fled after a few days, unable to stand the Spartan rigors tolerated by their senior with such serene indifference (*Living Age* 325 [May 30, 1925], p. 446).

Oil on canvas, 28⅛ × 36⅛ in. (71.4 × 91.8 cm.).

Signed at lower left: John S. Sargent.

RELATED WORKS: Preliminary drawings in Sketchbook, 1911; pencil, 10 × 14¼ in. (25.4 × 36.2 cm.); pp. 5, 8, 9 (with colored inks), studies for individual figures; pp. 6, 8v, studies for composition; Fogg Art Museum, Cambridge, Mass., 1937.7.23.

REFERENCES: *Times* (London), May 11, 1912, p. 10, reviews it in exhibition at the Royal Academy: "Here the first vivid illusion is everything; and afterwards one notices that the foreground figures are a little cold and lifeless in colour and that there is an awkward gap in the composition between them and the smaller

figures behind" // H. W. H., *Nation* 94 (May 30, 1912), p. 548 // *International Studio* 47 (July 1912), p. 13, reviews it in Royal Academy exhibition, saying it "shows admirably his ability to express complexities of illumination by the most summary methods" // Typed list, n.d., in MMA Archives, gives the vendor, date of acquisition, and price paid for it // F. N. L[evy], *MMA Bull.* 12 (July 1917), ill. p. 157, describes as part of the Harris B. Dick collection // W. H. Downes, *John S. Sargent* (1925), p. 238, includes it in list of works as The Marble Quarry at Carrara, gives provenance and describes // E. Charteris, *John Sargent* (1927; 1971), p. 254, discussed by Vernon Lee, in "J. S. S.: In Memoriam" (August 13, 1925); ill. opp. p. 254; p. 292, includes it as Marble Quarries at Carrara in a list of Sargent's oils, dates it 1913, lists exhibition // T. Bodkin, *Studies: An Irish Quarterly Review* 17 (June 1928), p. 261, notes it as a good late landscape // *Index of Twentieth Century Artists* 2 (Feb. 1935), p. 80, lists reproductions // C. M. Mount, *John Singer Sargent* (1955; 1969), p. 475, includes it as Marble Quarries in a catalogue of Sargent's oils (no. K117 in early editions), dates it 1911, Carrara // R. Ormond, *John Singer Sargent* (1970), p. 76, discusses his work at the Carrara quarries during the autumn of 1911 // D. McKibbin, letter in Dept. Archives, March 11, 1976, explains its provenance, says it was probably the painting exhibited at the Royal Academy

Below: Sargent, *Bringing down Marble from the Quarries to Carrara.* Above: Pencil sketches for the painting from Sargent's 1911 Sketchbook, pp. 5, 6, Fogg Art Museum.

Sargent, *Tyrolese Interior*.

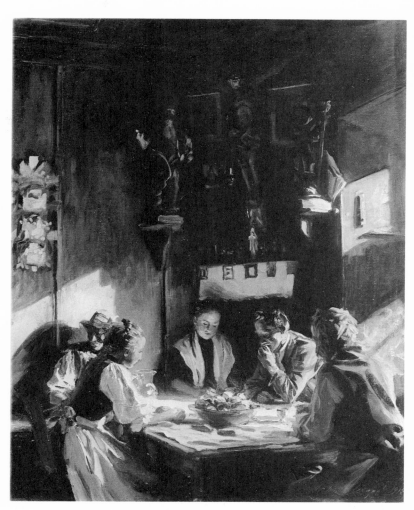

in 1912, describes painting at Harewood House (ex coll. R. Langton Douglas), says that all the other quarry pictures were watercolors.

EXHIBITED: Royal Academy, London, 1912, no. 121, as Bringing Down Marble from the Quarries to Carrara // MFA, Boston, 1925, *A Catalogue of the Memorial Exhibition of the Works of the Late John Singer Sargent*, no. 124.

Ex COLL.: with M. Knoedler and Co., New York, until 1912; Harris B. Dick, 1912–1917.

Harris Brisbane Dick Fund, 1917.

17.97.1.

Tyrolese Interior

During the summer of 1914, Sargent and a friend, Lt. Col. Ernest A. Armstrong, joined the British painter Adrian S. Stokes (1854–1935) and his wife in the Austrian Tyrol on the Seisser Alm, a plateau in the Dolomites, where Sargent had spent some time during his childhood. This

summer holiday was marred by the Austrian declaration of war on Serbia, July 28, 1914. Stokes later reminisced about that summer and autumn of 1914 (*Old Water-Colour Society's Club, 1925–1926* [1926], p. 57):

He had been there when a boy and wished to see it again. He did not find much to paint there, but always something—if only silvery palings with a graceful natural pattern of graining, or light coloured cattle in a dim cowshed.

However, a few days after their [Sargent's and Armstrong's] arrival, war was declared.... Hotels were closing in all directions, trains, we knew, were crowded to suffocation, and we had no passports. A *kellnerin* at Campitello suggested Colfuschg (the black pass) and we went there. A long drive ended at nightfall at the head of a gloomy valley where the landlord of the small inn told us it was closed after much discussion, we were able to persuade him that it would be worth his while to take us in and keep the cook.

There were Dolomite mountains rising like enor-

mous castles from the pass, there was a lovely brook, and there were a few houses with large projecting eaves richly coloured below by reflected light. All of these, and other things, Sargent painted, apparently quite happy and content. As yet he took no interest in the War.

Sargent and his companions were eventually touched by events of the war when Armstrong, a retired army doctor and a watercolor painter, was arrested trying to return to England. Later some soldiers confiscated Sargent's pictures and watercolors, easels and supplies and sent them to Innsbruck for examination. "Sargent's equanimity was disturbed by none of these things," continued Stokes. "He never grumbled, he never complained, but went out to work with what materials had been left to him" (p. 58). An old friend of Sargent's arranged for his party to move to a large old house at St. Lorenzen, in the Pustertal, and when it became too cold at Colfuschg, his party moved there.

Tyrolese Interior was probably painted in or near St. Lorenzen, in an old castle that had long since been transformed into a farmhouse. It shows a peasant family at their midday meal. The background of the picture is filled with local decorative and religious objects, which appear in other paintings executed by the artist at this time, such as *Tyrolese Crucifix*, 1915 (coll. of Mr. Myron Owen, New Bedford, Mass.). Richard Ormond suggests that Sargent's choice of subject matter—crucifixes, a graveyard, or in this case, a benediction over a noonday meal—is an oblique reference to the war that was raging around him (*John Singer Sargent* [1970], p. 77). The poses and gestures of the peasants who fill this interior, the artist's choice of a dark palette, and his use of a cool light, which filters through a window on the right, contribute further to the somber mood of the painting.

In 1915, *Tyrolese Interior* was exhibited at the Royal Academy in London, where it was well received. As Elizabeth Pennell, the wife of the etcher Joseph Pennell, wrote at the time:

He has eyes, and knows how to see through them, instead of relying upon somebody else's spectacles; he can paint, and he does so, not with hesitations and misgiving, but with vigor and evident enthusiasm. He shows this year mere notes made in the Tyrol. . . . In each he records the play of light, whether it falls through the window into the quiet, pleasant room or on the far mountain range . . . in each he gives the detail with a few broad, vigorous touches that reveal his mastery both of his own vision and his medium. There is no formula here—just the painter's impression

of a paintable subject put down because of his delight in it, and therefore retaining its spontaneity.

Oil on canvas, 28⅛ × 22 1/16 in. (71.4 × 56 cm.).
Signed and dated at lower right: John S. Sargent 1915.

REFERENCES: J. S. Sargent to E. Robinson, Dec. 24 [1914], and March 27, 1915, copies in MMA Archives, says that he has been back a few weeks from the Tyrol and encloses a photo of the painting, which he considers "the best oil picture I did in Tirol last summer. I think it has some good colours"; and again in March 1915, expresses his pleasure at its acquisition by MMA // N. N. [E. Pennell], *Nation* 100 (May 20, 1915), p. 579, reviews it in the exhibition at the Royal Academy, notes it as an example of "the intensely real, vivid living notes of things seen by Sargent" and praises the artist's treatment of light and color (quoted above) // *International Studio* 56 (July 1915), p. 26, reviews it in the exhibition at the Royal Academy, says that Sargent deals with "problems of lighting . . . most successfully" // B. B[urroughs], *MMA Bull.* 11 (Jan. 1916), pp. 21–22 // *American Magazine of Art* 7 (March 1916), p. 212, mentions its acquisition by MMA // L. M. Bryant, *American Pictures and Their Painters* (1921), ill. opp. p. 162; p. 163, discusses it as a portrait; *St. Nicholas Magazine* 51 (Nov. 1923), ill. p. 6, discusses it // N. Pousette-Dart, comp., *John Singer Sargent* (1924), unnumbered pl. // W. H. Downes, *John S. Sargent* (1925), p. 66, calls it among "the strangest" of Sargent's pictures; pp. 243–244, includes it in list of works, gives exhibition, dates it 1914, and quotes comments by C. H. Collins Baker // *Literary Digest* 85 (May 23, 1925), color ill. on cover // H. Gerwig, *Fifty Famous Painters* (1926), ill. opp. p. 392 // E. Charteris, *John Sargent* (1927; 1971), p. 293, includes it in a list of Sargent's oils, dates it 1914, lists exhibitions // *Index of Twentieth Century Artists* 2 (March 1935), p. 85, lists reproductions of it // C. M. Mount, *John Singer Sargent* (1955; 1969), pp. 327–328, quotes Sargent letters to Robinson; p. 328, says Robinson cabled the acceptance of the picture on January 19; p. 477, includes it in a catalogue of Sargent oils (no. K144 in early editions), dates it 1914, Austrian Tyrol.

EXHIBITED: Royal Academy, London, 1915, no. 859, as Tyrolese Interior // MFA, Boston, 1925, *A Catalogue of the Memorial Exhibition of the Works of the Late John Singer Sargent*, no. 111.

EX COLL.: the artist, 1914–1915.
George H. Hearn Fund, 1915.
15.142.1.

Philosophy:
A Preparation for the Mural in the Museum of Fine Arts, Boston

Between May 1916 and October 1921, Sargent worked on decorations for the rotunda of the new

Sargent, *Philosophy: A Preparation for the
Mural in the Museum of Fine Arts, Boston.*

Sargent, Plan for library entrance.
Museum of Fine Arts, Boston.

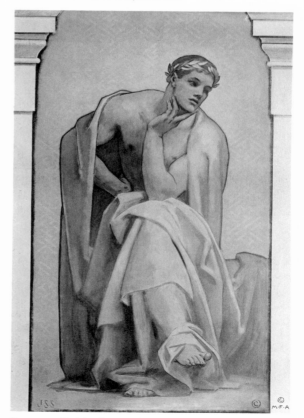

Sargent, *Sketch for Philosophy (Stairway)*,
28.804. Museum of Fine Arts, Boston.

Sargent, finished mural, *Philosophy*.
Museum of Fine Arts, Boston.

extension of the Museum of Fine Arts, Boston. In November 1921, a month after they were unveiled, the trustees asked Sargent to continue the project and decorate the ceiling over the main stairway to the rotunda, the ceilings of the corridors on either side of the staircase, and the wall which at that time served as the entrance to the library. Like the decoration in the rotunda, the reliefs and paintings he created depend heavily on traditional classical sources for their subject matter. The most immediate stylistic influence, however, seems to have been the paintings and murals of Puvis de Chavannes, examples of which were installed in the Boston Public Library in 1896. Like Puvis's works, Sargent's simplified and powerful compositions are peopled by solid idealized figures. His paint is applied to achieve variegated textures, with the pigment either roughed-in or thinly brushed over the canvas surface. To unite the murals with the decorations in the rotunda, he followed the same color scheme of neutral tones and golden ochre on a blue background.

In preparation for this work, Sargent made a scale model of the building, planned modifications in the architecture, and executed a number of charcoal drawings and oil studies. The original plan called for six reliefs and nine paintings. Sargent, however, added three paintings above the entrance to the library, making a total of twelve. The three additions, *Philosophy*, *The Unveiling of Truth*, and *Science*, are positioned beneath the lunette *The Danaïdes*, an allegorical representation of the sources of wisdom.

The Metropolitan has an oil study for *Philosophy* and one for *Science*. These must date between November 1921, when Sargent received the commission, and the spring of 1925, when he completed the murals shortly before his death. (They were installed by the architect Thomas A. Fox, according to Sargent's detailed instructions, and unveiled in November 1925.)

Like the finished work, the oil study for *Philosophy* shows the draped figure of a seated man, resting his chin on his hand. The face, anatomy, and costume, however, are less detailed and less thoroughly modeled than in the final version. The scored background is less regularized than the criss-crossed geometric pattern in the finished work. Sargent began using patterned backgrounds in his portraits during the late 1880s, for instance in his portrait of *Isabella Stewart Gardner*, 1888 (Isabella Stewart Gardner Museum, Boston). Around 1916, just when he

began to compose the Boston museum murals, he did a series of Gothic and Renaissance designs (coll. Edward K. Perry) stenciled on grasscloth. These abstract decorative patterns may have inspired his choice of background for the murals.

Oil on canvas, $13\frac{5}{8} \times 7\frac{1}{4}$ in. (34.6 × 18.4 cm.).

RELATED WORKS: Plan for library entrance, charcoal and pencil on paper, 59.6 × 40.8 cm., includes *Philosophy* and *Science*, with the latter figure in a pose different from that of the finished mural, MFA, Boston, 28.635 // *Study for Philosophy*, charcoal, $22\frac{1}{4} \times 16\frac{3}{4}$ in. (56.5 × 42.5 cm.), shows figure with chin resting on right hand rather than left, Corcoran Gallery of Art, Washington, D.C., 49.91 // *Sketch for Philosophy* (*Stairway*), charcoal on paper, 63 × 47.5 cm., shows figure in same pose as finished mural, with an additional detailed study of the left arm, MFA, Boston, 28.648 // *Sketch for Philosophy* (*Stairway*), pencil on paper, $15\frac{1}{2} \times 9\frac{1}{2}$ in. (39.4 × 24.1 cm.), MFA, Boston, 28.804 // *Philosophy*, oil on canvas affixed to wall, 79 × 44 in. (200.7 × 111.8 cm.), finished mural installed 1925, MFA, Boston, 25.637.

REFERENCES: MFA, Boston, *Decorations over the Stair-*

Sargent, *Science: A Preparation for the Mural in the Museum of Fine Arts, Boston.*

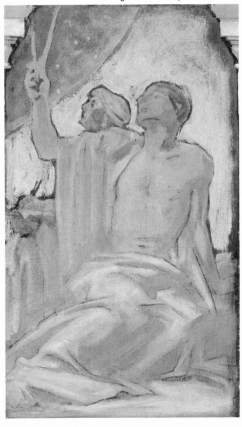

Sargent, A sheet of sketches for *Science*, verso of *Sketch for Orestes and the Furies* (*Stairway*). MFA, Boston.

way and Library Entrance . . . (1925), p. 3, in a discussion of the entire mural program includes the finished murals Philosophy and Science in a diagram of the decorative scheme; ill. p. 5, shows finished mural Philosophy; p. 6, discusses its subject matter // *Museum of Fine Arts Bulletin* 23 (Dec. 1925), pp. 65–68, discusses decorations over the main stairway and library entrance // E. Charteris, *John Sargent* (1927; 1971), pp. 205–209, discusses MFA decorations; p. 208, notes influence of Michelangelo in the Philosophy figure // *Museum of Fine Arts Bulletin* 25 (Aug. 1927), pp. 49–50, discusses an exhibition of Sargent studies for the MFA murals // C. M. Mount, *John Singer Sargent* (1955; 1969), pp. 387, 389, 399, discusses murals over the stairway and library entrance; pp. 478–479, lists studies for them; p. 479, lists it as Philosophy in a catalogue of Sargent oils (no. K232 in early editions), dates it 1923 // MFA, Boston, *Sargent's Boston*, exhib. cat. by D. McKibbin (1956), pp. 51–64, discusses decorations; p. 74, lists drawings for Philosophy // D. F. Hoopes, *Antiques* 86 (Nov. 1964), p. 591, discusses its patterned background // R. Ormond, *John Singer Sargent* (1970), pp. 78, 88, 93–94, discusses MFA decorations.

Ex COLL.: the artist's sister Violet (Mrs. Francis Ormond), London, until 1950.

Gift of Mrs. Francis Ormond, 1950.

50.130.1.

Science:
A Preparation for the Mural in the Museum of Fine Arts, Boston

Like *Philosophy* (see above) this is a study for one of the three finished murals above the former library entrance of the Museum of Fine Arts, Boston. A pendant to *Philosophy*, it also must be dated between 1921 and 1925.

Science is represented by an astronomer, studying the stars; a young woman behind him records the results of his observations. A sheet of preliminary drawings for *Science*, 28.795 (MFA,

Sargent, finished mural, *Science*. MFA, Boston.

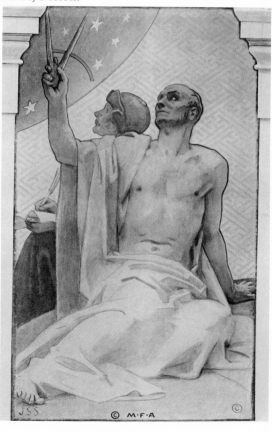

Boston) shows the variety of compositions that the artist considered before arriving at this particular solution.

Oil on canvas, $13\frac{5}{8} \times 7\frac{1}{2}$ in. (34.6 × 19.1 cm.).

RELATED WORKS (see above, *Philosophy*): A sheet of sketches for Science, verso of *Sketch for Orestes and the Furies (Stairway)*, pencil on paper, 26.5 × 44 cm. MFA, Boston (28.795) // *Sketch for Science (Stairway)*: *Torso partially draped*, and a separate sketch of a hand grasping a cylindrical object, MFA, Boston (28.650) // *Sketch for Science (Stairway)*, black chalk on paper, $18\frac{5}{8} \times$ 25 in. (47.3 × 63.5 cm.), MFA, Boston (28.702) // *Sketch for Science (Stairway)*, pencil on paper, $16\frac{1}{2} \times$ $10\frac{3}{8}$ in. (41.9 × 26.4 cm.), shows final pose, squared for transfer, MFA, Boston (28.803) // *Science*, oil on canvas affixed to wall, 79 × 44 in. (200.7 × 111.8 cm.),

finished mural installed 1925, MFA, Boston (25.639).

REFERENCES (see also, *Philosophy*): MFA, Boston, *Decorations over the Stairway and Library Entrance ...* (1925), ill. p. 5, finished mural; p. 6, discusses its subject matter // C. M. Mount, *John Singer Sargent* (1955; 1969), p. 479, lists it as Astronomy in a catalogue of Sargent oils (no. K231 in early editions), dates it 1923 // MFA, Boston, *Sargent's Boston*, exhib. cat. by D. McKibbin (1956), p. 74, lists drawings for *Science* // R. Ormond, *John Singer Sargent* (1970), p. 94, says that the finished mural *Science* "has some affinity with those in Raphael's *School of Athens* in the Vatican."

EX COLL.: the artist's sister Violet (Mrs. Francis Ormond), London, until 1950.

Gift of Mrs. Francis Ormond, 1950.
50.130.2.

JEFFERSON D. CHALFANT

1856–1931

The career of Jefferson David Chalfant can be divided chronologically according to the subject matter of his art. During the 1880s, after a decade of work as a cabinetmaker, he specialized in trompe l'œil still lifes; then, following a trip to Europe in the early 1890s, he turned to painting genre scenes; and, after 1905, he concentrated on portraiture. Chalfant was born in Chester County, Pennsylvania, and attended public schools in Lancaster. He learned the trade of cabinetmaking from his father and worked in nearby Lititz between 1870 and 1872. From 1873 until 1879, both he and his father worked for the J. G. Brill Company of Philadelphia, finishing railroad cars and painting parlor car interiors.

Chalfant moved to Wilmington, Delaware, the city usually associated with his artistic career, in 1879. Employed by Jackson and Sharp Car and Sash Works from 1881 to 1882, he continued to paint parlor car interiors but also worked as an artist. He took his first studio in 1883 and began painting trompe l'œil still lifes that were clearly influenced by those of WILLIAM MICHAEL HARNETT. Perhaps the finest of Harnett's many followers, Chalfant emulated that artist's repertoire of tabletop subjects and objects hanging on doors. His work is distinguished, however, by a silvery atmosphere, achieved with a monochromatic palette, and compositions that are strikingly simple in arrangement but show a strong interest in pattern and decoration. Although only about a dozen still lifes by Chalfant are known, his success with the trompe l'œil idiom makes it an important part of his work. In 1886, when he moved to a studio in the Wilmington Institute Building, the New York businessman H. Wood Sullivan became his agent and purchased a large number of his works over the next seventeen years. Chalfant began to exhibit paintings at the National Academy of Design and the Pennsylvania Academy of the Fine Arts in 1887.

In 1890, the New York art collector Alfred Corning Clark sent him to Paris, where he studied at the Académie Julian under Adolphe William Bouguereau and Jules Joseph Lefebvre. This formal art training strengthened Chalfant's realistic style and encouraged him to attempt more ambitious figure subjects such as *Atelier de Bouguereau à l'Académie Julian*, 1891 (Fine Arts Museums of San Francisco). On his return to Wilmington in 1892, he embarked on a series of small-scale genre paintings, many of which depict interior scenes showing an artisan or tradesman at work. This choice may have been governed by his own early training as a craftsman and by his continuing interest in machinery and inventions. Between 1894 and 1898, Chalfant obtained patents for a bicycle saddle, a pedal crank attachment, and a machine for justifying type; he also worked on plans for a seed planter and a hayrake. Although he had not done still lifes for nearly a decade, he did paint one in about 1898, *The Old Flintlock* (private coll., ill. in *Jefferson David Chalfant* [1979], no. 30, p. 43), perhaps his final endeavor in this genre.

Chalfant married Katharine Braunstein in 1903, and from 1905 to 1927, he painted portraits in the Wilmington area under the sponsorship of Senator and Mrs. Willard Saulsbury. Sometime during this period he moved his studio from downtown Wilmington to the picturesque Ashley house on the outskirts of the city. After suffering a stroke in 1927, however, he was no longer able to paint. He died four years later at the age of seventy-five.

BIBLIOGRAPHY: Alfred V. Frankenstein, *After the Hunt: William Harnett and Other American Still Life Painters, 1870–1900* (Berkeley and Los Angeles, 1953; rev. ed. 1969), pp. 125–128 // William H. Gerdts, "A Trio of Violins," *Art Quarterly* 22 (Winter 1959), pp. 370–383, discusses Chalfant's violin paintings // Wilmington Society of the Fine Arts, Delaware Art Center Building, *Jefferson D. Chalfant, 1856–1931* (Jan. 8–Feb. 1, 1959), brief catalogue of a major retrospective exhibition, includes a chronology of the artist's life // William H. Gerdts and Russell Burke, *American Still-life Painting* (New York, 1971), pp. 144–145, discuss the artist's career as a still-life painter; p. 250, list bibliography // Brandywine River Museum, Chadds Ford, Pa., and Newark Museum, *Jefferson David Chalfant, 1856–1931*, exhib. cat. by Joan H. Gorman (1979), the most complete discussion of the artist's career.

Violin and Bow

Chalfant used a violin for his model in at least four compositions. *Violin and Music*, 1887 (Newark Museum, N.J.), and *Music* (private coll.) represent a violin lying on a white tablecloth, set against an elaborately patterned wallpaper background. The remaining violin pictures—*The Old Violin*, 1888 (Delaware Art Center, Wilmington) and the Metropolitan painting, dated 1889—are composed on a vertical format and owe an obvious debt to WILLIAM MICHAEL HARNETT's *The Old Violin*, 1886 (coll. William J. Williams, Cincinati), which was made popular through a chromolithograph. Although the compositional arrangement and trompe l'œil realism are derivative, all four still lifes are distinguished by a generalized light and pale, monochromatic colors applied in subtle gradations that produce a glowing, silvery effect. *Violin and Bow* is the most austere of the artist's musical instrument subjects and demonstrates his preference for a few carefully chosen objects, simply arranged. The composition is limited to a nineteenth-century violin and a tautly strung bow, both of which hang against a plain paneled door. Details like the chin mark and the white rosin dust around the fingerboard are rendered with great precision, and the three-dimensional objects are convincingly modeled.

Although the artist's correspondence is filled with references to violin paintings, it is rarely possible to determine which of the four known treatments of the subject is being discussed. Chalfant's agent H. Wood Sullivan did write to him while *Violin and Bow* was on view at the Pennsylvania Academy in 1889, inquiring "when exhibit is closed what will be your lowest price to

Chalfant, *Violin and Bow*.

me *spot cash.*" It is by no means certain, however, that Sullivan purchased the painting; for he was not Chalfant's only dealer. Furthermore, *Violin and Bow* may have been exhibited in Philadelphia to attract the attention of a totally different purchaser, namely the art dealer J. G. Craig or one of his clients. The previous year, when *The Old Violin* was shown at the academy, Craig had written to Chalfant:

I have charge of the exhibition at the Academy of Fine Arts. And I have a great many inquiries in regard to your picture. Should you have another piece and care to place it on sale I would like to have it and perhaps I may find a customer among the many who have admired the one now here (March 17, 1888, Chalfant Papers, Arch. Am. Art.)

The Metropolitan painting, finished a year later, is so similar to *The Old Violin* that it seems likely that the artist was encouraged to repeat the subject.

Oil on canvas, 36 × 21⅝ in. (91.4 × 54.9 cm.).

Signed and dated at lower left: J. D. CHALFANT. 1889. Signed, dated, and inscribed on reverse: *Violin and Bow. | 1889—J. D. Chalfant.*

REFERENCES: H. W. Sullivan to J. D. Chalfant, Feb. 13, 19, 1889, Chalfant Papers, Arch. Am. Art, discusses the work exhibited at PAFA and asks its price (quoted above) // W. H. Gerdts, *Art Quarterly* 22 (Winter 1959), p. 381, mentions a fourth Chalfant violin painting, Violin and Bow, which was exhibited at the Pennsylvania Academy in 1889 // *Selections from the Collection of Hirschl and Adler Galleries* 5 (1963–1965), color pl. 129 // N. Hirschl, Hirschl and Adler Galleries, New York, orally, Oct. 26, 1966, gave information regarding the picture's provenance and exhibition history // W. H. Gerdts and R. Burke, *American Still-life Painting* (1971), p. 145, compare it to Chalfant's The Old Violin // S. Strickler, in E. H. Hawkes, *American Painting and Sculpture, Delaware Art Museum* (1975), p. 54, calls it a "simplified version" of The Old Violin // L. Libin, Musical Instruments, MMA, memo in Dept. Archives, August 1975, discusses the type of violin depicted // S. Feld, Hirschl and Adler Galleries, letter in Dept. Archives, Sept. 18, 1975, provides information on the provenance // H. Roman, letter in Dept. Archives, Sept. 25, 1975, provides information on the provenance.

EXHIBITED: PAFA, 1889, no. 38, as Violin and Bow, for sale, $350 // Cincinnati Art Museum, 1964, *American Painting III*, no. 13, lent by Hirschl and Adler Galleries // National Gallery of Art, Washington, D.C.; Whitney Museum of American Art, New York; University Art Museum, Berkeley, and California Palace of the Legion of Honor, San Francisco; Detroit Institute of Arts, 1970, *The Reality of Appearance*, exhib. cat. by A. Frankenstein, no. 100; p. 148, discusses it as a simplification of similar subjects by Harnett and compares it to Harnett's Still Life—Violin and Music (q.v.) // Hirschl and Adler Galleries, New York, 1973, *Retrospective of a Gallery* (for the benefit of the Youth Consultation Service), no. 19.

Ex COLL.: unspecified auction, Boston; with William's Antique Shop, Old Greenwich, Conn., 1962; with Galka and Roman, New York, 1962–1963; with Hirschl and Adler Galleries, New York, 1963–1966.

George A. Hearn Fund, 1966.
66.169.

JOHN HABERLE

1856–1933

Haberle is recognized today, along with WILLIAM MICHAEL HARNETT and JOHN F. PETO, as one of the most accomplished American trompe l'œil painters working at the end of the nineteenth century. His still lifes, done mainly from 1887 to 1894, are distinguished not only for the technical virtuosity they display but also for the artist's wit and originality of approach. Haberle was born in New Haven, Connecticut, where he worked most of his life in relative obscurity. He began drawing as a youth, often using himself as a model. Before he took up painting, probably in the late 1870s or early 1880s, he was employed as a preparator by the Yale paleontologist Othniel Charles Marsh, and among such duties as cleaning fossils and mounting

skeletons, he may also have done scientific drawings. Around 1887 he attended the school of the National Academy of Design, where in the autumn of that year he exhibited a still life of money entitled *Imitation* (unlocated). This painting was purchased by the prominent art collector Thomas B. Clarke, but most of Haberle's later patrons were less well known. Many were saloon or hotel keepers who were attracted more by the entertaining subject matter of the artist's work than by its aesthetic qualities. Although an infrequent participant in the major annual exhibitions, he did show his illusionistic still lifes at the Pennsylvania Academy of the Fine Arts and the Art Institute of Chicago from 1888 to 1890.

Haberle's work was especially popular in the Midwest, where one Detroit businessman collected a great number of his paintings, among them *The Changes of Time*, 1888 (coll. Marvin Preston, Detroit). This painting is a typical Haberle composition, with a variety of simulated flat objects arranged on an upright support. *Grandma's Hearthstone*, 1890 (Detroit Institute of Arts), is the artist's largest picture and one of the few in which he successfully attempts three-dimensional modeling. After completing this work and the elaborate *A Bachelor's Drawer*, 1890–1894 (q.v.), Haberle's eyesight was so strained that he could no longer meet the demands of his meticulous technique, and he abandoned trompe l'œil painting. Indeed on May 15, 1894, the *New Haven Evening Leader* reported that "after this Mr. Haberle is to devote himself entirely to broader work and will make a specialty of figure composition" (p. 3). Although most of his late still lifes are small-size depictions of fruit and flowers, he did return to trompe l'œil painting on at least one occasion, producing *Night*, 1909 (New Britain Museum of American Art, Conn.). This work shows a wall with a velvet curtain pulled aside to reveal what appears to be an unfinished painting between two mosaic panels.

The artist also did sentimental animal paintings, and, beginning in the early 1890s, modeled in clay and made plaster bas reliefs. In spite of the decline evident in his later work, Haberle's trompe l'œil paintings, described in 1894 as "the best in the country" remain a distinct contribution to American still-life painting. His work was neglected for a long time, however, and up until the early 1950s, he had been all but forgotten.

BIBLIOGRAPHY: Jane Marlin, "John Haberle, a Remarkable Contemporaneous Painter in Detail," *Illustrated American* 24 (Dec. 30, 1898), pp. 516–517 // Alfred Frankenstein, "Haberle: or the Illusion of the Real," *Magazine of Art* 41 (Oct. 1948), pp. 222–227 // Alfred Frankenstein, *After the Hunt: William Harnett and Other American Still Life Painters, 1870–1900* (Berkeley and Los Angeles, 1953; rev. ed. 1969), pp. 115–122 // New Britain Museum of American Art, Conn., *Haberle Retrospective Exhibition* (Jan. 6–28, 1962), foreword by Alfred Frankenstein // William H. Gerdts and Russell Burke, *American Still-life Painting* (New York, 1971), pp. 157–158, 250.

A Bachelor's Drawer

A Bachelor's Drawer was painted over a period of four years, from 1890 to 1894. Typical of Haberle's work not only in subject and composition but also in humor, it is the last of his successful trompe l'œil still lifes. Here the souvenirs of a bachelor's freedom—theater stubs, playing cards, a cigar box lid, a corncob pipe, and girlie photographs, to name but a few of the objects depicted—are arranged against a simulated wood drawer and rendered with incredible precision, fooling the eye to an extraordinary degree. Haberle has heightened the trompe l'œil effect by selecting an upright support, which limits spatial recession, and depicting mostly flat paper items, in which there is little need for modeling and shadows. The artist was not well versed in academic techniques; the various panels and moldings of the drawer and the few three-dimen-

Haberle, *A Bachelor's Drawer.*

sional objects placed against it appear flat.

The conspicuously placed caricature of an elegantly dressed and mustachioed gentleman at the upper right may represent the bachelor. His fate is suggested by the printed verse in the lower right, a paraphrase of the traditional wedding vow, and more pointedly by two printed items that overlap the caricature—a pamphlet entitled "How to Name the Baby" and a cartoon of a howling infant, the latter amusingly surrounded by pinup photographs. In the center of the canvas, along the upper edge, is the imprint left by a horseshoe, perhaps a sign that the bachelor's luck has run out.

The inclusion of the artist's self-portrait in a simulated tintype suggests that the work may be autobiographical, but since details of Haberle's life have not been well documented, it is difficult to draw conclusions in this regard. The four newspaper clippings depicted at the center of the drawer, however, do contain references to the artist's career, more specifically to his accomplishments as a trompe l'œil painter. Torn and partially covered by another clipping, an article entitled "It Fooled the Cat" which appeared in the *New Haven Evening Leader* on June 10, 1893, relates how a cat, convinced that Haberle's *Grandma's Hearthstone*, 1890 (Detroit Institute of Arts), was real, curled up in front of the painting when it was first exhibited. Not surprisingly, *A Bachelor's Drawer* invited an analogous response. When the picture was nearing completion, a friend visiting the artist mistook it for the model and asked when Haberle was going to begin the picture. The clipping superimposed on the text of "It Fooled the Cat" and the fragment below it relate to an incident that occurred while one of Haberle's pictures of money was on view at the Art Institute of Chicago in 1889. A critic accused the artist of fraud, claiming that he had simply pasted fragments of actual pieces of currency on the canvas, and Haberle went to Chicago to prove that he had indeed painted all the objects shown in the picture. The fourth and final newspaper notice reads: "A New Haven artist has plunged himself into trouble by making too perfect greenbacks in oil. Others have often had trouble by losing too perfect greenbacks in oil." This may be a reference to a warning the artist received from federal agents ordering him to stop creating what was in effect counterfeit money. In an intentional taunt the artist places these clippings beside some simulated currency. Then in another bit of wit, he covers the fragments of a ten-dollar bill with a foreign bill, a Confederate one, and another outdated note bearing the inscription: "This note with a lot of counterfeit money was taken by detectives from [illeg.] in New York Jan. 1 1865. Experts claim this to be genuine." Haberle attempts, quite successfully, to confuse the viewer about what is authentic, what is counterfeit, what is real, and what is simulated. He further tantalizes one by arranging these objects—presumably the contents of the inside of a drawer—on the outside, where they adhere inexplicably to the vertical support. Having aroused the viewer's curiosity about the imagined space behind the drawer front, the artist, in effect, denies him access to it by removing the drawer pulls and showing the escutcheon without its key. The center panel of the drawer, apparently the only part that can open, appears to be nailed shut, and only the cigar box lid, which holds a variety of objects behind it, is on hinges.

The painting was begun around the same time as *Grandma's Hearthstone*, and the effort of executing these two ambitious paintings so strained Haberle's eyesight that when *A Bachelor's Drawer* was finished he announced that he was abandoning the trompe l'œil genre.

Oil on canvas, 20 × 36 in. (50.8 × 91.4 cm.).
Signed and dated at upper left: · HABERLE · 1890–94.

REFERENCES: J. D. Gill, James D. Gill's Stationery and Fine Art Store, Springfield, Mass., to J. Haberle, copy, Dept. Archives, Feb. 19, 1894, requests that the picture be sent to an exhibition that is already up, as "we are having a large attendance and good sales" // *New Haven Evening Leader*, May 15, 1894, p. 3, reviews the painting on exhibition in Traeger's Hotel, saying that it was "undoubtedly destined to become well known throughout the United States", that it is done in Haberle's "imitative style"; gives size and notes that, except for Grandma's Hearthstone, it is the artist's largest work; describes contents in great detail, identifying the tintype as a self-portrait; relates anecdote about a friend of the artist mistaking the painting for the model; says that it is the last trompe l'œil work that he plans to execute // Gill to Haberle, copy, Dept. Archives, May 21, 1894, says that the painting "has attracted and is attracting considerable attention . . . Papers here have given it good notices which I will send you" // Mr. Bradish, Trans-Mississippi and International Exposition, to Haberle, copy, Dept. Archives, July 5, 1898, discusses its exhibition "in a most prominent position, in the centre of one of our galleries" at the exposition, where "it attracts no little attention & have had one or two nibbles for it" // A. H. Griffith, Trans-Mississippi and International

Detail from Haberle, *A Bachelor's Drawer*.

Exposition, to Haberle, copy, Dept. Archives, Oct. 19, 1898, states it "attracted a great deal of attention" at the exposition and he would like permission to send it to Detroit for another exhibition // A. H. Griffith, Detroit Museum of Art, to Haberle, copy, Dept. Archives, Jan. 31, 1900, requests permission to exhibit it in an "elegant" saloon in that city // A. Frankenstein, *Magazine of Art* 41 (Oct. 1948), ill. pp. 222 and 227; pp. 226–227, discusses objects in it // *Art News* 52 (Sept. 1953), ill. p. 25 // A. Frankenstein, *After the Hunt* (1953; rev. ed., 1969), p. xv, discusses it; pls. 98, 99, 100; pp. 120–122, discusses its subject and history; *Artforum* 4 (Oct. 1965), color ill. p. 30; pp. 31–32, discusses its relationship to Pop Art; *Art in America* 54 (March–April 1966), p. 78, discusses it; ill. p. 86 // R. B. Hale, *MMA Bull.* 25 (Oct. 1966), p. 67, notes it is on loan from J. W. Middendorf // V. Demmer to J. W. Middendorf II, copy, Dept. Archives, Feb. 3, 1967, says it hung "in the old home and the old studio from possibly 1900 to 1960" // W. H. Gerdts and R. Burke, *American Still-life Painting* (1971), p. 157, discuss it; ill. p. 152–153 // *Art Quarterly* 34 (Spring 1971), p. 124; ill. p. 136 // A. Frankenstein, *Artforum* 12 (May 1974), ill. p. 35, discusses it // M. L. d'Otrange-Mastai, *Illusion in Art* (1975), ill. p. 303; p. 309, discusses it.

EXHIBITED: Traeger's Hotel, New Haven, May 1894 (no cat.) // James D. Gill's Stationery and Fine Art Store, Springfield, Mass., June 1894 (no cat.) // Trans-Mississippi and International Exposition, Omaha, 1898, *Official Catalogue of the Fine Arts Exhibit*, no. 263, as A Bachelor's Drawer // Detroit Institute of Arts, 1898–1899, *Special Exhibition of Sixty-four Paintings from the Trans-Mississippi Exposition*, no. 33 // New Britain Museum of American Art, Conn., 1962, *Haberle Retrospective Exhibition*, unnumbered cat., lent by the Haberle estate // La Jolla Museum of Art and Santa Barbara Museum of Art, 1965, *The Reminiscent Object*, exhib. cat. by A. Frankenstein, no. 63, lent by Mrs. Vera Haberle Demmer, New Haven, and Mrs. Gloria Shiner, East Haven, Conn., unpaged ill., discusses its relationship to Pop Art // Whitney Museum of American Art, New York, 1966, *Art of the United States, 1670–1966*, no. 118, lent by Mr. and Mrs. J. William Middendorf II // MMA and Baltimore Museum of Art, 1967, *American Paintings and Historical Prints from the Middendorf Collection*, exhib. cat. by S. Feld et al., no. 47, p. 70, discusses it, giving exhibitions, references, and provenance; ill. p. 71 // MMA, 1970, *19th Century America, Paintings and Sculpture*, exhib. cat. by J. K. Howat and N. Spassky, ill. no. 190, lent by Mr. and Mrs. J. William Middendorf II, discusses it // Civic Museum of Turin, 1973, *Combattimento per un'Immagine, Fotografi e Pittori*, exhib. cat. by D. Palazzoli and L. Carluccio, unnumbered ill., as Il cassetto dello studente.

EX COLL: the artist, until 1933; daughter of the artist, Mrs. Vera Haberle Demmer, New Haven, and granddaughter of the artist, Mrs. Gloria Shiner, East Haven, Conn., until 1966; with Robert P. Weimann, Jr., Ansonia, Conn., as agent, 1966; J. William Middendorf II, 1966–1970.

Purchase, Henry R. Luce Gift, 1970.

1970.193.

CHARLES H. DAVIS

1856–1933

The landscape painter Charles Harold Davis was born in Amesbury, Massachusetts, where his father was a teacher. Although interested in drawing from childhood, he first worked in a carriage factory. In 1874, he settled on an artistic career after attending an exhibition at the Boston Athenaeum, where he was inspired by the Barbizon landscapes of the French painter Jean François Millet. Davis enrolled in a free drawing school in Boston and later, at the suggestion of his instructor Leslie W. Miller (1848–1931), entered the newly opened School of the Museum of Fine Arts, where he studied for about three years under Otto Grundmann (1844–1890). In 1880, a retired carriage manufacturer from Davis's hometown offered to finance the young artist for two years' study abroad.

Davis remained in France for nine years. After a brief period of study at the Académie Julian under Jules Joseph Lefebvre and Gustave Boulanger, he spent most of his time painting outdoors in rural areas like Fontainebleau. He exhibited at the Paris Salon for the first time in 1881, and two years later had his first American exhibition in Boston, the proceeds from which financed the remainder of his stay abroad. Meanwhile, his reputation at home grew, and in 1884 he began to exhibit at the National Academy of Design. Elected a member of the Society of American Artists in 1886, he held the first major exhibition of his work in New York at Reichard and Company the following year. On returning to America in 1890 with his French wife, the former Angele Legarde, Davis settled in Mystic, Connecticut, where he spent the remainder of his life. His first wife died in 1894, and three years later he married Frances Thomas.

Throughout the early years of his career, Davis painted landscapes, the subdued palette and romantic subject matter of which reveal the strong influence of the Barbizon School, but in 1895, he began to concentrate on the study of clouds under varying conditions, and from then on this became his specialty. A successful and popular painter, Davis was given one-man shows at William Macbeth's gallery in New York and at Doll and Richards in Boston, and his works appeared in both major expositions and annual exhibitions of the period. In 1903, he was elected an academician at the National Academy. He continued to work until his death at the age of seventy-seven.

BIBLIOGRAPHY: Charles H. Davis, "Notes Upon Out-of-Door-Life by One of Our Students in France," *Art Student* 1 (Dec. 1884), unpaged ∥ Charles H. Davis, "A Study of Clouds," *Palette and Bench* 1 (Sept. 1909), pp. 261–262 ∥ William H. Downes, "Charles H. Davis, Landscape Artist," *New England Magazine*, n.s. 27 (Dec. 1902), pp. 423–437 ∥ "Charles H. Davis—Landscapist," *International Studio* 75 (June 1922), pp. 176–183 ∥ Louis Bliss Gillet, "Charles H. Davis," *American Magazine of Art* 27 (March 1934), pp. 105–112.

August

Originally called *Midsummer*, this depiction of the New England countryside under an overcast sky is typical of the cloud studies that Davis made his specialty after 1895. In a 1909 article entitled "A Study of Clouds," Davis urged his readers to look at individual clouds and to "study the shapes

just as if they were solids, just as you study objects in still-life painting" (*Palette and Bench* 1 [Sept. 1909], p. 262). In *August* the artist shows a view with a low horizon and no prominent landscape features. Most of his canvas is devoted to capturing the changing movement of the clouds and the shadows they cast on the rolling hills below.

Correspondence with his dealer William Macbeth suggests that Davis completed the painting during the summer of 1908, when he was preparing for an important one-man exhibition, which he wanted "to make . . . the very best show I have had" (C. H. Davis to W. Macbeth, Jan. 28, 1909, Macbeth Papers, NMc6, Arch. Am. Art). The painting was first shown in a group exhibition at the Lotos Club in February, and after its purchase by the collector George A. Hearn, it was included in the one-man show at Macbeth's in March.

Davis, *August*.

Oil on canvas, 29 × 36½ in. (73.7 × 92.7 cm.).
Signed at lower left: C. H. Davis.
References: C. H. Davis to W. Macbeth, Macbeth Papers, NMc6, Arch. Am. Art, Dec. 11, 1908, asks him to return a 29 × 36 inch painting, "the summer with clouds" (probably this painting), and discusses including it in the Lotos Club exhibition; Feb. 23, 1909, changes title of painting from Midsummer to August, says he is putting it in Lotos exhibition; Feb. 26, 1909, forwards a letter from G. A. Hearn, requesting the price of the painting, and says he will not reduce price; Feb. 28, 1909, expresses the hope that Hearn will purchase the painting and allow it to be included in the upcoming exhibit at Macbeth's // *MMA Bull.* 4 (July 1909), p. 113; ill. p. 114 // C. H. Davis to W. Macbeth, Sept. 1, 1910, Macbeth Papers, NMc40, suggests it be sent to exhibition in Worcester // D. Bolger, *Arch. Am. Art Journ.* 15, no. 2 (1975), p. 10; ill. p. 11; pp. 12–14, discusses the painting and quotes letters regarding its exhibition and acquisition.

Exhibited: Lotos Club, New York, 1909, *Exhibition of Paintings by the Artist Members of the Lotos Club*, no. 19, as Midsummer // Macbeth Gallery, New York, 1909, *Paintings by Charles H. Davis, N.A.*, no. 4, as August.

Ex coll.: with Macbeth Gallery, New York, as agent, 1909; George A. Hearn, New York, 1909.

Gift of George A. Hearn, 1909.

09.72.3.

HOWARD RUSSELL BUTLER

1856–1934

Howard Russell Butler combined his artistic talent with an interest in science; as he once commented: "The painter touches life and nature in many ways. He is none the worse for having had a broad education" (Butler, p. 146). Born in New York, the grandson of Charles H. Marshall, owner of the Black Ball Packet Line, he first studied drawing in Yonkers, New York, at the age of fourteen. In 1876 he was graduated from Princeton, where he continued as a special student of Cyrus F. Bracket, professor of physics, and accompanied the Princeton Scientific Expedition to the Rocky Mountains in 1877. For the next five years, Butler was involved in several businesses, including the Gold and Stock Telegraph Company and the American Speaking Telephone Company. Receiving a law degree from Columbia University

in 1882, he went on to practice electrical patent law with the firm of Pope, Edgecomb, and Butler.

In spite of many business commitments, Butler found time to paint, and, in 1884, at the age of twenty-eight, he resolved to pursue his artistic career more seriously. Resigning his law partnership, he began art studies in Mexico under the landscape painter FREDERIC CHURCH, and later in New York, he enrolled at the Art Students League. Convinced that he would benefit from foreign study, Butler sailed for Europe in May 1885, but during the two years he spent abroad, his studies were fragmentary and sporadic. He worked under a variety of teachers, hoping, as he wrote to his sister Harriet on March 21, 1886, that "my plan of study . . . will give me . . . larger views of art, than if I remained constantly under the guidance of a single man" (Butler Papers, 1189, Arch. Am. Art). After a month of drawing at the Atelier Colarossi under Raphael Collin and Gustave Courtois, he spent the summer with ALEXANDER HARRISON at Concarneau in Brittany, doing plein-air scenes. There he made sketches for *The Seaweed Gatherers*, 1886 (coll. Howard Russell Butler, Jr., Princeton, N.J.), which won an honorable mention at the Paris Salon in the spring. After a trip to Italy in the winter of 1885–1886, Butler resumed his studies in Paris, this time under the figure painter Alfred Philippe Roll, and, early in 1887, he studied briefly with Henri Gervex. He continued to paint outdoors, working in the French and Dutch countryside, and at St. Ives, the artists' colony in Cornwall, England.

Butler returned to the United States in 1887, and, after another trip to Mexico, settled in New York. In 1888 he became a member of the Society of American Artists, and the following year he was elected to the Architectural League of New York. Elected an associate of the National Academy of Design in 1897 and a full member three years later, he served as its president between 1916 and 1921. Always interested in promoting cooperation among the city's art organizations, he helped establish the American Fine Arts Society, founded in 1889, and served as its head until 1905. Later, he was among those who organized the National Academy Association, which attempted to secure more exhibition space and permanent headquarters for a variety of art organizations.

At the turn of the century, many of the artist's business activities stemmed from his friendship with the industrialist Andrew Carnegie, whose portrait he painted at least seventeen times. Butler was president of the Carnegie Music Hall Company from 1898 to 1901 and supervised the building of Carnegie's New York residence (now the Cooper-Hewitt Museum). During the early years of the century, he directed the construction of Carnegie Lake in Princeton, and, after 1911, he lived in this New Jersey town. Butler's summer home, where he often painted, was for many years in East Hampton, Long Island. From 1905 to 1907, and again from 1921 until 1926, he lived in California.

Although he painted portraits and figure studies, Butler preferred marines and also made a specialty of astronomical pictures depicting solar and lunar phenomena, a subject which combined his artistic and scientific interests. In 1918, he accompanied a group from the United States Naval Observatory to Baker, Oregon, where he recorded the total eclipse on June 8, 1918; the painting was completed in 112 seconds. He also painted the solar eclipses on September 10, 1923, in Lompoc, California, and January 24, 1925, in Middletown, Connecticut. These are preserved in *The Eclipse Triptych*, 1918, 1923, 1925 (American Museum—Hayden

Planetarium, New York). In recognition of these achievements Butler was elected a member of the American Astronomical Society. He continued to paint until his death in Princeton at the age of seventy-eight.

BIBLIOGRAPHY: Howard Russell Butler Papers, microfilm 93 (coll. Howard Russell Butler, Jr.), and 347–349, 1189–1190, Arch. Am Art. Includes letters, 1875–1933, diaries, 1876–1877, an auto-biographical statement, clippings, and catalogues. Particularly informative about his years in Paris // Howard Russell Butler, *Painter and Space; or, the Third Dimension in Graphic Art* (New York, 1923). Butler presents his scientific approach to art, discusses perspective and color, and details his technique of painting astronomical pictures // F. Newlin Price, *Howard Russell Butler (1856–1934)* (Princeton, N.J., 1936). A biography, with a list of the artist's important paintings // E. R. Squibb and Sons, Princeton, N.J., *Howard Russell Butler: An Exhibition of His Oils, Pastels & Drawings* (1977), cat. by Elisabeth Stevens. A biography with many illustrations and bibliography // Elisabeth Stevens, "Howard Russell Butler: An American in Paris, 1885–1887," *Arch. Am. Art Jour.* 17, no. 4 (1977), pp. 2–5. A discussion of the artist's years in France with extensive quotations from the Howard Russell Butler Papers.

Yankee Point, Monterey

This painting, which Butler described as his "last California marine," was done between 1921 and 1926, the period of his second residence in California. Although painted in a bold impressionist style, the picture has a composition typical of an older tradition. The high horizon, oblique vantage point, and arrangement of rocks and pounding surf in the foreground was popularized in America by realists like FREDERICK J. WAUGH and earlier by WINSLOW HOMER. It was certainly conventional by the 1920s.

Fascinated by the coloristic qualities of water, Butler suggests its transparency with touches of color in the waves that reflect both the blue of the sky above and the darker, more varied colors of the rocks and sand below. As he once wrote:

The painter sees in the upturned wave two distinct sets of tones. Having been a student of physics he immediately recognizes them intelligently. There are the refraction tones and the reflection tones. The refraction tones give him the deep color of the water and perhaps, if that be shallow, the local color of the floor of the ocean—sand, rock, and seaweed. The reflection tones recall the dome of the heavens. Large sections of the sky are felt in these reflections, for each wave plane reflects a different part of the heavens. . . . there is one

Butler, *Yankee Point, Monterey.*

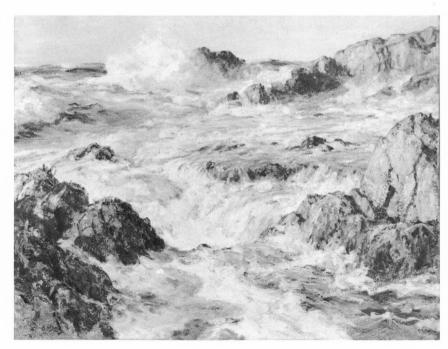

thing he must not do—that is, blend the refraction colors with the reflection colors. . . . blended tones cease to imply wateriness, so that the result looks like a board or other solid surface, lacking the transparency of water (*Painter and Space* [1923], pp. 147–148).

The roughened surface texture of the canvas was probably achieved by the procedure that Butler once detailed in an undated manuscript in which he advocated the use of canvases prepared well ahead of time so that "the picture can be finished under the inspiration of nature" (Howard Russell Butler Papers, 349, Arch. Am. Art). He usually prepared about twenty canvases at a time, cleaning them with benzol and applying a thin ground of flake white. After this had dried for two days, he developed a "suggestive texture" on each canvas, using a brush, rag, or bone spatula. He then toned the top and bottom areas of the canvas with black or violet, leaving the central area bright, a procedure that accounts for the concentration of the highest color values in the center of *Yankee Point, Monterey*. The textural variety seen on the surface of the painting was further enhanced by Butler's technique. He initially worked thinly "proceed[ing] for a time very much as in true water color work," and then painted "more richly," using a rag, the handle of his brush, and a penknife to manipulate the paint, at times wiping out the passages that did not please him. *Yankee Point, Monterey*, probably painted outdoors in the rapid manner Butler espoused, captures the immediate effects of light, color, and movement.

Oil on canvas, 40 × 50 in. (101.6 × 127 cm.).
Signed at lower left: H. R. Butler.
REFERENCES: H. R. Butler, biographical statement, n.d., Butler Papers, 347, Arch. Am. Art, includes it in a list of his "most important paintings" // F. C. Jones to H. R. Butler, April 19, 1926, Butler Papers, 347, Arch. Am. Art, notes that he brought it before the museum's purchasing committee and they were "very pleased" with it // H. R. Butler to F. C. Jones, April 22, 1926, copy, Butler Papers, 347, Arch. Am. Art, says "I have naturally long cherished the hope of being represented in the Met." and to R. de Forest [April 22, 1926], Butler Papers, 347, Arch. Am. Art, says it was done in California (quoted above) // F. N. Price, *Howard Russell Butler (1856–1934)* (1936), unpaged, includes it in a list of works as no. 6, Yankee Point, Carmel // H. R. Butler, Jr., letter in Dept. Archives, April 11, 1964, dates it to 1921, when his father visited Monterey // H. C. Milch, Milch Gallery, letter in Dept. Archives, ca. August 5, 1975, gives information on provenance.
EXHIBITED: Century Association, New York, 1926, *Exhibition of Paintings by Howard Russell, N.A., Including a Triptych of Eclipses and a Lunar Crater* (no cat. available) // NAD, 1926, no. 173, as Yankee Point, Monterey // E. R. Squibb and Sons, Princeton, N.J., 1977, *Howard Russell Butler*, no. 29, exhib. cat. by E. Stevens, ill. p. 25; p. 33, dates it 1926.
EX COLL.: with Milch Galleries,, New York, 1926.
George A. Hearn Fund, 1926.
26.103.

DOUGLAS VOLK

1856–1935

The portrait and figure painter Stephen Arnold Douglas Volk was named for Stephen A. Douglas, a distant relation and a leading contender for the Democratic presidential nomination the year of the artist's birth. Throughout his career Volk used the surname of Douglas as his first name. This is somewhat ironic as his father, the sculptor Leonard Volk (1828–1895), is best remembered for his 1860 portrait bust of Douglas's rival Abraham Lincoln, and the artist himself painted at least nine portraits of the president, whose face he described as "almost baffling in its superb, rugged unity and mystical contradictions, the features are so magically related" (*American Magazine of Art* 14 [Jan. 1923], p. 15).

Born in Pittsfield, Massachusetts, Volk spent his youth in Chicago, where his father was a leading member of the city's artistic community. In 1870, when the family went to Rome, young Volk began to sketch and paint there and received encouragement in these pursuits from GEORGE INNESS. In the summers of 1871 and 1872 he traveled to Venice with Inness's student WILLIAM LAMB PICKNELL. Remaining in Rome after his parents returned to Chicago, Volk was enrolled at St. Luke's Academy, where he began his formal art training. He soon went on to Paris, however, and worked under Jean Leon Gérôme at the Ecole des Beaux-Arts from 1873 to 1879. His work was exhibited at the Paris Salon in 1875, and the next year one of his paintings was included in the Centennial Exhibition in Philadelphia. He also participated in the first exhibition of the Society of American Artists held in New York in 1878.

On his return to the United States in 1879, Volk settled in New York. The following year he was elected a member of the Society of American Artists and also began to exhibit at the National Academy of Design. He embarked on an active career as a teacher, serving as an instructor at Cooper Union from 1879 until 1884. He then moved to Minneapolis and in 1886 helped to found the Minneapolis School of Art (now the Minneapolis College of Art and Design), of which he was director until 1893, when he came back to New York, his residence until the late 1920s. Volk taught portrait classes at the Art Students League from 1893 to 1898 and also advised and taught classes at the New York Society for Ethical Culture, where drawing and modeling were stressed in a curriculum that concentrated on manual training. It was probably this experience of training skilled workers that inspired Volk and his wife to conduct a school in handicrafts at their summer home in Lovell, Maine. The artist taught at Cooper Union again from 1906 until 1912 and at the National Academy from 1910 until 1917.

Volk's figure paintings from the 1880s and 1890s are mostly romanticized scenes of American colonial life, such as *Accused of Witchcraft*, 1884 (unlocated), or idealized treatments of a single contemplative figure, for example, *Ye Maiden's Reverie*, 1898 (Berkshire Museum, Pittsfield, Mass.). Like many artists of his generation, he participated in the revival of mural painting, working on such projects as the decoration of the Des Moines Court House, which was completed in 1913. Although best known for posthumous portraits of Lincoln, Volk painted many sitters from life, and in 1919, was among the artists commissioned by the National Art Committee to paint such World War I political and military figures as *Lloyd George*, 1919–1920 (National Collection of Fine Arts, Washington, D.C.), and *John H. Pershing*, 1920–1921 (National Portrait Gallery, Washington, D.C.). His intimate portraits of friends and acquaintances, however, are among his most effective works, for example *Felix Adler* (q.v.) and *William Macbeth*, 1917 (Brooklyn Museum).

Volk achieved much recognition among his contemporaries. In 1899, he won first prize at the Colonial Exhibition in Boston, and was elected an academician at the National Academy. He exhibited at annual shows and major expositions throughout the country and received awards at the Columbian Exposition in 1893, the Pan-American Exposition in 1901, the St. Louis Exposition in 1904, and the Panama–Pacific Exposition in 1915. He was a member of the Architectural League of New York, the National Society of Portrait Painters, and the Society of Mural Painters. Somewhat forgotten during his final years, Douglas Volk died at the age of seventy-nine in Fryeburg, Maine, where he had spent most of the last eight years of his life.

BIBLIOGRAPHY: Biography based on an interview with the artist [1927], De Witt M. Lockman Papers, NYHS, microfilm 504, Arch. Am. Art // "Douglas Volk's portrait of William Macbeth," *Brooklyn Museum Quarterly* 5 (Oct. 1918), pp. 245–246 // "Volk's Portrait of Lincoln to Tour," *American Magazine of Art* 17 (June 1926), pp. 302–303 // *The National Cyclopaedia of American Biography* (New York, 1930), C, pp. 138–139 // Obituary: *New York Times*, Feb. 8, 1935, pp. 22.

Felix Adler

The religious leader and teacher Felix Adler (1851–1933) was born in Alzey, in the Rhineland, and came to the United States at the age of six, when his father was appointed to head Temple Emmanu-El in New York. After graduating from Columbia College in 1870, young Adler went to Berlin to continue his studies and later received a doctorate at Heidelberg. By 1874 he held the chair of Hebrew and Oriental literature at Cornell University in upstate New York. He returned to the city in 1876, however, and helped to establish the Society for Ethical Culture. Dedicated to the moral development of the individual and of society, this organization attracted many who were disillusioned with traditional religions. Instead of rituals or prayers, weekly meetings with lectures on topics of current interest con-

Volk, *Felix Adler.*

stituted the services. The movement grew and societies were founded in Chicago, Philadelphia, St. Louis, Brooklyn, Boston, and several European cities.

A progressive educator, Adler established the first free kindergarten for the poor in the United States in 1877, and three years later founded the Workingman's School (called the Ethical Culture School after 1895), where manual skills were taught in addition to the usual academic subjects. Beginning in 1893, he helped run a school of ethics, held during the summers in Plymouth, Massachusetts, and from 1902 until his death, he taught social and political ethics at Columbia University. He lectured at home and abroad, organized committees and congresses, and served on editorial boards. He wrote several books expounding the principles of the Society for Ethical Culture, of which *An Ethical Philosophy of Life* (1918) is the most comprehensive statement of his philosophy.

Several New York artists, among them ALEXANDER SHILLING and GEORGE DE FOREST BRUSH, were attracted by the Ethical Culture movement. Volk met Adler about 1881, probably after one of his lectures at Chickering Hall, and began to advise him on the organization of his Workingman's School. When Volk returned to New York from Minneapolis in 1893, he wrote articles for the Society for Ethical Culture and lectured at its schools. His comments in an essay "Beauty and Falsity" suggest how deeply its philosophy affected him. Unlike many of his contemporaries who espoused the Whistlerian aesthetic of art for art's sake, Volk stressed the social content and meaning of art as well as the personal satisfaction experienced by the artist. "In the matter of Art, moral, as well as purely aesthetic considerations are involved," he wrote, "beauty has its root far below the surface of things, and would seem to be inseparable from considerations of integrity and genuineness. . . . When a thing is honestly, purposefully and joyously done, it of necessity contains the first essentials of beauty" (*Ethical Record* 2 [April–May 1901], p. 156). Volk undoubtedly supported Adler's decision to open an art school in connec-

tion with the Ethical Culture School in the spring of 1913.

Adler posed for this portrait, which was completed by 1914, at Volk's request. Reviewing it in the National Academy of Design exhibition the following year, the critic for the *New York Times* wrote:

In Mr. Volk's picture the head emerges quietly from its background, an affair of subtly developed shadow and half-tone, with discreet lights, a room with the curtains partly drawn to save the nerves from excitement or strain. The modeling is firm and slightly hard, built up on a solid foundation of draughtsmanship. The impression is simple and single, concentrating attention on the character of the sitter.

The picture was highly successful. It won the Isaac N. Maynard Prize at the National Academy in 1915 and the Carol H. Beck Gold Medal at the Pennsylvania Academy of the Fine Arts in 1916 and was exhibited throughout the country.

Oil on canvas, 29⅝ × 22¼ in. (75.3 × 56.5 cm.).
Signed at lower right: Douglas Volk/©.
REFERENCES: *New York Times*, March 19, 1915, p. 11; March 20, 1915, p. 6; March 21, 1915, sec. 5, p. 22, discusses the portrait in a review of the NAD exhibition (quoted above) // *American Magazine of Art* 6 (May 1915), ill. p. 225 // W. H. D. Nelson, *International Studio* 55 (May 1915), ill. p. lxxiii // *International Studio* 58 (May 1916), p. 205 // *Academy Notes* 12 (Jan.–Oct. 1917), p. 78; ill. p. 86 // *Art World* 3 (Jan. 1918), p. 282; ill. p. 283 // L. M. Bryant, *American Pictures and Their Painters* (1921), pp. 155–156, discusses it; ill. opp. p. 156 // D. Volk, letter in MMA Archives, May 12, 1926, discusses condition problems evident after he examined it // *American Magazine of Art* 17 (June 1926), p. 303 // Biography based on an interview with the artist [1927], in De Witt M. Lockman Papers, NYHS, microfilm 504, Arch. Am. Art, p. 43, says that the artist and subject met about 1881 after a lecture at Chickering Hall and that Adler sat for the portrait at Volk's request // Mrs. H. Friess (née Ruth Adler), daughter of the sitter, orally, Sept. 3, 1975, gave information on the relationship between the artist and the sitter.

EXHIBITED: Union League Club, New York, 1914, *An Exhibition of Portraits*, no. 42, as Dr. Felix Adler, lent by the Ethical Culture School (probably this painting) // NAD, 1915, no. 347 // Art Institute of Chicago, 1915–1916, no. 345 // PAFA, 1916, no. 314 // Corcoran Gallery of Art, Washington, D.C., 1916–1917, no. 141 // Albright Art Gallery, Buffalo Fine Arts Academy, 1917, no. 133 // National Association of Portrait Painters, held at the New-York Historical Society, 1945, *Portraits of Americans by Americans*, ill. no. 79; p. 118.

EX COLL.: the artist, New York, until 1915.
George A. Hearn Fund, by exchange, 1915. 15.81.

COLIN CAMPBELL COOPER

1856–1937

Colin Campbell Cooper specialized in painting urban street scenes and architectural views, usually of New York and Philadelphia. These, as Albert W. Barker commented in 1905, portray "the essence of the visible turmoil and glory of industrialization" (p. 330). The son of a surgeon, Cooper was born in Philadelphia, where he lived until the turn of the century. He attended antique and life classes at the Pennsylvania Academy of the Fine Arts and began to exhibit there in 1881. The first of his many European trips was made in 1885 when he traveled to Belgium, Holland, and France, apparently gathering material for his paintings. Between 1895 and 1898 he taught at the Drexel Institute in Philadelphia, offering instruction in watercolor, a medium he used frequently throughout his career. Most of Cooper's early works were destroyed in a fire at the Haseltine Gallery in Philadelphia in 1896, and thus little is known about his stylistic development during this period. Primarily a landscapist, he appears to have followed the popular Barbizon mode.

In 1897, Cooper married Emma Lampert (1855–1920), a painter who had been trained in France and Holland. Perhaps at his wife's encouragement, he went to Paris where he attended classes at the Julian and Delécluse academies. He spent a winter sketching in Madrid and Seville and traveled again through the Low Countries and France, where for several months he sketched châteaus along the Cher and Loire rivers. After another brief period in Philadelphia, he returned to Europe in 1902 and made a tour of England.

On his return Cooper settled in New York, and, working in an impressionist style, he turned to the subject that soon became his specialty, the skyscraper. His urban views seem to have been inspired not so much by direct contact with French art as by the derivative work of Americans like CHILDE HASSAM, who painted impressionist views of New York as early as 1890. Cooper began to achieve increasing recognition; he was awarded the Evans Prize at the American Water Color Society in 1903 and the Sesnan Prize at the Pennsylvania Academy in 1904. That same year he served as a member of the jury of awards at the St. Louis Exposition. The artist was elected an associate of the National Academy in 1909, and an academician three years later. To find new subjects for his paintings, he continued to travel and in 1906 made another trip to Europe. Some of his most memorable paintings, including *Taj Mahal* (unlocated) date from a trip to India in 1912–1913.

The artist visited California in 1916, and five years later retired to Santa Barbara, where he was dean of painting at the Santa Barbara Community School of Arts. A leader of the local artistic community, he was a founder of the Santa Barbara Art Club in 1924. Among his California works is *The Lotus Pool, El Encanto, Santa Barbara*, ca. 1921 (Reading Public Museum and Art Gallery, Pa.). He also wrote plays, which were produced locally, and became a member of the Strollers Club. In 1927, seven years after the death of his first wife, Cooper married Marie H. Freshee. He exhibited at the California Art Club from 1932 until 1935 and at the Academy of Western Painters from 1935 until 1937. After a brief illness, he died in Santa Barbara at the age of eighty-one.

BIBLIOGRAPHY: Albert W. Barker, "A Painter of Modern Industralism: The Notable Work of Colin Campbell Cooper," *Booklover's Magazine* 5 (March 1905), pp. 326–338, includes several color illustrations // Willis E. Howe, "The Work of Colin C. Cooper, Artist," *Brush and Pencil* 18 (August 1906), pp. 72–78 // Colin Campbell Cooper, "Skyscrapers and How to Build Them in Paint," *Palette and Bench* 1 (Jan. 1909), pp. 90–92; (Feb. 1909), pp. 106–108 // "The Poetry of Cities: Eight Paintings by Colin Campbell Cooper, N.A.," *Century*, n.s. 78 (Oct. 1920), pp. 793–800 // Nancy Dustin Wall Moure, with research assistance by Lyn Wall Smith, *Dictionary of Art and Artists in Southern California before 1930* (Los Angeles, 1975), pp. 52–53, includes information and bibliography on the artist's career in California.

Grand Central Station

Dated 1909, the painting shows a view of the train yard behind New York's Grand Central Station, with the gables and pediments of the train shed visible amidst smoke and steam. Constructed by the Architectural Iron Works between 1869 and 1871, the train shed was actually torn down in 1908 as part of a decade-long program to modernize and enlarge the terminal. Since the building was demolished a year before the painting was executed, it seems likely that Cooper based the work on his earlier, and nearly identical, composition *Old Grand Central Station*, 1906 (Montclair Art Museum, N.J.). Although it differs in several respects—the buildings are less obscured by haze and the smoke billowing from the stacks is more contained—the

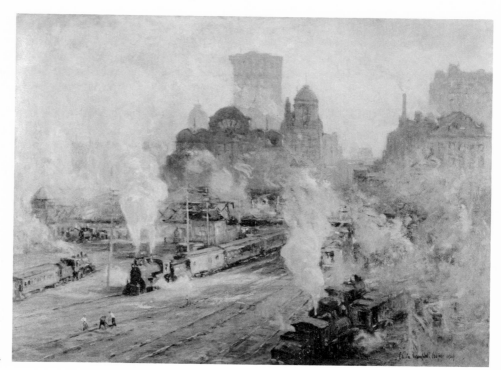

Cooper,
Grand Central Station.

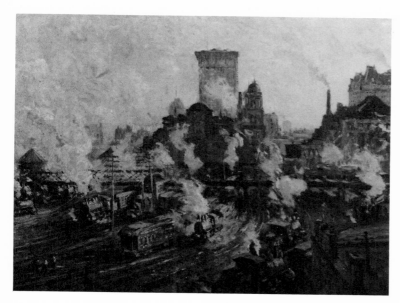

Cooper,
Old Grand Central Station.
Montclair Art Museum, N.J.

Montclair picture may actually be a study for *Grand Central Station*.

In an article entitled "Skyscrapers and How to Build Them in Paint," published the same year the Metropolitan picture was done, Cooper discussed his method of depicting urban scenes. He advocated the use of studies only when a work showed "effects which do not recur—such as sunsets, fogs, great sky displays" and maintained that in most cases "the sparkle of the thing . . . must be noted on the instant" (*Palette and Bench* 1 [Feb. 1909], p. 108). Ambitions in scale and in choice of subject, *Grand Central Station*, was probably not painted on the spot, and this may account for some loss of immediacy and freshness between it and the 1906 painting.

Colin Campbell Cooper

Oil on canvas, 33 × 44¾ in. (83.8 × 113.7 cm.).

Signed and dated at lower right: Colin Campbell Cooper 1909.

RELATED WORK: *Old Grand Central Station*, 1906, oil on canvas, 24 × 32 in. (61 × 81.3 cm.), Montclair Art Museum, N.J.

REFERENCES: *Nation* 88 (March 18, 1909), p. 286, calls the picture "the usual romance of blurring smoke and steam," in a review of the NAD exhibition.

EXHIBITED: NAD, 1909, no. 33, as Grand Central Station, New York // Alaska-Yukon-Pacific Exposition, Seattle, 1909, no. 242, as Grand Central Station // PAFA, 1910, no. 150.

EX COLL.: the artist, 1909–1937; his estate, 1937–1941; with Helene Seeley, as agent, 1941.

Gift of the family of Colin Campbell Cooper in memory of the artist and his wife, 1941.

41.22.

WALTER GAY

1856–1937

This prominent and successful American expatriate artist was born in Hingham, Massachusetts. When he was nine, his family moved to Dorchester, now a part of Boston, where he attended a local school. His uncle, Winckworth Allan Gay (1821–1910), a Boston landscape painter who had studied in France, first interested him in art. After spending a year on a relative's cattle ranch in Nebraska, young Gay returned to Boston in 1873 to take up painting. He shared a studio there with the landscape painter John Bernard Johnston (1847–1886) and drew from the living model, receiving occasional criticisms from WILLIAM MORRIS HUNT and attending a night class at the Lowell Institute. He supported himself during this period by painting still lifes such as *Wild Flowers*, 1876 (Yale University Art Gallery, New Haven).

Financial assistance from a group of friends enabled him to study in Europe beginning in the spring of 1876. After a brief stop in London, Gay went to Paris, where he was joined by Johnston. Traveling to Auvers-sur-Oise, they met the French painter Charles Daubigny, and in Barbizon, they visited the American expatriate William P. Babcock (1826–1899). Through these two older painters they became well acquainted with the Barbizon style. The following year Gay entered the studio of Léon Bonnat, where he worked for the next three years. It was due to Bonnat's encouragement that he made a trip to Madrid with his fellow student ALFRED Q. COLLINS to study the work of Velázquez.

Gay's early work reflects his French academic training. Concentrating on figure painting, he produced small genre pieces depicting eighteenth-century subjects, their themes and precise, but rich, treatment reminiscent of Jean Louis Ernest Meissonier and Mariano J. M. B. Fortuny. Around 1884, the artist painted larger works and chose for his subject matter contemporary people engaged in such activities as spinning, weaving, and cigarette-making. He also painted scenes of peasant life in Brittany.

Gay occasionally exhibited in New York, where he was elected to the Society of American Artists in 1880. He kept a residence in Boston, maintaining his ties there by serving as a correspondent and advisor to the Museum of Fine Arts. The style and subject matter of his art, however, remained thoroughly European, and his energies were increasingly occupied abroad. Exhibiting at the Paris Salon for the first time in 1879, Gay contributed regularly to the annual

exhibitions from then on. His success brought him commissions from English, French, Belgian, and German art dealers, and by the early 1890s, his work was also being shown in Vienna, Antwerp, Munich, and Berlin. He became a member of the Société des Peintres et des Sculpteurs, the Société de la Peinture à l'Eau, and the Brussels Royal Society of Water Colorists, as well as a committee member of the Luxembourg, then the French museum of contemporary art.

Beginning in 1895, Gay rented a country house not far from Paris, and there he turned to depicting the subject that would be his specialty for the remainder of his career—interiors like those painted by the Frenchman Gaston La Touche or the German Adolf von Menzel. In a sense he returned to the historic character of his early paintings but no longer included figures. Instead he featured eighteenth-century woodwork, furnishings, and decorative objects, a reflection not only of his taste as a collector but also of contemporary interest in the rococo style. Usually depictions of rooms in public buildings or distinguished private residences, these paintings are both an accurate record of the rooms they portray and a statement about the people who inhabited them. As his friend the painter Albert Gallatin (1882–1952) wrote in 1920, "Mr. Gay always suggests in a subtle manner the personality of the former, as well as the present, inhabitants of the charming old apartments which he has so delightfully delineated. These rooms are full of human interest. It is not necessary for our enjoyment to get even a glimpse of the occupants of these rooms, because we can feel their presence. Far are these apartments from being deserted" (p. 4).

In 1907, Gay purchased the Château du Bréau, a charming eighteenth-century residence in Dammarie-les-Lys, near Fontainebleau, where he lived and worked until his death at the age of eighty-one. Part of his collection of decorative arts was given to the Louvre.

BIBLIOGRAPHY: Theodore Child, "Gallery and Studio: Walter Gay," *Art Amateur* 14 (Feb. 1886), pp. 57–58 // Albert Eugene Gallatin, ed., *Walter Gay: Paintings of French Interiors* (New York, 1920) // Louis Gillet, "Peintres d'Amerique: Walter Gay," *Revue de L'Art Ancien et Moderne* 39 (Jan. 1921), pp. 32–44; pp. 79–80, provides summary in English // Walter Gay, *Memoirs of Walter Gay* (New York, 1930) // Dayton Art Institute, Ohio, *American Expatriate Painters of the Late Nineteenth Century* (1976), exhib. cat. by Michael Quick, pp. 100–101, 150–151, contains a biography and extensive bibliography.

William Henry Huntington

The Metropolitan Museum owns two portraits of William Henry Huntington (1820–1885), one by CAROLINE CRANCH (q.v.) and this one by Walter Gay. Gay's painting was presented to the museum by George A. Lucas, a longtime friend of Huntington's and an executor of his estate. Both men were collectors and lived in Paris, where they met in the 1850s. Lucas often made purchases for Huntington's collection of George Washington and Benjamin Franklin memorabilia (now in MMA), and his assistance proved invaluable after Huntington became housebound in his later years.

According to Lucas's diary, Walter Gay painted two portraits of Huntington, both posthumous. The first, now unlocated, was commissioned by Lucas on November 8, 1886, probably at the request of Huntington's niece, the wife of Henry Richardson Bond, a Connecticut banker. This work was delivered to Lucas on January 28, 1887, and sent to the Bonds in October, when Lucas finished making payments on it. On November 2, 1887, the artist offered him an "oil portrait small of WHH" and this is undoubtedly the bust portrait now in the Metropolitan. Intimate in scale and mounted in a standing frame, the painting must have appealed to Lucas as a memento of his friend.

Although the artist had met the subject and had also seen a death portrait of him by Georges Jeannin (now unlocated), he may have relied on a photograph for the likeness. This was certainly the case with the first portrait he did; for Lucas noted in his diary on November 21, 1886, that Gay requested payment "for Huntington's portrait from photo."

Gay, *William Henry Huntington.*

Oil on wood, 8⅝ × 6¼ in. (21.9 × 15.9 cm.).
Signed at lower left: Walter Gay. Stamp: A L'ARC EN CIEL / P. GAY / TOILES [illeg.] / 88 Avenue de Villiers. Label formerly on reverse: *Portrait of / W. H. Huntington / painted by* / WALTER GAY *to be given after my death / to the / N.Y. Metropolitan Museum / for the W. H. Huntington Collection / G. A. Lucas / Paris 1904.*
REFERENCES: G. A. Lucas, diary, Nov. 2, 1887, Walters Art Gallery, Baltimore, says Gay visited him and offered a small oil portrait of the subject (quoted above) // J. F. Hopkins, Maryland Institute, Baltimore, letter in MMA Archives, Jan 14, 1911, gives provenance // A. T. Gardner, *MMA Bull.* 15 (Summer 1956), ill. p. 17; pp. 17–18, discusses it // L. M. C. Randall, Walters Art Gallery, Baltimore, letters in Dept. Archives, May 23, June 4, 27, July 9, and Sept. 8, 1975, gives information about the subject and donor

of the portrait and provides excerpts from the Lucas diary.
ON DEPOSIT: Maryland Institute, College of Art, Baltimore, 1911.
EX COLL.: George A. Lucas, Paris 1887– died 1909; estate of George A. Lucas, 1909–1911.
Bequest of George A. Lucas, 1911, William H. Huntington Collection.
11.69.

The Green Salon

The painting depicts a green and gold paneled room in the artist's eighteenth-century home, the Château du Bréau, which was located outside the village of Dammarie-les-Lys near Fontainebleau. Built about 1705, the house was purchased in 1884 by the Comte and Comtesse de Gramont, who, as Gay reported, collected eighteenth-century furniture and paneling, which, added to their family portraits, "give the impression of a family seat" (W. Gay, *Memoirs of Walter Gay* [1930], p. 61). Gay rented the Château du Bréau from the countess in 1905, and, when he bought it two years later, he acquired many of its contents, a valuable addition to his own collection of drawings and decorative objects. He explained in his reminiscences: "We were fortunate enough to buy practically all this, Madame de Gramont taking away only a few pieces. She left the portraits, and even the bust of Henri IV in the antechamber" (p. 61). The house held a fascination for Gay, and he often painted views of the interior and furnishings.

In *The Green Salon* he has used a richly laden brush to suggest the varying surfaces and textures of the objects: chased and gilded bronze candelabras, a *bombé* commode in the style of Louis XV, a rococo sculpture in terra cotta, and two porcelain statuettes, probably Meissen. The picture, painted by 1912, was originally titled *Boiseries Vertes.* "About the title," Gay wrote to the Metropolitan on October 5 of the same year, "I think your translation is a happy one: 'The Green Salon.'"

Oil on canvas, 25½ × 21½ in. (64.8 × 54.6 cm.).
Signed at lower left: Walter Gay.
REFERENCES: W. Gay to E. Robinson, copy in MMA Archives, Oct. 5, 1912, approves translation of the title (quoted above) // A. E. Gallatin, *Art and Progress* 4 (July 1913), p. 1024; *Walter Gay Paintings of French Interiors* (1920), pl. I, as The Green Room, describes objects depicted in the painting // *Apollo* 26 (Sept. 1937), ill. p. 168 // *American Paintings in the Museum of Fine Arts, Boston* (1969), I, p. 120, compares

it to Gay's French Interior in the Boston collection
EXHIBITED: E. Gimpel and Wildenstein, New York
1913, *An Exhibition of Paintings and Water Colors by
Walter Gay*, no. 2, as The Green Salon.
Rogers Fund, 1912.
12.193.

Le Grand Salon, Musée Jacquemart-André

The painting shows a room in the Musée
Jacquemart-André in Paris. The museum is
housed in a residence which the architect Henri
Parent designed for Edouard André before 1870.
André and his wife, the portrait painter Nélie
Jacquemart, collected eighteenth-century French
decorative arts as well as paintings by Flemish,
Dutch, and Italian old masters. In 1912 Nélie
Jacquemart willed this collection to the Institut
de France with the provision that the interior
arrangement and furnishings remain unchanged.
Painted by 1913, the picture shows some of

Gay, *The Green Salon.*

Gay, *Le Grand Salon, Musée Jacquemart-André.*

the eighteenth-century furnishings collected by André and his wife. Gay, also a collector of the fine and decorative arts of this period, obviously shared their taste for these objects. In the foreground he shows two stools, a *tabouret* in the Louis XV style, on the left, and a *pliant* or folding stool, in the Louis XIV style, on the right. There is also a large writing desk, decorated in black lacquer and gilt, which was presented by Louix XV to the city of Langres. Several oriental objects are arranged on the top of the desk, among them two Chinese cloisonné boxes dating from the K'ang-hsi period. The walls of the room are decorated with Gobelins tapestries of the four seasons completed during the reign of Louis XV. In the painting we see the panels for winter on the left and autumn on the right. The two overdoor panels showing *fêtes galantes* are painted in the manner of Louis Joseph Watteau, the nephew of Antoine Watteau. Jean Marc Nattier's portrait *La Marquise d'Antin*, dated 1738, is seen in the corner of the room. Flanking the door leading to a vestibule are two large Chinese porcelain vases of the Yung-cheng period, and, in a view of the room beyond, called the Jardin d'Hiver, a Greco-Roman statue of Victory and a Greek head of Ephebus are visible.

The artist painted another identical view of this salon (now unlocated) as well as a view of its opposite end (Corcoran Gallery of Art, Washington, D.C.).

Oil on canvas, $27\frac{3}{8} \times 33\frac{7}{8}$ in. (69.5 × 86 cm.).
Signed at lower right: Walter Gay.
RELATED WORK: *Musée Jacquemart-André*, Paris, now unlocated, ill. in A. E. Gallatin, *Walter Gay* (1920), pl. 49.
REFERENCES: M. Knoedler and Co., New York, bill of sale to C. L. Hay, March 31, 1917, in Dept. Archives // *Art Digest* 12 (May 1, 1938), ill. p. 13 // J. Jeanson, Musée Jacquemart-André, letter in Dept. Archives, Oct. 12, 1965, discusses the objects seen in the painting // D. W. Phillips, *A Catalogue of the Collection of American Paintings in the Corcoran Gallery of Art* (1973), p. 29, compares it to the Corcoran painting // Mrs. C. L. Hay, orally, April 30, 1975, verified the provenance // R. Finnegan, M. Knoedler and Co., New York, letter in Dept. Archives, June 19, 1975, states that the painting was acquired directly from the artist in 1913 and sold in 1917 // N. Blondel, Musée Jacquemart-André, letter in Dept. Archives, Nov. 28, 1975, identifies objects in the painting.
EXHIBITED: MMA, 1938, *Memorial Exhibition of Paintings by Walter Gay (1856–1937)*, no. 13, as The Grand Salon, Musée Jacquemart-André, lent by Clarence L. Hay.

EX COLL.: with M. Knoedler and Co., New York, 1913–1917; Mr. and Mrs. Clarence L. Hay, New York, 1917–1961.

Gift of Mr. and Mrs. Clarence L. Hay, 1961.
61.91.

The Green Lacquer Room, Museo Correr, Venice

Although Walter Gay was most interested in French eighteenth-century rooms, he also painted a number of Venetian interiors, including those of the Palazzo Barbaro, the Palazzo Querini-Stampalia, and this one of the Museo Correr. The Teodoro Correr collection was bequeathed to the city of Venice in 1830 and, together with later gifts and purchases, has been housed in several different repositories. This painting shows a wall of the Green Lacquer Room as it was installed in the Museo Correr on the Grand Canal from around 1912 until 1922.

The room received its name from the green lacquered furniture that is one of its principal features. In the center of the composition, the artist shows a large Venetian mirror with a pierced frame and, below it, a mid eighteenth century Venetian chinoiserie commode flanked by two armchairs upholstered in painted silk. On top of the commode, he depicts a small lacquered box and two Chinese polychrome figures. The three paintings shown hanging on the wall are by Venetian artists. To the left of the mirror Gay depicts a Madonna, done during the 1730s by Rosalba Carriera, and beneath this pastel, *Veduta del Canal Grande a San Vio*, an oil painting of the 1740s or 1750s by a follower of Canaletto. Represented on the opposite side of the mirror is another oil painting, *Colloquio tra baute*, done around 1760 by Pietro Longhi. These objects are painted in Gay's usual fluid style with little delineation of detail and touches of impasto indicating the highlights. His goal does not seem to have been to render an exact record of the room and its contents but rather to capture the overall impression created by the rich colors and decorative patterns.

The artist sometimes repeated his subjects with slight compositional variations, and the donor of this picture owned a second version of the subject (now unlocated) in which Gay showed the objects on top of the commode in a different arrangement and added an armchair in the right foreground.

Gay, *The Green Lacquer Room, Museo Correr, Venice.*

Oil on canvas, 21½ × 18¼ in. (54.6 × 46.4 cm.).
Signed at lower left: Walter Gay.
REFERENCES: L. Gillet, *L'Illustration* 81 (May 12, 1923), color ill. p. 487 // *MMA Bull.* 19 (March 1924), p. 64 // L. C. Bellodi, Civici Musei Veneziani d'Arte e di Storia, letters in Dept. Archives, August 25, 1965,

identifies room, furniture, art objects, and paintings depicted in this painting; Sept. 13, 1975, gives titles of paintings on the wall.

EX COLL.: Anne D. Thomson, Paris, until 1923.

Bequest of Anne D. Thomson, 1923.

23.280.8.

ANNA ELIZABETH KLUMPKE

1856–1942

The portrait and figure painter Anna Elizabeth Klumpke spent most of her career in France, eventually becoming the protégé and biographer of the well-known animal painter and sculptor Rosa Bonheur. Three of Miss Klumpke's sisters also distinguished themselves, Augusta (later Mme. Jules Dejerine) as a physician, Dorothea (later Mrs. Isaac Roberts) as an astronomer, and Julia (who spelled the family name Klumpkey) as a musician. Anna, who was born in San Francisco, was lame as the result of a childhood accident. Her parents separated when she was young, and her mother raised the family abroad, in England, Germany, and Switzerland. Around 1877, mother and children settled in Paris, where Anna began her art studies by making copies in the Louvre. "In copying," she later wrote, "the beginner learns to appreciate the method of each artist,—his manner of approach, the mixing and gradations of color, and gains a sense of relative values. Then, too, the lingering in the great galleries in the atmosphere of noble work is in itself of value" (Klumpke [1940], p. 15). When the Académie Julian opened its doors to women in 1880, however, the young artist went beyond copying paintings and enrolled there, working under Tony Robert-Fleury and Jules Joseph Lefebvre. She also took lessons in modeling from a M. Prémier. In 1882, when one of her paintings was exhibited at the Paris Salon, she set up her own studio and began to work independently, although she continued to attend some classes at the Julian. She received an honorable mention at the Salon in 1885 and three years later captured first prize in the Julian competition. During this period, the artist traveled in France and Italy and painted a number of portraits, among them *Elizabeth Cady Stanton*, 1886 (National Portrait Gallery, Washington, D.C.). Her well-known genre scene *In the Wash House*, painted in 1888 (PAFA), was awarded the Pennsylvania Academy's Temple Gold Medal for the best figure painting in the annual exhibition that year.

Anna Klumpke returned to the United States in 1889 and settled in Boston, where she worked for the next nine years. She taught a class in painting, and important exhibitions of her work were held at the St. Botolph Club in 1892 and at the Williams and Everett gallery in 1896. She visited Paris in 1895 and returned there three years later to paint the portrait of Rosa Bonheur (q.v.), an artist whom she knew slightly but had long admired. Miss Klumpke soon became the older artist's companion at the Château de By near Fontainebleau, and when Rosa Bonheur died the following year, she inherited her home and the contents of her studio. Of this the artist wrote: "I look upon it as my life work to perpetuate her desires and to make

her works even more widely known" (quoted in Van Vorst, pp. 228–229). Indeed in this respect she accomplished a great deal. The Rosa Bonheur Memorial Art School was opened at the Château de By, which was maintained as it had been in the artist's lifetime, and there Anna Klumpke and eminent visiting artists offered instruction to women of all nationalities. The Rosa Bonheur prize for the best animal painting exhibited at the Salon was established in 1901 by the Société des Artistes Français, and Rosa Bonheur's paintings were widely exhibited in Europe and the United States. In 1908, *Rosa Bonheur, sa vie, son œuvre*, a record of the French artist's reminiscences and an account of her written by Anna Klumpke was published.

In 1912 Anna Klumpke made an extended visit to the United States, returning to France shortly before the outbreak of World War I. For five years the Château de By was used as a convalescent home for soldiers, and for this service the French government awarded Miss Klumpke a medal. Living at the Château de By she continued to paint and exhibit her work. Besides portraits, the artist was noted for her landscapes with figures, which were influenced by the Barbizon School. She was made a chevalier of the French Legion of Honor in 1924 and twelve years later an officer. In 1932, prompted by her astronomer sister, Anna Klumpke came to the United States to view an important eclipse of the sun. In that year there was also a retrospective exhibition of her paintings held at Doll and Richards Gallery in Boston, and some of her paintings were included in a Rosa Bonheur exhibition at the Palace of the Legion of Honor in San Francisco. It was at this time that Miss Klumpke returned to her native San Francisco, where she remained until her death a decade later. The artist's final years were devoted to writing her reminiscences, which were published in 1940 as *Memoirs of an Artist*.

BIBLIOGRAPHY: Bessie Van Vorst, "The Klumpke Sisters," *Critic* 37 (Sept. 1900), pp. 224–229 // Anna E. Klumpke, *Rosa Bonheur, sa vie, son œuvre* (Paris, 1908), discusses the artist's friendship with the well-known French painter // Thieme-Becker, 20 (Leipzig, 1927; 1964), p. 556, provides biography, bibliography, and exhibitions // Anna Elizabeth Klumpke, *Memoirs of an Artist*, ed. Lilian Whiting (Boston, 1940), the most complete record of the artist's career // *The National Cyclopaedia of American Biography* (New York, 1944), 31, pp. 403–406, provides biographical information on the artist and other members of her family.

Rosa Bonheur

While she worked on this portrait, Anna Klumpke kept a diary, excerpts of which are published in her *Rosa Bonheur, sa vie, son œuvre* (1908). From this account it appears that the French artist Rosa Bonheur (1822–1899), renowned for her paintings of animals, agreed in March 1898 to sit for Miss Klumpke, provided that she select a pleasing pose, depict her in feminine attire, and represent her at her actual age. Anna Klumpke arrived at the subject's home, Château de By, on June 11 and sittings began five days later. The two artists met at meals, and in the afternoons went outdoors, where the aspiring portraitist made studies. Her subject not only posed for her but also acted as her instructor, giving advice on the choice of colors and at one point lending her

a camera with which to take preparatory photographs. After the completion of a number of oil sketches and a conference with her former teachers Tony Robert-Fleury and Jules Joseph Lefebvre, Anna Klumpke began work on the actual canvas on July 19. The portrait was completed in time for the Carnegie International exhibition in Pittsburgh in November of 1898.

Rosa Bonheur is shown seated. On an easel to her right stands a study for *La Foulaison* (unlocated), and on the table by her side rest her palette and brushes. The dignified pose meets the requirements of academic portraiture and emphasizes the intellectual rather than the technical aspects of the artist's profession. The focus is on the subject's face, expressive in the "sparkling" eyes and framed by cropped white hair. "It seemed as though a halo surrounded her head as

Anna Elizabeth Klumpke

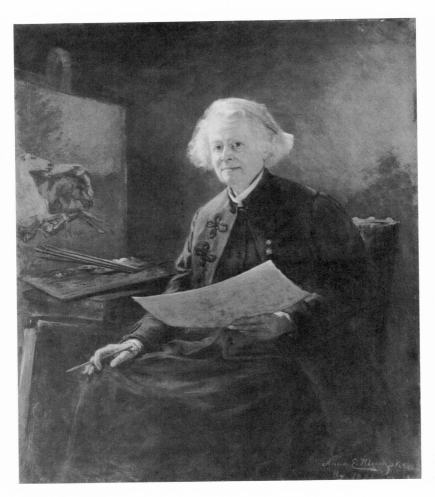

Klumpke,
Rosa Bonheur.

an aureole," Miss Klumpke reminisced after their first meeting in 1889 (*Memoirs of an Artist* [1940], p. 31).

The portrait remained in Anna Klumpke's possession until 1922, when she gave it to the Metropolitan Museum "in honor of Rosa Bonheur's Centenary & in memory of the great friendship in which she held me & all America in general." That same year, Miss Klumpke gave another portrait she had painted, *Rosa Bonheur avec son chien Charley*, 1899 (Musée du Château de Fontainebleau), to the Luxembourg, then the French museum of contemporary art.

Oil on canvas, 46⅛ × 38⅝ in. (117.2 × 98.1 cm.).

Signed, inscribed, and dated at lower right and again on the back: Anna E. Klumpke / By 1898. Canvas stamp: 54 Rue N. D. Des CHAMPS PARIS / PAUL FOINET / TOILES COULEURS FINES.

RELATED WORKS: *Portrait of Rosa Bonheur*, 1898, pastel on paper, 21⅞ × 17⅞ in. (55.6 × 45.4 cm.), a bust-length study, Bowdoin College Museum of Art, Brunswick, Me. // Additional studies not presently located are mentioned and illustrated in A. E. Klumpke, *Rosa Bonheur* (1908).

REFERENCES: *Art Collector* 9 (July 1, 1899), p. 248, says the painting is attracting attention in Berlin exhibition // *Harper's Bazaar* 32 (Dec. 2, 1899), p. 1022 // Galerie Georges Petit, Paris, *Catalogue des Tableaux par Rosa Bonheur*, sale cat. (May 31–June 2, 1900), ill. frontis. // B. Van Vorst, *Critic* 37 (Sept. 1900), ill. p. 227, shows a photograph of the artist at work on the portrait // A. E. Klumpke, *Rosa Bonheur* (1908), pp. 45–47, quotes from correspondence between the artist and the sitter regarding arrangements for the portrait; pp. 49–100, discusses sittings between June 16 and July 29, 1898; says final work begun on July 19 (based on the artist's diary); pp. 101–113, discusses completion of the work; ill. p. 113; ill. p. 303, shows the portrait in

a photograph of Bonheur's studio; p. 435, lists it // *Art News* 12 (Nov. 29, 1913), p. 5 // A. Klumpke, letter in MMA Archives, Dec. 30, 1913, offers it for sale to MMA // M. Knoedler and Co., New York, letter in MMA Archives, June 13, 1922, says artist wants to donate it to the museum // A. E. Klumpke, letter in MMA Archives, June 18, 1922, discusses giving it to the museum in honor of the sitter's centenary (quoted above) // D. K. Roberts (sister of the artist), letter in MMA Archives, July 7, 1922, discusses it // A. E. Klumpke, *Memoirs of an Artist*, ed. by L. Whiting (1940), pp. 37–38, quotes correspondence between the artist and the sitter arranging for sittings; pp. 40–44, discusses the painting of the portrait; ill. opp. p. 40 //

A. T. Gardner, *MMA Bull.* 7 (Dec. 1948), ill. p. 114 // T. A. Riggs, Worcester Art Museum, letter in Dept. Archives, Oct. 30, 1975, notes that the portrait was lent to that institution in 1913.

EXHIBITED: Carnegie Institute, Pittsburgh, 1898–1899, no. 30, as Portrait of Mlle. Rosa Bonheur // Berlin, Royal Academy, 1899, no. 498 // Worcester Art Museum, Mass., 1913, *Paintings by Rosa Bonheur and Anna Klumpke* (no cat. available).

EX COLL.: the artist until 1922; with her sister, Dorothea (Mrs. Isaac) Roberts, as agent, 1922.

Gift of the artist in memory of Rosa Bonheur, 1922. 22.222.

ROBERT BLUM

1857–1903

The son of a well-to-do German-American family, Robert F. Blum was born and raised in Cincinnati. After leaving high school in 1874 he became an apprentice in the lithographic firm of Gibson and Sons. In the evenings he studied drawing at the Ohio Mechanics Institute and a little later at the McMicken School of Design (now the Art Academy of Cincinnati), where his fellow students included Alfred Brennan (1853–1921) and KENYON COX. In 1876 Blum went to Philadelphia and studied at the Pennsylvania Academy of the Fine Arts for almost a year. The Centennial Exhibition was the great attraction in Philadelphia that year, and there the young artist was especially impressed by the paintings of Mariano J. M. B. Fortuny, whose virtuoso brushwork and elaborate compositions exerted a great influence on his style well into the 1880s. Throughout his career, Blum remained an eclectic artist who learned as much by observation as from formal education. "Good pictures are the best lessons you can get" he once advised a friend, "I can't help thinking that there is a great deal of nonsense in schools,— you are bound to come finally to the point of fighting out things for yourself and by yourself. . . . by looking and searching out the lessons that any good picture contains" (quoted in M. Birnbaum, pp. 3–4).

Blum returned to Cincinnati in 1877, but on a visit east the following year he was hired as an illustrator for *Scribner's*. Two years later he traveled in Europe with Alexander W. Drake, the magazine's art editor, visiting London, Paris, Genoa, Rome, and finally Venice. It was in Venice that Blum met FRANK DUVENECK, a fellow Cincinnatian, and JAMES MC NEILL WHISTLER. Under their influence, he took up etching and experimented with pastel. Not long after, Blum became president of the Society of Painters in Pastel in New York. He returned to Venice in 1881 and then went to Spain, where he made copies after Velázquez. On his next trip to Europe he visited Holland with WILLIAM MERRITT CHASE and William Baer (1860–1941) and spent a good deal of time working in Zandvoort, where he did landscapes in pastel.

In New York, where he returned in 1885, Blum continued to exhibit his work at the Society of American Artists, to which he had been elected in 1882, and the National Academy of Design, where he was made an associate in 1888. Typical of his work at this time is *Venetian Lace Makers*, 1887 (Cincinnati Art Museum), an ambitious composition that shows that he was moving away from the illustrative realism of his student years toward a mature style characterized by a freer, more facile technique. Using bright colors to depict informal, often outdoor, subjects, he emphasized immediate impressions created by light and atmosphere. His interest in light effects, exotic costumes, and decorative objects show the influence of his friend Chase, while his artisan and craftsman subjects recall contemporary works by CHARLES ULRICH whom he visited in Venice.

In May 1890 Blum embarked on a trip to Japan to prepare illustrations for a series of articles planned by *Scribner's*. Remaining in that country for about two years, he did an important group of works, among them *The Ameya* (q.v.). On his return, he purchased a home on Grove Street in New York, where he lived until his death. He was elected an academician at the National Academy in 1893, the same year that he began a commission to paint mural decorations at Mendelssohn Hall in New York. Entitled *The Vintage Festival* and *Mood to Music*, 1893–ca. 1898 (Brooklyn Museum), these works show graceful dancing figures. Blum's elegant treatment and the light-hearted gaiety of the scenes show the impact of rococo art, then enjoying a revival. The artist was at work on murals for the New Amsterdam Theater in New York when he died in 1903.

BIBLIOGRAPHY: Robert Blum, "An Artist in Japan (with illustrations by the author)," *Scribner's Magazine* 13 (April–June 1893), pp. 399–414, 624–636, 729–749 ‖ Charles H. Caffin, "Robert Frederick Blum," *International Studio* 21 (Dec. 1903), pp. clxxvii–cxcii ‖ Berlin Photographic Gallery, New York, *Catalogue of a Memorial Loan Exhibition of the Works of Robert Frederick Blum* (1913), intro. by Martin Birnbaum, reprinted in Birnbaum's *Introductions: Painters, Sculptors and Graphic Artists* (New York, 1919), pp. 91–100 ‖ Cincinnati Art Museum, *A Retrospective Exhibition, Robert F. Blum, 1857–1903* (April 1–May 7, 1966), essay by Richard J. Boyle, provides bibliography, chronology, and many illustrations ‖ American Federation of the Arts, traveling exhibition, *Revealed Masters: 19th Century American Art* (Sept. 1974–Sept. 1975), exhib. cat. by William H. Gerdts, pp. 54–55, 134–135, provides biography and bibliography.

The Ameya

In 1890 Robert Blum went to Japan to illustrate a series of articles on that country for *Scribner's Magazine*. Four of these accounts written by Sir Edwin Arnold appeared in the magazine in 1890 and 1891 (reprinted as *Japonica* in 1891) and another written by John Henry Wigmore was published in July 1891. From his correspondence with Scribner's (Publisher's Archives, Charles Scribner's Sons, Firestone Library, Princeton University), we know that the artist did not finish work on the Arnold and Wigmore articles until the end of March 1891 and that from then until the autumn of 1892 he was free to

pursue his own drawing and painting. Blum wrote and illustrated a three-part article for Scribner's entitled "An Artist in Japan" that ran in the April, May, and June 1893 issues. *The Ameya*, which depicts a Japanese candy-blower, was reproduced in the final installment of Blum's article and was most likely done in 1892 toward the end of his two-year stay in Japan.

The painting combines two themes of interest to Blum—the exotic Orient and the craftsman engaged in his work. Earlier in his career, while working in Italy, he had painted such local artisans as bead stringers, and lacemakers; in Japan he chose comparable subjects—umbrella, clog, and lantern makers, as well as candy-blowers. In

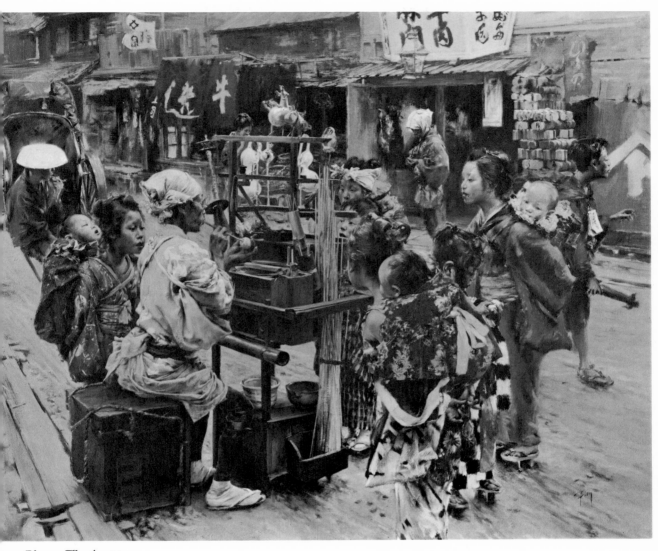

Blum, *The Ameya*.

an artist's note printed with an illustration of another *ameya*, Blum compared the candy-blower to a glassblower:

Very interesting things they do certainly perform, and in a most simple manner, using the candy like a glass-blower his lump of molten glass, and producing results, if hardly as beautiful or durable, certainly as artistic and finished as regards workmanship (*Scribner's Magazine* 9 [Jan. 1891], p. 26).

Two labels on the reverse of the frame, possibly in the artist's hand, note that the picture depicts a scene in Ikao. Blum spent about a week in this village near the end of his stay and wrote:

In the ladder-like streets and the sky-raking quality of its storied houses, the town affords a decidedly novel contrast to other Japanese villages, where, as a whole, picturesqueness restricts itself so much to individual and isolated "bits" (*Scribner's Magazine* 13 [June 1893], p. 759).

The Ameya was well received in the 1893 annual exhibition of the National Academy of Design, and its success probably helped Blum gain his status as an academician there. As the critic for the *New York Times* noted: "It is a kaleidoscope of colors, nicely adjusted, and admirably painted, not alone for color, but for composition and variety of characters." Firmly drawn and tightly painted, *The Ameya* demonstrates Blum's ability to orchestrate a large and complicated group of figures. The composition focuses on the vendor and the figures gathered around his stand. Many of the poses show caught-motion, and since the artist is known to have collected photographs on his trip, it seems possible that these served as the basis for some of the more animated poses in the composition. Rather than a mechanically recorded scene, however, the painting is a carefully contrived assemblage, with each colorful detail and expressive gesture selected to strengthen the effect of the whole.

Oil on canvas, $25\frac{1}{16} \times 31\frac{1}{16}$ in. (63.7 × 78.9 cm.). Signed at lower right: BLUM.
Canvas stamp: 25 / TAB[LEAUX] [COUL]EURS . . . TOILES . . . / P. APRIN / 45 Rue de DOUAI 45 / PARIS.
REFERENCES: *New York Times*, March 24, 1893, p. 4, discusses the painting on exhibition at the NAD (quoted above) // R. Blum, *Scribner's Magazine* 13 (June 1893), ill. p. 735, as The Ameya—a Curious Crowd // W. J. Baer, *Book Buyer* 10 (Oct. 1893), p. 354, calls it Blum's "most ambitious canvas" and says that its inclusion in NAD exhibition facilitated his election to full membership in that organization // *New York Times*, June 9, 1903, p. 9, in artist's obituary, describes it as "his most ambitious canvas" // Cin-

cinnati Art Museum, *Exhibiton of Paintings and Studies by the Late Robert Frederick Blum* (1905), biography by W. J. Baer, p. 4, says that it was painted between 1890 and 1892 and notes its acquisition by MMA // *Century Magazine*, n.s. 60 (Sept. 1911), color ill. opp. p. 635 // Berlin Photographic Gallery, New York, *Robert Frederick Blum* (1913), exhib. cat. by M. Birnbaum, pp. 5, 10; reprinted in M. Birnbaum, *Introductions* (1919), pp. 93, 98 // L. R. McCabe, *Form* (Nov. 8, 1913), p. 29 // J. W. Harrington, *International Studio* 82 (Nov. 1925), ill. p. 92 // Cincinnati Art Museum, *A Retrospective Exhibition, Robert F. Blum* (1966), cat. by R. J. Boyle, p. 4, calls it "the most important picture of his Japanese trip" // American Federation of Arts, traveling exhibition, *Revealed Masters* (1974), exhib. cat. by W. H. Gerdts, p. 55 // B. Weber, letters in Dept. Archives, Sept. 17, 1976, compares it to the work of Fortuny and says that photographs taken by Blum in Japan may relate to it; [Dec. 1976], and [April 1977], discusses provenance.

EXHIBITED: NAD, 1893, no. 274, as The Ameya, lent by Mrs. Alfred Corning Clark // Exposition Universelle, Paris, 1899–1900, *Catalogue Officiel Illustré de l'Exposition Décennale des Beaux-Arts*, under Etats-Unis, no. 34, as L'Ameya // M. Knoedler and Co., New York, 1904, *Exhibition of Paintings and Studies by the Late Robert Frederick Blum*, no. 1.

EX COLL.: Alfred Corning Clark, New York, by 1893–died 1904; estate of Alfred Corning Clark, 1904.

Gift of the Estate of Alfred Corning Clark, 1904.
04.31.

View from the Artist's Window, Grove Street

Although undated, this picture of a fenced-in garden with a row of buildings in the background was probably done around 1900. It is a view from Blum's New York home and studio at 90 (now joined to 88) Grove Street in Greenwich Village, where he lived from 1893 until his death a decade later. The artist's choice of an informal subject, seen from an unconventional vantage point, recalls earlier impressionist city scenes by French artists like Gustave Caillebotte. Blum also may have been influenced in his choice of subject by the urban views painted in the 1890s by American artists like CHILDE HASSAM. Here, as in much of Blum's late work, his style is distinguished by a light, almost pastel, palette and sketchy paint application.

Oil on canvas, $22\frac{5}{16} \times 19\frac{1}{2}$ in. (56.7 × 49.5 cm.).
Stamped at lower left: BLUM (enclosed in a rectangle). Inscribed on the back: *Painted by / Robt. F. Blum / about 1900 / View from studio / 90 Grove st. / W. J. Baer / Administrator.*

REFERENCES: Parke-Bernet, New York, *Paintings, Drawings, Sculptures, Prints by Modern Artists . . . the Entire Collection of Mrs. Cornelius J. Sullivan*, sale cat. (Dec. 6 and 7, 1939), p. 48, no. 94, describes the painting, gives provenance, and dates it ca. 1900 // A. Fernandez, M. Knoedler and Co., New York, orally, Dec. 21, 1976, provided information on the provenance // R. J. Horowitz, letter in Dept. Archives, Jan. 3, 1977, provides information about ownership and exhibition record // B. Weber, letters in Dept. Archives, March 24 and August 30, 1977, discusses the provenance and the subject // N. C. Little, M. Knoedler and Co., New York, letter in Dept. Archives, Sept. 19, 1977, provides information on provenance and exhibitions.

EXHIBITED: M. Knoedler and Co., New York, 1927, *Nineteenth Annual Summer Exhibiton of American Paintings*, no. 2, as View from the Artist's Window, 90 Grove St. // Cincinnati Art Museum, 1966, *A Retrospective Exhibition, Robert F. Blum, 1857–1903*, cat. by R. J. Boyle, no. 19, lent by Mr. and Mrs. Raymond J. Horowitz, dates the picture about 1900; p. 6, says it was painted at his Grove Street studio; ill. p. 20.

EX COLL.: William J. Baer, executor of the artist's estate, East Orange, N.J., and New York, until 1927; with M. Knoedler and Co., New York, 1927–1936; Mrs. Cornelius J. Sullivan, New York, 1936–1939 (sale, Parke-Bernet, New York, Dec. 6, 1939, no. 94, as View from the Artist's Studio Window: Grove Street, $120); with M. Knoedler and Co., New York, 1939–1963; Mr. and Mrs. Raymond J. Horowitz, New York, 1963–1976.

Blum, *View from the Artist's Window, Grove Street.*

Gift of Mr. and Mrs. Raymond J. Horowitz, 1976. 1976.340.2.

RUGER DONOHO

1858–1916

Gaines Ruger Donoho was born on a plantation in Church Hill, Mississippi, from which he fled with his widowed mother during the Civil War. They settled in Washington, where he attended school at the Emerson Institute. After studying at the State Normal School, in Millersville, Pennsylvania, he returned to Washington and worked for a time in the office of the United States Architect. He also began to paint, and studied for a few months under the direction of local artists. An admirer of the Hudson River landscapes of JERVIS MC ENTEE, Donoho spent the summer and autumn of 1878 sketching in oil in the Catskills. Then, beginning in November, he studied in New York at the Art Students League. At this time it is probable that he also worked under the landscape painter R. SWAIN GIFFORD, who was then teaching at Cooper Union.

Donoho left for Europe in 1879 and remained in France for eight years. Like many American artists abroad, however, he exhibited his works at home, notably in the annual exhibitions of

the National Academy of Design and the Society of American Artists, beginning in 1882. In Paris, he studied at the Académie Julian, where his instructors were Jules Joseph Lefebvre and Tony Robert-Fleury. Other American artists there at this time, WILLARD METCALF, FRANK BENSON, EDMUND C. TARBELL, CHILDE HASSAM, and JOHN H. TWACHTMAN, were later among the leading exponents of impressionism. Donoho's student work, as much of it as is known, is varied but mainly derivative in style and subject. In the early 1880s he painted Barbizon landscapes like *La Marcellerie*, ca. 1882 (Brooklyn Museum), which was the product of one of his many sketching trips in the French countryside. His figure paintings, for example *Shepherd*, 1884 (National Collection of Fine Arts, Washington, D.C.), like those of his friend ALEXANDER HARRISON, show the academic influence of the realist painter Jules Bastien-Lepage in their enobled presentation of peasant life. Donoho's sensitive *Self-portrait*, from the mid-1880s (New York art market, 1978), is Whistlerian in its thin paint surface, undefined contours, and limited palette. Both JAMES MC NEILL WHISTLER and Puvis de Chavannes are said to have admired Donoho's early work, which was exhibited at the Paris Salon beginning in 1881.

Returning to New York in 1887, he took a studio and continued to exhibit his work at the National Academy and the Society of American Artists. He won a silver medal at the Universal Exposition in Paris in 1889. Donoho, however, was not inclined to participate in New York art circles. He was not a member of the National Academy nor did he teach or write about art. After he moved to East Hampton in 1891, he remained there much of the time, except for a trip to Europe in 1901–1902. His early East Hampton landscapes reflect the influence of the Barbizon style, but by the late 1890s, his garden scenes, informal subjects painted in full daylight, were done in a more vibrant palette with broken brushstrokes, undoubtedly influenced by his friend Hassam. At the same time, in marked contrast to these impressionist works, he did a group of broadly painted nocturnes that are somber in mood.

After 1900, Donoho painted without much desire for public recognition, and his work was known primarily to his artist friends. Three of his paintings, however, were included in the Armory Show of 1913. He died at the age of fifty-eight, and was honored with a memorial exhibition at Macbeth Gallery in 1916. Paintings with Donoho's signature and the initials M. A. D. were signed after his death by his widow, the former Matilda Ackley, whom he married in 1894.

BIBLIOGRAPHY: Julia Ruger Donoho to Jervis McEntee, Sept. 21, 1878, Charles E. Feinberg Autograph Collection, D30, Arch. Am. Art. The artist's mother discusses his early career and admiration for McEntee // Gaines Ruger Donoho Papers, Arch. Am. Art. A small group of papers including letters, photographs, sketches, certificates, and awards // Macbeth Gallery, New York, *Memorial Exhibition, Paintings by the Late Ruger Donoho*, foreword by Childe Hassam // Hirschl and Adler Galleries, New York, and Parrish Art Museum, Southampton, N.Y., *G. Ruger Donoho (1857–1916): A Retrospective Exhibition* (1977), exhib. cat. by Ronald G. Pisano.

Wind Flowers

In the late 1890s, after he moved to East Hampton, Donoho specialized in garden pictures, many of which show a frieze of foreground blossoms with the surrounding landscape dramatically reduced. Here, in a late scene dated 1912, the artist has created a strong decorative pattern of grass, flowers, and leaves in the foreground, giving a limited view of the distant meadow, tree, and sky beyond. Donoho's composition and impressionist style, with its bright

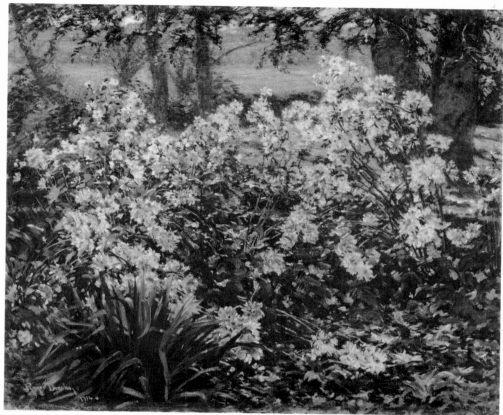

Donoho, *Wind Flowers.*

palette and vigorous broken brushstrokes, show the influence of his friend CHILDE HASSAM, who painted garden views of this type during the 1890s. Hassam's inspiration, and thus indirectly Donoho's, were the paintings done by Claude Monet beginning in the 1870s. Although Donoho strives for similar effects of light and atmosphere, he is more tied to the literal appearance of his subject matter. Admittedly, he also lacks the technical command and compositional originality of the French artist.

Wind Flowers was selected for the Metropolitan Museum by J. ALDEN WEIR and Hassam, who described Donoho's "landscape flower studies" as "very closely observed and well seen" (Macbeth Gallery, New York, *Memorial Exhibition, Paintings by the Late Ruger Donoho* [1916], unpaged).

Oil on canvas, 30 × 36 in. (76.2 × 91.4 cm.).
Signed and dated at lower left: Ruger Donoho / 1912–.

REFERENCES: *American Art News* 15 (Nov. 18, 1916), p. 2, notes the painting's inclusion in the artist's memorial exhibition // J. Alden Weir, letters in MMA Archives, Jan. 4, 1917, says that he will call on Mrs. Donoho to check the paintings; Jan. 31, 1917, says that he and Hassam have had "the flower piece" sent to the museum for consideration // M. A. Donoho, wife of the artist, letters in MMA Archives, Feb. 3, 1917, says that Weir asked specifically about Wind Flowers which had been in Washington, but since it was now returned, could be considered; Feb. 26, 1917, gives title as Wind Flowers // *MMA Bull.* 12 (May 1917), p. 120.

EXHIBITED: PAFA, 1912, no. 2, as Wind Flowers // Carnegie Institute, Pittsburgh, 1913, no. 76 // Panama-Pacific International Exposition, San Francisco, 1915, no. 2263 // Macbeth Gallery, New York, 1916, *Memorial Exhibition, Paintings by the Late Ruger Donoho*, No. 4 // Corcoran Gallery of Art, Washington, D.C., 1916–1917, no. 51, lent by Mrs. Donoho.

EX COLL.: the artist, East Hampton, N.Y., 1912– died 1916; his wife, Matilda Ackley Donoho, East Hampton, 1916–1917.

Rogers Fund, 1917.
17.36.

Ruger Donoho

FRANCIS COATES JONES

1857–1932

The figure painter Francis Coates Jones was born in Baltimore, the son of a well-to-do business-man and the younger brother of the landscape painter H. BOLTON JONES. He attended public school until eyestrain interrupted his education, forcing him to restrict his activities. Jones did not show any particular interest in art until he went abroad in 1876 with his brother. Traveling to London in July, the two first visited EDWIN AUSTIN ABBEY and then crossed the channel. They spent a year at the artist's colony in Pont-Aven, Brittany, with such artists as THOMAS HOVENDEN and Robert Wylie (1839–1877), and it was there that Francis first began to draw. In the autumn of 1877, he left Pont-Aven for Paris and studied drawing for a month under an elderly teacher who has not been identified. Soon after Jones enrolled at the Ecole des Beaux-Arts and worked in the antique class under Henri Lehmann. With the exception of a six-month trip to Baltimore, he remained abroad for about five years, studying under a variety of teachers and traveling extensively. With his brother he went to Spain and Tangier in the spring of 1878, and then joined by other members of their family, they made a sketching tour of Italy, Switzer-land, and France. The following summer was spent at Pont-Aven, and the winter of 1879–1880 saw Jones in London, employed on a military panorama. He continued his studies in Paris, however, at the Académie Julian under the direction of Adolphe William Bouguereau and Jules Joseph Lefebvre and attended a special class at the Ecole des Beaux-Arts, where he passed examinations in perspective, history, and life drawing.

A family illness brought the artist back to Baltimore in the late summer or autumn of 1881. He then went to New York, where he worked in his brother's studio for about a year. He exhibited at the National Academy of Design, where he had first shown his work in 1877, and, in 1882 he was elected a member of the Society of American Artists. After another brief period of study in Paris, he toured the continent and spent the summer at Pont-Aven. By 1884 Jones had settled permanently in New York, where he shared a studio with his brother, first at the Sherwood Studios, then at the Clinton, and finally at 33 West 67th Street. Winner of the National Academy's Thomas B. Clarke prize for figure painting in 1885, he was made an associate member of the academy that same year. In 1886, he held a joint exhibition with his brother in Baltimore.

Jones's activities during the 1890s were more varied. As an illustrator he did views of historic houses in Washington for *Scribner's* (Oct. 1893) and, beginning in 1895, worked as a mural painter. He also taught at the National Academy, where he was elected an academician in 1894. Around the turn of the century, both he and his brother began to spend their summers painting in the Berkshires at South Egremont, Massachusetts. A traditionalist, Jones was very active in the National Academy, serving as treasurer for twenty-two years and after 1916 as the administrator of the academy's Henry Ward Ranger Fund, a bequest made for the pur-chase of contemporary American art that was to be donated to museums. He was a trustee of the Metropolitan Museum from 1917 to 1930, at which time he was elected an advisory trustee for life. Considered at the time of his death as "a man of rare personality and sane judgment,"

it was noted that his advice had been "sought by many institutions" (quoted in E. Clark, *History of the National Academy of Design* [1954], p. 213).

Jones's artistic development has not been adequately studied. During the 1880s, he seems to have specialized in genre scenes set in interiors, richly decorated with elaborate furniture and accessories. Although these are contemporary scenes, they demonstrate an interest in costumes and decorative objects reminiscent of the historical genre scenes done in Pont-Aven by such artists as Hovenden. Working in a richly painted but tightly drawn academic style, Jones often did sentimental depictions of children like *Won't Play*, 1880 (Museum of Fine Arts, Springfield, Mass.), which shows two pretty young women entertaining an unresponsive child. By about 1910, however, he was painting mainly informal subjects, and his work showed the influence of impressionism, by then a style acceptable even to the most conservative painters.

BIBLIOGRAPHY (See also bibliography for H. Bolton Jones): *Representative Works of Contemporary American Artists* (New York, 1887), text by Alfred Trumble, sec. 3, unpaged, gives a brief biography // W[illiam] Laurel Harris, "Mobilizing Industrial Design: Unused Resources of American Artists," *Good Furniture* 10 (March 1916), pp. 129–144, discusses the studio that the artist shared with his brother // Notes and biographical sketch based on an interview with Francis Coates Jones [1927], De Witt M. Lockman Papers, NYHS, microfilm 503, Arch. Am. Art.

The Sisters

After many years of painting sentimental genre scenes, Jones turned, during the early years of the twentieth century, to figure paintings less narrative in content. These pictures often show women engaged in leisure activities or quiet domestic tasks. Probably painted by 1913, *The Sisters* depicts two languid figures relaxing in an intimate setting. The women are caught in what appears to be a private moment; one sits with her head turned away from the viewer, and the other gazes into space. The treatment of the figures, their lack of movement and expression, suggest that Jones was working from lay figures. Indeed, a photograph of the artist in his studio (Photograph Collection, Arch. Am. Art) shows him at his easel painting from a wooden mannequin, which is similiarly attired to the women in *The Sisters* (see ill. in Arch. Am. Art, *Artists and Models* [1975], unpaged exhib. cat.).

Jones's late painting style, which is derived from impressionism, is essentially decorative. Here, in broad brushstrokes, he has applied pastel colors, pale blues, lavenders, and pinks, to render the patterns of striped and printed cloth and loosely gathered draperies. A cool light plays on the fair hair and complexions of the two women.

Oil on canvas, 30¼ × 36¼ in. (76.8 × 92.1 cm.).
Signed at lower left and again on tacking edge: FRANCIS C. JONES.

Jones, *The Sisters*.

REFERENCES: J. H. Zeizel, "Hugh Bolton Jones, American Landscape Painter," M.A. thesis, George Washington University, 1972, p. 11, notes the exhibition of a painting by this title in Chicago in 1913. EXHIBITED: Art Institute of Chicago, 1913, no. 195, as The Sisters (probably this picture). EX COLL.: the artist, New York, until 1932; his sister, Louise A. Chubb, New York, 1932.

Gift of Mrs. Louise A. Chubb, 1932.
33.75.

BRUCE CRANE

1857–1937

The landscape painter Robert Bruce Crane was born in New York. His father, Solomon Bruce Crane, was an amateur painter and art enthusiast who often took him to art galleries and exhibitions. Educated in public schools, Crane planned to attend college until his father's illness forced him to seek employment. Working in the office of an architect and builder, probably in Elizabeth, New Jersey, he gained practical experience as a draftsman and began to paint in his spare time. After 1876 he was a regular contributor to the annual exhibitions at the National Academy of Design. Following a brief trip to Europe in 1878, Crane opened a studio in New York and the next year studied with the landscape painter ALEXANDER WYANT, who undoubtedly encouraged him to follow the style of the Barbizon School. It is likely that Crane also attended classes at the Art Students League around this time.

Crane went to Europe again in June 1880 and this time spent a year and a half in Paris and its environs, often working outdoors in the countryside near Grez-sur-Loing. Returning to New York in 1881, the artist achieved some recognition for his plein-air landscapes, which usually showed American scenes—views of the Adirondacks, Long Island, New Jersey, and Connecticut. As one critic commented:

> Mr. Crane had by this time proved to the satisfaction of the art public that he handled one kind of landscape subject with as much ability as another. His simple roadside studies, with geese taking their noon ease under quiet gray skies, were treated as skilfully as his broad stretches of snowy landscape with strong accents of dark trees, or his reaches of marshy meadow, with numerous delicate variations of the leading motive of tone and color (*Art Age* 3 [August 1885], p. 8).

He became a member of the Society of American Artists in 1881 and of the American Water Color Society in 1890. Elected an associate member of the National Academy of Design in 1897, he was made a full member four years later.

Starting about 1904, Crane spent many of his summers painting in Old Lyme, Connecticut, which was then a popular artists' colony. In 1910 he settled in a house in Bronxville, New York, and for the remainder of his career, continued to work in the decorative impressionist style he had followed since the turn of the century. His landscapes, painted in high-key colors, were often of a quietist nature. Toward the end of his career, however, his compositions became increasingly repetitive. Indeed in 1926 one critic noted that:

> In composition the recent canvases of Bruce Crane offer less in the way of variety than those of twenty years ago. He now devotes himself almost exclusively to designs of a single type. Some of these he succeeds in making into pictures of real charm. Though he confines himself to a single theme as it were, and though there is a sort of sameness about all of his later works, he is in a way a master of American landscape. His pictures, however, are obviously the product of limited powers of observation and expression and therefore never likely to rank with those of the greater American masters (*Art in America* 14 [August 1926], pp. 211–212).

Like landscapes by the more accomplished artist J. FRANCIS MURPHY Crane's are neither specific nor topographical but instead represent moods or effects, usually transitional moments

of time or weather conditions, twilight and autumn being the artist's favorite subjects. Although conservative, his work was very popular in the early 1900s, a sign of the continuing success of the Barbizon and impressionist modes in America. The artist was the recipient of awards at the Louisiana Purchase Exposition in 1904 and the National Academy in 1912. As late as 1915, Crane joined with several artists including EMIL CARLSEN, CHARLES H. DAVIS, and J. ALDEN WEIR to establish an exhibition organization known as the Twelve Landscape Painters, which was made up of artists working in popular representational styles.

BIBLIOGRAPHY: "Bruce Crane," *Art Age* 3 (August 1885), pp. 8–9, discusses his early career // Alfred Trumble, "A Poet in Landscape," *Quarterly Illustrator* 1 (Oct., Nov., and Dec. 1893), pp. 256–260 // "Bruce Crane and His Work," and Bruce Crane, "Landscape Sketching and Painting," *Ar Amateur* 31 (Sept. 1894), pp. 70–74, includes illustrations of the artist's sketches // Harold T. Lawrence, "A Painter of Idylls—Bruce Crane," *Brush and Pencil* 11 (Oct. 1902), pp. 1–10, discusses the artist's technique // Notes made during an interview with Bruce Crane, [1927], De Witt M. Lockman Papers, NYHS, microfilm 502, Arch. Am. Art.

Autumn Uplands

Painted by 1908, *Autumn Uplands* is one of many fall scenes by Crane, who specialized in depicting specific seasons and times of day. Here the transitional quality of the subject is underscored by the chopping block and cut wood in the foreground and the golden tones of the foliage, both reminders of the approaching winter season. Represented with little indication of spatial depth or modeling, elements such as the trees and rolling hills create a decorative pattern. The artist once described his method for painting generalized views of this type, noting that he began by sketching outdoors "to fill the memory with facts." Later, while painting in the studio, he would interpret these observations freely, depending on his memory to select the most essential qualities of the scene. Then working "in a rather high key," he used "light-toned pigments," applied to the canvas with "a scrubby brush" to achieve a rough, dry effect (quoted in *Brush and Pencil* 11 [Oct. 1902], p. 8).

Oil on canvas, 27 × 41 in. (68.6 × 104.1 cm.).
Signed at lower right: BRUCE CRANE.
REFERENCES: G. A. Hearn, letter in MMA Archives, April 19, 1909, offers the painting to the museum as a gift // *MMA Bull.* 4 (July 1909), p. 113, lists it; ill. p. 115 // *George A. Hearn Gift to the Metropolitan Museum of Art . . .* (1913), ill. p. 101 // *New York Times*, Oct. 30, 1937, p. 19, mentions it in the artist's obituary.
EXHIBITED: Carnegie Institute, Pittsburgh, 1908, no. 69, as Autumn Uplands // Corcoran Gallery of Art, Washington, D.C., 1908–1909, no. 280 // PAFA, 1909, no. 559.
EX COLL.: George A. Hearn, New York, by 1909.
Gift of George A. Hearn, 1909.
09.72.2.

Crane, *Autumn Uplands*.

HARRY W. WATROUS

1857–1940

Harry Willson Watrous was born in San Francisco. When he was seven his family moved to New York where he attended private schools and received his first instruction in art from an amateur artist, F. Hatch, who was his tutor. Following a trip to California in 1881, Watrous went abroad to study art. Except for occasional visits to his family in New York, he remained in Europe for about five years. He spent the first nine months in Malaga, Spain, with the painter Humphrey Moore (1844–1926) and then traveled through southern Spain and Morocco. By 1882, however, he was working in a studio he had taken in Paris with George Randolph Barse (1861–1938). He attended Léon Bonnat's life class, where he spent two terms, and supplemented this study with classes at the Académie Julian under Jules Joseph Lefebvre and Gustave Boulanger. By 1884 Watrous was working independently and exhibiting at the Paris Salon. He also received the benefit of some criticism from Jean Jacques Henner and Charles Edouard Frère, both well-known academicians. The most important influence on his work during this and the following decade, however, was Jean Louis Ernest Meissonier, of whom he later wrote, "I consider Meissonier one of the greatest *genre* painters of this or any age. He was . . . an artist whose every touch was filled with knowledge and intelligence" (Van Dyke, p. 94). Like this French artist, Watrous painted small-scale figure studies of men in historical costumes, surrounded by faithfully rendered interiors, furniture, and decorative objects.

Returning to New York in 1886, Watrous began to exhibit at the National Academy of Design. He married the painter and author Elizabeth Snowden Nichols (1858–1921) on April 27, 1897, and they set off for Europe. They stayed first in Florence and then in Munich, where they visited the Polish figure painter Jan Chelminski. Following this trip Watrous came back to New York and then made a tour of the Adirondacks. He bought land at Lake George, in Hague, New York, where he made his summer home after 1894. It was about this time that he befriended the eccentric painter RALPH BLAKELOCK who often used his studio. Over the years, when Blakelock was in financial need, Watrous handled his work for him, selling it to art dealers and collectors, something Blakelock often could not manage for himself. In 1894, after winning the Thomas B. Clarke prize for figure painting, Watrous was made an associate at the National Academy. Elected an academician the following year, he remained active there, serving as secretary from 1898 to 1920 and as president in 1933 and 1934.

The artist's eyesight began to fail around 1905, and he turned to painting more broadly conceived compositions on larger canvases. Already well known and accepted as an academic painter of conventional subjects, he embarked on a new, and more daring, direction in his career. In figure paintings like *The Passing of Summer* (q.v.) he depicted idealized women, often dressed in seductive black costumes and accompanied by mysteriously behaving birds or whimsical looking insects. Perhaps the most original of all his works, these paintings are very enigmatic, suggesting a symbolic intent or at least a psychological strangeness. Stylized in treatment, they have smooth, highly finished paint surfaces, crisp contours, and a simplicity of design that may have been influenced by modern art.

Watrous's subject matter continued to expand. By 1918 he had turned to landscapes and nocturnes. In their evocative mood, boldly designed compositions, and use of light and dark contrasts, these paintings resemble the work of his friend Blakelock, although Watrous retained the sharp outlines and smooth paint surfaces characteristic of his own early work. His precisely rendered still lifes, begun around 1923, are usually arrangements of the antique decorative objects that he collected with enthusiasm.

When Watrous had his first one-man show at the Grand Central Art Galleries in 1937, the modernist Marsden Hartley (1877–1943) commented appreciatively:

> It isn't a matter of what standard you wish to apply to these pictures—they can and must be judged from their own standpoint which is inherently and sincerely academic. And since we are decidedly on the eve of the return to what is called "academy" these pictures achieve their success by virtue of the fact that this artist is not trying to do anything but express his deep reverence for the facts before him and with an affection that in itself is appealing (*Magazine of Art* 30 [March 1937], p. 176).

Watrous, a painter whose career had prospered for half a century, died in New York at the age of eighty-three.

BIBLIOGRAPHY: Harry W. Watrous, "Jean-Louis Ernest Meissonier," in John C. Van Dyke, *Modern French Masters: A Series of Biographical and Critical Reviews* (London, 1896), pp. 93–101, includes a biographical note on Watrous // Frederic Fairchild Sherman, *American Painters of Yesterday and Today* (New York, 1919), pp. 55–60, contains a chapter on Watrous's early genre pictures // William B. McCormick, "Watrous, Public Force in Art," *International Studio* 78 (Oct. 1923), pp. 79–83 // Notes on Harry Watrous made during an interview with him and a typescript biography [1927], De Witt M. Lockman Papers, NYHS, microfilm 504, Arch. Am. Art, discusses in depth his early career in Paris and provides information about his painting technique // Parke-Bernet Galleries, New York, *Still Life Paintings, Landscapes, Genre Subjects by Harry W. Watrous: With a Small Selection of Art Objects and Decorative Paintings from His Collection*, sale cat. (Oct. 25, 1940), contains many illustrations.

The Passing of Summer

Dated 1912, this painting is typical of the large-scale idealized female figures that Watrous painted between 1905 and about 1918. An elegantly dressed young woman is shown sitting alone at a table. Lost in thought, she ignores the glass of cherries and the unopened book in front of her and gazes impassively at the delicate insects that hover before her. Her isolation is emphasized by the pose, in which her back is turned to the viewer and her face is only partly visible. The subject and title of the painting prompted some speculation when the work was acquired by the museum in 1912, and on July 6 the artist responded to inquiries about it from the *New York Times* with a telegram from his summer residence in upstate New York:

> Title to picture was suggested by a social tragedy I witnessed last Autumn. A beautiful young woman I knew slightly was seated at a table in the garden of a French restaurant. She had put her savings in a wardrobe for a last Summer campaign that had evidently failed. It was chilly, and she had brought out her Winter hat, though still clinging to her last presentable Summer dress. She was alone, and was eating *cerise*[s] from a glass that was not for cocktails. The air was full of insects, and on my asking her, "Well, has Prince Charming appeared?" she turned away her head and sighed, "No," and this is the "Passing of Summer."

Thus in this picture, Watrous presents us with a woman who mourns not only the passing of summer but that of her youth as well.

Almost Victorian in its sentimentality and narrative character, the subject is treated in a stylized manner that suggests at least a superficial awareness of modern art, which Watrous later praised for its "simplicity, nice lines and certain compactness" (*Art Digest* 8 [Nov. 1, 1933], p. 10). The artist has arranged the picture in broad areas of somber colors, balancing the dark silhouette of his model with a light, neutral

background. His paint is applied smoothly to create a highly finished surface, and his sparing use of detail heightens the impact of the design. The strong decorative effect that he achieves is partly the result too of his slightly unusual working method. He appears to have begun his figure paintings with a preconceived notion of the design. Starting with a quick figure sketch done from memory he would place his model in the same pose as the figure in the preliminary drawing, "instead of making the drawing to conform to my model" (Interview in De Witt M. Lockman Papers [1927]).

Oil on canvas, 36$\frac{3}{16}$ × 30 in. (91.9 × 76.2 cm.).

Signed at lower right: Watrous. Signed, dated, and inscribed on the back: The Passing of Summer / 1912 / HWW.

REFERENCES: *New York Times*, July 7, 1912, p. 11, notes that the painting has been purchased by the Metropolitan and says that due to "the unusual interest" in it, the newspaper has contacted the artist at his summer home, requesting an explanation of the title; prints his July 6 telegram (quoted above) // *Hearst's Magazine* 29 (April 1916), ill. p. 287; p. 288, discusses the picture // W. B. McCormick, *International Studio* 78 (Oct. 1923), ill. p. 80; p. 83 // *New York Times*, Feb. 7, 1937, sec. 10, p. 9, notes it as an example of the artist's middle period // P. Bird, *Art Digest* 11 (Feb. 15, 1937), p. 18.

EXHIBITED: NAD, 1912, no. 214, as The Passing of Summer.

George A. Hearn Fund, 1912.

12.105.3.

The Celebration of the Mass

Watrous worked on this still life from 1930 to about 1935. The principal object in the picture is a relief sculpture of three cardinals and four

Watrous,
The Passing of Summer.

Watrous,
The Celebration of the Mass.

priests celebrating mass before an altar. The model for this, a gilded and polychromed wood sculpture (now unlocated) was described in the 1940 sale catalogue of the artist's estate as a Spanish piece dating from the early sixteenth century. Watrous purchased it from the collection of Cora Timken Burnett in 1929 and soon after began this painting. Although exhibited in 1930, *The Celebration of the Mass* was still unfinished and after another exhibition in 1934, Watrous repainted part of the foreground. Finally completed in 1935, the painting was shown again, this time at the Pennsylvania Academy of the Fine Arts, where it was awarded the Lippincott Prize.

Realistic compositions of bric-a-brac and decorative objects became Watrous's specialty after 1923. Superficially, in subject and style, these still lifes recall paintings done by WILLIAM MICHAEL HARNETT during the 1880s. Most of Watrous's work in this genre, however, is merely a faithful record of his observations, with little attempt at the complicated arrangements and sensitive interpretations that distinguish the work of Harnett and his accomplished followers.

Oil on canvas, 40 × 36 in. (101.6 × 91.4 cm.).
Signed at lower left: Watrous.
REFERENCES: H. Cahill and A. H. Barr, Jr., ed., *Art in America in Modern Times* (1934), ill. p. 49 // *New York Times*, Jan. 27, 1935, p. 22, says that the picture received the Lippincott Prize at the Pennsylvania Academy // *Art Digest* 9 (Feb. 1, 1935), ill. p. 5; p. 6 // H. W. Watrous, letters in MMA Archives, Dec. 10, 1935, gives history of the painting and says he considers it his most important work; May 16, 1936, identifies the sculpture used as the model and gives its history; notes that the painting was unfinished when it was shown in 1930 and that after its exhibition in 1934 he repainted part of the foreground.
EXHIBITED: NAD, 1930, no. 55, as Old Still Life // Rockefeller Center, New York, 1934, *First Municipal Art Exhibition* (sponsored by the Honorable Fiorello H. La Guardia, Mayor of the City of New York), no. 880, as The Celebration of the Mass—Still Life // PAFA, 1935, ill. no. 128, as Celebration of the Mass.
Gift of the artist, 1935.
35.130.

Harry W. Watrous

CHARLES ULRICH

1858–1908

The figure painter Charles Frederick Ulrich was born in New York, where he began his early art training. Encouraged by his father who was a photographer and onetime painter, Ulrich is said to have received his initial instruction from a local drawing master named Professor Venino (perhaps Francis Venino, a painter and lithographer). He continued his studies at the National Academy of Design, where in 1875 he entered a student competition for drawing from antique casts. He may also have studied at Cooper Union about this time.

In October 1875, already well-trained as a draftsman, Ulrich enrolled in the Royal Academy at Munich, where he studied under Ludwig von Löfftz and Wilhelm Lindenschmit. Remaining in Munich for several years, he developed a deep appreciation for the old masters and absorbed the techniques and realistic style of the academic artists then popular there. The attention to still-life and costume details, the dark rich colors, and strong narrative interest seen in Ulrich's work resulted from the influence such German genre painters as Franz von Defregger and Ludwig Knaus had on him. Their scenes of peasant life were to remain a dominant influence on his painting throughout his career.

Ulrich returned to the United States sometime between 1879 and 1882, the year he first exhibited his work in an annual exhibition at the National Academy of Design. He was elected an associate there the following year and also became a member of the Society of American Artists and later of the Society of Painters in Pastel. Fascinated by national characteristics and costumes, he painted the Pennsylvania Dutch in 1882. Later he chose immigrants as the subject for his *In the Land of Promise—Castle Garden*, 1884 (Corcoran Gallery of Art, Washington, D.C.), a painting which won the Thomas B. Clarke prize for figure painting at the National Academy. About this time, Ulrich also produced an important series of genre scenes, many depicting craftsmen, which were praised by critics and purchased by such prominent collectors as Thomas B. Clarke, George I. Seney, and William T. Evans. Often executed on wood panels, these works were small in scale but ambitious in the complexity of their compositions, the variety of their well-drawn figures, and the extraordinary verisimilitude of their still-life details. As one writer observed:

> His cabinet pieces, full of character, minute in execution, and brilliant with their rendition of light, were entirely new to our art, and may be said to have marked a new departure in it. Without being in any sense imitations, they showed that the artist had been a close student of the old Dutch detail painters of the type of [Johann] Van der Meer and Pieter de Hooghe. His manner and matter were, however, entirely modern (*Catalogue of the Private Art Collection of Thomas B. Clarke* [1899], p. 110).

When Ulrich left New York in 1885, he intended to remain abroad for several years, having established himself with a London art dealer. One critic caustically attributed the artist's departure to a "proclaimed disgust at the sordidness of an unappreciative public, which refused to bankrupt itself in the purchase of over-priced pictures" (*Art Age* 3 [August 1885], p. 11). Ulrich first went to Holland and then to Venice, where he took up residence in 1886. His later career is obscure. Except for a visit to New York in 1891, he appears to have remained abroad

for the rest of his life, his art developing stylistically and thematically within the context of European rather than American art. At least during the 1880s and 1890s, he maintained contact with such American artists as ROBERT BLUM and WILLIAM MERRITT CHASE. He also helped to organize exhibitions of American art held in Munich in 1888 and 1892. His work was exhibited throughout Europe, in Paris at the Universal Exposition in 1889, in London at the Royal Academy in 1889 and 1890, and in Munich at the Glaspalast and after 1893 at the Secession exhibitions. He was married in Germany in 1897, worked in Rome around the turn of the century, and died in Berlin in 1908.

BIBLIOGRAPHY: George William Sheldon, *Recent Ideals of American Art* (New York, 1888–1890), p. 2; opp. p. 28; pp. 35–36 // American Art Galleries, New York, *Catalogue of the Private Art Collection of Thomas B. Clarke*, sale cat. (Feb. 14–18, 1899), intro. by William A. Coffin, pp. 110–111, includes a biographical statement on the artist // American Art Galleries, *Catalogue of American Paintings Belonging to William T. Evans*, sale cat. (Jan. 31–Feb. 2, 1900), pp. 75–76, includes a biographical note on the artist // Obituaries: *New York Times*, May 21, 1908, p. 7; *American Art News* 6 (June 3, 1908), p. 4 // Dayton Art Institute, Ohio, *American Expatriate Painters of the Late Nineteenth Century* (1976), exhib. cat. by Michael Quick, p. 138, contains a biography; p. 157, bibliography.

Glass Blowers of Murano

The painting, dated 1886, shows workers blowing glass, a craft revived in Venice during the late nineteenth century. It depicts a scene in the city's glassmaking center on the island of Murano, which Ulrich had visited the previous summer. ROBERT BLUM, who accompanied the artist on this trip, reported on July 5, 1885: "Ulrich has commenced a stunning thing of the Glass-Blowers." Since the Metropolitan painting is dated 1886, he must have begun it, or a related subject, that summer.

Although more graceful in composition and more painterly in technique, this work is similar in subject to Ulrich's *The Glass-Blowers*, 1883 (Museo de Arte de Ponce, Puerto Rico.) The earlier picture, set in New York, was purchased by the prominent art collector Thomas B. Clarke and widely exhibited at home and abroad. Its success may have inspired the artist to repeat the theme. Indeed *Glass Blowers of Murano* won a substantial cash prize in 1886 at the Second Prize Fund Exhibition in New York, where critics noted its superiority to earlier works by Ulrich.

This picture shows what may be regarded as a new departure for him, though entirely within the line of development that so strong a man was likely to follow. It is neither photographic nor microscopic, nor in any way mechanical, but is freely painted, and the details, of which it is full, are properly subordinated to the masses. There is, besides, a thoroughly understood artistic purpose, something which, to many people, seemed lacking in Mr. Ulrich's former productions.

The positive response to the picture—a foreign subject painted by an American under the influence of European art—demonstrates the international character of American taste during the late 1880s. The choice of subject is typical of American artists like Blum, GARI MELCHERS, and GEORGE HITCHCOCK, all of whom did genre scenes of European life, depicting local costumes, settings, and activities. Although done in Italy, the painting shows the impact of Ulrich's German training. His fascination with artisan subjects, in part a response to the Arts and Crafts movement of the 1880s, was probably first sparked by the revival of interest in artistic crafts in Munich, where a major exhibition of such works was held in 1876. At this time, some German artists were involved in decorative projects, while others, like the Austrian artist August von Pettenkofen, painted scenes of figures engaged in handicrafts. In this context, it is hardly surprising that Ulrich often chose such subjects as printmakers, needleworkers, and in this case, glassblowers.

Oil on wood, $26\frac{1}{8} \times 21\frac{1}{8}$ in. (66.4 × 53.7 cm.).
Signed and dated at upper right: *Ulrich* / 86. Label on reverse: GIUSEPPE BIASUTTI / PRESSO LA REGIA ACCADEMIA / N. 1024 Venezia / DEPOSITO OGGETTI / PER / PITTURA E DISEGNO.
REFERENCES: R. Blum to W. M. Chase, July 5, [1885], William Merritt Chase Papers, courtesy of Chapellier Gallery, microfilm N/68–101, Arch. Am. Art, says that he, Franz Léo Ruben, and Ulrich have recently gone to Murano (quoted above) // *Art Age* 3 (May 1886), p. 179, reviews it in the Prize Fund Exhibition, criticizes its lack of interest "both artistic

and local," and says Ulrich "is evidently not in sympathy with the Venetian types" // *Art Amateur* 15 (July 1886), p. 25, reviews it in the Prize Fund Exhibition (quoted above) // *New York Times*, May 8, 1886, p. 4, reviews it in the Prize Fund Exhibition, saying that at least ten other paintings were equally deserving of the honor it received // *Art Interchange* 16 (May 22, 1886), p. 162, reviews it in the Prize Fund Exhibition, noting that it is an improvement over the work the artist did before going abroad // G. W. Sheldon, *Recent Ideals of American Art* (1888–1890), ill. opp. p. 28; pp. 35–36 // American Art Galleries, New York, *Catalogue of the Private Art Collection of Thomas B. Clarke, New York*, sale cat. (Feb. 14–18, 1899), p. 110, says that it was awarded a $2,500 prize at the American Art Galleries in 1886 // American Art Galleries, New York, *Catalogue of American Paintings Belonging to William T. Evans*, sale cat. (Jan. 31–Feb. 2, 1900), p. 76, mentions that it won a prize in 1886 and that it was acquired by the Metropolitan // *New York Times*, May 21, 1908, p. 7, mentions it in the artist's obituary // *American Art News* 6 (June 13, 1908), p. 4 // J. Pennell, *Mentor* 10 (Oct. 1922), ill. p. 17.

EXHIBITED: American Art Galleries, New York, 1886, *American Paintings and Sculpture Contributed to the Second Prize Fund Exhibition*, no. 272, as Glass Blowers of Murano.

EX COLL.: subscribers to the Second Prize Fund Exhibition, W. T. Walters, H. G. Marquand, J. Dwight Ripley, William T. Evans, et al., 1886.

Gift of Several Gentlemen, 1886.

86.13.

HENRY WARD RANGER

1858–1916

The landscape painter Henry Ward Ranger began his career as a self-taught watercolorist and later working in oil became an important advocate of Barbizon painting in America. The son of a commercial photographer, Ranger was born and educated in Syracuse, New York, where he attended college from 1873 to 1875. It was at this time that he first took up painting in watercolor, inspired by an acquaintance who was a scene painter and illustrator. In the late 1870s, he moved to New York and supported himself writing music criticism. Soon after he received encouragement in painting from the collector William M. Laffan, who introduced him to Gustave Reichard, an art dealer who helped promote his watercolors. Ranger exhibited at the American Water Color Society in 1881 and was elected a member there seven years later. His early work is described as "painfully minute," but "after a couple of years his style became broader, his color finer and more harmonious and he commenced to show a command of atmospheric effect" (*Collector* 8 [Feb. 15, 1897], p. 113).

Ranger traveled extensively during the 1880s, visiting museums and galleries in England and France, where he developed an appreciation for Jean Baptiste Camille Corot and Adolphe Monticelli. One of Ranger's favorite sketching spots was a village in North Holland, Laren which he discussed in an article in *Century Magazine* in March 1893. While working in Holland he went on sketching trips and studied paintings by the Dutch artists Anton Mauve, Joseph Israels, Jacob Simon Hendrik Kever, and the Maris brothers. The picturesque landscapes and scenes of peasant life painted by these artists as well as those of the Barbizon School were important influences on the development of Ranger's style and subject matter.

The artist returned to the United States in 1888, and, although he continued to travel a great deal in search of landscape subjects, he was most active in New York. He exhibited there

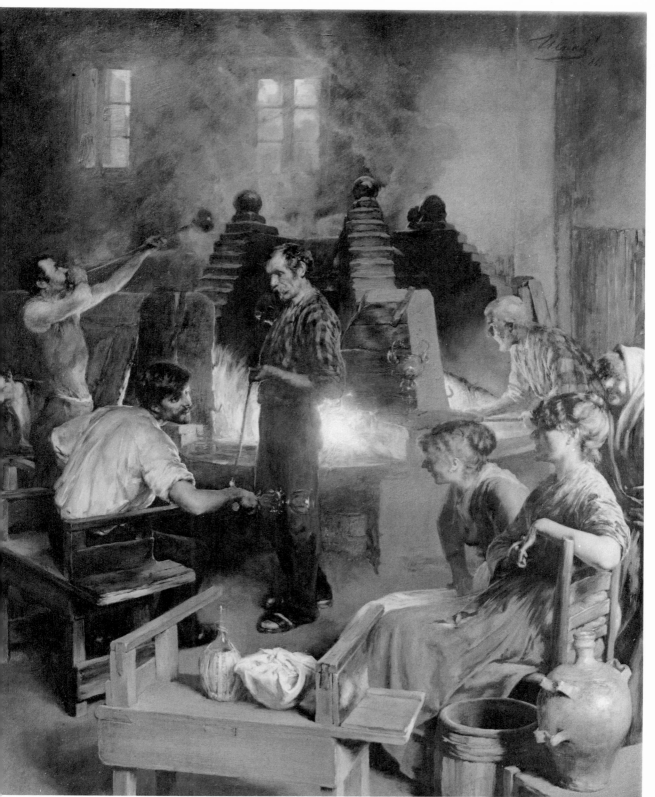

Ulrich, *Glass Blowers of Murano*.

at the National Academy of Design beginning in 1887 and from 1890 at the Society of American Artists. During this period he appears to have worked in a variety of media; for at the time of an important one-man show at Blakeslee galleries in New York in 1897, one critic noted his accomplishments in lithography, etching, and ceramic decoration, and commented on his "powerful subjects in monochrome" (*Collector*, p. 114). These aspects of the artist's work, however, are little known today. Influenced by the late work of GEORGE INNESS, Ranger's paintings from this period, such as *Connecticut Woods*, 1899 (National Collection of Fine Arts, Washington, D.C.), display similar atmospheric effects, achieved by the same rough application of pale colors, for which Inness was noted.

Beginning in 1899, Ranger became a leading member of the artists' colony at Old Lyme, Connecticut, where a group of painters influenced by the Barbizon and impressionist styles gathered in the summer at the home of Florence Griswold. Ranger later acquired a country home in Noank, on Long Island Sound, near New London, Connecticut, and did much of his sketching there. His winters, however, were spent in the warmer climates of Puerto Rico and Jamaica. He was elected an associate of the National Academy of Design in 1901 and a full member five years later. The last three years of his career were marred by illness, and he died in 1916 at the age of fifty-eight. Paintings remaining in Ranger's studio and his collection of contemporary art were auctioned at the American Art Galleries in New York the following year.

An astute businessman, Ranger left a substantial portion of his estate to the National Academy, establishing the Ranger Fund for the purchase of paintings by living American artists. An early effort to encourage the collection of contemporary American art by institutions in this country, the fund has been used to purchase over three hundred paintings and watercolors since 1919. These have been distributed to museums, art galleries, and libraries throughout the country, and a large group are in the National Collection of Fine Arts in Washington.

BIBLIOGRAPHY: H[enry] W[ard] Ranger, "Artist Life by the North Sea," *Century Magazine*, n.s. 23 (March 1893), pp. 753–759, discusses an artists' retreat in Laren, Holland // [Alfred Trumble], "News and Views," *Collector* 8 (Feb. 15, 1897), pp. 113–114, discusses Ranger's early career in a review of an exhibition of his work at Blakeslee galleries, New York // Harold W. Bromhead, "Henry W. Ranger," *International Studio* 29 (July 1906), pp. xxxiii–xliv // Ralcy Husted Bell, *Art-Talks with Ranger* (New York, 1914), includes a series of discussions with the artist on such topics as tonalism and the technique and history of painting. The most complete source of information on Ranger's aesthetic ideas // Elliott Daingerfield, "Henry W. Ranger: Painter," *Century Magazine*, n.s. 75 (Nov. 1918), pp. 82–89.

Spring Woods

The central focus of *Spring Woods* is a large tree, its rough bark illuminated by brilliant light and the surrounding landscape enveloped in an atmospheric mist. Dating from the late 1890s, the painting shows the influence of works done by GEORGE INNESS after 1884. Similar in subject and style, Ranger's painting exhibits the same warm autumnal colors, roughened paint surface, and soft definition of form characteristic of Inness's late landscapes, which were often featured in sales and exhibitions during the 1890s. Although not as strong in design or mood, Ranger's work follows Inness's in the attempt to go beyond the objective appearance of the landscape and endow it with a poetic quality. Here he paints a forest interior that suggests a quiet mood rather than a specific time of day or a clearly identifiable place. These "woodland

scenes" were typical of Ranger's work at the turn of the century, and in them, as ELLIOTT DAINGERFIELD wrote, "he strengthened his palette and his touch" (*Century*, n.s. 75 [Nov. 1918], p. 85).

Oil on canvas, 28¼ × 36 in. (71.8 × 91.4 cm.).
Signed at lower left: *H W Ranger*.
REFERENCES: C. H. Caffin, *International Studio* 15 (Nov. 1901), p. xxxiv, in a review of the Pan-American Exposition, says the picture is "pleasant rather than convincing" // W. S. Howard, *MMA Bull.* 1 (March 1906), p. 56, discusses it // *New York Times*, Nov. 8, 1916, p. 3, mentions it in the artist's obituary.
EXHIBITED: Lotos Club, New York, 1901, *American Paintings from the Collection of Mr. George A. Hearn*, no. 33, as Spring Woods // Pan-American Exposition, Buffalo, New York, 1901, *Catalogue of the Exhibition of Fine Arts*, no. 431.
Ex COLL.: George A. Hearn, New York, by 1901–1906.
Gift of George A. Hearn, 1906.
06.1293.

High Bridge, New York

Dated 1905, this painting shows High Bridge, which spans the Harlem River at 175th Street and Tenth Avenue, linking Manhattan to the Bronx. Before its massive stone arches were replaced by steel in the early 1920s, the structure

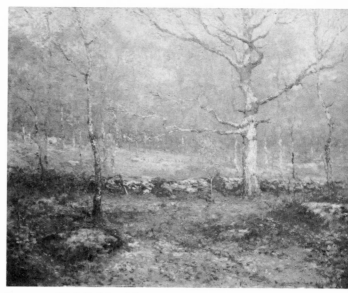

Ranger, *High Bridge, New York.*

attracted the attention of many New York artists. Here, in Ranger's romanticized interpretation of the urban landscape, the bridge, its curved forms mirrored in the water below, is the central focus of the picture. Viewed from an elevated vantage point, the scene is looking south toward Manhattan, where buildings, factories, and ships are immersed in an atmospheric haze.

Ranger, *Spring Woods.*

The painting was a gift to the museum from William T. Evans, a prominent collector who owned over two dozen works by Ranger.

Oil on canvas, 40¼ × 50⅛ in. (102.2 × 127.3 cm.).
Signed and dated at lower right: H W Ranger 1905.
REFERENCES: *Independent* 58 (Feb. 16, 1905), p. 372, says the painting is "large in character" // W. T. Evans, letter in MMA Archives, Jan. 4, 1907, says it is in a special exhibition at the Corcoran // *MMA Bull.* 2 (May 1907), p. 88, discusses it; ill. p. 89 // *New York Times*, Nov. 8, 1916, p. 13, notes it in the artist's obituary // E. Daingerfield, *Century Magazine*, n.s. 75 (Nov. 1918), ill. p. 85 // *American Artist* 16 (June 1952), p. 105 // W. H. Truettner, *American Art Journal* 3 (Fall 1971), p. 77, includes it in a checklist of American paintings acquired by William T. Evans.

EXHIBITED: PAFA, 1905, no. 211, as High Bridge (probably this painting) // Corcoran Gallery of Art, Washington, D.C., 1907, no. 77, as High Bridge, lent by Mr. William T. Evans.

EX COLL.: William T. Evans, Montclair, N.J., 1907.
Gift of William T. Evans, 1907.
07.111.

WILLARD METCALF

1858–1925

Best known for his impressionist landscapes of New England, Willard Leroy Metcalf was born in Lowell, Massachusetts. His family moved to Maine in 1863 and nine years later settled in Cambridgeport, Massachusetts. After working in a hardware store, Metcalf was apprenticed to a wood engraver and later to the landscape painter GEORGE LORING BROWN. He attended life classes at the Lowell Institute two evenings a week and in 1876 received a scholarship to the School of the Museum of Fine Arts, Boston, where he studied with the German-born painter Otto Grundmann (1844–1890). To recuperate from an illness, Metcalf went to New Mexico in 1881. He stayed in the Southwest for the next two years and while there illustrated several magazine articles on the Zuni Indians. During this time, he made a trip East with the ethnologist Frank Cushing and a delegation of Zunis who visited President Chester A. Arthur in Washington.

Financed by his work as an illustrator and by sales from an exhibition at Chase's Gallery in Boston, Metcalf went to Europe in 1883. He first spent the summer sketching in England and then went to Paris, where he studied at the Académie Julian under Jules Joseph Lefebvre and Gustave Boulanger. During the next two years, he made trips to England and Brittany, but much of his time was spent in the French villages of Giverny and Grez-sur-Loing. There, inspired by the Barbizon painters, he did landscapes and his well-known *Ten Cent Breakfast*, 1887 (Denver Art Museum), a lamplight interior depicting his fellow artists and friends JOHN H. TWACHTMAN, THEODORE ROBINSON, Robert Louis Stevenson, and a fourth man variously identified as Reginald Birch (1856–1948) or Birge Harrison (1854–1929). He was elected a member of the Society of American Artists in 1887, and, the following year his *Arab Market* (unlocated) won an honorable mention at the Paris Salon.

When Metcalf returned from Europe in 1889, he settled in New York. The 1890s were a busy time for him. "Painting, illustrating, teaching—that about sums up my uneventful career In this business we haven't even time to get into mischief," Metcalf told an interviewer for *Bookbuyer* in 1894 (p. 120). Teaching was the artist's main source of support, and for

ten years he conducted an antique class for women at Cooper Union. He also did illustrations for books and magazines like *Scribner's* and *Century*. Whenever possible, he did paint, although in the early 1890s, his work seems to have been mainly portraiture. Perhaps as a result of his friendship with artists like CHILDE HASSAM, J. ALDEN WEIR, and ROBERT REID, Metcalf soon came under the influence of impressionism. Landscapes with broken brushwork, bright colors, and unconventional compositions characterize his work beginning about 1895. In 1897 he became a founding member of the Ten American Painters, a group consisting largely of impressionist artists. He also undertook murals, such as the frieze of Justice in the Appellate Court Building in New York in 1898 and 1899.

In 1903, Metcalf stopped teaching and retreated to his parents' farm in Maine, where he devoted himself to landscape painting. The artist considered this juncture in his career his "Renaissance." Financial considerations, however, soon forced him to resume teaching again, this time at the Rhode Island School of Design. After a successful exhibition at the St. Botolph Club in Boston in 1906, however, his future was more secure.

In the early 1900s, Metcalf spent his summers at the popular artists' colony in Old Lyme, Connecticut. There he painted landscapes like *May Night*, 1906 (Corcoran Gallery of Art, Washington, D.C.), which shows the residence of Florence Griswold, the friend and patron of many artists. In New York he maintained a studio in the Hotel des Artistes and was an active member of the Century Association. After 1910, his work received many honors and awards and was purchased by such noted collectors as Charles Lang Freer. Metcalf declined membership in the National Academy of Design, although he did exhibit his work there as early as 1889. In 1924, however, he was elected to the American Academy of Arts and Letters. Up until the time of his death, Metcalf continued to paint, and his mature work of the 1920s, ambitious in scale and powerful in design, is perhaps his best.

BIBLIOGRAPHY: "Book Illustrators, III: Willard L. Metcalf," *Bookbuyer* 11 [April 1894], pp. 120–123. Based on an interview with the artist, the article discusses his career as an illustrator // Henry Milford Steele, "The Requirements of Black and White (with original illustrations by Willard L. Metcalf)," *Monthly Illustrator* 3 (Jan.–March 1895), pp. 93–96 // Catherine Beach Ely, "Willard L. Metcalf," *Art in America* 13 (Oct. 1925), pp. 332–336 // Bernard Teevan, "A Painter's Renaissance," *International Studio* 82 (Oct. 1925), pp. 2–11 // Museum of Fine Arts, Springfield, Mass., *Willard Leroy Metcalf: A Retrospective* (1976), exhib. cat. by Francis Murphy, biographical essay by Elizabeth de Veer. An illustrated catalogue for a traveling exhibition that included the Munson–Williams–Proctor Institute, Utica, N.Y.; Currier Gallery of Art, Manchester, N.H.; and the Hunter Museum of Art, Chattanooga, Tenn.

Hillside Pastures

Painted in 1922, only three years before the artist's death, this autumnal landscape depicts the hilly farmland around Springfield, Vermont. Not as panoramic nor quite as powerful as some of the landscapes Metcalf painted in the 1920s, this work contains, however, strong contrasts of light and shadow that lend strength to the composition. A late example of the artist's work in the impressionist mode, it is brightly colored, with dry, broken brushstrokes that often allow the bare canvas to show through.

For an exhibition in 1925, one writer noted that the constant theme in Metcalf's paintings "is the robust landscape of New England divested of its rigors."

For Mr. Metcalf does not deal in asperities. He was born to please. These rugged hills, to which he is native, these woods and stubborn fields and stony brooks reveal, under his hand, no more of their primitive harshness. He loves . . . these homely hills, and he sings

Metcalf, *Hillside Pastures.*

The North Country

Metcalf's most characteristic subject, particularly during the final two decades of his career, was the hilly New England landscape shown at various seasons. According to Horace Brown (1876–1949), whom the artist often visited during the early 1920s, *The North Country* depicts a scene in Perkinsville, not far from Springfield, Vermont. In the foreground is the Black River, and seen in the distance is Mount Ascutney or Hawks Mountain.

Painted in 1923, this is one of a series of large-scale panoramic views that the artist had started the previous year—*Indian Summer*, 1922 (Dallas Museum of Fine Arts) being the first. All the works in this group, including the Metropolitan painting, have similar compositions. A river flows diagonally from the foreground to the middle distance, where quaint New England buildings provide a focus, and in the background there are mountains and a cloud-filled sky above a high horizon. As Royal Cortissoz commented on Metcalf's interest in this motif, "his treatment of it springs from nothing so much as from his simplification of the great masses traversed" (*American Artists* [1923], p. 145). Here Metcalf works in just such "great masses," with alternating bands of light and dark color receding to the distant horizon. The paint application is dry, leaving areas of bare canvas visible between rapidly executed brushstrokes. The artist's palette is bright but not harsh, and the variety of his colors— verdant green pastures surrounded by leafless trees and the river bound by orange and brown reeds and foliage—suggest that it is an autumn scene.

The North Country was perhaps the best known of Metcalf's late works. In 1924, when the artist was elected to membership in the American Academy of Arts and Letters, Edward W. Kemble drew a caricature of him, dressed in warm winter clothing, at work at his easel with Father Time offering him membership in the academy. This watercolor (coll. Harold C. Milch, New York) is inscribed "In The North Country," and signed by Metcalf and his friends, presumably as a memento of the dinner held to honor his election to this organization.

their virtue and their grace with a loyalty which has not been misapplied (Corcoran Gallery of Art, Washington, D.C., *Paintings by Willard L. Metcalf* [1925], unpaged).

Oil on canvas, 26 × 28⅞ in. (66 × 73.3 cm.).
Signed and dated at lower right: W. L. METCALF. 1922.
REFERENCES: H. C. Milch, Milch Gallery, letter in Dept. Archives, Nov. 2, 1976, gives the picture's provenance and exhibition record and notes that it was painted at Springfield, Vermont // E. de Veer, letter in Dept. Archives, Jan. 1, 1977, notes another work with the same title in a private collection.
EXHIBITED: Corcoran Gallery of Art, Washington, D.C., 1925, *Paintings by Willard L. Metcalf*, no. 30, as Hillside Pastures // Milch Galleries, New York, 1925, *Exhibition of Paintings by Willard L. Metcalf*, no. 12, as Hillside Pasture // Wadsworth Atheneum, Hartford, 1950, *The Adelaide Milton de Groot Loan Collection* (no. cat.) // Columbus Gallery of Fine Arts, Ohio, 1958, *Masterpieces from the Adelaide Milton de Groot Collection*, No. 25, as Hillside Pasture.
ON DEPOSIT: Wadsworth Atheneum, Hartford, 1949–1956, lent by Adelaide Milton de Groot // MMA, 1956–1967, lent by Adelaide Milton de Groot.
EX COLL.: with Milch Galleries, New York, 1925; Hersey Egginton, Brooklyn and Garden City, N.Y., 1925–1947; with Milch Galleries, New York, 1947– 1949; Adelaide Milton de Groot, New York, 1949– 1967.
Bequest of Miss Adelaide Milton de Groot (1876– 1967), 1967.
67.187.134.

Oil on canvas, 40 × 45¼ in. (101.6 × 114.9 cm.).
Signed and dated: W. L. METCALF—1923.
REFERENCES: *New York American*, Feb. 24, 1924, sec. M, p. 10, in a review of the exhibition at Milch, says it is "the last word in American landscape painting," an

example "of a serene nobility and a very flowerlike loveliness and color" // *New York Morning Telegraph*, March 2, 1924, p. 7, in a review of the exhibition at Milch, notes that its space and light is "impressive" // Milch Galleries, New York, *Exhibition of Paintings by the Late Willard L. Metcalf* (1925), exhib. cat., unpaged, includes it in a list of his works in public collections // C. B. Ely, *Art in America* 13 (Oct. 1925), ill. p. 333; p. 335, calls it "a fine example of beautiful feeling for color" // L. H. Bugbee, letter in MMA Archives, Dec. 27, 1940, says that the area pictured is "somewhere between Brattleboro and Manchester. It may be on the road which goes around the southwest base of Ascutney Mountain in Windsor" // H. Brown to L. H. Bugbee, copy in Dept. Archives, Jan. 7, 1941, identifies the scene as Perkinsville, Vermont, and says that Metcalf stayed with him each spring and fall for several years and they went painting together // L. H. Bugbee, letter in Dept. Archives, Feb. 8, 1941, says that it represents Springfield, Vermont // H. C. Milch, Milch Gallery, letter in Dept. Archives, Nov. 2, 1976,

says that it was painted in Springfield, Vermont, gives provenance, and discusses the Kemble caricature of Metcalf // W. L. Lawrence, letter in Dept. Archives, Dec. 3, 1976, says that it depicts Perkinsville, Vermont, with Hawks Mountain in the distance // E. de Veer, letter in Dept. Archives, Jan. 17, 1977, provides reviews of its exhibition in 1924.

EXHIBITED: Milch Galleries, New York, 1924, *Exhibition of Paintings by Willard L. Metcalf*, no. 11, as The North Country // Art Students League and American Fine Arts Society, New York, 1943, *Fifty Years on 57th St.* (for the benefit of the American Red Cross), no. 154 // Museum of Fine Arts, Springfield, Mass., 1976, *Willard Leroy Metcalf, a Retrospective*, exhib. cat. by F. Murphy and E. de Veer, ill. no. 50; ill. p. xix, shows Kemble caricature inscribed "In The North Country".

EX COLL.: with Milch Galleries, New York, 1924.
George A. Hearn Fund, 1924.
24.60.

Metcalf, *The North Country*.

H. SIDDONS MOWBRAY

1858–1928

Henry Siddons was born in Alexandria, Egypt, the son of an English banker. Orphaned at an early age, he was adopted by his aunt and her husband, George Mordey Mowbray, a chemist who had built a petroleum refinery in Titusville, Pennsylvania, shortly before the Civil War. In 1869 the Mowbrays settled in North Adams, Massachusetts, where Henry attended local schools. He later obtained an appointment to the military academy at West Point, which proved a brief and unhappy period in his life. During the few months he spent there, however, he did some illustrations for Homer Lee's *West Point Tic Tacs: A Collection of Military Verse* published in 1878.

Returning to North Adams, he worked in the office of his uncle's chemical business. In the winter of 1877, he began to take instruction from the landscape painter Alfred Cornelius Howland (1838–1909), who was living in nearby Williamstown at this time. Then in October 1878, Mowbray went to study in Paris and, with the exception of a visit home, remained abroad for about seven years. He worked in the atelier of Léon Bonnat, where one of his fellow American students was WILLIAM COFFIN. There he learned to draw and paint the human figure, and he later wrote, "at Bonnat's stern realism was the law. A view of the output of nude torsos, legs, feet and heads suggested a butcher's shop" (*H. Siddons Mowbray, Mural Painter, 1858–1928* [1928], p. 20). In 1880 he and HENRY O. WALKER traveled to Spain to study works by Velázquez in the Prado, a typical pilgrimage for Bonnat's students. That same year Mowbray exhibited his *Young Bacchus*, 1879 (NAD), at the Paris Salon, and by 1883, his work had achieved critical recognition and some commercial success. He continued to attend Bonnat's class but did so less regularly. Instead he worked independently, sharing a studio for a time with the genre painter WALTER GAY. Throughout his student period, Mowbray was strongly influenced by the French academic artists, particularly Jean Léon Gérôme, who occasionally offered him criticism and advice. At first Mowbray painted genre scenes such as *The Story*, 1883, and *The Etchers*, 1883 (both unlocated), but by 1884, he was more often doing oriental figure paintings, which remained his specialty well into the 1890s.

When he returned to America in 1885, Mowbray settled in New York, taking a studio in the Sherwood Building. He allied himself with the more progressive artists of his generation and in 1886 joined the Society of American Artists. He only exhibited his work there once, however, in 1898. In 1888, after winning the Thomas B. Clark prize for figure painting at the National Academy of Design he was elected an associate of that institution. The following year, the founder of the prize commissioned Mowbray's first decorative work, *The Month of the Roses* (now unlocated), for the New York Athletic Club's reception room at Travers Island. Although mural painting was later to play an important role in his career, the artist continued to produce easel paintings of oriental subjects, some of which were drawn from romantic literature like Thomas Moore's *Lalla Rookh* (1817). In these years, he also painted a number of portraits, including ones of several members of his family, and from 1892 to 1897, he produced illustrations for *Harper's*, *Scribner's*, and *Century* magazines.

Mowbray was also active as a teacher, most notably at the Art Students League, where he was an instructor from 1886 until 1901, and at the Gotham Art Students, the Metropolitan School of Art, and the Misses Ely School in Brooklyn. His many students included Bryson Burroughs (1869–1934), F. Luis Mora (1874–1940), and Augustus Vincent Tack (1870–1949). After recuperating from a serious illness in 1901, Mowbray went to Italy and served as director of the American Academy in Rome from 1902 to 1904. At this school, which was founded by American artists and patrons in 1897, he made several changes in the program, established an annual exhibition of students' work, and encouraged closer ties with other academic institutions in the city.

From about 1897 on, however, Mowbray had devoted himself almost exclusively to painting murals, in which his idealized figure style was inspired by Renaissance art, which he first studied seriously on a trip to Italy in 1896. "His ideas were lofty," Royal Cortissoz wrote, "they were poetic, as they had been in his younger days of picture-making, but now, in his mural painting they took a more and more monumentally allegorical turn" (*H. Siddons Mowbray, Mural Painter, 1858–1928* [1928], p. 123). Often working in collaboration with the architect Charles F. McKim, Mowbray did murals for both public buildings and private residences. Among his many commissions were decorations for the New York home of Collis P. Huntington, 1892, the residence of F. W. Vanderbilt in Hyde Park, New York, 1897, and the home of Larz Anderson in Washington, 1909. Best known, however, are the scenes he did in New York for the University Club Library, 1904, and the Morgan Library, 1905–1907.

After 1907 the artist made his home in Washington, Connecticut. His first wife, the former Helen Amelia Millard, died in 1912, and, three years later, he married her sister Florence. Mowbray was active in the Red Cross and committees of relief during World War I, and in 1921 was appointed to the National Commission of Fine Arts, an important post previously held by FRANK MILLET and J. ALDEN WEIR. The artist continued to paint, and in 1924, he turned from decorative work to easel paintings depicting events in the life of Christ. At the time of his death, he had just completed a series of panels for an addition to the Morgan Library.

BIBLIOGRAPHY: William Walton, "The Recent Mural Decorations of H. Siddons Mowbray," *Harper's New Monthly Magazine* 72 (April 1911), pp. 724–735, includes many illustrations // Interview with the artist conducted Dec. 11, 12, 1926, De Witt M. Lockman Papers, NYHS, microfilm 503, Arch. Am. Art, includes a list of works prepared by Mowbray // Herbert F. Sherwood, ed., *H. Siddons Mowbray, Mural Painter, 1858–1928* (Stamford, Conn., 1928), includes autobiographical reminiscences by the artist, essays on his work for the National Commission of Fine Arts by Charles Moore and on his murals by Royal Cortissoz, a list of paintings, and genealogical notes // Royal Cortissoz, "H. Siddons Mowbray, American Mural Painter," *Scribner's Magazine* 83 (May 1928), pp. 650–658, reprinted in his *The Painter's Craft* (New York, 1930), pp. 387–399.

Harem Scene

Probably painted after 1884 and before 1897, *Harem Scene* is typical of the orientalist genre scenes that Mowbray made a specialty of early in his career. It is likely that he was attracted to this subject matter by the Salon successes of such academic painters as Jean Léon Gérôme. Unlike a number of Americans who chose similar subjects, however, Mowbray did not travel to North Africa or the Middle East; rather his orientalist scenes seem to be romantic interpretations drawn largely from literature that enjoyed a revival during the 1880s, for example, *Lalla Rookh* (1817) by Thomas Moore and *A Thousand and One Nights*, a collection of ancient Arabian tales. Here he

Mowbray, *Harem Scene*.

depicts several women lounging in a harem, their sensuous bodies and exotic costumes painted in rich colors, juicily applied. The picturesque effect of the scene is enhanced by gaily patterned walls, floors, and textiles. Mowbray's choice of an intimate interior setting, his treatment of the figures, and his painting technique suggest the influence of Frederick A. Bridgman (1847–1929), who was the most successful American painter of oriental scenes working in Paris in the early 1880s.

Oil on canvas, 17 × 22 in. (43.2 × 55.9 cm.).
Signed at lower left: H. SIDDONS MOWBRAY.
REFERENCE: H. F. Sherwood, ed., *H. Siddons Mowbray* (1928), p. 137, notes its presentation to the museum in 1926.
EX COLL.: Edward D. Adams, New York, until 1926.
Gift of Edward D. Adams, 1926.
26.158.3.

ROBERT VONNOH

1858–1933

Vonnoh was born in Hartford, Connecticut, the son of a German-born cabinetmaker. The family lived briefly in Salem and New Bedford, Massachusetts, before settling in Boston, where Vonnoh attended local schools until he was fourteen. He then went to work for Armstrong and Company, a lithographic firm, but also studied with a local artist and attended an evening art class under the direction of Walter Smith (1836–1886) and Charles C. Perkins (1823–1886). In the autumn of 1875 the young artist enrolled in the Massachusetts Normal Art School (later the Massachusetts School of Art), where Edward R. Smith was one of his instructors. Vonnoh later taught at this school as well as at the Boston Free Evening Drawing School and the Thayer Academy in South Braintree. As a student he did watercolor portraits, and some of his work was exhibited at the Centennial Exhibition in Philadelphia in 1876.

Vonnoh made two extended trips to Europe during his formative years. Beginning in 1881, he spent two years in Paris studying at the Académie Julian under Gustave Boulanger and Jules Joseph Lefebvre. Little is known about his work there, but he undoubtedly concentrated on drawing and painting the human figure. In 1887, after an interlude of four years in Boston, he returned to France, where in addition to doing the academic portraits that established his reputation, he worked outdoors, strongly influenced by the impressionist style that was then attracting the attention of many American artists. His plein-air landscapes like *November*, 1890 (PAFA), recall the paintings of such artists as the realist Jules Bastien-Lepage and the impressionist Camille Pissarro in their cool, almost silvery tonality, carefully structured compositions, and broken but restrained brushwork. The garden scene *Poppies*, 1888 (Indianapolis Museum of Art), a remarkably advanced painting, bears the influence of Claude Monet in its vigorous brushwork, vibrant palette, and unconventional format. After four years abroad Vonnoh returned to America, where he did much to promote impressionism, both as a teacher and through exhibitions of his work like the one held at Durand-Ruel in New York in 1896.

The artist taught in Boston at the Cowles Art School in 1884 and 1885 and at the School of the Museum of Fine Arts from 1885 to 1887. More important, beginning in 1891, he became instructor of figure and portrait painting at the Pennsylvania Academy of the Fine Arts, a post he held until 1896. There his pupils included Elmer Schofield (1867–1944) and Edward Redfield (1869–1965), both of whom later worked in an impressionistic style, and William Glackens (1870–1938), John Sloan (1871–1951), and Robert Henri (1865–1929), later members of "the Eight."

Vonnoh became a member of the Society of American Artists in 1892 and that same year began to exhibit at the National Academy of Design. During the 1890s, he worked on portrait commissions in several cities including Philadelphia and Chicago and produced such realistic portraits as *Edward Horner Coates*, 1893 (PAFA). In 1899, following the death of his first wife, he married the sculptor Bessie Potter. He maintained studios in both New York and Chicago around the turn of the century and spent a number of summers painting at the artists' colony in Old Lyme, Connecticut. His work continued to be exhibited widely throughout the early

1900s, in Paris at the Universal Exposition of 1900, in Buffalo at the Pan-American Exposition in 1901, in Munich and Berlin at the exhibition of American art held in those cities in 1910, and, in San Francisco at the Panama–Pacific Exposition in 1915. Around 1910 Vonnoh began to divide his time between New York and Grez-sur-Loing, in France, where he continued to paint landscapes in an impressionist style, albeit less accomplished than his earlier work. He returned to the Pennsylvania Academy as a teacher after 1918, but in 1925, his eyesight began to fail, and thereafter he spent much of his time at his home in France, unable to do much painting. Retrospective exhibitions of his work were held in New York at Ainslie Galleries in 1923 and Durand-Ruel Galleries in 1926. He died in Nice at the age of seventy-five.

BIBLIOGRAPHY: "Robert Vonnoh," *Art and Progress* 4 (June 1913), pp. 999–1003 // "The Vonnohs," *International Studio* 54 (Dec. 1914), suppl. pp. 48–52, discusses the artist and his wife // Robert Vonnoh, "The Relation of Art to Existence: A Noted Painter Voices Some Common-Sense Concerning Everyday Beauty," *Arts and Decoration* 17 (Sept. 1922), pp. 328–329, presents the artist's aesthetic philosophy // "Vonnoh's Half Century," *International Studio* 77 (June 1923), pp. 229–233 // Eliot Clark, "The Art of Robert Vonnoh," *Art in America* 16 (August 1923), pp. 223–232.

La Mère Adèle (Cordon Bleu)

Painted by 1911, *La Mère Adèle* is a sensitive portrait study of an elderly woman shrouded in a dark cloak, her wrinkled face and hands brightly illuminated. Done in a bluntly realistic style this portrait of a peasant woman represents something of a departure for Vonnoh, who had achieved prominence as a society portraitist. Nothing is known about the subject, but the painting's subtitle "Cordon Bleu," inscribed on the reverse, might well be an allusion to her abilities as a cook, perhaps in the Vonnoh household at Grez-sur-Loing.

Oil on canvas, 30 × 24 in. (76.2 × 61 cm.).

Signed at lower right: Vonnoh. Signed and inscribed on the reverse: Portrait · Study no. 2—/ Vonnoh / Madame Adele / (Cordon Bleu).

REFERENCES: R. W. Vonnoh, letter in MMA Archives, May 6, 1923, calls it "La Mere Adele (Cordon Bleu)" and notes that the museum has selected one of the "most representative efforts of my career as a painter" // *Kansas City [Mo.] Times*, April 25, 1923, and *Kansas City [Mo.] Journal*, April 26, 1923, clippings in the scrapbooks of the Kansas City Art Institute, note its acquisition by the MMA // *International Studio* 77 (June 1923), p. 233 // *New York Times*, Dec. 29, 1933, p. 21, mentions it in the artist's obituary // *Art News* 32 (Jan. 6, 1934), p. 10, mentions it in the artist's obituary // *Art Digest* 8 (Jan. 15, 1934), p. 21, mentions it in the artist's obituary // V. B. Riddle, Kansas City Art Institute, letter in Dept. Archives, May 10, 1976, provides clippings from 1923 Kansas City newspapers discussing it.

EXHIBITED: McClees Gallery, Philadelphia, 1911, *Paintings by Robert Vonnoh, N.A.; Sculpture by Bessie Potter Vonnoh, A.N.A.*, no. 42, as La Mère Adèle // Ainslie Galleries, New York, 1923, *Joint Exhibition by Bessie Potter Vonnoh, N.A., Sculpture; Robert Vonnoh, N.A., Paintings*, no. 4, as Madame Adele (Cordon Bleu).

EX COLL.: the artist, until 1923.

George A. Hearn Fund, 1923.

23.109.

Vonnoh, *La Mère Adèle (Cordon Bleu)*.

Vonnoh, *The Bridge at Grez*.

The Bridge at Grez

Vonnoh painted this view from his garden in Grez-sur-Loing near Fontainebleau, once the favorite haunt of the Barbizon painters and their followers. The village was also popular with such American artists as CHILDE HASSAM and WILL H. LOW who spent many summers painting there. As Low reminisced in his autobiography: "He who goes to Grez to-day will find the river, the pleasant garden of the inn, the much-depicted bridge (I believe myself the only painter of my generation who has sojourned there, who has not painted it), and, farther down the street the massive stone ruin of the palace" (*A Chronicle of Friendships* [1908], p. 136). Vonnoh regularly spent his summers in this French village beginning around 1910. Writing to the owner of this picture in 1923, he stated that the work was "painted ab[ou]t 10 years ago," but since the final number of the otherwise illegible date appears to be a five, 1915 is most likely the correct date of the painting.

In this landscape the artist shows the bridge with its simple but massive forms mirrored on the surface of the river. Working in cool, low-key colors, applied with dry, broken brushstrokes, Vonnoh devotes two-thirds of his canvas to the reflections on the water, which appear as solid as the actual forms themselves. The interest in light and atmosphere, the simplified, almost abstract composition, and the choice of subject—a riverside country retreat—recall the late paintings of Claude Monet, whom Vonnoh had admired since the 1880s.

Oil on canvas, $36\frac{1}{2} \times 51\frac{3}{8}$ in. (92.7 × 130.5 cm.).
Signed and dated at lower left: Vonnoh—[illeg.]5.
REFERENCES: R. Vonnoh to F. Lewison, letters in Dept. Archives, Aug. 31, 1921, acknowledges receipt of payment for "Grez Bridge"; April 15, 1923, in response to Mrs. Lewison's request for information about the picture, lists exhibitions and awards for it, notes that Emil Carlsen thought that it should be given to the MMA, says Elmer Schofield was willing to trade "one of his important canvases" for it, and dates it (quoted above) // F. Lewison, letter in MMA Archives, May 15, 1970, offers it to the museum and provides her correspondence with the artist // Mrs. P. C. Rogers, Art Association of Newport, letter in Dept. Archives, Nov. 30, 1977, says it won the Richard S. Greenough medal there in 1920.

EXHIBITED: Connecticut Academy of Fine Arts, Hartford (Annex Gallery of the Wadsworth Atheneum), 1920, no. 20, as Grey [*sic*] Bridge // Newport Art Association, 1920 (no cat. available).

Ex COLL.: the artist, until 1921; Mrs. Louis (Florence) Lewison, New York, 1921–1970.

Gift of Mrs. Louis Lewison, 1970.

1970.149.

HORATIO WALKER

1858–1938

Horatio Walker was born in Listowel, Ontario, the son of a Canadian timber merchant who had emigrated from England in 1856. Walker's early interest in drawing was encouraged by his father, and in 1873 at the age of fifteen, the young man left school to pursue an artistic career. Settling in Toronto, he spent three years working for a photography firm headed by William Notman and the landscape painter John Fraser (1838–1898). He received his first instruction in painting from Fraser and another employee of Notman and Fraser, the marine and landscape painter Robert Gagen (1847–1926), and also had the benefit of some professional criticism from the artists Henri Perré (1828–1890) and Lucius O'Brien (1832–1900). An admirer of Michelangelo and J. M. W. Turner, Walker was impressed by the paintings he was able to see in Toronto, largely works by the English artists Thomas Gainsborough, Sir Joshua Reynolds, and George Morland.

In 1876 Walker left the Toronto firm and went to Philadelphia, where he visited the Centennial Exhibition. He remained in the United States for the next five or six years, moving from place to place. He worked in New York in 1878, and in other years is believed to have been in Syracuse, Detroit, and Boston. In 1882 he lived in Rochester, New York, where he was a founding member of the local art club. The following year he returned to Toronto where he married Jeanette Pretty and worked as an assistant to the photographer Josiah Bruce. Around this time, he made his first trip to Europe, visiting Spain, Belgium, France, and Holland.

During the mid-1880s, when Walker opened a studio in New York, he established a pattern that he followed for much of his career. He traveled to Europe regularly and divided the remainder of his time between New York and Quebec, where in 1888 he purchased a summer home at Ste. Pétronille on the Ile d'Orléans. At first he worked mainly in watercolor and in 1888 won the Evans Prize at the American Water Color Society. By the late 1880s, however, he was more often painting in oil. He was elected a member of the Society of American Artists in 1887, became an associate of the National Academy of Design in 1890, and a full member there the following year. His paintings were promoted by the Montross Gallery in New York, where they were shown regularly, and in 1897 Cottier and Company also held an important exhibition of his work. Walker's greatest popularity was achieved during the next decade when he won medals at several major expositions and was patronized by such leading collectors as Thomas B. Clarke, William T. Evans, Alfred Corning Clark, and George A. Hearn.

No work from the artist's early years, that is prior to 1876, has been located, but it seems that once he took up oil painting in the late 1880s, his technique and subject matter changed little during the course of his career. He used dramatic light effects with strong contrasts and dark somber colors, applying his paint in thick, distinct brushstrokes. Like many of his contemporaries, he was strongly influenced by the Barbizon painters, and, in fact, was called "The American Millet." From typical paintings like *De Profundis*, 1914 or 1916 (National Gallery of Canada, Ottawa), and *Ploughing, the First Gleam*, 1900 (Musée de Québec), however,

it is evident that his subject, the peasant in his rural environment, is drawn as much from his experience on the Ile d'Orléans as from Barbizon precedents.

Not until 1900, when his reputation was well established in the United States, did Walker receive recognition in his native Canada. That year he participated in a four-man exhibition in Montreal. He continued to show his work in Canada and became a founding member of the Canadian Art Club, an organization of mainly expatriate artists formed in 1907. He contributed to their exhibitions from 1908 to 1915 and served as president of the group in 1915 and 1916. His paintings were also shown at the Royal Canadian Academy and the Canadian National Exhibitions, and, in 1915, a special Walker exhibition was held at the Art Gallery of Toronto. Canadian patrons like Sir Edmund Walker collected the artist's work, and in 1913 the Royal Canadian Academy elected him a non-resident academician. Walker maintained a studio in New York, however, until his retirement in 1928 at the age of seventy. The following year the Art Gallery of Toronto and the Galerie des Beaux-Arts in Montreal honored him with a retrospective show of his paintings and drawings, although by this time he was well past the peak of his popularity and his work had become repetitive. Nevertheless, writing the year of the artist's death, F. Newlin Price described the contribution made by this artist:

> Partisan of no recent day is this painter of the North. He sings of olden times, thatched roofs and bitter pioneer winters Those haunts untamed of Horatio Walker's art fade out and leave his paintings as documents of history and art—authentic documents of peasant life against an unstained sky, of a people of simple faith and rugged health, ruddy and buxom and wholesome, nurtured in the crystal air and the clear, cold dawn (*Horatio Walker* [1928], unpaged).

BIBLIOGRAPHY: Charles H. Caffin, "The Art of Horatio Walker," *Harper's Monthly Magazine* 67 (Nov. 1908), pp. 947–956 ‖ M. O. Hammond, "Horatio Walker, Painter of the Habitant," *Canadian Magazine* 53 (May 1919), pp. 21–29 ‖ F. Newlin Price, "Horatio Walker, the Elemental," *International Studio* 77 (August 1923), pp. 359–363; reprinted in a condensed version with additional reproductions in *Horatio Walker* (New York and Montreal, 1928) ‖ National Collection of Fine Arts, Washington, D.C., *American Art in the Barbizon Mood* (Jan. 23–April 20, 1975), exhib. cat. by Peter Bermingham, pp. 169–170; 188; gives biography and bibliography; places Walker's work in the context of the development of American Barbizon painting ‖ Agnes Etherington Art Centre, Queen's University, Kingston, Ontario, *Horatio Walker, 1858–1938* (Dec. 17, 1977–Jan. 28, 1978), exhib. cat. by Dorothy Farr. Most complete treatment of the artist's life and artistic career, includes bibliography and notes on works in exhibition.

The Sheepfold

The influence of the Barbizon School is very strong in the subject and style of this painting of 1890. In a scene of rural life, Walker focuses on a herd of sheep massed in front of a shelter. The artist made a specialty of painting farm animals like these, and as one critic noted: "He gives to the brutes he paints life and soul" (S. Hartmann, *A History of American Art* [1902], 2, p. 246).

Like Jean François Millet's *The Sheepfold, Moonlight* (Walters Art Gallery, Baltimore), Walker's painting shows a single shepherd leading his flock to safety for the night. Both artists imbue a simple rustic scene with a religious spirit by alluding to the theme of the good shepherd. The Millet painting was exhibited in New York in 1889, the year before Walker painted this picture, and it seems likely that he saw it there and was inspired by it. Although far less expressive than the Millet work, *The Sheepfold* captures the dignity of a life spent close to the soil.

Oil on canvas, $20\frac{1}{8} \times 28$ in. (51.1 × 71.1 cm.).

Signed and dated at lower left: Horatio Walker 1890.

Canvas stamp: A. SUSSMANN / dealer in / ARTISTS MATERIALS / 262 Sixth Av / N.Y.

REFERENCES: *The George A. Hearn Gift to the Metro-*

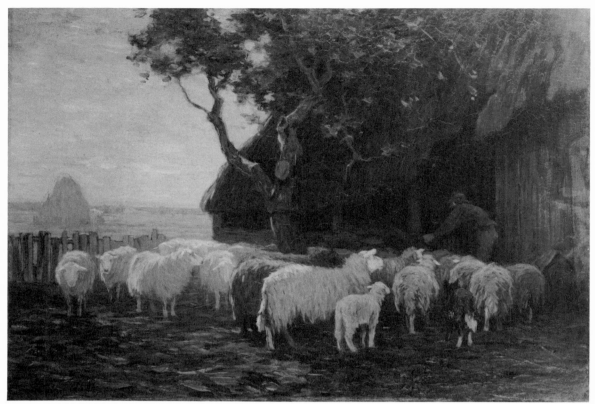

Walker, *The Sheepfold.*

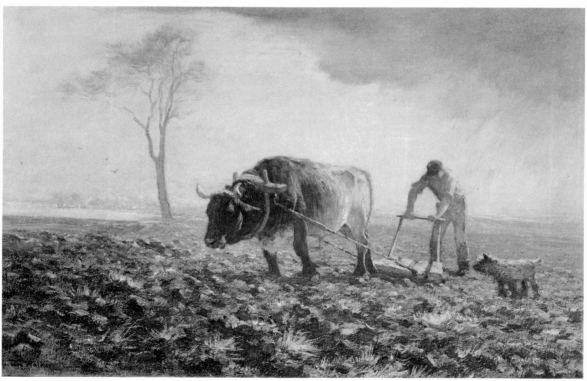

Walker, *The Harrower.*

politan Museum of Art . . . (1906), p. 200, discusses the painting; ill. p. 201 // *George A. Hearn Gift to the Metropolitan Museum of Art . . .* (1913), ill. p. 86 // G. Teall, *Hearst's Magazine* 30 (Nov. 1916), p. 363 // F. N. Price, *Horatio Walker* (1928), unpaged, mentions it // W. R. Johnston, Walters Art Gallery, Baltimore, notes that "Walker, who left Ontario in 1876, may well have seen the Walters version [of Millet's *Sheepfold, Moonlight*] in the Barye Monument Association exhibition in New York in 1889."

EXHIBITED: Lotos Club, New York, 1901, *American Paintings from the Collection of Mr. George A. Hearn*, no. 51, as The Sheepfold // National Gallery of Canada, Ottawa, 1941, *Horatio Walker, R.C.A., N.A., 1858–1938, Memorial Exhibition*, no. 7.

Ex COLL.: George A. Hearn, New York, by 1901–1906.

Gift of George A. Hearn, 1906.

06.1301.

The Harrower

Probably painted near Walker's summer home on the Ile d'Orléans during the early 1890s, *The Harrower* celebrates the labors of farm life. The firmly modeled figure conveys an impression of strength and solidity. Joined with the ox that he guides, he appears to be in close harmony with nature. Man and beast are silhouetted against the fields and distant sky, apparently illuminated by the first light of day. The foreground is strongly painted in a rich brown impasto, a foil to the lighter almost pastel colors of the sky. As one critic described Walker's palette:

His color, which is sometimes sombre, perhaps, or at any rate inclined toward the deeper notes is, however, always rich, pure and true, and in its brighter phases is joyous and vibrating, or serene and full of the intimate charm of sunshine, and bright skies, and the atmosphere which breathes and palpitates with that wondrous life which only he who is a poet at heart can feel and transcribe (*Collector* 8 [April 1, 1897], p. 161).

Oil on canvas, 24 × 36 in. (61 × 91.4 cm.).
Signed at lower left: Horatio Walker.

REFERENCES: B. B[urroughs], *MMA Bull.* 6 (August 1911), ill. p. 159; p. 171 // *George A. Hearn Gift to the Metropolitan Museum of Art . . .* (1913), ill. p. 113 // G. Teall, *Hearst's Magazine* 30 (Nov. 1916), p. 363 // F. N. Price, *Horatio Walker* (1928), unpaged, mentions it.

EXHIBITED: Art Institute of Chicago, 1895, no. 332, as The Harrower // Lotos Club, New York, 1901, *American Paintings from the Collection of Mr. George A. Hearn*, no. 50 // Pan-American Exposition, Buffalo, New York, 1901, *Catalogue of the Exhibition of Fine Arts*, no. 620, lent by George A. Hearn // Lotos Club, New York, 1901, *Exhibition of Paintings Selected from the Pan-American Exposition*, no. 24, lent by George A. Hearn // American Fine Arts Society, New York, 1904, *Comparative Exhibition of Native and Foreign Art* (under the auspices of the Society of Art Collectors), no. 168, lent by George A. Hearn // Carnegie Institute, Pittsburgh 1908, no. 320, lent by George A. Hearn // National Gallery of Canada, Ottawa, 1941, *Horatio Walker, R.C.A., N.A., 1858–1938, Memorial Exhibition*, no. 6 // National Collection of Fine Arts, Washington, D.C., 1975, *American Art in the Barbizon Mood*, no. 86, exhib. cat. by P. Bermingham, p. 169, lists it; ill. p. 170.

Ex COLL.: George A. Hearn, New York, by 1901–1911.

Gift of George A. Hearn in memory of Arthur Hoppock Hearn, 1911.

11.116.3.

MAURICE PRENDERGAST

1859–1924

Maurice Brazil Prendergast was born in St. John's, Newfoundland, where his father, an Irishman, owned a trading post. His mother was a Bostonian of Huguenot descent, and when the father's business failed in 1861, the family moved to Boston. Prendergast attended the Rice Grammar School there until he was fourteen and then went to work in a drygoods store. Relatively little documentation exists about his life and career during the 1870s and 1880s, but it is known that he was apprenticed in a commercial art firm and by 1883 was earning his living

doing illustrations and other commercial work. Three years later he went to Europe with his brother Charles (1863–1924), a painter and woodcarver. Their itinerary on this trip is not known, but they probably visited Paris briefly before returning to Massachusetts in the spring of 1887.

Over the next four years Maurice and Charles (who was always a loyal supporter of his brother's career) saved the money needed for Maurice to study abroad. By January 1891 he was in Paris where he spent the next three years. Studying first at the Atelier Colarossi under Gustave Courtois, he later moved on to the Académie Julian, where his instructors were Jean Joseph Benjamin-Constant, Joseph Blanc, and Jean Paul Laurens. There the Canadian painter James Wilson Morrice (1865–1924) introduced Prendergast to such artists as Charles Conder, Walter Sickert, and Aubrey Beardsley. Under Morrice's influence Prendergast did *pochades*, small oil sketches on wood panels. These usually depicted elegantly dressed women and playful children in the parks and on the avenues, festive urban scenes that remained typical subjects for the artist well into the twentieth century. On trips to French resorts like Dieppe and St. Malo, he filled his sketchbooks with fresh, rapidly executed drawings of figures relaxing on the beaches. He also began to print monotypes, producing as many as two hundred between 1891 and 1902. Initially influenced by the works of Edouard Manet and JAMES MCNEILL WHISTLER, Prendergast had the opportunity in Paris to view exhibitions featuring works by many avant-garde artists, and during his student years he developed a sophisticated modern style inspired by such post-impressionists as Pierre Bonnard and Edouard Vuillard.

Returning to Boston in late 1894 or early 1895, Prendergast joined his brother in nearby Winchester, Massachusetts. On sketching excursions to Beachmont, Marblehead, Revere Beach, and the South Boston Pier, the artist continued to record his impressions in sketchbooks like his large Boston Public Garden Sketchbook, ca. 1895–1897 (Robert Lehman Collection, MMA, 1975.1.924–967). He also prepared illustrations for Thomas Hall Caine's *The Shadow of a Crime* (1895) and James Barrie's *My Lady Nicotine* (1896). He participated for the first time in the annual exhibition of the Boston Watercolor Club in 1897, and a year later his work attracted the attention of such noted Boston collectors as Sarah Bradley and Mrs. J. Montgomery Sears.

In 1898 and 1899 Prendergast spent eighteen months in Europe, primarily in Venice, although he visited Paris briefly. Exposure to such Italian Renaissance painters as Vittore Carpaccio inspired him to attempt more complicated compositions with crowds of figures and striking decorative touches, such as brightly colored banners and umbrellas. He produced a number of monotypes and such masterful watercolors as *Piazza di San Marco* (MMA), in which crowds and flags appear in a myriad of colors and patterns against backgrounds of sunlit Venetian architecture. Returning to Boston, the artist continued to exhibit his work, which was shown at the Art Institute of Chicago and Macbeth Gallery in New York in 1900, the Pan-American Exposition in 1901, and in 1902 at a retrospective at the Cincinnati Art Association, which was the last exhibition devoted solely to his watercolors and monotypes.

During the early years of the twentieth century, Prendergast made many trips to New York, where he painted watercolors and joined five other artists in an exhibition held at the National Arts Club in 1904, a prelude to the landmark exhibition of "the Eight," which was held at the Macbeth Gallery four years later. During this period Prendergast often went abroad, in 1907,

1909–1910, and again in 1911–1912 (when he was hospitalized in Venice for two months with a serious illness). He helped select works for, and participated in, the Armory Show, held in New York in 1913, and the following year, Lizzie P. Bliss and John Quinn, prominent collectors of modern art, sponsored his final trip to Europe. That same year the artist and his brother moved to New York, seeking an environment more sympathetic to their creative efforts. An important Prendergast exhibition was held at the Carroll Gallery in 1914, and the next year another featured two of his large-scale works—*Promenade*, 1915 (Detroit Institute of Arts), and *Picnic*, 1915 (Museum of Art, Carnegie Institute, Pittsburgh)—which with paintings by ARTHUR B. DAVIES and Walt Kuhn (1877–1949), formed a set of decorations purchased by Quinn. During the final years of his career, Prendergast spent his summers sketching in New England and his winters painting in New York.

Although he started to paint in oil in Paris in the 1890s, it was not until 1903 or 1904 that he did so seriously. It is difficult to establish a chronology for his works in this medium as few of them are dated or even securely datable; the compositions of some were developed from earlier watercolors, and many were reworked over a long period of time. Then, too, the artist often repeated the same subjects, compositions, and titles, making conventional documentation through exhibition and sale catalogues, periodicals and newspapers useless unless, of course, they are illustrated. There are, however, certain general trends. His early work in oil, typically park scenes like *Central Park* (q.v.), are filled with animated crowds. In these he creates rich paint surfaces with thick brushstrokes, applied one on top of the other. Perhaps as early as 1905, he undertook portraits and still lifes in oil, but they are more common between 1909 and 1914, when his subject matter became more diversified and included idyllic pastoral and seaside scenes, sometimes with nudes. These later works still have rich paint surfaces, but the artist used a more brilliant palette, applying blocks of color to areas bounded by strong outlines. Then too the compositions are more complicated and tend to be more crowded.

Always a highly individual painter, Prendergast was in the vanguard of American modernism. In Paris during the 1890s, he had successfully adopted the principles of post-impressionism and had gone on to work in an advanced manner that was not widespread in America until after the Armory Show of 1913. In 1921 a small retrospective show of his work was held at the Brummer Gallery in New York. The following year Prendergast's health, never very strong, began to fail. In 1923 he was unable to make his annual summer trip to New England, and he died the following year.

BIBLIOGRAPHY: "Maurice Brazil Prendergast—Painter," *Index of Twentieth Century Artists* 2 (March 1935), pp. 93–96; suppl. Reprint with cumulative index. New York: Arno Press, 1970, pp. 358–361, 365, 367. The most complete bibliography on the artist up to this date, it lists awards and honors, affiliations, exhibitions, public collections that include his work, and reproductions of his major works // MFA, Boston, *Maurice Prendergast, 1859–1924* (1960). An exhibition catalogue for a retrospective show, 1960–1961, that traveled to the Wadsworth Atheneum, Hartford; Whitney Museum of American Art, New York; California Palace of the Legion of Honor, San Francisco, and Cleveland Museum of Art, it contains a biography and discussion of the artist's career by Hedley Howell Rhys, catalogue notes by Peter A. Wick, a bibliography, chronology, and many illustrations // Davis and Long Company, New York, *Charles Conder, Robert Henri, James Morrice, Maurice Prendergast: The Formative Years, Paris 1890's* (May 13–31, 1975), exhib. cat. by Cecily Langdale. A perceptive study of

Prendergast's years in Paris and their influence on his style // University of Maryland Art Gallery, College Park, *Maurice Prendergast* (1976). A catalogue for a traveling exhibition, 1976–1977, that also included the University Art Museum, University of Texas, Austin; Des Moines Art Center, Iowa; Columbus Gallery of Fine Arts, Ohio; Herbert F. Johnson Museum of Art, Cornell University, Ithaca, N.Y.; and Davis and Long Company, New York. Written by Eleanor Green, Ellen Glavin, and Jeffrey R. Hayes, it has a chronology and many illustrations.

Annie Sargent Jewett

Painted around 1905, this portrait depicts Annie Sargent Jewett (1872–?), a nurse for the children of Esther Baldwin Williams (1867–1964), a close friend and student of Prendergast's. Miss Jewett, one of eight children of the former Phebe F. Sargent and of William Henry Jewett, a dealer in leather and shoe findings, was raised in Gloucester, Massachusetts. She later lived in nearby Annisquam, where she worked for the Williamses who took a country house there in

Prendergast, *Annie Sargent Jewett.*

1901. Prendergast often visited Annisquam, and on May 14, 1905, he wrote to Mrs. Williams, praising the "country and seashore[,] the fine location of the house[,] the flowers and the neighbors and the solitary tent on the Dunes across the bay[,] all of which I am not going to forget for a long while and I shall enjoy going down there again even for a day" (Esther Williams Papers, 917, Arch. Am. Art).

Like Prendergast's portrait of Mrs. Oliver Williams, 1902–1905 (see University of Maryland Art Gallery, *Maurice Prendergast* [1976], p. 114), the painting depicts a full-length figure in an outdoor setting at Annisquam. Here, however, the artist uses richer colors and less fluid brushwork, applying the paint in pronounced, broken brushstrokes to create strong patterns of color and texture. The woman's figure is flat and reduced to a dark silhouette, which is suspended in front of a landscape backdrop that serves as a foil to her plain brown dress. Although highly abstracted, the setting can be identified as the grounds of the Williamses' Annisquam home from a family photograph album (Esther Williams Papers, 921, Arch. Am. Art), which shows the wall of a weathered tool shed with a similar trellis and shuttered window.

In 1905, around the time that this portrait was painted, the Williamses moved to 92 Mount Vernon Street in Boston not far from the home and studio Maurice Prendergast had taken only two years earlier at 56 Mount Vernon Street. The artist was probably a frequent visitor at the Williamses' Boston home, and the couple became enthusiastic patrons of his work. The painting remained in the Williams family until its presentation to the museum. There is in the collection another portrait of Annie Sargent Jewett painted about the same time (see FOLLOWER OF PRENDERGAST).

Oil on canvas, 30 × 19⅜ in. (76.2 × 49.2 cm.).
Signed at lower right: . Prendergast.
REFERENCES: MFA, Boston, *Maurice Prendergast, 1859–1924* (1960), cat. for traveling exhibition, essay

by H. H. Rhys, p. 48, includes it in a discussion of the artist's portraits, says it is unfinished, dates it 1902, the same year as the portrait of Mrs. Williams. // P. McKinney, stepson of the donor, letters in Dept. Archives, Dec. 1, 1976, provides information on the sitter, donor, and the donor's relationship with the artist; Jan. 1977, gives information on the provenance // O. Williams, brother of the donor, letter in Dept. Archives, May 1979, discusses the subject and setting.

Ex coll.: Esther Baldwin (Mrs. Oliver E.) Williams, Boston, died 1964; her daughter, Esther Williams McKinney, Boston and Rockport, Mass., after 1964–1969; estate of Esther Williams McKinney, 1969–1970.

Bequest of Esther Williams McKinney, 1970. 1970.123.1.

Central Park

This painting captures the festive spirit and leisure-time activities of people in New York's Central Park, where Prendergast often painted watercolors during the early years of the twentieth century. Showing the park's three-way transportation system with separate paths for carriages, horses, and pedestrians, the composition is divided into corresponding horizontal registers arranged parallel to the picture plane. The sense of movement given by the striding figures and galloping horses is punctuated by the strong vertical lines of the trees. Typical of post-impressionist compositions, the picture plane recedes upward rather than backward. The decorative treatment is similar to such French works of the 1890s as Paul Gauguin's oil painting *Ta Matete—The Market*, 1892 (Kunstmuseum, Basel) and Pierre Bonnard's color print *Boulevard*, from the album *Quelques aspects de la vie de Paris* (1895), both of which Prendergast could easily have known.

The picture, which has been called *Central Park in 1903*, is not dated and like many of the artist's oil paintings, it may have been reworked over an extended period of time. Thus, although the scene may be set in 1903, the ambitious scale and complete mastery of the oil medium suggest that it was painted between 1908 and 1910. The composition is based on a watercolor from about 1902, *The Bridle Path, Central Park* (now unlocated). Compared to the watercolor, however, the Metropolitan's painting shows some subtle refinements. There is less detail, especially in the foliage. Prendergast also made slight adjustments in the placement, poses, and outlines of the figures and

horses. Despite these differences, however, the oil and the watercolor are very similar in style and technique. In both works, for example, color is applied in distinctly separate, irregularly shaped brushstrokes, with occasional patches of the ground showing through. The close relationship between the watercolor and the oil is hardly surprising, as the artist was an accomplished watercolorist and only began to work seriously in oil in 1903 or 1904.

While working on *Central Park*, Prendergast made a number of changes in the foreground, adding several figures on the pedestrian path, none of which are evident in *The Bridle Path, Central Park*. Then he seems to have changed his mind and painted them out, returning to the original conception of the watercolor. These changes, which the artist barely disguised with rough layers of scumbled paint, are clearly visible today.

Oil on canvas, 20¾ × 27 in. (52.7 × 68.6 cm.). Signed at lower right: Prendergast.

RELATED WORK: *The Bridle Path, Central Park*, 1902, watercolor, 14¾ × 21¾ in. (37.5 × 55.2 cm.), unlocated, ill. in Whitney Museum of American Art Papers, New York, microfilm N/681, Arch. Am. Art.

REFERENCES: Typed notes, [1940s], Whitney Museum of American Art Papers, New York, microfilm N/680, Arch. Am. Art, dates this picture between 1903 and 1916, gives owner, lists exhibitions, and notes similarity to The Bridle Path, Central Park // D. Grafly, *American Artist* 18 (April 1954), ill. p. 41 // MFA, Boston, *Maurice Prendergast, 1859–1924*, exhib. cat. by H. H. Rhys, p. 42, says it was reworked as late as 1915; p. 90, discusses relationship to the watercolor The Bridle Path, Central Park and the Bonnard lithograph // A. Kraushaar, Kraushaar Galleries, letter in Dept. Archives, Dec. 8, 1976, gives provenance and lists exhibitions // C. B. Ferguson, New Britain Museum of American Art, Conn., letter in Dept. Archives, May 5, 1977, provides information on 1943 exhibition // C. Langdale and R. Davis, Davis and Long, New York, orally, Feb. 22, 1979, dated it about 1908 to 1910.

EXHIBITED: Whitney Museum of American Art, New York, 1934, *Maurice Prendergast Memorial Exhibition*, no. 52, as Central Park in 1903, lent by Charles Prendergast // Addison Gallery of American Art, Phillips Academy, Andover, Mass., 1938, *The Prendergasts*, no. 69, Central Park, New York, lent by Kraushaar Gallery, dates it from about 1903 to 1916 // Colorado Springs Fine Arts Center, 1940, *Paintings by Maurice Prendergast, Gifford Beal, and Guy Pène du Bois* (no cat.) // New Britain Museum of American Art, Conn., 1943, *19th Century and Contemporary Watercolors and Paintings* (checklist) // Brooklyn Museum; Carnegie Institute, Pittsburgh; Worcester Art Museum, 1943–1944, *The Eight*, no. 46, dates it from about 1903

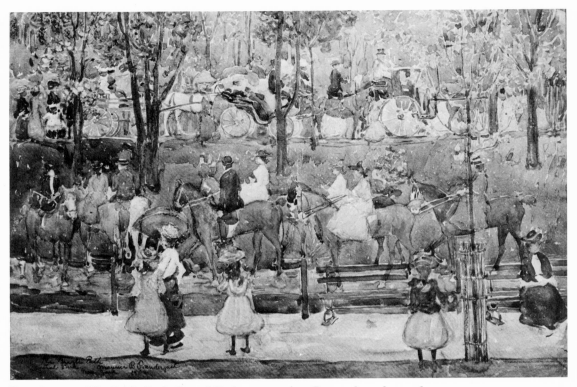

Prendergast, *The Bridle Path, Central Park*, watercolor. Presently unlocated.

to 1915 // MMA, 1950, *100 American Painters of the 20th Century*, intro. by R. B. Hale, p. xx, lists it; ill. p. 35; 1965, *Three Centuries of American Art* (checklist alphabetical); 1965, *American Painting in the Twentieth Century*, exhib. cat. by H. Geldzahler, p. 36, discusses it; ill. p. 37 // University of Maryland Art Gallery, College Park, traveling exhibition, 1976–1977, *Maurice Prendergast*, exhib. cat. by E. Green and E. Glavin, no. 39, pp. 106–107, dates it 1903, says it is a remembered view and includes some misinformation regarding provenance.

Ex COLL.: the artist's brother, Charles Prendergast, Westport, Conn., from about 1924 to at least 1934; with Kraushaar Galleries, New York, by 1938–1950.

George A. Hearn Fund, 1950.

50.25.

Portrait of a Girl with Flowers

The model for this painting was Edith Lawrence King (1884–1975), an artist and teacher who was born in Boston and raised in Chelsea, Massachusetts. Sometime between 1908 and 1910, after attending college briefly, she began to teach drawing and painting at the Buckingham School in Cambridge, Massachusetts. There she met Dorothy Coit, who first interested her in designing costumes and scenery for children's plays. The two continued to teach at the Buckingham School until 1922 and also collaborated on children's productions in New England and New York. They settled in New York in the early 1920s

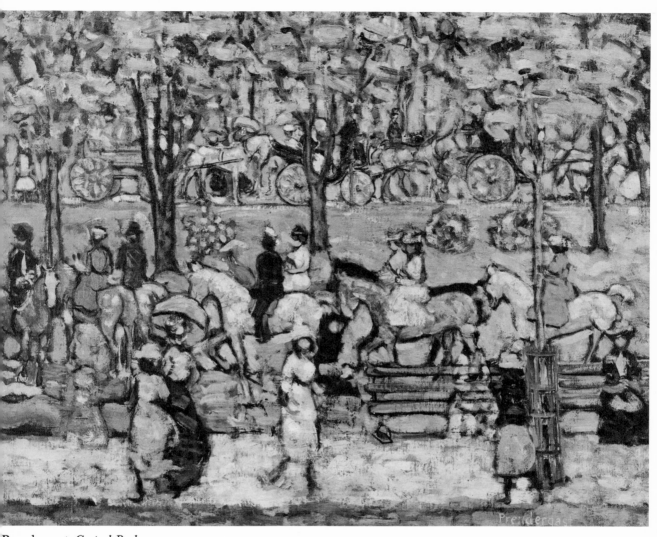

Prendergast, *Central Park*.

and in 1923 established the King-Coit School of Acting and Design, later the King-Coit Children's Theatre. Theatrical productions were the central focus of the school's curriculum, which stressed acting, dancing, drawing, and painting. Edith King designed the costumes and scenery for the school's plays. Photographs and examples of these designs can be found in the Lincoln Center Library for the Performing Arts, in New York, and the Harvard Theatre Collection, Cambridge, Massachusetts.

Miss King painted with Prendergast on Capri around 1910, and several of her early water-colors, strongly reminiscent of his style, were exhibited at the Armory Show in 1913. *Portrait of a Girl with Flowers* probably dates from about 1913, when both the artist and the sitter were working in the Boston area. Edith King also posed for *La Rouge*, ca. 1913 (Anna E. Wilson Memorial Collection, Lehigh University, Allentown, Pa.), a painting in which Prendergast also shows her beside an arrangement of flowers. Ambitious in composition, these two paintings of Edith King differ significantly from the simpler, bust-length children's portraits typical of

Prendergast's work at this period. In *Portrait of a Girl with Flowers* the subject is seated in front of a table which supports a vase of flowers, and behind her is the faint indication of a framed picture. With little concern for three-dimensionality or plausible spatial relationships, the artist concentrates on color and design. The composition is actually a calculated arrangement of flowing lines, seen in the swelling contours of the vase and its handle and in the sitter's broad-brimmed hat, round shoulders, and necklace of large beads. These curved shapes are often emphasized by strong outlines. Over most of the canvas Prendergast uses thick, irregularly-shaped blocks of color, fluidly applied to achieve a rich tapestry-like effect. His paint application, except in the relatively realistic face of the sitter, enhances the decorative quality of the picture.

Oil on canvas, 21 × 18 in. (53.3 × 45.7 cm.). Signed at lower right: Prendergast.

REFERENCES: MFA, Boston, *Maurice Prendergast* (1960), exhib. cat. with notes by P. A. Wick, p. 72, gives biography of sitter and describes the picture // A. Kraushaar, Kraushaar Galleries, New York, letter in Dept. Archives, Dec. 8, 1976, provides information

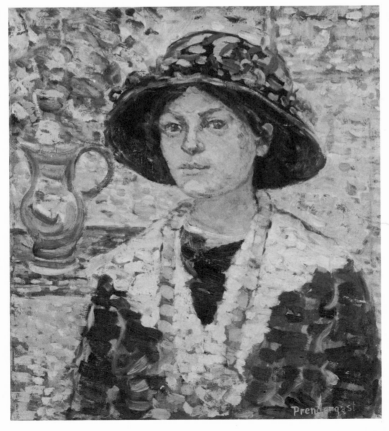

Prendergast, *Portrait of a Girl with Flowers*.

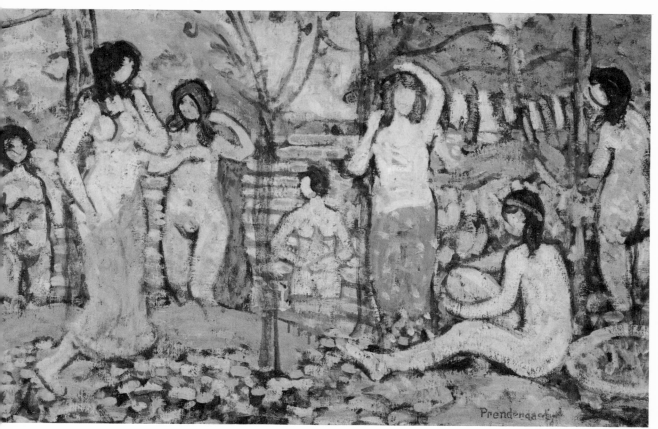

Prendergast, *Beach No. 3.*

on the provenance // E. Rodman, New York, letters in Dept. Archives, March 7 and 9, 1979, provides biographical information on the sitter and discusses the King-Coit School.

EXHIBITED: Kraushaar Galleries, New York, 1950, *Maurice Prendergast, Retrospective Exhibition of Paintings, Water Colors and Monotypes*, ill. no. 9, dates it 1913 // Wadsworth Atheneum, Hartford, 1955, *Twentieth Century Painting from Three Cities, New York, New Haven, and Hartford*, no. 43, lent by Adelaide M. de Groot; p. 16, dates it ca. 1910 // MMA, 1965, *Three Centuries of American Painting* (checklist alphabetical), lent by Adelaide Milton de Groot.

ON DEPOSIT: Wadsworth Atheneum, Hartford, Conn., 1950–1956, lent by Adelaide Milton de Groot // MMA, 1956–1967, lent by Adelaide Milton de Groot.

Ex COLL.: the artist's brother, Charles Prendergast, Westport, Conn., by about 1924; with Kraushaar Galleries, New York, 1950; Adelaide Milton de Groot, New York, 1950–1967.

Bequest of Miss Adelaide Milton de Groot (1876–1967), 1967.

67.187.137.

Beach No. 3

Like so many of Prendergast's idyllic subjects, this one shows figures by the waterside, in this case a body of water so abstract that the picture was for a time called *Bathers by a Waterfall*. Painted around 1913, *Beach No. 3* was obviously done under the influence of Puvis de Chavannes and Cézanne, whose works Prendergast studied on his trips to Europe in 1907 and 1909–1910. He actually drew copies of Puvis's nudes and draped figures in landscape settings, for example, the French artist's *Doux pays*, ca. 1882 (Musée Bonnat, Bayonne) and *L'Été*, 1873 (Musée des Beaux-Arts, Chartres) appear in Prendergast's sketchbooks (no. 13, p. 44 and no. 46, p. 34) now in the Museum of Fine Arts, Boston. In the Metropolitan's picture Prendergast captured the same tranquil, timeless spirit seen in many of Puvis's classical subjects.

In regard to Cézanne, Prendergast wrote from

Maurice Prendergast

Paris on October 10, 1907, when a Cézanne retrospective was on view at the Salon d'Automne, and predicted that "Cézanne will influence me more than the others" (letter to E. Williams, Esther Williams Papers, 917, Arch. Am. Art). Indeed, the distorted bodies, inflated limbs, and unnatural poses of the figures in *Beach No. 3* are much like those seen in such Cézanne paintings as *Bathers at Rest*, 1875–1876 (Barnes Foundation, Merion, Pa.). Prendergast's composition, however, is less tightly orchestrated than is usual in a Cézanne. Not only are Prendergast's figures separated by their self-contained poses, they are each placed on the canvas with little consideration for relative size, distance, or overall compositional coherence. In all probability the artist assembled his figures from the many quick drawings of nudes that fill his sketchbooks.

In this picture further French influence can be seen in the strongly patterned and richly textured paint application, which is not unlike that of the Nabis. The figures are outlined in dark colors like mauve and blue, and the flesh is made up of scumbled yellows, oranges, and pinks, with touches of chartreuse reflected from the surrounding landscape. The elements of the setting are suggested only in a general way. In the foreground, the artist uses bright green for the grass but adds dabs of orange and yellow for the foliage. At the top of the canvas, broadly applied ocher represents the distant landscape. The water in the middle ground is painted with horizontal strokes, fairly regular in appearance. These are done in a rich turquoise blue, brushed through with touches of such colors as yellow and pink. Fascinated by the coloristic possibilities of water, Prendergast once observed that even "drab water has a lot of lake[,] yellow whites[,] red pinks[,] purple[,] green whites[,] green blues" (Sketchbook, no. 67, p. 7, MFA, Boston).

Beach No. 3 is one of a large group of the artist's works bought from Carroll Galleries in 1915 by John Quinn, a prominent New York collector of modern art and an important patron of Prendergast's. As the artist painted a number of similarly titled works, it is not possible to document the early exibition history of this painting completely.

Oil on canvas, 18⅞ × 29⅞ in. (47.9 × 75.9 cm.).
Signed at lower right: Prendergast.
REFERENCES: Carroll Galleries, New York, bill to J. Quinn, Feb. 19, 1915, John Quinn Memorial Collection, Manuscript Division, NYPL, lists it as Beach No. 3 (1913), no. 20, $400, in a group of Prendergast works

sold to Quinn // J. Quinn, Art Ledger, coll. Thomas F. Conroy, copy in Archives of the Hirshhorn Museum and Sculpture Garden, Washington, D.C., vol. 1, p. 137, lists it as Beach No. 3, purchased in 1915; p. 141, says it was bought from Carroll Galleries on Feb. 19, 1915, where it was no. 20 in exhibition, and gives price as $400 // "Estate of John Quinn, Deceased, Catalogue of the Art Collection Belonging to Mr. Quinn (July 28, 1924), John Quinn Memorial Collection, Manuscript Division, NYPL, notes date acquired and price // *John Quinn . . . Collection of Paintings, Water Colors, Drawings & Sculpture* (1926), p. 25, lists it as "Beach," (no. 3), 1913 // American Art Association, New York, *Paintings and Sculptures, the Renowned Collection of Modern and Ultra-Modern Art Formed by the Late John Quinn* (1927), sale cat., p. 40, no. 93, lists it as Beach, dates it 1913; ill. p. 41 // *Art News* 25 (Feb. 19, 1927), p. 6, lists price and purchaser from Quinn sale // MFA, Boston, *Maurice Prendergast, 1859–1924* (1960), cat. for traveling exhibition, essay by H. H. Rhys, p. 52, mentions it as Bathers by a Waterfall in a discussion of nude figure studies, dates it 1913, and compares to Gauguin // University of Maryland Art Gallery, College Park, *Maurice Prendergast* (1976), exhib. cat., p. 65, says in chronology that according to the Carroll Gallery exhibition catalogue, it was painted in 1913, notes other exhibitions // Hirshhorn Museum and Sculpture Garden, Washington, D.C., "*The Noble Buyer," John Quinn Patron of the Avant-Garde* (1978), exhib. cat. by J. Zilczer, p. 193, notes that the painting was purchased by Kraushaar // A. Kraushaar, Kraushaar Galleries, New York, orally, Feb. 27, 1979, identified this picture as the Beach and said it was purchased at the 1927 Quinn sale by John Kraushaar // J. Zilczer, Hirshhorn Museum and Sculpture Garden, Washington, D.C., letter in Dept. Archives, March 1, 1979, gives detailed information on the provenance and exhibition history, supplying copies of manuscript material in Quinn collection.

EXHIBITED: Carroll Galleries, New York, 1915, *Maurice Prendergast*, no. 20, Beach No. 3 (no cat. available) // St. Botolph Club, Boston, 1916, *Paintings by William Glackens, Maurice B. Prendergast, William E. Schumacher*, no. 13, as The Beach, No. 3 (possibly this painting) // Kraushaar Galleries, New York, 1925, *Catalogue of a Memorial Exhibition of Paintings and Watercolors by Maurice Prendergast*, no. 33, as Beach Scene No. 3; 1950, *Maurice Prendergast Retrospective Exhibition of Paintings, Water Colors and Monotypes*, no. 13, as Bathers by a Waterfall, misdates it 1916 // Wadsworth Atheneum, Hartford, 1951, *100 Years of American Painting* (no cat.) // MMA and American Federation of the Arts, traveling exhibition, 1975–1976, *The Heritage of American Art*, cat. by M. Davis, ill. p. 183, as Bathers by a Waterfall, discusses it.

ON DEPOSIT: Wadsworth Atheneum, Hartford, 1950–1956, lent by Adelaide Milton de Groot // MMA, 1956–1967, lent by Adelaide Milton de Groot.

EX COLL.: with Carroll Galleries, New York, 1915; John Quinn, New York, 1915–1924; estate of John

Quinn, 1924–1927 (sale, American Art Association, New York, Feb. 9, 1927, no. 93, Beach, $1,050); with Kraushaar Galleries, New York, 1927–1950; Adelaide Milton de Groot, New York, 1950–1967.

Bequest of Miss Adelaide Milton de Groot (1876–1967), 1967.

67.187.135.

Group of Figures

Probably painted after 1916, this picture is typical of Prendergast's late work in subject, composition, and its unfinished appearance. He has misspelled his name in the signature, but the authenticity of the picture is not in doubt. Prendergast has, however, heavily reworked the canvas, for example, a number of the figures have been carelessly covered over, and parts of them still linger in the foliage and water. Then, too, many details, such as the tree which appears to grow through the park bench, are added casually with little concern for proper scale or spatial relationships.

In this park scene, Prendergast shows people compressed into a narrow foreground stage. Their poses are awkward, with limbs and torsos bent in arabesques that echo the curved trees that surround them. There is little spatial recession beyond the frieze of foreground trees and figures, and the water and distant shoreline merely serve as a flat backdrop. This decorative composition is enhanced by thick, bold brushwork, in which paint is applied unevenly in blocks, dabs, and rapid strokes to create lively patterns of texture and color. The picture has many of the qualities praised by the artist's friend Charles Hovey Pepper (1864–1950), a painter who tersely itemized the contents of Prendergast's park scenes:

People in movement, holiday folk in their saffron, violet, white, pearl, tan. Quaint design. Color powerful, but not crude. Canvasses built up with overpainting—color dragged on color. A paint quality as delicious as an old tapestry. This is the art of Prendergast (*World To-day* 19 [July 1910], p. 719).

Oil on canvas, 23¼ × 27¾ in. (59.1 × 70.5 cm.).
Signed at lower right: Prndergast.
REFERENCES: H. S. Francis, *Bulletin of the Cleveland Museum of Art* 20 (June 1933), p. 101, notes it in an exhibition there // "Works by Maurice Prendergast," typescript [1940s], Whitney Museum of American Art, New York, microfilm N/680, Arch. Am. Art, lists it as no. 108, Group of Figures, dates it 1917, and gives Kraushaar as owner // A. Kraushaar, Kraushaar

Prendergast, *Group of Figures*.

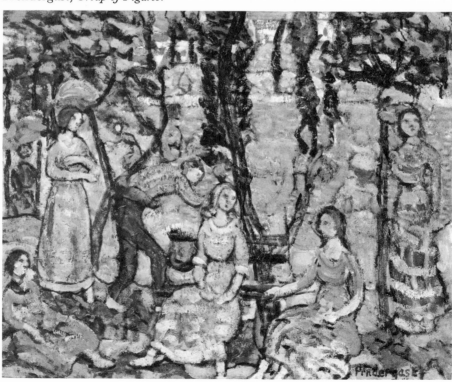

Galleries, letter in Dept. Archives, April 1, 1979, gives provenance and detailed exhibition history.

EXHIBITED: C. W. Kraushaar Art Galleries, New York, 1925, *Catalogue of a Memorial Exhibition of Paintings and Water Colors by Maurice Prendergast*, no. 30, A Group of Figures; 1933, *Maurice Prendergast*, no. 13, Group of Figures // Cleveland Museum of Art, 1933, *Thirteenth Exhibition of Contemporary American Oils*, checklist in *Bulletin* (June 1933) above // Whitney Museum of American Art, New York, 1934, *Maurice Prendergast Memorial Exhibition*, no. 70, lent by C. W. Kraushaar Art Galleries, dates it 1920 // Museum of Modern Art, New York, 1934–1935, *Fifth Anniversary Exhibition*, ill. no. 133, Group of Figures, lent by Kraushaar Galleries, New York, dates it ca. 1916 // Wadsworth Atheneum, Hartford, 1935, *American Painting and Sculpture of the 18th, 19th, and 20th Centuries*, no. 81, lent by Kraushaar Galleries, dates it about 1916 // Baltimore Museum of Art, 1938, *Two Hundred Years of American Painting*, no. 24, lent by C. W. Kraushaar Galleries, unpaged, lists exhibitions // Addison Gallery of American Art, Phillips Academy, Andover, Mass., 1938, *The Prendergasts*, p. 24, no. 84, lent by Kraushaar Gallery, dates it about 1917 // C. W. Kraushaar Galleries, New York, 1940, *Paintings by Maurice Prendergast*, no. 2, dates it

1914 // Wadsworth Atheneum, Hartford, Conn., 1960, *The Adelaide Milton de Groot Loan Collection* (no cat.) // Columbus Gallery of Fine Arts, Ohio, 1958, *Masterpieces from the Adelaide Milton de Groot Collection*, no. 30 // MMA, 1965, *Three Centuries of American Painting* (checklist alphabetical), lent by Adelaide Milton de Groot // Los Angeles County Museum of Art, and M. H. de Young Memorial Museum, San Francisco, 1966, *American Paintings from the Metropolitan Museum of Art*, no. 122, lent by Adelaide Milton de Groot.

ON DEPOSIT: Wadsworth Atheneum, Hartford, 1949–1956, lent by Adelaide Milton de Groot // MMA, 1956–1967, lent by Adelaide Milton de Groot.

EX COLL.: the artist's brother, Charles Prendergast, Westport, Conn.; with C. W. Kraushaar Galleries, New York, 1925–1949; Adelaide Milton de Groot, New York, 1949–1967.

Bequest of Miss Adelaide Milton de Groot (1876–1967), 1967.

67.187.136.

FOLLOWER OF PRENDERGAST

Annie Sargent Jewett

This unfinished oil sketch, done on a commercially made canvas-textured board, shows the same woman who appears in MAURICE PRENDERGAST's *Annie Sargent Jewett* (see above). The pose and setting in the picture are so similar to the Prendergast that this painting was once considered to be a study for that larger and more elaborate oil. Prendergast's portrait, however, differs too much from this work, not only in detail but in its entire conception, for this to have served as a preliminary study for it. Then, too, the oil sketch is not painted in Prendergast's style: the loose, almost formless, brushwork bears little resemblance to the innumerable broken brushstrokes the artist used to build up rich patterns of color and texture, and the composition lacks the strong design that is typical of his work. Furthermore, the making of a preliminary oil study does not correspond with the artist's known working technique. He usually developed his compositions either from drawings or watercolors—a preliminary oil sketch would be exceptional in his œuvre. Thus it is more likely that this painting was done by another artist, someone who was working with Prendergast when he painted Miss Jewett around 1905.

While not known with certainty, the painter of this picture is most likely Esther Baldwin Williams (1867–1964). Not only did Mrs. Williams own

Follower of Prendergast,
Annie Sargent Jewett.

this painting and the one by Prendergast, but Annie Sargent Jewett was her children's nurse and the scene depicted is her Annisquam summer home. Unfortunately not enough is known about her style at this time to attribute the work to her with complete assurance. Esther Williams was active as a painter from the late 1880s until about 1907, when the demands of family life curtailed her career. She began her art training with an uncle, the painter J. Foxcroft Cole (1837–1892), and then studied in Paris, first in 1887 and later from 1891 until 1892. It is not known precisely where or with whom she studied, but in a letter to a friend on March 20, 1887, she mentioned that she was planning to make copies in the Louvre and to attend the atelier of Emile Auguste Carolus-Duran (Esther Williams Papers, 917, Arch. Am. Art). Her early portraits like *Caroline Baldwin* (private collection) suggest just such academic training. Before her marraige to the banker Oliver E. Williams in 1898, she worked in a studio in Boston. Little is known of her work during the early 1900s, but she seems to have done watercolors and drawings of children at this time, and throughout her career, she made a specialty of cats.

Prendergast was a frequent visitor at Mrs. Williams's home in Annisquam, and beginning in 1905, they were neighbors on Mount Vernon Street in Boston. He served as her mentor, and in all probability they often painted together. In fact, in a letter of November 4, 1905, we find Prendergast asking her to share her studio with him. "I find," he wrote, "when two together are working from the same head there is more th[an] an inspiration" (Esther Williams Papers, 917, Arch. Am. Art). Given their close relationship, it is entirely likely that they both painted Miss Jewett in the garden of the Williamses' Annisquam home. This would explain the use of a similar palette in the two works as well as the same pose and setting. It would also account for the hesitant, almost amateur, quality of this painting, in which the artist has attempted only a representational plein-air portrait, eschewing the formal considerations of color and design that are always foremost in Prendergast's work.

Oil on artist's board, 21¾ × 15 in. (55.2 × 38.1 cm.).

Stamped on reverse before treatment: Winsor & Newton [LOND]ON / OIL SKETCHING [BOA]RDS / Made in all sizes and [supplied in the] / following [canvas] surfaces, [Griffin] / Ti[ck]en, [Winton,] / [Roman,] / [and British].

REFERENCES: J. B. Adams, Winsor and Newton, Secaucus, N.J., letter in Dept. Archives, Jan. 11, 1979, provides information on the artist's board and stamp // C. Langdale, Davis and Long, New York, orally, March 27, 1979, after examining the picture, agreed that it is not consistent with Prendergast's style // N. Williams, daughter-in-law of Esther Williams, April 18, 1979, letter in Dept. Archives, provides extensive information on that artist's life and career.

Ex COLL.: Esther (Mrs. Oliver E.) Williams, Boston, died 1964; her daughter, Esther Williams McKinney, Boston and Rockport, Mass., 1964–1969; estate of Esther Williams McKinney, 1969–1970.

Bequest of Esther Williams McKinney, 1970.
1970.123.1.

CARNIG EKSERGIAN

1859–1931

A portrait painter of Armenian descent, Carnig Eksergian was born in Constantinople (now Istanbul). He studied in Paris with Emile Auguste Carolus-Duran and at the Ecole des Beaux-Arts, and the few examples of his work known today show the influence of French academic portraiture. In 1882 Eksergian went to Boston, where he shared a studio with his brother Telemaque Eksergian (ca. 1841–1891), a painter of portraits and views of Turkish interiors who had immigrated to America three years earlier. After Telemaque moved to New York in 1886, Carnig continued to maintain a studio in Boston until at least 1911. There

he painted portraits of such prominent Bostonians as Mrs. Julia Ward Howe (MFA, Boston). He lived in Somerville, Massachusetts, with his wife, the former Zoe Huntington, and their three children. Between 1911 and 1923, however, he worked in New York, where M. Knoedler and Company held an exhibition of his paintings in 1913. His summers were spent in New Hampshire, where he painted landscapes, often with sunsets; he died there at the age of seventy-two.

BIBLIOGRAPHY: "Funeral of Telemaque Eksergian," *New York Times*, August 8, 1891, p. 8 // Twelfth Census of the United States, schedule 1, Population, Massachusetts, Enumeration District No. 944, sheet no. 12, provides information on the artist and his family // "Eksergian's Portraits in Harperly Hall," *New York Times*, March 2, 1913, sec. 5, p. 15 // Obituaries: *New York Times*, August 25, 1931, p. 21; *Art Digest* 5 (Sept. 1, 1931), p. 6.

Isaac D. Fletcher

Done in the realistic style popularized by nineteenth-century French academic painters like Léon Bonnat and Emile Auguste Carolus-Duran, this portrait was painted in 1914. Isaac Dudley Fletcher (1844–1917), a native of Bangor, Maine, settled in New York in 1865 and became a successful merchant. He was president of the Barrett Manufacturing Company and a member of the Lotos and Union League clubs. A benefactor of the Metropolitan, the subject bequeathed the museum money and his art collection, which included ancient art, European sculpture and decorative arts, as well as Chinese ceramics and paintings.

Oil on canvas, 40¼ × 30¼ in. (102.2 × 76.8 cm.).
Signed at lower right: *C. Eksergian/1914*.
REFERENCES: *MMA Bull.* 13 (March 1918), p. 61.
EX COLL.: Isaac D. Fletcher, New York, 1914–1917.
Bequest of Isaac D. Fletcher, 1917.
17.120.208.

Eksergian, *Issac D. Fletcher*.

ELLIOTT DAINGERFIELD

1859–1932

The artist was born in Harper's Ferry, Virginia, and raised in Fayettesville, North Carolina, where his father commanded the Confederate arsenal during the Civil War. In his youth Elliott Daingerfield painted watercolors, taking lessons from a local painter of china, Mrs.

William McKay. He was later apprenticed to a photographer who taught him to take and color photographs. Then he studied for six months in Norfolk, Virginia, with an artist who has not been identified. In 1880, Elliott Daingerfield settled in New York. He continued to visit North Carolina, however, and after 1886, he spent most of his summers at Blowing Rock, a resort town in the Blue Ridge Mountains, which provided the setting for many of his landscapes.

Following his arrival in New York, Daingerfield did some commercial work and helped the illustrator and painter Walter Satterlee (1844–1908) in his studio in exchange for instruction and criticism. The young artist also assisted in Satterlee's still-life class and studied off and on at the Art Students League. Paintings by Daingerfield were exhibited at the National Academy of Design as early as 1880 and at the Society of American Artists a decade later, but it was not until the early years of the twentieth century that the artist was elected a member of either organization. He never studied abroad but made two trips to Europe in 1897 and 1924, when his style was already established. Nevertheless, his early work shows the influence of Barbizon painting, the ideas and techniques of which he derived from the work of GEORGE INNESS, whom he met in the 1880s. Although never formally a student of Inness's, Daingerfield was greatly influenced by him and followed his lead, painting figure studies and landscapes from memory rather than direct observation. He praised Inness for "the principles underlying his composition, the science of his balances and rhythm, his knowledge and taste in truth of sky, of tree form, of ground construction—these are matters that should arouse the liveliest interest, and which will reward the utmost study" (*George Inness* [1911], p. 49).

Beginning in the 1890s, Daingerfield undertook religious subjects usually with Biblical themes like his *The Story of the Madonna*, ca. 1900 (coll. Mrs. Charles A. Cannon), which won the National Academy's Thomas B. Clarke prize for figure painting in 1902. That same year, the artist was commissioned to paint murals for the Lady Chapel of the Church of St. Mary the Virgin in New York. He continued, however, to paint landscapes and during the early years of the twentieth century produced a number of rapid, freshly painted small oil sketches. These and figure studies like his *High Noon*, 1908 (coll. Mrs. Worth B. Plyler, Blowing Rock, N.C.) show the influence of ARTHUR B. DAVIES in their composition and painting style.

In 1911, Daingerfield visited the Grand Canyon, and for at least four years it served as one of his principal subjects. Some of his Grand Canyon landscapes are highly imaginative, for example, *The Sleepers*, 1914 (coll. E. N. Seltzer, Charlotte, N.C.), which shows nude figures reclining on the canyon ledges. His late landscapes, done between 1915 and 1924, continued to reflect the intimate scale, poetic mood, rich colors, and roughened paint surfaces that characterize the work of Inness.

The artist was active as an art teacher and more notably as a critic. He often conducted summer classes at Blowing Rock and in 1896 taught at the Philadelphia School of Design and the Art Students League in New York. In 1903 he gave instruction in composition and oil painting at the Philadelphia School of Design for Women. Late in his career, Daingerfield became a spokesman for the poetic strain in American art and wrote books on Inness and RALPH BLAKELOCK and numerous articles on such artists as ALBERT PINKHAM RYDER, J. FRANCIS MURPHY, and HENRY WARD RANGER, as well as critical essays on art theory.

Daingerfield made a second trip to Europe in 1924, and the scenes he painted of Venice date

Daingerfield, *Slumbering Fog*.

from this trip and after. His health failed in 1925, and from then on he produced little of consequence. He died seven years later in New York, where a memorial exhibition of his work was held at the Grand Central Art Galleries in 1934.

BIBLIOGRAPHY: Dora Read Goodale, "An American Painter of Sentiment (with original illustrations by Elliott Daingerfield)," *Monthly Illustrator* 3 (Feb. 1895), pp. 177–182 ∥ Elliott Daingerfield, "Nature vs. Art," *Scribner's Magazine* 49 (Feb. 1911), pp. 253–256 ∥ Elliott Daingerfield, "Retrospect and Impression," *International Studio* 61 (March 1917), pp. iii–vi ∥ Elliott Daingerfield, "Color and Form—Their Relationship," *Art World* 3 (Dec. 1917), pp. 179–180 ∥ Mint Museum of Art, Charlotte, N.C., and North Carolina Museum of Art, Raleigh, *Elliott Daingerfield Retrospective Exhibition* (1971), exhib. cat. by Robert Hobbs. Includes an essay, many illustrations, bibliography, and chronology.

Slumbering Fog

Like several landscapes Daingerfield painted between 1900 and 1905, *Slumbering Fog* shows a transient moment in nature and represents a poetic mood rather than a specific locale. It is likely, however, that the rugged terrain shown in the picture was near the artist's summer studio at Blowing Rock in the Blue Ridge Mountains of North Carolina.

According to his daughter, Daingerfield considered "the presence of a tree against the sky . . . as real and vital in its message bearing quality as . . . a mother and her child. It is the thing that is pervaded with mystery, and that mystery is the presence of God in all His works" (*Blowing Rock* [*N.C.*] *Journal*, August 27, 1960, p. 8). The silhouetted trees on the edge of the cliff in *Slumbering Fog* are the focal point of the composition; they unite the darkened foreground with a panoramic

view of distant mountaintops shrouded in a luminous mist. By devoting most of the canvas to the ethereal elements of sky and fog, the artist gives the picture a quiet, mysterious quality. The silent mood of the scene is reinforced in the rocky foreground, which is only partially illuminated by sunlight and inhabited by a lone bear, lumbering toward the edge of the cliff.

Oil on canvas, $30\frac{5}{16} \times 36\frac{1}{16}$ in. (77 × 91.6 cm.).
Signed at lower left: Elliott Daingerfield.
REFERENCES: W. S. Howard, *MMA Bull.* 1 (March 1906), p. 58, discusses the painting // *George A. Hearn*

Gift to the Metropolitan Museum of Art . . . (1913), ill. p. 86 // L. M. Bryant, *American Pictures and Their Painters* (1921), pp. 136–137, says it depicts the Blue Ridge Mountains; ill. opp. p. 138.

EXHIBITED: Lotos Club, New York, 1905, *Exhibition of Paintings by the Artist Members of the Lotos Club*, no. 10 // Society of American Artists, New York, 1905, no. 59 // Mint Museum of Art, Charlotte, N.C., and North Carolina Museum of Art, Raleigh, 1971, *Elliott Daingerfield Retrospective Exhibition*, exhib. cat. by R. Hobbs, no. 143; ill. p. 23; p. 34, discusses it.

EX COLL.: George A. Hearn, New York.
Gift of George A. Hearn, 1906.
06.1276.

CHILDE HASSAM

1859–1935

Frederick Childe Hassam was born in Dorchester, Massachusetts (now a part of Boston), and although he spent the mature years of his career in New York, his ties to New England, where his ancestors had settled in the seventeenth century, remained strong. His interest in art began early, and as a boy he received instruction in drawing from Walter Smith (1836–1886). Hassam left school before graduating and went to work as a bookkeeper for a publishing firm but soon found more suitable employment designing and cutting woodblocks for an engraver. He also attended classes at the Boston Art Club and the Lowell Institute, and beginning about 1879 he studied painting with the Munich-trained artist IGNAZ MARCEL GAUGENGIGL, who was then conducting a life class. Establishing a studio in Boston in the early 1880s, Hassam worked mainly as an illustrator. Influenced, however, by the landscape painters at the Boston Art Club, he also painted outdoors, producing views of the city and its inhabitants. Tightly painted, somber in color, and filled with narrative detail, these paintings reflect his training in illustration. In 1883, he exhibited at the National Academy of Design in New York and made a brief trip to Holland, Spain, and Italy with the painter Edmund H. Garrett (1853–?). Hassam then returned to Boston and in 1884 married Kathleen Maud Doane.

Beginning in 1886, the artist spent three years in Europe, primarily in France. He studied at the Académie Julian in Paris under Lucien Dorcet, Gustave Boulanger, and Jules Joseph Lefebvre and also worked independently in a studio in the then fashionable boulevard Clichy, near the Place Pigalle. A frequent visitor to museums and galleries, Hassam probably gained as much from his observations and experiences as from his formal training. From this time on, his work developed under the influence of French art. Initially, in paintings like *Grand Prix Day*, 1887 (MFA, Boston), he showed a conservative response to impressionism, using decisive outlines and broken but restrained brushstrokes. His views of Paris recall paintings by Giuseppe de Nittis and Jean Béraud, artists to whom Hassam was sometimes compared by his con-

temporaries. He exhibited his work at the Paris Salon in 1887 and 1888 and in 1889 won a bronze medal at the Paris Exposition.

After a brief visit to England, the artist returned to the United States. Following a sale of his work at Noyes and Cobb in Boston, he settled in New York, where he became one of the most successful American painters working in the impressionist style. Many of his works from the 1890s show an increased sensitivity to effects of light and changes in the atmosphere. This is particularly evident in his views of the city in rain and snow, for example, *Winter in Union Square* (q.v.). Hassam's light palette, broken brushstrokes, roughened paint surfaces, and unconventional compositions were inspired by the works that such impressionists as Claude Monet and Camille Pissarro painted in the 1870s and 1880s. Hassam himself was particularly contemptuous of the term impressionism and even liked to deny his indebtedness to French painting, preferring to see himself following in the tradition of the English watercolorists Turner and Constable, who he said "cleared up the palettes of the painters in oil" (*Art News*, 26 [April 14, 1928], p. 27).

Hassam worked extensively in mediums other than oil. In 1890 he contributed to the fourth and final exhibition of the Society of American Painters in Pastel; in 1891 he joined the American Water Color Society; and, perhaps as early as 1898 he was making prints, which later became a more important part of his work. His summers were usually spent at country resorts popular with artists; such places as the Isles of Shoals off the coast of New Hampshire, Old Lyme, Connecticut, and Gloucester, Massachusetts, offered him pleasing subjects for his paintings. In 1895 Hassam visited Havana. Two years later he went abroad and spent a year in France, England, and Italy. In 1897 he resigned from the Society of American Artists, which had elected him a member in 1890, and joined the Ten American Painters, which held its first exhibition in 1898. He became a member of the National Academy of Design in 1902, and was elected an academician there four years later. The first of Hassam's many one-man shows was held at Montross Gallery in New York in 1905, and during the next two decades the artist won medals and awards at various exhibitions. He traveled to the West Coast in 1908 and went again to Europe in 1910.

During the early years of the twentieth century, Hassam's style began to show the influence of post-impressionism. Once again he applied a European style of painting, no longer avant-garde, to readily acceptable American subjects. Working in bright, harsh colors, regularized brushstrokes, and firm contours, he continued to paint landscapes and city views but turned more often to depicting outdoor scenes with nudes and interiors with figures. His last important oil paintings were done between 1916 and 1919, when he produced a number of views of Fifth Avenue decorated as the Avenue of the Allies. Although he painted until his death, his late works show a marked decline in quality. Many show scenes of East Hampton, New York, where he bought a home in 1919. Hassam's most significant work and primary interest during the 1920s and 1930s was undoubtedly in printmaking. He was elected to the American Academy of Arts and Letters in 1920, and it was to this institution that he bequeathed all the paintings remaining in his studio, authorizing their sale to establish a fund to purchase the works of American artists for presentation to museums. The artist died in East Hampton at the age of seventy-five after nearly a year of illness.

BIBLIOGRAPHY: Childe Hassam, "Twenty-Five Years of American Painting," *Art News* 26 (April 14, 1928), pp. 222, 227–228. Reminiscences on his career and comment on the origin of impressionism // "Childe Hassam—Painter and Graver," *Index of Twentieth Century Artists* 3 (Oct. 1935), pp. 169–183, with suppl. Reprint with cumulative index. New York: Arno Press, 1970, pp. 461–475, 477. The most complete bibliography available on the artist, it also lists awards, affiliations, representation in public collections, and exhibitions // Adeline Adams, *Childe Hassam* (New York, 1938). An appreciative biography published by the American Academy of Arts and Letters // University of Arizona Museum of Art, Tucson, and Santa Barbara Museum of Art, *Childe Hassam, 1859–1935*, exhib. cat. by William E. Steadman. A biographical essay, lists of awards, and one-man exhibitions, a bibliography, and many illustrations of the artist's work.

Spring Morning in the Heart of the City

Previously titled *Madison Square, New York*, this view by Hassam was painted in 1890 and later reworked. Madison Square Park, bounded by 23rd and 26th streets between Madison and Fifth avenues, was the center of one of Manhattan's fashionable neighborhoods. In a discussion in the *Art Amateur* in 1892, Hassam noted that he painted the scene from "the second-story window in Dunlap's about fifteen feet from the ground." Describing the area and the artist's treatment of it in an 1893 review in the *Boston Evening Transcript*, one critic wrote:

The porch of the Fifth-avenue Hotel is seen at the left of the foreground, and, above the trees in the square, the Hotel Brunswick towers against the gray sky. The wide street and sidewalks are fairly swarming with cabs, omnibuses, drags, cars and foot passengers, like the great human hive that New York is, and there arises from this vivid instantaneous glimpse of seething streets, to the ear of the fancy, that muffled roar of traffic which is the incessant voice of the metropolis. Nothing could be gayer or more characteristic of that part of the city which visitors are likely to know, and nothing could be more appropriate to the theme, th[a]n Mr. Hassam's sprightly and sparkling style.

In discussing the picture in 1892, Hassam said that his intention was to focus on the group of cabs in the foreground and have "the lines in the composition radiate and gradually fade out from this centre." "Of course all those people and horses and vehicles," he went on, "didn't arrange themselves and stand still in those groupings for my especial benefit. I had to catch them, bit by bit, as they flitted past."

In 1895 the painting was exhibited at the annual St. Louis Exposition, and presumably, sometime after its illustration in the catalogue for that show and before 1899 when it appeared in *Three Cities by Childe Hassam*, the artist reworked

the painting. Most noticeable is the elimination of a group of people crossing the street in the right foreground which has resulted in an unfortunate pentimento.

Spring Morning in the Heart of the City is typical of Hassam's conservative impressionist style, in which an elevated vantage point and an emphasis on light and movement are used in conjunction with a tightly controlled application of paint and decisive outlining of objects. The brushwork is delicate, much like that in Hassam's early views of Boston and Paris, and, except for occasional bright touches, such as the lime green in the crowns of the trees, the palette is fairly low in key. His approach in this painting is perhaps closest to the works of such artists as Jean Béraud and Giuseppe de Nittis.

Oil on canvas, 18⅛ × 20¾ in. (46 × 52.7 cm.).

Signed and dated at lower right: (crescent) Childe Hassam. 1890.

REFERENCES: *New York Times*, April 26, 1891, p. 5, notes it in a review of the Society of American Artists exhibition // Unidentified clipping, n.d., in Childe Hassam Papers, Am. Acad. of Arts and Letters, microfilm NAA-1, Arch. Am. Art, discusses the painting on view at Knoedler's // A. E. Ives, *Art Amateur* 27 (Oct. 1892), pp. 116–117, in an interview with Hassam in which the artist discusses painting street scenes, this picture is often referred to as an example (quoted above) // *Boston Evening Transcript*, Jan. 28, 1893, p. 4, discusses the painting in a review of a show at the Doll and Richards Gallery, says it is "not only his best urban picture, but it is probably the best delineation of a subject of the sort that anybody has made"; says "his facility of suggesting the movement of a crowd of figures is equal to that of Edouard Manet, and superior to that of Jean Béraud"; gives description of the scene (quoted above) // "The Fine Arts; Exhibition of Pictures by Mr. Hassam at Doll and Richards Gallery," unidentified clipping, [1893], in Childe Hassam Papers, Am. Acad. of Arts and Letters, microfilm NAA-1, Arch. Am. Art, says that it was painted from a balcony // M. G. Van Rensselaer, *Century*

Hassam, *Spring Morning in the Heart of the City*, as it looked in 1893.

Magazine 25 (Nov. 1893), ill. p. 10; pp. 13–14, discusses it // *Three Cities by Childe Hassam* (1899), unpaged ill. as The Heart of the City, shows the painting after removal of figures in the right foreground // [Macbeth Gallery] *Art Notes*, no. 66 (April–May 1918), ill. p. 1081; p. 1101, says that it has just arrived, is "most interesting both in subject and color," and will be on view // E. Clark, *Art in America* 8 (June 1920), ill. p. 175 // N. Pousette-Dart, comp. *Childe Hassam* (1922), ill. as Spring, Madison Square, owned by G. F. McKinney // R. B. H[ale], *Art News* 42 (May 1, 1943), ill. p. 13, in a review of exhibition at Milch Galleries.

EXHIBITED: Society of American Artists, New York, 1891, no. 112, as Spring Morning in the Heart of the City // Doll and Richards, Boston, 1893, no. 1, as Heart of the City (no cat. available) // St. Louis Exposition and Music Hall Association, 1895, no. 244, mistitled Winter in New York, ill. p. 43 // Carnegie Institute, Pittsburgh, 1900–1901, no. 115, as Madison Square in Spring // Macbeth Gallery, New York, 1918 (no cat. available) // MMA, 1939, *Life in America*, no. 273, as Madison Square, New York, lent by Ethelyn McKinney; ill. p. 205 // Milch Galleries, New York, 1943, *Paintings and Watercolors by Childe Hassam*, no. 13, as Madison Square (annotated copy

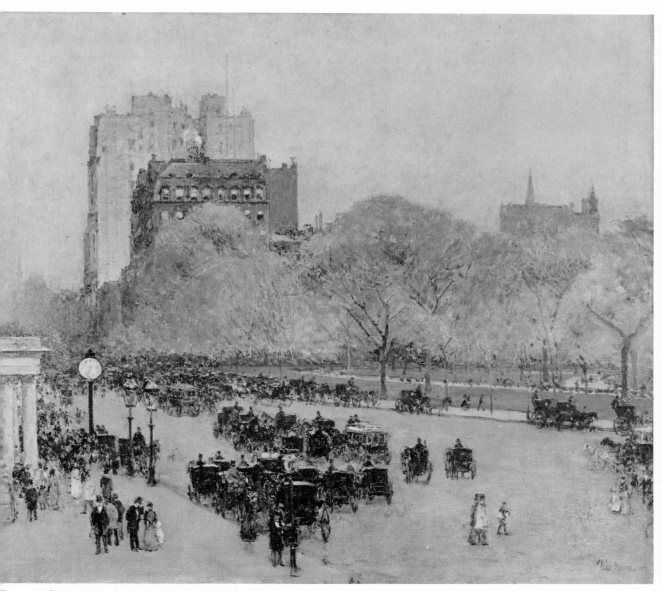

Hassam, *Spring Morning in the Heart of the City.*

in Milch Galleries Papers, N/M2, Arch. Am. Art, says that it was lent by McKinney and that it was to be sent to the Metropolitan Museum on June 17, 1943).

Ex COLL.: with Macbeth Gallery, New York, 1918; Glenn Ford McKinney, by 1920; his sister, Ethelyn McKinney, Greenwich, Conn., by 1939–1943.

Gift of Miss Ethelyn McKinney, 1943, in memory of her brother, Glenn Ford McKinney.

43.116.1.

Winter in Union Square

From 1889 to 1895 Hassam worked in a studio at 95 Fifth Avenue in New York not far from Union Square, one of his favorite subjects during this period. The appearance of the park, the visitors to it, and their activities there are recorded in many of the artist's paintings from the 1890s. These range from close-up studies of figures like *Rain Storm, Union Square*, 1890 (Museum of the City of New York), to overall views of the park and its surroundings like the Metropolitan's *Winter in Union Square*, done in the early 1890s. Showing trolleys, carriages, and pedestrians struggling through a snowstorm, the picture is a view of the square looking south from the corner of 16th Street. In the background, the hotel Morton House is seen on the left and across from it on the right is the domed building of the Domestic Sewing Machine Company. Barely visible between them is the spire of Grace Church.

The artist's interest in urban subjects, evident in his Boston pictures from the early 1880s, was heightened during his stay in Paris, where he came to know the impressionistic city views of such artists as Camille Pissarro and Claude Monet. The diagonal thrust of Hassam's composition and his ability to capture movement was undoubtedly inspired by these artists. His technique too was strongly influenced by the impressionists. In pastel colors of blue and lavender, applied unevenly but juicily with broken brushstrokes, he captured the appearance of a snowstorm. The brushwork in the sky is particularly effective with diagonal strokes representing the falling snow and rough touches of impasto indicating the clouds of smoke rising from the chimneys. With a spontaneity unusual in Hassam's work of this period, *Winter in Union Square* demonstrates the artist's ability to capture the ephemeral effects of light, atmosphere, and motion.

Oil on canvas, 18¼ × 18 in. (46.4 × 45.7 cm.).
Signed at lower left: (crescent) Childe Hassam.
REFERENCES: *Three Cities by Childe Hassam* (1899),

unpaged ill. in New York section as Winter in Union Square // N. Pousette-Dart, comp., *Childe Hassam* (1922), unpaged ill. as Union Square, gives owner as George Barr McCutcheon, New York // *Index of Twentieth Century Artists* 3 (Oct. 1935), p. 182, lists illustrations of it // F. Watson, *Magazine of Art* 32 (June 1939), ill. p. 325, gives owner as Ethelyn McKinney, mistakenly dates it 1910; p. 335, calls it an example of American painting "in its Impressionist phase."

EXHIBITED: PAFA, 1894–1895, no. 147, as Winter, Union Square, New York (probably this painting) // MMA, 1939, *Life in America*, no. 272, as Union Square, New York, lent by Ethelyn McKinney, ill. p. 205 // Milch Galleries, New York, 1943, *Paintings and Watercolors by Childe Hassam*, no. 17, as Union Square, lent by a private collector (Ethelyn McKinney according to annotated copy in Milch Gallery Papers, N/M2, Arch. Am. Art) // Dwight Memorial Art Gallery, Mount Holyoke College, South Hadley, Mass., 1956, *French and American Impressionism*, no. 35, as Union Square, New York // University of Arizona Museum of Art, Tucson, and Santa Barbara Museum of Art, 1972, *Childe Hassam, 1859–1935*, exhib. cat. by W. E. Steadman, no. 31, ill. p. 69, as Union Square, New York // MMA, Memorial Art Gallery of the University of Rochester, New York, and the Queens County Art and Cultural Center, New York, *19th Century American Landscape*, entry by M. Davis, ill. no. 26, as Union Square, New York, discusses it.

Ex COLL.: with Macbeth Galleries, New York; George Barr McCutcheon, New York, by 1922–died 1928; probably Glenn Ford McKinney; his sister, Ethelyn McKinney, Greenwich, Conn., by 1939–1943.

Gift of Miss Ethelyn McKinney, 1943, in memory of her brother, Glenn Ford McKinney.

43.116.2.

Coast Scene, Isles of Shoals

This painting, dated 1901, is a view from one of the islands in the group known as the Isles of Shoals which lie off the coast of New Hampshire. This remote resort was a favorite of Hassam's from the 1880s until about 1915. The major hotel, located on Appledore, the largest island, had been opened in 1848 by the Laightons, whose daughter Celia Thaxter, a poet and amateur artist, probably encouraged Hassam's first visit there in 1884. Appledore House was a gathering place for a number of artists, among them Ross Turner (1847–1915), J. Appleton Brown (1844–1902), and Hassam's teacher IGNAZ MARCEL GAUGENGIGL.

Around the turn of the century, Hassam undertook a series of views of the Isles of Shoals showing the rocky cliffs and coves and the vast expanse of

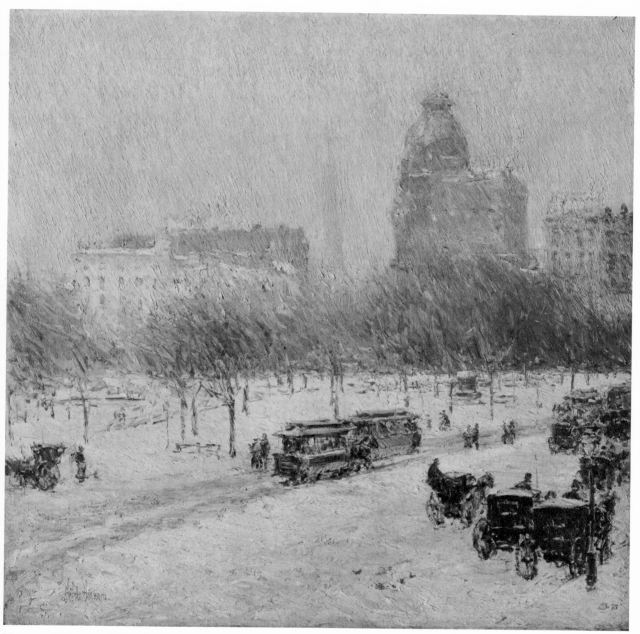

Hassam, *Winter in Union Square.*

blue ocean that surrounds them. Reminiscent of coastal scenes painted by Claude Monet at Pourville and Entretat during the early 1880s, most of them show the shore and water under calm, sunlit conditions. They are done from an oblique viewpoint looking down on the gorges and surf. Hassam gave the cliffs a monumental appearance by placing them in the foreground of the picture and isolating them from the main mass of land. The powerful shapes of the cliffs serve as a foil to the high, flat horizon and gently sloping spits of land in the distance. The colors in *Coast Scene, Isles of Shoals* are clear and bright, almost sparkling in their luminosity. The artist's brushstrokes are unevenly applied so that in some areas the texture of the canvas shows through and in others there are fluid touches of impasto. The brushwork is patterned to suggest form and texture: in the water the strokes are rapid, horizontal lines, evenly spaced like small waves; and on the jagged cliffs, they conform to the irregularity of the rocks. The painting is one of the most accomplished of the artist's coast scenes, incorporating carefully selected forms in nature with a strongly designed composition.

Oil on canvas, 24⅞ × 30⅛ in. (63.2 × 76.5 cm.).

Signed and dated at lower right: Childe Hassam/ 1901.

REFERENCES: *Catalogue of the Collection of Foreign and American Paintings Owned by Mr. George A. Hearn* (1908), ill. p. 210, as Coast Scene, Isle of Shoals // *MMA Bull.* 4 (July 1909), p. 116, includes it in a list of paintings given to the museum by Hearn // *George A. Hearn Gift to the Metropolitan Museum of Art* . . . (1913), p. xiv; ill. p. 91 // Form entitled "National Institute of Arts and Letters" [ca. 1928], in Hassam Papers, Am. Acad. of Arts and Letters, microfilm NAA-1, Arch. Am. Art, lists it among his principle works // A. Adams, *Childe Hassam* (1938), p. 67 // F. J. Mather, Jr., *Magazine of Art* 39 (Nov. 1946), ill. p. 307, discusses it.

EXHIBITED: Carnegie Institute, Pittsburgh, 1910, no. 114 or no. 117, as Isles of Shoals // University of Arizona Museum of Art, Tucson, and Santa Barbara Museum of Art, 1972, *Childe Hassam, 1859–1935*, no. 56 // MMA and American Federation of Arts, traveling exhibition, 1975–1976, *The Heritage of American Art*, exhib. cat. by M. Davis, no. 83, p. 185, discusses it.

EX COLL.: George A. Hearn, New York, by 1908–1909.

Gift of George A. Hearn, 1909.

09.72.6.

Hassam, *Coast Scene, Isles of Shoals.*

Broadway and 42nd Street

Dated 1902, the painting shows a scene in New York's Times Square during an evening snowstorm. Hassam's interest was not so much in depicting the physical appearance of this well-known site but in capturing the mood of the city. "The spirit, that's what counts," he once commented, "and one should strive to portray the soul of the city with the same care as the soul of a sitter." For Hassam the city was at its best "viewed in the early evening when just a few flickering lights are seen here and there and the city is a magical evocation of blended strength and mystery" (*New York Sun*, Feb. 13, 1913, sec. 4, p. 16).

Here black carriages and darkly dressed figures are crowded in the middle ground beneath towering buildings and illuminated by harsh, artificial lights. The artist's feathery brushstrokes and uneven paint surface are typical of his impressionist style at this time, but the composition and subject, a close-up view of a busy New York street, are not unlike those later used by such realists as Robert Henri (1865–1929) and John Sloan (1871–1951).

Hassam, *Broadway and 42nd Street.*

Oil on canvas, 26 × 22 in. (66 × 55.9 cm.).

Signed and dated at lower right: (crescent) Childe Hassam / 1902. Signed and dated on reverse: C. H. (in a circle with a crescent) / 1902.

REFERENCES: Parke-Bernet Galleries, *Old Masters and XIX Century Paintings*, sale cat. (1946), ill. p. 61, no. 95, gives early provenance and incorrect measurements // *Art News* 46 (March 1947), p. 24, mentions it in a review of an exhibition at Milch Galleries // H. C. Milch, Milch Gallery, New York, letter in Dept. Archives, August 6, 1976, gives information on provenance // P. Rathbone, Sotheby Parke Bernet, New York, letter in Dept. Archives, August 20, 1976, gives information on provenance // M. Mills, Am. Acad. of Arts and Letters, New York, letter in Dept. Archives, Sept. 8, 1976, provides information on provenance // M. St. Clair, Babcock Galleries, New York, orally, Sept. 14, 1976, provided information on the provenance.

EXHIBITED: Milch Galleries, New York, 1947, *Childe Hassam, Paintings*, no. 4, as 42nd Street and Broadway, Winter // Wadsworth Atheneum, Hartford, 1950, *The Adelaide Milton de Groot Loan Collection* (no cat.).

ON DEPOSIT: Wadsworth Atheneum, Hartford, 1947–1956, lent by Adelaide Milton de Groot // MMA, 1956–1967, lent by Adelaide Milton de Groot.

EX COLL.: with E. & A. Milch, New York; A. Ludlow Kramer, ca. 1940 (sale, Parke-Bernet Galleries, New York, May 16, 1946, no. 95, as Early Morning: Forty-Second Street and Broadway, $600);

with Milch Galleries and Babcock Galleries, New York, 1946–1947; Adelaide Milton de Groot, New York, 1947–1967.

Bequest of Miss Adelaide Milton de Groot (1876–1967), 1967.

67.187.128.

Golden Afternoon

This landscape is one of nearly thirty paintings done by Hassam when he visited the desert area of Oregon's Harney County in the fall of 1908. When Hassam traveled west that year, he planned only a brief visit, but he was so fascinated by the colors of the desert that he felt compelled to stay a while. Describing the landscape to an interviewer on his return to New York, he noted: "The air is limpid and liquid, the skies are stupendous and the distance amethystine" (Clipping [1909], Childe Hassam Papers, Am. Acad. of Arts and Letters, microfilm NAA-1, Arch. Am. Art).

With its low horizon and its panoramic view of Steen's Mountains in the distance, *Golden Afternoon*, painted on the P Ranch, captures the vastness of the desert. Hassam's friend Charles Erskine Scott Wood, who accompanied him to Oregon, called this painting "the most poetical thing" the artist had done. Indeed, in it, Hassam appears quite sensitive to the essential character

of the desert landscape. The dry, crisp atmosphere is suggested by the clear blue sky and the warm colors of the grass and foliage. The brushwork is varied to suit each element depicted; there are juicy touches of pigment in the grass and brush and an even, almost flat, application of paint in the sky.

The frame for *Golden Afternoon* appears to be original to the painting, and, although similar to the ones Hassam designed himself, it bears an incised inscription with the name Carnig Rohane and the date 1909.

Oil on canvas, 30$\frac{1}{16}$ × 40$\frac{3}{8}$ in. (76.4 × 102.6 cm.).

Signed and dated at lower left: (crescent) Childe Hassam 1908. Signed and dated on reverse: CH (in a circle with a crescent) / 1908.

REFERENCES: C. E. S. Wood, *Pacific Monthly* 21 (Feb. 1909), ill. p. 141, notes that it is a view "looking up to Stein's [*sic*] Mountain from the P Ranch, Harney Valley" // *New York Times*, Feb. 14, 1909, picture sec. part 1, unpaged, ill. in review of exhibition at PAFA // L. Mechlin, *Studio* 48 (Oct. 1909), ill. p. 3; *International Studio* 39 (Nov. 1909), ill. p. 3 // C. Hassam, letter in MMA Archives, March 28, 1911, offers the picture to the museum // *Index of Twentieth Century Artists* 3 (Oct. 1935), p. 179, lists reproductions of it // A. Adams, *Childe Hassam* (1938), p. 67 // D. W. Young, *Life and Letters of J. Alden Weir* (1960), p. 254, quotes letter from Wood to Weir, Dec. 29, 1916, calling it poetical (quoted above), also says it never would have existed if he had not "been attracted by the brooding beauty" of the day, "gone to the carpenter shop, made the stretcher, stretched the canvas and galvanized" Hassam.

EXHIBITED: PAFA, 1909, no. 440, as Golden Afternoon // Montross Gallery, New York, 1909, *Exhibition of Paintings of East Oregon by Childe Hassam*, no. 18.

Ex COLL.: the artist, New York, 1908–1911.

Rogers Fund, 1911.

11.40.

July Fourteenth, Rue Daunou, 1910

Inscribed "1910/14 Juillet," this painting of Bastille Day celebrations in Paris was done on a trip Hassam made to Europe with his wife in the summer of 1910. On July 21, he wrote to his friend J. ALDEN WEIR that he had been in Paris for two weeks and found it noisy and dirty and was about to move on, but he added, "I have made a 14th July from the balcony here." A view from an elevated vantage point at the Hotel l'Empire at 7 rue Daunou, the picture captures the scene in the street below, where people and carriages are crowded beneath the flag-draped buildings.

Obviously inspired by his renewed contact with the urban views of such impressionists as Camille Pissarro and Claude Monet, Hassam returned in this picture to the type of composition he had used in his works of the late 1880s. Often cited as the first example of his interest in the flag motif, the picture actually marks a return to a subject the artist had treated during his student years in Paris. One of these early works, the water-color *14 Juillet Montmartre*, 1889 (coll. Albert E. McVitty, Jr., Princeton, N.J.) established the composition the artist used in the Metropolitan painting, the same one he later repeated in his *Avenue of the Allies* (q.v.)—a sweeping view up an avenue with crowds of people and carriages beneath tall buildings. The cool, tonal colors and broken brushstrokes of *July Fourteenth, Rue Daunou, 1910* are also similar to the works Hassam did during the late 1880s and 1890s. This painting, however, lacks the spontaneity of those city views. The surface is more finished, the brushwork more regularized, and the composition more rigid, with flags that appear motionless and

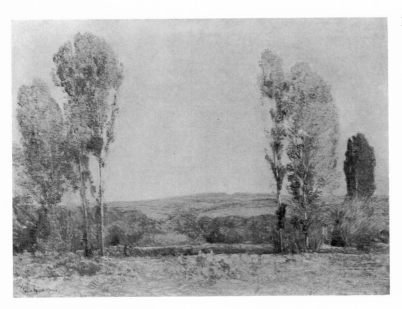

Hassam, *Golden Afternoon.*

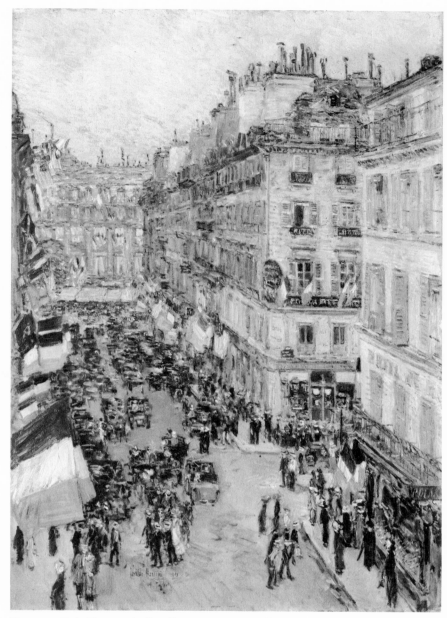

Hassam, *July Fourteenth, Rue Daunou, 1910*.

figures that seem arrested rather than caught in action.

Oil on canvas, 29⅛ × 19⅞ in. (74 × 50.5 cm.).

Signed, dated, and inscribed at lower left: (crescent) Childe Hassam 1910/14 Juillet. Signed and dated on reverse: C H (in a circle with a crescent)/1910.

REFERENCES: C. Hassam to J. A. Weir, July 21, 1910, copy in Childe Hassam Papers, Am. Acad. of Arts and Letters, microfilm NAA-1, Arch. Am. Art (quoted above) // "National Institute of Arts and Letters," [ca. 1928], in Childe Hassam Papers, microfilm NAA-1, Arch. Am. Art, includes it among his "principal works" // Acquisition form, MMA Archives, May 28, 1929, notes exhibition of it // [Macbeth Gallery] *Art Notes*, no. 87 (Nov. 1929), ill. p. 1580 // *New York Times*, Sept. 8, 1935, sec. 8, n.p., calls it one of the artist's "best-known paintings" // *Index of Twentieth Century Artists* 3 (Oct. 1935), p. 179, lists reproductions of it // A. Adams, *Childe Hassam* (1938), p. 67 // R. B. Hale, *MMA Bull.* 12 (March 1954), p. 177 // Corcoran Gallery of Art, Washington, D.C.,

Hassam, *The Church at Gloucester*.

traveling exhibition, *Childe Hassam, a Retrospective Exhibition* (1965), essay by C. E. Buckley, p. 21, mentions it as an example of Hassam's accomplishments after 1900 // D. Sutton, *Apollo* 85 (March 1967), ill. p. 221.

EXHIBITED: Buffalo Fine Arts Academy, Albright Art Gallery, 1929, *Exhibition of a Retrospective Group of Paintings Representative of the Life Work of Childe Hassam, N.A.*, no. 73, as July Fourteenth, Rue Daunou—1910 // MMA, 1977, *Childe Hassam as Printmaker*, exhib. cat. by D. Kiehl and D. B. Burke, no. 34.

EX COLL.: the artist, New York, 1910–1929; with Macbeth Gallery, New York, 1929.

George A. Hearn Fund, 1929.

29.86.

The Church at Gloucester

The church pictured is the Universalist Independent Christian Church, built during the early nineteenth century in Gloucester, Massachusetts. Childe Hassam visited Gloucester as early as 1880 or 1881, occasionally painted views of this fishing village during the 1890s, and returned there in 1917 and 1918. *The Church at Gloucester*, which recalls the artist's earlier paintings of the church at Old Lyme, Connecticut, was done in 1918, shortly before the end of World War I.

Perhaps as a result of his childhood surroundings, Hassam was often attracted by old buildings. He once commented on his native Dorchester, Massachusetts, and its architecture, especially the white church on Meeting House Hill:

I can look back and very truly say that probably and all unconsciously I as a very young boy looked at this New England church and without knowing it appreciated partly its great beauty as it stood there then

against one of our radiant North American clear blue skies and as it still stands there now (Autobiographical statement, n.d., Childe Hassam Papers, Am. Acad. of Arts and Letters, microfilm NAA-1, Arch. Am. Art).

Here the church at Gloucester is set against just such a "radiant" and "clear blue" sky. Devoid of people and activity, the composition has a timeless quality that is enhanced by the church's emphatically frontal position. The path leading to the central entrance is flanked by two parallel rows of elms, the symmetry of which further adds to the static quality of the scene.

A lithograph by the artist, *Colonial Church, Gloucester*, 1918 (MMA, 40.30.30), is quite close in composition to that of the painting, except that it includes the entire steeple of the church and shows the building under different lighting conditions. In 1923 Hassam also made an etching of the church, which is a mirror image of the lithograph. Both of these prints and the painting may be related to an unlocated 1918 drawing of the subject (formerly coll. George J. Dyer).

Oil on canvas, 30 × 25 in. (76.2 × 63.5 cm.).
Signed and dated at lower left: (crescent) Childe Hassam 1918. Signed and dated on reverse: CH (in a circle with a crescent) / 1918.
REFERENCES: Macbeth Gallery, copy of typed receipts to C. Hassam, Macbeth Papers, NMc51, Arch. Am. Art, Oct. 3, 1919, records payment of $4,500 for The Church, Gloucester; March 14 and Dec. 23, 1925, records it again as framed and glazed // A. Adams, *Childe Hassam* (1938), p. 67 // R. B. Hale, *MMA Bull.* 12 (March 1954), ill. p. 187 // *MMA Bull.* 33 (Winter 1975–1976), ill. p. 243.
EXHIBITED: Rhode Island School of Design, Providence, Autumn 1923, no. 14, as Church at Gloucester // Art Center, Kalamazoo Institute of Arts, Mich., 1966, *Paintings by American Masters*, Bulletin no. 18, p. 12 // MMA, 1976, *A Bicentennial Treasury* (see *MMA Bull.* 33 above); *Childe Hassam as Printmaker*, exhib. cat. by D. Kiehl and D. B. Burke, ill. no. 44, discusses it.
Ex COLL.: with Macbeth Galleries, New York, probably 1919–1925.
Arthur Hoppock Hearn Fund, 1925.
25.206.

Avenue of the Allies, Great Britain, 1918

During World War I Hassam often painted views of New York's Fifth Avenue decorated as "the Avenue of the Allies." He first turned to this theme in 1916, when the United States adopted a policy of "preparedness" for war. After the country entered the conflict the following year, he became increasingly absorbed in the subject.

Hassam, lithograph, *Colonial Church, Gloucester*.

The Metropolitan painting depicts part of the most ambitious flag display, held between September 28 and October 19, 1918, in support of the fourth Liberty Loan Drive. This spectacle was planned by a committee of artists and architects and involved the decoration of Fifth Avenue between 26th and 58th streets. The allied nations were honored by a display of their flags on specific blocks of the avenue, and the remaining blocks were devoted to Liberty Loan decorations.

In this painting Hassam shows a segment of Fifth Avenue looking uptown from the corner of 54th Street. He includes part of the decorations of the British block between 53rd and 54th streets, the Brazilian block between 54th and 55th streets, and the Belgian block between 55th and 56th. The most prominent flag is the British

Union Jack, which fills the upper righthand quadrant of the canvas. This is flanked by the New Zealand merchant flag on the left and the Canadian flag on the right. Directly beneath and behind the British flag is the Brazilian green and yellow flag with a blue celestial globe. The black (blue in Hassam's painting), yellow, and red banded flag behind it is Belgian. There are also some United States flags, and, on the left, a vertical banner, undoubtedly urging spectators to purchase Liberty bonds.

As in a number of his views of the Avenue of the Allies, Hassam places colorful flags above a street filled with people and vehicles. The subject and the slightly elevated vantage point recall his earlier views of Paris on Bastille Day, for example, *July Fourteenth, Rue Daunou, 1910* (q.v.). Here, however, his treatment is more decorative.

Against the clear sky and towering buildings, his facile brushstrokes create a pattern of mainly blues and reds heightened with white. This pattern is enhanced by long feathery strokes applied irregularly over the surface of the canvas.

The artist painted at least thirty flag pictures, and these were exhibited on several occasions, often in groups of twenty-two, a reminder of the number of allied nations. In 1919 a group of New Yorkers attempted to raise one hundred thousand dollars to purchase twenty-two of these paintings as a war memorial for the city. This endeavor was unsuccessful. Today, however, many of Hassam's Avenue of the Allies pictures are in public collections.

Oil on canvas, 36 × 28¾ in. (91.4 × 72.1 cm.).
Signed and dated at lower right: (crescent) Childe

Hassam, *Avenue of the Allies, Great Britain, 1918.*

Hassam—1918. Signed, dated, and inscribed on reverse: CH (in a circle with a crescent) /1918.

REFERENCES: *New York Tribune*, Nov. 24, 1918, part 3, ill. p. 3, as Great Britain.

EXHIBITED: Durand-Ruel Galleries, New York, 1918, *Exhibition of a Series of Paintings of the Avenue of the Allies by Childe Hassam*, no. 2, as Avenue of the Allies—Great Britain, 1918 // Parish House, Church of the Ascension, New York, 1919, *Patriotic Street Scenes by Childe Hassam and Verdun Church Relics* (loaned by the French High Commission), no. 16 // Corcoran Gallery of Art, Washington, D.C., 1922, *Exhibition of the Series of Flag Pictures by Childe Hassam*, no. 2 // Wadsworth Atheneum, Hartford, 1950, *The Adelaide Milton de Groot Loan Collection* (no cat) // MMA, 1965, *Three Centuries of American Painting* (checklist alphabetical),

lent by Adelaide Milton de Groot // MMA and American Federation of Arts, traveling exhibition, 1975–1977, *The Heritage of American Art*, exhib. cat. by M. Davis, no. 84, ill. p. 186; rev. ed., 1977, no. 85, color ill. p. 189.

ON DEPOSIT: Wadsworth Atheneum, Hartford, 1947–1956, lent by Adelaide Milton de Groot // MMA, 1956–1967, lent by Adelaide Milton de Groot.

EX COLL.: the artist, New York, until 1935; estate of the artist, 1935; Am. Acad. of Arts and Letters, New York, 1935–1946; with Milch Galleries, New York, 1946–1947; Adelaide Milton de Groot, New York, 1947–1967.

Bequest of Miss Adelaide Milton de Groot (1876–1967), 1967.

67.187.127.

ALEXANDER SHILLING

1859–1937

There is little clear biographical information available on the printmaker and landscape painter Alexander Shilling. He was the son of a German-born leather-worker and his Dutch wife, and like many people of German origin in the United States at the outset of World War I, he changed the spelling of his family name (from Schilling to the more anglicized Shilling). His early years were spent in Chicago where he attended school until the age of twelve. Because of his family's financial needs, however, he spent the next five or six years working. His art training did not begin until the late 1870s when he was apprenticed for a year to the local artist Henry A. Elkins (1847–1884). George S. Collis, the painter who is often credited as Shilling's teacher, probably offered him some criticism and encouragement at this time, but Shilling does not ever appear to have been formally Collis's student. At the age of nineteen, the artist attended life classes at the Chicago Academy of Design and also opened his own studio. Among his fellow students at the academy were ARTHUR B. DAVIES and the sculpture George Grey Barnard. Shilling supported himself by teaching a class there and taking private pupils as well. In 1883 and 1884 he served as secretary to Sara Hallowell, the director of the Inter-State Industrial Exposition. In these years Shilling did mostly etchings, some of which were exhibited at the New York Etching Club in 1882 and 1885.

The artist moved to New York in December of 1885 and soon found a studio at Broadway and Ninth Street. He joined the New York Etching Club as well as the New York Watercolor Society and the Salmagundi Club. Throughout the 1880s, etching and drypoint were his mainstays. The art dealer Newman Emerson Montross commissioned him to make etchings after paintings by DWIGHT W. TRYON and HORATIO WALKER, and this enabled Shilling to afford his first trip to Europe in 1888.

Around 1892 the artist took a studio in the Van Dyke Building in New York, and it was then that he began to do more oil painting. By 1894 he seems to have developed the style and preference in subject matter that remained his specialty for the rest of his career. The artist's oil paintings and chalk drawings, often of rural landscapes at night, show the influence of Barbizon painting, especially the work of Horatio Walker, whom Shilling often visited in Quebec. Other sketching haunts included the Adirondacks and in later years the area near Twin Lakes, Connecticut. Shilling frequently traveled abroad, staying very often in Veere, a village on the island of Walcheren, in Holland, and after World War I, in Bruges. He developed close and lasting friendships with a number of artists, including the engraver Ernest D. Roth, whom he instructed at the Country Sketch Club in Hackensack, New Jersey, and ALBERT PINKHAM RYDER, whose style exerted a strong influence on him. Just as his friends were preparing *The Book of Alexander Shilling* (1937), an illustrated collection of his work with essays, the artist contracted pneumonia and died at the age of seventy-seven. A memorial exhibition of his paintings, drawings, and drypoints was held at Macbeth Gallery in New York in April of 1937. Funds from Shilling's estate were used to purchase works for donation to museums and to aid students at the Art Students League in New York.

BIBLIOGRAPHY: *The Book of Alexander Shilling* (New York, 1937), a collection of essays by Royal Cortissoz, Horatio Walker, Howard Giles, Willem A. van Konijnenburg, Ernest D. Roth, Karel H. de Haas, Leontine Luykx, and Alec J. Hammerslough is the most complete monograph on the artist // Obituaries: *New York Times*, Jan. 22, 1937, p. 22; *Art Digest* 11 (Feb. 1, 1937), p. 15 // Karel H. de Haas, "Alexander Shilling: In Memoriam," *Nieuwe Rotterdamsche Courant*, Feb. 2, 1937, sec. E, p. 2, reprinted as a pamphlet // "Shilling Who 'Painted from Knowledge,'" *Art Digest* 11 (April 13, 1937), p. 16.

Midnight

Shilling, who specialized in romantic nocturnal scenes, enjoyed nighttime walks with his friends. "The greatest joys were the moonlight walks on the old farm roads, where no automobiles disturbed the quiet atmosphere," Leontine Luykx wrote about the artist's visits to her country home. She recalled: "There was a lane leading down from the gate through the woods,

Shilling, *Midnight*.

and one birch tree which stood silvery and slim against the dark background. 'Black' I called that background, but he corrected me. It was full of colors, all shades of browns, greens and greys" (*The Book of Alexander Shilling* [1937], p. 38). In this picture Shilling used just such dark, subtly varied colors, applying them thickly but smoothly to create an enamel-like surface. His subject matter and painting style are clearly influenced by the work of his friend ALBERT PINKHAM RYDER. Like Ryder, Shilling painted a mood-filled image from memory, with little specific detail and a few carefully chosen landscape elements arranged in strong patterns of light and dark. Although similar to works Shilling did as early as the 1890s, *Midnight* dates from about 1930.

Oil on canvas, 18¾ × 24½ in. (46.7 × 62.2 cm.).
Signed at lower right: Shil[ling]. Inscribed on a label on the back of the frame: Nacht met Maan / door Alexander Shilling (tot in den oorlag 1914–1918 Schilling!) [Night with Moon / by Alexander Shilling (until the 1914–1918 war Schilling!)] / 939 Eighth Avenue, *New York*, N.Y.

REFERENCES: K. H. de Haas, in *The Book of Alexander Shilling* (1937), p. 33; ill. opp. p. 36, calls it Midnight, dates it 1930, and lists owner as Karel H. de Haas, Rotterdam // Donor, letters in MMA Archives, August 2, 1938, discusses its condition and restoration; Sept. 19, 1938, discusses title and suggests the painting be exhibited under glass // D. Rosenthal, European Paintings Department, MMA, memo in Dept. Archives, Sept. 1976, provides translation of inscription on frame.

EXHIBITED: Montross Gallery, New York, 1930, *Exhibition: Paintings, Drawings, and Drypoints by Alexander Shilling*, no. 11, as Midnight (probably this painting).

EX COLL.: Karel de Haas, Rotterdam, 1937.
Anonymous Gift, 1938.
38.162.

WILLIAM L. LATHROP

1859–1938

Contemporary accounts of William Langson Lathrop's life tend to romanticize the adversities he faced during the early years of his career. They also provide contradictory information so that it is not always possible to document his activities and whereabouts before the late 1880s. Born in Warren, Illinois, the son of a medical doctor and sometime farmer, he spent his youth in rural Iowa and in Painesville, Ohio, not far from Lake Erie. As a child he was interested in painting, and after his graduation from high school in 1876 he set out to study art in New York. There Lathrop worked in a printing establishment but was unable to support himself and soon returned to the Midwest where he taught school and also worked on the family farm. In 1880 he again went to New York, where he is said to have worked for several months for *Harper's Magazine* under Charles Parsons (1821–1910). Between 1881 and 1884 he again returned home but also traveled to Buffalo where he did some illustrating.

Up until the late 1880s, the artist worked first as a printmaker and then as a watercolorist. Although some biographers maintain that he began etching in Painesville during the late 1870s, an 1891 catalogue for the New York Etching Club dates his first work as a printmaker to 1886. That year he exhibited at the club for the first time and two years later became a member. The New York art dealer Christian Klackner promoted the etchings Lathrop did during the late 1880s, and although some of these reproduced popular works by other artists, many were original compositions.

The artist went abroad in 1888, supposedly on the advice of WILLIAM MERRITT CHASE, and is said to have visited both London and Paris. He seems to have spent most of his time, however, in the scenic English countryside rather than in art galleries and museums. After returning to New York in 1889, he found the field of etching too commercialized. Disillusioned, he left the city and stayed at the farm of his friend J. ALDEN WEIR in Connecticut. Lathrop later settled in Greenport, Long Island, but in 1891, financial difficulties again forced him to return to Painesville, where he took up farming. He did little oil painting at this time but exhibited at the New York Water Color Club, and by 1892–1893 was a member of that organization. Encouraged by the artist Henry Snell (1858–1943), Lathrop moved back to New York in 1896, and that year he was awarded the American Water Color Society's William T. Evans Prize and elected a member there. Landscapes by the artist were exhibited at the National Academy of Design in 1898 and the next year he won the Webb Prize at the Society of American Artists. In 1902 he was elected to the National Academy of Design, and five years later he was made an academician.

Lathrop was working extensively in oil by 1897, when he painted *The Meadows* (q.v.). His early landscapes are strongly influenced by Barbizon painting and usually depict rural scenes at transitional times of day like twilight. Somber colors and simple compositions with little action or detail enhance the contemplative mood of these paintings. The artist's later work is even more austere, focusing on the ephemeral qualities of the sky and a few landscape elements. Paintings like *The Three Trees* (National Collection of Fine Arts, Washington, D.C.) show greater freedom of technique. The brushwork is rapid, the paint more thickly applied, and the colors are less restrained with occasional bright touches. The subject matter and style of the late works recall those of a number of the artist's contemporaries, especially the work of CHARLES H. DAVIS, who produced competent but conventional paintings in the early years of the twentieth century.

In 1898 Lathrop settled in New Hope, Bucks County, Pennsylvania, where he had first gone on a walking tour the previous year. He bought the old stone Phillips house there in 1899, and thereafter many of his landscapes show his appreciation of the Delaware River area. In the ensuing years such artists as Snell, John Folinsbee (1892–1972), Albert Rosenthal (1863–1939), and Daniel Garber (1880–1958) came to this area. For about ten years Lathrop served as president of the Phillips Mill Association, which was founded in 1928 to organize annual art exhibitions in New Hope. During the late 1920s, he built a large sailboat on which he spent part of each summer cruising. In 1938, at the age of seventy-nine, he was swept from his boat, off Montauk Point, Long Island, during a hurricane. Memorial exhibitions of his work were held at Phillips Mill and the Ferargil Galleries in New York the following year.

BIBLIOGRAPHY: Sherman Gwinn, "Lathrop Studied Art Behind the Plow," *American Magazine* 104 (Nov. 1927), pp. 34–35, 146, 148–152. A romanticized account of his early career // Phillips Mill, New Hope, Pa., *A Memorial Exhibition of Paintings by William L. Lathrop, N.A.* (Sept. 11–24, 1939), with brief tributes by Henry B. Snell, Daniel Garber, and William F. Taylor // Ferargil Galleries, New York, *William L. Lathrop* (Dec. 11–24, 1939), with a biographical statement by F. N. P.[rice] // William L. Bauhan, "William L. Lathrop, 1859–1938," [1968], typescript in FARL, lists works in public collections and notes awards and honors received by the artist.

Lathrop, *The Meadows*.

The Meadows

Painted in 1897, this tonal landscape, with its simplified composition and attention to mood, is an early example of Lathrop's work in oil, a medium he adopted in the late 1890s after a long career as an etcher and watercolorist. Like most of his paintings, it was probably done from memory rather than nature. In this regard the critic Frederic Newlin Price related an anecdote about Lathrop painting at J. ALDEN WEIR's farm in Connecticut:

I recall Weir telling me of finding Lathrop one day out painting and of being amazed to see that his canvas was not that of the surrounding landscape. "What are you doing?" asked Weir. "A little of the Irish coast that haunts me," Lathrop replied. "By Jove, with all this beautiful country around you!" Weir exclaimed (*International Studio* 78 [Nov. 1923], p. 137).

The Metropolitan's painting, which has also been called *The Lonely Pasture*, is typical of the landscapes in which Lathrop attempted to imbue simple, modest scenes with emotion.

Oil on canvas, 18¼ × 26⅛ in. (46.4 × 66.4 cm.).

Signed and dated at lower right: W LATHROP/ '97.

REFERENCES: H. B. Snell to W. L. Lathrop, April 2, 1911, coll. W. L. Bauhan, Dublin, N.H., copy in Dept. Archives, calls the painting "the lonely pasture" and notes its inclusion in the Schemm sale; says that he met George A. Hearn at the sale and had a "lengthy seance" with him "over the merits of the work" // American Art Association, New York, *The Valuable Modern Paintings and Watercolors Collected by the Late Peter A. Schemm of Philadelphia*, sale cat., March 14–17, 1911, no. 200, as The Meadows (copy in MMA Library gives purchaser and price) // *George A. Hearn Gift to the Metropolitan Museum of Art* . . . (1913), ill. p. 100, as The Meadow // W. L. Bauhan, "William L. Lathrop, 1859–1938," typescript, 1968, FARL, includes it in a list of the artist's works and says it is also called The Lonely Pasture; letters in Dept. Archives, Oct. 2 and 19, Nov. 1 and 2, 1976, discusses the painting and includes a copy of the 1911 letter to Lathrop from Snell.

EX COLL.: Peter A. Schemm, Philadelphia (sale, American Art Association, New York, March 16, 1911, no. 200, as The Meadows, $250); George A. Hearn, 1911.

Gift of George A. Hearn, 1911.
11.88.

HENRY ALEXANDER

1860–1894

Henry Alexander was born in San Francisco, a member of a well-to-do family of merchants who had emigrated from eastern Europe. During the 1870s, when he began his training under Virgil Williams (1830–1886), a strong artistic community was just developing in the city: the San Francisco Art Association was incorporated in 1871 and opened its doors in 1877; the School of Design was organized in 1873, and throughout the decade, artists of national reputation like WILLIAM KEITH and THOMAS HILL were at work there. Despite this atmosphere, the painter Toby Rosenthal (1848–1917), apparently a friend of the Alexander family, encouraged the young artist to continue his studies in Munich. After arriving in that city in 1877 or 1879, Alexander spent several years studying at the fine arts academy under Wilhelm Lindenschmidt, Ludwig von Löfftz, and Karl Raupp. Throughout his career Alexander's precisely rendered and intensely realistic figure studies and portraits reflected the academic style of these German instructors.

In 1883 the artist settled in New York, where he was welcomed at a reception in the studio of CHARLES ULRICH, another Munich-trained artist who introduced him to the prominent collector Thomas B. Clarke. While in New York, Alexander lived with his uncle whose Greene Street factory provided the subject matter for *Capmaker at Work*, 1884, which was purchased by Clarke. In 1884 the artist exhibited this painting at the National Academy of Design and another, *The Old Man's Pleasure*, at the Society of American Artists (both works are unlocated). By 1885, however, he was back in San Francisco, where his studio is listed in city directories through 1887. He supported himself by painting portraits and also did interior genre scenes, some depicting life in San Francisco's Chinatown. These were shown at the San Francisco Art Association's exhibitions during the 1880s and early 1890s, although Alexander never became a member of this organization. One of his paintings, *Chinese Merchants* (now unlocated) was exhibited at the World's Columbian Exposition in Chicago in 1893, and about this time the artist went back to New York intending to go on to Munich. He remained in New York, however, and is reported to have received permission from the director of the Metropolitan Museum to paint still lifes of objects in the collection. *Still Life of Pheonician Glass* (coll. Dr. and Mrs. Bruce Friedman, San Francisco) is typical of the paintings Alexander did during the final years of his career. The extraordinary verisimilitude of these works resembles that of paintings by WILLIAM MICHAEL HARNETT and Joseph Decker (1853–1924), who had also studied in Munich. In 1893 Alexander was working in the Tenth Street Studio Building and finding it difficult to sell his paintings. He soon began to drink heavily. Deeply affected by financial problems and the death of his closest friend, the painter Norton Bush (1834–1894), he committed suicide on May 15, 1894. Many of his works, which had been gathered for a memorial exhibition, were destroyed in the San Francisco earthquake of 1906.

BIBLIOGRAPHY: Obituaries: *San Francisco Examiner*, May 16, 1894, p. 1; *San Francisco Chronicle*, May 16, 1894, p. 1 // Alfred Trumble, "Artists and Bread: Young Alexander's Suicide and Its Pathos," *New York News*, May 20, 1894, reprinted in the *Collector* 5 (June 1, 1894), pp. 227–228 // S. and G.

Gump, San Francisco, *Paintings by Henry Alexander*, exhib. cat. (Sept. 27–Oct. 16, 1937) ∥ Alfred Frankenstein, *After the Hunt: William Harnett and Other American Still Life Painters, 1870–1900* (Berkeley and Los Angeles; 1953, rev. ed. 1969), pp. 145–146.

In the Laboratory

This painting is one of several interior scenes in which Alexander depicted people at work surrounded by their instruments, tools, and equipment. Such settings permitted him to show both his abilities as a figure and still-life painter to advantage. Probably painted between 1885 and 1887, the picture shows the chemist and assayer Thomas Price (1837–1912) in his laboratory at 524 Sacramento Street in San Francisco. The building seen through the window is the What Cheer House, a popular hotel that was located across the street. The Welsh-born Price came to San Francisco in 1862. He purchased silver, gold, and copper ores and was later in charge of the assaying and chemical department of the San Francisco Refinery. He also taught chemistry and toxicology at Toland Medical College (now the University of California Medical School). When the San Francisco Refinery went out of business, Price founded his own establishment and served as a consultant to mining companies throughout the world. He was noted for his practical as well as his theoretical knowledge of metals and mining.

Alexander, *In the Laboratory*.

The artist shows an extraordinary concern in this painting for still-life objects, an interest that he developed into a specialty during the 1890s. Price is surrounded, almost overwhelmed, by beakers, test tubes, and a marvelous array of scientific instruments, which are rendered with a realistic precision usually associated with the trompe l'œil style of WILLIAM MICHAEL HARNETT and his followers. Like Harnett, Alexander records the surfaces and textures of objects, exploiting the formal possibilities of their shapes and colors. Compared to the work of this artist, however, his paint application is thinner and his colors more varied. Here the glass vessels are filled with vibrant yellow, chartreuse, turquoise, orange, and purple fluids.

This particular type of *portrait d'apparat*—the scientist surrounded by his equipment—has strong roots in European painting. There are also several good American examples, such as CHARLES WILLSON PEALE's *The Artist in His Museum*, 1784 (PAFA) and ROBERT W. WEIR's *The Microscope*, 1849 (Yale University Art Gallery, New Haven). In the late nineteenth century American artists frequently chose to show scientists and craftsmen at work. THOMAS EAKINS with his many portraits of physicians and scientists and Alexander's friend CHARLES ULRICH in his interior views of craftsmen provided strong precedents for this laboratory scene.

Oil on canvas, 36 × 30 in. (91.4 × 76.2 cm.).
Signed at lower right: HENRY ALEXANDER.
REFERENCES: *Art Digest* 12 (Oct. 15, 1937), p. 11, discusses the painting then on view at Gump's // J. L. Allen, *MMA Bull.* 34 (July 1939), ill. p. 183; pp. 183–184, discusses it in MMA exhibition // J. Alexander, the artist's brother, letter in Dept. Archives, June 25, 1940, provides biographical information on the sitter // M. R. Gillis, State Librarian, California State Library,

Sacramento, letter in Dept. Archives, August 29, 1940, provides biographical information on the sitter // A. Frankenstein, *After the Hunt* (1953; rev. ed. 1969), p. 145; pl. 123, following p. 146, shows another Alexander painting of Price's laboratory; *This World* (Feb. 4, 1973), ill. p. 37, discusses the picture, calling it "most impressive"; letter in Dept. Archives, Sept. 21, 1976, provides additional information on it // C. J. Doran, San Francisco, letter in Dept. Archives, Sept. 24, 1976, provides information on the provenance // K. I. Pettitt, California State Library, Sacramento, letter in Dept. Archives, Oct. 7, 1976, provides information on the artist and the location of the setting, discusses the What Cheer House and its proprietors // H. M. Fishbon, letters in Dept. Archives, Oct. 20, 28, 1976, provides information on the subject and the artist.

EXHIBITED: San Francisco Art Association, Spring 1891, no. 8, as In the Laboratory, for sale (probably this painting) // S. & G. Gump, San Francisco, 1937, *Paintings by Henry Alexander*, no. 4, as The Laboratory of Thomas Price // MMA, 1939, *Life in America*, no. 257, as Laboratory of Thomas Price, ill. p. 195 // Cleveland Museum of Art, 1944, *American Realists and Magic Realists* (no cat.) // Montclair Art Museum, N.J., 1952, *The Illusion of Reality*, no. 2 // National Gallery of Art, Washington, D.C., Whitney Museum of American Art, New York, University Art Museum, Berkeley and California Palace of the Legion of Honor, San Francisco, Detroit Institute of Arts, 1970, *The Reality of Appearance*, exhib. cat. by A. Frankenstein, no. 102, p. 150, discusses it in the context of trompe l'œil still-life painting // M. H. de Young Memorial Museum, San Francisco, 1973, *Henry Alexander Retrospective* (no cat.) // Los Angeles County Museum of Art, 1974, *American Narrative Painting*, exhib. cat. by D. F. Hoopes with catalogue notes by N. Moure, no. 86, p. 180, discusses and dates the painting ca. 1886; ill. p. 181.

EX COLL.: the artist, San Francisco and New York, until 1894; his brother and sister, James and Rae Alexander, San Francisco, 1894–1937; with S. & G. Gump, San Francisco, 1937–1939.

Alfred N. Punnett Fund, 1939.
39.46.

JOHN KANE

1860–1934

The meteoric career of this primitive painter, who did not begin to exhibit his work until he was sixty-seven years old, recalls that of the Douanier Rousseau. The son of Irish immigrants, the artist was born John Cain in West Calder, near Edinburgh, Scotland. He attended school

there until he was nine and then worked in a mine and later a candle factory. Kane came to the United States in 1879 to join family members who had settled in Braddock, Pennsylvania, and although he never returned to Scotland, his memories of the country later provided inspiration for many of his paintings. He worked in western Pennsylvania, usually in the Pittsburgh area, as a laborer on the railroad, in a pipe factory, and in a steel mill. Then, beginning in 1884, he spent two years working in mines in Alabama, Tennessee, and Kentucky. He returned to Pittsburgh and continued to work in mines; he also laid stones for roadways. As the result of an accident around 1891, Kane lost a leg and was forced to seek less arduous employment, working, for example, as a night watchman for the Baltimore and Ohio Railroad.

In 1898, a year after his marriage to Maggie Halloran, John Kane was employed painting freight cars, and during the early years of the twentieth century, he supported himself by coloring photographic portraits. Despondent over the death of his infant son in 1904, he drifted from job to job, working as an itinerant house painter and carpenter and spending less time with his wife and two daughters. It was at this time that he changed the spelling of his name to Kane, evidently conforming to a bank clerk's error. He spent his leisure time drawing and painting and about 1910, according to his own account, "made the greatest forward strides in my pictorial work" (*Sky Hooks* [1938], p. 126). Kane returned to Pittsburgh, where during World War I, he worked in an ammunition factory. Separated from his wife and children, who had long since moved to Washington, D.C., he lived in rooms in the Pittsburgh slum neighborhood called "the Strip." Although he continued to work as a carpenter and house painter, he now spent much of his time painting pictures.

Beginning in 1925, Kane attempted to show his work in the annual exhibitions at the Carnegie Institute. Two years later, at the insistence of one of the jurors, the painter Andrew Dasburg (1887–1979), Kane's *Scene in the Scottish Highlands*, ca. 1927 (Museum of Art, Carnegie Institute, Pittsburgh), was accepted for inclusion in this prestigious exhibition. Among the first of the modern American primitive artists to gain public approbation, Kane achieved a great deal of recognition over the next seven years. He contributed his work regularly to the Carnegie International and to the exhibitions of the Associated Artists of Pittsburgh, which awarded him a prize in 1928. His first one-man show was organized by the Junior League of Pittsburgh in 1931, and, in spite of criticism that he had at times painted over photographs (a fact Kane never denied), exhibitions followed at two New York galleries. By 1930, examples of his work had been purchased by such prominent collectors as Abby Aldrich Rockefeller. Despite his success, however, Kane continued to live a simple, almost penurious existence. He was reunited with his wife in 1927 and spent his final years painting and also recording his reminiscences, which, with the help of Marie McSwigan, a newspaper reporter, appeared as *Sky Hooks* in 1938, four years after the artist's death.

The study of Kane's work is complicated by his repetition of subjects, his indifference to titles, and the infrequent dating of his canvases. He began to draw seriously around 1890, but few examples of the drawings or pastels he is said to have done have come to light. Although he began painting in oil after the turn of the century, when he was in his forties, most of his serious work in that medium was not done until the final decade of his life, in the late 1920s and early 1930s. The artist's subject matter was most often industrial Pittsburgh, but he sometimes painted portraits of himself and his family and occasionally of more prominent people, such

as Bishop Hugh C. Boyle (coll. Dr. Edward W. zur Horst, Pittsburgh). A number of his most ambitious paintings are drawn from childhood memories of Scotland, for example *The Campbells Are Coming*, ca. 1925 (Museum of Modern Art, New York). More unusual in his work are historical subjects like *George Washington* and religious ones like *Christ in the Temple*, 1932 (both John Kane estate). Kane's paintings show a strong sense of overall design and incredible attention to detail. A few of his pictures, usually the religious subjects, were copies of works by other artists, but most are original in conception, the result of his personal vision and experience.

BIBLIOGRAPHY: M. B. Mullet, "Maybe It's All I'll Ever Get, but It's Worth While," *American Magazine* 105 (April 1928), pp. 18–19 ‖ *Index of Twentieth Century Artists* 3 (Dec. 1935), 213–214 and suppl. Reprint ed. with cumulative index. New York: Arno Press, 1970, pp. 505–506, 509 ‖ John Kane, *Sky Hooks* (Philadelphia, 1938). The artist's autobiography as told to Marie McSwigan with foreword by Frank Crowninshield ‖ Sidney Janis, *They Taught Themselves: American Primitive Painters of the 20th Century* (New York, 1942). Reprint ed. Port Washington, N.Y.: Kennikat Press, 1965, pp. 76–98. An early evaluation of the artist's work with a foreword by Alfred H. Barr, Jr., it includes a list of exhibitions and a detailed study of several paintings ‖ Leon Anthony Arkus, comp., *John Kane, Painter* (Pittsburgh, 1971). A catalogue raisonné of Kane's work with provenance, exhibitions, and references; it provides a list of one-man and group exhibitions, many illustrations, an extensive bibliography, and reprints *Sky Hooks* (1938).

Old Elm

The painting, done around 1927 or 1928, is very likely of an actual home in the Pittsburgh area. Kane may have even made it to sell to the occupants of the house, a practice he followed early in his career. The focal point of the picture, however, is not the house but the large elm tree in front of it. Silhouetted against the sky, the elm's network of branches and foliage creates a striking pattern. Although Kane has carefully delineated each sinuous branch and many of the small leaves, he has captured both the overall impact of the tree's graceful structure and the fluid contour of its leafy crown. His flowing lines serve as a foil to the few rectilinear elements of the composition, for example, the Victorian house and the diagonal path leading to it. The sky, crowded with soft clouds of various and somewhat unusual shapes, also exemplifies the artist's strong sense of design.

Like many untrained artists, Kane devised his own system of perspective to indicate spatial relationships. The tree, perhaps because it is the most important feature in the composition, is greatly enlarged, way out of scale with the house behind it. Unable to draw the house in perspective, the artist shows both the front and a side view. The work does indicate some knowledge of atmospheric perspective, however, for the foreground and middle ground are more darkly and tightly painted than the distance, where rows of box-like houses are represented in light colors and with less decisive outlines. By and large, though, Kane eschews academic concerns to produce a strong design. He orchestrates a wealth of detail to create lively patterns and expressive lines.

Oil on canvas, $21\frac{1}{8} \times 25$ in. (53.7 × 63.5 cm.).

Signed and inscribed at lower right: OLD ELM / JOHN KANE.

REFERENCES: *Art Digest* 6 (Nov. 15, 1931), ill. p. 9, discusses the picture in a review of an exhibition at Gallery 144 West 13th Street ‖ *Index of Twentieth Century Artists* 3 (Dec. 1935), p. 214, notes illustration ‖ S. Janis, *They Taught Themselves* (1942), p. 83, lists it as a work exhibited at the Addison Gallery in 1932 ‖

Kane, *Old Elm*.

Kane, *Monongahela Valley.*

L. A. Arkus, comp., *John Kane, Painter* (1971), p. 169, lists it under Pittsburgh subjects as no. 97 in a catalogue raisonné of the artist's work, dates it about 1927–1928, and gives exhibitions and reference; ill. p. 274.

EXHIBITED: Harvard Society of Contemporary Art, Cambridge, Mass., 1929, *Paintings by Nine Americans*, no. 20, as Old Elm // Contemporary Arts, New York, 1931, *John Kane*, no. 15 // Gallery 144 West 13th Street, New York, 1931, *John Kane* (no cat. available) // Addison Gallery of American Art, Phillips Academy, Andover, Mass., 1932, *One Man's Taste in Contemporary American Art*, exhib. cat. by R. G. McIntyre, no. 5 (lenders listed separately, probably Gallery 144 West 13th Street) // Wadsworth Atheneum, Hartford, 1935, *American Painting and Sculpture of the 18th, 19th and 20th Centuries*, no. 69, as The Elm, lent by Valentine Gallery, New York // Valentine Gallery, New York, 1937, *Paintings by John Kane (1860–1934)*, no. 1, as The Elm // Arts Club of Chicago, 1939, *Exhibition of Paintings by John Kane*, no. 2 // Carnegie Institute, Pittsburgh; Corcoran Gallery of Art, Washington, D.C., 1966–1967, *3 Self-Taught Pennsylvania Artists*, ill. no. 60, as The Old Elm, lent by Miss Adelaide Milton de Groot.

ON DEPOSIT: Yale University Art Gallery, New Haven, 1942–1952, lent by Adelaide Milton de Groot // MMA, New York, 1952–1967, lent by Adelaide Milton de Groot.

EX COLL.: the artist, Pittsburgh, until at least 1931; probably with Gallery 144 West 13th Street, New York, 1931–1932; with Valentine Gallery, New York, by 1935–at least 1937; Adelaide Milton de Groot, New York, by 1942–1967.

Bequest of Miss Adelaide Milton de Groot (1876–1967), 1967.

67.187.166.

Monongahela Valley

Painted in 1931, the picture shows the steel mills, railroad tracks, and warehouses that line the Monongahela River in industrial Pittsburgh, a workingman's and, thus, this artist's milieu. "I have been asked why I am particularly interested in painting Pittsburgh, her mills with their plumes of smoke, her high hills and deep valleys and winding rivers," Kane once commented. His answer was:

Because I find beauty everywhere in Pittsburgh. It is the beauty of the past which the present has not touched. The city is my own. I have worked on all parts of it, in building the blast furnaces and then in the mills and in paving the tracks that brought the first street cars out Fifth Avenue to Oakland. The filtration plant, the bridges that span the river, all these are my own. Why shouldn't I want to set them down when they are, to some extent, children of my labors and when I see them always in the light of beauty? (*Sky Hooks* [1938], p. 181.)

For Kane, Pittsburgh was beautiful at its grimiest, and here he shows the city at the height of activity, smoke belching from stacks, a crazy quilt of roadways, train tracks, freight cars, bridges, fences, factories, steel mills, and houses. Five small figures working on the railroad tracks (a job once held by the artist) are dwarfed by the factories behind them, and the verdant landscape across the river seems beyond their reach.

This industrial scene, like so many of Kane's works, is panoramic in scope, yet the artist repre-

John Kane

sents many small features, such as railroad ties and mortared blocks of stone that would hardly be visible from such a distance. The strongly designed composition, with the sweeping curve of the railroad tracks and the snake-like river, lends cohesiveness to this assemblage of minute detail.

The artist began a smaller and slightly different version of this picture, *Monongahela Valley* (coll. John, Joseph, and Robert Conley, Pittsburgh). This painting is unfinished and lacks many of the more subtle effects of the Metropolitan picture, for example, the smoke pouring from the chimneys.

Oil on canvas, 28 × 34¼ in. (71.1 × 87 cm.).

Signed and dated at lower left: JOHN KANE / 1931.

RELATED WORK: *Monongahela Valley*, oil on canvas, 24 × 32 in. (61 × 81.3 cm.), unfinished, coll. John, Joseph, and Robert Conley, Pittsburgh, ill. L. A. Arkus, *John Kane, Painter* (1971), p. 306.

REFERENCES: *Art Digest* 6 (Nov. 15, 1931), p. 9 // *Carnegie Magazine* 10 (April 1936), pp. 21–22, notes that the picture was included in the annual exhibition of the Carnegie Institute in 1931; p. 24 // J. Kane, *Sky Hooks* (1938), ill. p. 49, says it shows Pittsburgh as he saw it fifty years after his immigration // S. Janis, *They Taught Themselves* (1942), p. 83; p. 84, notes the painting as an example of a work the artist repeated with some variations and change in size // A. H. Barr, Jr., ed., *Painting and Sculpture in the Museum of Modern Art* (1948), p. 310, lists it as no. 364, and says it is on extended loan // *Fortune* 40 (Dec. 1949), color ill. p. 136 // D. L. Smith, *American Artist* 23 (April 1959), ill. p. 48 // W. Gill, *Pittsburgh Press, Sunday Roto*, Dec. 27, 1959, ill. p. 10 // L. A. Arkus, comp., *John Kane, Painter* (1971), p. 178, lists it under Pittsburgh as no. 130 in a catalogue of the artist's works, and gives exhibitions and references // D. Jablon, Museum of Modern Art, New York, letter in Dept. Archives, Oct. 31, 1977, provides information on provenance and exhibition record // L. A. Arkus, Museum of Art, Carnegie Institute, Pittsburgh, letter in Dept. Archives, Feb. 8, 1979, discusses the relationship between it and the Conley picture.

EXHIBITED: Carnegie Institute, Pittsburgh, 1931, no. 92, as Monongahela Valley // Gallery 144 West 13th Street, New York, 1932, *John Kane Exhibition*, no. 2 // Art Institute of Chicago, 1932–1933, no. 95 // U.S. Department of Labor Building, Washington, D.C., 1935, *John Kane's Paintings* (no cat. available) // Valentine Gallery, New York, 1935, *Memorial Exhibition of Selected Paintings by John Kane 1860–1934*, no. 4 // Carnegie Institute, Pittsburgh, 1936, *A Memorial Exhibition of the Paintings of John Kane (1860–1934)*, no. 15, lent by Adelaide Milton de Groot // Museum of Modern Art, New York, 1938, *Masters of Popular Painting*, exhib. cat. by H. Cahill, M. Gauthier, J. Cassou, et al. (in collaboration with the Grenoble Museum), no. 150, lent by Adelaide Milton de Groot //

Art Institute of Chicago, 1939–1940, *Half a Century of American Art*, exhib. cat. by D. C. Rich, no. 87, lent by Adelaide Milton de Groot through the courtesy of the Museum of Modern Art, New York; p. 26, quotes an early review of it; ill. pl. lvii // Columbus Gallery of Fine Arts, Ohio, 1958, *Masterpieces from the Adelaide Milton de Groot Collection*, no. 19 // Carnegie Institute, Pittsburgh; Corcoran Gallery of Art, Washington, D.C., 1966–1967, *3 Self-Taught Pennsylvania Artists*, ill. no. 67, unpaged text, quotes review of it // ACA Galleries, New York, 1969, *John Kane*, exhib. cat. by L. A. Arkus, ill. no. 13; 1972, *Four American Primitives*, no. 29.

ON DEPOSIT: MMA, 1936, lent by Adelaide Milton de Groot // Museum of Modern Art, New York, 1937–1956, lent by Adelaide Milton de Groot // MMA, 1956–1958 and 1959–1967, lent by Adelaide Milton de Groot.

EX COLL.: with Valentine Gallery, New York, by 1935; Adelaide Milton de Groot, New York, 1936–1967.

Bequest of Miss Adelaide Milton de Groot (1876–1967), 1967.

67.187.165.

From My Studio Window

Dated 1932, the picture is a view from the artist's studio at 1700 Fifth Avenue in Pittsburgh. It is not a simple record of the actual scene, however, but an imaginative rearrangement of reality; for, as Kane commented "no camera was ever constructed to get the view of objects that I, as an artist, see and paint" (*Sky Hooks* [1938], p. 166). The truth of Kane's comment was demonstrated in 1940 when the writer and art dealer Sidney Janis had photographs of the site taken from the building next door to Kane's. After comparing the painting and the photographs, Janis concluded that "in order to get in all the buildings Kane had compressed into his painting, it would have been necessary to take a panorama shot, and from two levels, at that." Kane's picture is thus a composite of several views, arranged in a carefully structured composition. The street, the buildings, and the distant skyscrapers are ordered in neat rows parallel to the picture plane. The scale and spatial relationships have been altered so that, for example, the skyscrapers in the distance are larger and have greater clarity and detail than they would have had when viewed from the artist's window. The tenement buildings that line the avenue are attenuated and, particularly at the far left, compressed until the windows are only narrow slits. The people and vehicles below are reduced in size so they are overwhelmed

...ne, *From My Studio Window.*

by the buildings that serve as a backdrop to them, heightening the impression that they move in a crowded, monumental environment.

An early photograph, presumably taken before this picture was signed and dated, shows *From My Studio Window* without the N. Rice Cigar Company truck and without smoke pouring from the chimneys, indicating that these details, which contribute so much to the painting's decorativeness, were among the last features added.

Oil on canvas, 22⅜ × 34⅜ in. (56.8 × 87.3 cm.).
Signed and dated at lower left: JOHN KANE / 1932.

REFERENCES: J. O'Connor, Jr., *Carnegie Magazine* 10 (April 1936), ill. p. 20; p. 23, says the picture exemplifies Kane's ability to enclose large, complicated areas within a small canvas // J. Kane, *Sky Hooks* (1938), p. 167, says that in 1931, he took rooms at 1700 Fifth Avenue, where he painted the picture, which he exhibited in 1932; ill. p. 169 // S. Janis, *They Taught Themselves* (1942), p. 83, notes Pittsburgh exhibition of it in 1932; pp. 85–88, illustrates and compares it to a photograph of the site, made eight years after the painting and concludes that it combines several differ- ent views (quoted above); describes the artist's use of "diminishing perspective" // A. H. Barr, Jr., ed., *Painting and Sculpture in the Museum of Modern Art* (1948), p. 311, lists it as no. 365 in catalogue of the collection and notes that it is on extended loan from Adelaide Milton de Groot // D. C. Miller, in J. I. H. Baur, ed., *New Art in America* (1957), p. 140, says it is on extended loan to the Museum of Modern Art from Adelaide Milton de Groot; color ill. p. 141 // D. L. Smith, *American Artist* 23 (April 1959), ill. p. 48; dates it 1932 // W. Gill, *Pittsburgh Press, Sunday Roto*, Dec. 27, 1959, ill. p. 10 // W. Haftmann, *Painting in the Twentieth Century* (1961; 1966), p. 177 // H. Geldzahler, *American Painting in the Twentieth Century* (1965), ill. p. 123, discusses, noting Janis's observations // L. A. Arkus, *Carnegie Magazine* 40 (Oct. 1966), ill. p. 259, in a review of an exhibition // *Pittsburgh Post-Gazette*, Oct. 17, 1966, ill. p. 39, mentions it in a review of an exhibition // L. A. Arkus, comp., *John Kane, Painter* (1971), pp. 94, 123; p. 176, lists it under Pittsburgh subjects as no. 125, in a catalogue of the artist's works, giving exhibitions and references and noting that an early photograph of it, taken before it was signed and dated, indicates that the N. Rice Cigar truck and the smoke from various chimneys were added later, creat- ing a better designed work; ill. p. 301 // D. Jablon,

Museum of Modern Art, New York, letter in Dept. Archives, Oct. 31, 1977, provides information on provenance and exhibition record.

EXHIBITED: Carnegie Institute, Pittsburgh, 1932, *Exhibition of Paintings by Pittsburgh Artists*, no. 22, as Scene from My Studio // Gallery 144 West 13th Street, New York, 1934, *John Kane Exhibition*, no. 6 // Valentine Gallery, New York, 1935, *Memorial Exhibition of Selected Paintings by John Kane, 1860–1934*, no. 12, as View from My Window // Carnegie Institute, Pittsburgh, 1936, *An Exhibition of American Genre Paintings*, no. 59, as From My Studio Window, lent by Adelaide Milton de Groot; 1936, *A Memorial Exhibition of Paintings of John Kane (1860–1934)*, no. 30, lent by Adelaide Milton de Groot // Museum of Modern Art, New York (in collaboration with the Grenoble Museum), 1938, *Masters of Popular Painting*, exhib. cat. by H. Cahill, M. Gauthier, J. Cassou, et al., no. 151, lent by Adelaide Milton de Groot // Museum Boymans-van Beuningen, Rotterdam, 1964, *De Lusthof der Naïeven*, essay by O. Bihalji-Merin, no. 83, as Gezicht vit het raam van mijm atelier, ill. // MMA, *Three Centuries of American Painting* (checklist alphabetical), lent by Adelaide Milton de Groot // Carnegie Institute, Pittsburgh, and Corcoran Gallery of Art, Washington, D.C., 1966–1967, *3 Self-Taught Pennsylvania Artists*, pl. 74, lent by Adelaide Milton de Groot; unpaged text discusses it // ACA Galleries, New York, 1972, *Four American Primitives*, no. 23.

ON DEPOSIT: MMA, 1936–1937, lent by Adelaide Milton de Groot // Museum of Modern Art, New York, 1937–1956, lent by Adelaide Milton de Groot // MMA, 1956–1967, lent by Adelaide Milton de Groot.

EX COLL.: with Gallery 144 West 13th Street, New York, by 1934; with Valentine Gallery, New York, by 1935; Adelaide Milton de Groot, 1936–1967.

Bequest of Miss Adelaide Milton de Groot (1876–1967), 1967.

67.187.164.

GARI MELCHERS

1860–1932

This leading figure painter and portraitist spent much of his career abroad. He was born Julius Gari Melchers in Detroit, the son of a woodcarver and sculptor from Westphalia, Julius Theodore Melchers. Encouraged by his father, who gave him his first instruction in drawing, young Melchers went to Germany in 1877 and studied at the Düsseldorf Academy under Karl von Gebhardt and Peter Janssen. Four years later he moved to Paris and continued his studies at the Académie Julian under Gustave Boulanger and Jules Joseph Lefebvre. Within a year, one of Melchers's paintings, *The Letter*, 1882 (Corcoran Gallery of Art, Washington, D.C.), was shown at the Salon. The artist stayed in Paris for three years, until 1884, and then settled in Holland, where he worked for much of the next thirty years in a studio in Egmond on the coast of the North Sea. There a colony of artists, many of them British and American, like Cecil Jay and GEORGE HITCHCOCK, painted scenes of local life. Melchers continued to exhibit his paintings in Paris at the Salon des Artistes Français until 1888 and at the Société Nationale des Beaux-Arts until 1908. At the Universal Exposition of 1889 in Paris, he and JOHN SINGER SARGENT were the only Americans awarded a grand prix.

Melcher's motto in art, "Waar en Klaar," true and clear, is born out by his scenes of Dutch peasants. Often representations of mother and child themes or scenes of religious ceremonies, his early paintings, like *The Sermon*, 1886 (National Collection of Fine Arts, Washington, D.C.), depict ordinary people in everyday settings. Melchers's realistic treatment of the figure, his use of bright, natural light, and his tendency to ennoble the peasant show the influence of such progressive German painters as Max Liebermann and Fritz von Uhde. It is also evident from

his austere and carefully arranged interior scenes that Melchers admired Dutch old masters like Vermeer. The artist continued to depict peasant subjects during the 1890s, but, perhaps because of his exposure to post-impressionism, his style became more decorative, with a greater emphasis on flat patterns, bright colors, and paint surfaces built up on coarse canvas. Also inspired by the murals of Puvis de Chavannes, Melchers did decorations for the World's Columbian Exposition, held in Chicago in 1893, and shortly thereafter for the Library of Congress in Washington. Around this time too, he began a series of religious paintings, among which is his *Last Supper* (Virginia Museum of Fine Arts, Richmond). During the next decade, single portraits became more common in his œuvre, and in 1908 he painted the most important of these, *President Theodore Roosevelt* (Freer Gallery of Art, Washington, D.C.). Following his marriage in 1903 to an art student, Corinne Lawton Mackall (1880–1955), Melchers more often depicted intimate domestic interiors, in which brilliant almost harsh colors are freely applied.

Throughout his career, the artist won many awards at home and abroad, and in 1909, he accepted the invitation of the grand duke of Saxe-Weimar to teach at the art academy in Weimar. The outbreak of World War I in 1914, however, brought the artist back to the United States, and two years later he bought Belmont, a country house in Falmouth, near Fredericksburg, Virginia. He lived there for the rest of his life, although he maintained a studio in New York and often traveled to execute portrait commissions. During the 1920s, Melchers undertook two large decorative commissions, treating subjects from local history: three murals for the Detroit Public Library and four for the State House in Jefferson City, Missouri. He was active in a number of organizations, serving as president of the New Society of Artists from 1920 to 1928, and beginning in 1923 as chairman of the federal commission that set up the National Gallery of Art (now the National Collection of Fine Arts) in Washington. He continued to paint until his death at Belmont in 1932. Memorial exhibitions of the artist's work were held at the Corcoran Gallery of Art in 1933, the Carnegie Institute in 1934, and the Virginia Museum of Fine Arts in 1938. More than twenty years after his death Melcher's home in Virginia became a memorial to him, and today Belmont, administered by Mary Washington College, houses an impressive collection of his work.

BIBLIOGRAPHY: Christian Brinton, "The Art of Gari Melchers," *Harper's Monthly Magazine* 114 (Feb. 1907), pp. 430–439, reprinted with revisions in the author's *Modern Artists* (New York, 1908), pp. 211–225 // Henriette Lewis-Hind, *Gari Melchers, Painter* (New York, 1928), an appreciation by a longtime friend of the artist // *Index of Twentieth Century Artists* 1 (Oct. 1933), pp. 1–12, with suppls. Reprint ed. with cumulative index. New York: Arno Press, 1970, pp. 2–12, 17–18, 20, 21. Gives biography, list of awards and affiliations, public collections where work is represented and exhibitions, provides extensive bibliography and notes illustrations of major works // Mary Washington College, Fredericksburg, Va., *Gari Melchers (1860–1932): Selections from the Mary Washington College Collection* (1973), exhib. cat., includes: Leslie Lenore Gross, "Melchers' Art from Detroit and Dusseldorf" and "Paris Years"; Sylvia Payne and Patricia Marshall, "Melchers' 'Last Supper' Series"; Julia Blair and Sarah Schroth, "The Realism of Gari Melchers"; Gayle Easter, Andrea Hurd, and Patricia Rosenberg, "Detroit Public Library Murals"; Debby Williams, "The Etchings of Gari Melchers"; Sarah Schroth, "The Zeeland Madonna"; and a selected bibliography // Graham Gallery, New York, *Gari Melchers, 1860–1932, American Painter* (organized in association with Victor D. Spark and Belmont, the Gari Melchers Memorial Gallery), exhib. cat. (1978), essay by Janice C. Oresman, chronology, list of honors and awards, exhibitions, and catalogue of works shown.

Melchers, *Madonna*.

Madonna

Probably painted in 1906 or 1907, *Madonna* is one of Melchers's many treatments of the mother and child theme. The composition follows traditional religious paintings with a madonna and child accompanied by a supplicating figure, but the subject is put in a modern context. In his work, the artist presents an ennobled and somewhat sentimental view of the peasant that recalls paintings by his friend GEORGE HITCHCOCK and such European realists as Jules Bastien-Lepage and Fritz Uhde.

Praised in a 1911 review for "a sunny atmosphere" and "the accomplished handling of the whole color scheme," the painting shows figures in bright light, set against a screen of trees and foliage. This brilliantly colored backdrop and the placement of the figures in a shallow space, close to the picture plane, emphasize the surface of the painting. Here, as is typical of Melchers's work at the turn of the century, the texture is richer and the treatment less finished than in the artist's earlier works. As Henriette Lewis-Hind noted: "There was no longer a sameness of texture, there was a kind of ecstasy in the way he built up the pigment, or kept it transparent" (*Gari Melchers, Painter* [1928], unpaged).

The Metropolitan's painting is sometimes described as a variant of the artist's *Le Bosquet*, ca. 1908 (Musée National d'Art Moderne, Paris). Instead both paintings appear to be part of a series that occupied Melchers's attention from about 1906 until at least 1913.

Oil on paper, mounted on canvas, $47\frac{1}{4} \times 39\frac{5}{8}$ in. (120 × 100.7 cm.).

Signed at lower center: *Gari Melchers*.

REFERENCES: P. Clemen, *Die Kunst für Alle* 25 (May 1910), color ill. opp. p. 316; p. 368, discusses the picture, which was then on exhibition in Germany // H. Reisinger to G. Melchers, Feb. 4, 1910, Belmont, Gari Melchers Memorial Gallery, Falmouth, Va., microfilm 1182, Arch. Am. Art, says it is one of three of the artist's paintings included in German exhibition // G. Melchers to F. D. Millet, Feb. 21, 1911, MMA Library, expresses his pleasure at hearing the museum is interested in it; to E. Robinson, director MMA, Feb. 27, 1911, MMA Archives, says he appreciates that the museum's board is interested in purchasing it // E. Robinson; letter in MMA Archives, March 1, 1911, expresses enthusiasm of John White Alexander and Bryson Burroughs for the acquisition of the painting and notes "Mr. Melchers himself says that he would like to be represented by it" // D. C. French, letter in MMA Archives, March 2, 1911, approves of its acquisition // *American Art News* 9 (March 4, 1911), p. 6, mentions it in a review of an exhibition at Montross Gallery // *New York Times*, March 3, 1911, p. 11, praises the painting in a review of the Montross exhibition (quoted above) // G. Melchers, letter in MMA Archives, March 17, 1911, says "I can not help saying it to you again how very much pleased I am that the Metropolitan Museum has become the owner of this picture—for I know it represents me at my very best" // *Craftsman*, 20 (April 1911), p. 112, notes that of three "mother-and-child subjects" in the Montross exhibition, this picture is "the loveliest" // B. B[urroughs], *MMA Bull.* 6 (April 1911), p. 100, says it was painted in 1906–1907, has recently been acquired by the museum, and is on view // J. M. Laurvik, *International Studio* 48 (Dec. 1912), ill. p. xxxii // C. T. MacChesney, *New York Times*, Jan. 19, 1913, sec. 5, p. 14, says that the Luxembourg has recently purchased a painting similar to it // H. Lewis-Hind, *Gari Melchers, Painter* (1928), unpaged ill. // G. Melchers, letter in MMA Archives, Nov. 17, 1928, requests loan of the painting for a retrospective exhibition at Anderson Galleries // *Art News* 31 (Dec. 10, 1932), p. 9, mentions it in the artist's obituary // *Index of Twentieth Century Artists* 1 (Oct. 1933), p. 9, lists illustrations of it.

EXHIBITED: PAFA, 1909, no. 570, as Madonna // Royal Academy of Art, Berlin, and Royal Art Society, Munich, 1910, *Ausstellung Amerikanischer Kunst*, no. 69 // Art Institute of Chicago, 1910, no. 151 // Montross Gallery, New York, 1911, *Exhibition of Pictures by Gari Melchers*, no. 3 // Detroit Institute of

Arts, 1927, *Retrospective Exhibition of Paintings by Gari Melchers*, cat. by C. H. Burroughs, no. 6; p. vii // Anderson Galleries, New York, 1929, *Paintings and Drawings by Gari Melchers*, no. 26 // Carnegie Institute, Pittsburgh, 1934, *A Memorial Exhibition of the Work of Gari Melchers*, no. 22 // Virginia Museum of Fine Arts, Richmond, 1938, *Gari Melchers: A Memorial Exhibition of His Work*, no. 69.

Ex coll.: the artist, until 1911; with Montross Galleries, New York, 1911.

Rogers Fund, 1911.

11.42.

In the Studio (Gari Melchers and Hugo Reisinger)

This double portrait, dated 1912, shows the artist Gari Melchers, palette and brushes in hand, at work on a portrait of Hugo Reisinger (1856–1914), who is seated in profile in the foreground. *In the Studio* documents the friendship of these two men, who among other things shared an enthusiasm for German art and culture.

Reisinger, who was born in Wiesbaden, settled in New York in 1884 and eventually became a leading importer and exporter. A discriminating collector of modern art, he patronized a number of contemporary American artists, including Melchers, J. ALDEN WEIR, and CHILDE HASSAM. Reisinger helped organize an exhibition of German art at the Metropolitan Museum in 1909 and a major exhibition of American art in Berlin and Munich the following year. He also promoted other cultural exchanges between his native country and the United States, supporting the publication of German literature in America and encouraging German museum officials to study different procedures here. In 1914, he succeeded his father-in-law, the brewer Adolphus Busch, as president of Harvard University's Germanic Museum (now the Busch-Reisinger Museum, Cambridge, Mass.). Reisinger, who in 1908 had been elected an honorary fellow for life at the Metropolitan Museum, bequeathed a fund for the acquisition of paintings and sculpture by German artists.

Melchers, *In the Studio (Gari Melchers and Hugo Reisinger)*.

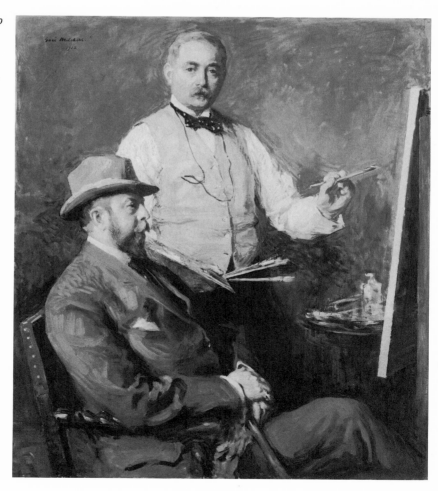

The relatively academic treatment of this portrait is a departure from the vibrant colors and rich surfaces that are usually associated with Melchers's figure paintings at the turn of the century (see *Madonna* above). Here he works instead with the subdued palette and facile brushwork typical of the international style of portraiture popular during the period, choosing an informal composition that reveals his intimacy with the sitter. The artist arrived at this particular solution after a number of preliminary studies, two of which show Melchers and Reisinger seated, and a third, possibly final, study showing the two men in poses only slightly different from the finished work.

Oil on canvas, $54\frac{3}{16} \times 47\frac{13}{16}$ in. (137.6 × 119.9 cm.).

Signed and dated at upper left: Gari Melchers. / 1912. Inscribed on the reverse: "In the studio" / (Hugo Reisinger / Gari Melchers).

RELATED WORKS: *Portrait Sketch of Hugo Reisinger and Gari Melchers*, watercolor and pencil on paper, $9\frac{15}{16} \times 7\frac{5}{16}$ in. (25.2 × 20.2 cm.), Belmont, Gari Melchers Memorial, Falmouth, Va., MCW-121. In this work both figures are seated; Reisinger is hatless in the right foreground and Melchers in the left background, the reverse of their positions in the finished portrait // *Portrait Sketch of Hugo Reisinger and Gari Melchers*, oil on canvas, 16 × 20½ in. (40.6 × 52.1 cm.), Belmont, Gari Melchers Memorial, Falmouth, Va., MCW-1314. In this study Reisinger is seated essentially in the same pose as in the finished work but Melchers is also seated // *Portrait Sketch of Hugo Reisinger and Gari Melchers*, oil on canvas, 20 × 16 in. (50.8 × 40.6 cm.), coll. E. W. Stroh. This composition has the same vertical format as the finished work and shows the figures similarly posed.

Melchers, watercolor portrait of Hugo Reisinger and Gari Melchers, Belmont.

REFERENCES: H. Reisinger to G. Melchers, Feb. 10, 1914, Belmont, Gari Melchers Memorial Gallery, Falmouth, Va., discusses the varnishing of the painting and his plans to exhibit it in Boston, Pittsburgh, New York, and San Francisco // G. Melchers to his wife, C. Melchers, May 31 [1917], ibid., microfilm 1180, Arch. Am. Art, says that "the double portrait of Hugo R. and myself must probably be sold at auction" // H. Lewis-Hind, *Gari Melchers, Painter* (1928), unpaged ill., as owned by Mrs. Charles Greenough // *Bulletin of the Dayton Art Institute News* 2 (April 1930), ill. p. 5, discusses its inclusion in an extension of the Melchers retrospective in Buffalo // *Art News* 29 (April 25, 1931), ill. p. 1, as The Double Portrait, says on view at Milch Galleries; 31 (Dec. 10, 1932), ill. p. 9, shows a detail of the standing figure // *Index of Twentieth Century Artists* 1 (Oct. 1933), p. 8, lists illustrations of it // *Carnegie Magazine* 7 (Jan. 1934), ill. p. 227, as coll. of Mrs. Busch Greenough // E. R. Morsman, granddaughter of the subject, letter in Dept. Archives, March 5, 1979, gives information on the provenance.

EXHIBITED: Copley Society of Boston, 1914, *Portraits by Living Painters*, no. 33, as In the Studio, lent by Hugo Reisinger // Carnegie Institute, Pittsburgh, 1914, no. 207 // Panama-Pacific International Exposition, San Francisco, California, 1915, *Official Catalogue . . . of the Department of Fine Arts*, no. 3681, as Portrait Group, lent by Hugo Reisinger Estate // Buffalo Fine Arts Academy, Albright Art Gallery, and Dayton Art Institute, Ohio, 1930, *Exhibition of a Retrospective of the Life Work of Gari Melchers, N.A.*, ill.

Melchers, oil *Portrait Sketch of Hugo Reisinger and Gari Melchers*, Belmont.

no. 11, lent by Mrs. Charles Greenough // Am. Acad. of Arts and Letters, New York, 1932–1933, *A Catalogue of an Exhibition of Paintings by Gari Melchers at the American Academy of Arts and Letters*, ill. no. 23, lent by Mrs. Busch Greenough // Carnegie Institute, Pittsburgh, 1934, *A Memorial Exhibition of the Work of Gari Melchers*, no. 50, lent by Mrs. Busch Greenough.

Ex COLL.: Hugo Reisinger, New York, until 1914; estate of Hugo Reisinger, 1915; his wife, Edmée Busch Reisinger, later Mrs. Busch Greenough, New York, by 1928–died 1955; her son, Curt H. Reisinger, by 1956.

Gift of Curt H. Reisinger, 1956.

56.88.

STACY TOLMAN

1860–1935

The portrait and figure painter Stacy Tolman was born in Concord, Massachusetts, and educated in local schools. He received his early training in art at the School of the Museum of Fine Arts, Boston, beginning in 1878. Tolman's instructor was the German-born painter Otto Grundmann (1848–1890) in whose class he served as an assistant from 1881 to 1882. The next year he opened his own studio in Boston. Soon after, in 1884, he went to Paris for two years. At first he studied at the Académie Julian under Gustave Boulanger, William Adolphe Bouguereau, and Jules Joseph Lefebvre and later at the Ecole des Beaux-Arts, where Alexandre Cabanel was his teacher. One of Tolman's important early paintings, *Woman and Goat*, 1884 (coll. Lewis Glaser)—probably the *Un jardin en Normandie* which he exhibited at the Paris Salon in 1885—shows the influence of such French realists as Jules Bastien-Lepage.

On his return to the United States in 1886, Tolman reportedly took a studio in Concord, Massachusetts, but he soon moved to Boston and in 1887 began to share a studio with the printmaker William W. H. Bicknell (see below *The Etcher*). During the late 1880s, Tolman continued his studies at the Cowles Art School in Boston, where he worked under DENNIS MILLER BUNKER, whose interior genre scenes were a strong influence on him. Tolman's *The Musicale*, 1887 (Brooklyn Museum), for example, shows the same firm draftsmanship and somber palette usually associated with Bunker's painting at this time. During these years, Tolman supported himself with decorative work and illustrations and by assisting C. L. Adams, an instructor at the Massachusetts Institute of Technology. One of the artist's first commissions, done in 1888, was for a copy of GILBERT STUART's *George Washington* (the copy is unlocated).

In 1889, Tolman went to teach at the Rhode Island School of Design in Providence, and during the early 1890s he seems to have divided his time between that city and Boston. He settled in Providence, however, in 1895, took a studio in the Fleur de Lys (later Lis) Building, and there over the next several years painted a series of conventional genre scenes reminiscent of the work of earlier artists like EASTMAN JOHNSON. A prominent figure among local artists, Tolman was a member of the Providence Art Club and the Providence Water Color Club. He was head of the Rhode Island School of Design's department of drawing and painting until 1905, after which time he taught the school's anatomy class. He conducted a summer class at Rumford, Maine, in 1900, and probably other years as well, and also took private students,

among them Robert H. Nisbet (1879–1961). Following his marraige in 1902 to Helen Manton Bradford, a former student, Tolman made several trips to Europe. He occasionally visited Munich and seems to have spent at least a year there at one point, probably in 1906. His late painting style shows a belated influence of impressionism. The bright palette and plein-air subjects of such works as *The Swimming Hole*, 1908 (Providence art market, 1979) may have been inspired in part by WILLARD METCALF, who also taught at the Rhode Island School of Design during the early 1900s. Although these paintings represent a decline in the artist's work, his late drawings and watercolors have the same strong draftsmanship that is evident in his early paintings.

Tolman continued to live and work in Providence during the final years of his career. He died in nearby Pawtucket at the age of seventy-five.

BIBLIOGRAPHY: Ralph Davol, "An Appreciation of Stacy Tolman," *Brush and Pencil* 7 (Dec. 1900), pp. 163–172 // Obituary: *Providence Journal*, Feb. 21, 1935, pp. 1, 12 // John I. H. Baur, "A Painter of Painters: Stacy Tolman (1860–1935)," *American Art Journal* 11 (Jan. 1979), pp. 37–48.

The Etcher

The painting depicts Tolman's friend and fellow student William Henry Warren Bicknell (1860–1947) at work on an etching, probably in the studio the two artists shared at 247 Washington Street, Boston. *The Etcher* is not dated, but it was done sometime between 1887, when Tolman and Bicknell began to share a studio, and 1890, when the painting was lent to the Museum of Fine Arts, Boston. The canvas stamp of Meade, Dodge and Company further substantiates this dating, as that firm was not listed in Boston city directories until 1887.

Bicknell is shown seated beneath a skylight. The cool natural light that emanates from it is diffused by a translucent screen that hangs at an angle above his head. He appears to be engaged in etching, working from a mirror that reflects a page from the book propped up slightly to his left. Beside him are the tools and materials of his craft, including a printing press, which stands at the far right. The interior is simply furnished with a couple of slat-back chairs, utilitarian tables, and a simple chest. The three wine bottles hanging under the skylight are the only hint of gaiety in this atmosphere of intense concentration.

Tolman, *The Etcher*.

Oil on canvas, 40⅛ × 30¾₆ in. (101.9 × 76.7 cm.).
Signed at lower left: STACY TOLMAN.
Canvas stamp: MEADE, DODGE & CO. / Artists Materials / 4 PARK ST. / BOSTON, MASS. / FRAMING / A SPECIALTY.
REFERENCES: W. H. Downes, *New England Magazine*, n.s. 8 (May 1893), p. 359, notes it as one of the important paintings exhibited at the World's Columbian Exposition; ill. p. 364; p. 367, calls it a portrait, "and a very good one" // R. Davol, *Brush and Pencil* 7 (Dec. 1900), p. 169, discusses it as "perhaps his best-known production," identifies sitter and says the painting hung in MFA, Boston, ill. p. 171 // *Old Print*

Shop Portfolio 21 (May 1962), ill. p. 212, dates it about 1887 // S. P. Feld, *Antiques* 87 (April 1965), ill. p. 443, identifies sitter as an artist with whom Tolman shared a studio in Boston, says the dry handling of paint is the result of Tolman's Parisian training, and states that the painting passed into obscurity and has recently been rediscovered // D. C. Hill, Westwood, Mass., letters in Dept. Archives, July 6, Sept. 1, 1965, and Jan. 1, 17, 1966, gives biographical information on the sitter // H. S. Newman, Old Print Shop, New York, letter in Dept. Archives, Sept. 13, 1965, gives information on provenance // T. N. Maytham, MFA, Boston, letter in Dept. Archives, Sept. 14, 1965, says it was exhibited there in March 1890, lent by the artist and then returned to William Everett, that it was lent to the museum again and sent in 1893 to Chicago // C. D. Childs, Childs Gallery, Boston, letter in Dept. Archives, Sept. 21, 1976, states that he owned the painting for many years and thinks that he may have purchased it from Bicknell's estate // J. I. H. Baur, Whitney Museum of American Art, letters in Dept. Archives, Sept. 21 and 30, 1976, discusses the painting in the context of the artist's career; *American Art Journal* 11 (Jan. 1979), p. 37; ill. p. 38; pp. 40–41, discusses it and dates it after 1887 and before 1893; p. 43, notes its "freer realism"; p. 48.

EXHIBITED: World's Columbian Exposition, Chicago, 1893, *Official Catalogue*, p. 27, no. 976, as The Etcher.

ON DEPOSIT: MFA, Boston, 1890 and 1893, lent by Stacy Tolman.

EX COLL.: with Williams and Everett, Boston, 1890; possibly the estate of the subject, Winchester, Mass., after 1947; with Childs Gallery, Boston, and then jointly with the Old Print Shop, New York, until 1962.

Purchase, Bertram F. and Susie Brummer Foundation, Inc. Gift, 1962.

62.92.

THEODORE EARL BUTLER

1860–1936

Butler was born in Columbus, Ohio, where his father, originally from upstate New York, ran a general store. The family was modestly well off, and Butler attended Marietta College in Ohio from 1876 until 1880. He received his first artistic training from an itinerant painter of panoramas, a Mr. Fowley or Foley. In 1882, Butler went to New York and enrolled in the Art Students League. Three years later he was in Paris, where he continued his studies at the Académie Julian, the Atelier Colarossi, and the Grande Chaumière. In 1888 he exhibited his work at the Paris Salon for the first time and won an honorable mention. That same year a fellow American artist THEODORE ROBINSON took him to Giverny to meet Claude Monet. Greatly influenced by Monet's style and subject matter, Butler began to paint impressionist garden scenes and plein-air figure studies.

Butler returned to the United States in 1890 when his father died, but by the following year he was back in Giverny. In 1892 he married Monet's stepdaughter Suzanne Hoschedé and thus became a member of the French artist's family. Butler's wife became ill in 1894 and died five years later. In 1899 the artist married her sister Marthe Hoschedé, who had cared for the Butlers' two children throughout Suzanne's illness. Soon after, he took his children and new wife to visit his family in Ohio. Before returning to France, they also spent some time in New York, where Butler painted and arranged for an exhibition of his work, which was held at Durand-Ruel in 1900. Around the turn of the century there were also exhibitions of Butler's paintings in France and Germany.

The artist is said to have executed mural decorations for the American pavilion at the

International Exposition held in Turin in 1911. He completed a series of historical murals begun by the ailing American decorative painter James Wall Finn (d. 1913), another resident of Giverny. Butler arrived in New York in January 1914 to supervise the installation of these works, and although he only planned a brief visit at this time, due to the outbreak of World War I, he remained and did not return to France until 1921. While in New York, he painted urban scenes of skyscrapers, neon signs, and picturesque docks. He also became well-acquainted with a number of New York artists, most notably John Sloan (1871–1951). In 1917 Butler contributed his work to the first exhibition of the Society of Independent Artists, which elected him one of its directors the following year. The final fifteen years of his career were spent in Giverny, where he continued to work in an impressionist style. The quality of his work declined greatly during this time. His son James Butler (b. 1893) also became a painter.

BIBLIOGRAPHY: Jean-Pierre Hoschedé, *Claude Monet, ce mal connu, intimité familiale d'un demi-siècle à Giverny de 1883 à 1926* (Geneva, 1960), i, pp. 19–31, 70–89, 99–105. Written by Monet's stepson (Butler's brother-in-law), this appreciative account deals incidently with events in Butler's life. // Charles E. Slatkin Galleries, New York, *Claude Monet and the Giverny Artists* (1960), exhib. cat., includes essays "The Art Colony at Giverny" by Regina Slatkin and "The Butlers of Giverny" // Signature Galleries, Chicago, *Theodore Earl Butler (1860–1936)* (1976), exhib. cat. with essays on the artist by Richard H. Love and Harold M. Rowe, contains illustrations and a chronology.

Un Jardin, Maison Baptiste

Butler often painted garden scenes during the 1890s, and his first one-man show, held at the Galerie Vollard in Paris in 1897, included several of these subjects. *Un Jardin, Maison Baptiste*, dated 1895, probably shows a garden in the French village Giverny where Butler lived after his marriage to Claude Monet's stepdaughter Suzanne in 1892. Before the onset of Mrs. Butler's illness in 1894, the young couple spent much of their time outdoors in their own garden. As Butler wrote to his friend the Boston painter Philip Leslie Hale (1865–1931) on February 22, 1893: "We be a living and painting and sewing and working in the garden the same as usual and only stop now and then to wish that you . . . would take the little pink house next to us" (Philip Leslie Hale Papers, D98, Arch. Am. Art).

The subject, oblique vantage point, and broken brushstrokes of this painting recall similar scenes painted by Monet during the 1870s and 1880s. Butler's work, however, is distinguished from that of his accomplished French mentor by its soft pastel palette, less forceful brushwork, and lack of an effective compositional focus.

Butler, *Un Jardin, Maison Baptiste*.

Oil on canvas, 21⅛ × 25¾ in. (53.7 × 65.4 cm.).
Signed and dated at lower left: T. E. Butler '95.
Canvas stamp: 54 RUE N.D. DES CHAMPS PARIS / PAUL FOINET / (VAN EYCK) / TOILES & COULEURS FINES.
REFERENCES: R. J. Horowitz, letter in Dept. Archives, Jan. 3, 1977, provides information on provenance // R. Slatkin, letter in Dept. Archives, April 25, 1979, provides early provenance and history of the painting.
EX COLL.: the artist's son, James Butler; with Charles E. Slatkin, New York, 1960–1967; Mr. and Mrs. Raymond J. Horowitz, New York, 1967–1976.
Gift of Mr. and Mrs. Raymond J. Horowitz, 1976. 1976.340.1.

ARTHUR FRANK MATHEWS

1860–1945

The versatile artist Arthur Frank Mathews worked not only as a painter but also as an architect and a designer of furniture, decorative objects, and interiors. Through his publications and teaching at the turn of the century, he did much to popularize his variation of art nouveau, sometimes referred to as the California decorative style. He was born in Markesan, Wisconsin, and at the age of six moved with his family to Oakland, California, where his father established an architectural office. In 1867 young Mathews was enrolled in a local school and given private drawing lessons with Helen Tanner Brodt, who was the art director for the Oakland public schools. From about the age of fifteen to nineteen, he was apprenticed in his father's office and also studied with Henry Bruen, a local artist. Mathews worked in San Francisco from 1881 to 1884 as a designer and illustrator for the Britton and Rey Lithography Company. He then worked on his own and saved enough money for a trip to Europe.

In 1885 Mathews began the first of four years of study in Paris. Attending the "little studios" of the Académie Julian, he worked under Jules Joseph Lefebvre and Gustave Boulanger and in 1886 won the school's medal for distinction in composition, drawing, and painting. He spent the summer of 1887 in Holland, and in that year his work was exhibited for the first time at the Paris Salon. During this period, Mathews responded to his academic instructors' emphasis on figure painting, producing realistic well-drawn and accomplished portraits and figure studies such as *Paris Studio Interior*, ca. 1887, and *Imogen and Arviragus*, 1887 (both Oakland Museum).

On his return to San Francisco in 1889, Mathews taught life classes at the San Francisco Art Students League and joined the faculty of the California School of Design (renamed the Mark Hopkins Institute of Art in 1893). He was appointed director there in 1890 and held that post for the next sixteen years. Under his direction, the school emphasized the study of the human figure and encouraged students to work independently. Among Mathews's students were Francis McComas (1874–1938), Gottardo Piazzoni (1872–1945), Armin Carl Hansen (1886–1957), and Xavier Martinez (1874–1943). In June 1894, Mathews married Lucia Kleinhaus (1870–1955), a pupil at his school who later collaborated with him on many projects.

In the early 1890s, Mathews experimented briefly with an impressionist style, mainly in his studies for *A Picnic at El Campo*, a major painting, now unlocated, which showed a large group of figures in a landscape setting. In 1896 he did an ambitious history painting, *Discovery of the Bay of San Francisco by Portola* (San Francisco Art Institute), and that same year, received his first mural commission, which was for Horace L. Hill's home in San Francisco. With his brother, the architect Walter J. Mathews, he collaborated on decorations for several residences in the San Francisco Bay area.

Mathews and his wife spent 1898 and 1899 in Paris, where she studied painting at the Académie Carmen and he opened an atelier and taught a small group of students. It was at this time that his mature style seems to have developed. His paintings from this period are highly decorative and usually depict mood-filled landscapes or figures drawn from Biblical and

mythological sources. They are characterized by dramatic and simple compositions, sinuous lines and shapes, and flat areas of color, usually low in key and close in value. Done in the fin de siècle spirit of art nouveau, these imaginative paintings show the influence of oriental art, the symbolism of Paul Sérusier, whom Mathews may have met when he was a student in Paris, the decorative work of Puvis de Chavannes, and the tonal paintings of JAMES MC NEILL WHISTLER, with whom Lucia Mathews was studying at this time. Mathews later praised Puvis and Whistler for rejecting "the prevalent notion that realism in art was art" (*Philopolis* 2 [Dec. 25, 1907], p. 56), and like them he developed a style that emphasized formal rather than naturalistic considerations.

On his return to San Francisco in 1899, Mathews resumed his position at the Mark Hopkins Institute and continued also as a decorator, designing tapestries for the St. Francis Hotel and painting murals, for example, two for the vestibule of the Mechanics' Institute Library (later destroyed). In 1905, the Vickery Gallery held a one-man show of his work. In 1906, following the San Francisco earthquake, Mathews resigned from the Hopkins Institute, and he and his wife began a program to aid in the rebuilding of the city. Their varied activities included the magazine *Philopolis*, which featured articles on art and city planning, the Philopolis Press, which published essays, poetry, books on art and California topics, and finally, the Furniture Shop, where until 1920, the Mathewses, their business partner John Zeile, and their chief assistant Thomas McGlynn produced furniture, frames, and a wide variety of decorative objects such as clocks, candelabra, and screens. These furnishings were often designed for particular rooms and buildings, the Masonic Temple in San Francisco for example. The distinct decorative style of the Furniture Shop, inspired in part by oriental art, was also influenced by the work of William Morris and the British arts and crafts movement.

Although much of Mathews's energy was spent on his business, he painted several murals during the early 1900s, among them twelve panels on the history of California for the State Capitol Building in Sacramento (1914) and *The Victorious Spirit* for the Palace of Education at the Panama-Pacific International Exposition in San Francisco (1915). He also continued to do easel paintings but produced fewer as time went by, devoting himself instead to writing a treatise on aesthetics, *Comedy Artistic*. A large collection of the artist's paintings, frames, furniture, and other decorative objects can be found in the Oakland Museum.

BIBLIOGRAPHY: *Philopolis* 1–10 (Oct. 1906–Sept. 1916). This monthly magazine produced by Mathews, his wife, and friends, contains articles on art and city planning and includes numerous illustrations of the artist's works. Articles on aesthetics by Mathews are featured including, "Mural Painting or Painting as a Fine Art" (Dec. 25, 1907); "Various Lessons: From the Exhibition of Paintings in the Sketch Club Rooms" (April 25, 1909); "The Nude in Art" (August 25, 1909); and "Whistler's 'Ten O'Clock'" (Feb. 25, 1916) // Gene Hailey, ed., "Arthur Mathews . . . Biography and Works," *California Art Research* (San Francisco, 1937), vol. 7, pp. 1–30. Part of the Works Progress Administration series, includes frequent quotations from contemporary sources, includes a list of representative works, awards, and exhibitions, and provides additional bibliography // Oakland Museum, *Mathews: Masterpieces of the California Decorative Style* (1972), foreword by Paul C. Mills, biographical chronology, essay by Harvey L. Jones, select bibliography, and many illustrations. Treats the artist's work in the decorative as well as the fine arts and discusses the work of his wife.

Afternoon among the Cypress

The painting, which dates from about 1905, shows a group of cypress trees near a beach. The scene is very likely the Monterey peninsula where Mathews painted so many of his landscapes. He has silhouetted the bent limbs and wide flat crowns of the cypress trees to achieve a strong decorative effect. On a warm dark ground, which is still visible in the foreground, he has simplified detail and created a striking pattern of flat areas of color, low in key and limited in range. Some of these areas have smooth even edges but others are less regular, with roughened touches of paint, especially in the shadow in the foreground. This shadow, the darkened copse on the right, and the large elegant cypress contribute to a moody and slightly mysterious impression.

In *Afternoon among the Cypress*, as in all of his mature landscapes, Mathews has refined the actual appearance of nature and strengthened the formal qualities of the picture. He developed this approach through his study of oriental art and his exposure to modern painting in Paris during the 1880s and 1890s.

The painting was presented to the museum by Henrietta Zeile, whose son John Zeile was an associate of Mathews's Furniture Shop. A special decorative frame was supposed to be designed and constructed for *Afternoon among the Cypress*, but unfortunately, there is no record of the Metropolitan's ever receiving such a frame.

Oil on canvas, 26¼ × 30 in. (66.7 × 76.2 cm.).
Signed at lower right: *Arthur F. Mathews*.
REFERENCES: *San Francisco Chronicle*, March 13, 1905, p. 7, in a discussion of an exhibition at Vickery Gallery, says that in The Cypress (probably this painting) "the wonder of the trees is told and the atmosphere is fine and free and appealing" // W. Macbeth, letter in MMA Archives, Oct. 16, 1909, acting as Zeile's agent, offers the museum a choice of one of Mathews's paintings // J. W. Alexander, letter in MMA Archives, Nov. 15, 1909, endorses its acceptance by the museum // J. Zeile, letters in MMA Archives, Dec. 1909, asks that the painting be returned so that Mathews can examine it and so it can be placed

Mathews, *Afternoon among the Cypress.*

in a "carved wood frame"; Dec. 27, 1909, notes "as soon as the frame is finished I will send it to you" and asks that the painting be recorded as the gift of his mother // *Philopolis* 8 (Oct. 25, 1911), ill. p. 2, as Cypress // J. Zeile, letter in MMA Archives, March 27, 1927, says that the artist will soon be in New York: "Do you think the painting you have of his could be hung so that he could look at it" // G. Hailey, ed., *California Art Research* (1937), 7, p. 27, includes it in a list of Mathews's works as Monterey Cypress // B. Bowman, Oakland Museum, letter in Dept. Archives, Oct. 15, 1976, provides information about its exhibition and critical reception in 1905–1907.
EXHIBITED: Vickery, Atkins and Torrey, San Francisco, 1905, as The Cypress (probably this painting) (no cat. available) // San Francisco Art Association, 1906, no. 228, as Afternoon among the Cypress // Art Gallery, Hotel Del Monte, Monterey, Calif., 1907, unnumbered checklist, ill. as Afternoon Among the Cypress // Oakland Museum, 1972, *Mathews: Masterpieces of the California Decorative Style*, dates it ca. 1904.
EX COLL.: John Zeile and his mother, Henrietta Zeile, San Francisco, until 1909; with William Macbeth, New York, as agent, 1909.
Gift of Mrs. Henrietta Zeile, 1909.
09.186.

ANNA MARY ROBERTSON (GRANDMA) MOSES

1860–1961

Anna Mary Robertson Moses, a self-taught painter, achieved wide acclaim as a modern American folk artist. Like the paintings of her contemporaries, JOHN KANE and Horace Pippin (1888–1946), her naive work shares aesthetic qualities not only with nineteenth-century folk art but also with the work of trained modern artists, such as Samuel Wood Gaylor (1883–1957), who worked in self-consciously primitive styles. The interest in primitive art in the late 1930s created a climate in which Grandma Moses's work was discovered, promoted, and appreciated.

The artist's youth and middle age were typical of countless other American women of her generation and social position. She was born in Greenwich, New York, and did household chores on nearby farms from 1872 until 1887, when she married Thomas Salmon Moses. She settled in Virginia with her husband and lived there for eighteen years, bearing ten children, half of whom died in infancy. In 1905 the family returned to New York and bought a farm in Eagle Bridge, about thirty miles from Albany. This remained Anna Moses's home until 1951, except for the years from 1930 to 1935, when she lived in nearby Bennington, Vermont. In 1951 she moved into a more modern house near her farm, where she stayed until she entered a nursing home at Hoosick Falls, New York, a few months before her death.

Grandma Moses did not begin to paint seriously until the late 1930s, when she was in her seventies, a widow with her children raised. Her talent was "discovered" in the spring of 1938 by Louis J. Caldor, a New York art collector, who saw three of her pictures in a Hoosick Falls drugstore. He arranged to have her work included in an exhibition that fall in the Members' Rooms of the Museum of Modern Art, New York. An entire show of Grandma Moses's paintings soon followed at the Galerie St. Etienne, New York. Thereafter her work was often featured in single and group exhibitions, including a show that traveled throughout Europe in 1950.

An extremely prolific artist, Grandma Moses produced over fifteen hundred oil and tempera paintings. A few date as early as 1918, but most were done after she received recognition in the late 1930s. She also embroidered in wool about fifty "worsted pictures," most of which were done early in her career. During the 1950s, she made a group of eighty-five ceramic tiles. Her naive style underwent some development in the course of her career. Although a number of her early paintings were just copies of reproductions, others were original. All tended to be small in scale and simple in composition, usually focusing on a single object, such as a bridge or a building. By the early 1940s, however, her paintings were larger in scale and less tentative in execution. As her style matured, her compositions became more ambitious and her landscapes were often panoramic in scope. They usually showed seasonal rural activities like harvesting, chopping wood, sugaring, sledding, and picnicking. Grandma Moses also depicted imaginative reminiscences of her childhood in New York and her married life in Virginia. She told her biographer Otto Kallir in 1944: "I'll not paint something that we know nothing about, might just as well paint something that will happen 2 thousand years hence"

(*Grandma Moses* [1973], p. 186). She did, however, paint some historical scenes, particularly from the American Revolution, and, in 1960, she did a series of paintings to illustrate Clement Clarke Moore's poem *The Night before Christmas*. When she was in her late eighties and still painting, she summed up her life: "I look back on my life like a good day's work, it was done and I feel satisfied with it. I was happy and contented, I knew nothing better and made the best out of what life offered" (*Grandma Moses: My Life's History* [1952], p. 140). It was the scenes from just such a life that she chose to paint in her simple, uncomplicated manner.

BIBLIOGRAPHY: Otto Kallir, ed., *Grandma Moses: American Primitive* (New York, 1947), includes an introduction by Louis Bromfield, an essay by Otto Kallir, "My Life's History" by Grandma Moses, forty plates with the artist's comments on each, and a list of exhibitions ‖ Otto Kallir, ed., *Grandma Moses: My Life's History* (New York, 1952), the artist's autobiography, includes facsimiles of letters and illustrations of her work ‖ Otto Kallir, *Grandma Moses* (New York, 1973), a well-illustrated catalogue of the artist's works with a discussion of her art and life, selected bibliography, and a list of exhibitions.

Thanksgiving Turkey

Probably done during the autumn of 1943, the picture is one of many depictions of Thanksgiving painted by the artist around this time. This harvest holiday was significant for Grandma Moses who once selected it as the major event of the autumn in discussing the cycle of the seasons. "Thanksgiven [*sic*], in some homes there will be rejoicing, in others there will be sorrow," she noted, "but we, that can give thanks, should, there is so much to be thankful for, and praise God for all blessings, and the abundance of all things" (O. Kallir, ed., *Grandma Moses* [1952], p. 50).

Most of Grandma Moses's Thanksgiving scenes are set outdoors and show preparations for, or travel to, the Thanksgiving dinner rather than the meal itself. The subject of the Metropolitan painting, catching the turkey, is one she treated at least a dozen times between 1940 and 1955. This repetition can be explained in part by her commercial success; for after the early exhibitions of her work, enthusiastic clients asked for pictures like those they had seen on display, and she interpreted these requests quite literally. Thus, it is not surprising that this painting follows the overall composition and setting seen in *Turkey in the Straw*, ca. 1940 (private coll., ill. in O. Kallir, *Grandma Moses* [1973], p. 42), with such motifs as the tool sharpener beneath the tree, the dog in the brush, the pile of straw, and the open door of the barn appearing in both pictures. In both paintings Grandma Moses shows a close-up view of the farmyard, empha-

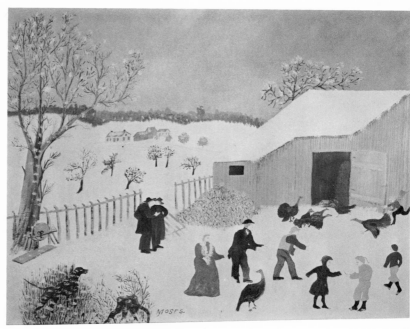

Moses, *Thanksgiving Turkey*.

sizing the figures and their activities rather than the landscape setting. *Thanksgiving Turkey*, however, is a more animated scene. The poses and gestures of the people in the foreground create a rhythmic pattern of extended arms that direct our attention to the turkeys which dash about in the middle ground. In a humorous touch, the movements of the people echo those of the fowl.

The picture is painted on masonite board and appears to have its original frame, a commercial type made of inexpensive narrow molding, painted white. Grandma Moses usually began her preparations for painting by cutting a masonite panel to fit whatever frame she had chosen. She then treated the board with linseed oil and applied several coats of white tempera for her ground. Her preliminary drawing was often limited to a thin pencil line to indicate the horizon. After painting in the sky, she blocked in the main components of the composition with a few quick strokes, later adding finer details like leaves. She outlined the figures and filled them in with color, creating crisp silhouettes against the background. Her palette was determined largely by the season depicted, and like most of her snow scenes, *Thanksgiving Turkey* has predominantly whites and cool tones with occasional warm colors seen in the people's garments, in the hay, and in the group of houses in the distant landscape.

The picture is signed with the artist's characteristic large block letters. On the reverse is one of the record labels prepared by her younger brother Fred E. Robertson, and the date of the picture's sale, October 13, 1943, is entered in her record book.

Tempera and oil on masonite board, $15\frac{1}{16} \times 19\frac{3}{16}$ in. (38.3 × 48.7 cm.).

Signed at lower left: MOSES. Label on reverse: [photograph of the artist] / Anna Mary Robertson Moses / Eagle Bridge, N.Y. / Born Sept. 6, 1860 / 1943 Date of Painting Oct. 13. / Number of Painting 458 / Title Thank/given turkey. Stamped twice on reverse: REPRODUCTION RIGHTS / TO THIS PAINTING / EXPRESSLY RESERVED BY GALERIE ST. ETIENNE / 46 WEST 57th ST / NEW YORK CITY.

REFERENCES: A. M. R. Moses, "A Record of the various paintings by Anna Mary Robertson Moses," MS in possession of Mrs. Forrest Moses, p. 23, October 13, 1943, lists the painting as "Thanksgiven turkey," no. 458, sold to Mrs. Story for $18; paid for by October 29 // Typed form, Feb. 19, 1951, MMA Archives, gives medium, support, and early exhibition history, and states that the picture was painted at Eagle Bridge, New York, in October 1943 // O. Kallir, *Grandma Moses* (1973) ill. p. 64; color pl. 49; p. 65, says it was exhibited often; p. 292, no. 293, includes it in a catalogue of the artist's work; *Grandma Moses* (1974), color ill. p. 40; p. 42; letter in Dept. Archives, Oct. 19, 1976, provides information about its history and notes other treatments of the subject // S. R. Pike, Jr., Bennington Museum, Vt., letter in Dept. Archives, Nov. 9, 1976, provides a copy of the appropriate pages of the artist's record book.

EXHIBITED: Galerie St. Etienne, New York, 1947, *Grandma Moses Paintings*, no. 4, as Catching the Thanksgiven Turkey // Art Gallery of Toronto, 1952, *Paintings by Grandma Moses*, no. 2, Thanksgiving Turkey // Syracuse Museum of Fine Arts, 1952, *Grandma Moses*, no. 22, The Thanksgiving Turkey // Memorial Art Gallery, Rochester, 1952, *Grandma Moses* (no cat.) // Seattle Art Museum, 1953, *Contemporary American Painting and Sculpture* (cat. arranged alphabetically) // IBM Gallery, New York, 1955, *A Tribute to Grandma Moses*, no. 8 // Dallas Museum of Fine Arts, 1958, *Famous Paintings and Famous Painters*, no. 23 // Smithsonian Institution, Washington, D.C., traveling exhibition, 1958–1959, *American Primitive Paintings*, no. 89 // IBM Gallery of Arts and Sciences, New York, 1960, *My Life's History* (not in cat.) // Galerie St. Etienne, New York, 1962, *Grandma Moses (1860–1961): Memorial Exhibition*, cat. by O. Kallir, no. 18 // National Gallery of Art, Washington, D.C., 1979, *Grandma Moses*, no. 8, ill. p. 39; p. 65, lists exhibitions of the picture.

EX COLL.: with Ala Story, of American British Art Center, New York, 1943; Mary Cass Canfield, until 1946; with Galerie St. Etienne, New York, 1946–1947; Mary Stillman Harkness, Waterford, Conn., and New York, 1947–1950.

Bequest of Mary Stillman Harkness, 1950.

50.145.375.

DENNIS MILLER BUNKER

1861–1890

The artist was born in New York and spent his youth in Garden City, Long Island, where his family lived simply and comfortably. His father, Matthew Bunker, was secretary-treasurer of the Union Ferry Company.

An early sketchbook, 1877 (MFA, Boston), attests to Dennis Miller Bunker's precocious ability as a draftsman. Around 1878, he attended art classes in New York at the National Academy of Design and the Art Students League, where his instructor was WILLIAM MERRITT CHASE. He also studied with CHARLES MELVILLE DEWEY, who painted landscapes in the Barbizon style. Bunker first exhibited at the National Academy in 1880. He spent the summers of 1881 and 1882 on Nantucket Island in Massachusetts where he painted a number of shore scenes, including *Mending the Nets*, 1881 (private coll.; ill. in *Dennis Miller Bunker (1861– 1890) Rediscovered* [1978], exhib. cat., no. 2).

In the fall of 1882, Bunker went to Paris to continue his training. He worked first with Antoine Auguste Ernest Hébert at the Académie Julian and then under Jean Léon Gérôme at the Ecole des Beaux-Arts. Bunker spent his summers in the French countryside, often in the company of other American art students such as Charles Adams Platt (1861–1933). There he painted landscapes like *Brittany Town Morning, Larmor*, 1884 (coll. Mr. and Mrs. Ralph Spencer, New York; ill. in *Dennis Miller Bunker (1861–1890) Rediscovered*, no. 10), which were inspired by the works of such Barbizon painters as Jean Baptiste Camille Corot. Carefully modeled forms, cool colors, and clear light are characteristics of Bunker's paintings at this time. Some, like *Low Tide*, ca. 1882 (coll. Mr. and Mrs. Raymond J. Horowitz, New York; ill. *Dennis Miller Bunker (1861–1890) Rediscovered*, no. 6), recall the work of Edouard Manet. There is a slight influence of impressionism in their sketchy treatment and unconventional compositions.

After two and a half years abroad, Bunker returned to the United States in 1885. He worked briefly in New York and then settled in Boston—the city most often associated with his career. A one-man show of his work was held at the Noyes and Blakeslee Gallery there that year, and he taught at the Cowles Art School, where such later well-known artists as STACY TOLMAN and William McGregor Paxton (1869–1941) were his students. A member of the Tavern Club and the St. Botolph Club, Bunker enjoyed the friendship of several well-known men, including the artist HENRY O. WALKER, the novelist William Dean Howells, and the violinist and composer Charles Martin Loeffler. One of his most enthusiastic supporters was Isabella Stewart Gardner, the art patron. The portraits and figure paintings that Bunker did during these years were strongly influenced by his academic training. Austere settings, understated poses, and a somber, limited palette characterize his best figure paintings, a good example of which is the sensitive portrait *Miss Anne Page*, 1887 (coll. Mr. and Mrs. G. L. Hersey; ill. *Dennis Miller Bunker (1861–1890) Rediscovered*, no. 21). The landscapes that Bunker painted in New England each summer, however, soon showed the influence of impressionism. His major inspiration for this style of painting seems to have been JOHN

SINGER SARGENT whom he met in Boston around 1887. Bunker joined Sargent in the summer of 1888 at Calcot, an English village near Reading, and thereafter painted landscapes that have the bold brushwork and brilliant colors that characterize Sargent's painting at this time. The compositions in works like *The Pool, Medfield*, 1889 (MFA, Boston), are especially impressionistic.

In the autumn of 1889, Bunker became engaged to Eleanor Hardy of Boston. Shortly afterwards, he moved back to New York, where, unable to obtain portrait commissions, he depleted his savings and overtaxed his health. The many letters he wrote to his fiancée record the difficulties and constant self-doubt that clouded his life during this period. His closest friends were Charles Adams Platt (1861–1933), ABBOTT H. THAYER and THOMAS DEWING. After Bunker married Eleanor Hardy in Boston on October 2, 1890, he began work on a mural project for Whitelaw Reid's home in New York. Less than three months later, while visiting Boston over the Christmas holidays, the young artist died of "heart failure." A memorial exhibition of his work was held at the St. Botolph Club in 1891.

BIBLIOGRAPHY: MFA, Boston, *Dennis Miller Bunker: Exhibition of Paintings and Drawings* (Oct. 5–31, 1943), cat. by Robert Hale Ives Gammell // Robert Hale Ives Gammell, *Dennis Miller Bunker* (New York, 1953) // MMA, *American Impressionist and Realist Paintings & Drawings from the Collection of Mr. and Mrs. Raymond J. Horowitz* (1973), exhib. cat. by Dianne H. Pilgrim, pp. 47–51 // New Britain Museum of American Art, Conn., and Davis and Long Company, New York, *Dennis Miller Bunker (1861–1890) Rediscovered* (April 1–May 7, 1978, and June 7–30, 1978), exhib. cat. with introduction by Theodore E. Stebbins, Jr., and essay by Charles B. Ferguson, includes chronology, bibliography, and list of exhibitions.

Eleanor Hardy Bunker

Dennis Bunker married Eleanor Hardy (1870–1953) on October 2, 1890. This undated portrait was probably painted during the few months of their marriage before the artist died on December 28. His voluminous correspondence with his fiancée from 1889 and 1890 often mentioned his desire to paint her portrait. In one letter he wrote: "I don't believe I'll be able to paint at all the first month or two that we're married—I shall be so much occupied looking at you and talking to you I think the best way will be for me to begin a great big portrait of you that will be very difficult to do and perhaps in that way I can combine the two things and look at you and paint at the same time" (D. M. Bunker Papers, I, pp. 122–123, Arch. Am. Art).

This painting, one of several known portraits the artist did of his wife, shows the influence of ABBOTT H. THAYER whom Bunker once described as "the greatest painter we've ever had over here" (Ibid., p. 32). Mrs. Bunker's face is realistically depicted, strongly illuminated, and set against a dark, unarticulated background. Although in contemporary dress, she is crowned with a classical laurel wreath, a feature typical of the idealized women in Thayer's paintings. Bunker once wrote to his wife-to-be that THOMAS DEWING "says he hears that you are magnificent—and that you resemble the Venus of Milo" (Ibid., p. 49). In this portrait the artist attempts to associate her beauty with just such a classical ideal.

Less than a month after his death, Bunker's friends Stanford White, Augustus Saint-Gaudens, and Charles Adams Platt (1861–1933) organized a subscription under the auspices of the Society of American Artists. As White explained to Henry Marquand, president of the Metropolitan Museum:

I do not know whether you noticed the sad death of young Bunker, or knew of his work. He was one of the most talented young artists; and all of us, St. Gaudens, and everybody, have the greatest respect for his work, and anticipated the brightest results. Now that he is dead we are going to purchase a very beautiful portrait of his wife, which he painted just before his death, and present it to the Metropolitan Museum.

In 1892 CHARLES ULRICH selected the portrait

for an important exhibition of American art held in Munich. Thus, although offered to the museum in 1891, the portrait did not actually enter the collection until 1893.

Eleanor Hardy Bunker was married in July 1893 to Charles Adams Platt, a widower who had been a close friend of her late husband. They lived in New York, where Platt pursued a many faceted career, first as an etcher, then as a painter, and finally as an architect and landscape designer. The Platts spent their summers in Cornish, New Hampshire. They were part of the art colony there that included Thayer, Saint-Gaudens, Dewing, KENYON COX, GEORGE DE FOREST BRUSH, Herbert Adams (1858–1945), and Maxfield Parrish (1870–1966). Of their four sons, two followed their father's profession and became architects.

Oil on canvas, 24 × 20⅞ in. (61 × 53 cm.).

RELATED WORK: *Pencil Study for a Portrait*, unlocated, ill. in R. H. I. Gammell, *Dennis Miller Bunker* (1953), following p. 50.

REFERENCES: A. Saint-Gaudens to H. Marquand, Jan. 8, 1891, MMA Archives, explains that a subscription has been started to purchase the portrait and urges the museum to accept it // S. White to Marquand, Jan. 8, 1891, MMA Archives, notes that he and others wish to present the portrait to the museum (quoted above) // *Art Amateur* 24 (March 1891), p. 91, calls it "notable" and says that a group of New York artists have "combined to buy this picture" // R. H. I. Gammell, *Dennis Miller Bunker* (1953), p. 43, says that the artist's wife posed for it shortly after their marriage; ill. following p. 50; p. 54, attributes the greenish halftones in Bunker's portraits of his wife to Thayer's influence // R. H. I. Gammell, letter in Dept. Archives, Jan. 12, 1977, discusses portraits of the sitter and biographical information he obtained years earlier during an interview with her // New Britain Museum of American Art, Conn., and Davis and Long Company, New York, *Dennis Miller Bunker (1861–1890) Rediscovered* (1978), exhib. cat. by C. B. Ferguson, unpaged, says the portrait was done in 1890 and is probably the last portrait painted by the artist; confuses it with another portrait and

Bunker, *Eleanor Hardy Bunker*.

mistakenly says that Gammell considered it unfinished and that it was cut down from a three-quarter length portrait // W. Platt, son of the sitter, orally, 1979, explained that another portrait of the sitter, in his possession, was cut down from three-quarter length and that the museum's portrait had not been cut down.

EXHIBITED: Kgl. Glaspalaste, Munich, 1892, no. 291, as Porträt // MFA, Boston, 1943, *Dennis Miller Bunker*, exhib. cat. by R. H. I. Gammell, no. 6, p. 7, says it shows an experiment in technique.

EX COLL.: the artist's wife, Eleanor Hardy Bunker, New York, 1891; subscribers under the auspices of the Society of American Artists, Charles A. Platt, Augustus Saint-Gaudens, and Stanford White, as agents, 1891–1893.

Gift of Several Gentlemen, 1893.

93.20.

FREDERIC REMINGTON

1861–1909

"Eastern people have formed their conceptions of what the Far-Western life is like, more from what they have seen in Mr. Remington's pictures than from any other source" (W. A. Coffin, *Scribner's Magazine* 11 [March 1892], p. 348). The illustrator, sculptor, and painter Frederic Sackrider Remington was born in Canton, New York, and in 1872, moved with his family to nearby Ogdensburg. He attended a military academy in Massachusetts between 1876 and 1878 before going to Yale. A year and a half studying drawing under John Henry Niemeyer (1839–1932) at the university's School of Fine Arts was his only formal art training except for a brief period at the Art Students League in New York in 1886. Remington left Yale following his father's death in 1880 and took a clerical job in Albany. He made a brief trip West in 1881, and, two years later, gained firsthand knowledge of western life, when he bought an interest in a ranch in Kansas. He married Eva Caten in Canton, New York, in 1884 and then opened a small studio in Kansas City, Missouri.

Remington returned to New York in 1885 and embarked on his career as an artist and illustrator. His illustrations appeared in a dozen American magazines between 1886 and 1913 and in books by such well-known authors as Theodore Roosevelt, Hamlin Garland, and Francis Parkman. He also wrote and illustrated his own books and articles, recording his observations and experiences on travels in the West. In 1892 Remington went to North Africa and Europe with the journalist Poultney Bigelow. During the Spanish-American War six years later he went to Cuba as a war correspondent. Throughout his career, however, the American West remained his favorite subject.

Until around 1900, he worked in a highly realistic and increasingly accomplished style. His martial subject matter and literal treatment were probably influenced by French academic painters like Jean Baptiste Edouard Detaille, Alphonse Marie Adolphe de Neuville, and Jean Louis Ernest Meissonier. Like these artists, he used luminous light effects and rapid but controlled brushwork.

The 1890s proved to be a time of change for the artist. In 1890 he moved to the New Rochelle home and studio that was to be the center of his activities for the next nineteen years, and, in 1899, he bought Ingleneuk Island in the St. Lawrence River, where he spent his summers. Remington began to gain some recognition as a serious painter. In 1891, after exhibiting at the National Academy of Design for four years, he was elected an associate member there. In 1893 and 1895 two sales of his paintings were held at the American Art Association. After observing the sculptor F. Wellington Ruckstuhl at work on a commission, Remington undertook his first sculpture, *The Bronco Buster*, 1895 (MMA). In the realistic style that characterized his paintings and illustrations, he modeled about twenty subjects, almost all of them representing western themes. A number of his bronzes, among them *Comin' Through the Rye*, 1902 (MMA), and *The Buffalo Horse*, 1907, are taken from compositions he had already developed in other media. Remington's sculpture, however, was much more than an extension of his work as a painter and illustrator; for his ability to suggest action and motion in that

medium was exceptional. The Metropolitan owns an impressive group of Remington's bronzes; several were purchased directly from the artist in 1907, and the Jacob Ruppert bequest of 1939 included ten fine examples.

The final decade of Remington's career was marked by public recognition, commercial success, and further artistic development. Yale University awarded him an honorary bachelor of fine arts degree in 1900. Three years later, he made an exclusive contract with *Collier's* for a series of double-page color illustrations. After 1905, his paintings and bronzes were handled by M. Knoedler and Company, which held several successful one-man exhibitions of his work. Challenged by competition from other realistic painters of western life, particularly CHARLES SCHREYVOGEL, Remington chose more imaginative subjects and revised his style. Influenced by artists like J. ALDEN WEIR and CHILDE HASSAM, who had adopted elements of impressionism in their work in the late 1880s, he placed a new emphasis on landscape, and his paintings show brighter colors, softened contours, varied brushwork, and heightened atmospheric effects. Impressed by the nocturnes of Charles Rollo Peters (1869–1928), Remington also experimented with nighttime effects in many of his pictures. The plein-air landscapes he exhibited at Knoedler in 1909 signaled yet another direction in his development. Around this time, he sold his home in New Rochelle and moved to a farm in Ridgefield, Connecticut. His untimely death at the age of forty-eight ended a career remarkable not only for its intense focus on a single subject, the American West, but also for its accomplishments in a broad range of media.

The artist's wife bequeathed some of his works and memorabilia to the Remington Art Memorial in Ogdensburg. Two other important collections of his work can be found at the Amon G. Carter Museum of Western Art, in Fort Worth, Texas, and the Whitney Gallery of Western Art, in Cody, Wyoming.

BIBLIOGRAPHY: Harold McCracken, *Frederic Remington: Artist of the Old West* (Philadelphia, 1947). Contains a bibliographical checklist of Remington's pictures and books // Knoedler and Co., New York, *A Catalogue of the Frederic Remington Memorial Collection* (New York, 1954). Printed for the Remington Art Memorial, Ogdensburg, New York, it includes a chronology, notes by Harold McCracken, and illustrations of works in the collection at Ogdensburg and elsewhere // Harold McCracken, ed., *Frederic Remington's Own West* (New York, 1960). A selection of the artist's western writings and illustrations // Peter H. Hassrick, *Frederic Remington: Paintings, Drawings, and Sculpture in the Amon Carter Museum and the Sid W. Richardson Foundation Collections* (New York, 1973). Provides a biography and analysis of the artist's development // Jeff Dykes, *Fifty Great Western Illustrators* (Flagstaff, Ariz., [1975]), pp. 270–343, includes an extensive bibliography.

Hiawatha's Friends

Late in 1888 Remington received a commission to illustrate Henry Wadsworth Longfellow's poem *The Song of Hiawatha* (1855). The new edition was to be published by Houghton Mifflin and Company of Boston in 1890. Remington executed nearly four hundred line drawings for the margins of the book and twenty-two grisaille paintings, one for each of the cantos of the poem.

Hiawatha's Friends, dated 1889, accompanies canto 6 of the poem, which describes the hero's two closest friends, Chibiabos the musician and Kwasind the strong man. The painting does not appear to depict a particular incident in the canto. The Indians cannot be identified with certainty. In the book, the illustration is captioned "Pitched it sheer into the river.../ Where it still is seen in Summer." This and the setting, with a boulder in the river, allude to one

of Kwasind's feats of strength. Taunted with accusations of laziness, he threw a huge rock into the Pauwating River where it was visible above the waterline during the summer months.

The illustrations for *The Song of Hiawatha* show a marked improvement over others that Remington did during the late 1880s. Harold McCracken explained their importance for the artist's career:

The drawings for *Hiawatha* established Remington's reputation beyond venture of a doubt Because of these pictures alone, Remington's name, when he was barely thirty years old and with such a comparatively short experience behind him, was already on the way to becoming a household word. (*Frederic Remington* [1947], p. 61).

Oil on canvas, 20 × 28¼ in. (50.8 × 71.8 cm.).
Signed at lower right: FREDERIC REMINGTON/'89.
REFERENCES: H. W. Longfellow, *The Song of Hiawatha* (1890; 1968) ill. opp. p. 64 // H. McCracken, *Frederic Remington* (1947), p. 149.
EXHIBITED: Whitney Gallery of Western Art, Cody, Wyo., 1974, *The Art of Frederic Remington*, exhib. cat. by D. Hedgpeth, ill. no. 58.
EX COLL.: with Scott and Fowles, New York (according to a label on the back); anonymous private collector.
Anonymous gift, 1962.
62.241.3.

On the Southern Plains

The American soldier in the West was one of Remington's favorite themes. "No man earns his wages half so hard as the soldier doing campaign work on the Southwestern frontier," he wrote in 1889. "His heroism is called duty, and it probably is" (quoted in H. McCracken, ed., *Frederic Remington's Own West* [1960], pp. 17–18). Painted in 1907, *On the Southern Plains* shows a group of soldiers, led by a scout in buckskin, charging an unseen enemy. The painting, which the artist called "Cavalry in Sixties" in his diary, is probably meant to show a scene in the war against the Plains Indians during the 1860s. The uniforms and weapons Remington depicts, however, date from the Civil War into the 1870s. Like the gear used by many soldiers stationed in the rugged West, they do not always adhere strictly to army standards. The jackets with standup collars and fastened by a row of buttons are regular army issue. The soldiers wear forage caps, adopted in 1861, or broad-brimmed hats commonly used by western settlers for protection from the sun.

The placement of the soldiers, who charge toward the foreground in a seemingly disorderly group, does not follow the actual attack formation practiced by United States cavalrymen in the West. The enemy was ordinarily approached in a straight horizontal line. The treatment of the scene with its complicated arrangement of soldiers, horses, and weapons recalls aspects of French academic martial subjects, for example, Jean Louis Ernest Meissonier's 1875 painting *Friedland—1807* (MMA). Like Meissonier, Remington shows a historical scene with nationalistic associations. The picture, which is painted in the impressionist style that he adopted around 1900, shows a new interest in the landscape and has bright colors and rapid, sometimes stippled, brushstrokes that are particularly appropriate to the rough terrain, the rising dust, and the flicker-

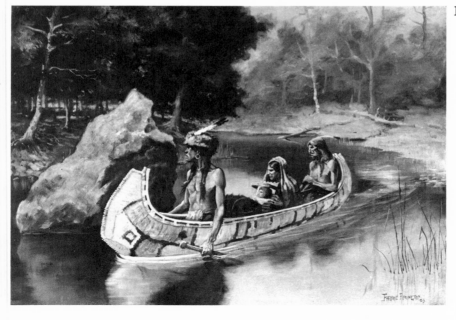

Remington, *Hiawatha's Friends*.

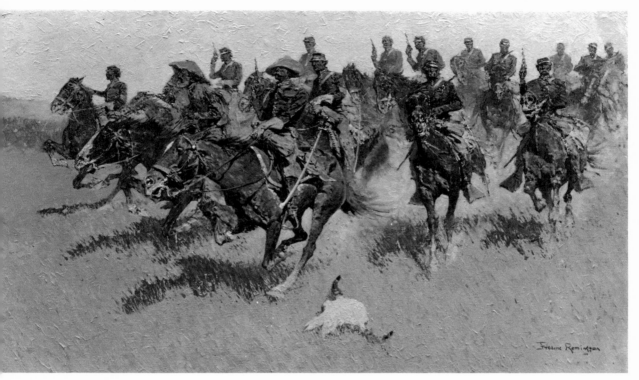

…emington, *On the Southern Plains.*

ing effects of brilliant sunlight. This western scene, with its masterful depiction of action, is one of Remington's most accomplished paintings. It was bought from the artist's widow for the Metropolitan Museum by a group of subscribers in 1911.

Oil on canvas, 30⅛ × 51⅛ in. (76.5 × 129.9 cm.).
Signed at lower right: Frederic Remington/1907. Inscribed at lower center: Copyright 1907 P. F. Collier & Son.

REFERENCES: F. Remington, diaries, Remington Art Museum, Ogdensburg, N.Y., Sept. 23, 1907, says that he is reworking "Cavalry in Sixties"; Sept. 24, 1907, says he has "nearly finished Cavalry Sixties over again"; Sept. 28, 1907, says "finished my Cavalry Sixties"; Oct. 31, 1907, notes that he has asked "Brokan" $2,400 for it // *Collier's* 44 (Nov. 27, 1909), ill. p. 8, as On the Southern Plains in 1860 // H.

Smith, letter in MMA Archives, March 7, 1910, says that Remington had wished to have one of his paintings in the museum and "mentioned the picture that he thought was most characteristic of his work, and asked me to use my efforts towards this end" // D. C. French, letter in MMA Archives, March 30, 1910, says that he and Frank D. Millet consider the picture "a very representative example of Remington's work," and, although John White Alexander "is not enthusiastic over Remington's painting as painting," he agrees that it should be accepted // H. Smith, letter in MMA Archives, Dec. 15, 1911, lists the fifteen subscribers who purchased it from the artist's widow // E. D. Allen, *Bulletin of the New York Public Library* 49 (Dec. 1945), p. 900, lists it // H. McCracken *Frederic Remington* (1947), p. 127 // A. Lansford, *Art Digest* 22 (Jan. 1, 1948), p. 13 // H. McCracken, *A Catalogue of the Frederic Remington Memorial Collection* (1954), pp. 30, 33; ill. p. 38 // H. McCracken, ed.,

Frederic Remington

Frederic Remington's Own West (1960), ill. p. 16 // H. McCracken, *The Frederic Remington Book* (1966), color ill. p. 128 // R. N. Gregg, *Connoisseur* 165 (Aug. 1967), ill. p. 272, says high-keyed colors and the brushstrokes show his "late, free style" and that the picture probably depicts troopers charging Comanche warriors in the 1860s // T. P. F. Hoving, *Art in America* 58 (March–April, 1970), ill. p. 63 // P. H. Hassrick, *Frederic Remington* (1973), p. 48 // D. Kloster and C. R. Goins, National Museum of History and Technology, Smithsonian Institution, Washington, D.C., orally, May 8, 1978, provided information about the weapons and uniforms // M. B. Dillenbeck, Remington Art Museum, Ogdensburg, N.Y., letter in Dept. Archives, May 19, 1978, provides excerpts from Remington diaries // N. C. Little, M. Knoedler and Co., New York, letter in Dept. Archives, May 30, 1978, provides information on exhibition.

EXHIBITED: M. Knoedler and Co., New York, 1907, *Paintings by Frederic Remington*, no. 2, On the Southern Plains // Reinhardt's Annex Gallery, Chicago, 1908, *Recent Paintings by Frederic Remington and Portraits by A. de Ferraris of Vienna*, no. 1 // Doll and Richards, Boston, 1909, *Exhibition and Private Sale of Paintings by Frederic Remington*, no. 1, says it is set in 1868 // MMA, 1939, *Life in America*, cat. by H. B. Wehle, ill. p. 177 // Grand Central Art Galleries, New York, *Remington to Today*, no. 48 // Gallery of Western Art, Buffalo Bill Historical Center, Cody, Wyo., 1961, *Frederic Remington Centennial Exhibition and Paintings, Drawings, and Sculpture by Other Notable Documentary Artists of the Old West . . .*, no. 1 // Paine Art Center and Arboretum, Oshkosh, Wisc.; Minneapolis Institute of Arts; Sterling and Francine Clark Art Institute, Williamstown, Mass., 1967, *Frederic Remington*, exhib. cat. by W. Parker and R. N. Gregg, ill. no. 68, discusses uniforms, guns, and accessories // Amon Carter Museum, Fort Worth, 1973, *Frederic Remington*, exhib. cat. by P. H. Hassrick, no. 78 // Whitney Gallery of Western Art, Cody, Wyo., 1974, *The Art of Frederic Remington*, exhib. cat. by D. Hedgpeth, no. 60, color ill.

ON DEPOSIT: NYHS, 1947–1948 // Whitney Gallery of Western Art, Cody, Wyo., 1960–1963.

EX COLL.: the artist's wife, Eva Caten Remington, 1909–1910; subscribers to a fund for its presentation to the museum (A. Barton Hepburn, Augustus Thomas, James Wall Finn, Harry Folsom, John C. Howard, George A. Hearn, Horace Russell, William R. Mygatt, W. B. Wheelock, Mrs. G. P. Hilton, William T. Evans, George M. Wright, Samuel T. Shaw, Ray L. Skofield, and Henry Smith), 1911.

Gift of Several Gentlemen, 1911.

11.192.

CHARLES SCHREYVOGEL

1861–1912

Charles Schreyvogel, like his contemporaries Charles Marion Russell (1864–1926) and FREDERIC REMINGTON, specialized in scenes of the American West. Accurate in detail and romantic in spirit, his paintings and sculptures record a way of life that was rapidly disappearing in the 1890s.

The son of German immigrants, Schreyvogel was born in New York and later lived in Hoboken, New Jersey. He demonstrated artistic talent at an early age but was apprenticed first to a die-sinker and then to a New York lithographer. At the lithography firm his artistic talent was encouraged by a fellow worker, the portrait and figure painter H. August Schwabe (1843–1916). Schreyvogel attended Schwabe's classes at the Newark Art League and explored the New Jersey countryside with him in his free time. He continued to work at the lithography establishment until 1886. Then, with the financial support of his brothers, he quit his job and went to Munich, where he spent the next three years studying art under Johann F. Kirchbach and the American expatriate Carl Marr (1858–1936).

In 1890 Schreyvogel returned to Hoboken and opened a studio, where he barely managed

to support himself by painting oil portraits, ivory miniatures, and pictures for calendars. He became fascinated with frontier life while sketching Buffalo Bill's Wild West Show. He also made friends with Bill Cody and his manager Nathan Salsbury. His interest in the American frontier and the hope of finding a climate that would relieve his chronic asthma prompted the first of Schreyvogel's many trips West. In 1893 he visited the Ute reservation in Ignacio, Colorado, and went on to Arizona, where he sketched the Apaches. On this and subsequent trips he collected many Indian, cowboy, and military artifacts that later served as models for the costumes and accessories in his paintings. Schreyvogel took a limited interest in sculpture. He modeled his first bronze, *White Eagle*, in 1899, and *The Last Drop*, which was based on a 1900 painting of the same title, was cast in 1903.

Throughout the 1890s Schreyvogel endured financial hardship. Ignored by New York art dealers and collectors, he was encouraged only by a few friends in New Jersey like Dr. William Redwood Fisher. National recognition finally came in 1900 when *My Bunkie* (q.v.) won the Thomas B. Clarke prize at the National Academy of Design. Schreyvogel was elected an associate member of the academy the following year. His reputation as a painter of western scenes soon rivaled Remington's. In 1903 Remington criticized him publicly for supposed inaccuracies in his important painting *Custer's Demand*, 1903 (Thomas Gilcrease Institute of American History and Art, Tulsa). Schreyvogel, however, lost none of his admiration for Remington, whom he once described as "the greatest of us all" (*Junior Munsey* 8 [June 1900], p. 438).

As a result of his friendship with the painter, sculptor, and illustrator Edwin Willard Deming (1860–1942), Schreyvogel made his only known effort at book illustration. He helped Deming illustrate Herbert Myrick's *Cache la Poudre: The Romance of a Tenderfoot in the Days of Custer* (1905). In 1905 Schreyvogel purchased a farm in upstate New York near West Kill. From then on, he spent summers there rather than in the West.

After Remington's death in 1909, Schreyvogel assumed a position of leadership among American artists representing western scenes. His untimely death, caused by blood poisoning, ended this long-awaited success. His brief career and exhaustive preliminary research limited the number of paintings he could complete; fewer than one hundred canvases are known.

BIBLIOGRAPHY: Gustav Kobbé, "A Painter of the Western Frontier," *Cosmopolitan* 31 (Oct. 1901), pp. 563–573 // *Souvenir Album of Paintings by Chas. Schreyvogel* (Hoboken, N.J., 1907), includes a biography of the artist and many illustrations of his paintings, some with text // Gustav Kobbé, "Schreyvogel's American Soldier Pictures," *Uncle Sam's Magazine* 15 (June 1909), pp. 13–22 // James D. Horan, *The Life and Art of Charles Schreyvogel* (New York, 1969), includes biography, bibliography, a record of copyrights obtained by the artist and his widow, facsimile reproductions of newspaper articles about the artist, and many illustrations // Jeff Dykes, *Fifty Great Western Illustrators* (Flagstaff, Ariz., [1975]), pp. 372–379, provides an extensive bibliography on the artist.

My Bunkie

Completed by 1899, *My Bunkie* shows cavalrymen engaged in a battle with an unseen enemy, presumably warring Indians. The soldier in the foreground has lost his mount and is being rescued by his "bunkie" or barracks bunkmate. Although the scene was reportedly suggested by an actual incident, Schreyvogel's choice of subject was undoubtedly inspired by FREDERIC REMINGTON's well-known bronze sculpture *The Wounded Bunkie*, 1896 (MMA), which shows two

soldiers mounted on galloping horses, with one man reaching out to support a wounded comrade. Not surprisingly, the Schreyvogel painting has also been compared to Remington's paintings. At least one critic, writing in *Brush and Pencil* in 1900, maintained that the Schreyvogel "is drawn better, painted better, and has some notion of color, a quality not often claimed for the better known illustrator."

In an interview with Gustav Boehm in 1900, Schreyvogel described the difficulties he encountered in his efforts to exhibit and sell the painting:

I finished 'My Bunkie' some time ago I got hard up—you know, artists sometimes do . . . so I tried to sell it to a firm of lithographers to use it at the head of a calendar. They liked it, but it did not reduce to the right size. So they sent it back to me.

Then, still being hard up, I sent it to a certain well known restaurant. I wanted them to hang it on their walls, as they had some of my other pictures. But I heard after a while that they hadn't hung it at all, and that it was lying in a dark corner. I was put out by that, and I took it away.

Then a man in Rochester who has bought some of my work saw it, and said he would buy it in November. November came, but he didn't. And so I kept having providential escapes until, at the beginning of the year, I was persuaded to enter it for the Clarke prize. I think I was probably as much astonished as any one at receiving the prize.

Winning the Thomas B. Clarke prize for figure painting brought Schreyvogel his first public recognition. Shortly thereafter, HARRY W. WATROUS, then corresponding secretary of the National Academy, responded to Gustav Kobbé's (1901) inquiry about the artist:

You are about the hundredth person who has asked me But I can't answer your question. I never have heard of the artist, we even have not his address to send him word that he has won the Clarke prize. Unless he strolls in here to see how 'My Bunkie' looks, he won't know about the matter until he reads it in the newspapers I have asked every artist whom I have met here today for information concerning him, but they know as little as I do. All that we are sure of is that the man's name is Charles Schreyvogel and that he has painted a great picture.

Oil on canvas, 25 3/16 × 34 in. (64 × 86.4 cm.).
Inscribed and dated at lower left: Copyrighted/99.
Signed at lower right: Chas Schreyvogel.
REFERENCES: *New York Daily Tribune*, Dec. 30, 1899, p. 10, in a review of the NAD, says that it and a similar subject by Gilbert Gaul "would be among the best things in the show if only their tones were not so hard" // *New York Tribune Illustrated Supplement*, Dec. 31, 1899, ill. p. 9 // *New York Herald*, Jan. 1, 1900, ill. p. 4, says that it was awarded the Clarke prize, relates the incident which inspired it, compares it to Remington's work, and says that the artist plans to send it to the Paris Exposition // C. Schreyvogel to Curtis and Cameron, Jan. 2, 1900, in Philadelphia Museum of Art, microfilm P14, Arch. Am. Art, discusses reproducing it // C. H. Caffin, *Harper's Weekly* 44 (Jan. 13, 1900), ill. p. 31, in a review of the NAD exhibition says "the conception of the subject is stirring, but not very convincing" and criticizes the artist's drawing // *International Studio* 9 (Feb. 1900), pp. xxx–xxxi, discusses it in NAD // *Brush and Pencil* 5 (Feb. 1900), p. 218, discusses it in NAD and compares it to Remington's work (quoted above) // *Art Interchange* 44 (Feb. 1900), p. 31, in review of NAD, notes that "the color, draughtsmanship and composition are pleasing and correct" // NAD to Schreyvogal, Feb. 10, 1900, in Charles Schreyvogel Memorial, National Cowboy Hall of Fame and Western Heritage Center, Oklahoma City, informs the artist that he is the recipient of the Clarke prize // G. Boehm, *Junior Munsey* 8 (June 1900), p. 432; ill. p. 435; pp. 437–438, the artist relates in an interview the circumstances under which the picture was submitted for exhibition at the NAD (quoted above) // G. Kobbé, *Cosmopolitan* 31 (Oct. 1901), pp. 563–568, discusses it and prints Watrous's comments (p. 566, quoted above); pp. 569, 570, 573 // *Harper's Weekly* 46 (Nov. 15, 1902), p. 1668 // *New York Herald*, April 19, 1903, Literary Section, p. 9 // *Collier's* 38 (March 23, 1907), p. 17, compares Remington's work to it // *Souvenir Album of Paintings by Chas. Schreyvogel* (1907), unpaged ill., discusses it // *My Bunkie and Others* (1909), ill. // G. Kobbé, *Uncle Sam's Magazine* 15 (June 1909), pp. 13–15 // *New York Times*, Jan. 29, 1912, p. 11 // *American Art News* 10 (Feb. 3, 1912), p. 4 // J. S. Isidor, letters in MMA Archives, Feb. 10, 1912, says he and a group of the artist's friends want to organize a subscription for its presentation to the museum; Feb. 11, 1912, says the picture will be on exhibition at the Salmagundi Club in March; Feb. 14 and March 14, 1912, discusses its availability for inspection; March 19, 1912, says that "the idea is to pay a big tribute to Mr. Schreyvogel, and all his fellow artists, friends and admirers wish to contribute towards a fund for the purchase of this picture" // *American Art News* 10 (May 25, 1912), p. 1, announces that friends of the artist are trying to raise a subscription of $5,000 to present the picture to the Metropolitan // J. S. Isidor, letters in MMA Archives, June 11, 21, Nov. 2, 21, Dec. 17, 1912, discusses difficulties in raising funds, acknowledges museum's contribution to the fund, notes completion of the subscription, names Ludwig as treasurer and notes that Mrs. Schreyvogel holds the copyright // L. W. Schreyvogel, artist's widow, acquisition form and letter in MMA Archives, Dec. 20, 1912, lists exhibitions, expresses pleasure at its acquisition, and asks to retain copyright // J. S. Isidor, letter in MMA

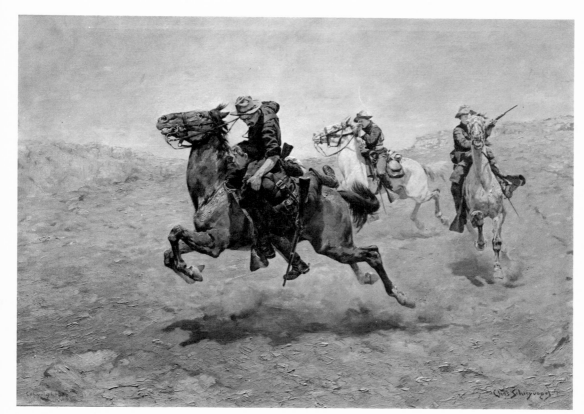

Schreyvogel, *My Bunkie.*

Archives, Jan. 9, 1913, says that the artist's wife is anxious to view it on exhibition at MMA // H. McCracken, *Portrait of the Old West* (1952), color ill. p. 177; pp. 199–201, discusses it // R. Taft, *Artists and Illustrators of the Old West, 1850–1900* (1953), pp. 227–228; ill. following p. 384, no. 80 // W. H. Gerdts, Jr., *Painting and Sculpture in New Jersey* (1964), p. 193, discusses it // C. Willenborg, Jr., letter in MMA Archives, May 20, 1968, says that it was presented to the museum by ten of the artist's friends // J. D. Horan, *The Life and Art of Charles Schreyvogel* (1969), p. 3, in a preface by R. S. Carothers, the artist's daughter, says that Schreyvogel considered it "among his greatest paintings;" ill. p. 22, in a photograph of the artist's studio; pp. 23–26, discusses it; p. 28, says artist refused to sell it in spite of generous offers; pp. 34, 35, 40; ill. p. 41, discusses it; p. 51; pp. 54–56, lists copyright records for it; pp. 57–58, color pl. 1 // R. S. Carothers, artist's daughter, copy of a letter to J. D. Horan in MMA Archives, June 3, 1969, lists the names of ten subscribers, members of the Samstag Abend Kegel Club of Hoboken // *The National Cowboy Hall of Fame and Winchester Western Extend an Invitation for You to Participate . . . through . . . the Purchasing and*

Assembling of the Important Charles S. Schreyvogel Studio Collection and Major Works Memorial, pamphlet [ca. 1969], in FARL, unpaged ill., mentions a picture by H. A. Schwabe of Schreyvogel painting it // Chapellier Galleries, New York, *Charles Schreyvogel, 1861–1912,* exhib. cat. (1971), unpaged, discusses it // G. Brown, *Arts* 45 (April 1971), p. 66, mentions it in a review of the Chapellier exhibition // P. H. Hassrick, *Frederic Remington* (1973), p. 41, says that its success caused Remington to become jealous and quotes review comparing it favorably to works by Remington; p. 45, quotes a critic who compares it to Remington's work // D. Dawdy, *Artists of the American West* (1974), p. 207 // P. and H. Samuels, *The Illustrated Biographical Encyclopedia of Artists of the American West* (1976), p. 428.

EXHIBITED: NAD, New York, 1900, no. 121, ill. // Exposition Universal, Paris, 1900, *Catalogue Général Officiel,* Etats-Unis, Groupe 2, Classe 7, no. 275, as *My Bunke* // Pan-American Exposition, Buffalo, 1901, *Catalogue of the Exhibition of Fine Arts,* no. 281 // NAD, New York, 1912, no. 104, p. 18 // Corcoran Gallery of Art, Washington, D.C.; Grand Central Art Galleries, New York, 1925–1926, *Commemorative Exhibition by Members of the National Academy of Design,*

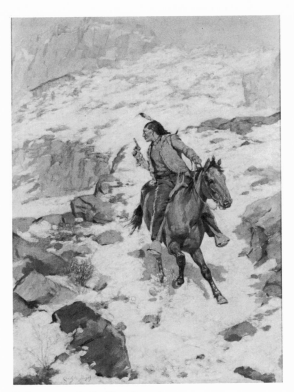

Schreyvogel, *In Hot Pursuit.*

1825–1925, no. 101 // MMA, *Life in America* (1939), exhib. cat. by H. B. Wehle, no. 231, discusses // Grand Central Art Galleries, New York, 1955, *Remington to Today*, no. 71 // Gallery of Western Art, Buffalo Bill Historical Center, Cody, Wyo., 1961, *Frederic Remington Centennial Exhibition and Paintings, Drawings, and Sculpture by Other Notable Documentary Artists of the Old West . . .* , no. 68 // MMA and the American Federation of the Arts, traveling exhibition, 1975–1976, *The Heritage of American Art*, cat. by M. Davis, p. 188; ill. p. 189, discusses it.

Ex COLL.: the artist, Hoboken, N.J., 1899–1912; his wife, Hoboken, N.J., 1912; a group of the artist's friends by subscription (C. M. Bernegau, J. F. Eppens, E. F. Henning, Willie L. E. Keuffel, C. Huening, Henry Lambelet, A. Ludeke, H. Maerlender, with Adolf Ludwig, as treasurer, and Joseph S. Isidor, as agent), 1912.

Gift of the Friends of the Artist, by subscription, 1912.

12.227.

In Hot Pursuit

Like most of Schreyvogel's western scenes, *In Hot Pursuit* is full of action. An armed Indian on a galloping horse is being pursued down a rough mountainside by several riders, barely visible in the distance. The instantaneous, snap-shot view and the forward thrust of the horse and rider, who seem about to plunge into the viewer's space, add to the sense of movement. To capture naturalistic effects Schreyvogel developed his compositions from casts, photographs, and the sketches he made during his trips West. He often painted outdoors, where he studied his model in natural light against the rugged Palisades near his Hoboken studio. In this scene, however, he has not succeeded in integrating the horse and rider with the setting. The landscape is extremely general compared to the detailed figures. Probably painted after 1900, *In Hot Pursuit*, with its firm draftsmanship, exemplifies Schreyvogel's illustrative style. The colors, mainly creamy whites and pale browns, are subdued.

Oil on canvas, $34\frac{1}{8} \times 24\frac{3}{4}$ in. (86.7 × 62.9 cm.).

Signed at lower left: Chas Schreyvogel.

REFERENCES: C. Newhouse, Newhouse Galleries, New York, letter in Dept. Archives, May 10, 1977, provides information on provenance.

Ex COLL.: with E. J. Rowsuck, New York, 1930s; Allan P. Kirby; private collection.

Anonymous gift, 1962.

62.241.4.

WILTON LOCKWOOD

1861–1914

Robert Wilton Lockwood, named in part for his birthplace, Wilton, Connecticut, later dropped his Christian name. When he was four his mother died, and the family moved to New

404

York. He soon returned to Connecticut, however, and lived with two of his aunts on a farm in Rowayton, where he attended the local school. As a young man, he was employed in a New York broker's office, and it was there that someone introduced him to JOHN LA FARGE, in whose studio he trained as a designer of glass in the early 1880s. He also studied at the Art Students League in New York and then in 1886 in Paris under Jean Joseph Benjamin-Constant. For much of the next decade Lockwood remained abroad, returning to New York for a short time to paint portraits to finance the remainder of his stay in Europe. This was probably about 1891, as his portrait of John La Farge (MFA, Boston) is dated that year. Lockwood married in London in 1892 and then went to live in Munich and later in Paris. His work was exhibited in both Munich and Berlin, but he achieved his first real critical success in Paris when he exhibited a group of portraits at the Champs de Mars exhibition in 1895. In December of that year a one-man exhibition of his work was held at the St. Botolph Club in Boston.

Lockwood returned to the United States in 1896 and settled in Boston. At this time he painted mostly portraits, such as *Rev. Edward Abbott* (Bowdoin College Museum of Art, Brunswick, Me.) and *Dr. Robert Fletcher* (National Library of Medicine, Bethesda, Md.). During an exhibition of his paintings at the Durand-Ruel Gallery in New York in 1902, one critic noted that, in his portraits, the artist attempted "to give each canvas some special quality not only of artistic presentment but of human characterization" (*International Studio* 16 [April 1902], p. lxx). He is, however, best known for his still lifes, the subjects of which are often the peonies that he cultivated at his summer home in South Orleans on Cape Cod.

In the early 1900s, Lockwood's paintings were awarded honors at exhibitions in Paris, Buffalo, and St. Louis. He was a member of a number of major art organizations, including the Society of American Artists, from 1898, and the National Academy of Design, where he became an associate in 1902 and an academician a decade later. In 1912 he took a studio in New York and worked there until he became ill. He died at the age of fifty-two in Brookline, Massachusetts, and the following year the St. Botolph Club mounted a memorial exhibition of his work.

BIBLIOGRAPHY: T. R. Sullivan, "Wilton Lockwood," *Scribner's Magazine* 23 (Feb. 1898), pp. 178–184 // M. I. G. Oliver, "An American Portrait-Painter, Wilton Lockwood," *International Studio* 32 (Oct. 1907), pp. 262–268 // Obituaries: F. W. Coburn, *Boston Herald*, March 21, 1914, pp. 1–2; [W. H. Downes], *Boston Evening Transcript*, March 21, 1914, p. 7 // Arthur Edwin Bye, *Pots and Pans: or Studies in Still-Life Painting* (Princeton, 1921), p. 196 // Frederick W. Coburn, *DAB* (1933; 1961), s.v. "Lockwood, Robert Wilton."

Peonies

Probably painted during the first decade of the twentieth century, the picture shows a vase of evanescent peony blossoms arranged off-center on a square canvas—a slightly uneven composition of softly rounded forms against a dark empty background. Lockwood cultivated peonies, and by 1895 he was using them almost exclusively as the subjects of his still lifes. The artist Charles Hovey Pepper (1864–1950) once described these paintings: "They are marvelously fragile, tender, delicately varied in color, most subtle in values, yet freely and masterfully and unflinchingly painted" (Brooks Reed Gallery, Boston, *Wilton Lockwood* [1912], unpaged).

In this painting, as in many others, his working method was unusual. He mounted his canvas on the stretcher with the primed side on the reverse and used the unprimed side for his working sur-

Lockwood, *Peonies.*

face. The soft, pastel-like effects so evident in the picture are partly the result of painting on a highly absorbent ground. The paint is applied in extremely thin layers, showing little evidence of brushwork and leaving the irregular weave of the canvas visible. The texture of the paint is more tactile in the petals where it is thicker and more fluidly applied. In the background, pronounced patches of color add some visual interest to the otherwise austere setting. The delicate atmospheric quality and soft illumination of the work are typical of Lockwood's still lifes.

Oil on canvas, 30 × 30⅛ in. (76.2 × 76.5 cm.).

REFERENCES: *American Art News* 9 (Dec. 24, 1910), p. 3, says that George Hearn purchased the painting at the NAD exhibition for $1,000 // G. A. Hearn, letter in MMA Archives, Feb. 10, 1911, says it was included in the last exhibition at the NAD and that John White Alexander recommends its acquisition // *Art News* 12 (March 28, 1914, p. 7, notes the painting in the artist's obituary // E. A. Bye, *Pots and Pans* (1921), p. 195, mentions it as an example of the use of an atomspheric "envelope"; ill. opp. p. 196 // W. H. Gerdts and R. Burke, *American Still-life Painting* (1971), p. 192 // J. Bienenstock, New York, orally, April 4, 1979, pointed out the artist's unusual technique // W. Beebe, Paintings Conservation, MMA, orally, April 4, 1979, discussed Lockwood's use of the unprimed side of the canvas for this work.

EXHIBITED: NAD, Winter, 1910–1911, no. 301, as Peonies.

Ex COLL.: George A. Hearn, New York, 1910–1911.

George A. Hearn Fund, 1911.

11.33.

GARDNER SYMONS

1861–1930

The landscape and marine painter George Gardner Symons was born in Chicago, the son of German immigrants whose surname was Simon. Few specific facts are known about his life and career. The year of his birth is given in various biographical sources as 1861, 1865, or 1866. His death certificate, however, sets it at 1861. He is reported to have received his first professional training at the Art Institute of Chicago, but there is no mention of his name in the records of that institution. He studied in Paris, Munich, and London, remaining in Europe for nearly a decade. He made at least one trip home, in 1896, when he traveled to California with the landscape painter William Wendt (1865–1946). Symons first exhibited a painting at the Royal Academy in London in 1899. At about the same time he began to work at the artists' colony in St. Ives, Cornwall. Although such landscape painters as Adrian Stokes, Julius Olsson, and Rudolf Hellwag painted there at this period, Symons's known work bears little resemblance to the paintings of these artists. He did, however, adopt their plein-air technique. Within a few

years Elmer Schofield (1867–1944) also joined the colony at St. Ives, and thereafter his and Symons's work developed along parallel lines.

Symons seems to have returned to the United States in 1906. He maintained a studio part-time in Laguna Beach, California, from 1906 until 1915. His paintings were exhibited at the California Art Club from 1914 to 1917 and with the Society of Men Who Paint the Far West beginning in 1912. Most of his career, however, was spent on the East Coast. Between frequent visits to Europe, he lived in New York and Colerain, Massachusetts, where he did many of the snow scenes that became his specialty. Even the largest of his paintings were reportedly done outdoors, with only the final touches added in the studio. "The greatest art does not come from the studio, neither does the greatest virtue emanate from the convent—they both find their greatest stimulant in Nature," the artist told an interviewer in 1916 (Parkhurst, p. 563).

Symons's first real critical success came in 1909 when he won the Carnegie prize at the National Academy of Design. Between 1910 and 1913 he won a number of major awards. He was elected an associate member of the National Academy in 1910 and an academician the following year. He was honored with several one-man shows between 1910 and 1922: at the Art Institute of Chicago, Pratt Institute in Brooklyn, Vose Gallery in Boston, the Macbeth Gallery in New York, the Cincinnati Art Association, the John Herron Art Museum, Indianapolis, and the City Art Museum, St. Louis. His landscapes, which were enormously popular, are similar in scale, style, and subject matter to those of his friends Schofield and Edward Redfield (1869–1965). Heralded as participants in the "emancipating struggle of the younger men" (J. N. Laurvik, *International Studio* 41 [August 1910], p. 29), these artists all painted in an impressionist style but with vitality and directness that separates them from the previous generation of American impressionists. Working on large-scale paintings, Symons generally did panoramic views. He developed imposing compositions in which broad areas of color created strong patterns. Although his landscapes often represent specific scenes, they are treated decoratively. His colors, applied in wide varied brushstrokes, are bright and harmonious.

Symons died in Hillside, New Jersey, after a long illness.

BIBLIOGRAPHY: Marie Louise Handley, "Gardner Symons—Optimist," *Outlook* 105 (Dec. 27, 1913), pp. 881–887 // Thomas Parkhurst, "Little Journeys to the Homes of Great Artists," *Fine Arts Journal* 33 (Oct. 1915), suppl. pp. 7–9, describes visit to the artist's Laguna Beach studio // Thomas Shrewsbury Parkhurst, "Gardner Symons, Painter and Philosopher," *Fine Arts Journal* 34 (Nov. 1916), pp. 556–565, is an interview with the artist // Obituaries: *Art Digest* 4 (Jan. 1930), p. 18; *Art News* 28 (Jan. 25, 1930), pp. 14–15; *American Magazine of Art* 21 (March 1930), p. 163 // Nancy Dustin Wall Moure, with research assistance by Lyn Wall Smith, *Dictionary of Art and Artists in Southern California before 1930* (Los Angeles, 1975), p. 247, discusses the artist's career in California, gives bibliography.

An Opalescent River

Although there is an Opalescent River in New York, it seems likely that the title of this painting is meant to describe the coloristic qualities of the water. Indeed, according to the label, written by the artist, the painting depicts a scene in New England, and in all probability represents the Deerfield River near his home in Colerain, Massachusetts. The date of the painting is not

Symons, *An Opalescent River.*

known. In a letter of 1911, however, Symons claimed that the canvas was "hardly dry" when it was shown at the National Academy of Design late in 1909. A year earlier in Liverpool, England, he had exhibited a painting, now unlocated, titled *Winter (Sketch)*. Judging from the catalogue illustration, the sketch is so similar to the Metropolitan painting that it could be the study for it. The similarity of the scenes, the closeness of the measurements given for *Winter (Sketch)* to those of *An Opalescent River* (it is the same width and only two inches less in height), and the Liverpool sticker on the stretcher of the latter suggest another alternative—that is, that the Metropolitan painting is *Winter (Sketch)* reworked after the Liverpool exhibition. The painting would not necessarily show that kind of reworking today.

Large in scale, *An Opalescent River* is composed in broad areas of color, in which the lavender and blue water of the river is in strong contrast to the bright patches of snow and ice. Symons's wide rapid brushstrokes and thick touches of impasto are applied on a coarse canvas, giving the paint surface textural variety.

Oil on canvas, $50\frac{1}{2} \times 60\frac{1}{16}$ in. (128.3 × 152.6 cm.).

Signed at lower right: Gardner Symons. Label on reverse inscribed: *Gardner Symons* / St. Ives, Cornwall / *The Opalescent River* / New England. Label on stretcher: LIVERPOOL. / 1908 / DICKSEE & CO.

RELATED WORK: *Winter (Sketch)*, oil, 48 × 60 in. (121.9 × 152.4 cm.), unlocated, ill. in *Liverpool Autumn Exhibition*, 1908, p. 71.

REFERENCES: *New York Evening Post*, Dec. 11, 1909, p. 9, in a review of the NAD, calls it "a scene of great beauty" and notes that it has been awarded the Carnegie prize; Dec. 14, 1909, p. 9, says it shows "disciplined and thoughtful naturalism" and the influence of Edward Redfield // *Nation* 89 (Dec. 16, 1909), ill. p. 608, in a review of NAD exhibition says it shows influence of Redfield // *International Studio* 39 (Feb. 1910), pp. ci–cii, in a review of NAD exhibition says that with it Symons "joins himself to those painters of landscape who study the forms of nature, and particularly of the earth itself with that sort of seriousness which is always demanded of figure painters in portraying human form" // *MMA Bull.* 5 (Feb. 1910), ill. p. 47 // E. McMillin, letter in MMA Archives, Sept. 1, 1910, says he had never heard of the artist before buying the painting and the artist did not know of his intention of giving the work to the museum // G. Symons, letters in MMA Archives, April 26, 1911, says "I think my painting without the glass and the frame without the shadow-box is a great improvement," claims picture was "hardly dry" when he sent it to the NAD and now that the glass has been removed he would like to retouch it "with a little varnish"; June 14, 1911, acknowledges permission to retouch it and says he will do it in September // M. L. Handley, *Outlook* 105 (Dec. 27, 1913), pp. 886–887 // T. S. Parkhurst, *Fine Arts Journal* 34 (Nov. 1916), pp. 564–565 // *Art Digest* 4 (mid-Jan. 1930), p. 18, mentions it in the artist's obituary // *Art News* 28 (Jan. 25, 1930), p. 15, mentions it in the artist's obituary.

EXHIBITED: NAD, New York, Winter 1909–1910, no. 220, as An Opalescent River; ill. p. 47 // Carnegie Institute, Pittsburgh, 1910, ill. no. 269.

EX COLL.: Emerson McMillin, New York, 1909.

Gift of Emerson McMillin, 1909.

09.223.

FREDERICK J. WAUGH

1861–1940

Best known as a painter of seascapes, Frederick Judd Waugh was born in Bordentown, New Jersey. The young artist was raised in Philadelphia, where he attended public schools and later a military academy. His family was an artistic one—his father was the portrait and landscape painter Samuel Bell Waugh (1841–1885), his mother, Mary Eliza Young Waugh, was a miniaturist, and his half-sister Ida Waugh (d. 1919) was a figure painter. Undoubtedly he received his first art training at home. In 1880, at the age of nineteen, he entered the Pennsylvania Academy of the Fine Arts, where he studied for three years under THOMAS EAKINS and THOMAS ANSHUTZ. There he met Clara Eugenie Bunn, who later became his wife. He made his first trip to Europe in the summer of 1882 with Henry Rankin Poore (1859–1940). They visited Paris and spent some time in the French countryside. At this period, Waugh was painting landscapes and some seascapes. Little, however, is known about this early work.

In 1883 Waugh again went to Paris, where he continued his studies at the Académie Julian under the direction of Adolphe William Bouguereau and Tony Robert-Fleury. The following year he exhibited at the Paris Salon and, while abroad, he continued to send his paintings to major annuals at the Pennsylvania Academy of the Fine Arts, the National Academy of Design, and the Art Institute of Chicago. In the summer he painted at Grez-sur-Loing, a popular artists' colony near Fontainebleau, and in Brittany, where he met ALEXANDER HARRISON, a well-known admirer of the French peasant painter Jules Bastien-Lepage. Waugh's paintings also show the influence of Bastien-Lepage's plein-air realism. Called back to Philadelphia because of his father's death in 1885, he spent the next seven years there, doing commerical work and some portraits.

When Waugh married in 1892 he took a honeymoon trip to Europe. After traveling in Scotland and England, he settled in a studio in Paris and painted *Consider the Lilies*, 1893 (now unlocated), which he presented to St. Luke's Church on the rue de la Grande Chaumière. In return the rector of the church helped finance his trip to Sark in the Channel Islands, where Waugh lived from 1893 until 1895. There he began to paint marine subjects like *La Grande Greve* (now unlocated) which was exhibited at the Royal Academy in 1894. The following year he moved to England and worked in St. Ives, Cornwall, for about nine months. He shared a studio with Hayley Lever (1876–1958) and probably met a number of the painters who frequented this popular artists' colony, among them the marine painter Julius Olsson and others of the "Newlyn School" of plein-air painters, who, like Waugh, had been strongly influenced by Bastien-Lepage. In 1896 he moved to Bedfordshire, and then in 1899 to Hendon, outside of London. He supported himself by illustrating articles for *Harmsworth Magazine* and the *Graphic*. In 1901 he moved his family to London, where he lived until 1907. Throughout this period, Waugh maintained a studio at St. Ives where he painted seascapes influenced by the English painter Henry Moore. In 1907 Waugh, who had been a frequent exhibitor at the Royal Academy, had some paintings refused for an exhibition. That rejection and the memory of a pleasant visit home two years earlier prompted his return to the United States.

Frederick J. Waugh 409

He stayed first with relatives in Elizabeth, New Jersey, and then settled near Montclair. There he enjoyed the patronage of the art collector William T. Evans. Waugh was able to give up illustrating and to concentrate on his seascapes, which were often views of waves and sky uncomplicated by shoreline or vessels. This direction in his career was affirmed by George A. Hearn's purchase and presentation to the Metropolitan Museum of *The Roaring Forties*, 1908 (q.v.). Public recognition soon followed. In 1909 he was elected an associate member of the National Academy of Design and two years later a full member. His first one-man show, an exhibition of paintings inspired by the summers he spent at Bailey Island, Maine, in 1908 and 1909, was held at the Macbeth Gallery in 1910. That same year his ambitious figure painting *The Buccaneers* (Public Library, Brockton, Mass.) won the Thomas B. Clarke prize at the National Academy.

Waugh moved to Kent, Connecticut, in 1915, and made his home there until 1927. He was a frequent visitor to Monhegan Island, Maine, which provided him with the inspiration for his only book, *The Clan of the Munes* (1916). During World War I he participated in a government project for camouflaging ocean-going vessels. Throughout the next decade, he traveled in search of fresh material for his seascapes: in 1920, he visited the Caribbean and in 1922 he made a trip to British Columbia. His last years were spent close to the ocean at Provincetown, Massachusetts, near his son, Coulton Waugh (1896–1973), who was also a painter. Continued commercial, critical, and popular success marked this period. Waugh won the Carnegie Institute's popular prize an unprecedented five times beginning in 1934. Major collections of his work can be seen at the Edwin A. Ulrich Museum, Hyde Park, New York, and the Edwin A. Ulrich Museum of Art, Wichita State University, Kansas.

BIBLIOGRAPHY: Frederick J. Waugh, "Some Words Upon Sea Painting," *Palette and Bench* 3 (Nov. 1910), pp. 32–33, contains the artist's comments on painting seascapes // A. Seaton Schmidt, "An American Marine Painter, Frederick J. Waugh," *International Studio* 51 (Feb. 1914), pp. 273–278 // Henry Rankin Poore, "The Many-Sided Waugh," *International Studio* 74 (Dec. 1921), suppl. pp. 124–135. Written by an artist friend of Waugh's, it includes a brief list of major works and illustrates a wide range of his artistic work // George R. Havens, "Frederick Waugh," *American Artist* 31 (Jan. 1967), pp. 30–37, 68–69 // George R. Havens, *Frederick J. Waugh, American Marine Painter* (Orono, Me., 1969). A detailed account of the artist's life and work, with an extensive bibliography and several lists of Waugh's work, which give exhibitions, current locations of works in public and private collections, and the Waugh family collection.

The Roaring Forties

The picture was painted in January 1908, shortly after Waugh's return home after fifteen years abroad. It is a mid-ocean view showing turbulent waves in the stormy region of the North Atlantic between the fortieth and fiftieth degrees north latitude. Waugh did the painting in a New York loft belonging to W. S. Budworth, the fine arts shipper, but it is probably based on his observations of the ocean during his Atlantic crossing the previous November or December. The title, originally suggested to him by Marcus Ward, a London acquaintance, was used two years earlier for a smaller seascape exhibited at the Royal Academy, *Mid-Atlantic: The Roaring Forties*, 1906 (Edwin A. Ulrich Museum of Art, Wichita State University, Wichita, Kan.).

In an article entitled "Some Words Upon Sea Painting" (*Palette and Bench* 3 [Nov. 1910], pp. 32–33) written after he painted *The Roaring Forties*, Waugh described his method for doing seascapes. He suggested that the artist observe the ocean and study its movement, looking for repetitions, "one peculiarly attractive phase." Once the painter became intimately familiar

with the sea it was no longer necessary to work from nature, and the seascape could be painted from memory. "I spend part of each summer studying the sea from nature and what I learn from it then, lasts me until the next time. . . . in that way I fix certain forms clearly in my memory." He also recommended using "impasto, thick painting . . . an even, rugged, ragged thickness all over" and applying the pigments "as unmixed as possible" on a canvas "previously prepared with a rough coat of paint of a dark color." Here, working on a large scale, the artist used broad, bold brushwork and clear green colors to represent the ocean water.

The painting was exhibited several times in 1908 and 1909. On March 3, 1909, while it was on view at the Pennsylvania Academy of the Fine Arts, the New York art collector George A. Hearn, acting on the advice of the painter Henry B. Snell (1858–1943), went to see it. Hearn offered to buy the painting, and the next day John E. D. Trask, the academy's manager, wrote to him that Waugh "has decided to accept your offer." The sale of *The Roaring Forties* and its addition to the Metropolitan Museum—Waugh's first real success after his return to the United States—did much to establish his reputation.

Waugh, *The Roaring Forties*.

Oil on canvas, 48 × 60⅛ in. (121.9 × 152.7 cm.).
Signed at lower right: *Waugh*.
REFERENCES: *New York Times*, Feb. 14, 1909, picture section, part 1, ill. in review of PAFA exhibition // W. Rankin, *Nation* 88 (Feb. 18, 1909), p. 178, in a review of PAFA, says, "In sheer truth of literal presentation, with a more conventional style and without atmosphere, Frederick J. Waugh's deep-sea piece is impressive" // J. E. D. Trask, PAFA, to G. A. Hearn, March 4, 1909, PAFA Archives, in G. R. Havens, *Frederick J. Waugh* (1969), p. 101, says he discussed Hearn's offer with the artist (quoted above) // Hearn to Trask, March 5, 1909, PAFA Archives, in ibid., p. 102, discusses payment for and shipping of the painting // Trask to Hearn, March 6, 1909, PAFA Archives, in ibid., p. 102, acknowledges receipt of payment and provides information about the painting's size // *MMA Bull.* 4 (July 1909), p. 116, includes it in a list of paintings presented to the museum by Hearn // F. J. Waugh, *Palette and Bench* 3 (Nov. 1910), ill. p. 33; letter in Dept. Archives, Sept. 5, 1912, discusses title and says he used it for an earlier work // *George A. Hearn Gift to the Metropolitan Museum of Art . . .* (1913), ill. p. 99 // A. Hoeber, *Mentor* 1 (July 7, 1913), ill. and discusses it following p. 12 // A. S. Schmidt, *International Studio* 50 (Feb. 1914), ill. p. 275 // J. B. Carrington, *International Studio* 60 (Dec. 1916), p. 50, describes it // *Century*

98 (August 1919), color ill. frontis. // H. R. Poore, *International Studio* 74 (Dec. 1921), ill. p. 124; p. 134, lists it // E. Neuhaus, *The History and Ideals of American Art* (1931), ill. p. 292; p. 301 // [E. S. Barrie], *Paintings of the Sea by Frederick Judd Waugh, N.A.* (1936), p. 3; ill. p. 11 // *Art Digest* 15 (Oct. 1, 1940), p. 12 // M. R., *Art Digest* 17 (March 1, 1943), p. 6, says it was Waugh's first marine painting done after his return from England // Bronxville Public Library, N.Y., *Exhibition of Sea Paintings by Frederick Judd Waugh* (1944), unpaged, mentions it // Brooks Memorial Art Gallery, Memphis, *Paintings of the Sea* (1945), exhib. cat., unpaged, mentions it // G. R. Havens, *Down East* 14 (June 1968), pp. 34–35, discusses purchase by Hearn; *Frederick J. Waugh, American Marine Painter* (1969), pp. 95–102, discusses it and earlier use of the title; describes how it was painted at Budworth's; says it was shown at Carnegie International in 1908 and 1909 PAFA exhibition; discusses its acquisition by Hearn on the advice of Snell, and quotes correspondence between Hearn and Trask, March 4–6, 1909; p. 111, says it was painted during the first few weeks of 1908; pp. 194–195, 219–220, 270, 278, 298, pl. 5 // M. S. Young, *Apollo* 97 (April 1973), p. 439.

EXHIBITED: Carnegie International, Pittsburgh, 1908, no. 326, as The Roaring Forties // Art Institute of Chicago, 1908, no. 314 // PAFA, 1909, no. 351, ill. as The Roaring Forties // Grand Central Art Galleries, New York, 1943, *Memorial Exhibition of Paintings of the Sea by Frederick Judd Waugh, N.A., 1861–1940*, ill. no. 1; unpaged introduction, notes it was painted in a loft belonging to Budworth soon after Waugh's voyage home.

EX COLL.: with J. E. D. Trask, manager PAFA, as agent, 1909; George A. Hearn, New York, 1909.

Gift of George A. Hearn, 1909.
09.96.

Waugh, *Wild Weather*.

Wild Weather

This picture of waves breaking on a rocky shoreline was painted by 1930. The frigid looking water and the overcast sky suggest winter and an approaching storm. The pounding waves, the ominous sky, and the desolate beach in the foreground—the viewer's only link with land and safety—convey a sense of the ocean's awesome power.

Waugh painted another picture entitled *Wild Weather* (Corcoran Gallery of Art, Washington, D.C.).

Oil on masonite, $29\frac{7}{8} \times 48\frac{1}{8}$ in. (75.9 × 122.2 cm.). Signed at lower right: *Waugh*.

REFERENCES: R. Frost, *Art News* 42 (March 15, 1943), p. 19, mentions a painting by this title in an exhibition at Grand Central Art Galleries // G. T. Nelson, Grand Central Art Galleries, New York, orally, May 18, 1950, said it was painted about 1938 // D. G. Lazarus, Grand Central Art Galleries New York, letter in Dept. Archives, Feb. 2, 1979, states that the painting is now believed to have been painted before 1930 and was probably the work exhibited that year; states that it was acquired directly from the artist and discusses Waugh exhibitions at the gallery.

EXHIBITED: Grand Central Art Galleries, New York, 1930, *Recent Marines by Frederick J. Waugh*, N.A., no. 10, as Wild Weather (probably this painting); 1930, *Exhibitions of Paintings and Sculpture Contributed by Artist Members, Yearbook 1930*, ill. no. 5; 1943, *Memorial Exhibition of Paintings of the Sea by Frederick Judd Waugh, N.A., 1861–1940*, no. 71 (possibly this painting) // Heckscher Museum, Huntington, N.Y., 1958, *Marine Paintings by American Artists* (unnumbered cat.) // Phoenix Art Museum, 1967–1968, *The River and the Sea*, no. 22.

EX COLL.: with Grand Central Art Galleries, New York, 1930–1950.

George A. Hearn Fund, 1950.

50.111.

IRVING R. WILES

1861–1948

The artist was born in Utica, New York, and grew up in New York City. He was educated at home before attending a number of schools, including one in Great Barrington, Massachusetts, where he showed interest in music, ornithology, and medicine. In 1878 he studied art with his father, Lemuel M. Wiles (1826–1905), a landscape painter and art instructor. The following year Irving R. Wiles exhibited at the National Academy of Design. On his father's advice, he

enrolled in the Art Students League in New York, where he studied under WILLIAM MERRITT CHASE and J. CARROLL BECKWITH from 1879 to 1881. A year later, Wiles went to Paris and attended the Académie Julian, where he painted under the direction of Gustave Boulanger and Jules Joseph Lefebvre. He then entered the atelier of Emile Auguste Carolus-Duran. During these student years Wiles produced a number of watercolors of Paris street scenes. Besides working in France, he spent several months traveling in Italy.

Wiles returned to New York in the spring of 1884 and exhibited two of his sketches at the Salmagundi Club. These works attracted the attention of the art editor of *Century Magazine*, W. Lewis Fraser, who asked him to do illustrations for the magazine. "I got into illustration by accident, . . . and I stay in it because it means bread and butter," Wiles noted in 1894. "I have divided my time between painting and illustrating Portrait painting is what I really delight in, but there is not enough of it coming my way to keep me busy" (*Bookbuyer* 11 [Sept. 1894], pp. 387–388). Besides *Century* his illustrations also appeared in *Harper's* and *Scribner's* magazines. He further supplemented his income by conducting classes in his New York studio during the winters and at his father's school at Ingham, New York, each summer. In 1886 Wiles was elected a member of the Society of American Artists. Three years later when his *The Sonata*, 1889 (Butler Institute of American Art, Youngstown, Ohio) was awarded the Thomas B. Clarke prize for figure painting at the National Academy of Design, he became an associate member there. By 1897, when he was elected an academician, he had begun to devote more of his time to portraiture and figure studies in oil. *Russian Tea*, ca. 1896 (National Collection of Fine Arts, Washington, D.C.), is typical of the paintings Wiles did at the end of the century in the fluid brushwork, the dark harsh colors, and the careful drawing. Elaborate studio interiors such as *The Studio, 57th Street* (Am. Acad. of Arts and Letters) show the continued influence on his style of Chase.

During the late 1890s, Wiles and his father moved their summer classes to Peconic on Long Island, which eventually became their year-round home. The artist made several trips to Europe during the early years of the twentieth century: in 1904 he and the illustrator William T. Smedley (1858–1920) went to Holland; in 1905 Wiles visited Spain, where he copied works by Hals and Velázquez; in 1910 he traveled in Italy; and two years later, in England. He achieved great success as a portraitist, particularly after 1910, when M. Knoedler and Company held an exhibition of his portraits in New York. His many sitters included William Sowden Sims, 1919 (National Portrait Gallery, Washington, D.C.), and John A. Garver (Oliver Wendell Holmes Library, Phillips Academy, Andover, Mass.). Wiles is best known, however, for his elegant portraits of women, such as *Julia Marlowe*, 1901 (National Gallery of Art, Washington, D.C.). Throughout his career, he painted a wide variety of subjects in addition to portraits. His plein-air seascapes and landscapes, many done at Peconic, are unexpectedly free and informal.

BIBLIOGRAPHY: P.G.H. Jr., "Irving R. Wiles," *Bookbuyer* 11 (Sept. 1894), pp. 387–390 ∥ Theodore Dreisser, "Art Work of Irving R. Wiles," *Metropolitan Magazine* 7 (April 1898), pp. 357–361 ∥ Irving R. Wiles, "Portrait Painting," *Palette and Bench* 1 [Jan. 1909], pp. 84–85, records the artist's comments on portraiture ∥ William B. McCormick, "The Portraits of Irving R. Wiles," *International Studio* 77 (June 1923), pp. 256–262 ∥ Chapellier Galleries, New York, *Irving Ramsey Wiles, 1861–1948* (1967), exhib. cat. by Nelson C. White; lists awards and includes many illustrations and a bibliography.

Wiles, *Lemuel Maynard Wiles*.

Lemuel Maynard Wiles

The portrait of Lemuel Maynard Wiles (1826–1905), the artist's father and one of his favorite subjects, was painted in 1904. In addition to this picture, Irving Wiles represented his father in a double portrait, *The Artist's Mother and Father*, 1889 (Corcoran Gallery of Art, Washington, D.C.), in a bust portrait, 1898, and in an ink drawing (both New York art market, 1967) that has a composition similar to the Metropolitan portrait.

The fluid brushwork, somber palette, and concentration on the face, brightly illuminated and set against a dark background, show the continuing influence of WILLIAM MERRITT CHASE, Wiles's friend and teacher. Like Chase, Wiles advocated a direct approach to portraiture. In describing his technique, he noted that he rarely made studies but began to paint on the canvas immediately, "suggesting the composition, light, shade, and color." Later, working with a simple palette limited to half a dozen colors, he painted in the head, trying for an overall effect rather

than the details of individual features. He urged students: "Above all things try for the values Try to paint the head as a sculptor would model it, giving it rotundity, and its proper planes, but not forgetting the general value, which will place it within the canvas, not coming out of it" (*Palette and Bench* 1 [Jan. 1909], pp. 84–85). The dark colors and careful relationship of values in this work show Wiles's portrait painting technique to advantage.

Like his son, Lemuel Maynard Wiles was also an artist. A student of WILLIAM HART and JASPER F. CROPSEY, he is best known for his landscape views of Panama, California, and Colorado. He taught and painted in Washington, D.C., Albany and Utica, New York, before settling in New York City in 1864. Thereafter, in the summer, he taught at the Silver Lake Art School in Ingham not far from his birthplace at Perry, New York. In the late 1890s, both he and Irving taught summer classes at Peconic, New York. Irving Wiles began his artistic career at his father's insistence and continued it with his encouragement and support.

Oil on canvas, 22⅛ × 18¼ in. (56.2 × 46.4 cm.).
Signed at upper left: Irving R. Wiles / 1904.
REFERENCES: *American Art News* 3 (Dec. 31, 1904), p. 3, says that it is included in unidentified exhibition; 8 (Feb. 12, 1910), p. 6, discusses it in an exhibition of the artist's portraits at Knoedler's; says "the best work in the exhibition is the well-remembered bust portrait of the artist's father . . . painted con amore and very broadly, most natural in expression, fine in fresh tones and the head beautifully modeled" // *New York Evening Post*, Feb. 12, 1910, p. 7, praises it // Mrs. I. R. Wiles, letter in MMA Archives, Dec. 20, 1912, notes that "Mr. Wiles says that he is very glad to be represented in the Museum by his *best* head" // I. R. Wiles, letter and acquisition form, Dec. 28, 1912, MMA Archives, discusses the painting // L. M. Bryant, *American Pictures and Their Painters* (1921), p. 260; fig. 203 opp. p. 260 // W. B. McCormick, *International Studio* 77 (June 1923), p. 256 // *Literary Digest* 89 (April 17, 1926), p. 99.
EXHIBITED: M. Knoedler and Co., New York, 1910, *Catalogue of Portraits by Irving R. Wiles, N.A.*, no. 16, as Mr. L. M. Wiles // Art Students League and American Fine Arts Society, New York, 1943, *Fifty Years on 57th St.* (for the benefit of the American Red Cross), no. 221 // Chapellier Gallery, New York, 1967, *Irving R. Wiles, 1861–1948* (not in cat.).
EX COLL.: the artist, New York, 1904–1912.
Rogers Fund, 1912.
12.218.

George A. Hearn

The New York merchant George A. Hearn (1835–1913) was an important benefactor of the Metropolitan Museum of Art during the last twenty years of his life. Between 1893 and 1906, he gave the museum a number of paintings, mostly by English artists. After 1906, however, he established a fund for the purchase of paintings by living artists of American citizenship, and thereafter his gifts were almost exlusively American paintings. He served as a trustee of the museum from 1903 until 1913, participating on a number of committees including one which organized the 1911 Winslow Homer memorial exhibition. That same year, he established a second fund for the purchase of American paintings in memory of his son Arthur Hoppock Hearn.

On June 19, 1911, the Metropolitan's trustees, in recognition of Hearn's generosity, asked him to sit for a portrait by the artist of his choice. It was not until the spring of 1913, however, that Hearn is known to have contacted Irving Wiles. The delay may have been caused by Hearn's reluctance to sit for a portrait; for, as he confessed to Robert W. de Forest, then vice president and secretary of the museum, "I am getting too old to have my portrait painted." Evidently Hearn's doubts were assuaged by de Forest's response that he was "at just the right age for an impersonation of maturity, vigor and the aesthetic elements that make so many of Rembrandt's pictures of mature men so effective."

It is not known exactly when Wiles began the portrait, but, when Hearn died on December 1, 1913, it was not finished. Although a resolution passed by the board of trustees on December 15 asserted that Hearn's "portrait was practically completed before his death," this may not have been the case; for on December 8 Wiles had written to Curtis Bell, asking him to deliver "the photographs of Mr. Hearn," which suggests that the portrait was done mainly from photographs (I. R. Wiles to C. Bell, Dec. 8, 1913, in Albert Duveen Collection, DDU-1, Arch. Am. Art). In fact, it was April 14, 1914, before Wiles reported that the portrait would be finished "in a few days." Hearn's family seems to have visited Wiles's studio at this time to approve the portrait, which was accepted by the museum on May 18.

The painting, hardly one of Wiles's best efforts, has the appearance of an official portrait and lacks the strong brushwork and vigorous

Irving R. Wiles

quality usually apparent in his imaginative compositions. There is a disturbing contrast between the unflatteringly realistic rendition of the face and the generalized treatment of the costume and setting, another indication that Wiles painted the likeness from photographs. The formal pose, the neutral backdrop, and the elegant accessories—a Louis XV style table and a figurine of a woman, probably a muse or an allegorical representation of the arts—indicate that Wiles was simply following a formula.

Oil on canvas, 57 × 38¼ in. (144.8 × 97.2 cm.).

Signed and dated at lower right: Irving R. Wiles 1914. Inscribed on reverse: George A. Hearn / Irving R. Wiles / 1914.

REFERENCES: Board of Trustees, MMA Archives, June 19, 1911, passes resolution asking Hearn to sit for his portrait by the artist of his choice // G. A. Hearn, letter in MMA Archives, March 31, 1913, says that he has discussed the portrait and terms of the commission with Wiles but feels he is too old to sit (quoted above) // R. W. de Forest, copy of a letter to G. A. Hearn, MMA Archives, April 1, 1913, assures him that he should pose for it (quoted above) // Board of

Wiles, *George A. Hearn.*

Trustees, MMA Archives, April 21, 1913, discusses Hearn's wishes regarding the portrait and approves of the arrangements he has made // I. R. Wiles, letter in MMA Archives, Dec. 13, 1913, says that it is not yet finished // Board of Trustees, MMA Archives, Dec. 15, 1913, says that the portrait is nearly completed (quoted above) // I. R. Wiles, letter in MMA Archives, April 14, 1914, says that it is almost finished (quoted above) // B. Burroughs, copy of a letter to I. R. Wiles, May 2, 1914, in MMA Archives, says that when the portrait is completed, he should invite the Hearn family to view it and then send it to the Metropolitan for consideration // H. W. Kent, copy of a letter to I. R. Wiles, May 29, 1914, in MMA Archives, announces that it has been accepted // I. R. Wiles, letter in MMA Archives, May 30, 1914, says that he is pleased by its acceptance // *MMA Bull.* 9 (July 1914), ill. p. 157 // W. B. McCormick, *International Studio* 77 (June 1923), pp. 256 and 261, notes its "charm" and says that the artist's "genius" has saved it from being purely official // *Literary Digest* 89 (April 17, 1926), p. 99 // D. Bolger, *Arch. Am. Art Journ.* 15, no. 2 (1975), ill. p. 9.

EXHIBITED: Chapellier Gallery, New York, 1967, *Irving Ramsey Wiles, 1861–1948,* exhib. cat. by N. C. White, no. 16, ill.

Rogers Fund, 1914.
14.98.

JAMES J. SHANNON

1862–1923

James Jebusa Shannon, like his contemporary JOHN SINGER SARGENT, had great success as a portraitist in England, where he was knighted for his achievements in 1922. "His work is admirable, broad and sure, full of beauty and of character," Samuel Isham wrote, "but there is little in it that betrays the American" (*The History of American Painting* [1905; 1915], p. 427). The son of Irish immigrants, Shannon was born in Mount Auburn, New York. He was eight when his family moved to Canada and settled in Saint Catharines, Ontario, where he received his first training from a local painter named Wright. It was on his teacher's advice that he continued his studies in London, where in 1878 he entered the South Kensington School (now the Royal College of Art). Encouraged by his instructor, the successful academician Sir Edward John Poynter, Shannon studied there for three years, supporting himself with money he earned painting portraits. At the age of nineteen he was commissioned to paint a portrait of one of the queen's maids of honor, the Hon. Horatia Stopford (unlocated). This painting was well received at the Royal Academy exhibition in 1881, and by the late 1880s Shannon's reputation was established.

With such artists as JAMES MC NEILL WHISTLER and George Clausen, Shannon was a founding member in 1886 of the New English Art Club. There the exhibitions that helped spread the influence of modern French painting in England were organized. Shannon continued to paint portraits, but he also did many figure paintings, often using his wife and daughter as models. Described as "subject pieces," these were exhibited in his first one-man show at the Fine Art Society in London in 1896. The two paintings in the Metropolitan collection, decorative in treatment with colorful patterns and elaboratedly costumed figures, exemplify the new direction Shannon's work took in these years. Although his style is not unusual in Victorian English painting, it seems to have developed under the influence of GEORGE HITCHCOCK and GARI MELCHERS, with whom he often painted at Egmond, a popular artists' colony in Holland.

Several of his works from the turn of the century appear to be set in Egmond, for example, *George Hitchcock*, ca. 1897 (Telfair Academy of Arts and Sciences, Savannah) and *The Flower Girl*, 1900 (Tate Gallery, London). *The Flower Girl*, which won the Chantrey Prize in 1901, has the maternal subject matter, decorative patterns, and roughened paint surface often associated with the paintings of Melchers.

Shannon became an associate member of the Royal Academy in London in 1897; he won medals and prizes at the Carnegie International Exhibition in 1897, the Pennsylvania Academy of the Fine Arts in 1899, and the Pan-American Exposition in 1901. After 1900 he paid several visits with his family to the United States. Accepting a number of portrait commissions, he worked mostly in New York, where in 1905 he shared a studio with FRANK MILLET. Among the Americans Shannon painted, according to his daughter, were "Mrs. Rockefeller, Mrs. Unter-meyer, Mrs. Sears and her two daughters . . . and Mrs. Mellon" (K. Shannon, *For My Children* [1933], p. 118). His portrait of Catherine Marshall Gardiner, 1908 (Lauren Rogers Library and Museum of Art, Laurel, Miss.), however, is one of his few late portraits in an American public collection. He was elected an associate of the National Academy of Design in New York in 1907.

Shannon continued to enjoy success in London, where he became an academician at the Royal Academy in 1909. He belonged to the Chelsea Arts Club, the Royal Hibernian Academy, the Royal British Colonial Society of America, and served as president of the Society of Portrait Painters. Around 1914 he was injured in a fall from a horse, and thereafter he spent much of his time on a farm in Kent. He continued, however, to paint until his death. Memorial exhibitions of Shannon's work were held at the Leicester Galleries in London in 1923 and in 1924 at the Columbus Gallery of Fine Arts in Ohio and the Buffalo Fine Arts Academy, Albright Art Gallery. Many of the artist's works, such as his nudes, elaborate Victorian interiors, and his more imaginative portraits are not very well known today. Indeed, little has been written about Shannon or the development of his style.

BIBLIOGRAPHY: James Creelman, "An American Painter of the English Court," *Munsey's Magazine* 14 (Nov. 1895), pp. 129–137; excerpted in *Review of Reviews* 12 (Nov. 1895), p. 613 // Lewis Hind, "The Work of J. J. Shannon," *Studio* 8 (July 1896), pp. 66–75 // Alfred Lys Baldry, "J. J. Shannon, Painter," *Magazine of Art* 20 (Nov. 1896), pp. 1–5 // Christian Brinton, *Modern Artists* (New York, 1908), pp. 228–242. Based on two earlier articles by this author: "Shannon and Pictorial Portraiture," *Harper's Monthly Magazine* 111 (July 1905), pp. 204–213; and "A Painter of Fair Women," *Munsey's Magazine* 35 (May 1906), pp. 133–143 // Kitty Shannon, *For My Children* (London, 1933). A reminiscence by the artist's daughter.

Jungle Tales
(Contes de la Jungle)

Christian Brinton wrote that "Mr. Shannon's gallery of fair women constitutes his chief claim to recognition," but "it is, however, his wife and his daughter, Miss Kitty Shannon, whom he loves to put upon canvas, either in definite portraits or in some delightfully fanciful or decorative vein" (*Munsey's Magazine* 35 [May 1906], p. 143). *Jungle Tales*, dated 1895, shows Mrs. Shannon reading to two children, one of whom is her daughter Kitty (in profile). Kitty's white dotted swiss dress, her mother's white and lavender lace blouse, and the elaborate design of red and white flowers and a yellow bird on the brilliant blue drapery behind them create a pattern of bright, high-keyed colors. The decorative treatment of the setting and costumes contrasts noticeably with the intensely realistic

Shannon, *Jungle Tales.*

faces of the children; this feature of the painting recalls works by such symbolist painters as Gustav Klimt.

The painting was exhibited in Paris at the Exposition Universelle in 1900 as *Contes de la jungle.* This title may identify the book which has these two girls so captivated—Rudyard Kipling's *The Jungle Book,* published in 1894. For many years the painting was called *Fairy Tales.*

Oil on canvas, 34¼ × 44¾ in. (87 × 113.7 cm.).
Signed at lower left: J. J. SHANNON / 1895.
REFERENCES: L. Hind, *International Studio* 8 (July 1896), p. 68, notes it among works exhibited at the New English Art Club and calls it a "charming study of child-life" // *Magazine of Art* (March 1901), ill. p. 220, in a view of Room XXVIII, south side, British section, at the Paris Exposition // C. Brinton, *Harper's Monthly Magazine* 111 (July 1905), p. 211, says that it is "on that border-land between fact and fancy";

Modern Artists (1908), p. 239, mentions it as one of the artist's family groups // *The McCulloch Collection of Modern Art . . . Royal Academy Winter Exhibition, 1909, Special Number of the Art Journal* [1909], ill. p. 109, as Fairy Tales // Christie, Manson and Woods, London, *Catalogue of the Well-Known Collection of Modern Pictures and Water Colour Drawings of the British and Continental Schools . . . Formed by the Late George McCulloch . . . ,* sale cat., March 23, 29, 30, 1913, p. 29, no. 87, discusses it, noting that it was exhibited at the Paris Exposition // *George A. Hearn Gift to the Metropolitan Museum of Art . . .* (1913), ill. p. 117.

EXHIBITED: New English Art Club, London, 1896 (no cat.) // Universal Exposition, Paris, 1900, *Catalogue Générale Officiel,* Grand-Bretagne Group II, Classe 7, no. 232, as Contes de la jungle // Royal Academy, London, Winter 1909, no. 136, as Fairy Tales, lent by G. McCulloch.

EX COLL.: George McCulloch, London, died 1907; estate of George McCulloch, London, 1907–1913 (sale, Christie, Manson and Woods, London, May 23, 1913,

no. 87, as Fairy Tales, £420); T. Permain as agent, 1913.

Arthur Hoppock Hearn Fund, 1913.

13.143.1.

Magnolia

Dated 1899, this painting shows the artist's daughter, Kitty Shannon (1887–1974), holding a sprig of magnolia blossoms, which in Victorian literature were often a sign of the love of nature. More to the point, however, are the stylized fleur-de-lys that decorate the green backdrop. This royal heraldic insignia and the costume, with its fur-trimmed cape, embroidered dress, and elaborate jewelry, suggest a somewhat contrived presentation of the young girl as a princess. Shannon intensifies this impression with a formal pose and a composition that is almost symmetrical in arrangement. W. Stanton Howard (1921) commented on the make-believe quality of the picture:

The young girl in the trailing robe indulges in dreams of things to come. There is a questioning wonder, a note of expectancy in her face, as though she had stepped forth from fairyland and had not yet awakened to reality. The artist seems to hint [at] the longing of the child to be grown up, and, at the same time, to give expression to the longing for youth which fills those who have left it behind them.

The artist's only child, Kitty Shannon was one of his favorite models, appearing in many of his single and group figure paintings. Raised in London, where artists, actors, social and literary figures were frequent visitors in her father's studio, she later wrote several books, including an autobiography *For My Children* (1933) that discusses her early life and recollections of her father. In 1912 she became the wife of Walter Keigwen. Except for two years in Australia, the Keigwens, who had two children, made their home in England.

Oil on canvas, 71⅝ × 39¼ in. (182.2 × 99.7 cm.).

Signed and dated at lower left: J. J. SHANNON / 1899.

REFERENCES: *George A. Hearn Gift to the Metropolitan Museum of Art* . . . (1913), ill. p. 76 // W. S. Howard, *Harper's Magazine* 142 (April 1921), p. 640, discusses the picture (quoted above); ill. p. 641, shows an engraving after it by Henry Wolf // K. Shannon, *For My Children* (1933), color ill. opp. p. 32 // J. Gibbons, daughter of the subject, letters in Dept. Archives, May 27, August 12, 1977, provides biographical information on her mother.

EXHIBITED: Guildhall, London, 1900, *Catalogue of the Loan Collection of Pictures by Living British Painters*, no. 50, as Magnolia, lent by George McCulloch, notes by A. G. Temple describe it // Royal Academy, London, Winter 1909, no. 37, lent by G. McCulloch // Dayton Art Institute, Ohio, PAFA, and Los Angeles County Museum of Art, 1976–1977, *American Expatriate Painters of the Late Nineteenth Century*, exhib. cat. by M. Quick, no. 46, p. 132, identifies the subject and discusses the painting as an example of the English "Studio Style," relating it to the art nouveau movement; ill. p. 134.

EX COLL.: George McCulloch, London, died 1907; his estate, London, 1907–1913 (sale Christie, Manson and Woods, London, May 23, 1913, no. 88, as Magnolia, £756); T. Permain, as agent, 1913.

George A. Hearn Fund, 1913.

13.143.2.

Shannon, *Magnolia*.

ARTHUR B. DAVIES

1862–1928

Arthur Bowen Davies is remembered as much for his role in organizing the Armory Show in 1913 and furthering the cause of modern art as he is for his own accomplishments as a painter. He was born in Utica, New York, the son of a Welsh businessman who settled there in 1861. In 1877, having shown an early interest in art and mechanics, he received his first art training from Dwight Williams (1856–1949), a landscape painter from nearby Cazenovia. Two years later Davies's family moved to Chicago, where he worked as a clerk and studied at the Chicago Academy of Design. At the age of about nineteen, Davies joined an expedition to Mexico as a draftsman on an engineering project. He returned to Chicago by 1883 and resumed his studies there, this time under Charles A. Corwin (1857–1938). He supported himself by working on a number of projects, for example, painting billboards and a panorama.

Davies settled in New York in 1885 or 1886. He attended classes at the Art Students League and the Gotham Art Students. In 1887 his illustrations began to appear in magazines like the *Century* and *St. Nicholas*. The first public exhibition in which he participated was held at the American Art Galleries in New York in 1888. In 1890 Davies began to show his work at the National Academy of Design. Around this time he met Lucy Virginia Meriwether Davis, a physician, whom he married in 1892. The couple took up farming in rural Congers, New York, soon after. Davies continued to paint and worked in a studio in nearby Rockland Lake Village. By 1893, however, he was back in New York and commuting to see his family on weekends. The art dealer William Macbeth did much to encourage him and arranged for Benjamin Altman to finance Davies's first trip to Europe in 1893. He spent much of his time in Holland, where he admired the old masters as well as contemporary artists like the Maris brothers. After brief stops in Paris and London, Davies returned home. At this time, he experimented with lithography and worked on a design for a mural, later rejected, for the New York Appellate Court House. His first one-man show was held at the Macbeth Gallery in 1896, and thereafter his work was featured there often. (There were major exhibitions in 1897, 1901, 1905, 1909, and 1918.) Davies made a second trip to Europe in 1897, visiting England, Holland, Germany, and Italy. Throughout the 1890s he produced fairly conventional landscapes like *Along the Erie Canal*, 1890 (Phillips Collection, Washington, D.C.). Although more realistic than his later works, the early paintings are consciously stylized. By the end of the decade, however, Davies was also painting less conventional, imaginative figure subjects like *Athlete and Dancer* (q.v.).

The artist continued to divide his time between his studio in the city and the farm upstate, but after 1900 his relationship with his wife deteriorated. He traveled a great deal during this period, visiting Newport and Newfoundland in 1900; Ashfield, Massachusetts, in 1902; and Utica and Cazenovia, New York, in 1904. He made a trip west in 1905, and the open western landscape had a profound influence on the subjects and compositions of his paintings. At this time Davies began to live in New York with Edna Potter, a model. The couple had a child and Davies used a pseudonym; he kept his second family a secret throughout his life. Increas-

ingly interested in new developments in art, he was a friend of many progressive young painters in New York like Marsden Hartley (1877–1943) and Rockwell Kent (1882–1971). He advised the collector Lizzie P. Bliss, whose important collection of post-impressionist paintings is now in the Museum of Modern Art, New York, on what to buy. Although Davies's work was not characteristic of the urban realism championed by most members of the group known as the Eight, he participated in its controversial exhibition at the Macbeth Gallery in 1908. At this time he was painting idealized subjects, such as visions and dreams. Stylized paintings, often of nudes in landscape settings, represented increasingly obscure themes, their content and titles often suggesting mythological or literary interpretations. Davies developed a sensitive, highly individual style. His work is often compared to the decorative paintings of Pierre Puvis de Chavannes, and his paintings like *Unicorns* (q.v.) are best understood in the context of the symbolist movement.

Davies traveled in Greece and Italy in 1910 and 1911 and studied ancient art, which had a strong influence on him. The painter Marsden Hartley (1877–1943) wrote of Davies's paintings: "the color is mostly Greek, and the line is Greek." He then went on to compare him to ALBERT PINKHAM RYDER and Odilon Redon:

He is first of all the poet-painter in the sense that Albert Ryder is a painter for those with a fine comprehension of the imagination. Precisely as Redon is an artist for artists, . . . he too, satisfies the instinct for legend, for transformation In the work of Davies, and of Redon, there is the splendid silence of a world completed by themselves, a world for the reflection of self. There is even a kind of narcissian arrogance, the enchantment of the illumined face (*Touchstone* 6 [Feb. 1920], pp. 278–283).

In 1911 Davies became president of the Association of American Painters and Sculptors. In 1913, with Walter Pach (1883–1958), he helped select works for, and organize, the International Exhibition of Modern Art, better known as the Armory Show. It was at Davies's instigation that the exhibition was expanded to include the most recent European art. Between 1914 and 1917, Davies himself worked in a cubist-inspired style drawn largely from the synchronist paintings of Morgan Russell (1886–1953) and Stanton Macdonald-Wright (1890–1973). *Day of Good Fortune* (Whitney Museum of American Art, New York) is typical of these in its use of rhythmic lines and geometric areas of color set against a flat background. Here, as before, however, he remained tied to a representational subject. Around this time Davies also worked as a sculptor, producing about eighty works in a variety of styles and material, including bronze and wood. During the final decade of his life, he returned to the romantic style of his earlier work—painting primarily Arcadian landscapes and elegant figure subjects, which were influenced by the theory of "inhalation," that is, showing figures with held breath. Between 1917 and 1924 Davies worked as a printmaker. In the latter year, he began to divide his time between New York and Europe, first Paris and then Florence. He worked extensively in watercolor and supervised the weaving of his tapestry designs at Gobelins. He died of a heart attack in Florence in 1928, and two years later the Metropolitan Museum held a memorial exhibition of his work.

BIBLIOGRAPHY: Phillips Memorial Gallery, Washington, D.C., *Arthur B. Davies: Essays on the Man and His Art* (Cambridge, Mass., 1924), includes essays by Duncan Phillips, Dwight Williams, Royal Cortissoz, Frank Jewett Mather, Jr., Edward W. Root, and Gustavus A. Eisen and contains many illustrations of the artist's work // Royal Cortissoz, *Arthur B. Davies* (New York, 1931). A volume in the

American Artists Series published by the Whitney Museum of American Art, it includes a biographical note, bibliography, illustrations, and a list of the artist's known paintings compiled by his wife // *Index of Twentieth Century Artists* 4 (Feb. 1937), pp. 385–400. Reprint ed. with cumulative index. New York: Arno Press, 1970, pp. 679–694. Contains the most complete bibliography available on the artist to that date and lists awards and honors, affiliations, and paintings in public collections // Munson-Williams-Proctor Institute, Utica, N.Y., *Arthur B. Davies [1862–1928]: A Centennial Exhibition* (1962), cat. for a traveling exhibition with a recollection by Walter Pach and an introduction by Harris K. Prior // Brooks Wright, *The Artist and the Unicorn: The Lives of Arthur B. Davies (1862–1928)* (New City, N.Y., 1978) is a full-length biography of the artist.

Athlete and Dancer

Davies probably painted this work between 1895, after his first trip to Europe, and 1897, when it was included in his one-man show at the Macbeth Gallery. The picture is one of contrasting elements in which the lithe grace of a female dancer is opposed to the resolute strength of a male athlete. In paintings such as this Davies's work took a new direction not only in the imaginative, interpretive subject matter and idealized figure style but in technique as well. Working on a small canvas, he painted in rich colors, applied thickly in pronounced brushstrokes that created a tactile surface. Contemporaries attributed this new approach to the influence of such French painters as Adolphe Monticelli. It is just as likely, however, that he was influenced by an admirer of Monticelli, ALBERT PINKHAM RYDER, whom Davies knew and whose works he liked.

Oil on canvas, 17 × 22 in. (43.2 × 55.9 cm.).
Signed at lower center: ABDavies.
REFERENCES: *Critic*, n.s. 27 (May 8, 1897), p. 328, discusses the painting in a review of Macbeth exhibition, noting that Davies "contrasts a robust male figure, nude, with a lithe and graceful female figure, clad in fluttering draperies" // R. Cortissoz, *Arthur B. Davies* (1931), p. 21, includes it in a list of Davies's

Davies, *Athelete and Dancer.*

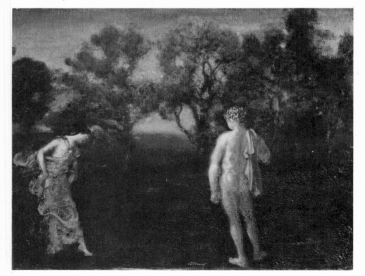

paintings compiled by his wife, dates it 1897, and gives Pratt as owner.
EXHIBITED: Gallery of William Macbeth, 1897, *Exhibition of Paintings by Arthur B. Davies*, no. 1, as Athlete and Dancer.
EX COLL.: George D. Pratt, New York, by 1931–1935; Mrs. George D. Pratt, New York, life interest until 1948, when relinquished.
Bequest of George D. Pratt, 1935.
48.149.11.

Visions of the Sea

Visions of the Sea, painted by Davies around 1904, focuses on the world of the child, a favorite theme of his at the turn of the century. He shows a boy seemingly lost in thought. The landscape may be real or imaginary, for it is not clear whether the child actually inhabits or imagines his surroundings. In explaining Davies's approach to art Royal Cortissoz wrote: "There is fantasy to be encountered in his earlier work . . . especially . . . the phase of that work which points to his sympathy for maternity and childhood" (*Scribner's Magazine* 80 [Sept. 1926], p. 350).

Oil on canvas, 23 × 28 in. (58.4 × 71.1 cm.).
Signed at lower right: A·B·Davies.
REFERENCES: *Literary Digest* 100 (Jan. 19, 1929), ill. p. 22, as The Boy and the Sea, courtesy of Macbeth Gallery and calls it "sweeping and so noble in the expression of an attitude" // R. Cortissoz, *Arthur B. Davies* (1931), p. 35, includes it as Visions of the Sea in a list of the artist's known paintings compiled by his wife, dates it 1904, and gives owner as Mrs. Meredith Hare // Disposition card, Macbeth Gallery Papers, Arch. Am. Art, notes that it was received by Macbeth from Mrs. Hare in 1942 and sold to Miss de Groot in 1949.
EXHIBITED: PAFA, 1908, *An Exhibition of Paintings by Arthur B. Davies, William J. Glackens, Robert Henri, Ernest Lawson, George Luks, Maurice B. Prendergast, Everett Shinn, John Sloan*, no. 60, as Visions of the Sea // Brooklyn Museum; Carnegie Institute, Pittsburgh; and Worcester Art Museum, 1943–1944, *The Eight,*

no. 84, lent by Mrs. Meredith Hare, courtesy of Macbeth Gallery, dates it ca. 1904; ill. p. 38 // Wadsworth Atheneum, Hartford, 1950, *The Adelaide Milton de Groot Loan Collection* (no cat.) // Columbus Gallery of Fine Arts, Ohio, 1958, *Masterpieces from the Adelaide Milton de Groot Collection*, no. 4, as Visions of the Sea.

ON DEPOSIT: Wadsworth Atheneum, Hartford, 1949–1956, lent by Adelaide Milton de Groot // MMA, 1956–1967, lent by Adelaide Milton de Groot.

EX COLL.: Mrs. Meredith Hare, New York, by 1931–1942; with Macbeth Gallery, New York, 1942–1949; Adelaide Milton de Groot, New York, 1949–1967.

Bequest of Miss Adelaide Milton de Groot (1876–1967), 1967.

67.187.149.

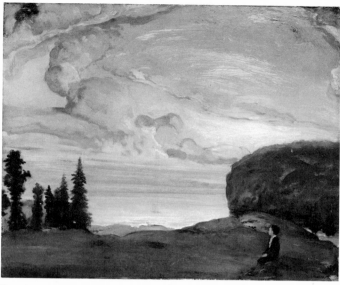

Davies, *Visions of the Sea.*

Unicorns
(Legend—Sea Calm)

Unicorns, which was originally entitled *Legend—Sea Calm*, was painted about 1906 and is probably Davies's most famous painting. It shows two women and four unicorns in a tranquil seaside landscape. The nude woman at the right appears to be offering a sprig of leaves to the approaching unicorns. The standard mythology that the unicorn will only approach a virgin does not seem central to Davies's theme in this picture. The impression that he was striving for may be best indicated by the early title, but his intent is not very clear. The critic James Gibbons Huneker, who was a friend and supporter of Davies, wrote an essay "In Praise of Unicorns," which may have appeared as early as 1906 (published in *Unicorns* [New York, 1917]). Unfortunately it is not clear which was done first, Davies's painting or Huneker's essay (Davies did own the book. See Anderson Galleries, New York, *The Library of Arthur B. Davies*, sale cat., Oct. 5, 1926, no. 136). Huneker, who was the leading spokesman for the symbolist movement in America and promoted the form of aestheticism that Davies's followed, offers a key to understanding the artist's mood in this picture when he writes:

With Unicorns we feel the nostalgia of the infinite, the sorcery of dolls, the salt of sex, the vertigo of them that skirt the edge of perilous ravines, or straddle the rim of finer issues. He dwells in equivocal twilights; and he can stare the sun out of countenance" (*Unicorns* [New York, 1917], pp. 3–4).

Huneker saw the unicorn as an advocate of the ideal and symbolic, the adversary of the lion whom he dubbed "a realist born." More important, he looked forward to a time when they would be united, "Strength and beauty should represent the fusion of the Ideal and the Real" (ibid., p. 4). There can be little doubt that Davies shared this view. Indeed Huneker's essay was used as the introductory statement to the catalogue of Davies's 1918 retrospective exhibition at the Macbeth Gallery.

It is difficult to isolate a single visual source for the painting. The extremely thin paint application and striking horizontal format, emphasized by the flat horizon and the long narrow piece of land in the distance, recall certain decorative paintings done by ALBERT PINKHAM RYDER, for example *Smugglers' Cove* (q.v.). Like Ryder, whom he admired, Davies may have been influenced by the work of the Italian quattrocento painter Piero di Cosimo, two of whose paintings entered the Metropolitan Museum's collection in 1875. Davies's landscape, painted in broad areas of flat color, and the contrived arrangement of nude and clothed figures also recall, in a general way, the paintings of Pierre Puvis de Chavannes. Then too the influence of oriental art is felt strongly in the timeless mood of the painting. The careful balancing of empty areas of water and sky with decorative details and the delicate paint application—largely thin washes of color with the mountains darkly edged—resemble Chinese handscroll paintings. Concerning Davies's interest in oriental art, the collector Abel W. Bahr wrote:

Arthur B. Davies

His deep interest in my field of work, Chinese art, brought us very close together in our mutual enjoyment. He shared the spirit and observation of the great Chinese tradition and understood the eloquence of empty space. In his work is so much of lyric romance, imagination, sensitive harmony of color, deep poetic passion (Gallery of Mrs. Cornelius J. Sullivan, New York, *Exhibition of Early and Middle Periods of the Work of Arthur B. Davies* [1939], unpaged cat.).

Although not shown in New York in 1908, the painting was included in the traveling segments of the exhibition of the Eight; it was bequeathed to the museum by Lizzie P. Bliss, one of the most avid collectors of Davies's work.

Oil on canvas, 18¼ × 40¼ in. (46.4 × 102.2 cm.).
Signed at lower left: A.B.Davies
REFERENCES: Disposition card, Macbeth Gallery Papers, Arch. Am. Art, notes that it was received as "Legend—sea calm" from Alexander Morten on March 9, 1917, and sold to Miss Bliss on March 10, 1917 // R. Cortissoz, *New York Tribune*, Jan. 6, 1918, part 3, ill. p. 3, discusses it in a review of an exhibition at Macbeth's and says that it relates to work by Piero di Cosimo // *American Art News* 16 (Jan. 12, 1918), ill. p. 3 // *Literary Digest* 56 (Jan. 26, 1918), p. 23; ill. p. 24 // *Current Opinion* 64 (March 1918), ill. p. 205 // H. Tyrrell, *International Studio* 72 (Feb. 1921), p. cxxvii, calls it "symbolistic" // F. N. Price, *International Studio* 75 (June 1922), p. 218 // R. Cortissoz, *American Artists* (1923), pp. 103–104, discusses and compares it to Piero di Cosimo and Puvis de Chavannes // *Arthur B. Davies: Essays on the Man and His Art* (1924), pp. 10, 15, D. Phillips discusses it; p. 41, R. Cortissoz discusses it; p. 62, E. W. Root, mentions it; unpaged ill. // *Vanity Fair* 22 (May 1924), ill. p. 66 // R. Cortissoz, *Scribner's Magazine* 80 (Sept. 1926), ill. p. 346; p. 351, mentions it // J. MacD[onald], *Bulletin of the Art Institute of Chicago* 20 (Dec. 1926), p. 122, discusses it // *Art News* 27 (April 27, 1929), sec. 1, p. 72 // V. N., *International Studio* 94 (Dec. 1929), p. 98, mentions it in a review of an exhibition at Ferargil Galleries // L. Burroughs, *MMA Bull.* 25 (Feb. 1930), ill. p. 32, in a discussion of the memorial exhibition // *Art News* 28 (Feb. 22, 1930), ill. p. 8 // *Art Digest* 4 (March 1, 1930), ill. p. 16, quotes H. McBride in the *Sun* // *Literary Digest* 104 (March 29, 1930), ill. p. 21 // R. Cortissoz, *Arthur B. Davies* (1931), pp. 9–10, discusses it; p. 35, includes it in a list of the artist's works compiled by his wife and dates it 1906; ill. p. 55 // B. Burroughs, *Creative Art* 8 (Feb. 1931), ill. p. 98 // G. P. du Bois, *Arts* 17 (June 1931), p. 609, mentions it in a discussion of the Bliss collection then on view at the Museum of Modern Art // F. Thompson, *Commonweal* 14 (July 29, 1931), p. 319, mentions it in exhibition held at the Museum of Modern Art // B. Burroughs, *MMA Bull.* 26 (Nov. 1931), p. 261, mentions it as part of the Bliss bequest; pp. 261–262, says that it was included in the 1920 Fiftieth Anniversary exhibition; ill. p. 263 // G. H., *Bulletin of the Memorial Art Gallery Rochester* 4 (Dec. 1931), p. 6, quotes E. L. Cary's comments // *Index of Twentieth Century Artists* 4 (Feb. 1937), p. 399, lists reproductions // H. Saint-Gaudens, *Carnegie Magazine* 14 (Oct. 1940), ill. p. 143 // *Syracuse Museum of Fine Arts Quarterly Bulletin* 8 (April–June, 1947), p. 11, quotes a poem about it by Louis How // F. Watson, *Magazine of Art* 45 (Dec. 1952), ill. p. 367 // L. Campbell, *Art News* 61 (Oct. 1962), ill. p. 41, calls it his "most famous work"; p. 43, dates it about 1906, compares style to Maxfield Parrish and says it might have been inspired by Böcklin's *Isle of the Dead* // M. L. d'Otrange-Mastai, *Connoisseur* 152 (Jan. 1963), p. 68 // A. T. Gardner, *Antiques* 87 (April 1965), ill. p. 437 // B. Wright, *The Artist and the Unicorn* (1978), p. 36, suggests that Böcklin's Isle of the Dead influenced it; ill. opp. p. 56; pp. 115–118, discusses connection to Huneker's essay and possibility that the two women may represent Davies's wife and mistress.

EXHIBITED: Art Institute of Chicago; Toledo Museum of Art; Detroit Museum of Art, 1908, *Paintings by Eight American Artists Resident in New York and Boston*, no. 3, as Legend—sea calm // Cincinnati Museum, 1909, *Special Exhibition of the Work of Eight American Artists*, no. 3 // Carnegie Institute, Pittsburgh, 1909, *Catalogue of Paintings by Eight American Artists*, no. 3 // Women's Cosmopolitan Club, New York, 1911–1912, *Catalogue of a Loan Collection of Paintings by Arthur B. Davies*, no. 6, as The Unicorns, lent by Alexander Morten // Macbeth Galleries, New York, 1918, *Loan Exhibition of Paintings, Watercolors, Drawings, Etchings & Sculpture by Arthur B. Davies*, no. 40, as Unicorns, includes the essay by J. G. Huneker "In Praise of Unicorns" // Brooklyn Museum, 1926, *Modern French and American Painters* (no cat.), lent by Lizzie P. Bliss // MMA, 1930, *Catalogue of a Memorial Exhibition of the Works of Arthur B. Davies*, cat. by B. Burroughs, ill. no. 62, as Unicorns, lent anonymously // Museum of Modern Art, New York, 1931, *Memorial Exhibition: The Collection of the Late Miss Lizzie P. Bliss, Vice-President of the Museum*, no. 35, as The Unicorns, bequeathed to the MMA, unpaged ill. // Carnegie Institute, Pittsburgh, 1940, *Survey of American Painting*, no. 231, pl. 83 // Munson-Williams-Proctor Institute, Utica; Whitney Museum of American Art, New York; Memorial Art Gallery, University of Rochester, N.Y.; Virginia Museum of Fine Arts, Richmond; Cincinnati Art Museum; City Art Museum of St. Louis; MFA, Boston, 1962–1963, *Arthur B. Davies, 1862–1928*, exhib. cat. by H. K. Prior, ill. no. 25, dates it 1906 // MMA and American Federation of Arts, traveling exhibition, 1975–1976, *The Heritage of American Art*, entry by M. Davis, no. 87, ill. p. 193, discusses it; (rev. ed., 1977), no. 89, ill. p. 197 // Museum of Modern Art, New York, 1976, *The Natural Paradise*, exhib. cat. ed. by K. McShine, essay by R. Rosenblum, ill. p. 24, discusses it and calls Davies's landscapes "ideally harmonious and unpolluted."

Davies, *Unicorns.*

Davies, *Girdle of Ares*.

Ex COLL.: Alexander Morten, 1911–1917; with Macbeth Galleries, New York, 1917; Lizzie P. Bliss, New York, 1917—died 1931.

Bequest of Lizzie P. Bliss, 1931.

31.67.12.

Girdle of Ares

The picture shows a frieze of men battling in a landscape where dark mountains rise beneath an eerie sky. Begun by 1908, it is one of many compositions in which Davies placed figures in active poses, dancing or moving through a landscape. As in many of his works he drew his subject from classical mythology. Ares, an impetuous lover and instigator of violence, is the Greek god of war.

James Gibbons Huneker, writing in 1908, saw the conflict in *Girdle of Ares* as possibly a fight between the forces of good and evil and called it "a symbolic picture of unearthly hues in which the struggle for life is shown."

Both the subject and composition of the painting owe something to Davies's study of Italian Renaissance art. Royal Cortissoz called him "a modern Piero di Cosimo, a child of the Renaissance out of his time," and noted that like Piero, "the precise imaginative meaning of the work is of less importance than the vague, pervasive sense of mythical romance and beauty" (*New York Tribune*, Jan. 6, 1918, part 3, p. 3). Davies probably knew Piero's *A Hunting Scene* and *The Return from the Hunt*, 1505–1507, both of which entered the Metropolitan Museum's collection

in 1875. Then, too, the artist was undoubtedly familiar with a number of similar subjects, for example, Antonio Pollaiuolo's engraving *The Battle of the Ten Nudes*, 1471–1472, which also could have inspired his treatment of the struggling men, each figure carefully related to the group by pose and gesture.

Davies's painting style, however, lacks the finish and detail of the Italian works he admired. The mountains and sky are thinly painted in delicately colored washes that barely suggest form and distance. The treatment of the figures is similar to that in his drawings and watercolors, in which the outlines are filled with rough patches of color and faces and hands are only summarily represented.

The painting was unfinished when it was shown at the exhibition of the Eight at the Macbeth Gallery in 1908 and traveled with this exhibition for over a year. It was returned to the artist and completed sometime before its acquisition by the museum in 1914.

Oil on canvas, 26 × 40⅛ in. (66 × 101.9 cm.).

Signed at lower left: A·B·DAVIES.

REFERENCES: *New York Times*, Feb. 6, 1908, p. 6, lists it in a review of the Macbeth exhibition // W. B. McC[ormick], *New York Press*, Feb. 9, 1908, sec. 2, p. 6, in a review of the Macbeth exhibition, says it was developed on the artist's trip to California and depicts "a California bay, with its down-sweeping mountains," and that the men are "sons of the Greek god of war" // J. G. Huneker, *New York Sun*, Feb. 10, 1908, p. 6, in a review of the Macbeth exhibition, discusses it (quoted above); June 4, 1908, p. 6, says that he "saw the designs for Davies's exhibited but unfinished work, The

Girdle of Ares"; *The Pathos of Distance* (1913), p. 121 // Macbeth Gallery, New York, copy of a financial statement to the artist, April 1, 1914, Macbeth Gallery Papers, NMc37, Arch. Am. Art, notes sale and price // *MMA Bull.* 9 (March 1914), p. 76; ill. p. 79 // H. Tyrrell, *International Studio* 72 (Feb. 1921), p. cxxvii // *Arthur B. Davies: Essays on the Man and His Art* (1924), essay by E. W. Root, p. 63 and unpaged ill. // C. B. Ely, *Modern Tendencies in American Painting* (1925), p. 80, discusses it // [Macbeth Gallery] *Art Notes* no. 85 (June 1927), p. 1515 // R. Cortissoz, *Arthur B. Davies* (1931), p. 25, includes it in a list of the artist's works compiled by his wife and dates it 1910 // *Index of Twentieth Century Artists* 4 (Feb. 1937), p. 394, lists reproductions of it.

EXHIBITED: Macbeth Galleries, New York, 1908, *Exhibition of Paintings by Arthur B. Davies, William J. Glackens, Robert Henri, Ernest Lawson, George Luks, Maurice B. Prendergast, Everett Shinn, John Sloan*, no. 63, as Girdle of Ares // PAFA, 1908, *An Exhibition of Paintings by Arthur B. Davies, William J. Glackens, Robert Henri, Ernest Lawson, George Luks, Maurice B. Prendergast, Everett Shinn, John Sloan*, no. 62 // Art Institute of Chicago, Toledo Museum of Art, Detroit Museum of Art, 1908, *Paintings by Eight American Artists Resident in New York and Boston*, no. 2 // Cincinnati Art Museum, 1909, *Special Exhibition of the Work of Eight American Artists*, no. 2 // Carnegie Institute, Pittsburgh, 1909, *Catalogue of an Exhibition of Paintings by Eight American Artists*, no. 2.

EX COLL.: the artist, New York, 1908–1914; with Macbeth Galleries, New York, as agent, 1914.

George A. Hearn Fund, 1914.

14.17.

A Measure of Dreams

The picture was painted by 1908 when it was discussed in the *New York Sun*. Silhouetted against a broadly painted landscape, a woman is seen leaning forward with one hand raised in a tentative, groping gesture, not unlike a sleep-walker. She is almost rooted in her central position. In a rather unconventional manner, Davies has immobilized her further by cropping the composition at her ankles. George Meredith's poem "A Faith on Trial," first associated with the painting in 1921, describes just such a woman "earth-rooted alive" and calls her "Huntress of things worth pursuit / Of souls; in our naming, dreams" (*Poems* [1903], p. 360).

Placed close to the picture plane, the woman divides the landscape setting in half. Behind her on the right is a fairly conventional view of a river or a lake, and before her on the left is a dream-like landscape cast in murky gray shadow. Oblivious to her surroundings, the woman has

been described as passing from a waking to a sleeping state with the real world behind her and a dream world ahead.

In 1908 the art critic James Gibbons Huneker described the picture:

One woman of noble contour walks as in a dream through a delicious landscape. She has come from a dream and is crossing the bridge of transition; soon she shall be enveloped in the splendors and terrors of a new dream. She is ever in motion. Is she the ideal that haunts the artist's soul? We have the sense of something vanishing, like music overheard in sleep.

Whatever the precise state of consciousness depicted, the painting is a visual record of the artist's interest in dreams, which was aroused not only by his study of psychology but also by his familiarity with the works of such symbolists as Odilon Redon. Upon waking, Davies sometimes recorded his dreams in notes and sketches and then hung them in his studio where he later developed them in his paintings. "Art is nature seen through the prism of an emotion," he once wrote in some undated notes.

And it is not the way you string things together, either, but the feelings that go with them that makes them of value . . . These transitions of emotion—this flower of the consciousness is not . . . to be felt under cool examination but as in a sleep—a dream or an intoxication (quoted in Wright [1978], p. 112).

For Davies, the imagination was liberated in sleep, and thus it is not surprising that many of his paintings depict dreams or dreamers.

Here, as in other of his paintings done around this time, he seems to have been influenced by photography. The forward motion of the figure is instantaneously frozen, and the body has been cropped. Then, too, the use of photographic focus would explain the strong contrast between the crisp treatment of the figure and the blurred landscape. Furthermore, Davies's composition, in which the landscape setting accentuates and enhances the outline of the figure, parallels that in photographs of similar subjects by Anne W. Bridgman, who was exhibiting in New York by 1905 (see W. Naef, *Fifty Pioneers of Modern Photography* [1978], pp. 278–285).

Oil on canvas, 18 × 30 in. (45.7 × 76.2 cm.).
Signed at lower left: A·B·Davies
REFERENCES: [J. G. Huneker], *New York Sun*, June 4, 1908, p. 6, discusses it (quoted above) // *MMA Bull.* 4 (July 1909), ill. p. 113, discusses it // J. G. Huneker, *The Pathos of Distance* (1913), pp. 120–121, discusses it // Macbeth Gallery, New York, *Paintings by American Artists* (1914), ill. p. 24, as A Dream // J.

Cournos, *Forum* 41 (May 1914), pp. 771–772, discusses it // D. Phillips, *Art and Archaeology* 4 (Sept. 1916), ill. p. 171 // G. P. duBois, *Arts and Decoration* 7 (Oct. 1917), p. 539, cites it as an example of Davies's early work with "an idealized single figure or two" // L. M. Bryant, *American Pictures and Their Painters* (1921), pp. 220–221, discusses it, saying that the theme is taken from Meredith's poem; ill. opp. p. 220 // *Arthur B. Davies* (1924), essay by D. Phillips, p. 22, describes the setting as "Pale waters and shadowy shores of the subconscious land"; unpaged ill. // C. B. Ely, *The Modern Tendency in American Painting* (1925), p. 80, discusses it // [Macbeth Gallery] *Art Notes*, no. 85 (June 1927), p. 1515 // V. N., *International Studio* 94 (Dec. 1929), p. 98 // R. Cortissoz, *Arthur B. Davies* (1931), p. 29, includes it in a list of known works compiled by the artist's wife and misdates it 1910 // E. Neuhaus, *The History & Ideals of American Art* (1931), ill. p. 344 // *Index of Twentieth Century Artists* 4 (Feb. 1937), pp. 393–394, lists reproductions of it // L. Campbell, *Art News* 61 (Oct. 1962), ill. p. 41 // W. H. Gerdts, *The Great American Nude* (1974), p. 157, discusses it; ill. p. 158 // B. Wright, *The Artist and the Unicorn* (1978), pp. 114–115, discusses Davies's treatment of the dream theme and says that the landscape on the right resembles the area of the Hudson River near Davies's home.

EXHIBITED: Macbeth Gallery, New York, 1909, *Catalogue of Paintings by Arthur B. Davies*, no. 29, as A Measure of Dreams // Munson-Williams-Proctor Institute, Utica, N.Y.; Whitney Museum of American Art, New York; Memorial Art Gallery, University of Rochester, New York; Virginia Museum of Fine Arts, Richmond; Cincinnati Art Museum; City Art Museum of St. Louis; MFA, Boston, 1962–1963, *Arthur B. Davies (1862–1928)*, ill. no. 26, as Dream // MMA, 1965 *American Painting in the 20th Century*, exhib. cat. by H. Geldzahler, p. 33, gives Meredith poem "A Faith on Trial" as literary source for the painting // New York Cultural Center; Minneapolis Institute of Arts; University of Houston Fine Art Center, 1975, *Three Centuries of the American Nude*, no. 60, dates it 1908.

EX COLL.: with Macbeth Gallery, New York, 1909; George A. Hearn, New York, 1909.

Gift of George A. Hearn, 1909.

09.72.4.

Artemis

The painting was completed by 1909, when it was included in an exhibition of Davies's work at the Macbeth Gallery. It depicts Artemis, the Greek goddess of hunting and childbirth who was first associated only with wild nature. She is the precurser of the Roman goddess Diana. Here she is shown in a somewhat tame setting with horses grazing in the middle distance. On her right she

is flanked by a fawn and on the left by a stag. The latter may refer to the hunter Actaeon, who was changed into a stag after he surprised the goddess bathing.

Like the figure in *A Measure of Dreams* (q.v.), Artemis's legs are cropped at the ankles, and she appears to be rooted in the center of the composition. The centrality and careful balance of the composition lend an air of quiet repose to the painting. Marsden Hartley (1877–1943) claimed that in Davies's paintings, "often you have the sensation of looking through a Renaissance window upon a Greek world—a world of Platonic verities in calm relation with each other" (*Touchstone* 6 [Feb. 1920], p. 277). Indeed the meticulous finish and use of color in this work owe much to Davies's study of Italian Renaissance art.

Oil on canvas, $16\frac{1}{8} \times 13\frac{1}{8}$ in. (41×33.3 cm.).

Signed at lower left: A·B·Davies.

REFERENCES: R. Cortissoz, *Arthur B. Davies* (1931), p. 20, includes it in a list of the artist's paintings compiled by his wife, dates it 1910 // Parke-Bernet Galleries, New York, *Furnishings of the Helen Hay Whitney Residence*, sale cat. (1946), p. 65, no. 357, dates it 1910 and provides provenance // Mrs. McLaughlin, secretary to J. W. Payson, letter in Dept. Archives, Nov. 23, 1976, provides provenance and exhibition record.

EXHIBITED: Macbeth Gallery, New York, 1909, *Catalogue of Paintings by Arthur B. Davies*, no. 6 // Women's Cosmopolitan Club, New York, 1911–1912, *Catalogue of a Loan Collection of Paintings by Arthur B. Davies*, no. 4, lent by Mrs. Payne Whitney // William A. Farnsworth Library and Art Museum, Rockland, Me., 1964, *Paintings to Live with from the Collection of Mr. and Mrs. Charles Shipman Payson*, no. 4.

EX COLL.: with Macbeth Gallery, New York, 1909; Mrs. Payne Whitney, New York, by 1911 (Parke-Bernet Galleries, Inc., New York, February 7, 1946, no. 357, $200); Mr. and Mrs. Charles Shipman Payson, New York, 1946–1975.

Bequest of Joan Whitney Payson, 1975.

1976.201.5.

Adventure

The painting is undated but was probably done by 1914 when a drawing for it was sold at the Macbeth Gallery. The mysterious setting and the primitive-looking figures in loincloths are typical of Davies's imaginary scenes. When the painting was exhibited in 1918, one critic offered this romantic interpretation of it: "Against a hilly background of great beauty two figures pause, wistfully, in wan delight ere they

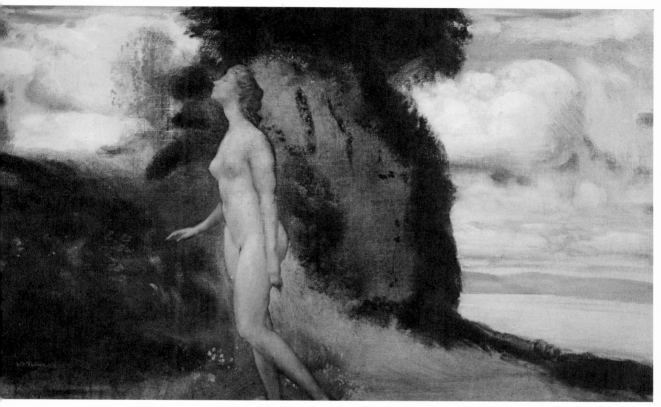

Davies, *A Measure of Dreams*.

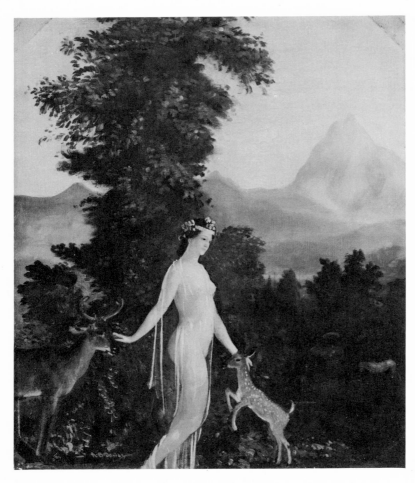

Davies, *Artemis.*

Davies, *Adventure.*

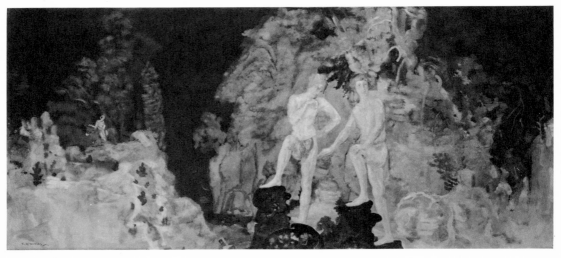

advance again into the land of adventure, where a figure shines, luring them on to a dream of freedom."

In this painting, as in *Unicorns* (q.v.), Davies selected a long horizontal format. The paint application in *Adventure*, however, is less uniform. The brushwork in the mountains varies from delicate stains to drily brushed areas of impasto. Against a flat background, Davies has created a decorative effect, uniting the figures and the setting in a rich pattern of color.

Oil on canvas, 18⅛ × 30⅛ in. (46 × 76.5 cm.).

Signed at lower left: A·B·DAVIES.

REFERENCES: Macbeth Gallery, copy of a statement to the artist, May 6, 1915, Macbeth Gallery Papers, NMc37, Arch. Am. Art, mentions the sale of a drawing for it on November 30, 1914 // G. P. [du] B[ois], *Arts and Decoration* 8 (Jan. 1918), p. 113, discusses it in a review of an exhibition held at the Macbeth Gallery // Q. R., *Christian Science Monitor*, Jan. 14, 1918, p. 16, discusses it (quoted above) // *Arthur B. Davies: Essays on the Man and His Art* (1924), unpaged ill., lists Miss L. P. Bliss as owner // *New York Sun*, May 16, 1931, p. 12, mentions it in a review of an exhibition of Miss Bliss's collection at the Museum of Modern Art // R. Cortissoz, *Arthur B. Davies* (1931), p. 20, includes it in a list of the artist's known paintings compiled by his wife // B. Burroughs, *MMA Bull.* 26 (Nov. 1931), ill. p. 261, discusses it // *Index of Twentieth Century Artists* 4 (Feb. 1937), p. 391, lists reproductions of it.

EXHIBITED: Macbeth Galleries, New York, 1918, *Loan Exhibition of Paintings, Watercolors, Drawings, Etchings and Sculpture by Arthur B. Davies*, no. 30, unpaged ill. // MMA, 1920, *Fiftieth Anniversary Exhibition*, p. 10, lent by Miss Lizzie P. Bliss // Brooklyn Museum, 1926, *Modern French and American Painters* (no cat.) // MMA, 1930, *Catalogue of a Memorial Exhibition of the Works of Arthur B. Davies*, cat. by B. Burroughs, ill. no. 99, lent anonymously // Corcoran Gallery of Art, Washington, D.C., 1930, *Special Memorial Exhibition of Works by the Late Arthur B. Davies*, no. 58, lent anonymously // Museum of Modern Art, New York, 1931, *Memorial Exhibition: The Collection of the Late Miss Lizzie P. Bliss*, no. 38, as bequeathed to the MMA // Munson-Williams-Proctor Institute, Utica, N.Y.; Whitney Museum of American Art, New York; Memorial Art Gallery, University of Rochester, N.Y.; Virginia Museum of Fine Arts, Richmond; Cincinnati Art Museum; City Art Museum of St. Louis; Museum of Fine Arts, Boston, 1962–1963, *Arthur B. Davies (1862–1928): A Centennial Exhibition*, no. 29.

EX COLL.: Lizzie P. Bliss, New York, by 1920—died 1931.

Bequest of Lizzie P. Bliss, 1931.

31.67.13.

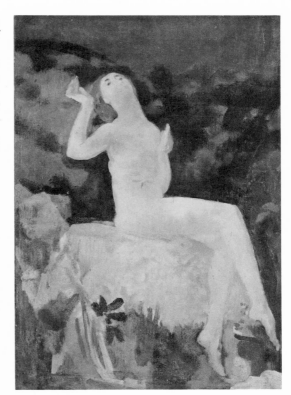

Davies, *Exaltation.*

Exaltation

In this undated painting, as in much of Davies's work, the artist's meaning is not completely clear. The picture can be seen as an attempt to express an emotional state by means of a representational mode. The solitary woman beneath a still and starry sky conveys something of the splendor, mystery, and intoxication of the night, and perhaps a corresponding sense of elation. Whether the title was meant to be "Exaltation" or "Exultation" is not certain. The gallery that handled Davies's estate called the picture "Exultation: The Spell of the Falling Star," but the artist's widow, who may have known his intentions better, simply refers to "Exaltation." The difference in meaning is slight and both could convey the feeling that Davies wished to express.

Oil on canvas, 16 × 11 in. (40.6 × 27.9 cm.).

Signed at lower left (incised in the paint surface): A B DAVIES. Inscribed on the stretcher: *Exhultation* [sic] *The Spell of the* [?] / *Falling* [?]. Inscribed on a

Ferargil Gallery label on the stretcher: A. B. Davies /
The Spell of the Fa[lling] S[t]ar.

REFERENCES: F. N. Price, F. Kouchakji, and A.
Rudert, "Inventory and Appraisal of the Art and
Literary Property Belonging to the Estate of the late
Arthur B. Davies...," Misc. MS Ferargil Gallery,
New York, Feb. 9, 1929, p. 3, under folio 7, no. 30,
lists it as Exultation, gives measurements, and values
at $750 // "Works by Arthur B. Davies from the
Registry of Ferargil Galleries," [1928–1941], type-
script in Misc. MS Davies, Arch. Am. Art, p. 12,
notes that on p. 47 of the Ferargil Registry, no. 5462
(number inscribed on the reverse of this painting), the
Spell of the Falling Star, 12 × 16, was entered on May
31, 1930; p. 16, notes that on p. 96 of the registry, no.
6842 (number inscribed on the reverse of this painting)
was entered on March 1935 as sold to Miss de Groot //
R. Cortissoz, *Arthur B. Davies* (1931), p. 24, calls it
Exultation in a list of the artist's works compiled by his
wife // Form for the American Art Research Council
[1930s], Whitney Museum of American Art Papers,
microfilm N651, Arch. Am. Art, gives title as The Spell
of the Falls, describes, mentions Ferargil label, and
gives owner as Miss de Groot.

EXHIBITED: Wadsworth Atheneum, Hartford,
1950, *Adelaide Milton de Groot Loan Collection* (no cat.);
1951, *100 Years of American Painting* (no cat.).

ON DEPOSIT: Wadsworth Atheneum, Hartford,

Davies, *Dance—Uplift.*

1946–1956, lent by Adelaide Milton de Groot //
MMA, 1956–1967, lent by Adelaide Milton de Groot.

EX COLL.: estate of Arthur B. Davies, 1928–1930;
with Ferargil Galleries, by 1930–1935; Adelaide
Milton de Groot, New York, 1935–1967.

Bequest of Miss Adelaide Milton de Groot (1876–
1967), 1967.

67.187.148.

Dance—Uplift

In this undated painting, a dancer with
raised arms and head tilted upward strains to
hold a pose. Her muscular body is centered on a
flat gray background and stretches almost from
the bottom edge of the canvas to the top. The
subject, costume, and use of artificial light, which
casts a yellow-green tone on the dancer's flesh
and dress, suggest a theatrical inspiration,
perhaps a dance performance. The contrived
pose seems to demonstrate Davies's theory of
inhalation, in which he attributed the expressive
power of classical sculpture to the depiction of
figures with held breath. Gustavus A. Eisen
explained the theory to which Davies subscribed:

The air is inhaled, the chest is lifted, blood is sent
pulsing through the veins producing a nervous force
which flows through the body as an electric charge is
thought to do, and which creates in its turn that life-
like activity of pose, of outline and of muscular accen-
tuations which we have always admired in Greek
art" (*Arthur B. Davies* [1924], p. 70).

Whether his source was modern dance or classical
art, Davies's approach to painting figures was
novel, and often, as here, there is a sense of
movement and unity to his work.

Davies's use of wax as a medium may have
been inspired by the encaustic painting tech-
nique used in classical art. As Eisen noted, "it was
the Greek painted figures and painted sculptures
which occupied his studies during months and
years" (*Art News* 27 [Dec. 22, 1928], p. 12).

Wax on canvas, 24 × 18 in. (61 × 45.7 cm.).
Signed at lower left: A·B·DAVIES.

REFERENCES: B. Burroughs, *MMA Bull.* 26 (Nov.
1931), p. 261, notes its acquisition and says it was in the
1930 Davies memorial exhibition // *Index of Twentieth
Century Artists* 4 (Feb. 1937), p. 393, lists a reproduction
of the painting // G. A. Reynolds, Brooklyn Museum,
letter in Dept. Archives, March 4, 1977, provides
information on Miss Bliss's loan of the painting to the
Brooklyn Museum in 1926.

EXHIBITED: Brooklyn Museum, 1926, *Modern
French and American Painters* (no cat.) // MMA, 1930,
Catalogue of a Memorial Exhibition of the Works of Arthur

B. Davies, cat. by B. Burroughs, ill. no. 128 (mistakenly listed under drawings and watercolors), as Dance—Uplift, lent anonymously.

Ex coll.: Lizzie P. Bliss, New York, by 1926–1931.
Bequest of Lizzie P. Bliss, 1931.
31.67.6.

Italian Hill Town

Davies often visited Italy, particularly after 1923 when he was in poor health and found it a restful place to work. The idyllic mood of this picture recalls his Italian subjects from the turn of the century, but the relatively large scale, panoramic scope, and fluid paint application, thin in places, date it to about 1925. Like *The Umbrian Mountains*, 1925 (Corcoran Gallery of Art, Washington, D.C.), this painting shows the influence of the artist's experiments in watercolor, one of his main interests during the last years of his career.

Davies, *Italian Hill Town*.

Oil on canvas, 25⅞ × 39⅞ in. (65.7 × 101.3 cm.).
REFERENCES: L. Burroughs, *MMA Bull.* 25 (Feb. 1930), p. 32, in a discussion of the Davies memorial exhibition, mentions it as an example of a large-scale landscape done in Italy // R. Cortissoz, *Arthur B. Davies* (1931), p. 27, includes it as Italian Hill-town in a list of the artist's works compiled by his wife and dates it 1925 // B. Burroughs, *MMA Bull.* 26 (Nov. 1931), p. 261, mentions it as part of the Lizzie P. Bliss bequest and notes that she lent it anonymously to the 1930 memorial exhibition // *Index of Twentieth Century Artists* 4 (Feb. 1937) p. 395, mentions illustration of it // W. S. Baldinger, *Art Bulletin* 19 (Dec. 1937), ill. p. 582.

EXHIBITED: MMA, 1930, *Catalogue of a Memorial Exhibition of the Works of Arthur B. Davies*, cat. by B. Burroughs, ill. no. 123, as Italian Hill Town, lent anonymously.

Ex coll.: Lizzie P. Bliss, New York, by 1930–1931.
Bequest of Lizzie P. Bliss, 1931.
31.67.3.

ROBERT REID

1862–1929

The portrait, figure, and mural painter Robert Lewis Reid was born in Stockbridge, Massachusetts, where his father was headmaster of a boys' school. In 1880 Reid entered the School of the Museum of Fine Arts, Boston, and studied under Otto Grundmann (1844–1890). The curriculum of the school stressed draftsmanship, portrait painting, and the study of anatomy. For three of his four years there, Reid served as an assistant instructor and was editor of the school's publication *Art Student*, which was started in 1882. Of the students who studied at the Boston school at this time, FRANK W. BENSON, WILLARD METCALF, and EDMUND C. TARBELL were among Reid's closest associates and remained so throughout his career.

In 1885, after a brief period of study at the Art Students League in New York, Reid went to Paris. He studied at the Académie Julian under Jules Joseph Lefebvre and Gustave Boulanger.

In 1887 he toured Italy, exhibited his work at the Paris Salon, and painted in Normandy. The catalogues of the Paris Salons for the late 1880s illustrate several examples of his work at this time, few of which are now located. These paintings, like his *Death of the First Born*, 1888 (Brooklyn Museum) are sentimental depictions of peasants in interior settings or painted outdoors in a plein-air style reminiscent of Jules Bastien-Lepage, whom Reid had long admired.

After his return to the United States in 1889, Reid settled in New York. Such paintings as *Reverie*, 1890 (coll. Richard D. and Jane Burns; ill. *Arch. Am. Art Journal* 15, no. 1 [1975], p. 10), show a departure from his academic style and indicate his growing interest in impressionism. Throughout the 1890s his energies were generally focused, however, on mural painting. He undertook several important commissions, among them the decoration of a dome for the Manufactures and Liberal Arts Building at the World's Columbian Exposition in Chicago begun in 1892; a series of octagonal panels for the Library of Congress in Washington, 1897; and a large mural of Justice for the New York Appellate Court House, in 1899. These decorative works had a great influence on Reid's figure paintings, of which *Fleur de Lis* (q.v.) is an example. In outdoor settings with flowers, he often depicted large-scale figures of women. Although Reid's pictures are often compared with those of Benson, they are generally brighter and more decorative. His paint is applied in long, irregular brushstrokes on coarse canvas.

Reid worked as a teacher and was active in a number of art organizations. From 1893 to 1896 he was an instructor at the Art Students League. He was a founding member of the Ten American Painters, which was formed in 1897. He was elected to the National Academy of Design in 1902, four years after receiving the Hallgarten prize there, and became an academician in 1906.

After 1900 Reid became even more involved in decorative work. He painted a mural *America Revealing Her Natural Strength* for the United States Pavilion at the Paris Exposition in 1900, and between 1901 and 1905, he did a group of stained-glass windows for the H. H. Rogers Memorial Church in Fairhaven, Massachusetts. Other murals were painted for the State House in Boston, the Central High School in Springfield, Massachusetts, and the Fine Arts Building at the Panama-Pacific Exposition in San Francisco.

In 1917 Reid settled in Colorado Springs where he worked as a portraitist. He was instrumental in founding the Broadmoor Art Academy there. His final years were marred by poor health. In 1927, after suffering a stroke that paralyzed his right side, Reid moved to a sanatorium in Clifton Springs, New York, where he taught himself to paint with his left hand. An exhibition of his late works was held at the Grand Central Art Galleries in New York in 1928, a year before his death.

BIBLIOGRAPHY: *In Summertime: Paintings by Robert Reid* (New York, 1900), contains an introduction by Royal Cortissoz and many illustrations of paintings by Reid from the 1890s // Evelyn Marie Stuart, "Finished Impressions of a Portrait Painter," *Fine Arts Journal* 36 (Jan. 1918), pp. 32–40 // Stanley Stoner, *Some Recollections of Robert Reid* (Colorado Springs, 1934), an anecdotal account of the artist's late years in Colorado, written by a friend // W. H. Downes, *DAB* (1935; 1963), s.v. Reid, Robert, has a bibliography // H. Barbara Weinberg, "Robert Reid: Academic 'Impressionist,'" *Arch. Am. Art Jour.* 15, no. 1 (1975), pp. 2–11, is a detailed treatment of the artist's student years.

Reid, *Fleur de Lis*.

Fleur de Lis

Fleur de Lis, probably painted during the late 1890s, shows a large-scale figure close to the picture plane and surrounded by irises. In nineteenth-century books on floral symbolism irises were usually interpreted as messages or messengers, an allusion to their namesake Iris, the Greek goddess of the rainbow and messenger of the gods. When *Fleur de Lis* was exhibited in 1899, no such specific interpretation was offered by the artist or the critics who discussed it. One writer, however, did see an analogy "between flowers and moods of emotion," and it seems likely that Reid intended to convey such an idea by comparing the woman to the fragile blossoms that surround her.

The painting recalls the artist's mural *Smell*, part of his decorative series *The Five Senses*, installed in the Library of Congress in 1897, but the treatment is less restrained and the outlines less decisive. Here Reid has painted long feathery brushstrokes on a coarse canvas. The

light palette, mainly blue and lavender, is cool, and it seems likely that this painting was among the artist's works criticized for "an overindulgence in strong blues" (*Art Interchange* 42 [May 1899], p. 115).

Reid's paintings from the 1890s have not received much attention. Several artistic sources may have influenced the development of his style and subject matter. Although far more sentimentalized, his treatment of the woman, who seems detached from everyday events, is not unlike that of such contemporary European symbolists as Edmond Aman-Jean. His choice of the iris motif, popular with such turn of the century artists as Vincent Van Gogh, could have been inspired by oriental art.

Another Reid painting with the same title was exhibited in 1896 at the Pratt Institute in Brooklyn. That painting, now unlocated, was described as "a half-length of a violet-clad young woman holding a gray jar out of which rises a stalk of purple iris" (*Pratt Institute Monthly* 5 [Jan. 1897], pp. 153–154).

Robert Reid

435

Oil on canvas, 44⅛ × 42¾ in. (112.1 × 108.6 cms.).
Signed at lower right: ROBERT REID.

REFERENCES: *New York Sun*, March 30, 1899, p. 6, in a review of Reid's studio exhibition, held at 142 East 33rd Street, says that it is included as no. 20, Fleur de Lis, and is among the works not exhibited previously // *New York Daily Tribune*, April 4, 1899, p. 6, in a review of the Ten American Painters, says that "a purification of the lighter tones in 'Fleur de Lys' would give that picture a more luminous and more engaging character, yet its present condition is not unlovely" // *New York Press*, April 5, 1899, p. 6, in a review of the Ten, mentions it in studio exhibition // *New York Sun*, April 6, 1899, p. 6, in a review of the Ten, mentions it and other works by Reid as "better than anything that he had hitherto painted" // *New York Times Saturday Review of Books and Art*, April 8, 1899, p. 240, in a review of the Ten, discusses it, implying that it was included in Reid's studio exhibition, held the previous week // *Art Collector* 9 (April 15, 1899), p. 180, in a review of the Ten, notes it // *Art Interchange* 42 (May 1899), p. 115, in a review of the Ten, calls it a "bewilderingly rich canvas" // *Artist* 25 (May–June 1899), p. ix, in a review of the Ten, describes and discusses its meaning (quoted above), says that "Metaphor apart, there are too many brush-strokes, indiscriminately applied . . . so that there is a lack of subordination in the parts of the picture and an absence of a controlling emphasis anywhere" // R. Cortissoz, *In Summertime* (1900), unpaged ill. // S. Isham, *The History of American Painting* (1905), ill. p. 477 // M. E. Townsend, *Brush and Pencil* 16 (Dec. 1905), ill. p. 203, in a review of the Carnegie exhibition // E. T. Bush, *Brush and Pencil* 17 (March 1906), p. 98, calls it "opalescent" in a review of the PAFA exhibition // D. Lloyd, *International Studio* 28 (March 1906), suppl. p. 13, in a review of the PAFA exhibition, says that since Reid has been devoting so much time to mural painting "he has been represented by this interesting work in several exhibitions" // R. Cortissoz, *Scrip* 1 (March 1906), p. 194, in a review of the PAFA exhibition, refers to it as an excellent figure composition // J. W. Pattison, *House Beautiful* 20 (July 1906), ill. p. 19, describes it // G. A. Hearn, letter in MMA Archives, April 10, 1907, states that he is having it and another work by Reid sent to the museum for inspection but that Reid thinks this is "a better picture" // C. P. Clarke, letter in MMA Archives, April 19, 1907, comments on Hearn's favorable opinion of the picture // *George A. Hearn Gift to the Metropolitan Museum of Art . . .* (1913), ill. p. 77 // E. Stuart, *Fine Arts Journal* 36 (Jan. 1918), ill. p. 34 // R. E. Jackson, *American Arts* (1928), p. 171 // D. Hoopes, *The American Impressionists* (1972), ill. pp. 106–107, discusses it // H. B. Weinberg, *Arch. Am. Art Journ.* 15, no. 1 (1975), ill. p. 11, discusses it // P. J. Pierce, *The Ten* (1976), ill. p. 105; p. 107, dates it 1896.

EXHIBITED: Durand-Ruel, New York, 1898, *Exhibition of Robert Reid*, no. 38, as Fleur de Lis (crossed out so possibly deleted from exhibition) // the artist's studio, New York, 1899, no. 20, as Fleur de Lis (no cat. available) // Durand-Ruel Galleries, New York, 1899, *Ten American Painters*, as Fleur de Lys (no cat. available) // Union League Club, New York, 1899, *Paintings by Living American Artists*, no. 3, as Fleur de Lis // St. Botolph Club, Boston, 1905, *Exhibition of Paintings by the "Ten American Painters,"* no. 15, as Fleur de Lys // Carnegie Institute, Pittsburgh, 1905–1906, ill. no. 219 // PAFA, 1906, no. 3 // Montclair Art Museum, N.J., 1946, *American Paintings by The Ten*, no. 26.

EX COLL.: George A. Hearn, New York, as agent, 1907.

George A. Hearn Fund, 1907
07.140.

EDMUND C. TARBELL

1862–1938

Tarbell was born in West Groton, Massachusetts, the son of a ship designer who died young. When his mother remarried and moved to Milwaukee, Tarbell went to live with his grandparents in Boston. Having shown an early interest in art, he studied at the Massachusetts Normal Art School with a Mr. Bartlett and in 1876 went to work for the Forbes Lithography Company. Three years later he gave up his job and became a student at the School of the Museum of Fine Arts, Boston. There he studied with Otto Grundmann (1844–1890) and met a number of young artists, among them FRANK W. BENSON, with whom he later developed a distinct school of painting. Around 1882 Tarbell went to study at the Académie Julian in Paris,

where he worked under Gustave Boulanger and Jules Joseph Lefebvre in a program that emphasized figure painting. As Frederick W. Coburn noted, however, this "admirable teaching was supplemented by influences outside the classroom. Impressionism was at its height in Paris during the early eighties" (*International Studio* 32 [Sept. 1907], p. lxxviii). Little is known about Tarbell's years in Paris, but it seems likely that his interest in impressionist ideas dates from that time. He traveled in Germany and spent the winter in Venice before returning to Boston in 1888.

Soon after his arrival home, he married Emeline Arnold Souther and took up a post as instructor at the School of the Museum of Fine Arts, where he taught from 1889 until 1913. He exhibited his work frequently and exerted a tremendous influence on both his students and such contemporaries as Joseph R. De Camp (1858–1923) and Philip Leslie Hale (1865–1931). The critic Sadakichi Hartmann dubbed these Boston artists the "Tarbellites."

Tarbell was awarded the Thomas B. Clarke prize for figure painting at the National Academy of Design in 1890, and the following year an important exhibition of his work and Benson's was held at the St. Botolph Club in Boston. During the 1890s Tarbell painted a number of ambitious plein-air subjects such as *A Study in June/Sunlight*, 1890 (Milwaukee Art Center) and *In the Orchard*, 1891 (coll. Dr. Albert Cannon). These paintings show the firm draftsmanship characteristic of his academic training, but they also have the broken brushwork, bright colors, and compositional features of impressionism.

Toward the end of the 1890s, Tarbell's style and subject matter began to change. Perhaps inspired by Benson and other contemporaries like THOMAS DEWING, he often chose to paint women in interior settings that contained a few carefully chosen decorative objects. More somber in color than his works of the early nineties, such pictures as *Across the Room* (*q.v.*) are illuminated by a cool light, which is often filtered through the slats of Venetian blinds. In 1897, after ten years of membership, Tarbell resigned from the Society of American Artists and joined the newly formed Ten American Painters, an impressionist organization that held its first exhibition in 1898. That year, too, his first one-man show opened at the St. Botolph Club, and thereafter he became increasingly successful. He was elected to the National Academy in 1904 and became an academician two years later. His work was awarded a medal at the Carnegie International exhibition in 1906, and his paintings were included in a number of international expositions. Tarbell's late interiors, such as *Girl Reading*, ca. 1910 (MFA, Boston) are among his most important works. He also painted portraits and received a number of important commissions, among them *Edward Robinson*, 1906 (MFA, Boston) and *Herbert Hoover*, 1921 (National Portrait Gallery, Washington, D.C.). In 1918, the artist left Boston to serve as the head of the Corcoran School of Art in Washington. Seven years later he retired to his summer home in New Castle, New Hampshire, where he painted until his death in 1938.

BIBLIOGRAPHY: Frederick W. Coburn, "Edmund C. Tarbell," *International Studio* 32 (Sept. 1907), pp. lxxiv–lxxxvii, contains many illustrations of the artist's work // Kenyon Cox, "The Recent Work of Edmund C. Tarbell," *Burlington Magazine* 14 (Jan. 1909), pp. 254–259 // John E. D. Trask, "About Tarbell," *American Magazine of Art* 9 (April 1918), pp. 216–228 // MFA, Boston, *Frank W. Benson; Edmund C. Tarbell: Exhibition of Paintings, Drawings, and Prints* (1938), exhib. cat. with essay on Tarbell by Frederick W. Coburn // C. C. Cunningham, *DAB* (1933; 1958), s.v. Tarbell, Edmund Charles, contains additional bibliography.

Across the Room

Tarbell's painting, first entitled *The White Dress*, was shown in 1899 at the second annual exhibition of the Ten American Painters. Perhaps in acknowledgement of its distinct composition it soon became known as *Across the Room*. "It might just as well have been called 'The Studio Floor,'" one reviewer noted at the time, "for three-quarters of the picture represented its polished surface, reflecting a little light that came in between the closed slats of the blind." The oblique vantage point, the effective organization of the composition in subtle diagonals, and the cool highlights on the polished floor suggest that Tarbell was strongly influenced by the interior scenes of Edgar Degas, for example, *The Dancing Class*, ca. 1872 (MMA). Like Degas, Tarbell may have been inspired by oriental art, especially in the asymmetrical composition, where the accessory elements and the figure are massed in the upper part of the painting and viewed across an empty foreground.

During his lifetime, Tarbell's work was most often compared to that of the seventeenth-century Dutch painter Vermeer. KENYON COX wrote that Tarbell's interiors displayed

the same simplicity of subject . . . , the same exquisite sensitiveness to gradation of light . . . , and there is the same willingness to use a few elements of composition— a few objects—again and again, in confidence that slight differences of effect and a fresh observation will ensure sufficient variety (*Burlington Magazine* 14 [Jan. 1909], p. 259).

In *Across the Room*, the artist does indeed repeat motifs he used in other paintings, combining them in a particularly striking arrangement. The source of light in the picture is the same as in *The Venetian Blind*, late 1890s (Worcester Art Museum) and *Interior* (Cincinnati Art Museum), and the Federal style sofa, recorded in a photograph of the artist's studio (ill. in P. J. Pierce, *The Ten* [1976], p. 150) appears in a number of his paintings. The Chinese porcelain jar and the Japanese screen, familiar studio props in Tarbell's work, probably enhanced the painting's appeal for its first known owner, the collector William M. Laffan, a connoisseur of oriental art.

For a number of years the painting was titled *Leisure Hour*.

Oil on canvas, 25 × 30⅛ in. (63.5 × 76.5 cm.).
Signed at lower right: Tarbell.
REFERENCES: *New York Daily Tribune*, April 4, 1899, p. 6, in a review of the Ten American Painters exhibi-

tion, calls it The White Dress and praises "the skilful painting of texture, the deft handling of the light that drifts through the Venetian blinds" // *New York Press*, April 5, 1899, p. 6, in a review of the Ten American Painters says it "seems scarcely important enough to offer in such an exhibition" // *New York Sun*, April 6, 1899, p. 6, in a review of the Ten American Painters, calls it "a trivial interior It is an attractive enough little thing, this interior; it is painted with much skill, but at an exhibition of this sort we instinctively look for the very best that a man has to show" // B. F., *New York Evening Post*, April 6, 1899, p. 7, reviews it in the Ten American Painters, saying "Mr. Tarbell forsakes for once the life-size figures he has led us to expect from him, and sends instead a small figure seated on a sofa at the far side of a spacious interior, whose only light comes in through the slats of a Venetian blind, and, illuminating the little lady in white, casts a fascinating wake across the polished floor." // *New York Times Saturday Review of Books and Art*, April 8, 1899, p. 240, in a review of the Ten American Painters, says it is "quiet in color, and well painted as to details, but it is really hardly more than a sketch" // [C. H. Caffin], *Artist* 25 (May–June 1899), p. vii, in a review of the Ten American Painters, discusses it (quoted above) // F. Coburn, *World To-Day* 11 (Oct. 1906), ill. p. 1079, as By the Window // *International Studio* 32 (Sept. 1907), suppl., ill. p. 8 // American Art Association, *Catalogue of Ancient and Modern Paintings . . . Collected by the Late William M. Laffan* (1911), no. 12, describes the painting // *American Art Annual* 9 (1911), p. 91, gives price and purchaser at Laffan sale // M. T. Schaeffer, daughter of the artist, letter in Dept. Archives, June 2, 1967, says that the figure was a studio model // M. Heckscher, American Wing, MMA, orally, June 20, 1975, provided information on the furniture and decorative objects in the painting // H. C. Milch, Milch Gallery, letter in Dept. Archives, June 26, 1975, supplies information on the provenance // W. Platt, New York, orally, August 27, 1975, provided information on the provenance.

EXHIBITED: Durand-Ruel Galleries, New York, 1899, *Ten American Painters*, as The White Dress (no cat. available) // Cincinnati Museum Association, 1899, ill. no. 75, as Across the Room // St. Botolph Club, Boston, 1899, *Exhibition of Sculpture by Charles R. Harley, and of Pictures by Several Boston Artists*, no. 5, as Across the Room // Universal Exposition, Paris, 1900, *Catalogue Générale Officiel*, Etats-Unis, Groupe II, Classe 7, no. 304, as De l'autre côté de la chambre // MFA, Boston, 1938, *Frank W. Benson; Edmund C. Tarbell: Exhibition of Paintings, Drawings and Prints*, no. 120, lent by Mrs. Charles A. Platt // Wadsworth Atheneum, Hartford, 1950, *The Adelaide Milton de Groot Collection*, no. 40, as Leisure Hour // MMA, 1965, *Three Centuries of American Painting* (checklist alphabetical), as Leisure Hour, lent by Adelaide Milton de Groot.

ON DEPOSIT: Wadsworth Atheneum, Hartford, 1949–1956, lent by Adelaide Milton de Groot // MMA, 1956–1967, lent by Adelaide Milton de Groot.

arbell, *Across the Room*.

Ex COLL.: William M. Laffan, New York, died 1909; his estate, 1909–1911 (sale, American Art Association, New York, Jan. 20, 1911, no. 12, as Across the Room, $360); Charles Adams Platt, Boston, 1911—died 1933; his wife, Eleanor Hardy Bunker Platt, Boston, 1933–1949; their son, William Platt, New York, as agent, 1949; with Milch Galleries, New York, 1949; Adelaide Milton de Groot, New York, 1949–1967.

Bequest of Miss Adelaide Milton de Groot (1876–1967).

67.187.141.

FRANK W. BENSON

1862–1951

Frank Weston Benson was one of the most influential artists and art teachers in Boston at the turn of the century. He was born and raised in Salem, Massachusetts, and began his art training in 1880 at the School of the Museum of Fine Arts, Boston. There he studied for three years under Otto Grundmann (1844–1890) and met EDMUND C. TARBELL who influenced his work over the next three decades. Benson continued his training in Paris, where he studied at the Académie Julian for two years under Gustave Boulanger and Jules Joseph Lefebvre. During the summer months, he painted at Concarneau in Brittany, then a popular artists' colony. The first major painting he exhibited was *After the Storm* (now unlocated), which was shown at the Royal Academy in London in 1885. Unfortunately little is known about Benson's work at this time. One of his few known works from this period, the portrait of a seated guitar player, *Joseph Lindon Smith*, 1884 (private coll.) shows the influence of Edouard Manet in the somber colors, fluid brushwork, and summary treatment of detail.

On his return to the United States, Benson began a long and successful career as an art teacher. He first taught in Maine at the Portland Society of Art in 1886 and 1887 and then in Boston at the School of the Museum of Fine Arts from 1889 until 1917. He also found time for his own paintings, which were well-received. The first time he exhibited at the National Academy of Design in 1889 he won the Hallgarten prize there. Two years later his *Twilight* (now unlocated) won the Thomas B. Clarke prize for figure painting. Also at this time, a joint exhibition of works by Benson and Tarbell was held at Chase's Gallery in Boston. Benson later won medals at the World's Columbian Exposition in Chicago, the Pan-American Exposition in Buffalo, the Louisiana Purchase Exposition in St. Louis, and at major annuals in Philadelphia and Pittsburgh. A founding member of the Ten American Painters, organized in 1897, he was elected an associate member of the National Academy the same year and became an academician in 1905.

In the 1890s and early 1900s, Benson often depicted women in interiors, a subject also favored by Tarbell and his other Boston colleagues. At first, in paintings like *Girl in a Red Shawl*, 1890 (MFA, Boston), Benson's settings were austere. He used rich, dark colors, fluidly applied. His lighting, often from an artificial source, was dramatic, and his figures were placed close to the picture plane. In 1896 he completed murals showing allegorical figures in landscape settings, *The Seasons* and *The Graces*, for the Library of Congress. Perhaps as a result of working

on such a large scale, his paintings, for example, *Portrait of a Lady*, 1901 (q.v.), became more decorative. He also tended to use more elegant costumes and lavish settings. After 1901, when he bought a summer home in North Haven, Maine, outdoor subjects became his specialty. For more than a decade he worked on plein-air paintings that often depicted his wife and children. Clearly influenced by impressionism, Benson painted in bright, luminous colors, boldly applied in long varied brushstrokes. Such paintings as *Eleanor*, 1907 (MFA, Boston), which shows a figure in profile silhouetted against a light-filled landscape, are typical of his work at this period.

Benson began to paint wildlife subjects during the late 1890s, and these became more prevalent in his work after 1912 when he began to work seriously as a printmaker. His etchings, first shown at the Guild of Boston Artists in 1915, often depicted wildlife and sportsmen. These popular subjects were also typical of his late paintings, for example, *Salmon Fishing*, 1927 (MFA, Boston) and *Great White Herons*, 1933 (PAFA). These late paintings are less spontaneous than his early outdoor scenes. Their decisive contours, bright, almost garish colors and narrative quality are not unlike contemporary illustrations.

The artist was honored with a number of retrospective exhibitions during his lifetime. The most important was a joint show with Tarbell held at the Museum of Fine Arts, Boston, in 1938. For most of his career Benson lived in Salem, Massachusetts, where he died in 1951 after a long illness. His brother John P. Benson (1865–1947) was also a painter.

BIBLIOGRAPHY: William Howe Downes, "Frank W. Benson and His Work," *Brush and Pencil* 6 (July 1900), pp. 145–157, includes many illustrations of the artist's early works // Minna C. Smith, "The Work of Frank W. Benson," *International Studio* 35 (Oct. 1908), pp. xcix–cvi // Charles H. Caffin, "The Art of Frank W. Benson," *Harper's Monthly Magazine* 119 (June 1909), pp. 105–114 // MFA, Boston, *Frank W. Benson; Edmund C. Tarbell: Exhibition of Paintings, Drawings, and Prints* (Nov. 16–Dec. 1938), exhib. cat. with introduction by Lucien Price, includes biographical information // Samuel Chamberlain, "Frank W. Benson—The Etcher," *Print Collector's Quarterly* 25 (April 1938), pp. 166–183.

Portrait of a Lady

Around the turn of the century, Benson painted a number of decorative pictures of women in interior settings. These show studio models in costumes and with accessories selected and arranged to create satisfying patterns of color and line. For this painting, dated 1901, the artist seated his model in front of a patterned backdrop of large yellow flowers on an olive ground. Painted in dry, feathery brushstrokes, her dark dress is relieved by colorful highlights— green on the draped neckline and yellow and orange in the shawl. With its relatively low-cut neckline, snug bodice, and frilled half-length sleeves, the dress appears to be a "Watteau style" dinner gown, which was fashionable in this period. It is worn inappropriately, however, with a large black hat suitable for daytime wear.

In this picture, as in his more accomplished *Lady Trying on a Hat*, 1904 (Museum of Art, Rhode Island School of Design, Providence), Benson concentrated on the shadows cast by the hat on the woman's face. Overall, the strong contrasts of light and dark produce a dramatic lighting effect that is typical in his work.

Benson did not regard the picture very highly; for shortly after its acquisition, he wrote to the museum that "it is not one that I should have chosen to represent me." The reason for this can readily be seen in the rather crude treatment of the raised arm, where there is little modeling, and in the costume, where flashing brushstrokes bear little relation to the forms they depict. More noticeable, however, is the placement of the left arm, with its jutting elbow, which makes for an awkward pose.

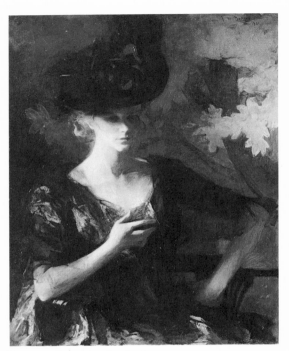

Benson, *Portrait of a Lady*.

Oil on canvas, 40⅛ × 32⅜ in. (101.9 × 82.2 cm.).

Signed and dated at upper right: F. W. BENSON / 1901.

REFERENCES: *The George A. Hearn Gift to the Metropolitan Museum of Art* . . . (1906), ill. in supplement // F. W. Benson, letter in MMA Archives, Jan. 15, 1907, says Hearn bought the picture from him and he regrets it is to represent him in the museum (quoted above) // *MMA Bull.* 2 (Feb. 1907), p. 24 // M. C. Smith, *International Studio* 35 (Oct. 1908), p. c, says subject resembles an eighteenth-century lady; ill. p. ci; p. civ, discusses it as an example of the artist's "decorative bent" // *George A. Hearn Gift to the Metropolitan Museum of Art* . . . (1913), ill. p. 66 // F. W. Benson, letter in MMA Archives, Jan. 24, 1921, requests loan of the painting for an exhibition // P. Ettesvold, Costume Institute, MMA, memo in Dept. Archives, April 24, 1979, confirms that the dress is probably a Watteau dinner gown from the period and observes that such a hat would not ordinarily have been worn with it.

EXHIBITED: Corcoran Gallery of Art, Washington, D.C., 1921, *Paintings, Etchings and Drawings by Frank W. Benson*, no. 22.

Ex COLL.: George A. Hearn, New York, by 1906.

George A. Hearn Fund, 1906.

06.1221.

Benson, *Children in Woods*.

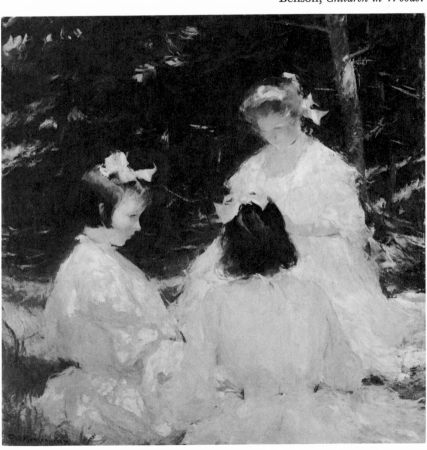

442

Children in Woods

Benson painted forest scenes with close-up views of children as early as 1898. They continued to be among his favorite subjects during the first decades of the twentieth century. "His pictures of children and youth, in the open, bathed in sunlight and fresh air, are among the best ever painted," one critic noted in 1910, "and their chief beauty is in their purely individual styles, blending brilliancy with delicacy" (*Boston Evening Transcript*, Jan. 11, 1910, p. 13). In this particular scene, three young girls are seated in a circle in a grassy clearing. A backdrop of luscious green trees offers a strong contrast to the girls' light dresses. One girl, seated quite close to the picture plane, blocks our view of the group's activity. The placement of that figure and the profile pose of the girl on the left are typical of Benson's compositions, in which attention is focused on the foreground. Also characteristic of his work are the strong contrasts of light and shadow and the varied brushwork that creates a rough paint surface.

Oil on canvas, 32 × 30 in. (81.3 × 76.2 cm.).
Signed at lower left: F. W. Benson 1905.
REFERENCES: Mrs. R. King, letter in MFA, Boston, Oct. 8, 1938, says that she purchased the painting at an exhibition in Baltimore but does not remember when or where the exhibition was held // U.S. Embassy, Moscow, *Amerikanskaya Zhivopis, 1830–1970* [*American Painting, 1830–1970*] (1974), color ill. p. 21 // H. C. Milch, Milch Gallery, letter in Dept. Archives, Feb. 6, 1979, discusses provenance and exhibition history // C. Scallen and P. Lioko, MFA, Boston, letters in Dept. Archives, March 5 and 26, 1979, discuss 1938 loan to Boston and provide a copy of lender's 1938 letter.
EXHIBITED: MFA, Boston, 1938, *Frank W. Benson; Edmund C. Tarbell*, no. 5, Children in Woods, lent by Mrs. Ralph King.
ON DEPOSIT: Wadsworth Atheneum, Hartford, 1950–1956, lent by Adelaide Milton de Groot // MMA, 1956–1967, lent by Adelaide Milton de Groot // U.S. ambassador's residence, Spaso House, Moscow, 1974–1979.
EX COLL.: Mrs. Ralph King, Mentor, Ohio, by 1938; estate of Mrs. Ralph King (sale, Tobias, Fischer and Company, New York, Sept. 15, 1950, no. 740); with Milch Gallery, New York, 1950; Adelaide Milton de Groot, New York, 1950–1967.
Bequest of Miss Adelaide Milton de Groot (1876–1967), 1967.
67.187.210.

Benson, *Two Boys.*

Two Boys

In this painting Benson outlined the figures firmly and applied clear, bright colors in broad strokes. Not unlike popular illustrations of the 1920s, the work has a narrative, anecdotal quality. In fact it was once used as an illustration in the children's magazine *St. Nicholas* (1931).

Dated 1926, the picture shows the artist's grandsons. Frank Benson Lawson (1914—) sits on the grass, and Ralph Lawson, Jr. (1916—), stands with a model boat in his hands. Accompanied by a dog, they are depicted outdoors at Wooster Farm in North Haven, Maine, where the artist spent his summers beginning in the early 1900s. "I well remember posing for this picture," Ralph Lawson recalled in a letter to the museum (1979). "My grandfather was sitting under an apple tree—part of the apple orchard behind the house, and we were standing in the grass with the Fox Island thoroughfare off to the right in the picture. We actually posed for a water-color. The oil painting must have been done in his studio from the water-color." The oil painting is slightly different than the watercolor, 1924 (private coll.); for example, in the oil, Benson moved the figures a little farther back in space and eliminated much of the shadow in the foreground. The "Two

Boys" were sons of Benson's eldest daughter Eleanor and her husband Ralph Lawson, a cotton merchant. Raised in Salem, Massachusetts, both children attended the Noble and Greenough School in nearby Dedham and graduated from Harvard College. Since the 1940s Ralph Lawson, Jr., has been associated with the textile firm Lawson Products and Frank Benson Lawson has taught at, and been business manager of, the Noble and Greenough School.

Oil on canvas, $32\frac{3}{16} \times 40\frac{1}{8}$ in. (81.8 × 101.9 cm.).
Signed at lower left: F. W. Benson / '26.
RELATED WORK: *Study for Two Boys*, 1924, watercolor and pencil on paper, 19 × 24½ in. (48.3 × 62.2 cm.), private coll.
REFERENCES: F. C. Jones, letter in MMA Archives, Feb. 17, 1927, says that he is sending the picture from Macbeth Gallery for consideration // F. W. Benson, printed form, March 1926, in MMA Archives, lists exhibitions for it // *St. Nicholas* 58 (August 1931), ill. p. 678 // F. W. Benson, letter in MMA Archives, Oct. 2, 1938, requests loan of the painting for exhibition in Boston: "I should like to have it for this exhibit more than any picture I have painted" // R. Lawson, Jr., grandson of the artist, letter in Dept. Archives, March 13, 1979, identifies the subjects and setting, noting that the painting was done from a watercolor (quoted above); orally, March 28, 1979, supplied biographical information on the subjects // F. B. Lawson, grandson of the artist, orally, April 20, 1979, gave information on the painting.
EXHIBITED: Guild of Boston Artists, 1927 (no cat. available) // Macbeth Gallery, New York, 1927, *Paintings by a Group of Members of the Guild of Boston Artists* (not in cat. but probably included) // Am. Acad. of Arts and Letters, New York, 1930–1931, *A Catalogue of an Exhibition of Works by the Living Artist Members of the National Institute of Arts and Letters*, no. 60 // MFA, Boston, 1938, *Frank W. Benson; Edmund C. Tarbell*, no. 44; ill. p. 37 // Bristol Art Museum, R. I., 1965, *Frank W. Benson, 1862–1951*, no. 4 // William A. Farnsworth Library and Art Museum, Rockland, Me., 1973, *Frank W. Benson, 1862–1951*, unnumbered checklist, ill., mistakenly says undated.
Ex COLL.: the artist, Salem, Mass., 1926–1927; with William Macbeth, 1927.
George A. Hearn Fund, 1927.
27.61.

EDWARD MARTIN TABER

1863–1896

Edward Martin Taber was born on Staten Island, New York, and spent part of his childhood abroad. He suffered from poor health for much of his life and died of tuberculosis at the age of thirty-three. A few months of study in 1887 and 1888 with ABBOTT H. THAYER was all the formal art training he received. Beginning in 1886 his work was exhibited occasionally at the Society of American Artists.

In 1889 Taber left New York and settled in Stowe, Vermont, for his health. Except for brief trips to Georgia and the Carolinas, he lived in Stowe until shortly before his death. From Vermont he corresponded with Thayer and Joe Evans (1857–1898), both of whom encouraged him in his work. Taber died in Washington, Connecticut, in 1896. Two years later a memorial exhibition of his work was held at the St. Botolph Club in Boston.

Aside from the publication in 1913 of *Stowe Notes*, which includes some of the artist's notebooks, journals, and letters, little has been written about him. Moreover, few of his paintings are in public collections. His landscapes, sometimes painted from a portable hut, depict Vermont scenery in all seasons, although winter subjects were his favorite. These realistic views show a concern for the accurate depiction of weather and atmospheric conditions, but firm

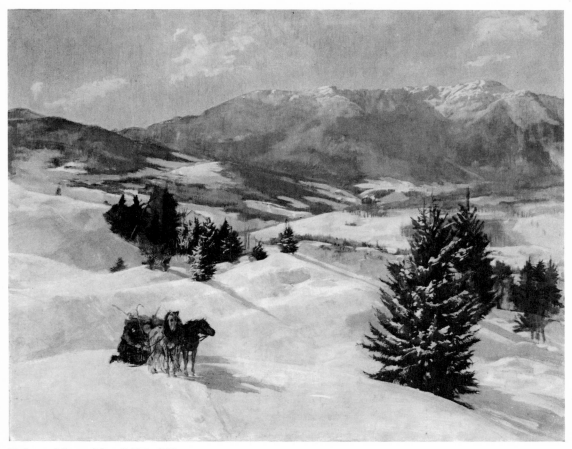

Taber, *Mount Mansfield in Winter.*

draftsmanship and smooth finished paint surfaces distinguish them from the impressionistic style popular with many Americans during the 1890s.

BIBLIOGRAPHY: St. Botolph Club, Boston, *Memorial Exhibition of Paintings and Drawings by Edward Martin Taber* (Feb. 14–24, 1898), includes a biographical statement // George de Forest Brush and Abbott H. Thayer, "The Fine Arts: The Tributes of Two Eminent American Painters to Edward Martin Taber," *Boston Evening Transcript*, Feb. 18, 1898, p. 6 // Edward Martin Taber, *Stowe Notes: Letters and Verses* (Boston, 1913), includes a preface by the artist's sister, Florence Taber Holt; an introduction by Abbott H. Thayer; the artist's "Stowe Notes", 1890–1893; his notebook, 1887–1888; excerpts from his letters, 1882–1896; and illustrations // Royal Cortissoz, "Edward Martin Taber," in *American Artists* (New York, 1923), pp. 263–266 // Century Association, New York, *Exhibition of Paintings and Drawings by Edward Martin Taber* (May 2–31, 1925), biographical information and statements by artists and critics.

Mount Mansfield in Winter

Painted in 1895, this winter scene depicts Mount Mansfield, near Stowe, Vermont, one of Taber's favorite subjects. Although he studied the mountain under a variety of conditions, he wrote that: "The Mountain is seen at its best in winter, with snow and ice along the rocky summit—the 'bald.' In this hoary coating it seems like some great Colossus, maimed and

time-eaten, more majestic, more inscrutable, with loftier riddles than the Sphinx" (*Stowe Notes* [1913], pp. 25–26).

Mount Mansfield in Winter was painted from Taber's portable hut, which was equipped with a glass window and a stove. The painting, however, was never finished. Writing to his sister Florence on February 18, 1895, he explained his difficulties with it:

The reason why I gave up . . . is that the subject is too great to be treated otherwise than with the best of whatever powers one may possess. This winter I have been conscious of the beauty of the country rather as pain than as pleasure. It has oppressed without inspiring me; all this winter's painting I have done under a compelling sense of duty, and not because I have found interest or amusement in it. I have felt the difficulties much more than heretofore, and they are great. In the first place, the weather is so variable that the same effect (or what is approximately the same, sufficiently so for a painter's purpose) occurs perhaps at intervals of four or five days; then the excessive cold compels one to paint in a cumbersome fur coat, and causes such difficulties as the clouding of the glass, the stiffening of the fingers, and limits *my* endeavors to the little space of some two hours My eyes, also, have suffered from the snow glare—in painting the Mountain picture particularly, for in that case I faced the sun, though not directly.

The controlled brushwork, crisp contours, and cool palette of this icy landscape prompted one critic to describe its treatment as "metallic". Taber found "sharper, more sudden" transitions and an "unusual amount of color" in the winter landscape (*Stowe Notes* [1913], p. 80). To best capture these characteristics he used strong lavenders and blues in the shadows and the distance, with little gradation between the dark areas and the brilliant surface of the snow.

Oil on canvas, 24 × 30 in. (61 × 76.2 cm.).
Canvas stamp, enclosed in a palette: PREPARED BY / F. W. DEVOE & CO. / [illeg.] / AND IMPORTERS . . . / ARTISTS MATERIALS.

REFERENCES: E. M. Taber, *Stowe Notes* (1913), p. vii, writing in the 1890s, says it is unfinished, dates it 1895; ill. opp. p. 3; pp. 290–291, in a letter from the artist to his sister, Feb. 18, 1895, says that he has stopped working on it and explains why (quoted above) // *New York Times Saturday Review of Books and Art*, March 27, 1897, p. 15, in a review of the Society of American Artists, says it is "a remarkably strong work, with rich color quality and fine distance, although a little metallic in atmosphere" (quoted above) // C. H. Caffin, *International Studio* 15 (Nov. 1901), suppl. p. 33, in a review of the Pan-American Exposition, says it "is essentially a product of the artist's temperament, a mood of feeling" // S. Isham, *The History of American Painting* (1905; rev. ed. 1936), ill. p. 441 // F. T. Holt, the artist's sister, letter in MMA Archives, Nov. 5, 1912, says that it is being lent by her mother, Mrs. C. C. Taber, that "it is a pleasure to know that the Mount Mansfield is being exhibited"; copy of a letter to R. W. de Forest, June 26, 1914, MMA Archives, mentions it has been on view at the MFA, Boston and calls it "my brother's last and most important painting"; orally, Jan. 1935, recorded by H. B. Wehle, says done in 1895 // L. Luckey, MFA, Boston, letter in Dept. Archives, August 21, 1978, provides information about loan to MFA.

EXHIBITED: Society of American Artists, New York, 1897, no. 122, as Mount Mansfield in Winter, lent by Mrs. C. C. Taber // St. Botolph Club, Boston, 1898, *Memorial Exhibition of Paintings and Drawings by Edward Martin Taber*, no. 4, as Mount Mansfield, lent by Mrs. C. C. Taber // Universal Exposition, Paris, 1900, *Catalogue Générale Officiel*, Etats-Unis, Group II, Classe 7, no. 301, as Le Mont Mansfield en hiver // Pan-American Exposition, Buffalo, 1901, *Catalogue of the Exhibition of Fine Arts*, no. 251 // Century Association, New York, 1925, *Exhibition of Paintings and Drawings by Edward Martin Taber*, no. 1, as Mount Mansfield—Mid-Winter, unfinished.

ON DEPOSIT: MFA, Boston, 1902–1912, lent by Mrs. C. C. Taber // MMA, 1912–1924, lent by Mrs. C. C. Taber.

EX COLL.: the artist's mother, Mrs. C. C. Taber, by 1898—at least 1914; the artist's sister, Florence (Mrs. Henry) Holt, New York, by 1925–1926.

Morris K. Jesup Fund, 1926.
26.51

FREDERICK MAC MONNIES

1863–1937

Frederick William MacMonnies began to paint seriously after establishing a reputation as one of America's most accomplished sculptors. He was born in Brooklyn and attended grammar school until his father's financial ruin forced him to take a variety of menial jobs. In the evenings he attended art classes at Cooper Union and the school of the National Academy of Design, where his instructors were Lemuel E. Wilmarth (1835–1918) and EDGAR MELVILLE WARD. He also studied briefly at the Art Students League. When he was sixteen or seventeen, he became assistant to the sculptor Augustus Saint-Gaudens. During the next three years, he worked on a number of that sculptor's projects, among them the decorations for the Cornelius Vanderbilt II residence in New York.

Financial assistance from the architect Charles F. McKim enabled MacMonnies to go to France, where he lived for most of the next thirty years. At the Ecole des Beaux-Arts he studied under Jean Alexandre Falguière. MacMonnies began to exhibit his sculpture at the Paris Salon in 1887, and two years later his *Diana* won an honorable mention there, the first of many awards. In 1888, shortly after his marriage to the painter Mary Fairchild (1858–1946), he received a commission for three bronze angels for St. Paul's Church in New York. Two years later Edward D. Adams commissioned *Pan of the Rohallion* for his home in Seabright, New Jersey. As was the case with many of MacMonnies's sculptures, a reduced version of this work was cast in the form of a statuette. The Metropolitan owns several of these reductions, including *Young Faun and Heron*, ca. 1890, and *Nathan Hale*, 1890.

MacMonnies's full-length *Nathan Hale* in City Hall Park, New York, was unveiled in 1893, as was his enormous *Columbia Fountain* (later destroyed) for the Chicago World's Fair. Following a great success at the fair, he received several major commissions, and, working in close collaboration with the architect Stanford White, he produced some statues for Prospect Park, Brooklyn. His *Bacchante and Infant Faun*, 1893 (MMA), was installed by Charles F. McKim in the garden of the Boston Public Library in 1896, but after local temperance advocates objected, it was removed and presented to the Metropolitan Museum in 1897. Throughout the 1890s, MacMonnies's style and subject matter, which at first had been strongly influenced by Falguière's, became more individual and more assured. His decorative sculptures, with their active poses and lively, reflective surfaces, make a distinct contribution to American sculpture of the period.

At the height of his creative abilities, during the late 1890s, MacMonnies taught at a school in Paris run by a Mme. Vitté (or Vitti). He also taught a class in 1899 with JAMES MC NEILL WHISTLER and often took students and assistants into his own studio. Among his well-known pupils were the portrait painter Ellen Emmet Rand (1876–1941) and the sculptor Janet Scudder.

Drained by his work as a sculptor, MacMonnies seriously took up painting around the turn of the century. Previously he had studied under painters in New York, and during the early 1880s he had even assisted in painting decorations for the Metropolitan Opera House. When he arrived in Paris, several of his letters of introduction were to painters—Jules Bastien-

Lepage, Paul Baudry, and JOHN SINGER SARGENT. Although circumstances prevented him from working with any of these men, he later spent a brief period in Munich, where he studied painting with Johann Caspar Herterich and Josef Widmann. In 1898 MacMonnies went to Madrid to copy works by Velázquez and then made an intensive study of painting materials and techniques. By 1901 he was exhibiting his paintings at the Paris Salon and won an honorable mention that year and a third class medal in 1904, proving that "an artist can be equally apt in painting and sculpture" (E. Pettit, p. 324). MacMonnies's career as a painter, which spanned at least six years, has never been carefully studied. His early paintings were realistic and directly executed, recalling Sargent's portraits from the previous decade. MacMonnies's approach was conventional and his style decorative. A group of his portraits exhibited at Durand-Ruel, New York, in 1903, received mixed reviews. One reviewer, however, called them "brilliant painting, brilliant to the point of glitter" (*New York Daily Tribune*, Jan. 21, 1903, p. 9).

MacMonnies soon returned to sculpture with renewed enthusiasm. He produced two equestrian monuments, *General Slocum* for Brooklyn, in 1905, and *General McClellan*, unveiled in Washington, D.C., in 1907. Other commissions received before World War I included the Denver *Pioneer Monument* and the *Princeton Battle Monument*. In 1910, following a divorce from his first wife, he married Alice Jones. Five years later wartime conditions forced them to leave their home in Giverny and return to America. MacMonnies continued working on monuments; among those he did in the 1920s were the unpopular *Civic Virtue*, 1922, eventually moved from its site in New York's City Hall Park to Kew Gardens, Queens, and the *Marne Battle Monument*, 1926, in Meaux, France. Several portrait busts, for example, of James McNeill Whistler and Thomas Hastings, date from the 1930s.

MacMonnies's style in sculpture was outdated long before his death in 1937. Nevertheless, from the late 1880s until World War I, his facile modeling and imaginative compositions made an important contribution to the advancement of the Beaux-Arts style first popularized in America by Saint-Gaudens. MacMonnies's paintings, although less original and less influential, demonstrate his virtuosity and add another dimension to his work.

BIBLIOGRAPHY: Will H. Low, "Frederick MacMonnies," *Scribner's Magazine* 18 (Nov. 1895), pp. 617–628, an early discussion of MacMonnies's career as a sculptor, written by a close friend and fellow artist // Edith Pettit, "Frederick MacMonnies, Portrait Painter," *International Studio* 29 (Oct. 1906), pp. 319–324, discusses his career as a painter and its relationship to his sculpture // Wayne Craven, *Sculpture in America* (New York, 1968), pp. 420–428, discusses MacMonnies's career as a sculptor // Edward J. Foote, "An Interview with Frederick W. MacMonnies, American Sculptor of the Beaux-Arts Era," *New-York Historical Society Quarterly* 61 (July/Oct. 1977), pp. 102–123, discusses material contained in De Witt M. Lockman interview with the sculptor in 1927, original in NYHS, microfilm 503, Arch. Am. Art.

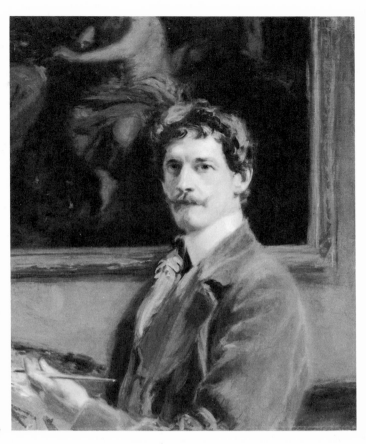

MacMonnies, *Self-portrait*.

Self-portrait

The self-portrait of Frederick MacMonnies, painted around the turn of the century, can be seen as a tribute to Diego Velázquez. Mac-Monnies, who went to Madrid in 1898 to copy works by Velázquez, acknowledges the Spanish master's influence by alluding to several of his paintings in the Prado. In the self-portrait, MacMonnies stands in front of what is probably his own copy of Velázquez's *Bacchus*, 1628–1629 (Prado, Madrid; ill. López-Rey, *Velázquez* [1963], pl. 48). The painting is shown in reverse, probably because the artist posed before a mirror. His arm is extended across his chest in a gentle curve which repeats the gesture of Bacchus. The inclusion of the Roman god of wine may be a humorous reference to MacMonnies's bohemian life in Paris or an allusion to one of his most famous and controversial sculptures *Bacchante and Infant Faun*, 1893 (MMA), which represents one of Bacchus's priestesses.

The pose recalls two portraits of artists by Velázquez as well. MacMonnies holds the reverse position of that of the sculptor Juan Martínez Montañés in Velázquez's portrait of 1635–1636 (Prado, Madrid; ill. López-Rey, pl. 102). This pose, with its "arrested and intent attitude," Velázquez later used for his own self-portrait in *The Royal Family*, the so-called *Las Meninas*, 1656 (Prado, Madrid; ill. López-Rey, pl. 147; quote p. 79).

MacMonnies's rich colors, bold brushwork, and the immediacy of his portrait most closely resemble JOHN SINGER SARGENT's portraits of the 1890s.

Oil on canvas, 31 × 25 in. (78.7 × 63.5 cm.).

REFERENCES: *Kennedy Quarterly* 6 (Oct. 1966), ill. p. 222, as Self-Portrait with Palette; p. 223, notes Velázquez copy in background // *Connoisseur* 164 (Jan. 1967), ill. p. xlix // R. G. Wunderlich, Kennedy Galleries, New York, letters in Dept. Archives, August 14 and Sept. 8, 1978, discusses provenance.

EXHIBITED: American Federation of Arts, traveling

exhibition, 1974–1975, *Revealed Masters*, exhib. cat. by W. H. Gerdts, no. 28, as Portrait of the Artist; p. 31, discusses influence of Velázquez; ill. p. 98.

Ex COLL.: family of the artist, France; with William Frantz of Taconic Art Services, Old Chatham, N.Y., as agent; with Kennedy Galleries, New York, by 1966–1967.

Mrs. James Fosburgh Gift, 1967.

67.72.

May Suydam Palmer

May Suydam Palmer (ca. 1870–1941), the daughter of Courtlandt Palmer and the former Catherine Amory Bennett, was born in Stonington, Connecticut. She was raised in New York, where her father was founder and president of the Nineteenth Century Club, a literary and social group. She studied painting with JOHN WHITE ALEXANDER in New York and sculpture with Auguste Rodin in Paris, but her work is little known. Miss Palmer lived in France from at least 1920 until the outbreak of World War II, when she returned to the United States. She died in New York at the age of seventy-one.

Miss Palmer posed for several portraits by MacMonnies, some painted at Giverny. In a 1901 letter to his student Mary Foote (1872–1968), he explained that Miss Palmer "begged me to paint her portrait[,] a desire shared by her brother & I agreed on condition that she could acquire it *If* I am satisfied with it when done." He continued: "I'm going to paint Miss P. if the sun holds out in the late afternoon[—] Sunset on her red hair—& blown around in her best Chinese gown, toss't by the winds on the alley walk to Monet's boathouse" (Sept. 3, 1901, Mary Foote Papers, Beinecke Rare Book and Manuscript Collection, Yale University). The result of this first effort was undoubtedly the full-length portrait now in the Bennington Museum, Vermont. The small portrait in the Metropolitan was apparently executed afterwards. According to the inscription MacMonnies gave it as a birthday gift in 1903 to the pianist and composer Courtlandt Palmer, the subject's brother.

Miss Palmer wears a bright red dress with intricate lace trim that adds to the decorative effect created by the rich green foliage behind her. In this picture MacMonnies strives for his self-proclaimed goal in portraiture—to paint a likeness that "'is more like the sitter than the sitter himself'... an aim that has required a loving study of detail, a patient and amused observation of trifles" (E. Pettit, *International Studio* 29 [Oct. 1906], p. 319). Emphasizing his subject's slender neck, fiery auburn hair, and penetrating blue eyes, he depicts a strong, sensitive woman. Carefully drawn and firmly modeled, the portrait is facilely handled and shows MacMonnies's understanding of academic technique.

Oil on canvas, 19 × 19⅛ in. (48.3 × 48.6 cm.).

Signed at upper right: MacMonnies. Inscribed on stretcher: *This picture presented to Courtlandt Palmer / by F. MacMonnies on his birthday 1903.*

REFERENCES: M. Vander Velde, granddaughter of MacMonnies, letter in Dept. Archives, Sept. 28, 1965, says that he did several portraits of Miss Palmer, a full-length, two ovals, and this one // R. C. Barret, Bennington Museum, Vt., letters in Dept. Archives, March 9 and April 15, 1966, discusses this portrait and the full-length work.

EXHIBITED: Theodore B. Starr and Durand-Ruel Galleries, New York, 1903, *Exhibition of Paintings and Bronze Statuettes by Frederick MacMonnies*, either no. 3 or 11, as Miss May Palmer (possibly this painting) // Union League Club, New York, 1903, *Portraits of Americans*, no. 23, as Portrait of Miss P., lent by Miss May Palmer (possibly this painting).

Ex COLL.: the subject's brother, Courtlandt Palmer, New York, 1903–1950.

Gift of Courtlandt Palmer, 1950.

50.220.3.

MacMonnies, *May Suydam Palmer.*

AUGUST R. FRANZÉN

1863–1938

The Swedish-born painter August R. Franzén became an established portraitist in the United States at the turn of the century. He was born and spent his childhood near the Baltic city of Norrköping, where he attended school until he was twelve. He was then apprenticed to a local artist for three years. In the evenings, Franzén studied at a drawing school as well. When his apprenticeship was completed, he took further training in Stockholm with the genre painter Carl Larsen and two other artists.

Franzén went to Paris in 1881. For the next five years he divided his time between France and the United States, where an older brother had immigrated. He studied at the Académie Julian under Adolphe William Bouguereau and Tony Robert-Fleury and attended an evening drawing class conducted by Pascal Adolphe Jean Dagnan-Bouveret. On trips to the United States he visited California and worked on a cyclorama in Chicago, where he studied for a time with Charles A. Corwin (1857–1938). Back in Paris in 1886, he worked briefly at the Julian and then enrolled in the Atelier Colarossi. Each summer he traveled in Europe or painted at the artists' colony at Grez-sur-Loing. Franzén was soon selling his work—mostly genre scenes and landscapes—to enthusiastic French and English buyers.

In 1890 the artist settled in New York where he took a studio. Just a year later he met with success when he exhibited a group of landscapes he had painted at Grez-sur-Loing. Among the purchasers of these works were the collectors William Laffan and Catholina Lambert and the painter J. ALDEN WEIR. In 1892 Franzén became a member of the Society of American Artists and began to exhibit his work at the National Academy of Design.

Franzén took up painting portraits seriously in 1893, and this genre became his specialty for the remainder of his career. He traveled a great deal to undertake commissions and study art. Although his painting is little recognized today, he enjoyed considerable success. In 1906 he was elected an associate member of the National Academy. About the same time he bought a home in Bar Harbor, Maine, where he painted in the summer. Among his portraits are *William Howard Taft*, which he painted for Yale University in 1913 and *Mrs. William Bedlow Beekman*, 1915 (NYHS). Franzén helped to organize the cooperative Gainsborough Studio in New York, and he worked there among such artists as ELLIOTT DAINGERFIELD and COLIN CAMPBELL COOPER. He was elected an academician at the National Academy in 1920. The acute accent in his surname is often dropped, but Franzén used it in his signature.

Sometime in the 1920s the artist sold his home in Maine. He was in Europe in 1921 and 1923 and married there in 1924. He continued to paint in his New York studio, however, until his death at the age of seventy-four.

BIBLIOGRAPHY: "American Studio Talk," *International Studio* 12 (Jan. 1901), p. xiii // *American Art News* 3 (March 4, 1905), [p. 6] and (May 6, 1906), [p. 3], contains brief announcements about Franzén's activities // "August Franzen, Painter," clipping from *Bar Harbor Life*, [1907], in G. W. Stevens Collection, D34, Arch. Am. Art, contains an interview with the artist // "August Reynolds Franzen," interview, March 1927, De Witt M. Lockman Papers, NYHS, microfilm 503, Arch. Am. Art, the most complete account of the artist // Obituary: *New York Times*, Sept. 8, 1938, p. 24.

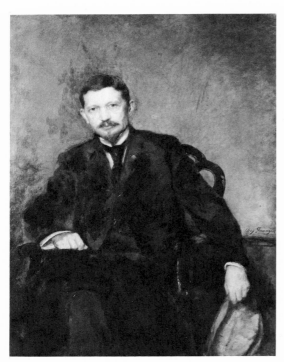

Franzén, *Alphonso T. Clearwater.*

Alphonso T. Clearwater

This portrait of Alphonso Trumpbour Clearwater (1848–1933) was painted after 1893, when Franzén began to specialize in portraiture, and by 1907, when it was exhibited in New York. The realistic treatment of the sitter's face and the understated pose recall the work of Franzén's academic teachers and place him among the more conservative artists of his day.

The subject was a well-known judge and a collector. Born at West Point, New York, Clearwater was admitted to the New York bar in 1871. He was district attorney in Ulster County from 1877 to 1886 and served as a county judge there from 1889 until 1898. He was then appointed a justice of the New York State Supreme Court. In addition to his distinguished legal career, Clearwater was active in civic affairs. Beginning around 1906, he formed an important collection of American silver, which according to R. T. H. Halsey, "demonstrated to the thousands who have studied it the dignity and the beauty of our Colonial craftsmanship" (*American Silver of the XVII & XVIII Centuries* [1920], p. x). Clearwater's collection of silver and this portrait were left to the museum at the time of his death.

Oil on canvas, 48⅝ × 37⅜ in. (123.5 × 94.9 cm.).
Signed at lower right: *Aug Franzén.*
REFERENCE: *Bar Harbor Life* [1907], clipping of an interview with Franzén, in G. W. Stevens Collection, D34, Arch. Am. Art, mentions it.
EXHIBITED: M. Knoedler and Co., New York, 1907, *Portraits by August Franzen,* no. 5, as Hon. A. T. Clearwater // PAFA, 1910, no. 566, as Portrait, lent by Hon. A. T. Clearwater // Carnegie Institute, Pittsburgh, 1910, no. 87, as Portrait of the Honorable A. T. Clearwater.
EX COLL.: Alphonso T. Clearwater, Kingston, N.Y., until 1933.
Bequest of Alphonso T. Clearwater, 1933.
33.120.344.

ALBERT STERNER

1863–1946

Albert Edward Sterner first achieved recognition and made his most original contribution as an illustrator and printmaker. He was born in London, the son of American parents. His father was a merchant. During the early 1870s the family lived in Brussels. In 1874, however, they settled in Birmingham, England, where Sterner studied at King Edward's School. He showed artistic ability, and was soon sent to Birmingham Art Institute, where he attended drawing classes two afternoons a week. In the late 1870s Sterner's father had financial prob-

lems and the family went to the United States, leaving young Sterner with relatives in Germany. After an unhappy period as a clerk in Gaggenau, he ran away to Freiburg, where he lived for at least six months. He joined his family in Chicago sometime between 1879 and 1882. There he worked first for the lithographers Shober and Carqueville and then for a German named Bertram. He also assisted Walter Wilcox Burridge (1857–1913) painting scenery and collaborated with the librettist Harry B. Smith to produce illustrated articles for a local publication.

Over the next two decades, Sterner divided his time between New York, where he settled in 1885, and Europe. He spent five months in Paris in 1886 studying at the Académie Julian under Gustave Boulanger and Jules Joseph Lefebvre. He attended the Ecole des Beaux-Arts, "and drew in the afternoon from the antique casts in the gallery of that school" (*Art Age* 6 [Nov. 1887], p. 67). He returned to Paris in 1891, exhibited at the Paris Salon, and worked independently. Throughout this period he did illustrations for such periodicals as *Life*, *Century*, *St. Nicholas*, and *Harper's*. His first notable commission for book illustration was George William Curtis's *Prue and I* (1892). The one hundred pen-and-ink and wash drawings done for this publication comprised his first one-man exhibition, held in New York at Keppel's in 1894. Regarding his work as an illustrator, he told an interviewer: "I am afraid that there is serious danger in the tendency to consider illustration as something apart from serious art work, something mechanical, something partaking of business rather than art, and I fight against it as hard as I can" (*Bookbuyer* 11 [June 1894], p. 246). Sterner worked in other media as well. In 1893 he joined the American Water Color Society. Two years later, during a stay in Germany, he continued to experiment with lithography. His lithographs were printed in Munich at the firm of Klein and Volbert, and he sold his work to two German institutions. Sterner did not work in this medium again until 1912, the year after a successful exhibition of his early lithographs was held at the Berlin Photographic Gallery in New York.

When Sterner came back to the United States, he settled in Nutley, New Jersey. A group of sensitive portrait drawings, many in red chalk, were exhibited at M. Knoedler and Company, New York, in 1901. Sterner's drawings, lithographs, and the monotypes he was working on by 1908 show the same strong draftsmanship as his illustrations. His direct treatment and uneasy psychological effects were probably the result of his contact with the European symbolist and expressionist movements.

Sterner, who moved to Newport in 1907, was a founder of the Art Association of Newport and taught there. By 1915 he was back in New York, where he helped to establish the Painter-Gravers of America, an organization that promoted the appreciation of printmaking. That same year M. Knoedler and Company held an exhibition of his pastels. Two years after his divorce in 1922 from Marie Walther Sterner, who ran an art gallery, he married Flora Lash. For the remainder of his career, he enjoyed continued success. Several New York galleries sponsored one-man shows for him, and his work was frequently included in major annual exhibitions. He became an academician at the National Academy of Design in 1934, twenty-four years after his election as an associate there.

Relatively little is known about Sterner's oil paintings. Although he was exhibiting paintings in Paris and New York in the early 1890s, it was not until 1905, when one of his portraits won a medal at an exhibition in Munich, that he achieved recognition for his work in this medium.

His figure studies and portraits are painted in dark colors and executed in a broad, facile style. He painted landscapes in the Berkshires in the late 1920s, and his still lifes also seem to date from late in his career. He continued to paint up until his death at the age of eighty-three. His son Harold Sterner (1895–1976) was also a painter.

BIBLIOGRAPHY: Arthur Hoeber, "Albert E. Sterner," *Brush and Pencil* 5 (Feb. 1900), pp. 192–200 // Christian Brinton, "Apropos of Albert Sterner," *International Studio* 52 (May 1914), pp. lxxi–lxxviii // Martin Birnbaum, "Albert Sterner's Lithographs," *Print Collector's Quarterly* 6 (April 1916), pp. 213–224. Discusses and illustrates the artist's lithographs, providing a list of those done before that date // Mary Siegrist, "Problems of Art: An Interview with Albert Sterner," *Outlook* 137 (May 21, 1924), pp. 99–102 // Ralph Flint, *Albert Sterner: His Life and Work* (New York, 1927). The most detailed discussion of the artist's life and work, includes illustrations.

Celery, Cock and Bowl

Sterner, in an interview in 1924, asserted that even a "prize cock . . . is a magnificent subject . . . , providing the artist can make it beautiful" (*Outlook* 137 [May 21, 1924], p. 102). In this still life, done nine years later, he chose a dead cock as his subject and painted it lying on a crisp white cloth. Behind the bird on the blue tabletop is a crystal vase filled with celery and a blue and white soup tureen. Some vegetables balance the composition on the right.

Painted in clear bright colors with fluid brushwork, *Celery, Cock and Bowl* is essentially a decorative painting. It represents a style and genre adopted by the artist in the final decades of his career. The simple subject and careless draftsmanship are a departure from his earlier realistic paintings.

Oil on canvas, 25 × 30¼ in. (63.5 × 76.8 cm.).

Signed and dated at upper left: Albert Sterner/ 1933.

REFERENCES: A. Sterner, letter in MMA Archives, March 30, 1933, says that his wife acted as "mediator" in the painting's sale to the museum, gives title, and expresses his pleasure at the museum's acquisition of his work; printed form, MMA Archives, April 4, 1933, says it was never exhibited.

EXHIBITED: Berkshire Museum, Pittsfield, Mass., 1941, *The Works of Albert Sterner*, intro. by S. C. Henry, no. 27 // Ira Spanierman, New York, 1968, *Albert Sterner*, no. 11, as Still Life.

EX COLL.: with the artist's wife, Flora Lash Sterner, as agent, 1933.

Arthur Hoppock Hearn Fund, 1933.

33.51.

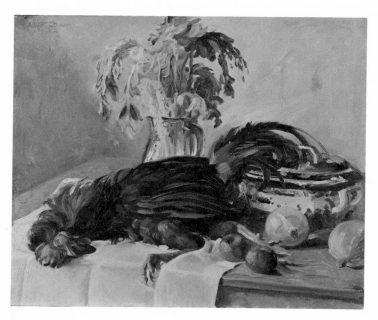

Sterner, *Celery, Cock and Bowl*.

LOUIS MICHEL EILSHEMIUS

1864–1941

The eccentric painter Louis Michel Eilshemius, a self-proclaimed poet, composer, inventor, and prophet, did most of his important painting before 1910. He was not much noticed, however, until 1917, when Marcel Duchamp (1887-1968) declared an Eilshemius painting one of the few really significant paintings in the exhibition of the Society of Independent Artists. Eilshemius was soon lionized by such avant-garde painters of the period as Joseph Stella (1877–1946) and Abraham Walkowitz (1878–1965). In 1920 and 1924 the Société Anonyme sponsored one-man shows of his work. In 1925, five years after the artist had ceased to paint, Valentine Dudensing organized the first of several Eilshemius exhibitions at the Valentine Gallery in New York.

Eilshemius was born at Laurel Hill, his parents' Arlington, New Jersey, estate. The family was wealthy and traveled widely. Eilshemius was educated first in Geneva and from 1875 to 1881 in Dresden. He studied agriculture at Cornell University from 1882 until 1884, when his father agreed to his studying art. Eilshemius enrolled in the Art Students League in New York and studied privately with the landscape painter Robert C. Minor (1839–1904). After two years in New York, he went to the Académie Julian in Paris. His training there was further augmented by a summer of study under the landscape painter Joseph Van Luppen in Antwerp. Not surprising Eilshemius's early works were almost exclusively landscapes. During the late 1880s and early 1890s they show the influence of John Baptiste Camille Corot and also the Barbizon painters, particularly in their clear, bright light.

Eilshemius returned to New York in 1888, and that year, as in 1887, his work was accepted for exhibition at the National Academy of Design. He also showed his paintings at the Pennsylvania Academy of the Fine Arts in 1890 and 1891. Following his father's death in 1892, he received a substantial inheritance and traveled in Europe and North Africa. He worked briefly in Los Angeles in 1893 and 1894 and then settled in New York. It was about this time that he became an untiring writer of letters to newspapers. He also wrote poetry, and during the course of his career he printed at least thirty books at his own expense, including one full-length novel, *Sweetbrier* (New York, 1901). He was editor of the *Art Reformer* in 1909, 1911, and 1912 and *Three Arts' Friend* from 1925 to 1926.

Although a few of his early paintings were accepted for exhibition, his career as an artist did not go well for many years. His entry for the World's Columbian Exposition in 1893 was rejected, and his 1897 exhibition at the New York shop of framemaker Philip Suval attracted no notice at all. Unable to establish close friendships with fellow artists, Eilshemius moved from studio to studio and in 1904 quit the Salmagundi Club where he had been a member for six years. In 1901 he made a trip to Samoa and the South Seas. His memories of that trip provided the subject matter for an important group of paintings he did between 1906 and 1909. In 1903 he went to Italy with the idea of opening a studio in Rome, but he soon returned to New York.

By 1897 Eilshemius's painting style had become less conventional. His landscapes, less

finished than before, have a stylized, almost primitive appearance. His subject matter also varied. He painted nudes, such as *Afternoon Wind*, 1899 (Museum of Modern Art, New York), which show women floating in tranquil landscapes. Nocturnal views of New York and literary subjects also engaged him. Many of his paintings, such as *American Tragedy: Revenge*, ca. 1901 (Hirshhorn Museum and Sculpture Garden, Washington, D.C.), show a preoccupation with death and violence.

Following his unsuccessful studio exhibition in 1909, Eilshemius began to issue handbills that glorified his artistic achievements, and it was obvious that he was suffering from delusions. By 1910 his ability declined dramatically; his works were not only fewer and smaller in scale but of far less quality. He often chose to paint on such supports as cigar box lids and surrounded his compositions with painted frames. He continued to paint until about 1920.

By the early 1930s, a number of museums, including the Metropolitan, had acquired his paintings, but by this time the artist was ill and embittered. He felt his genius had gone unrecognized. Injured in an automobile accident in 1932, he was confined to his home in New York where his brother looked after him. Eilshemius died in December 1941 of pneumonia.

BIBLIOGRAPHY: William Schack, *And He Sat Among the Ashes* (New York, 1939). An appreciative biography // Eilshemius File, [1940s–1950s], Whitney Museum of American Art, New York, microfilm NWh2 and NWh3, Arch. Am. Art. Contains the files of the American Art Research Council which has information compiled by dealers and collectors and includes catalogues, photographs, and bibliographic material // Paul J. Karlstrom, "Louis Michel Eilshemius, 1864–1941: A Monograph and Catalogue of the Paintings," Ph.D. diss., University of California, Los Angeles, 1973. Includes a detailed biography, critical discussion of the artist's work, and a catalogue of the artist's paintings // Paul J. Karlstrom, *Louis Michel Eilshemius* (New York, 1978). Discussion of the artist's life and work, based on the author's dissertation, with many illustrations // Hirshhorn Museum and Sculpture Garden and Smithsonian Institution Traveling Exhibition Service, *Louis M. Eilshemius: Selections from the Hirshhorn Museum and Sculpture Garden* (1978), exhib. cat. by Paul J. Karlstrom. Includes an essay on Eilshemius and modernism, a detailed catalogue of works, chronology, bibliography, and many color illustrations.

Delaware Water Gap Village

Delaware Water Gap Village depicts a scenic area in Pennsylvania, where the Delaware River cuts through the Kittatinny Mountain ridge to New Jersey. It shows the influence of French landscape painting, especially the work of Jean Baptiste Camille Corot, and was probably painted soon after Eilshemius's return from Paris in 1888. The picture has been compared to Corot's *View of Saint-Lô*, 1850–1857 (Louvre, Paris), in both style and composition. Like Corot, Eilshemius organized his composition in broad bands parallel to the picture plane. The most detailed treatment is in the middle ground, where the geometric shapes of the buildings are relieved by soft foliage, represented by scumbled patches of paint. He also adopted Corot's use of a cool, clear light.

Perhaps because this picture was inspired by such a popular and successful painting style, it was included in exhibitions at both the National Academy of Design and the Pennsylvania Academy of the Fine Arts. When submitted for exhibition at the World's Columbian Exposition in Chicago in 1893, however, it was rejected. This was the beginning of a long series of rejections that plagued Eilshemius until about 1917.

Oil on canvas, 25⅛ × 30 in. (63.8 × 76.2 cm.).
Signed at lower right: Eilshemius.
REFERENCES: W. Schack, *And He Sat Among the Ashes* (1939), p. 50, says that in 1888 the NAD accepted for exhibition this painting, which had been done the previous summer in Milford, Pennsylvania; p. 68, notes that it was rejected for the World's Columbian Exposition // M. Fried, orally, June 1950, said that the painting was sold to the artist's father who willed it to his son Henry, and it remained in the Eilshemius

Eilshemius, *Delaware Water Gap Village*.

home until Fried bought it around 1935 // Artists' Gallery, New York, "Masterpieces of Eilshemius, Notes on the Paintings," [1959], no. 1, gives provenance // P. J. Karlstrom, "Louis Michel Eilshemius, 1864–1941," Ph.D. diss., University of California, Los Angeles, 1973, 1, p. 48, n 21, notes its exhibition at NAD; pp. 76–77, compares it to landscape by Corot; p. 99, n 33, notes similarity to compositions by Claude Lorrain; p. 109, notes similarity to Hudson River School landscapes; ill. p. 366, fig. 24, dates it about 1886; 2, p. 7, includes it as no. 3 in a catalogue of the artist's work and gives exhibition history and provenance, dating Fried's acquisition 1937; *Louis Michel Eilshemius* (1978), p. 44, discusses it, noting similarity to Corot's View of Saint-Lô; p. 45, color pl. 32; p. 56, notes it as an example of the artist's early style; p. 104, n 4, discusses its exhibition history; p. 110, says it was rejected by Chicago exposition.

EXHIBITED: NAD, Autumn, 1888, no. 415, as Delaware Water Gap Village, Pa., for sale, $150 // PAFA, 1891, no. 91 // Artists' Gallery, New York, and Phillips Collection, Washington, D.C., 1959, *Masterpieces of Eilshemius*, no. 1, dates it about 1886.

Ex COLL.: the artist's father, Henry G. Eilshemius, Arlington, N.J., until 1892; the artist's brother, Henry G. Eilshemius, New York, 1892– about 1935; Maurice Fried, New York, about 1935–1950.

Arthur Hoppock Hearn Fund, 1950.

50.125.

Girl in a Field

In this work, dated 1889, a girl in a white dress stands viewing a meadow. The sparseness of foliage on the tree beside her and the sprinkling of flowers in the foreground suggest that it is

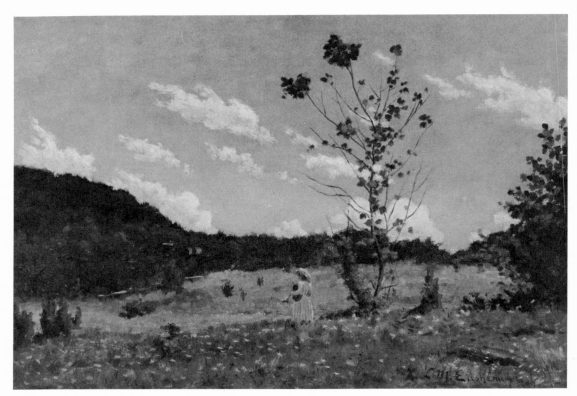

Eilshemius, *Girl in a Field*.

spring. The picture contains some of the deliberately primitive aspects characteristic of Eilshemius's painting style, which became more exaggerated over the next decade. Three-dimensional objects like the limbs and trunks of trees are not modeled but are painted in single lines. Details, such as leaves and flowers, are reduced to daubs of paint.

Oil on canvas, 14⅜ × 20½ in. (36.5 × 52.1 cm.).

Signed and dated at lower right: L. M. Eilshemius / 1889.

REFERENCES: [V. Dudensing], "List of Eilshemius Paintings," [1930s], Louis M. Eilshemius Papers, D193, Arch. Am. Art, includes it as no. 874, Girl in a Field, in an inventory of the artist's paintings sold by Valentine Gallery; says it was sold to S. C. Clark // V. Dudensing, "Paintings by Eilshemius owned by Valentine Gallery," Jan. 1944, Eilshemius File, Whitney Museum of American Art, New York, microfilm NWh2, Arch. Am. Art, notes that the painting was sold to Clark // P. J. Karlstrom, "Louis Michel Eilshemius, 1864–1941," Ph.D. diss., University of California, Los Angeles, 1973, 2 p. 11, includes it as no. 25 in a catalogue of the artist's paintings.

EX COLL.: with Valentine Gallery, New York,

1930s; Stephen C. Clark, New York, by 1944–died 1960; his wife, Susan Vanderpoel Clark, New York, until 1967.

Bequest of Susan Vanderpoel Clark, 1967.

67.155.4.

Delaware Water Gap Village

One of several views Eilshemius painted of the Delaware Water Gap region during his frequent visits there, the painting was done in the late 1890s. When compared to his earlier work of the same title (see above), this painting shows a new phase in his development. There is none of the Barbizon-inspired naturalism of his earlier paintings, and the style is intentionally primitive. Some details, like the tree trunks and the fence along the roadway, are done with single child-like strokes of paint. Other parts of the picture, for example, the distant meadows and hills, are merely flat, unmodeled areas of color. The puffy clouds and rounded crowns of the trees are highly

stylized. The painting bears the signature which the artist used between 1888 and 1913.

Oil on canvas, 18 × 35⅛ in. (45.7 × 89.2 cm.).
Signed at lower left: Elshemus.

REFERENCES: R. Flint, *Art News* 31 (Nov. 27, 1932), p. 4, mentions it in the Whitney Biennial // D. Dayton, *New York Sun*, Dec. 24, 1932 // L. M. Eilshemius, printed form in MMA Archives, Dec. 30, 1932, says it was painted in 1898 and lists exhibitions; letter in MMA Archives, Jan. 3, 1933, says that he appreciates "that the Metropolitan acquired *one* of my best paintings" // *Art News* 31 (Jan. 7, 1933), p. 10 // L. M. Eilshemius, letter to J. Force, Jan. 14, 1933, Eilshemius File, Whitney Museum of American Art, New York, microfilm NWh3, Arch. Am. Art, says "Your appreciation to hand. Glad my oil painting proved favorable to your Exhibit. Also, it developed into a sale to the Metropolitan Museum of Art. This was gratifying to me" // *Studio News* 4 (Jan. 1933), ill. p. 3 // E. M. Benson, *American Magazine of Art* 27 (Sept. 1934) ill. p. 541 // M. MacKaye, *New Yorker* 11 (Sept. 14, 1935), p. 24, discusses its purchase // [V. Dudensing], "List of Eilshemius Paintings," [1930s], Louis M. Eilshemius Papers, D193, Arch. Am. Art, includes it as no. 528 in an inventory of the artist's work sold by Valentine Gallery, dates it 1894 // E. McCausland, *Springfield* [*Mass.*] *Union and Republican*, August 23, 1936, p. 6E // Valentine Gallery, 1937, told J. L. A[llen], MMA, that it dates from 1895 to 1900 // W. Schack, *And He Sat Among the Ashes* (1939), ill. p. 59, dates it ca. 1895; p. 272 // Records of the American Art Research Council, [1940s], Eilshemius File, Whitney Museum of American Art, New York, microfilm NWh2, Arch. Am. Art, lists references and provenance // K. Klitgaard, *Through the American Landscape* (1941), p. 9; ill. opp. p. 20 // Bernard Danenberg Galleries, New York, *The Romanticism of Eilshemius*

(1973), exhib. cat. by P. J. Karlstrom, pp. 16–17 // P. J. Karlstrom "Louis Michel Eilshemius, 1864–1941," Ph.D. diss., University of California, Los Angeles, 1973, 1, pp. 39–40; ill. p. 359, fig. 9, dates it about 1895; 2, p. 21, includes it as no. 77 in a catalogue of the artist's paintings // U.S. Embassy, Moscow, *Amerikanskaya Zhivopis, 1830–1974* [*American Painting, 1830–1974*] (1974), color ill. p. 22 // P. J. Karlstrom, *Louis Michel Eilshemius* (1978), pp. 38–39, discusses its acquisition; p. 105 n 18, says privately the artist was pleased that his painting was acquired by the museum; p. 112; pl. 109.

EXHIBITED: Valentine Gallery, New York, 1932, *Louis M. Eilshemius*, no. 17, as Iron Mt. House, Delaware Water Gap (probably this painting) // Whitney Museum of American Art, New York, 1932–1933, *First Biennial Exhibition of Contemporary American Paintings*, ill. no. 95, // MMA, 1950, *20th Century American Painters*, p. xv // New Jersey State Museum, Trenton, 1965, *New Jersey and the Artist* (cat. alphabetical), dates it 1898.

ON DEPOSIT: U.S. ambassador's residence, Spaso House, Moscow, 1974–1979.

EX COLL.: with Valentine Gallery, New York, 1932.
Arthur Hoppock Hearn Fund, 1932.
32.168.

Birthplace of the Artist

This painting of Laurel Hill, the Eilshemius family home in Arlington, New Jersey, was done in 1902. It shows the estate where the artist was born and spent some of the happiest years of his childhood. The picture is nostalgic, like his poem "Short Recollection of My Home: Laurel Hill," which ends "Be immortal in memory mine, to the last" (*Fragments and Flashes of Thought* [1907],

Eilshemius, *Delaware Water Gap Village.*

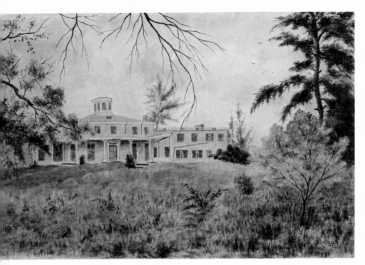

Eilshemius, *Birthplace of the Artist.*

Oil on canvas, 20 × 30 in. (50.8 × 76 cm.).

Signed at lower right: Elshemus. /1902.

REFERENCES: [A. M. de Groot], form for American Art Research Council, August 2, 1943, Eilshemius File, Whitney Museum of American Art, New York, microfilm NWh2, Arch. Am. Art, says it was purchased from the artist in 1937 and is on deposit in Springfield // P. J. Karlstrom, "Louis Michel Eilshemius, 1864–1941," Ph.D. diss., University of California, Los Angeles, 1973, 1, p. 13, says Laurel Hill is the subject of several "nostalgic canvases"; p. 46, n 4, says this painting is an example of the artist's depictions of his childhood home; p. 355, fig. 1; 2, p. 30, includes it as no. 128 in a catalogue of the artist's paintings, gives provenance and exhibition for it.

EXHIBITED: New Jersey State Museum, Trenton, 1965, *New Jersey and the Artist* (catalogue alphabetical), lent by Adelaide Milton de Groot // American Federation of Arts, traveling exhibition, 1975–1976, *The Heritage of American Art*, exhib. cat. by M. Davis, no. 88; ill. p. 194; p. 195, discusses it; (rev. ed., 1977), no. 91; ill. p. 200; p. 201.

ON DEPOSIT: Museum of Fine Arts, Springfield, Mass., 1942–1956, lent by Adelaide Milton de Groot // MMA, 1956–1967, lent by Adelaide Milton de Groot.

EX COLL: the artist, New York, until 1937; Adelaide Milton de Groot, New York, 1937–1967.

Bequest of Miss Adelaide Milton de Groot (1876–1967), 1967.

67.187.150.

p. 381). The artist's preoccupation with his childhood and himself grew until he lost touch with reality. Toward the end of his life, he suffered from delusions of grandeur.

Eilshemius painted several pictures of his boyhood home. Some of these, for example, *Laurel Hill, Arlington, New Jersey,* 1907 (private coll., New York; ill. P. J. Karlstrom, *Louis Michel Eilshemius*, pp. 14–15), are known to have been done from photographs. Such a working method would explain the stiffness of the Metropolitan painting. It is thinly painted with no attempt at modeling. The house is outlined and then filled in with color. The trunks and limbs of the trees are only single brushstrokes, and the leaves are scumbled paint. Eilshemius began to work in this deliberately primitive style in the early 1890s. The painting is signed with the shortened signature that he used between about 1890 and 1913.

Landscape, Binghamton, New York

Eilshemius's view of the Susquehanna Valley from the Lookout, a summit in Binghamton's Ross Park, is dated 1907. A rustic summer house is seen in the foreground and in the distance Mount Prospect. The landscape is painted in the primitive, almost crude style that the artist developed beginning in the late 1890s. In a letter to the editor of the *New York Sun* in 1936, he cited this painting as an example of his method of combining impressionist effects with a finished treatment: "You see I painted the impression first, then the second draft I introduced most of the interesting detail. Thus I was partial to the detailist, at the same time delighting the impressionist."

The painting has the form of signature Eilshemius often used from about 1888 to 1913.

Oil on composition board mounted on masonite 26½ × 37⅞ in. (67.3 × 96.2 cm.).

Signed and dated at lower right: Elshemus/1907.

REFERENCES: J. Lansing, Paintings Department, MMA, record in Dept. Archives, 1934, identifies the site and buildings in the picture // *Art News* 33 (Jan.

Eilshemius, *Landscape, Binghampton, New York.*

12, 1935), ill. p. 12 // L. M. Eilshemius to the editor of the *New York Sun*, Feb. 16, 1936, Henry McBride Papers, Collection of American Literature, Beinecke Rare Book and Manuscript Library, Yale University, microfilm NMcB10, Arch. Am. Art., discusses the painting as an example of his combining detail with impressionist effects (quoted above) // [V. Dudensing], "List of Eilshemius Paintings," [1930s], Louis M. Eilshemius Papers, D193, Arch. Am. Art, includes it as no. 823 in an inventory of the artist's paintings sold by Valentine Gallery and lists the Metropolitan Museum as the purchaser // W. Schack, *And He Sat Among the Ashes* (1939), p. 146, discusses it // Records of the American Art Research Council [1940s], Eilshemius File, Whitney Museum of American Art, New York, microfilm NWh2, lists references // P. J. Karlstrom, "Louis Michel Eilshemius, 1864–1941," Ph.D. diss., University of California, Los Angeles, 1973, 1, p. 57, note 84; p. 125, quotes the artist's comments on it (1936) and discusses the scene; pp. 126, 158, note 19; p. 397, fig. 70; 2, p. 38, includes it as no. 170 in a catalogue of the artist's paintings; *Louis Michel Eilshemius* (1978), pp. 60, 106, note 6.

EXHIBITED: City Art Museum of St. Louis, 1934, no. 17, as Landscape, Binghamton, New York, lent by Valentine Gallery.

EX COLL.: with Valentine Gallery, New York, by 1934.

George A. Hearn Fund, 1934.

34.157.

Sunset, Samoa

Based on Eilshemius's recollections of his trip to Samoa in 1901, this tropical landscape of women bathing was painted in 1907, during a period when the artist was concentrating on South Sea subjects. In a landscape setting, which is intentionally simplified, he has framed the scene on two sides with bushy trees. The other elements are arranged in horizontal bands parallel to the picture plane. Tall trees, a bridge, and two bathers are silhouetted against a slightly abstract landscape. The figures, awkwardly drawn and in exaggerated poses, foreshadow the grotesque treatment of the nude that was later a hallmark of Eilshemius's style.

The spelling of the artist's name in the signature is typical for the period.

Oil on composition board, $23\frac{3}{8} \times 27\frac{5}{16}$ (59.4 × 69.4 cm.).

Signed at lower left: Elshemus / 1907.

REFERENCES: [V. Dudensing], "List of Eilshemius Paintings," [1930s], Louis Michel Eilshemius Papers, D193, Arch. Am. Art, includes the picture as no. 543 in an inventory of the artist's paintings sold by Valen-

tine Gallery and lists purchaser as de Groot // H. Cahill and A. H. Barr, Jr., *Art in America in Modern Times* (1934), ill. p. 44, as Sunset, Samoa, owned by Valentine Gallery // Records of the American Art Research Council, [1940s], Whitney Museum of American Art, New York, microfilm NWh2, Arch. Am. Art, notes that Lloyd Goodrich examined it in November 1944 // P. J. Karlstrom, "Louis Michel Eilshemius, 1864–1941," Ph.D. diss., University of California, Los Angeles, 1973, 2, p. 44, includes it as no. 203 in a catalogue of the artist's paintings, gives provenance.

EXHIBITED: Columbus Gallery of Fine Arts, Ohio, 1958, *Masterpieces from the Adelaide Milton de Groot Collection*, no. 13, as Samoa.

ON DEPOSIT: MMA, 1936–1967, lent by Adelaide Milton de Groot.

EX COLL.: with Valentine Gallery, New York, by 1934; Adelaide Milton de Groot, New York, by 1936–1967.

Bequest of Miss Adelaide Milton de Groot (1876–1967), 1967.

67.187.159.

Eilshemius, *Sunset, Samoa.*

New York at Night

This city view dates from about 1910. Eilshemius painted scenes like this one often after 1907, probably in response to paintings by members of the so-called Ashcan School like John Sloan

(1871–1951) and Robert Henri (1865–1929), who did much to popularize urban subjects. The painting emphasizes the loneliness and alienation of urban life. The eerily lighted street, where a man hastens toward the viewer as a couple walk away arm in arm, suggests a distinct mood of isolation. The extreme length of the shadows, the brightness of the full moon, and the glare of the street lights only add to this feeling. Eilshemius wrote of the city as a dehumanizing force in a 1905 poem "New York" in which he called it a "godless Monster . . . merciless to man and beast" (*Fragments and Flashes of Thought* [1907], p. 397).

He signed the painting with the signature he used from about 1888 to 1913.

Oil on composition board, 28 × 22⅜ in. (71.1 × 56.8 cm.).

Signed at lower right: Elshemus.

REFERENCES: [A. M. de Groot], form for the American Art Research Council, August 2, 1943, Eilshemius File, Whitney Museum of American Art, New York, microfilm NWh2, Arch. Am. Art, says that she purchased the painting from the artist in 1936 and that it is on deposit in Springfield // P. J. Karlstrom, "Louis Michel Eilshemius, 1864–1941," Ph.D. diss., University of California, Los Angeles, 1973, 1, p. 200, note 6, dates it about 1910; 2, p. 68, includes it as no. 340 in a catalogue of the artist's paintings and notes that although Geldzahler dates it 1917, the form of the signature indicates that it was done before 1913.

EXHIBITED: Columbus Gallery of Fine Arts, Ohio, 1958, *Masterpieces from the Adelaide Milton de Groot Collection*, no. 12 // MMA, 1965, *American Painting in the Twentieth Century*, exhib. cat. by H. Geldzahler, pp. 120–121, dates it about 1917.

ON DEPOSIT: Museum of Fine Arts, Springfield, 1939–1956, lent by Adelaide Milton de Groot // MMA 1956–1967, lent by Adelaide Milton de Groot.

EX COLL.: Adelaide Milton de Groot, New York, 1936–1967.

Bequest of Miss Adelaide Milton de Groot (1876–1967), 1967.

67.187.158.

Eilshemius, *New York at Night.*

Tragedy of the Sea

Sometimes called *Found Drowned*, this painting
is dated 1916. The subject is vaguely reminiscent
of the classical story of Hero, a priestess of
Aphrodite at Sestos, and Leander, her lover,
who swam across the Hellespont from Abydos to
see her each night. When the light that guided
him was extinguished by a storm, Leander
drowned, and Hero, grieved by her loss, followed
him into the sea. In an 1895 poem entitled
"Death" the artist described walking along a
deserted beach and fantasized about his own
death by drowning:

> . . . It was such easy doing
> No pain, no tomb, no prayers, no suing,—
> Walk through the breakers, on and on,
> Till all the swells would cover me,
> So die, unwept, unknelled, alone,
> In moment's time, so silently
> (*The Moods of a Soul* [1895], p. 48).

Oil on composition board, 40 × 61⅛ in. (101.6 ×
155.3 cm.).

Signed and dated at lower right: *1916—Eilshemius—*
REFERENCES: E. A. Jewell, *New York Times*, Jan.
12, 1933, p. 15, mentions it in a review of Valentine
Gallery exhibition; Jan. 15, 1933, sec. 9, ill. p. 12, as
Tragedy at Sea // Photograph, [1930s], Louis M.
Eilshemius Papers, D193, Arch. Am. Art, inscribed,
probably by V. Dudensing, as inventory no. 622, sold
to de Groot // L. M. Eilshemius to H. McBride, Dec.
5, 1937, Henry McBride Papers, Collection of Ameri-
can Literature, Beinecke Rare Book and Manuscript
Library, Yale University, microfilm NMcB10, Arch.
Am. Art, describes it as a marine // W. Schack, *And
He Sat Among the Ashes* (1939), ill. p. 239, as Found
Drowned, lent by Adelaide Milton de Groot to Wads-
worth Atheneum // D. Phillips, *Magazine of Art*, 32
(Dec. 1939), p. 724, discusses it // Records of the
American Art Research Council, [1940s], Eilshemius
File, Whitney Museum of American Art, New York,
microfilm NWh2, notes that it is on loan to the Wads-
worth Atheneum // L. Goodrich, in J. I. H. Baur,
ed., *New Art in America* (1957), ill. p. 36, as Tragedy or
Found Drowned // Artists' Gallery, New York, "Mas-
terpieces of Eilshemius, Notes on the Paintings,"
[1959], no. 31, gives exhibition and references //
P. J. Karlstrom, "Louis Michel Eilshemius, 1864–
1941," Ph.D. diss., Univ. of California, Los Angeles,
1973, 1, p. 179, discusses it as an example of Eilshe-
mius's interest in the theme of death; ill. p. 423, fig.
117; 2, p. 105, includes it as no. 568 in a catalogue of
the artist's work; gives provenance, references, and
exhibition; *Louis Michel Eilshemius* (1978), pp. 75, 77,
discusses it; ill. p. 76, pl. 56.

EXHIBITED: Valentine Gallery, New York, 1933, *A
Group of Paintings, 1916–1917, by Louis M. Eilshemius*, no.

Eilshemius, *Tragedy of the Sea.*

4, as Tragedy of the Sea // Wadsworth Atheneum,
Hartford, 1930, *Adelaide Milton de Groot Loan Collection*
(no cat.) // Artists' Gallery, New York, 1959, *Master-
pieces of Eilshemius*, no. 31, as Tragedy, lent by Adelaide
Milton de Groot.

ON DEPOSIT: Wadsworth Atheneum, Hartford,
1936–1956, lent by Adelaide Milton de Groot //
MMA, 1956–1967, lent by Adelaide Milton de Groot.

EX COLL.: with Valentine Gallery, New York, 1933;
Adelaide Milton de Groot, New York, by 1936–1967.

Bequest of Miss Adelaide Milton de Groot (1876–
1967), 1967.

67.187.160.

Haunted House

The *Haunted House* was painted around 1917.
According to the artist "the house & landscape
are real," and the painting was based on a
drawing he made in Auckland, New Zealand,
on his 1902 trip to the South Seas. The house is
in an isolated landscape, in which the dramatic
sunset sky and dark copse of trees at the right
contribute to a sense of foreboding. Eilshemius
complained, however, that at the time it was
exhibited the critics could not see the ominous
quality in the painting.

Applying his paint in an almost careless
fashion, Eilshemius has treated forms and tex-
tures in a generalized manner. He has also
simplified spatial relationships. This deliberately
primitive style is typical of his late works. He has
surrounded the landscape with a decorative
frame painted on the canvas, a feature that
became common in his work around 1910. Done
in yellow to simulate gilt and given an added
three-dimensional quality by a trompe l'oeil cast
shadow, the frame focuses attention on the center

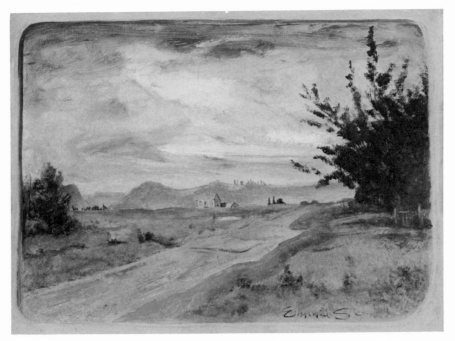

Eilshemius,
Haunted House.

of the composition and adds a further primitive touch to the painting.

Oil on composition board, mounted on masonite, 30¼ × 40½ in. (76.8 × 102.9 cm.).
Signed at lower right: Eilshemius—.

REFERENCES: M. Morsell, *Art News* 32 (Nov. 25, 1933), p. 16, mentions it in a review of an exhibition at Valentine Gallery // M. Davidson, *Art News* 35 (May 29, 1937), ill. p. 9; p. 10, discusses it in a review of contemporary works on view at MMA and calls it "a characteristic work" of the artist's later period // L. M. Eilshemius, letter in MMA Archives, [June 1937], says it was done from a drawing he made in New Zealand and discusses (quoted above) // C. Van Vechten, letter to V. Dudensing, Jan. 14, [1938], Louis M. Eilshemius Papers, D193, Arch. Am. Art, quotes Leo Stein's comment on it: "When I first saw the new acquisitions at the Metropolitan this winter I noticed one picture that was really good. The others at best good enough. I didn't know Eilshemius even by name. Afterwards I saw a number of others" // W. Schack, *And He Sat Among the Ashes* (1939), p. 12, says Leo Stein considered it the best painting in the American section at the museum; p. 210, says based on a sketch done fifteen years earlier in New Zealand; ill. p. 258, dates it ca. 1917 // D. Phillips, *Magazine of Art* 32 (Dec. 1939), p. 697, discusses it // Records of the American Art Research Council, [1940s], Eilshemius File, Whitney Museum of American Art, microfilm NWh2, Arch. Am. Art, lists exhibitions and references // S. Cheney, *The Story of Modern Art* (1941), ill. p. 381 // Artists' Gallery, New York, "Masterpieces of Eilshemius," Notes on the Paintings, [1959], no. 35, discusses history and exhibition record // P. J. Karlstrom, "Louis Michel Eilshemius, 1864–1941," Ph.D. diss., Univ. of California, Los Angeles, 1973, 1, p. 40; p. 111, discusses it; p. 386, fig. 54; 2, p. 111, includes it as no. 607 in a catalogue of the artist's paintings, gives provenance, exhibition, and references, and dates it about 1917; *Louis Michel Eilshemius* (1978), p. 39; p. 59, discusses the style of the painting; pl. 221.

EXHIBITED: Valentine Gallery, New York, 1932, *Louis M. Eilshemius, an Authentic American Painter: "Lyrical Poetry,"* no. 6, as Haunted House, Auckland, New Zealand // M. H. de Young Memorial Museum, California Palace of the Legion of Honor, San Francisco, 1935, *Exhibition of American Painting*, no. 316, lent by Valentine Gallery, dates it 1916 // Tate Gallery, London, 1946, *American Painting*, no 79 // MMA, 1950, *20th Century Painters*, p. 5, dates it about 1917 // Artists' Gallery, New York, and Phillips Collection, Washington, D.C., 1959, *Masterpieces of Eilshemius*, no. 35, dates it about 1917 // MMA, 1965, *American Painting in the 20th Century*, exhib. cat. by H. Geldzahter, pp. 119–120.

EX COLL.: with Valentine Gallery, New York, 1932–1937.

George A. Hearn Fund, 1937.

37.41.

GEORGE H. BOGERT

1864—1944

George Henry Bogert, a landscape painter who is often confused with the painter George Hirst Bogart (1864–1923), was born in New York. He was the son of Henry Bogert, a collector of coins and medals, and the nephew of J. Augustus Bogert, an engraver. He showed artistic talent young and seems to have begun his studies at the National Academy of Design in the early 1880s. In 1884, at the age of twenty, he went to France, and, after painting landscapes at Grez-sur-Loing, settled in Paris, where he reportedly studied with Raphael Collin, Aimé Nicolas Morot, and Pierre Puvis de Chavannes. Returning home four years later, he continued his training under THOMAS EAKINS, who taught in New York at the National Academy and the Art Students League between 1888 and 1895. Bogert began exhibiting his work at the National Academy in 1889, and the Society of American Artists elected him a member that same year.

During the 1890s Bogert made several trips abroad, traveling to the Isle of Wight, Venice, and Etaples in northern France, where he worked with the French plein-air painter Eugène Boudin. Major one-man exhibitions of his works were held in New York at Reichard and Company in 1893 and at Boussod Valadon and Company in 1894. As one critic wrote of the artist's endeavors:

> Mr. Bogert has been steadily forging ahead toward the leaders among American landscapists. He paints European seas and lands as often as American, but it is with a richness and a subtlety not acquired of any one foreign master. He belongs to the band of landscapists including Tryon, Ochtman, Dewey, Walker, and Twachtman, who look at nature unlike any foreigner. They approach nearest to Israels and Mesdag in Holland, Boudin in France. They are not the followers of the romantic landscapists of 1830, nor of the modern realists or painters of decomposed sunlight, yet they have leanings toward both these camps (*New York Times*, Nov. 20, 1893, p. 8).

By the end of the decade Bogert had begun to receive attention. In 1898 he won the Webb prize for the best landscape exhibited at the Society of American Artists and in 1899 the first Hallgarten prize for the best painting exhibited at the National Academy by an American artist under thirty-five. That same year he was elected an associate of the academy and joined the newly formed Society of Landscape Painters, a group of about a dozen artists working in the popular Barbizon and impressionist styles. Bogert won medals at the Paris Exposition in 1900, the Pan-American Exposition in 1901, and the St. Louis Exposition in 1904. His work was acquired by a number of prominent collectors of American art, most notably George A. Hearn, who presented his paintings to several museums, including the Metropolitan. Despite his popularity at the turn of the century, little is known about Bogert's later years. After 1900 he spent several summers in Holland, and, by the 1920s, he had joined the artists' colony in Old Lyme, Connecticut. He died in New York at the age of eighty after a brief illness. His artistic development remains unexamined. Several of his landscapes done around the turn of the century show Boudin's influence and also that of Gustave Courbet. His style is tempered, however, by the more conservative Barbizon mode popular in America. His Venetian views and Dutch beach scenes are Turneresque in their dramatic light effects, impasto, and loose

brushwork. Other paintings done at the same time, however, are more decorative. Executed with little modeling and almost no realistic detail such tonalist pictures as *September Evening* (q.v.) convey a quiet mood.

BIBLIOGRAPHY: City Art Museum, St. Louis, *A Collection of Paintings by Mr. George H. Bogert, A.N.A.* (1910), brief catalogue of a retrospective exhibition // "The Bogert Exhibition," *Academy Notes* 6 (April 1911), pp. 60–61 // *American Art Annual* 22 (1925), pp. 413–414, lists awards and collections that include examples of his work // Obituaries: *New York Times*, Dec. 14, 1944, p. 23; *Art Digest* 19 (Jan. 1, 1945), p. 20 // *National Cyclopaedia of American Biography* 33 (New York, 1947), p. 412.

September Evening

Painted in 1898, *September Evening* shows a darkened foreground with a graceful tree, the undulating outlines of its trunk and crown silhouetted against a flat backdrop of sky, foliage, and reflective water. This dramatic composition, with its asymmetrical arrangement and abrupt transition between foreground and background, recalls Claude Monet's *Antibes*, 1888 (Courtauld Institute Galleries, University of London). Like Monet, Bogert may have been inspired by Japanese prints. Stylistically, however, his picture owes little to impressionism. Predominately blue in tone, the scene is illuminated by soft moonlight. Touches of impasto indicate the stars in the sky, which are mirrored on the water below. The limited palette, silhouetted shapes, and romantic subject seem most influenced by JAMES MC NEILL WHISTLER'S nocturnes of the 1870s. The cool tonalities and thick, sometimes dense, paint application also resemble the treatment in paintings by one of Bogert's teachers, Puvis de Chavannes. Finally, the artist's use of evocative half lights and blurred forms may have been inspired by the soft-focus work of photographers at the turn of the century who manipulated their negatives and prints to create interpretive landscape views.

September Evening was one of Bogert's most successful paintings. When it was exhibited at the National Academy of Design in 1899, it won the

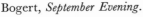
Bogert, *September Evening*.

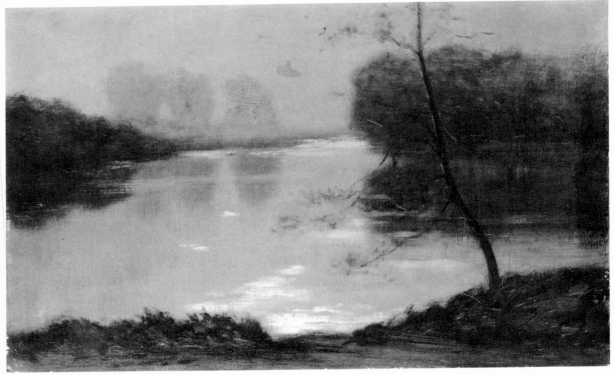

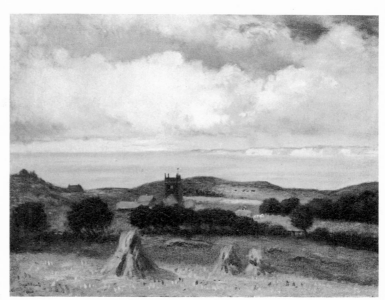

Bogert, *Chale, Isle of Wight,*
Looking Towards the Needles.

Hallgarten prize and was praised for its "senti-
ment and beauty." The painting was soon
purchased by the collector George A. Hearn.

Oil on canvas, 19¼ × 30⅝ in. (48.9 × 77.8 cm.).

Signed and dated at lower right: George H. Bogert.
98.

REFERENCES: *New York Daily Tribune*, April 1, 1899,
p. 8, in a review of the NAD exhibition, praises it
(quoted above) // *New York Times Saturday Review*,
April 1, 1899, p. 224, in a review of the NAD exhibition,
calls it "one of the best he has yet produced, soft in tone
and color, and filled with tender sentiment" // *Art
Amateur* 40 (May 1899), p. 115, in a review of the NAD
exhibition, notes that it won the Hallgarten prize //
Art Interchange 42 (May, 1899), p. 144, in a review of
the NAD exhibition, calls it "one of the most tender
and beautiful landscapes that has come from his easel"
and "perhaps the most poetic transcript of nature in
the Exhibition" // *New York Times*, March 31, 1901,
p. 20, describes it in a review of Hearn's collection on
exhibition at the Lotos Club // *The George A. Hearn
Gift to the Metropolitan Museum of Art . . .* (1906), p. 212.
discusses it; ill. p. 213, as October Moonlight // W. S.
Howard, *MMA Bull.* 1 (March 1906), p. 56 // *George
A. Hearn Gift to the Metropolitan Museum of Art . . .*(1913),
ill. p. 87, as October Moonlight.

EXHIBITED: NAD, 1899, no. 198, as September
Evening // Lotos Club, New York, 1901, *American
Paintings from the Collection of Mr. George A. Hearn*, no.
10A, as September Night // Pan-American Exposition,
Buffalo, 1901, *Catalogue of the Exhibition of the Fine Arts*,
no. 419, as September Evening, lent by George A.
Hearn // M. H. de Young Memorial Museum and
the California Palace of the Legion of Honor, San
Francisco, 1972, *The Color of Mood, American Tonalism,
1880–1910*, exhib. cat. by W. M. Corn, no. 5.

EX COLL.: George A. Hearn, New York, by 1901–
1906.

Gift of George A. Hearn, 1906.

06.1271.

Chale, Isle of Wight,
Looking Towards the Needles

Completed in 1900, the painting shows St.
Andrew's Church in Chale, a town on the Isle
of Wight. The view is looking west toward the
Needles, three tall landmark rocks not visible
in the picture. The work was commissioned in
1895 by George A. Hearn, whose ancestors were
connected with the church. Hearn, who donated
stained-glass windows to the parish, owned
another picture of St. Andrew's by Bogert. This
second view, which shows the church and tower
"seen close at hand" (*New York Times*, March
31, 1901, p. 20), may be the Chale painting now
in the University of Kentucky Art Museum,
Lexington.

The Metropolitan's landscape is described in
detail in a review of a 1901 exhibition of Hearn's
American pictures:

The outlook is over the church tower and the sea to a
line of white cliffs very beautifully bathing in the soft
atmosphere of England, and above this line appears
another line of cloud-cliffs in the sky, very restful, very
majestic. The correspondence between the real cliffs
floating unreal on the water and the cloud-cliffs
towering most real in the heavens gives the landscape
a particular splendor.

George H. Bogert

467

The emphasis on the sky in this simple landscape scene recalls works by seventeenth-century Dutch painters like Jan van Goyen. The view most closely resembles some of the plein-air marine paintings of the French artist Eugène Boudin, whom Bogert admired.

Oil on canvas, 28⅛ × 36⅛ in. (71.4 × 91.8 cm.).

Signed at lower left: *George H. Bogert* / 1900 / CHALE. Inscribed on reverse, vertically: CHALE / [illeg.] *Bogert*; horizontally: HEARN / [illeg.].

REFERENCES: *New York Times*, March 31, 1901, p. 20, reviews it in an exhibition of Hearn's collection at the Lotos Club (quoted above) // *The George A. Hearn Gift to the Metropolitan Museum of Art* . . . (1906), p. 212, says it was commissioned by Hearn in 1895 because one of his ancestors was a rector of Chale Church; ill. p. 213 // W. S. Howard, *MMA Bull.* 1 (March 1906), p. 56, discusses it // *George A. Hearn Gift to the Metro-politan Museum of Art* . . . (1913), ill. p. 87 // R. H. Mitchell, University Art Museum, University of Kentucky, Lexington, letter in Dept. Archives, Sept. 29, 1978, provides information about a second Bogert view of Chale.

EXHIBITED: Lotos Club, New York, 1901, *American Paintings from the Collection of Mr. George A. Hearn*, no. 10, as Chale, Isle of Wight, Looking Towards the Needles // Union League Club, New York, 1902, *Paintings from the Collection of George A. Hearn, Esq.*, no. 34, as Chale, Isle of Wight (possibly this painting) // Union League Club, New York, 1904, *Landscapes by Eight American Artists*, no. 4, as Chale—Isle of Wight, lent by George A. Hearn (possibly this painting).

EX COLL.: George A. Hearn, New York, by 1901–1906.

Gift of George A. Hearn, 1906.

06.1270.

DEWITT PARSHALL

1864–1956

Born in Buffalo, DeWitt Parshall was raised in Lyons, New York, where his family settled in 1870. He was educated in a nearby preparatory school and in 1885 graduated from Hobart College, in Geneva, New York. Parshall began his artistic training in Europe, attending the Royal Academy in Dresden from 1886 to 1887 and continuing his studies at the Académie Julian in Paris. He also attended a class given by ALEXANDER HARRISON in 1888–1889, and, at the same time, began to work under the French academic painter Fernand Cormon, who remained his instructor until 1891. Sketching tours of Europe and North Africa were probably made at this time. In 1890 Parshall exhibited a portrait at the Paris Salon.

Parshall settled in New York in 1893 and married two years later. He first exhibited at the National Academy of Design in 1897 but was not made an associate there until 1910. Very little is known about his artistic activities until that year, when he made a trip west with four other artists. Commissioned by the American Lithographic Company, Parshall traveled to Arizona with THOMAS MORAN, ELLIOTT DAINGERFIELD, F. Ballard Williams (1871–1956), and Edward Potthast (1857–1927) to do scenes of the Grand Canyon. Thereafter the canyon was his favorite subject, and, working in a decorative impressionist style, he depicted it under a variety of conditions. In 1912 he was among the founders of the Society of Men Who Paint the Far West, a group of painters of western subjects who held annual traveling exhibitions until at least 1917. He also served as secretary-treasurer of this organization. After his election as an academician in 1917, Parshall left New York and settled in Santa Barbara, where he became a member of the local artists' community. He began to exhibit at the California Art Club in 1919, and there were a number of retrospective exhibitions of his work. He served as vice president

of the Santa Barbara Museum of Art and director of the Faulkner Art Gallery there. Parshall suffered a stroke in 1955 and was hospitalized until his death a year later. His son Douglass Ewell Parshall (1899–) is also a painter.

BIBLIOGRAPHY: DeWitt Parshall, letter in Dept. Archives, May 28, 1909, provides biographical data // *American Art News* 9 [Nov. 5, 1910], p. 1, contains a note on the trip to the Grand Canyon // Obituary: *New York Times*, July 8, 1956, p. 64 // Santa Barbara Museum of Art, *DeWitt Parshall*, *N.A.* (May 6–26, 1957), checklist of a retrospective exhibition with a foreword by Ala Story // Nancy Dustin Wall Moure, with research assistance by Lyn Wall Smith, *Dictionary of Art and Artists in Southern California before 1930* (Los Angeles, 1975), provides brief biography and further bibliography.

The Great Abyss

After Parshall made his first trip to the Grand Canyon in November 1910, it was reported that he was enthusiastic "about the paintable qualities of that phenomenon" and intended to paint pictures from the sketches he had made "at once" (*American Art News* 9 [Dec. 17, 1910], p. 3). Following a second trip a year later, the canyon became his favorite subject. In this dramatic view, dated between 1910 and 1912, Parshall emphasizes the precipitous drop by excluding the rim of the canyon in the foreground. He is little concerned with topographical details and concentrates on formal expression and a "decorative arrangement," which he considered one of the chief aims in painting (D. Parshall to B. Grant, March 24, 1932, copy in DeWitt Parshall Papers, Arch. Am. Art).

Parshall, *The Great Abyss*.

Oil on canvas, 44¾ × 49⅞ in. (113.7 × 126.7 cm.). Signed at lower left: DeWitt Parshall N.A.

REFERENCES: D. Parshall to W. Macbeth, Nov. 8, 1912, Macbeth Gallery Papers, NMc10, Arch. Am. Art, says the painting is his contribution to the upcoming exhibition of the Society of Men Who Paint the Far West and prices it at $1,500 // *American Art News* 11 (Feb. 8, 1918), p. 8, in a review of Parshall's exhibition at the Folsom Galleries, says it "holds the place of honor" and "is beautiful in color and is a well proportioned and interesting composition" // A. Andersen, *Los Angeles Times*, Oct. 24, 1920, part III, p. 3, in a review of the annual exhibition of the California Art Club, says it is "a superb study" and "full of awe and mystery" // D. Parshall, letter in MMA Archives, March 9, 1921, offers the painting in exchange for another work by him (The Catskills) in the Hearn collection // *New York Times*, July 8, 1956, p. 64, mentions it in the artist's obituary // U.S. Embassy, Moscow, 1974, *Amerikanskaya Zhivopis, 1830–1970* [*American Painting, 1830–1970*] color ill. p. 25.

EXHIBITED: Macbeth Gallery, New York, 1912, *First Annual Exhibition by the Painters of the Far West*, no. 11, as The Great Abyss // Folsom Galleries, New York, 1913, *DeWitt Parshall* (no cat. available) // Art Institute of Chicago, 1913, *Painters of the Far West*, no. 14 // PAFA, 1914, no. 61 // NAD, Winter, 1914–1915, no. 125, as Great Abyss // Panama-Pacific International Exposition, San Francisco, 1915, *Official Catalogue of the Department of Fine Arts*, no. 2370, as Great Abyss // Art Institute of Chicago, 1917, *Paintings by DeWitt Parshall*, no. 14 // California Art Club, Los Angeles, 1920, no. 85.

ON DEPOSIT: U.S. ambassador's residence, Spaso House, Moscow, 1974–1979.

EX COLL.: the artist, New York and Santa Barbara, until 1921.

Gift of George A. Hearn, by exchange, 1921. 21.62.

INDEX OF FORMER COLLECTIONS

Flagg, Ellen Earle, 61
Flagg, Gertrude, 146
Fleishman, Mr. and Mrs. Lawrence A., 53
Fletcher, Isaac D., 348
Folsom, Harry, as subscriber, 400
Folsom Gallery, 166
Frantz, William, as agent, 449
Fried, Maurice, 457
Frost and Reed, probably, 55, 56
Fukushima, O., 39
Fuller, W. H., as subscriber, 180

G

Galerie St. Etienne, 392
Galka and Roman, 277
Gallery 144 West 13th Street, 378; probably, 375
Gary, Elbert H., 94, 193
Gary, Emma T., 94, 193
Gellatly, John, as agent, 104
Gerard, Leon, 183
Gibbs, Frederick S., 38, 43
Graham, James, and Sons
 (also Graham Gallery), 58, 106
Grand Central Art Galleries, 92, 412;
 as agent, 30, 32
Grant, Edna M., 38
Grant, Mr. and Mrs. Hugh J.
 (parents and son and wife), 38
Grant, Julia M., 38
Greenough, Mrs. Busch. *See* Reisinger,
 Mrs. Edmée Busch
Greims, Mary Hearn, 212
Guerry, George P., 173
Gump, S. & G., 372

H

Hadden, Mrs. Harold (Valerie Burckhardt), 229
Hare, Mrs. Meredith, 423
Harkness, Mary Stillman, 392
Harriman, Joseph W., 197
Hatch, Mr. and Mrs. John Davis, Jr., 205
Hay, Mr. and Mrs. Clarence L., 296
Hearn, Arthur H., 90
Hearn, George A., 10, 41, 43, 90, 102, 108, 109,
 129, 135, 143, 151, 166, 182, 198, 222, 283, 311,
 321, 335, 351, 358, 369, 406, 411, 428, 442, 467,
 468; as agent, 97, 155, 212, 436;
 as subscriber, 400
Hedges, John, 56
Heermann, Norbert, as agent, 66
Hellinger, Samuel and Bertha, 189
Hendricks, Ethel, 45
Hendricks, Harmon W., 45
Hendricks, Helen R., 45
Henning, E. F., as subscriber, 404
Hepburn, A. Barton, as subscriber, 400
Hewitt Gallery, Edwin, 50

Hilton, Mrs. G. P., as subscriber, 400
Hirschl and Adler Galleries
 (also Norman Hirschl Gallery), 53, 117, 277
Holt, Mrs. Henry (Florence Taber), 446
Hornblow, Mrs. Arthur, 53
Horowitz, Mr. and Mrs. Raymond J., 91, 305, 386
Howard, John C., as subscriber, 400
Howe, Fanny Quincy (Mrs. Mark A. DeWolfe), 66
Huening, C., as subscriber, 404
Hughes, William, 174

I

Inglis, James S., 10, 13.
 See also Cottier and Company
Isidor, Joseph S., as agent, 404

J

Jennings, Oliver B., 58, 171
Jesup, Maria DeWitt, 79
Jesup, Morris K., 79
Jewett, George Langdon, 109, 110
Johnson, John G., 161
Jones, Margarette A., 159

K

Kennedy, Edward Guthrie, 91, 96
Kennedy Galleries, 91, 187, 449
Keuffel, Willie L. E., as subscriber, 404
Keyes, Bessie Potter Vonnoh, 95
King, Mrs. Ralph, 443
Kirby, Allan P., 404
Kirby, Thomas E., as subscriber, 139
Knoedler, M., as subscriber, 180
Knoedler and Comapny, M., 55, 56, 92, 117, 188,
 222, 257, 269, 296, 305; as agent, 135, 143,
 191, 198
Kramer, A. Ludlow, 359
Kraushaar Galleries (also C. W. Kraushaar),
 340, 343, 345, 346
Kuhne, Frederick, 27

L

Laffan, William M., 39, 440
Laird Collection, 92
Lambelet, Henry, as subscriber, 404
Lanthier, L. A., 89
Lawrence, C. J., as subscriber, 180
Lazarus, Fanny H., 45
Lefferts, Kate, 177
Lefferts, Mrs. Barent, 177
Lewis, August, 195
Lewison, Mrs. Louis (Florence), 331
Libbey, Edward Drummond, 115
Little, Joseph J., as subscriber, 139
Loeb, Eda K., 39
Lucas, George A., 294

INDEX OF ARTISTS AND TITLES

L

Lady in Black, by Chase, 86–87
Lady, with Fan, by Duveneck, 63–66
Lady with the Rose (Charlotte Louise Burckhardt),
 by Sargent, 226–229
Lake of Orta, by Beckwith, 136
Landscape, by Blakelock, 44–45
Landscape, by Cox, 214–215
Landscape, by Murphy, 153–154
Landscape, by Ryder, 26–27
Landscape and Figures, formerly attributed to
 Blakelock, 46–47
Landscape, Binghamton, New York,
 by Eilshemius, 460–461
Landscape with Goatherd, by Sargent, 263–264
Lathrop, William L., 367–369
Leisure Hour, by Tarbell. See *Across the Room*
Letter, The, by Dewing, 122–124
Lilac Dress, by Dewing, 124
Lockwood, Wilton, 404–406
Lonely Pasture, The, by Lathrop. See *Meadows, The*
Low, Will H., 167–168

M

MacMonnies, Frederick, 447–450
Madame X (Madame Pierre Gautreau),
 by Sargent, 229–235
Madison Square, New York, by Hassam. See *Spring*
 Morning in the Heart of the City
Madonna, by Melchers, 380–381
Magnolia, by Shannon, 219
Male Model, Standing before a Stove, A,
 by Sargent, 220–221
Mannikin in the Snow, by Sargent, 238
Marquand, Henry G., by Sargent, 241–253
Mathews, Arthur Frank, 387–389
Meadows, The, by Lathrop, 369
Measure of Dreams, A, by Davies, 427
Melchers, Gari, 378–383
Melchers, Gari, by Melchers. See *In the Studio*
Mère Adèle, La (Cordon Bleu), by Vonnoh, 330
Metcalf, Willard, 322–325
Midnight, by Shilling, 366–367
Midsummer, by Davis. See *August*
Millet, Frank, 3–7
Milton, Mrs. William F., by Thayer, 98–100
Moeller, Louis, 184–189
Monongahela Valley, by Kane, 375–376
Moonlight, by Tryon, 107–108
Moonlight Marine, by Ryder, 17–23
Moonrise at Sunset, by Tryon, 108–109
Moorish Buildings in Sunlight, by Sargent, 224
Moorish Buildings on a Cloudy Day, by Sargent, 224
Moses, Anna Mary Robertson (Grandma), 390–392
Mother and Child, by Brush, 195–197
Mount Mansfield in Winter, by Taber, 445–446
Mowbray, H. Siddons, 326–328
Mrs. Chase in Prospect Park, by Chase, 85–86

Murphy, J. Francis, 152–155
Music and Good Luck, by Harnett.
 See *Still Life—Violin and Music*
My Bunkie, by Schreyvogel, 401–404

N

New York at Night, by Eilshemius, 461–462
New York Daily News, by Harnett, 55–56
North Country, The, by Metcalf, 324–325
Nourmahal, formerly attributed to Ryder, 31–32

O

Oak Door, The, by Pope, 105–106
Office Board, by Peto, 172–173
Old Barn, The, by Murphy, 154–155
Old Cremona, The, by Peto, 173–174
Old Elm, by Kane, 374–375
Old Mill, The (Vieux moulin), by Robinson, 129
Old Souvenirs, by Peto, 169–171
On the Southern Plains, by Remington, 398–400
On the Thames, by Boggs, 181–182
Opalescent River, An, by Symons, 407–408
Open Doorway, Morocco, by Sargent, 223
Open Sea, The, by Carlsen, 166

P

Padre Sebastiano, by Sargent, 261–263
Palmer, May Suydam, by MacMonnies, 450
Palmer, Walter Launt, 174–176
Paris Street Scene, by Boggs, 183
Parshall, DeWitt, 468–469
Passing of Summer, The, by Watrous, 313–314
Pasture at Evening, formerly attributed to Ryder, 32–34
Pearce, Charles Sprague, 117–119
Peonies, by Lockwood, 405–406
Peto, John F., 169–174
Philosophy: A Preparation for the Mural in the Museum
 of Fine Arts, by Sargent, 270–273
Picknell, William, 145–146
Pipe Dance, The, by Blakelock, 41–43
Pope, Alexander, 104–106
Portrait of a Girl with Flowers,
 by Prendergast, 340, 342–343
Portrait of a Lady, by Benson, 441–442; by Dannat,
 see Jones, Margarette A.
Prendergast, Maurice, 335–347

Q

Quartette, The (Un quatuor), by Dannat, 156–158

R

Rain, The, by Coffin, 179–180
Rajah Starting on a Hunt, The, by Weeks, 78–79
Ranger, Henry Ward, 318–322
Reapers Resting in a Wheatfield, by Sargent, 236

Woodland Vista, formerly attributed to
 Blakelock, 47–48
Wyndham Sisters: Lady Elcho, Mrs. Adeane,
 and Mrs. Tennant, The, by Sargent, 253–257

Y

Yankee Point, Monterey, by H. R. Butler, 285–286
Young Woman, by Thayer, 100–102